changing the way the world learns

To get extra value from this book for no additional cost, go to:

http://www.thomson.com/wadsworth.html

thomson.com is the World Wide Web site for Wadsworth/ITP and is your direct source to dozens of on-line resources. *thomson.com* helps you find out about supplements, experiment with demonstration software, search for a job, and send e-mail to many of our authors. You can even preview new publications and exciting new technologies.

thomson.com: *It's where you'll find us in the future.*

Additional Broadcast Titles by Wadsworth Publishing Company

Broadcast/Cable Programming
Strategies and Practices Fifth Edition

Susan Tyler Eastman
Indiana University

Douglas A. Ferguson
Bowling Green State University

Wadsworth Publishing Company

I(T)P® An International Thomson Publishing Company

Belmont, CA • Albany, NY • Bonn • Boston • Cincinnati • Detroit • Johannesburg • London • Madrid
Melbourne • Mexico City • New York • Paris • San Francisco • Singapore • Tokyo • Toronto • Washington

Assistant Editor: Lewis DeSimone
Editorial Assistant: Michael Gillespie
Production: Cecile Joyner
Print Buyer: Barbara Britton
Permissions Editor: Robert Kauser
Interior Designer: Harry Voigt
Cover Designer: Janet Wood
Copy Editor: Kay Mikel
Compositor: TBH/Typecast, Inc.
Printer: Quebecor/Fairfield

This book is printed on
acid-free recycled paper.

For more information, contact Wadsworth Publishing Company, 10 Davis Drive, Belmont, CA 94002,
or electronically at *http://www.thomson.com/wadsworth.html*

International Thomson Publishing Europe
Berkshire House 168-173
High Holborn
London, WC1V 7AA, England

International Thomson Editores
Campos Eliseos 385, Piso 7
Col. Polanco
11560 México D.F. México

Thomas Nelson Australia
102 Dodds Street
South Melbourne 3205
Victoria, Australia

International Thomson Publishing Asia
221 Henderson Road
#05-10 Henderson Building
Singapore 0315

Nelson Canada
1120 Birchmount Road
Scarborough, Ontario
Canada M1K 5G4

International Thomson Publishing Japan
Hirakawacho Kyowa Building, 3F
2-2-1 Hirakawacho
Chiyoda-ku, Tokyo 102, Japan

International Thomson Publishing GmbH
Königswinterer Strasse 418
53227 Bonn, Germany

International Thomson Publishing Southern Africa
Building 18, Constantia Park
240 Old Pretoria Road
Halfway House, 1685 South Africa

Library of Congress Cataloging-in-Publication Data

Eastman, Susan Tyler.
 Broadcast/cable programming : strategies and practices / Susan
Tyler Eastman, Douglas A. Ferguson. — 5th ed.
 p. cm.
 Includes bibliographical references and index.
 ISBN 0-534-50744-1
 1. Television programs—Planning. 2. Radio programs—Planning.
3. Cable television—Planning. I. Ferguson, Douglas A. II. Title.
PN1992.55.E18 1996
791.45'0236'0973—dc20 96-17888

#34721633

Sydney W. Head contributed immeasurably to the lives of countless students and colleagues during four decades of teaching and writing. His influence was enormous, both as a scholar of unquestionable integrity and standards and as a respected teacher. His ground-breaking first edition of *Broadcasting in America* (1956) helped define the conceptual parameters and scholarly directions of domestic and international radio and television. His major works included five subsequent editions of that book, three editions of the book you hold in your hands (the first in 1981), plus an anthology on *Broadcasting in Africa* (1974) and a path-breaking text on *World Broadcasting Systems* (1985). He will be long missed for his sage advice, penetrating editing skills, and gentle sense of humor. He died of cancer in 1991 at the age of 77.

Robert F. Lewine, a valued contributor to the chapter on prime-time network television, was president of the Academy of Television Arts and Sciences Foundation, an office he assumed in 1964. He had the distinction of having served as a vice-president of programming at all three networks—ABC and NBC in New York and CBS in Hollywood—and as vice-president of television at Warner Brothers. His background included commercial production, program research, advertising, and program production. In addition to founding *Television Quarterly*, Mr. Lewine was actively involved in the development of the Emmy awards from their inception and the establishment of the ATAS/UCLA television archival library in Los Angeles. He taught often at the University of California in Los Angeles, the University of South-ern California, Columbia College, and California State University at Northridge. While serving as trustee of Columbia College and of the American Women in Radio and Television Foundation, Columbia College awarded him an honorary doctorate of Humane Letters in 1982. He died in 1993.

Edd Routt, as general manager of several radio stations and writer on radio, brought a wealth of expertise in news, sales, and station management to his chapter on music programming. He created a hypothetical market in which the reader goes step by step through the process of selecting a competitive format. After deciding on rock music for this proposed station, he detailed a system for song classification and delineated the role of research. For the chapter on music radio programming Mr. Routt drew on his experience as a broadcast consultant and general manager of KSLM/KSKD, Salem, Oregon; vice-president and general manager of WKRG/WKRG-FM, Mobile, Alabama; general manager of KLIF, Dallas; general manager of WRR-AM/FM, Dallas; and sales manager of WFAA/KZEW, Dallas. He taught station administration for many years at Southern Methodist University and wrote three books on broadcasting: *The Business of Radio Broadcasting* (TAB Books, 1972), *Dimensions of Broadcast Editorializing* (TAB Books, 1974), and *The Radio Format Conundrum* (with McGrath and Weiss, Hastings House, 1978). At the time of his death in 1991, Mr. Routt and his son owned and operated two Class-A FM stations in Texas: KCKL at Cedar Creek Lake and KXAL in Pittsburg. His family continues to operate both stations.

Brief Contents

Detailed Contents

Preface

In the years since the fourth edition of this book, programming has continued to evolve dramatically.

Broadcast networks have lost more of their audience to cable, independent stations, and home video; Fox has become an established prime-time competitor, and additional networks have joined the fold; the technologies of digital compression and fiber promise hugely expanded cable capacity and the possibility of multiplexed channels, eliminating the channel capacity crunch that has driven cable strategy for more than a decade; the foundation cable networks have developed strongly competitive programming strategies; direct-to-home satellite broadcasting is a reality; pay-per-view television is finally succeeding; local cable television has risen to the threshold of profitability; public television is fighting a hostile legislative environment; peoplemeters have permanently altered the process of collecting audience estimates for television; programmers have begun to weigh the international market's potential in choosing programs; coproductions and joint ventures have begun to invigorate the new program production process for broadcasting and cable; and satellites have further stimulated radio syndication and networking.

In response to changes in the industry and the suggestions of users of this book, a number of changes have been incorporated in this fifth edition:

- The chapter on broadcast affiliates has been rewritten to explore the new challenges of being broadcast in an increasingly narrowcast world.
- The chapter on premium and pay-TV now encompasses the expanding arena of DBS and other alternative delivery systems.
- The chapters on cable programming have been reorganized and condensed.
- The chapter on information radio now includes public radio, shortening the number of chapters and providing a unified perspective on non-music formats.
- The chapters on national and local public television were merged into one to explore PBS's complex mission.
- The opening chapter has been rewritten to provide an updated perspective on programming and to introduce the book's simplified structure.

Despite these changes, the fundamental approach to the subject of programming characteristic of earlier editions has been retained.

Only at the most generalized level can we make statements about programmers and their functions that apply equally to all sorts of programming situations. The book starts with such generalizations because all types of broadcasting

and cable ultimately share certain common attributes, no matter how diverse the surrounding circumstances. But the heart of the book lies in the testimony of actual practitioners in varied programming situations, and these authors evaluate programming in the pragmatic way that programmers themselves judge programs—by their ability to attract targeted audiences

Organizing Principles

Throughout this book, the job of the programmer is divided into three activities—*scheduling, evaluation,* and *selection*. Part One opens with a chapter defining these activities, along with other common programming concepts such as the basics of television and radio scheduling. Chapter 2 reviews the central tools of evaluation, *ratings,* and Chapter 3 examines the syndication side of the program selection process. The three activities of selection, scheduling, and evaluation guide the organization of the remaining chapters, each of which deals with a particular programming situation from the perspective of a practitioner specializing in that type of programming.

Structure of the Book

The book divides into four major sections. Part One introduces the concepts and vocabulary for understanding the remaining chapters, and Parts Two, Three, and Four look at programming strategy for television, cable, and radio broadcasting, respectively, from the perspective of industry programming experts.

- Each *part* begins with a brief overview, relating the set of chapters to each other, and to the rest of the book.

- Each *chapter* starts with an outline containing chapter headings and subheadings. Information about the contributing authors has been moved to the back of the book with this edition.

- A *summary* concludes each chapter, followed by suggested sources and notes. The sources provided at the end of the chapter include works

that expand, support, complement, or contrast with the point of view expressed by the authors.

- A list of *abbreviations and acronyms* appears near the end of the book.

- A *glossary* summarizes the concepts and vocabulary pertaining to programming. Glossary entries appear in **boldface** in the text; however, boldfacing is not limited to glossary terms.

- An *annotated bibliography* of recent and seminal works on programming provides a comprehensive list for further reading. References appearing in the notes are not repeated in the bibliography if they are highly topical or do not relate mainly to programming.

- An *index* to the movie, television, and radio program titles mentioned in the text precedes the *general index*.

- Finally, a supplementary *Instructor's Guide* provides syllabi, short assignments, information on major projects, lists of videotapes, test questions, and other resources.

Acknowledgments

The most marked change in this new edition is the addition of Douglas Ferguson as co-author in a seamless transition. For more than a decade, Sydney Head and Lewis Klein worked with Susan Eastman to envision the framework and direction of previous editions of this programming book. They provided gentle guidance and invaluable help in securing access to people and materials that greatly enhanced three previous editions. They both contributed strong chapters to earlier editions, and much of their work remains in this edition. Both colleagues devoted long hours to editing and polishing the book's language and have left indelible stamps on this book.

Warm thanks go to the individuals and organizations that assisted with this edition. Special thanks go to Karin Gattringer, who helped organize a huge clipping file that was forwarded regularly from Susan Eastman's office at Indiana University. Dave Miller of WRGT in Dayton, Ohio, supplied some ratings material for Chapter 2.

We also wish to recognize those who reviewed the fifth edition in preparation and thank them for their generous compliments and useful suggestions: Don Edwards, Syracuse University; Robert Finney, California State University, Long Beach; Barry Janes, Rider College; Leslie Smith, University of Florida, Gainesville; and Joan Van Tassel, Pepperdine University. In addition, several individuals contributed student materials to the Instructor's Guide, and we wish to express our appreciation for their efforts: William J. Adams, Kansas State University; Christopher Rapp, Tele-Communications, Inc. (TCI); and Mitchell Shapiro, University of Miami.

At Wadsworth Publishing Company, Katharine Hartlove supported us with wise counsel. Cecile Joyner efficiently supervised the book's production phase, and Kay Mikel employed her extraordinary copyediting skills to polish and smooth the text. We are grateful to all these people for their help, as well as to the National Association of Television Program Executives, and to both the Department of Telecommunications and the College of Arts and Sciences at Bowling Green State University for their support.

More than anyone, my wife Cindy receives my thanks for enduring my stressful behavior.

Douglas A. Ferguson

Broadcast/Cable Programming

PART ONE

Programming Resources and Constraints

Today American homes typically have two, three, or more TV sets and one or two VCRs. Adults now watch nearly five hours of television daily and listen to nearly two hours of radio; children and teens watch television about three and a half hours daily, and teens consume five or more daily hours of radio. Thus, television and radio play a crucial role as sources of entertainment and information in American lives. This book explains how programs get on the broadcast and cable media, who makes them, why they are the way they are, and what limits operate on programmers and management. It reveals the strategies of network, station, and system programmers as well as describing common industry practices.

Part One consists of three chapters. These chapters introduce concepts used throughout the book and provide a broad perspective for understanding subsequent chapters.

Chapter 1 introduces the major **concepts and vocabulary of programming strategy.** It lays the groundwork for conceptualizing the essential nature of the programming function. Despite the tremendous variety of programming in broadcasting and cable, all programmers face similar problems and approach them with similar strategies.

Common assumptions that underlie programming behaviors can be understood by examining the programmer's options. Some constraints operating on programming situations are beyond the programmer's immediate control; others leave room for exercise of the programmer's skills. In this chapter the author spells out the wide range of skills and types of knowledge a programmer needs, including a discussion of the impact of regulation and ownership on programming.

Chapter 2 introduces the major concepts of **program and audience ratings** crucial to understanding programming strategies. In this chapter the authors describe the qualitative and quantitative research tools of broadcasting and cable, explain how they can be put to use, and assess their programming value. The focus is on national and local market ratings, because they are the industry's primary method of program evaluation. Ratings are the major measure of success or failure and as such provide the means for setting advertising rates. Chapters 3, 4, 8, and 12 supplement the measurement tools introduced in Chapter 2 and discuss specialized data collection methods and review highly specialized research and rations reports. Chapter 2 provides a basic understanding of how the industry evaluates programs and audiences and lays the foundation for further study.

1

Chapter 3 introduces the topic of **program syndication in the United States.** It begins by following the syndication process from initial production of a program to station purchase, tracing the roles of the major participants in the domestic syndication business. (International syndication is covered in Chapter 11 on premium cable networks.) In Chapter 3 the author details the process of making a deal for a first-run or off-network program and the influence of station representative firms in helping their client stations purchase and schedule programming. The role of ratings in decision making about program purchase and scheduling is outlined, and many of the research reports available to programmers and syndicators are discussed. The mechanisms of negotiation and bidding and pricing syndicated programs are described along with methods of paying for programs. These concepts and practices are especially important to understanding broadcast television programming as it relates to affiliates and independent station strategies and practices (Chapters 6 and 7). The ideas covered here also influence network prime-time programmers.

The three chapters making up **Part One,** then, discuss programming strategies from a broad perspective, supplying an overview of programming strategies and specific tools for interpreting the more specialized chapters in the rest of the book.

A Framework for Programming Strategies

Douglas A. Ferguson

A GUIDE TO CHAPTER 1

The late Sydney Head of Temple University, Susan Tyler Eastman, associate professor of telecommunications at Indiana University, and Lewis Klein of Gateway Communications, Inc., were contributors to previous editions of this chapter.

WHAT IS PROGRAMMING?

In the media world, programming is the software that gives the hardware a reason for existing. Both are necessary for the system to work, but without programming no broadcasting or wired services would exist.

In this chapter and the ones that follow, you will be introduced to the realm of programming. Programming can describe either *a group of programs* on a radio station or television channel, as in "I really enjoy the programming on that new channel," or *the act of choosing and scheduling programs* on a broadcast station or a subscribed channel, as in "I do most of the programming at this station."

Programming is an outcome or a process. The process of selecting and scheduling programs defines the work of a programmer. You may be designated as program director, program manager, or operations manager, but your job will be to choose the programs that the audience wants or needs and then design a schedule for them. If the station for which you work as a programmer has weak programming, then the outcome may seem more important than the process. You need new programming, in the most tangible sense. Your employer seeks a large audience for the station's advertisers. The new shows you choose must appeal to more viewers (or listeners, in the case of radio) than did the old shows.

The kind of programming covered in this book deals with electronically delivered materials. It does not deal directly with feature films projected in theaters, although companies that make feature films are responsible for much of the content of commercial television. Similarly, the book does not directly address the music industry that makes recorded music for compact disc or cassette, although these companies (usually owned by the same entertainment conglomerates that produce video programming) are responsible for much of the content of commercial radio.

Distribution of programming is a lot less important than you might believe, but a programmer should understand the different means for getting programs to the consumer. The basic distinction is *wired* versus *broadcast*. Wired communication takes place over a coaxial or fiber optic cable, which can originate with a **community antenna cable company (CATV)** or a telephone company (telco). In the mid-1990s the telephone companies tested video services (known broadly as video dialtone or open video systems) to compete with cable television systems, but many telcos decided to move cautiously into these areas.[1] USWest, for example, purchased Continental, an existing multiple system operator (MSO).

Broadcast signals are typically transmitted over-the-air signals from radio (AM and FM) and television stations (VHF and UHF), but the use of special high-frequency signals also fits the definition of broadcasting. One example is *wireless cable*, a **multichannel multipoint distribution service (MMDS)** sending out line-of-sight signals to receiving antennae. Another example is the **direct broadcast satellite (DBS)** service that transmits programming from geostationary orbiting transmitters to small receiving dishes. This service is also referred to as **direct-to-home (DTH)** and **television receive-only (TVRO)** broadcasting. Competition has been fierce among the early entrants: DirecTV, USSB, Primestar, Echostar, and Alphastar. Box 1.1 has more on this changing media landscape.

The Process of Programming

Programming is not rocket science or brain surgery, but being successful at programming is still very challenging. The primary goal in programming is to *maximize the size of an audience targeted by advertisers*. The only way to accomplish this goal is to *satisfy the needs and wants of that audience*.

In the case of mass-appeal channels, such as the major television networks and basic cable channels, the programmer wants as many people as possible, targeted or not. Ideally, the demographic characteristics popular with various advertisers will be well-represented in the total audience.

1.1 THE CHANGING MEDIA LANDSCAPE

At the approach of a new millennium, the landscape of broadcast programming is undergoing revolutionary change. Phone companies want to get into cable TV. Cable threatens to enter the phone business. Over-the-air stations have begun to summon their forces against dangerous competitors in cable, telephone, and direct satellites.

For decades, Nielsen and Arbitron competed in the local TV ratings arena; now only Nielsen survives. For many years, students needed to understand regulations based on FCC jargon like Fairness Doctrine, fin-syn, and PTAR; now those rules are gone. The Big Three networks, all of which changed hands in the mid-1980s, are undergoing drastic change. CapCities/ABC was purchased in 1995 by Disney; during that same week CBS found a new owner in Westinghouse. Having finished in first place in 1994, CBS finished in third place in 1995 and, almost beyond belief, began the first week of the 1995–96 season in *fourth* place. In 1994 the Fox network turned the broadcast world on end by capturing NFL Football from CBS and by snapping up several CBS-affiliated stations in major markets. Time Warner purchased Ted Turner's media holdings in 1995 for $8 billion. Two new television networks (UPN and WB) debuted in early 1995, and rumors of a merger surfaced later that year.

At the close of 1995, Microsoft and NBC announced plans to offer interactive services in a coventure.

Changes came to the radio industry as well in 1995. Evergreen Media and Chancellor Broadcasting each acquired a dozen or more stations to join the ranks of the largest radio-only companies.[2] ABC Radio and CBS Radio were experimenting with radio programs delivered by the World Wide Web over the Internet computer network. Such **cybercasting** allows radio programmers to distribute materials directly to the consumer via a computer modem, bypassing local radio affiliates.

The year 1995 may be remembered as the time the "family viewing hour" finally passed away. In the 1970s, the Big Three networks targeted the 8–9 P.M. time slot for shows the entire family could watch. Cable channels and the Fox network have chipped away at this idea, which was popular with many viewers, if not the programmers. The demise of the family viewing hour is looked on by some as part of a general erosion in values in the United States. Others point to flaws in the original idea, which assumed that people watching simultaneously scheduled programs in the Central time zone went to bed earlier than viewers in the Eastern time zone (and that children neither stayed up past 9 P.M. nor

watched objectionable content on daytime TV).

Finally, the Telecommunications Act of 1996 made sweeping changes to the regulatory environment for cable, broadcast, and telco ownership. It also provided for content controls via the V-chip, described later in this chapter. The most significant outcome of the Act has been to permit radio and television stations to attain a larger critical mass via reduced ownership limits. Broadcasters should also benefit from longer license terms.

Some expected developments in the 1990s have been notable for *not* coming to be. For example, huge companies involved in cable, telephony, and broadcasting failed to act on announced coalitions. TCI and Bell Atlantic called off their merger in 1994, as did Southwestern Bell and Cox. These and other mergers were victims of FCC regulations that changed the profitability of the cable television business.

What does the future hold? Your opinion may be more informed than those in this book because events continue past publication deadlines. The educated guess in 1995 is that the survivors in the monumental battle to agglomerate huge media empires will result in a handful of mega-winners: TCI, Time Warner, Comcast, Cox, and USWest.[3]

In the case of specialty cable channels (called **niche networks**) such as the History Channel or The Nashville Network, the programmer is more interested in pleasing the target audience than in expanding audience size. Of course, the larger the size of the target audience, the easier it is to make money.

All programmers must deal with certain limitations, most of them economic. Program resources are scarce. Good shows cost a lot of money. Unfortunately, bad shows are also expensive.

Audience resources are scarce in terms of time and money. The audience is available to use the media for only so many hours per day. In the case of programming for which viewers pay a fee, there is a limit to how much they can spend before they start complaining to Congress about subscription fees.

A step-by-step procedure for doing programming would go something like this. First, choose programs that seem to meet the needs and wants of an audience. Second, organize them into a coherent schedule that flows from one program into the next. Finally, evaluate the results (see Chapter 2) and make necessary adjustments. This is the basic recipe for cooking the perfect program schedule (see 1.2).

Programming Is Like Food

At its basic level programming represents individual shows (programs) that people choose. The restaurant metaphor is a useful basis for understanding program choice. *TV Guide* is your menu. The channels are the restaurants. The shows are the food.

When you think about food, a seemingly endless combination of choices is available, but they all come from a few food groups: meat, vegetables, dairy, and fruit. Similarly, programs originate in a few program types or genres. The prime examples are situation comedy (sitcoms), drama, news, talk, music, sports, and movies.

Quality or quantity or convenience—which do you want? If you want good food without much wait, you can expect to pay more. If you want fast

1.2 RECIPE FOR SUCCESSFUL PROGRAMMING

1. Target a demographically desirable audience.
2. Choose appropriate programs for that audience.
3. Evaluate reasonable costs for program types and time slots.
4. Evaluate competition to determine scheduling strategy.
5. Make sure a program fits in with neighboring programs.
6. Employ talented performers who are liked by the public.
7. Hire producers/directors/writers with a record of success.
8. Deal with currently topical subject matter.
9. Emulate comparable high-rated series.

food at a low cost, you can expect lower quality. It is the same with programming. Program producers can deliver high quality if audiences are willing to wait for those special events or if viewers are willing to bear the cost (see 1.3). For the most part, broadcast programming follows the fast food analogy: plenty of food, low cost, but not a wide selection, and certainly not the quality you might desire.

Eating food requires no special skills, and neither does the consumption of media programming. Unlike books, where reading skills are required, radio and television require no intelligence at all. This may explain the snobbish disdain among some critics for entertainment and information distributed over the electronic media.

Like the food in some restaurants, broadcast programming is continuously available from various sources. Just as restaurants may be national, regional, or local, the distributors of media programs operate on three different levels. The *net-*

1.3 WHAT IS QUALITY?

Whenever the word *quality* is attached to programming, viewers think they know what that means. Do they?

Quality often connotes strong production values (lavish sets, famous performers, riveting scriptwriting, technical achievement) and critical acclaim. Those who fight to save quality programs often see some substantial social value in such shows.

So why is quality lacking in most television shows? Is it money, or could it be that the masses want circuses instead of high culture?

Perhaps quality signifies only that a group of viewers finds some subjective value that is independent of objective criteria. If we cannot agree on what constitutes quality, does it really exist? Maybe those who use the phrase "quality television" really mean to say "programs that we really like."

Programmers are well-advised to be careful with the word *quality* as long as so little consensus exists about what it is. It might be better to strive toward shows that are popular by external standards, rather than programs that have intrinsic quality.

French fries can be copied much more easily than *Friends* or *NYPD Blue*.

How Programming Is Unique

If programming is not exactly like food or some other analogous product, what attributes make it distinct? How is programming unique?

Certainly, *ease of delivery* is key. What other product can be simultaneously delivered to nearly every consumer? Even so, there are still *barriers to entry* for budding suppliers. In theory, anyone can conceive an idea and sell it to a network or cable channel, but the distributors (broadcast and cable networks through their stations and systems) still exert a large measure of control over what programs are run. Yet, it is possible for some programmers to start small and build a national audience. Oprah Winfrey, and Phil Donahue before her, started at a small station doing a local talk show before achieving national television prominence.

Reaching a national audience is becoming less difficult. Satellite dishes are getting less cumbersome and less costly with each passing year, and a growing number of program suppliers are looking for program sources. Video rentals are another growing avenue for program suppliers.

Broadcast programming is also unique because there is *no direct cost* to the consumer for the most popular shows. Although cable and satellite programmers may eventually siphon away the most desired programs, the broadcast networks are able to provide very popular comedy and drama programs, along with top sporting events and live news coverage, absolutely free to the audience. The advertiser pays for the programs in exchange for the commercials that are presented to the audience.

It is not entirely clear that the high cost of advertising is passed along to the consumer. The advertiser's ability to market products to huge audiences may actually decrease the cost of the products because of economies of scale. It usually costs more for producers to market products to a small number of people, thereby raising the price.

work buys or produces programs to distribute over its affiliated stations (see Chapter 6). Program *syndicators* buy or produce shows to sell directly to stations or cable channels (see Chapter 3). Finally, each *local station* produces its own programs to meet the unique needs of its audience, although not to the extent each did during the early days of radio and television.

Thus, the stations and cable channels are the restaurants and the networks/studios are the wholesale suppliers. Rerun programs are the leftovers. With the exception of videotape rentals, the normal mode of distribution is home delivery.

Such an analogy, of course, can only go so far. Food is a necessity, entertainment is not. Food is a commodity, programming has a unique identity.

Why should the radio or television programmer care how "free" the programs are to the receiver? In the case of broadcast programming, *the low cost of the programming is key to creating an audience large enough to sell to advertisers.* Contrary to popular belief, broadcasters are not in the business of creating programs; they are in the business of creating audiences that advertisers want to reach. Even in the case of cable channels, advertiser support is very important to the programmer because costs are seldom borne entirely by subscriber fees.

Only premium pay channels like HBO and Encore sell their programs directly to the audience. The television programs most watched by viewers are advertiser-supported. Programming is a unique product in that it is used to lure the attention of consumers so advertisers can distract them with commercial messages that help sell other products. Programmers only work indirectly for the audience; the primary customer is the advertiser, without whom there would be few programs to see or hear.

What Does the Audience Want?

The most important part of programming is understanding the audience. What appeals to them? Quite simply, audiences want to be entertained, and they want to be informed. These two elements comprise the whole of programming (see 1.4).

The demand for entertainment encompasses a mixture of comedy and drama. Narrative stories represent the norm. These stories have a beginning, a middle, and an end. Characters have goals resulting from a desire. Along the way, they encounter some form of conflict. In a comedy program, the conflict is a humorous situation that is resolved in a way that causes the audience to laugh. **Situation comedies (sitcoms)** usually appear in half-hour episodes. In a drama program, the conflict results from a counterforce, often "the bad guys." Most dramas last an hour, occasionally longer.

Comedies and dramas are composed of various ingredients that appeal to most audiences: engaging dialogue, attractive characters, sexual themes,

1.4 A PROGRAMMING MYTH

The late Sydney W. Head was a frequent contributor to earlier editions of this textbook, and he had this to say about programming:

A popular fallacy holds that innumerable workable new program ideas and countless usable new scripts by embryonic writers await discovery and that only the perversity or shortsightedness of program executives keeps this treasure trove of new material off the air. But television executives hesitate to risk huge production costs on untried talents and untested ideas. Even when willing, the results rarely differ much because mass entertainment remains the goal. A national talent pool, even in a country the size of the United States (and even for superficial, imitative programming), is not infinitely large. It takes a certain unusual gift to create programs capable of holding the attention of millions of people hour by hour, day by day, week after week.

nostalgia, and high emotion, to name a few. The audience for both types of entertainment shows are also interested in seeing or hearing something novel, even if it is an old idea with a new twist.

Information programming is also driven by novelty. Viewers want fresh stories that promise something new. Critics can complain about the trivialization of information, but news and information programming with an entertainment approach (**infotainment**) attract a larger audience.[4] Local stations' news broadcasts necessarily pay close attention to the lighter side of community events because there are fewer opportunities for hard news than on the national level.

Researchers have studied the appeal of different types of programming. Television and radio audiences look for different program types that can be classified by genre: comedy, drama, sports, news. Looking at the type of program demanded by the

audience is one way to study what people want, although it is not a perfect method. For example, some situation comedies have "serious" episodes that address social issues, and some dramas venture into comedy.

Uncovering the Mystery

Merely asking the audience what they want is difficult. Many times they do not know what they want until they see it, and a short while later they tire of it and crave something new. Programmers must become accustomed to dealing with fickle audiences. The only refuge is to uncover the mystery of how the audience makes choices about what to watch.

The process whereby audience members make choices is seldom clear. Theoretical models of choice have their origins in scholarly research.[5] To date, these models have served less to predict or explain than to describe. Part of the problem with academic investigation of program strategy is that the folklore of programming tactics is too appealing to program producers and distributors.

There are three basic approaches to predicting choice. One way is to look at the uses and gratifications of media consumption. This approach frequently substitutes the self-reported attitudes of viewers for more concrete information on their actual behavior. Additional predictors (market size, program length, awareness, cable/VCR penetration, and audience availability) are also used to predict choice. Research findings in this area are often unsatisfying, or unusable, because the really strong predictors such as audience availability are not usually controlled by the programmers (or the viewers).

The most promising way to predict choice is to study the actual content variables of programming. What is the most important element of the television or radio program? Some say it is the likability of the main characters. Others point to the compelling nature of the story or the format. Oddly enough, little academic research has been done in this area, perhaps because using structural predictors is easier than using content variables.

In any case, getting anyone to study programming as a serious topic is not easy. The networks and other program suppliers do not sponsor much theoretical research, although applied research (ratings) is a must. Ideas are tested, pilots are tested (see Chapter 2), but programming seems to remain one big gamble where instinct is more important than science.[6]

Adding to the misinformation about programming is the fact that viewers and listeners believe they are programming experts merely because they watch or listen. Most people who tune to a broadcast program feel that they could do a better job of choosing the shows and selecting the time slots. If that were really true, of course, there would be no need for a book on how to be a programmer. It may not be rocket science, but programming is a bit more difficult than it seems to many people.

The Lure of Lore

Everyone watches television, so nearly everyone professes to understand what programs ought to be like. Yet merely having preferences does not qualify a viewer, or a programmer, to make accurate decisions or judgments about program strategy.

Because television viewing is so easy, the audience is confident that putting shows on is really simple. Just make good programs and schedule them where they do not conflict with other good shows. Never make any bad shows. What could be easier?

The professionals who work at the major broadcast and cable networks, along with their counterparts at the individual stations in each city, sometimes take a similarly simplistic stand. Always do this. Never do this. Give the people what they want.

Out of this no-brainer philosophy has grown a garden of "rules" that the wisdom of experience has nurtured. Call it folklore, or just lore, many programmers believe that achieving success in broadcast programming is a matter of avoiding common mistakes. Unfortunately, programming is much more complicated. But it is useful to

examine some of the lore that has grown up around programming. Certainly some of it may be good advice. Like most lore, however, the student of programming should be suspicious of universal truths.

First there is the matter of dead genres. A genre is a type of program, such as a Western or a situation comedy. At various times in the history of programming, each genre has been declared dead, according to common wisdom. Westerns are dead, they said—until *Dr. Quinn Medicine Woman* came along. Family sitcoms were dead in 1982, they said—until *Cosby* went on the air.

At this writing, the pundits are sounding the death knell for prime-time newsmagazines and syndicated reality TV. Perhaps such programs have passed their peak. The presumption, of course, can be undone by one show that is the exception.

Another good example is the medical show. In the 1960s the medical genre was very popular, with hits like *Dr. Kildare* and *Ben Casey*. In the 1970s, the medical genre returned with *Medical Center* and *Marcus Welby*, but with the exception of a moderate dent made by *St. Elsewhere*, the genre was comatose and presumed unworkable by the 1990s. In 1994, however, shows like *ER* and *Chicago Hope* became very popular. Perhaps genres are cyclical.

Second, program lore would have us believe that there is a formula approach to building a successful show. For example, take a grizzled veteran of an action profession and pair that character with a young person—you get dual appeal, something for the older and the younger viewers. Or hire a big-name star from the world of movies, or music, or sports. The problem with such recipes is that they lead to bland television.

Third, program lore preaches that certain formats always fail. Anything with chimps. Science fiction has never spawned a major network hit, not even *Star Trek*. Never bank on satire.

There is really no harm in attending to programming lore, as long as the programmer is careful to remember that short-term trends are not the same as permanent laws. It only takes one exception to prove a programming guru wrong.

STRUCTURAL CONSIDERATIONS

Programming is a matter of choosing materials and building a schedule. These two elements are the essence of what a programmer does. Choosing a program depends on circumstances that are closely linked to the source of the programming. Similarly, scheduling is influenced by the type of channel: broadcast, cable, or home video. Types of programs and scheduling are the topics of this section.

Types of Programs

Three basic program sources exist: broadcast network programs, syndicated programs (including feature films), and local programs produced "in-house." These compartments, however, are by no means watertight. Locally produced shows sometimes develop into hybrid blends of local production and syndication. Network entertainment programs "go into syndication" to stations after their initial plays on the national network. Networks sometimes produce **made-for-TV movies (MFTV).** Pay-television suppliers may produce made-for-pay movies and entertainment specials—on-location taping of live performances at concerts, at nightclubs, and in theaters. Live sports events crop up on both cable and broadcast network services and also as syndicated local/regional productions.

Network Programs

The national, full-service, interconnected network is broadcasting's distinctive contribution toward conservation of program resources. Newspapers shared news and features by means of news agencies and syndicates long before broadcasting began, but broadcasting introduced the elements of instantaneous national distribution and simultaneous programming. The national television networks (ABC, CBS, Fox, NBC, UPN, WB) supply the bulk of all broadcast television programs. Nearly 100 cable program networks deliver the bulk of cable systems' content by means of satellite.

Aside from news and news-related public affairs materials, the broadcast networks buy most of their programs from studios and independent production firms. The tortuous route from program idea to finished, on-the-air network series is described in Chapter 4 on prime-time television. Each year, network programmers sift through thousands of initial proposals, shepherding them through successive levels of screening, ending up in the fall with many new programs for each network's new schedule. Outside authors write the scripts, and production houses do the rest of the creative work.

Cable networks differ in major respects from broadcast television networks. In technical delivery, they are similar: In both cases a central headquarters assembles programs and distributes them nationwide, using orbiting satellites to reach individual broadcast stations or cable systems. But the financial and working relationships between broadcasting affiliates and their networks and between cable affiliates and their networks differ fundamentally. Cable systems depend almost totally on satellite-distributed programming to fill their channels, and because they have many channels, they deal with many networks. The traditionally symbiotic relationship between each broadcast network and its affiliates does not exist in the cable field. Most cable network programmers have far less input into the creative aspect of programming than do their broadcast counterparts.

The great bulk of cable network programming comes from the same sources as broadcast programming—distributors of feature films and syndicated programs—and, indeed, much of it is old network programming, although this is changing. Pay and pay-per-view cable, of necessity, increasingly venture on their own production enterprises. The multiplication of splinter channels has greatly increased the programmer's problems.

Two developments with regard to cable networks warrant attention. First, the larger cable networks are spending much more money on original programming than they did in the 1980s, breaking the $140 million level in 1995. Second, cable networks in the United States have gone global via satellite, with international distribution of TBS, ESPN, Discovery, HBO, and Country Music Television. These trends underscore the importance of cable's role in programming.

The traditional radio networks once offered by ABC, CBS, and NBC no longer qualify as full-service networks. Those that have not been sold now resemble syndicators, supplying features and program inserts such as newscasts. Conversely, some radio program syndicators supply stations via satellite with complete schedules of ready-to-air music in various established formats, much like the networks except that stations now pay the networks. Formerly, the old radio networks paid the stations to compensate the loss of advertising revenue.

Public broadcasting network programmers face still a different situation. Originally designed as an alternative to the commercial system, **Public Broadcasting Service (PBS)** programming comes ready-made from the larger member stations specializing in production for the network, from small independent producers, and from foreign sources, notably the British Broadcasting Corporation. Foreign sources supply more elaborate productions than PBS can generally afford to commission, costing PBS about one-tenth of what a similar program would if produced in the United States. **Coproduction,** sharing production costs by broadcasting organizations in different countries, accounts for an increasingly large proportion of Public Broadcasting Service programming.

Syndicated Programs and Feature Films

Local broadcast programmers come into their own when they select syndicated programs for their individual stations. They draw upon these sources:

- **Off-network series:** programs that have reverted to their copyright owners after the network that first ran them has used up its contractual number of plays.

- **First-run syndicated series** and **specials:** programs packaged independently by producers and marketed directly to individual stations rather than being first seen as network shows;

typical of such series are *Entertainment Tonight*, *Oprah*, and holiday specials.

- **Feature films:** movies made originally for theatrical exhibition.

Of all the program types, the feature film is the most in demand because of its popularity on so many different delivery systems. The term **window**—borrowed from the world of space flight in which rockets can be launched only through certain time-space openings when conditions are just right—has been applied to the release sequence by which feature films reach their various markets. First, of course, comes the traditional window of theatrical release, either simultaneously in several thousand theaters throughout the country or in stages of "limited release." Next in the usual order of priority (see Chapter 11) come releases through the windows of home video and pay-per-view cable, regular pay cable, broadcast networks and, finally, general broadcast and cable syndication. Prices for rentals decrease at each stage of release as products age and lose their timeliness.

Local Production

As the chapters on television station programming will show, local news programs play an important role in broadcast station program strategies (even these programs, though locally produced, often contain a great deal of syndicated material as inserts). But aside from news, locally produced material plays only a minor role as a program source. True, all-news, all-talk, and all-sports radio stations depend almost entirely on local production, but those formats cost so much to run and have such a specialized appeal that they remain few in number. Stations simply find syndicated material cheaper to obtain and easier to sell to advertisers.

A few **cable systems** have undertaken competitive local news production, but most do not invest the kind of money in facilities and staff required for a competitive news department unless they have a cooperative arrangement with a broadcast TV station. Even though metropolitan cable franchises usually mandate one or more **access** chan-

nels for use by the general public, municipal agencies, and education, these sources account for only a tiny fraction of cable system programming. **Local origination** channels, used by cable systems for their own programming and syndicated material, contribute valuable options to the total program service supplied by cable systems in many cities.

Scheduling

Of all the programmer's basic skills, perhaps **scheduling** comes closest to qualifying as uniquely a radio and television specialty. One critic has referred to broadcast television scheduling as an "arcane, crafty, and indeed, crucial" operation; another has said that "half a (network) program director's job is coming up with new shows; the other half, some would say the other 90 percent, is in knowing how to design a weekly schedule, in knowing where to put shows to attract maximum attention."[7]

Scheduling a station, cable system, or network is a singularly difficult process. It demands use of the principles of compatibility, habit formation, flow control, and resource conservation. Even with multichannel competition and the proliferation of remote controls, the audience for one show can influence adjacent programs. Furthermore, scheduling requires understanding one's own and one's competitors' coverage patterns, market, and audience demographics. Access commitments and owner policies complicate scheduling for cable channels. Cable programmers also have to weigh the claims of competing services for specific channel locations. VHF television stations, for example, much prefer a cable channel that matches their over-the-air channel number, and UHF stations would like a channel between 2 and 13 (there being no necessary relationship between the cable channel number a station occupies and its own assigned broadcast channel number). Stations particularly object to **repositioning,** moving them to higher number cable channels. But cable operators prefer to give the choicest positions to the most popular (or most lucrative) services, whether they are broadcast or cable-only (especially the cable channels they own all or part of).

Each of the specialist chapters later in the book deals with the strategies of scheduling within a particular programming environment. Each situation has its own strategies, yet all of them rely on fundamental programming principles.

THE ELEMENTS OF PROGRAMMING

The most anyone can hope to learn about programming is to understand the various strategies for selecting and scheduling programs. In previous editions of this textbook, Sydney Head organized these strategies into various "themes." This approach is still useful in the new media environment. Briefly, these themes can be summarized as strategies capitalizing on these specific elements:

- Compatibility
- Habit formation
- Control of audience flow
- Conservation of program resources
- Breadth of appeal

These elements may seem old-fashioned in an era where dozens of channels compete for tinier slices of the universe of viewers, but the structural impact of the elements has not vanished. Judicious attention to the overall programming environment continues to be important to programmers who assemble schedules for program services, whether the focus is broadbased or tightly targeted.

Compatibility

Scheduling strategies take advantage of the fact that programs can be timed to coincide with what people do throughout the daily cycle of their lives. The continuous unfolding nature of radio and television allows programmers to schedule different kinds of program material, or similar program materials in different ways, in various **dayparts.** They strive to make their programming compatible with the day's round of what most people do—getting up in the morning and preparing for the day, driv-

ing to work, doing the morning household chores, breaking for lunch, enjoying an afternoon lull, the homecoming of the children after school, the accelerating tempo of home activities as the day draws to a close, relaxing during early prime time, indulging in the more exclusively adult interests of later prime time, the late fringe hours, and the small hours of the morning. And, of course, compatibility calls for adaptation to the changed activity schedules of Saturdays and Sundays. Programmers speak of these strategies in terms of **dayparting**—scheduling different types of programs to match parts of the day known by such terms as **early fringe, prime time** and, in the case of radio, **drivetime.**

Cable television's approach to compatibility has historically differed from broadcasting's approach. Because each broadcast station or network has had only a single channel at its disposal, broadcast programmers must plan compatibility strategies for what they judge to be the "typical" lifestyles of their audiences. Some broad-appeal cable services such as USA Network follow this same pattern. Cable systems, however, can devote entire channels to atypical audiences, ignoring dayparts. They can cater to the night-shift worker with sports at 6 A.M., to the single-person household with movies at 6 P.M., to the teenager with round-the-clock videos, using a different channel to serve each interest. Even so, cable capacity is limited at present to an average of 36 channels, but by the year 2000 digital compression and multiplexing technology will radically alter these limits for both broadcasting and cable.

Habit Formation

Compatibility strategies acquire even more power because audience members form listening and watching habits. Scheduling programs for strict predictability (along with promotional efforts to make people aware of both the service as a whole and of individual programs) establishes tuning habits that eventually become automatic. Indeed, some people will go to extraordinary lengths to avoid missing the next episode in a favorite series.

Programmers discovered this principle in the early days of radio when the *Amos 'n' Andy* habit became so strong that movie theaters in the 1930s shut down their pictures temporarily and hooked radios into their sound systems at 7:15 P.M. when *Amos 'n' Andy* came on. About that time the fanatic loyalty of soap opera fans to their favorite series also became apparent, a loyalty still cultivated by today's televised serial dramas.

Ideally, habit formation calls for **stripping** programs—scheduling them Monday through Friday at the same time each day. To strip original prime-time programs, however, would require building up a backlog of these expensive shows, which would tie up far too much capital. Moreover, networks want maximum latitude for strategic maneuvers in the all-important prime-time schedule. If a broadcast network stripped its three prime-time hours with the same 6 half-hour shows each night, it would be left with only 6 pawns to move around in the scheduling chess game instead of the 22 or so pawns that weekly scheduling of programs of varying length makes possible.

However, when weekly prime-time network shows go into **syndication,** stations and cable systems schedule them daily, a strategy requiring a large number of episodes. A prime-time series must have been on a network five years to accumulate enough episodes for a year's stripping in syndication (including a substantial number of reruns). Since few weekly shows survive five years of prime-time competition, the industry periodically faces a nagging shortage of quality off-network programs suitable for syndication.

No one knows whether audiences find themselves more comfortable with the structured, compatible, predictable scheduling of traditional broadcasting than with a multitude of programming choices. However, researchers investigating **channel repertoire** have often observed that when dozens or scores of options are available to listeners and viewers, most tune in to only a very few of the possible sources. For example, A.C. Nielsen surveys of homes with access to 30 or more television channels have consistently found that viewers watched only 8 to 10 of them for more than an hour per week. Recent research data on people's feelings about television (as compared with simple tuning data) suggest that the increased variety of programs and schedule options made possible by cable television and home video recording may be weakening viewing habits. Only about half of viewers (mostly women) choose in advance the programs they watch. Furthermore, active channel switching occurs more often in cable homes than in broadcast-only homes. But even so, we can hypothesize that some people may sometimes prefer to have only a limited number of choices. They may find it confusing and wearying to sift through scores of options before settling on a program. Broadcast scheduling, as a result of compatibility strategies, preselects a varied sequence of listening and viewing experiences skillfully adapted to the desires and needs of a target audience. People can then choose an entire service—an overall pattern (or "sound" in the case of radio)—rather than individual programs.

Control of Audience Flow

The assumption that audiences welcome, or at least tolerate, preselection of their programs most of the time accounts for strategies arising from the notion of **audience flow.** Even in a cable environment with dozens of choices, the next program in a sequence can capture the attention of the viewers of the previous program. At scheduling breaks, when one program comes to an end and another begins, programmers visualize audience members as flowing from one program to the next in any of three possible directions: They try to maximize the number that *flow through* to the next program on their own channel and the number that *flow in* from rival channels or home video, at the same time minimizing the number that *flow away* to competing channels or activities. Many strategies at all programming levels hinge on this concept. Audience flow considerations dominate the strategies of the commercial networks and affiliates as well as their rivals, the cable networks and independent television stations (see 1.5). **Counter-**

1.5 TV VERSUS BOOKS, NEWSPAPERS, AND MOVIES

Controlling audience flow becomes problematic because listeners and viewers have freedom of choice. Unlike the consumer faced with the limited decision of whether or not to buy a book, subscribe to a newspaper, or attend a movie, broadcasting and cable consumers can choose instantaneously and repeatedly by switching back and forth among programs at will. Hence, the programmer cannot count on even the slight self-restraint that keeps a book buyer reading a book or a ticket buyer watching a movie so as not to waste the immediate investment. And, obviously, the polite social restraint that keeps a bored lecture audience seated does not inhibit radio and television audiences. Programmers have the job of holding the attention of a very tenuously committed audience. Its members take flight at the smallest provocation. Boredom or unintelligibility act like a sudden shot into a flock of birds.

programming (simultaneously scheduling programs with differing appeals), for example, is crucial to the strategies of independent television stations seeking to direct the flow away from competing network affiliates to themselves. When a programmer chooses a different type of show to compete with another program, such as scheduling a romantic melodrama versus a sporting event, the strategy is known as *countering*. Conversely, when a similar program is shown opposite a competing show, such as an action movie versus another action movie, the strategy is known as *blunting*.

Fortunately for programmers, many audience members remain afflicted by **tuning inertia.** Although dozens of options often exist in a cable environment, people tend to leave the dial or keypad alone unless stimulated into action by some forceful reason for change. Many times, viewers are engaged in simultaneous activities that preclude a focused attention to what programs might be available on other channels. For example, programmers believe that children can be used as a kind of stalking horse: Adults will tend to leave the set tuned to whatever channel the children chose for an earlier program. Chapter 4 includes some of the common strategies for taking advantage of tuning inertia: lead-in/lead-out, tent-poles, hammocks, bridging, and seamless breaks.

Increased program options provided by cable and the convenience of remote controls have lessened the effect of tuning inertia.[8] Home videocassette recording can defeat the idea of tuning entirely. Researchers recognize several ways the audience uses the remote control keypad to manipulate programming: **grazing,** hunting up and down the channels until one's attention is captured; **flipping,** changing back and forth between two channels; **zapping,** changing the channel or stopping a taping to avoid a commercial interruption; and **zipping,** fast-forwarding a recording to avoid commercials or to reach a more interesting point. Moreover, the VCR has undermined Saturday evening ratings for both broadcast and cable programmers: Huge numbers of viewers regularly rent videocassettes on Saturday nights. Tuning inertia continues therefore as only a modest factor to consider in broadcast programming strategies.

However, formats such as all-news radio and specialized cable channels invite audience flow in and out. They aim not at keeping audiences continuously tuned in but constantly coming back. As a widely used all-news radio slogan goes, "Give us 22 minutes, and we'll give you the world." One cable news service says, "Around the world in 30 minutes."

In any case, the overall strategic lesson taught by the freedom-of-choice factor is that programs must always please, entertain, and be easily understood. Much elitist criticism of program quality arises simply because of the democratic nature of the medium. Critics point out that programs must descend to the lowest common denominator of the audience they strive to attract. This fact need

not mean dismissal of program quality. After all, some programs aim at elite audiences among whom the lowest common denominator can be very high indeed.

Conservation of Program Resources

Radio and television notoriously burn up program materials faster than other media. This is an inevitable consequence of the continuousness attribute. That fact makes program conservation an essential strategy. Satellite networks actively compete for channels on cable systems, suggesting an excess of programs. In fact, the reverse holds true. A high percentage of the programming on cable networks consists of repeats of the same items. The broadcast networks, too, repeat many programs in the form of **reruns,** for example. Cable has stimulated production of new programs and program types, but on the whole cable heightens program scarcity rather than alleviating it. Cable makes parsimonious use of program resources all the more essential.

Anyone doubting the difficulty of appealing to mass audiences need only consider the experience of the older media. Of 27,000 new books printed in one year, only 33 sold 100,000 or more copies; of 13,000 records copyrighted that year, only 185 albums went gold; of 205 feature film releases, only 11 grossed the $20 million reckoned as the minimum to break even. And yet audiences for these media are small compared to the nightly prime-time television audience.[9] Sometimes audience demands and conservation happily coincide, as when the appetite for a new hit song demands endless replays and innumerable arrangements. Eventually, however, obsolescence sets in, and the song becomes old hat. Radio and television are perhaps the most obvious examples of our throwaway society. Even the most massively popular and brilliantly successful program series eventually loses its freshness and goes into the limbo of the umpteenth rerun circuit.

Frugality must be practiced at every level and in every aspect of programming. Consider how often

you see or hear "the best of so-and-so," a compilation of bits and pieces from previous programs; news actualities broken into many segments and parceled out over a period of several hours or days; the annual return of past years' special-occasion programs; sports shows patched together out of stock footage; the weather report broken down into separate little packets labeled marine forecasts, shuttle-city weather, long-term forecast, weather update, aviation weather, and so on.

The enormous increase in demand for program materials created by the growth of cable television would be impossible to satisfy were it not that the multichannel medium lends itself to repeating programs much more liberally than does single-channel broadcasting. A pay-cable channel operates full time by scheduling fewer than 50 or so new programs a month, mostly movies, and runs each film four to six times. Furthermore, movies first scheduled one month turn up again in the following months in still more reruns, which pay-cable programmers euphemistically call **encores.** As cable systems increase their capacity to 150 or more channels by the turn of the century, frugality in sharing and repeating programs will become more essential.

Even the basic cable channels rotate the showing of the same movies, based on the idea that the audience at 8 P.M. will be different from the audience at 1 A.M. A&E double-runs many of its prime-time programs, as does the American Movie Classics channel.

Programmers can also make creative use of low quality shows. Comedy Central and the Sci-Fi channel have featured old horror movies repackaged as *Mystery Science Theater 3000*. Repackaging snippets of talk shows with humorous wraparounds, as in *Talk Soup* on the E! cable channel, is another example. A similar strategy is evident in scheduling programs like *Soap Opera Digest*.

A major aspect of the programmer's job consists, then, of devising ingenious ways to get the maximum mileage out of each program item, to develop formats that require as little new material as possible for the next episode or program in the

series, and to invent clever excuses for repeating old programs over and over. Any beginner can design a winning schedule for a single week; a professional has to plan for the attrition that inevitably sets in as weeks stretch into the indefinite future.

Breadth of Appeal

Stations and cable systems recoup their high capital investment and operating costs only by appealing to a wide range of audience interests. This statement might seem self-evident, yet initially some public broadcasters made a virtue out of ignoring "the numbers game," leaving the race for ratings to commercial broadcasters. But as John Fuller explains in Chapter 8 on national public television programming, this fundamentally unrealistic viewpoint has given way to the strategy of aiming for a high cumulative number of viewers rather than for high ratings for each individual program. This strategy coincides with that of cable television, whose many channels enable it to program to small audiences on some channels, counting on the cumulative reach of all its channels to bring in sufficient subscriptions to make a profit.

The difference between the two goals has been expressed in terms of **broadcasting** versus **narrowcasting.** Gene Jankowski, former president of the CBS/Broadcast Group, uses the terms *aggregation* and *disaggregation,* pointing out that the former deals with shared feelings and interests and the latter with highly personalized tastes and needs. Jankowski's terms take into account our complementary needs for belonging to the group while at the same time retaining our personal individualities.[10]

Only the national television broadcasting networks continue to "cast" their programs across the land from coast to coast with the aim of filling the entire landscape. Of course, no network expects to capture all the available viewers. A top-rated prime-time program draws only 25 percent of the potential audience, although extraordinary programs get up to three times that many viewers.

Nevertheless, by any standard, audiences for prime-time broadcast television networks are enormous. Although broadcast network audience shares have dropped from 90 percent of viewers to less than 75 percent today,[11] a single program can still draw an audience so large it could fill a Broadway theater every night for a century. Such size can only be achieved by cutting across demographic lines and appealing to many different social groups. Network television can surmount differences of age, sex, education, and lifestyle that would ordinarily segregate people into many separate subaudiences.

FIVE ISSUES FOR PROGRAMMERS

Beyond learning the nuts-and-bolts programming framework, the novice programmer must face several external issues that affect decision making. I will present five issues here, but the order is arbitrary. Distribution systems make all programming possible, so technological issues are considered first (also see 1.6 for more on this topic). Without money (economic issues), of course, there can be no widespread development of new technologies. From economics flows some kind of structure, creating ownership issues. Whenever corporations and economies get in the way of individual rights, you can expect the government to create regulatory issues. Finally, we need to think about what is morally right about the work of a programmer (ethical issues). For example, does the end (ratings success) justify the means (pandering to viewers)?

Technology Issues

The ultimate effect of satellites, **high-definition television (HDTV),** and technologies such as compressed digital television and digital audio will be to lessen station dependence on traditional national networks for television (and radio) programming, both as sources of original material and for off-network syndicated material. HDTV is beginning to attract topnotch production talent. At the same time, the broadcast networks find themselves less able to invest in high-cost programming

1.6 THE CHANGING TECHNOLOGY LANDSCAPE

Part of the change in the media business is fueled by technological change. Computers are converging with TV sets, and the phone lines were the first to facilitate the merger. Satellites deliver channels to a tiny dish on your roof or in your window. The number of choices available on some cable systems is staggering and promises to grow geometrically.

The technology exists, but is there anything to put on the additional channels? If the programs could be produced, is there a source of money to pay for it? Media companies continue to shift their focus and evolve into new areas. Despite the uncertainties of the 1990s, however, programming will be the key to mass media entertainment.

The impact of technology on programming is even being felt by stand-alone UHF and VHF television stations, where little has changed since 1948. Advances in digital television may provide these stations with a good deal more than just high-definition television. There is growing debate on whether more channels per station, using the same frequency allocation, is better than more quality per channel. This is called standard-definition television, and it may revolutionize the local marketplace, allowing stations to customize their offerings to a less-than-mass audience.

The regulatory climate changed considerably in 1995. The FCC decided to shed two rules that greatly impinged on network programming: fin-syn and PTAR. These rules dated from the early 1970s when the nearly monopolistic networks entered into a consent decree with the Justice Department. Since that time, the networks have encountered increasing competition, leading to deregulation.

Finally, by 1995 the information superhighway had become important to the networks: ABC, CBS, Fox, NBC, and UPN started "home pages" on the World Wide Web (the WWW allows computer users to "surf" the Internet with ease). Television and radio enthusiasts can point-and-click their way through a myriad of home pages designed by the networks, their affiliates, cable channels, and even the programs themselves. Not to be outdone, this textbook has a home page linked from *http://www.wadsworth.com* on the Internet.

because of the audience's shift to cable networks and home VCR playback.

Contributing to this audience erosion is the increased difficulty of persuading affiliates to clear all requested time for network schedules. At one time the networks had considerable leverage over affiliates because the networks leased the coaxial-microwave relays that were the sole real-time program distribution system. Clearances were virtually automatic then. Now, however, satellite dishes, possessed by virtually all stations, give affiliates many alternate sources of instantaneous delivery at reasonable cost.[12] All this encourages emergence of new program providers. Nonnetwork group owners will play a prominent role among them.

Another huge technological influence will be convergence of computers, telephones, and television. Opinions vary widely on when (or if) the various media will come together.[13] Certainly, the telcos' initial foray into video dialtone testing has not been too successful. However, demand may have been inadequate because the technology had not yet been fully developed. The phone companies so far are reluctant to spend additional money on open video systems unless viewers demand it. This chicken-or-egg situation may alter by the year 2000.

Economic Issues

There is a saying in business: "Good, fast, cheap—choose two." The idea that quality, speed, and price cannot occur at the same time is also true for programming. If most programming is like cheap fast food, then we should not be surprised that the quality is not high.

The cost of extremely well-executed programming is high, if only because the cost of ordinary programming is so high. According to Gene Jankowski, former president of CBS:

Each network will review two thousand program ideas a year. About 250 of these will be judged good enough to go on into the script form. About thirty or forty of the scripts will move along into pilot production. About ten pilots will make it into series form. Perhaps two or three series will survive a second season or longer. Each year, program development costs $50 to $60 million. In other businesses it is known as Research and Development. In television it is called failure, or futility, or a wasteland.[14]

The high failure rate of television programs attracts constant attention in newspapers and magazines and in TV programs like *Entertainment Tonight*). But when we compare prime-time television shows to other sources of entertainment, such as movies, books, and Broadway plays, the TV failure rate does not seem so serious.

The kinds of programs prevalent at any given time can be directly linked to economics. Some programs can be produced cheaply: soaps, game shows, talk shows, reality format, and tabloid news. In each case, there is little expense involved, because there is no need for top-name stars or sophisticated writing. These shows may not win many awards, but they create audience demand without incurring huge costs.

Incubation Time

Economic issues also involve the cost of waiting for a show to "grow" into its time slot. Considerable lore has evolved about several programs that had early low ratings and might never have become successful but which were, for various rea-

sons, allowed to stay on the networks' schedules despite their ratings. For example, *The Dick Van Dyke Show* in the early 1960s was not popular at first and would never have survived today's cutthroat marketplace. Some shows seem to need incubation time to "find an audience." *Hill Street Blues* was such a series. Some program producers feel that the audience never gets a chance to discover some shows because cancellations come too quickly.

Some shows are rolled out on several successive nights (for example, miniseries) or in-between hit shows (the hammock strategy) in an attempt to increase sampling by the audience. These ploys count toward the total incubation time required to nurture a hit show.

As compelling as this idea is, the programmer has to be realistic when millions (or even thousands) of dollars are at stake. For every show that really needs more time to build, there are dozens more that were turkeys from the first day. Programmers can trust their hunches, or they can go with the ratings. Neither way is wrong or right, but very few programmers are fired for canceling a show too soon. If the program seems to be missing its audience (or vice versa), the wise decision is to try it on a different night or in a different time slot with a better lead-in. If it fails there, it's time to admit defeat.

There is also the problem of killing shows too early. Anecdotal evidence abounds on shows cut down in their prime. *Gilligan's Island* was doing just fine when CBS axed it after only two years. *WKRP in Cincinnati* was a huge success in syndication, but its network had run this program against very popular shows on competing networks, making it look less desirable. The lore of a winner-made-bad worries the programmer who wants to fine-tune a schedule.

Finally, a situation can arise where a show is canceled even when it finishes among the top shows for the week. Anyone who remembers *Chicken Soup* with Jackie Mason or *Slap Maxwell* with Dabney Coleman will realize that some successful shows owe most of their success to the

preceding program. If the lead-in show has a huge audience, even a precipitous falloff can have a strong audience share for the weaker following program. But programmers want shows that maintain or build the audience shares from the preceding shows. Programs that "drop share" are canceled, regardless of high rankings.

Deficits

A peculiar fiscal fact of life about prime-time entertainment is that the original license fees paid by the broadcast networks for the use of these programs by no means cover the costs of production. This loss-leader type of pricing is known as **deficit financing.** The producers count on recouping their losses by selling **off-network syndication** rights after the show's network run, and indeed they profit handsomely from these rights (if the program ever gets on a network in the first place). Exposure of a successful series on a network creates tremendous demand for it in the syndication market. For example, as a result of its top-rated run on NBC, the syndicated version of *The Cosby Show* grossed for Viacom, holder of the syndication rights, something on the order of half a billion dollars. Suffering as they are from cable and independent station competition, the networks look with envy on such windfalls. After all they, the networks, created the appetite for the *Cosby* series (as well as making a profit), yet the network syndication and financial interest rules prevented their profiting further from such shows once they had scheduled their two **plays** (original showing plus one repeat). The networks began experimenting with new ways of handling prime-time productions after the consent decrees expired in 1990, and now they can share in the profits for syndication of some programs.

Ownership Issues

The Players

To fully understand broadcast programming, it is necessary to know who the major players are. The top 12 media companies are shown in 1.7.

1.7 THE TOP 12	
Company (plus owned programmers)	1994 revenues (billions)
1. Walt Disney Company (CapCities ABC)	$23.8
2. Time Warner (Turner, HBO, Warner Brothers)	$18.7
3. Viacom (Paramount)	$10.1
4. News Corp. Ltd. (Fox)	$8.0
5. Sony (Columbia-TriStar)	$7.7
6. TCI	$4.9
7. Seagram Co. Ltd. (Universal)	$4.8
8. Westinghouse-CBS	$4.6
9. Gannett	$4.5
10. General Electric (NBC)	$3.4
11. Cox	$2.9
12. Washington Post	$1.6

Source: *Broadcasting & Cable,* 4 September 1995, p. 11.

In the case of commercial television, the major studios and producers are listed in 1.8. A great deal of consolidation is under way, and many changes will be seen in this list. In 1995, for example, two major producers were acquired by larger studios and networks, and more mergers and acquisitions can be expected in the coming decade.

Executives concerned with programming, as indeed with every other aspect of broadcasting and cable television, need constantly to update their knowledge of the rapidly evolving field and the rapidly increasing competition. The trade press provides one source of updates, but even more important are the many trade and professional associations that provide personal meetings, demonstrations, exhibits, seminars, and publications. Dozens of such associations bring practitioners together at conferences on every conceivable aspect of the media, all of which touch on programming in one way or another—conferences on advertising, copy-

1.8 THE PRODUCERS

The veteran movie and television producers, the traditional **Big Seven studios** of the Hollywood entertainment motion picture industry, are Columbia-TriStar, Walt Disney Studios, Paramount, MGM-UA, 20th Century-Fox, Universal, and Warner Brothers. In 1994, Steven Spielberg, David Geffen, and Jeffrey Katzenberg formed a new studio, Dreamworks SKG, which could shake up the established order in Hollywood.

However, the independent production houses also make Hollywood their base of operations. Among **independent producers,** Witt-Thomas, Carsey-Werner, Brillstein-Grey, David E. Kelley, and Steven Bochco have been regular and prolific producers for the networks and the syndication market. Independents are sometimes acquired by large studies, as when New World bought Stephen Cannell Productions and Viacom purchased Spelling Entertainment.

Consider the lineup for fall 1995. That year, prime-time network television consisted of 113 program series, 42 of them new that season.[15] Of the 113, the networks themselves produced 32 programs for airing on their own networks. Coproductions between networks and independent producers accounted for an additional 6 shows. Interestingly, network owners also produced or coproduced 31 shows to run on other networks![16] A total of 19 Hollywood producers accounted for all program series, except for the feature film series. And the number of producers has dwindled over the years.

In 1991, only 5 prime-time series were produced by the networks for themselves, compared to 32 shows in 1995. The repeal of financial interest and network syndication rules (fin-syn) has apparently encouraged the networks to return to **vertical integration,** as practiced by the cable companies. Studio ownership seems key to the change in network philosophy. ABC, having overspent on shows like *Moonlighting* in the 1980s, announced early in 1995 that in-house production was not lucrative. A few months later Disney purchased ABC, and many observers expected the network to get more involved in making its own prime-time product. When fin-syn ended, NBC folded its in-house production operation, NBC Production, into the network's programming to help NBC produce more of its own shows by making in-house production executives part of the team that develops the network's schedule.[17]

right, education, engineering, finance, law, management, marketing, music, news, production, programs, promotion, research, and satellites, to name a few. Licensing groups provide the legal and economic environment that ensures that artists get paid royalties for their works. These organizations and groups are listed in 1.9.

Ownership affects the programmer at the lower levels of the hierarchy. Most broadcast stations and the larger cable systems belong to companies owning more than one station or system. The profitability of broadcast and cable investments attracts corporate buyers, who gain important economies of scale from multiple ownership (see 1.10 for more on this topic). Because they can buy centrally in large quantities, they can get reduced prices for many kinds of purchases, including programs. FCC and Justice Department permissiveness also encourages the formation of multimedia companies and very large, diversified conglomerates, making group ownership a growing trend within the industry.

In broadcasting, the owner of two or more stations of a given type (AM, FM, TV) is called a **group owner,** while in cable television the owner of several systems is called a **multiple system**

1.9 MEDIA ORGANIZATIONS

Here is a list of important organizations, along with the home page listings (when available) for the World Wide Web.

Major industry organizations
 National Association of Broadcasters (NAB) *http://www.nab.org/*
 National Cable Television Association (NCTA)
 Radio-Television News Directors Association (RTNDA) *http://www.rtnda.org/*
 Wireless Cable Association (WCA)

Programming organizations
 National Association of Television Program Executives (NATPE) *http://www.natpe.org/*
 Association of Local Television Stations (ALTV, formerly INTV)
 Television Programmers' Conference (TVPC)
 Community Broadcasters Association (CBA)
 National Federation of Local Cable Programmers (NFLCP)

Music licensing groups
 American Society of Composers, Authors, and Publishers (ASCAP) *http://www.ascap.com/*
 Broadcast Music Inc. (BMI) *http://bmi.com/*

Technical societies
 Society of Motion Picture and Television Engineers (SMPTE) *http://www.smpte.org/*
 Society of Broadcast Engineers *http://www.sbe.org/*
 International Radio-Television Society (IRTS)

Sales organizations
 Television Bureau of Advertising (TvB)
 Radio Advertising Bureau (RAB)
 Cable-Television Advertising Bureau (CAB)
 Cable Television Administration and Marketing Society (CTAM)

operator (MSO). About three-quarters of the 1,200 commercial television stations are under group control, as are three-quarters of the 12,000 radio stations.[18] In cable, the percentage is even higher, with about 90 percent owned by an MSO (defined as owning three or more cable systems).[19] For more on the advantages of group ownership, see 1.11.

Programming Control

Because broadcast stations have a legal obligation to serve their specific communities of license, group owners must necessarily give their outlets a certain amount of latitude in programming deci-

sions, especially decisions that affect obligations to serve local community interests. Beyond that, broadcast group owners have no common method or standard for controlling programming at their stations. Most employ a headquarters executive to oversee and coordinate programming functions with varying degrees of decentralization.

As for cable, the largest MSOs now focus more on adding subscribers to their existing systems than on adding new systems; some also have given slightly more autonomy to their local managers as they try to trim headquarters' budgets to reduce overhead. Nevertheless, cable group owners tend to centralize programming more than broadcasting

1.10 WHERE THE PROFITS ARE

Group ownership of the right stations in the right markets can be remarkably profitable. ABC, CBS, and NBC's **owned-and-operated stations (O&O)** constitute the most prominent group-owned constellations. Of the network O&Os, those in each of the top three markets alone—WABC, WCBS, and WNBC in New York; KABC, KCBS, and KNBC in Los Angeles; WLS, WBBM, and WMAQ in Chicago—gross more revenue than any other groups. Fox, with the fourth largest potential television reach, close behind CBS, is owned by Rupert Murdoch, an international media magnate, and is linked with 20th Century-Fox. Fox now has 180 affiliates, putting it nearly at parity with the three traditional networks, which each have about 200 stations. UPN and WB have many fewer affiliates.

groups do because cable has no special local responsibilities under federal law (as does broadcasting). Many of the largest MSOs also own several cable program networks.

Regulatory Issues

Radio and television, more than most businesses (including other media), must live within constraints imposed by national, state, and local statutes and administrative boards. Moreover, public opinion imposes its own limitations, even in the absence of government regulation.

The most recent trend in media regulation has been to "let the marketplace decide" and remove the interference of government. Whether this policy will continue is anyone's guess, but this trend has been dominant from the mid-1980s to the mid-1990s. Only a few rules remain that programmers must know to avoid possible violations within their jurisdictions. The chief regulatory

constraints programmers should be familiar with are discussed next.

Fairness and Equal Opportunity

Both broadcast and local cable-originated programming must observe the rules governing appearances by candidates for political office (**equal time**), station editorials, and personal attacks. The equal-time rule for political candidates demands that broadcasters (not cable operators) provide equal opportunities for federal candidates, effectively preventing entertainers and news personnel from running for office while still remaining on their programs. Although the FCC has formally abandoned its specific Fairness Doctrine concerning discussion of controversial issues of local importance, Congress could reintroduce the rule by amending the Communications Act. In any event, many managers continue to adhere to the basic fairness concepts as a matter of station policy. Day-to-day enforcement of such rules and policies devolves largely on the production staff in the course of operations, but programmers often articulate station policies regarding balance and stipulate compliance routines. Fairness looms large in talk radio and talk television, because the talk so often deals with controversial topics.

Monopoly

Various rules limit concentrations of media ownership, all of them aimed at ensuring diversity of information sources, in keeping with implicit First Amendment goals. Group owners of broadcast stations are particularly sensitive to regulatory compliance in this area. They have a high financial stake in compliance and, of course, are conspicuous targets susceptible to monopoly charges. This sensitivity affects programming policies. The situation will intensify with arrival of services offered by the telephone companies. In a way, cable franchises may be regarded as "natural monopolies," for it would normally seem uneconomic to duplicate cable installations (**overbuilds**). But if monopoly is construed as denial of freedom of speech,

1.11 GROUP OWNERSHIP ADVANTAGES AND DISADVANTAGES

The main programming advantages of group ownership are the cost savings in program purchases, equipment buys (such as computers and cameras), and service charges (such as by reps and consultants) that accrue from buying at wholesale, so to speak. Insofar as groups produce their own programs, they also save because production costs can be divided among the several stations in the group—a kind of built-in syndication factor. Moreover, group-produced programs increasingly are offered for sale to other stations in the general syndication market, constituting an added source of income for the group owners.

Group buys often give the member stations first crack at newly released syndicated programming as well as lower cost per station. Distributors of syndi-cated programs can afford such discounts because it costs them less in overhead to make sales trips to a single headquarters than to call on widely scattered stations individually, and the larger groups can deliver millions of households in a single sale.

Large group owners can also afford a type of negative competition called **warehousing.** This refers to the practice of snapping up desirable syndicated program offerings for which the group has no immediate need but which it would like to keep out of the hands of the competition by holding them on the shelf until useful later (see Chapter 3). Also, group executives have a bird's-eye view of the national market that sometimes gives them advance information, enabling them to bid on new programs before the competi-tion even knows of their availability. For their part, producers often minimize the risk of invest-ing in new series by delaying the start of production until at least one major group owner has made an advance commitment to buy the series. Many promis-ing program proposals for first-run access time languish on the drawing boards for lack of an advance commitment to purchase.

The stations in the top four markets that are owned and operated by the national televi-sion networks exercise extraordi-nary power by virtue of their group-owned status. Each such O&O group reaches about a fifth of the entire U.S. popula-tion of television households, making their collective decisions to buy syndicated programs cru-cial to the success of such pro-

then even the "natural monopolies" created by franchising one operator may violate the First Amendment.

Localism

The FCC has traditionally nudged broadcasters to-ward a modicum of **localism** in their program mix. The FCC expects licensees to find out about local problems in a station's service area and to offer programs dealing with such problems (the infor-mal **ascertainment** requirement—a quarterly list of local issues and programming dealing with these issues that stations must place in their public files). In licensing and license renewals, the FCC gives preferential points for local ownership, owner par-ticipation in management, and program plans tai-lored to local needs.

Cable operators are not licensed by the FCC and so have no such federal public-interest man-date. As a result, cable programmers differ funda-mentally in their programming outlook from broadcast programmers. Municipalities that fran-chise cable systems have discretion over **public, educational, and government (PEG) access channels** described in the 1984 Cable Act. PEG access requirements therefore vary widely with lo-cation, and the cooperativeness of cable MSOs in encouraging the success of PEG channels also varies widely.

Increased competition for audiences now drives broadcasters and cable operators toward increased localism. In many cases, localism has boosted the financial return for those stations with a long, hon-orable history of community orientation, although

1.11 CONTINUED

- -

grams. Thus, these few group-owned stations influence national programming trends for the entire syndicated program market.[20] So important to the success of programs is their exposure in the top markets that some syndication companies offer special inducements to get their wares on the prestigious prime access slots on network O&O stations. These inducements can take the form of attractively structured barter syndication deals or cash payments to ensure carriage. The latter type of deal, known as a **compensation incentive,** occurs primarily in New York, the country's premiere market.

MSOs have much the same advantages as broadcast groups. However, cable systems normally obtain licenses to carry entire channels of cable programming

(cable network services) rather than individual programs or program series. Thus, major MSOs, negotiating on behalf of hundreds of local cable systems gain enormous leverage over program suppliers. Indeed, a cable network's very survival depends on signing up one or more of the largest MSOs. As of 1995, all but about 300,000 cable subscribers were served by systems owned by the top 100 cable MSOs, and the independence of the remaining small systems is threatened by the high cost of rebuilding to increase channel capacity.

Nongroup program directors (at the minority of independent stations and cable systems) enjoy more autonomy and can move more aggressively and rapidly than their group-controlled counterparts. Group

headquarters programmers and their sometimes extensive staffs impose an additional layer of bureaucracy that tends to slow down local decision making. Local program executives know their local markets best and can adapt programming strategies to specific needs and conditions. A group-acquired broadcast series or cable network that may be well suited to a large market will not necessarily meet the needs of a small-market member of the group. When a huge MSO such as TCI makes a purchase for hundreds of different systems, not every system will find the choice adapted ideally to its needs. Group ownership imposes some inflexibility as the price of the economies of scale it can realize.

there are some markets in which stations have not fully explored localism. Even the onset of direct-to-home satellite distribution will not end the need for local service. It is simply good business to serve the community, not merely a requirement.

Copyright

Except for news, most public affairs programs, and most local productions, all programs entail the payment of royalties to copyright owners. Programmers should understand how the **copyright royalty** system works, how users of copyrighted material negotiate licenses from distributors to use them, and the limitations on program use that the copyright law entails.

Broadcast stations and networks usually obtain **blanket licenses** for music from copyright licens-

ing organizations, which give licensees the right to unlimited plays of all the music in their catalogs. For the rights to individual programs and films, users usually obtain licenses authorizing a limited number of performances ("plays") over a stipulated time period. One of the programmer's arts is to schedule the repeat plays at strategic intervals to get the best mileage possible out of the product.

Stations and networks obtain licenses for the materials they broadcast, with fees calculated on the basis of a station's usual over-the-air coverage areas. But cable television systems introduced a new and exceedingly controversial element into copyright licensing. The problem lurked in the background while early cable systems merely improved weak broadcast coverage but came to the forefront when cable companies began picking

up distant television stations relayed to them by satellite and delivering them on the cable. Importation of distant signals stretched the original single-market program license to include hundreds of unrelated markets all across the country to the obvious detriment of copyright owners (the producers).

The Copyright Law of 1976 tried to solve this problem. It introduced **compulsory licensing** of cable companies that retransmit television station signals. It provided retransmission compensation to the copyright owners in the form of a percentage of cable companies' revenues. The Cable Act of 1992 insisted that cable systems receive **retransmission consent** from broadcast stations for their signals, which led some to believe that cable operators would finally pay for retransmission. In 1993 the issue was largely resolved when most affiliates of major television networks made deals with cable operators for a second local cable channel in lieu of cash payment.

A related copyright matter, the **syndicated exclusivity rule,** often called **syndex,** was reinstated in the late 1980s and now gives television stations local protection from the competition of signals from distant stations (notably superstations) imported by cable systems. The rule is based on the long-held principle that a station licensed to broadcast a given syndicated program normally paid for exclusive rights to broadcast that program within its established market area. Cable's ability to import programs licensed for broadcast in distant markets (especially the superstations) undermines this market-specific definition of licensing and divides audiences. The rule requires cable systems to black out imported programs that duplicate the same programs broadcast locally. Most syndicators attempt to avoid selling their shows to superstations to make the shows "syndex-proof."

Lotteries, Fraud, Obscenity, Indecency

Federal laws forbid **lotteries,** fraud, and obscenity, and laws regarding them apply to locally originated cable as well as to broadcast programs. Shows that feature state-run lotteries are an excep-

tion to the rule. Programmers also need to be aware of special Communications Act provisions regarding fraudulent contests, **plugola,** and **payola. Indecency,** a specialized interpretation of obscenity laws, appears to apply only to broadcasting.

The 1984 Cable Act sets specific penalties for transmitting "any matter which is obscene or otherwise not protected by the Constitution" (Sec. 639). A subsequent Supreme Court decision affirmed that cable operators qualify for First Amendment protection of their speech freedom. This puts the heavy burden on those alleging obscenity of proving the unconstitutionality of material to which they object; in fact, several court decisions have overthrown too-inclusive obscenity provisions in municipal franchises. In practice, cable operators have greater freedom to offend the sensibilities of their more straitlaced viewers than do broadcasters, whose wider reach and dependence on the "public airwaves" (electromagnetic spectrum) make them more vulnerable to public pressure. Congress has shown some signs of tightening the restrictions on cable, however, including restrictions on nudity.

A 1987 FCC ruling broadened its previous definition of prohibited words in broadcasting to cover **indecency.** That definition had been based on a 1973 case involving the notorious "seven dirty words" used by comedian George Carlin in a recorded comedy routine broadcast by WBAI-FM in New York. Responding to complaints about raunchy talk-radio hosts (**shock jocks**), the FCC has repeatedly advised broadcasters that censorable indecent language could include anything that "depicts or describes, in terms patently offensive as measured by contemporary community standards for the broadcast medium, sexual and excretory activities or organs." Raunchy radio content from Howard Stern led to a $1.7 million settlement by his syndicator to the FCC.

However, the FCC designated late night as a **safe harbor** for adult material. It is noteworthy that the commission used the words for the broadcast medium, implying that broadcasting should be treated differently from other media, a

concept out of keeping with much FCC-sponsored deregulation.

Libel

News, public affairs programs, and radio talk shows in particular run the risk of inviting libel suits. Because of their watchdog role and the protection afforded them by the First Amendment, the media enjoy immunity from punishment for libel resulting from honest errors in reporting and commentary on public figures. However, due care must be taken to avoid giving rise to charges of malice or "reckless disregard for the truth." Though the media have traditionally won most libel cases brought against them, in the early 1990s this trend was reversed, and juries awarded huge fines. Moreover, win or lose, it costs megadollars to defend cases in court. Managers responsible for news departments and radio talk shows need to be aware of libel pitfalls and to institute defensive routines. These defenses include issuing clear-cut guidelines, ensuring suitable review of editing, and taking care that promotional and other incidental material does not introduce libelous matter. As an example of the National Association of Broadcasters' (NAB) assistance to programmers, it has issued a videocassette illustrating some of the common ways news programs inadvertently open themselves to libel suits.

Ethical Issues

Programmers continually wrestle with standards. It is not necessarily a question of freedom but of taste. What is good taste? Like anything else, the definition depends on a consensus of the people who have to live with the definition.

Over a period of time, the erosion of public taste standards has mirrored the erosion of other aspects of public life (like manners). Viewers might be offended if television were the only culprit, but it is increasingly impractical to take a walk in the mall or go for a drive on the highway without being assaulted by someone's "free speech" in the form of a lewd T-shirt or scatological bumper sticker. In the process, the public consensus about "what is shocking" impinges on "what is good taste"; bad taste is precluded by definition.

Some viewers will defend a program with violent or sexual content by saying, "You think Show A is bad. It's not nearly as bad as Show B." Show A becomes the standard, and Show B is the exception, until Show C comes along. Then Show B becomes the new standard, and Show C the new exception. The downward spiral may not be rapid, but there seems to be a steady decline. Programmers are caught between the expectations of one audience that wants "in your face" entertainment and the complaints from another audience that struggles to hold onto civility.

A minority of producers (and their networks) go for shock value and try to lower the standards one small notch at a time. Like the drops of limestone slowly accumulating on the floor of a cavern until a stalagmite forms, the amount of impolite language and situations has grown into high peaks in some programs on evening television, especially late-night shows.

In addition, talk show topics on daytime television have become more seamy with each passing year. In the mid-1990s, retired general Colin Powell spoke out against the erosion of public decency, holding the talk shows largely responsible; Senate majority leader Dole blamed the movie industry. Likewise, other politicians such as President Bill Clinton railed against the lack of family programming on television.[21]

Arguments and Counterarguments

Not everyone agrees there is a problem with program standards. Here is a look at the arguments currently in vogue when the topic of ethical standards is discussed.

"It's just entertainment." The public derives its values from institutions like family, schools, churches, and the mass media. But with the decline of the family, schools, and churches, the content of radio and television programs takes on a larger role in the socialization of young people.

"If you don't like it, turn it off." True, but I can only turn off my own television set. My neighbors'

kids will still be intoxicated by the violence in afternoon children's programs like the *Mighty Morphin Power Rangers*. They will also learn that it's all right to be promiscuous from prime-time television and soap operas. The cultural values of a nation are not wired to my individual ability to shut off my set. If someone poisoned all the drinking water in my area, you might say "if you don't like it, don't drink it." I guess I could buy bottled water.

"Parents have the responsibility to monitor programming." This argument rarely comes from a parent, unless it's a parent who works as an executive at one of the broadcast networks. Anyone who thinks this will work is overly wishful. Children will see what they want to see if it is readily available at a friend's house, their daycare center, the mall, or other group viewing locations. One person who has some control over the ready availability of seamy programming is the programmer.

"Censorship, even voluntary censorship, violates First Amendment rights." The Bill of Rights has ten amendments but somehow the first gets all the attention, perhaps because the media control what gets our attention. A lot of other freedoms are equally precious to the well-being of citizens, such as the right to a fair trial. The community standards of the present age would easily shock the framers of the Constitution.

What Is the Programmer's Responsibility?

The drinking water analogy is apt. If a very slow poison is released into the water supply that results in amoral, uninformed residents, then the culprits are those who work for the treatment plant. Likewise, those who choose and schedule programs for radio and television have the means to maintain some level of decency in the mass media.

How did things get out of whack? When there were only three networks, the Standards and Practices departments held a pretty tight rein. Some of the rules may seem very silly now. When pay movies and cable came along, however, the competition for audiences heated up. Certainly the most egregious examples of sex and violence come

from movies, yet some viewers wanted uncut movies and more adult topics. But the slow erosion of public behavior took its toll also.

It is clear that the programmer is responsible for the content, but it is less clear what the programmer's responsibility is. Is money all that matters? Will wealth be very enjoyable in a disintegrating society? What can one person do? Oprah Winfrey is one of the highest paid people in the media business, and she works very hard to keep her program "decent." Drama and comedy in prime time need not pander to the low-brow viewer. As students of mass media, which is clearly one powerful influence on young people's lives, you can make a difference.

If programmers do not act responsibly, the regulators will devise other schemes. In 1995 legislation prescribed a device called the **V-chip.** This device is installed in every television set to automatically limit the amount of violence (or other unwanted content) available to children. The presumption, of course, was that all parents would remember to activate the device when they left the room.

TRENDS

One development that may revolutionize mass communication is the growth of interactivity. Until now, audiences (whether they perceived themselves as active or passive) were receivers of program content. New technological breakthroughs such as popularization of the Internet (and other online services) may herald increased audience participation.

What will change in the future is the role of the computer. Networking capabilities of computers will increasingly be built into television receivers and cable converters, creating "smart" machines. It is entirely possible that viewers will be able to "web surf" during commercial breaks once the Internet is tied to living room TVs via cable modems. One of the important benefits of cable modems is that home computing need not tie

1.12 NATIONAL ASSOCIATION OF TELEVISION PROGRAM EXECUTIVES (NATPE)

When television programmers formed their own professional organization in 1962, they called themselves the National Association of Television Program Executives—tacitly acknowledging that membership would be dominated by general managers and other executives who play more important programming roles than those specifically designated as programmers. The broadcast station programming team is usually made up of the general manager, sales manager, and program manager. In cable organizations, the executive in charge of marketing plays a key management role and may be the one with the most influence on programming decisions. In recent years, the role of program manager at many network affiliates has diminished as higher level staff members frequently make programming decisions.

Syndicators put programs on display nationally and internationally at a number of annual meetings and trade shows. For showcases, they rely especially on the annual conventions of the National Association of Television Program Executives (NATPE) and the National Cable Television Association (NCTA) held each spring.

At the 1995 NATPE convention, hundreds of syndicators fought for the attention of television programming executives, offering a huge array of feature films (singly and in packages), made-for-television movies, off-network series, first-run series, specials, miniseries, documentaries, docudramas, news services, game shows, cartoons, variety shows, soap operas, sports shows, concerts, talk shows, and so on. Trade publications carry lists of exhibitors

and their offerings at the time of the conventions. (Chapter 3 gives a selection of syndicators along with examples of their offerings.)

Europe has a similar annual program trade fair, MIP-TV. Formerly, at that fair the flow of commercial syndicated programming between the United States and other countries ran almost exclusively from the United States. Public broadcasting first whetted American viewers' appetites for foreign programs. And with such specialized cable services as The Discovery Channel featuring foreign documentaries and Arts & Entertainment featuring foreign dramatic offerings, the international flow has become somewhat more reciprocal, although the United States is still much more often an exporter than an importer.

up a residential telephone connection. Another scheme is for broadcasters to "datacast" information via compressed portions of standard-definition television signals.

Of course, the most popular cable networks may not always be freely available on basic cable. MTV Europe began moving its service off the basic tiers onto pay TV. This and many other trends from the international programming arena may impinge on domestic practices of media companies. Although the focus here is on domestic issues and strategies, the growing importance of international markets cannot be discounted. Networks and studios have begun to reach out to less-

developed nations with programming produced in the United States. So far, the influx of foreign-produced programming to U.S. TV sets (with the notable exception of PBS, A&E, and Discovery) has been a mere trickle, but that could easily change (see 1.12).

Not everyone predicts a brave new world for programming. In *Television: Today and Tomorrow*, Gene Jankowski and David Fuchs state: "In the era of new technologies' rapid growth, distribution . . . has received all the attention. Rarely are the production or funding implications considered. Yet it is the strength of each component and the balance among them that determine success" (p. 53).

The Telecommunications Act of 1996 significantly freed the networks, cable operators, and telephone companies to compete, but this did not guarantee any of them success. The best program service is still essential to attract audiences. No matter what form of program distribution (or combination thereof) prevails, the consumer is likely to be a winner.

SUMMARY

Programming can be defined as the strategic use of programs arranged in schedules or tiers to attract target audiences. Programmers need the knowledge and skills to define such audiences and to select, acquire, and place programs that will attract them. In carrying out their tasks, programmers use strategies based on the inherent characteristics of radio and television, whether delivered by broadcast signals, cable signals, or other means. These strategies cluster around the concepts of compatibility, habit formation, audience flow, program conservation, and wide audience reach. From these broad concepts come the specific strategies such as dayparting, stripping, counterprogramming, and rerunning. Programmers should have some knowledge of laws and regulations affecting programming decisions, such as fairness and equal employment opportunity, monopoly, localism, copyright, carriage rules, lotteries, fraud, obscenity, and indecency.

SOURCES

Auletta, Ken. *Three Blind Mice: How the Networks Lost Their Way.* New York: Random House, 1991.

Barnouw, Erik. *Tube of Plenty: The Evolution of American Television.* New York: Oxford University Press, 1990.

Head, Sydney W., Sterling, Christopher H., and Schofield, Lemuel B. *Broadcasting in America: A Survey of Electronic Media.* 7th ed. Boston: Houghton Mifflin, 1994.

Jankowski, Gene F., and Fuchs, Davis C. *Television Today and Tomorrow.* New York: Oxford, 1995.

NOTES

1. In August 1995, high expenses and technology that are out of reach were cited as the two major reasons for USWest's withdrawal from its two-year-old interactive TV shopping venture, US Avenue. Executives said they planned to delay entry into the video dialtone service for a few years, hoping that the technology would improve and demand would increase. The telco's decision to quit the risky venture was the latest of several halted projects in the quest to add video to telephone service. See *Electronic Media*, 14 August 1995, p. 24. However, telcos feel obliged to battle for video services because their share of short-haul toll revenues is declining. Bell Atlantic, Nynex, and Pacific Telesis launched Tele-TV to battle cable television. See Tom Kerner, "The Plot to Cripple Cable," *Cablevision*, 3 July 1995, pp. 16–23.

2. Harry A. Jessell, "Getting Ahead of the Curve," *Broadcasting & Cable*, 31 July 1995, pp. 1, 12.

3. Kevin Maney, *Media Shakeout: The Inside Story of the Leaders and the Losers in the Exploding Communications Industry* (New York: Wiley, 1995).

4. For more information on the ill effects of infotainment, see Neil Postman, *Amusing Ourselves to Death: Public Discourse in the Age of Show Business* (New York: Viking, 1985).

5. Carrie Heeter and Bradley S. Greenberg, *Cableviewing* (Norwood, NJ: Ablex, 1988), pp. 11–50; James G. Webster and Lawrence Lichty, *Ratings Analysis: Theory and Practice* (Hillsdale, NJ: Lawrence Erlbaum, 1991), p. 179.

6. Even most universities that teach programming treat the topic as a real-world application where those who do the work are wiser than those who study the task. *Broadcasting & Cable* magazine is more often assigned for reading than is *Journal of Broadcast & Electronic Media.*

7. William H. Read, *America's Mass Media Merchants* (Baltimore, MD: Johns Hopkins University Press, 1976); Thomas Thompson, "The Crapshoot for Half a Billion: Fred Silverman Rolls the Dice," *Life*, 10 December 1971, pp. 46–48.

8. Nearly every TV set has a remote because new sets include them as standard features. When existing sets are replaced, nearly every receiver will have a remote control. In the mid-1990s the Electronic Industries Association gave the following estimates for remote control penetration: 72 percent of TV sets, 87 percent of VCRs, 73 percent of cable boxes, 63 percent of audio CD players. Wayne Walley, "Remotely Related," *Electronic Media*, 3 July 1995, pp. 13, 21.

9. Gene F. Jankowski, as President of CBS/Broadcast Group, in "Choices and Needs: The Meaning of the New Technologies," address to Connecticut Broadcasters Association, 20 October 1982.

10. Gene F. Jankowski and David C. Fuchs, *Television Today and Tomorrow* (New York: Oxford University Press, 1995), p. 25.

11. There is some confusion about how to estimate the network share. Those who wish to demonstrate a large decline in network viewing will cling to the three-network prime-time share (ABC, CBS, NBC), which has fallen below 60 percent on average. The four-network prime-time share with Fox included, however, is around 72 percent, although viewing takes a big dive during the summer months.

12. Distribution via satellite is another development likely to affect group-owner programming activities. Satellite relay facilities have reduced the cost and trouble of sharing programs among small as well as large groups of users (see Chapter 12).

13. The popular consensus is that new technologies will completely alter the face of the mass media and have a huge impact on programming. For alternate views, see Gene F. Jankowski and David C. Fuchs, *Television Today and Tomorrow* (New York: Oxford University Press, 1995); W. Russell Neuman, *The Future of the Mass Audience* (New York: Cambridge University Press, 1991); Clifford Stoll, *Silicon Snake Oil: Second Thoughts on the Information Highway* (New York: Doubleday, 1995).

14. Gene F. Jankowski and David C. Fuchs, *Television Today and Tomorrow* (New York: Oxford University Press, 1995), p. 37.

15. This is compared to 75 total shows in 1987 without the Fox, United Paramount, and WB networks. There were 22 new shows in 1987, about half the number in 1995.

16. Warner Brothers produced 17 such programs (including *Friends* and *ER*), with a few of them actually competing with shows on the WB network. Paramount and Viacom (partners in the UPN network) produced 9 shows for the competition. Oddly, NBC had two programs where the coproducer was either ABC or CBS.

17. Some interesting synergies also developed in 1995. CBS Inc. and Time Warner Inc.'s Home Box Office agreed to develop prime-time television series together. Under the pact, CBS got a first look at all programming developed by HBO Independent Productions and all films by HBO pictures. If CBS decided not to run the series, the network would still have a financial stake in them.

18. Limitations on broadcasting group ownership changed drastically in 1985 when, in one of its many deregulatory initiatives, the FCC liberalized ownership rules. The new rules increased maximum total ownership from 21 (old 7-7-7 rule) to 36 stations (12 of each type—12 AM radio, 12 FM radio, and 12 television), if the potential aggregate television audience of any one owner did not exceed 25 (presently 35) percent of the national population. As a concession to the lower coverage potentials of UHF television stations, only half of a UHF's potential market is counted in adding up the 25 percent maximum. Further loosening of the cable/broadcast **crossownership** and **duopoly** rules resulted from the Telecommunications Act of 1996 which relaxed ownership limits.

19. No rules limit multiple ownership of cable television installations, and about 500 MSOs own three or more cable systems. The largest MSOs actually dominate the cable market by virtue of owning most of the major-market and more profitable systems, while also having financial interests in several cable program services. The top two MSOs, Tele-Communications Inc. (TCI) and American Television and Communications (ATC, owned by Time Warner) each control millions of subscribers and hundreds of systems. Broadcasters have an interest in about a third of the cable systems, but the FCC does not allow broadcast licensees to own cable systems within their own broadcast coverage areas.

20. Although O&O stations remain legally responsible for serving their individual local markets, they naturally also reflect the common goals and interests of their networks. As an example of a rather subtle network influence, consider the choice of the prime access program that serves as a lead-in to the start of the network's evening schedule. An ordinary affiliate (that is, one bound to its network only by contract rather than by the ties of ownership) can feel free to choose a program that serves its own best interests as a station. An O&O station, however, must choose a lead-in advantageous to the network program that follows, irrespective of its advantage to the station. O&O stations also must take great care in choosing and producing programs to protect the group image, especially in New York, where they live next door to company headquarters.

21. Ironically, former Vice President Dan Quayle was the target of derision for speaking out on the glorification of out-of-wedlock birth featured on *Murphy Brown*. Many who were doing all the laughing voted for Clinton, who then adopted Quayle's same message.

Chapter 2

Program and Audience Research

Douglas A. Ferguson
Timothy P. Meyer
Susan Tyler Eastman

A GUIDE TO CHAPTER 2

DECISION-MAKING INFORMATION FOR PROGRAMMERS

"How could those idiots cancel that show? It was my favorite. Why do they always get rid of the good stuff and keep all the junk?" Sound familiar? It should. Most people have, at one time or another, heard the news that a favorite television show has been canceled. The reason? Usually the one given is "low ratings," a way of saying that not enough people watched the program. Why are the ratings so important? Why do so many shows fail? Can't a network executive tell whether a show will succeed in the ratings? In this chapter we look at ratings and other forms of audience research and explain what they are, how they are used and misused, and why.[1] We will examine the industry's current program research practices and qualitative audience measurement techniques and then, because of their special position in industry economics, explain and interpret audience ratings.

Broadcast and cable programmers are interested in one goal: *reaching the largest possible salable audience*. Programmers define audiences differently depending on particular circumstances, but regardless of definition, determining audience size is the paramount concern. The separations between program creation and presentation and reception by the audience mean that programmers must always guess who will be there and how many there will be, estimating how predictable and accurate those guesses are. Because networks and stations sell commercial time at dollar rates based on *predicted* audiences, it is no surprise that program and audience research is critical for the financial health of the broadcast and cable industries. Program and audience research, usually involving ratings, guides the process of selecting and scheduling programs to attract the desired audience and provide feedback on programming decisions.

The broadcast and cable industries use many research approaches to evaluate programs and audiences, most of which fall into one of three groupings:

- qualitative and quantitative measures of the programs themselves
- qualitative and quantitative measures of audience preferences and reactions
- quantitative measures of audience size

Qualitative research tries to explain why people make specific program choices and what they think about those programs. Quantitative data, in the form of ratings and surveys, report what programs (and commercials, presumably) people are listening to or watching.

Programmers use qualitative information on programs to select and improve programs and to understand audiences' reactions to program content; qualitative audience data help explain people's reactions to programs. Quantitative audience data generally provide measures of the size and demographic composition of sets of viewers, listeners, or subscribers. Of all these findings, however, **ratings** are the major form of program evaluation, and they have the most influence on the other concerns of this book, program selection and scheduling.

In the late 1980s a sweeping change occurred in the national television ratings—the shift by ratings companies from measuring people's viewing by diaries and simple passive meters to peoplemeters, a much more elaborate, interactive measurement process. **Peoplemeters** consist of a computer and an electronic, handheld device with which individuals signal when they are viewing. The "black box" computer sits on top of the television set, registering each viewer's presence (from the handheld device) and all channel selections; background demographic information (age and sex) on every viewer in the household is stored in its memory to be matched with the viewing information. Meters of either the active or passive type are now used in both the national ratings sample and in the major markets, but meters remain impractical for small markets because of their cost. As some ratings wit once said, "There will always be diaries in Duluth."

In the future, **passive peoplemeters** promise to measure audiences without their active participation. Various ideas, ranging from wristwatch devices to intelligent pattern-recognition receivers atop the television receiver, have been developed to measure viewing with greater accuracy and less reliance on viewer participation. But a reliable system has yet to gain popularity, although Nielsen announced its forthcoming A/P Meter peoplemeter in 1995.

Other new forms of audience measurement are also being tested by competitors to the established ratings companies. These include various **passive meters**, devices that silently monitor and log the programs a person views or listens to, and personal viewing diaries (instead of diaries assigned to TV sets or VCRs) that permit recording of out-of-home viewing and have separate versions for children and adults. It will take several years to judge the effectiveness and acceptance of new ratings methods, but no way of measuring audiences will ever be error-free or problem-free. We can only assess the competing methods and the measurement problems these practices create with an eye to their advantages and drawbacks.

PROGRAM TESTING

The enormous expense of producing television programs necessitates testing them before and during the actual production of a show. In addition, promotional announcements advertising programs are usually tested to gauge their effectiveness and ability to communicate a program's most attractive features.

Concept, Pilot, and Episode Testing

Concept testing is asking audiences whether they like the ideas for proposed programs. Producers generally conduct this type of test before a program has been offered to a broadcast or cable network. **Pilot testing** occurs when a network is con-sidering purchase of a new series, and audiences are asked to react to the pilot episode. This process is described in detail in Chapter 4 on network prime-time programming. **Episode testing** occurs when a series is under way. Plot lines, the relative visibility of minor and major characters, the appeal of the settings, and so on can be tested to gauge audience preferences.

ASI Market Research, based in Los Angeles, is one of the best known companies conducting program tests (and tests of commercials). Typically, ASI researchers invite people into a testing theater to watch a television program, a film, or a commercial, asking them to rate it by pushing "positive" and "negative" buttons attached to their seats. Generally the participants are paid, often in products rather than cash, for taking part in the test. Computers monitor individual responses, producing a graph of the viewer's "votes" over time. These data are correlated with demographic and other information (**psychographics**) obtained via questionnaires from each participant (see 2.1).

Concept and pilot testing stress general plot lines and main characters, seeking to discover if they are understood and appeal to a variety of people. Ongoing program testing focuses on more subtle evaluations of the voices, manners, style, and interactions of all characters. In fact, different actors and plot lines are sometimes used for separate screenings to find out which cast and plot audiences prefer. Postproduction research can discover a poor program opening or difficulty in understanding the main theme of an episode. Unfortunately, the theater environment cannot reflect at-home viewing conditions and is thus a less than ideal research method. It does, however, supply detailed data that can be matched to screen actions, adding fodder for programming decisions. In some test markets where insertion equipment is available, researchers send alternate versions of pilot programs (and commercials) to different cable homes and interview the viewers on their reactions. This necessitates producing alternate versions of a program, however, a huge expense not lightly undertaken.

2.1 ASI THEATER TESTING

ASI research has been criticized for its unrepresentative audience samples, yet it remains a major contributor to network and movie studio program testing in America. ASI provides valuable data because its audiences are *consistent* from one time to the next. It has established norms from all its previous testing of programs, films, and commercials against which new findings are weighed. Given the many programs evaluated over past decades and the fact that few programs are really "new" in any significant way, how well a new show tests compared to others like it in past tests is use-

ful information. The results are especially noteworthy when a program produces a negative or low evaluation because the average ASI audience evaluates programs positively. Not all programs that test positively are successful when put on a network schedule (factors independent of the show's content have more influence on ratings), but very few of those that test negatively at ASI later succeed.

Frequently prime-time series that have slipped in the ratings are tested with live audiences to determine which aspects of the program, if any, can be manipulated to improve the popularity

of the series. The testing instruments range from simple levers and buttons, such as used in ASI theaters, to more controversial methods, such as galvanic skin response meters measuring respiration and perspiration. Programmers seek aids in understanding the weaknesses and strengths of a series performing below expectations. Sometimes the research suggests a change of characters or setting that revitalizes a program. (If research results are no help, the cynical programmer usually suggests adding a dog or a child.)

Promotion Testing

Competition for audiences requires that most programmers continually produce effective promotional materials. Promotional spots advertise particular episodes of a series, special shows, movies, newscasts, or unique aspects of a station's or service's programming (images and identities).[2] These **promos** can be tested before they are aired to find out whether they communicated what was intended. Testing firms generally conduct tests in shopping centers, intercepting people at random to invite them to view promos in return for cash or merchandise. Other types of promo evaluation include group and theater testing, emphasizing such measures as *memorability, credibility,* and *persuasibility.* Demographic data are gathered and other questions are asked and associated with participants' opinions. Promo-copy testing has become a standard practice in the industry.

As multichannel television moves closer to an online era, promotion testing will become far more important and more widely used. Menu-driven program selection, called preprogramming, will be more influenced by on-air promos and **barker channels** than by schedule-driven program selection.

QUALITATIVE AUDIENCE RESEARCH

In addition to program testing, which applies mostly to television programs and movies, stations use qualitative research to get audience reactions to program materials, personalities, and station or system image. Using focus groups is one such research method. Radio stations also use call-out research to test their programming, and network television and major-market stations make use of

TvQs. Qualitative audience research is the most common phrase used in the industry to refer to all of these research techniques.

Focus Groups

One method of gathering information from a group of people is to conduct small group testing. A **focus group** is a set of 10 or 12 people involved in a controlled discussion. A moderator leads a conversation on a predetermined topic, such as a music format or television newscast, and structures the discussion with a set of questions. Predetermined criteria guide group recruitment. Station management may want people who listen to country music or women aged 25 to 34, for example. Finding people who fit the predetermined criteria (**screening**) can be costly; more qualifications result in a greater turndown rate, increasing the price for screening. Assembling a typical focus group generally costs between $2,500 and $3,000, including the fee paid to each participant ($30 is the standard fee, although it is sometimes as high as $150 for individuals difficult to recruit, such as physicians and other professionals).

Focus group research is especially useful to elicit reactions to visual material and gain insight into subtle responses to televised characters and individuals. These small group discussions can be used to develop precise questions for later field 39surveys of a large sample of people. For example, researchers commonly use focus groups to evaluate whether a station has enough news, how people react to the newscasters, whether music is too soft or loud, whether personalities are perceived as interesting or friendly, and so on. The particular advantage of focus groups is that videotapes, newspaper ads, and recordings can be evaluated in the same session, providing immediate feedback while avoiding confusion in recall after a lapse of time.

Approximately 100,000 focus groups are conducted each year, and that number is expected to double by the end of the century. The latest trend is to use video-conferencing for focus group observers to save travel costs and allow more people to observe the groups during the session. Focus

Vision Network of New York is an early leader in this growing industry.

Due to the small size of focus groups, research results cannot be generalized to the larger audience. Such a small number of people, reacting under completely artificial viewing or listening conditions, is only rarely representative of the entire audience. However, focused discussions can elicit some respondents' perceptions that would be overlooked by testing techniques such as survey questionnaires that are used with larger groups of people. Focus groups are especially suited to answering some of programmers' *why* questions in depth.

Music Research

Radio programmers want to know their audiences' opinions of different songs and different types of music. They need to know which songs are well liked and which ones no longer have audience approval (which songs are "burned out"). **Call-out research** is one popular, although controversial, method for discovering what listeners think about music selection.

Programmers conduct call-out research by selecting 5- to 15-second "hooks" from well-established songs and playing them for respondents over the telephone. A **hook** is a brief segment or musical phrase that captures the song's essence, frequently its theme or title. Programmers ask randomly selected respondents to rate 15 or 20 song hooks on a predetermined scale. Often a scale of 1 to 10 is used, where 1 represents "don't like" and 10 represents "like a lot." Call-out research indicates listeners' musical tastes at a given moment. When tied to the same songs for some time, it indicates song popularity but does not tell the programmer how often a particular song should be played. That remains the programmer's decision.

In the mid-1990s some research services began using computers to make the phone calls for call-out research. If stations perform call-out research frequently (and some use it every day), a track record for each song develops, and based on it the music programmer can decide whether to leave

the song in the station's rotation or drop it. Chapter 13 describes a particular form of this research in detail and shows how it can be applied to radio programming decisions.

Another popular method of testing music is **auditorium research**. Programmers invite 75 to 150 people to a location where they jointly listen to and rate a variety of songs. Instead of rating just 15 or 20 hooks, as in telephone research, auditorium tests involve 200 to 400 hooks. Like call-out research, the method tells which songs are liked and disliked at the moment but not how often they should be aired.

Music testing is expensive. Call-out research requires an investment in employees to make the calls as well as computer time to analyze the results. Auditorium tests involve recruiting costs and "co-op" money for participants (usually $20 to $35). Those stations lacking facilities and personnel for music testing can hire commercial firms specializing in such work.

Television Quotient Data (TvQs)

Television quotient data (TvQs) are used by many programmers to supplement Nielsen ratings. Nielsen provides information on how many people watched a program; **TvQs** measure the popularity and familiarity of a program and the performers in it (or in commercials). Bill Cosby, for example, is said to have twice as high a Q-score as anyone else in television. Networks and programmers use TvQs as indicators of an actor's potential, assessing both likability and recognition. Some research companies make use of TvQs in computer programs that project the eventual success of a network program in syndication. Unlike ratings, these models consider how the people who watched *felt* about a show, not how many watched it.

RATINGS SERVICES

Ratings exert a powerful influence on the industry, from the decisions of syndicators and station representatives in programming as illustrated in Chapter 3 to network television programming discussed in Chapters 4 and 5. Radio programmers also use ratings information to evaluate their market positions and convince advertisers to buy time (see Chapters 12 and 13). And ratings are used in public broadcasting and cable in specialized ways (see Chapters 8 and 10). In fact, all programmers use ratings in program decision making. Consequently, the rest of this chapter focuses on how programmers use and interpret ratings data.

Using audience ratings is not restricted to programming applications. In fact, ratings were originally intended to provide information for advertisers curious about audience size. Unsponsored programs, including presidential addresses and political programs, are unrated by Nielsen exactly because they do not carry advertising. But once the statistical reliability of ratings data became accepted, programmers began using these data to gauge the success of their decisions. As competition among networks and stations increased, ratings became the most important decision-making data in commercial broadcasting. Broadcast revenues, programs, stations, and individual careers depend on audience ratings. In the business of broadcasting, high ratings normally result in profits (and continuing careers). Broadcasting also has public service obligations and other aspirations and commitments, but on the purely economic side, a network or station will eliminate a program that receives low "numbers" if other, more viable options are available.

Cable and broadcast ratings cannot be compared directly because cable's potential audience is only 65 percent that of the commercial networks (as of the late 1990s), and some of cable's programs are scheduled in rotating rather than one-time-only patterns. Therefore, in addition to using standard ratings numbers, cable programmers analyze ratings to determine audience reach—how many people over a period of time viewed a program or channel—much as public television programmers use ratings.

Articulating the power of audience ratings may sound crass to those who consider broadcasting an art form, but the reality is that ratings are the most

important measure of commercial success. The efforts of most people involved in commercial broadcasting focus on achieving the *highest possible numbers.* Targeting more precisely defined audiences such as women 25 to 54 is a fallback position for television networks and stations that cannot immediately achieve a number one position in the adults 18+ category.

Ratings affect television and radio programming and sales at stations and at networks; they affect independent producers, Hollywood studios, distributing companies, and advertisers and their agencies. Understanding the basics of the all-powerful numbers is essential in all of these businesses. Nearly all basic cable networks are advertiser-supported, and they need ratings information to convince advertising agencies to purchase time. The premium cable services such as HBO use their national ratings to convince local cable systems that their programs are watched and important to promoting the local system. High ratings, demonstrating television's widespread household penetration, also carry clout with Congress. Legislators generally use television to get elected and re-elected, and politicians pay attention to their local broadcasters and the four largest national networks because they reach such enormous numbers of people. Increasingly, the major cable system operators have become influential because of their ability to reach certain types of audiences (especially upper socioeconomic levels) and the availability of low-cost time for political candidates on local cable channels.

Television Services

The most important distinction in television ratings is between *national* and *local* (called market) ratings. A. C. Nielsen is the sole company in the United States producing nationally syndicated network audience measurements, although not all of its clients are satisfied with the apparent monopoly. With the departure of Arbitron from television measurement, Nielsen is also the sole company in the United States producing local station

ratings for television (also leading to some criticism about pricing).[3] Other research firms collect and analyze television audience measurements of specialized types for only a portion of the country. Nielsen covers the entire country continuously for network ratings, using a separate sample of 5,000 households with peoplemeters. The four broadcast networks and the largest cable networks contract with Nielsen for this ratings service.

Nielsen conducts four nationwide **sweeps** of all local television stations—November, February, May, and July—producing the most important local television reports (see 2.2). These market-by-market reports allow stations to compare themselves with the other stations in their market. A separate ratings book is published (independently by each company) for each of the 211 markets in the country for each ratings period. These data are based on a mix of diaries and local tuning-sensors (old style passive meters) in the larger markets, diaries only in the smaller markets. One ratings point represented the viewing of 959,000 television households in 1996, and each household represented 2.61 people.[4]

A **ratings period** consists of four sequential weeks of data, reported week by week and averaged for the month. In addition to the four major nationwide television sweeps, **large-market stations** purchase ratings for as many as four more ratings periods (most commonly two more books in October and January, and sometimes books for March and September). Midsized and smaller television markets perhaps purchase one ratings book beyond the four sweeps. The stations in a market must contract with Nielsen for a ratings book, paying the cost of data collection, analysis, and reporting. In the very largest markets, stations pay as much as $1 million a year for ratings; in very small markets, however, the price may be as low as $10,000 annually. Other companies, such as advertising agencies, station representatives, and syndicators, can subsequently purchase the network, cable, and local ratings books. It is important to understand that stations pay for ratings in their market, and the quality could be better if stations could afford to

2.2 NIELSEN MEDIA RESEARCH

Headquartered in Northbrook, Illinois, Nielsen gathers and interprets data on a wide range of consumer products and services as well as television (no radio). Nielsen's network audience estimates are reported in the *Nielsen National TV Ratings* (often abbreviated NTI for the division that collects the data) twice a year summary books and in the abbreviated weekly booklets called *The Pocketpiece Report* (see Chapter 4 for a sample pocketpiece page). Besides the network-by-network ratings based on the audience for their affiliates, **pocketpieces** now include the collective ratings for independent television stations, superstations, national public broadcasting (PBS), basic cable networks, and premium cable networks, giving network programmers a handy tool for comparing the performance of the networks and their competitors. (Eventually, VCR viewing will be fully incorporated in these reports.) National viewing data are also reported in other forms described in Chapter 3, often combined with product purchase and usage data.

Nielsen also collects nightly ratings called **overnights** in the top 20 metered markets, publishing this information every morning for the benefit of network executives and purchasing stations. Overnights, because of the smaller samples used and the big-city nature of the view-

ers, are only indicators of what the network ratings probably will be when the six-month NTIs are issued. But as more and more major markets are added to the overnight sample, the match between the overnight sample and the total sample comes much closer.

Nielsen also measures local market television viewing. These reports are known as the Nielsen Station Index (NSIs) and published in *Viewers in Profile* for each market. These ratings books are purchased by most television stations and advertising agencies. Nielsen household samples are drawn from the most recent national census, and its ratings are *not* weighted (adjusted to fit national or local population percentages). NSI prepares county-by-county reports on television viewing, various reports for commercial time buyers, several reports for cable networks and system operators, and an online computer service for customized analysis of reach, frequency, and audience flow.

Nielsen also offers a tracking service called the *Scan-Track National Electronic Household Panel.* This national panel consists of about 30,000 households who use handheld barcode scanners to record all purchases, including prices, and whether each item was on sale. This information is then correlated with television viewing

data derived from peoplemeters, plus magazine and newspaper data. Each household transmits all its media data (TV and print) weekly over phone lines to Nielsen's center for data analysis. This service has enormous benefits for corporate brand managers and advertising agency media buyers.

Nielsen also has a service called *Monitor-Plus,* which uses computer-recognition technology to identify all commercials airing in the top 50 major markets. The Nielsen Station Index data is combined with the commercial data to provide gross rating point measurement for each TV spot overall as well as being broken out by brand category and in comparison to competitors. *Monitor-Plus* measures advertising effectiveness, although it took nine years for a major agency to adopt the service.

In 1995 Nielsen launched a new television audience rating service for commercials called AdViews. The service calculates how many households specific advertisers reach in a given week. For example, Nielsen reported that AT&T won the ad war the week of Sept. 4, 1995, with a 256.2 rating. Each rating point equals one-hundredth of the total TV households. In September 1995 there were 95.5 million American TV households. That rating means that AT&T reached 245 million

(continued)

2.2 NIELSEN MEDIA RESEARCH (*continued*)

households that week on prime-time broadcast TV.

The measurement of television audiences will eventually involve computer users as the convergence of media develops in the future. Neilsen and I/Pro Form formed a new service in 1995 to measure online audiences on the World Wide Web. However, the service is limited to general information such as the number of "hits" on a file, where the users came from (domain addresses), and where the user's domain is.

pay more (advertisers, agencies, and reps cover little of the cost). For example, samples could be larger and more representative, diaries could be more carefully double-checked, more call-backs could be made, and data analysis could be more reliable, but each of these steps would substantially increase the cost of ratings to the stations.

Normally, station programmers purchase only the books for their own market, but programmers dealing with groups of stations may purchase all 211 local market reports for the entire country or a subset of books for markets where they have stations or cable systems. These books can be used to cross-compare the performance of programs in different markets, at different times of day, with different lead-in shows, and so on. Subsequent chapters contain discussions about how ratings are used in specific sets of circumstances and point out specific weaknesses.

Network viewing estimates now come from a nationwide peoplemeter sample of 5,000 households with and without cable television (for many years, Nielsen's national sample was just over 1,100 households). To be included in Nielsen reports, at least 3 percent of viewer meters (or diaries in local reports) must record viewing of a cable service. This means that only the top two-dozen or so cable networks figure in most ratings calculations. Multiple-set households are only counted once in total households (TVHH), even though the sum of the audiences to several programs telecast simultaneously may be bigger than the number of households said to be viewing at one time (HUT) because one household may tune to more than one program.

Radio Services

For more than a decade, Arbitron Radio and Birch Radio competed head-to-head across the country to provide local radio ratings. In the view of many advertisers and agencies, Birch provided better data at lower cost, but the economic recession in the early 1990s forced too many radio stations to cut back on the service, driving Birch out of the ratings business in 1991. Since that time, new companies like AccuRatings have attempted to recapture Birch's markets. The services offered today include the following:

1. Arbitron Ratings Company. A subsidiary of Control Data Corporation based in Laurel, Maryland, Arbitron rates radio audience size using diaries. Arbitron's *Radio Market Report* tracks both in-home and out-of-home listening (in cars, offices, and other places) for local radio stations in about 260 markets. The data come from weekly diaries mailed to a sample of households in each market. The size of the sample depends on the past history of response in the market and how much data collection the stations are willing to pay for (larger samples cost more money). Arbitron collects ratings for 48 weeks each year (called continuous radio measurement) in the larger markets and as few as 16 weeks in the smaller markets. It also offers county-by-county reports of radio listening, annual ratings for wired and unwired networks,

and AID (Arbitron Information on Demand), a radio online computer service for diary research.

2. Strategic Radio Research (AccuRatings). Founded in 1980 by Kurt Hanson, this Chicago-based firm launched a service in 1992 after Birch Radio stopped measuring radio audiences. Birch had refined a technique of qualitative ratings research based on using the telephone to collect data. AccuRatings is a very similar service, where listeners are called at random and asked what they listen to and what they've listened to in the last few days. Computer Assisted Telephone Interviewing (CATI) allows AccuRatings to dial dozens of phone numbers simultaneously. Respondents are asked a variety of questions that measure product usage in addition to the usual radio ratings information.

3. RADAR Reports. RADAR (Radio's All Dimension Audience Research), produced by Statistical Research, Inc. (SRI) in Westfield, New Jersey, reports on the performance of the national radio services. RADAR reports cover the size and demographics composition of 20 major radio services, including ABC's six radio networks, CBS's two radio services, Westwood's services (NBC Radio, Westwood One, and Mutual), US I and II, Sheridan, Satellite Program Network's multiple services, and others. Called the network radio ratings, RADAR reports are published twice annually, fall and spring, based on analyses of 32 weeks of continuous measurement beginning at the end of August and running through the end of April. Statistical Research, Inc., collects the data by telephone, and reports are issued in print and directly by computer. These are the only nationwide radio network ratings.

Because different methods usually produce different results, many observers believe that competing radio rating services provide different numbers to their clients. At least one study, however, found no such difference. Telephone recall (AccuRatings) and listener diaries (Arbitron) both possess advantages and limitations, but neither method alone or combined provides a clear record of what the audience is actually listening to or when they listen.

In general, rating procedures for each method are similar from company to company, although each competes to sell more information to its clients. The quantity of demographic detail in local television and radio market reports steadily increased in the late 1970s and early 1980s because of increased competition among the ratings companies and pressure from programmers and advertisers for more information about an increasingly fragmented audience. The advent of cable and the larger audience shares captured by Fox and independent television stations created demand for an even more precise understanding of audience viewing habits. Thus, in local market reports, the rating companies broke demographic information into smaller units (such as 10-year jumps for radio) and more useful categories for different groups of advertisers (both women 18–34 and women 25–49 are now included, for example, as well as similar subgroups of men, children, and teens).

In addition to local and national ratings reports, the largest companies offer a variety of customized reports covering narrower views of the audience (women 18–34 only or Hispanic women 25–54 or children, for example) and specialized programming, such as the Nielsen's analyses of syndicated program ratings, which are particularly useful to stations making program purchases. Chapters 3 and 7 make a special point of the importance of syndicated program reports, which are illustrated later in this chapter.

RATINGS TERMINOLOGY AND MEASUREMENT COMPUTATIONS

Nielsen collects television audience estimates by randomly selecting viewers from the 211 U.S. broadcast television markets. The number of markets varies slightly from year to year and has grown along with population increases. Nielsen calls the markets **Designated Market Areas** (**DMAs**). These areas are roughly equivalent to

Areas of Dominant Influence (ADIs) as determined by Arbitron for measuring radio markets, although Arbitron no longer measures local television markets.

Survey Areas

Nielsen collects ratings data from more than DMAs, as shown in Box 2.3. In the illustration, the smallest measurement unit is the **Metro Area,** the next largest is the local **DMA,** and the largest unit (not shown) is the **Nielsen Survey Index Area (NSI Area).** The NSI Area includes the DMA and the Metro area but also encompasses counties outside the DMA where viewing can be attributed to a station in the DMA. These three geographical areas are described more fully next.

1. **NSI Area.** The NSI Area includes all counties measured in a ratings survey, including counties outside the DMA when substantial viewing of stations inside the DMA occurs in them—viewership is usually attributable to the presence of cable systems. Rarely used by commercial television programmers, NSI Area figures show a station's total estimated reach or circulation. As indicated earlier, **reach** tells how many people have viewed or listened to a station in the past, and it therefore suggests how many could view or listen in the future. In cable, reach tells how many households subscribe to basic cable service. Reach is an important measure for radio, public television, and cable. Another name for reach is cumulative audience, or **cume.**

2. **DMA.** Each county in the United States is assigned to only *one* DMA. When Arbitron measured local television ratings, Arbitron's ADIs and Nielsen's DMAs would occasionally differ in size because each company independently decided which counties belonged to the particular market. Generally, a DMA centers on a single city, such as Dayton or Denver or New York, but in some cases two or even three cities are linked in hyphenated markets, as in the Dallas-Ft. Worth and Springfield-Decatur-Champaign markets. All stations in these multiple markets reach most viewers, making the cities one television viewing market.

Nielsen ranks each DMA according to the estimated number of television households within its counties. As of 1995, the top five DMAs in rank order were New York (with 7 million TV households), Los Angeles, Chicago, Philadelphia, and San Francisco.

3. **Metro Areas.** The third geographical area, the Metro Survey Area (MSA) in radio and Metro Rating Area (MRA) or simply "Metro" in television, is the smallest of the three survey areas and is the one most frequently used for radio programming. The Metro includes only a small number of counties closest to the home city of the DMA and consists of only a single, large county in some parts of the United States, especially in the West. Because competing big-city radio signals generally blanket the Metro, urban radio programmers use it to determine the success or failure of programming decisions. (Coverage patterns in outlying areas may vary too widely to compare.) The Metro represents the majority of the urban radio listeners, the bulk of office and store listening, and a large part of in-car listening. Altogether, more than 250 Metro areas are measured by Arbitron for radio listening. Radio stations on the fringe of the Metro area are more likely to refer to TSA/NSI area measures, and television programmers rarely use Metro ratings because no demographic breakouts are available.

To use any of these ratings services for programming decisions, programmers must understand how the estimates are produced. Using ratings without this knowledge is like trying to play chess without ever learning the rules. Pieces can be moved, but winning the game is unlikely. "Audiences count, but only in the way they are counted." The following subsections provide an overview of the basics of audience computations.

Ratings/Shares/HUTs

A **rating** is an estimate of the percentage of the total number of people or households in a population tuned to a specific station or network during a specific time period (**daypart**) such as morning

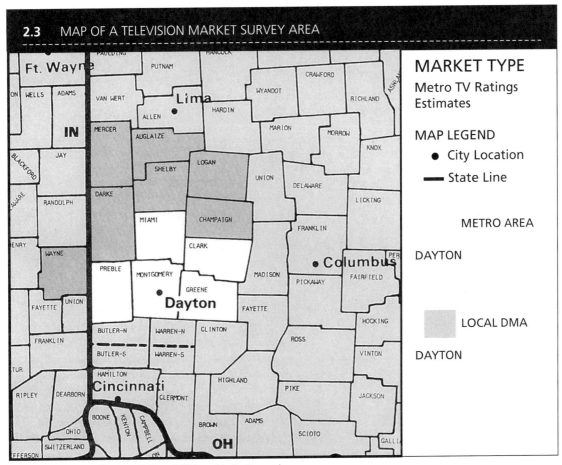

2.3 MAP OF A TELEVISION MARKET SURVEY AREA

MARKET TYPE
Metro TV Ratings Estimates

MAP LEGEND
- City Location
— State Line

METRO AREA

DAYTON

LOCAL DMA

DAYTON

Source: Reprinted by permission of Nielsen Media Research.

drive or access. A **share** is an estimate of the percentage of people or households actually using radio or television and who are tuned to a specific station or network during a specific daypart. Ratings depend on a count of all receivers; shares on a count of all users. Shares are always bigger percentages than ratings for the same program or station because some people who could watch television (or listen to radio) are not watching (they are sleeping or playing or working).

Ratings are always a percentage estimate of an entire population, whether the **population** refers to all households in the country or all people age 25–54 or all adults 12+ or all women 18–49. A

share is always a percentage of those households or people in that population using the particular medium at a specific time. To repeat, *shares always appear larger than ratings because they are based on a smaller sample of people*. Fewer people use television (or radio or cable) than could use it if all were at home, awake, and choosing television above other activities. Both estimates are percentages of an entire group, although the percent sign is often omitted.

Sales staffs use ratings to set advertising rates. Programmers generally use shares in decisions about programs because shares show how well a program does against its competition. Shares

eliminate all the people who are not watching TV and show how many of those watching TV are tuned to a program or station. Programmers at broadcast networks and stations and cable services typically refer to their shares of an actual audience, not their percentage of all households having receivers (or cable service), although newspaper articles often report ratings.

The combined ratings of all stations or networks during a particular daypart provide an estimate of the number of households using television (HUTs) or the persons using television (PUTs) or the persons using radio (PURs). HUTs, PUTs, and PURs are used to compute the shares for each station or network.

To illustrate these concepts, let's assume there are four network television options in the United States and that Nielsen's 5,000 metered households indicate the following hypothetical data for prime time:

Network	Household Viewing
ABC	952
CBS	964
NBC	988
Fox	611
Not watching	1,485
Total	5,000

The HUT level is .703 or 70.3 percent (3,515 / 5,000), calculated by adding households watching television and dividing by the total number of households with television (952 + 964 + 988 + 611 divided by 5,000 equals .703). The answer is changed from a decimal to a percent by multiplying by 100. A HUT of 70.3 means an estimated 70 percent of all households had a television set on at the time of the measurement.

The individual ratings and shares for the four networks can now be calculated.

$$\text{RATING} = \frac{\text{Households Watching a Network}}{\text{Households with Receivers}}$$

$$\text{SHARE} = \frac{\text{Households Watching a Network}}{\text{Households Watching TV}}$$

Network	Ratings	Share
ABC	$\frac{952}{5000} = .190$ or 19%	$\frac{952}{3515} = .271$ or 27.1%
CBS	$\frac{964}{5000} = .193$ or 19.3%	$\frac{964}{3515} = .274$ or 27.4%
NBC	$\frac{988}{5000} = .198$ or 19.8%	$\frac{988}{3515} = .281$ or 28.1%
Fox	$\frac{611}{5000} = .122$ or 12.2%	$\frac{611}{3515} = .174$ or 17.4%

To calculate a rating, the number of households watching a network was divided by the total number of households having receivers. To calculate shares, the number of households watching ABC, for example, was divided by the total number of households watching television.

The individual ratings for all the stations in a market during a given daypart should approximately equal the HUT. Network programmers primarily use rating and share estimates to compare program audiences, but often they also will be interested in the specific number of persons in the audience. Ratings can be used to project to any particular population. For example, the data for the four networks listed produced these estimates for the entire United States (having a total population of about 96 million households).

Network	Rating	× Population	=	Population HH Estimate
ABC	.190	× 96 million	=	18,240,000
CBS	.193	× 96 million	=	18,528,000
NBC	.194	× 96 million	=	19,008,000
Fox	.122	× 96 million	=	11,712,000
	.703 (or 70.3%)		=	67,488,000

The number 18,240,000 represents the 18+ million people estimated to be watching ABC (at this specific time). These calculations can be verified

by multiplying the HUT, 70.3, by the total number of households: .703 × 96 million = 67,488,000, the total for the four networks.

Using part of a page from a Dayton Nielsen book (see 2.4), we can see how ratings and shares were computed for the local television stations WDTN, WHIO, and WKEF.

To calculate the rating and share for WDTN, in this early morning example, Nielsen first analyzed diaries from a sample of households (HH) in the Dayton DMA. It then projected the sample returns to the DMA household population. Approximately 9 percent of the total diaries were tuned to WDTN from 7 A.M. to 9 A.M. If we assume that 9 percent of the diaries reflects 9 percent of the total households, the number of homes watching WDTN can then be calculated. An estimated 503,440 households in the Dayton DMA (this information is supplied on another page) produces a 9 rating for WDTN (45,300/ 503,440 = .09 or 9 percent). The share for WDTN was computed by using the HUT (see the H/P/T totals), which was 27 or 27 percent. Twenty-seven percent of 503,440 yields 135,929 HH, and when that figure is divided into WDTN's 45,300 HH, a share of 33 results.

Nielsen always rounds rating and share figures to the nearest whole number, making numbers easier to read but creating some interpretive problems. If you refer again to the 7 A.M. to 9 A.M. time period on the Nielsen report, you will see that WPTD and WRGT both have "2" ratings, but each station's share is different. We can compute more accurate ratings by manipulating the basic formula, usually written as:

$$\frac{\text{Rating}}{\text{HUT}} \times 100 = \text{SHARE}$$

The calculated value is multiplied by 100 to create whole numbers instead of decimals for shares and ratings. If we transpose to

$$\text{RATING} = \frac{\text{Share} \times \text{HUT}}{100}$$

we can rate more accurately.

$$\text{WPTD Rating} \quad \frac{6 \times 27}{100} = 1.62$$

$$\text{WRGT Rating} \quad \frac{8 \times 27}{100} = 2.16$$

Keep in mind that all ratings and shares are percentages and must include decimal points for all calculations, although, to make their reports easy to read, ratings companies do not print the decimals (see 2.5).

One final point concerning the 7 A.M. to 9 A.M. example is that the HUT/PUT/TOTAL line is 27, but if we add all the stations, the total rating is actually 23. The uncounted rating points means that 4 percent of the households in the DMA were using their television sets for other things—viewing cable stations from other markets, playing video games, or displaying for a computer. Individual shares for all the stations should equal 100 percent when totalled.

PUTs/PURs

Ratings and shares for television generally represent households but occasionally refer to specific demographic groups such as women 18–49. Radio ratings always represent individuals or persons, and therefore, the term *persons using radio* (PUR) is used. *Persons using television* (PUT) is appropriate when calculations of individual viewers are made. Sales staffs and time buyers tend to be more interested in these calculations than programmers, and one of the big advantages of peoplemeters is that they supply individual person as well as household data for the advertising industry.

AQH/Cume

Programmers use two very important computations in calculating ratings: **average quarter-hour (AQH)** audiences and cumulative audience estimates (cume). Program audiences are typically measured in fifteen-minute intervals, hence "quarter-hour audience." Meters can, in fact,

2.4 PORTION OF NIELSEN LOCAL MARKET REPORT, DAYTON MARKET

DAYTON, OH

Column key (left to right): METRO HH [RTG, SHR] · DAYPART TIME(ETZ)/STATION · DMA HOUSEHOLD [RTG, SHR, IN MKT SHR] · SHARE TREND [NOV'92, JUL'92, MAY'92, FEB'92] · DMA RATINGS PERSONS [2+, 12-24, 12-34, 18-34, 18-49, 21-49, 25-54, 35+, 35-64, 50+] · WOMEN [18+, 12-24, 18-34, 18-49, 25-49, 25-54, WKG] · MEN [18+, 18-34, 18-49, 21-49, 25-49, 25-54] · TNS [12-17]

Column numbers: 1 · 2 · | 7 · 8 · 9 | 10 · 11 · 12 · 13 | 15 · 17 · 18 · 19 · 20 · 21 · 22 · 23 · 24 · 25 | 26 · 27 · 28 · 29 · 31 · 32 · 34 | 35 · 36 · 37 · 38 · 39 · 40 | 41

MON.-FRI. 6:00A-7:00A

Station	M-RTG	M-SHR	H-RTG	H-SHR	IN-MKT-SHR	NOV'92	JUL'92	MAY'92	FEB'92	P2+	P12-24	P12-34	P18-34	P18-49	P21-49	P25-54	P35+	P35-64	P50+	W18+	W12-24	W18-34	W18-49	W25-49	W25-54	WKG	M18+	M18-34	M18-49	M21-49	M25-49	M25-54	T12-17
WDTN A	6	39	5	34	42	32	25	24	28	3	1	2	2	3	3	3	4	4	4	4	1	3	3	4	4	4	3		2	2	2	2	2
WHIO C	6	40	6	41	50	36	32	36	41	3	1	2	2	4	4	4	5	5	4	5	2	3	5	6	6	6	3	1	2	2	3	3	1
WKEF N	1	5	1	4	6																	1				1							
WKOI I	<<		<<			NR																											
WPTD P	<<		<<																														
WRGT IF	<<		<<					5	8																								1
WCPO C	<<		<<				NR		NR																								
WKRC A	<<		<<			NR	NR	NR																									
WTBS T	<<		<<																														
WXIX IF	<<		<<																														
ESP	<<		<<						NR																								
NIK	<<		<<			NR		NR	NR																								
TNT	<<		<<			NR	NR	NR																									
USA	<<		<<																														
H/P/T.*	16		15		12	13	7	10	11	8	3	5	5	8	9	10	11	11	11	11	3	7	10	12	12	11	7	3	6	6	7	8	4

6:00A-9:00A

Station	M-RTG	M-SHR	H-RTG	H-SHR	IN-MKT-SHR	NOV'92	JUL'92	MAY'92	FEB'92	P2+	P12-24	P12-34	P18-34	P18-49	P21-49	P25-54	P35+	P35-64	P50+	W18+	W12-24	W18-34	W18-49	W25-49	W25-54	WKG	M18+	M18-34	M18-49	M21-49	M25-49	M25-54	T12-17
WDTN A	9	38	8	33	45	29	32	30	31	3		1	2	3	3	3	6	5	7	5	1	2	3	4	4	4	3	1	2	2	2	2	1
WHIO C	5	24	6	24	33	25	25	27	27	3	1	1	2	3	3	3	4	4	5	4	1	2	3	4	4	4	2	1	2	2	2	2	1
WKEF N	3	12	2	11	15	7	7	9	6	1	1	1	1	1	1	1	2	2	3	2	1	1	1	1	1	1	1		1		1	1	1
WKOI I	<<		<<			NR																											
WPTD P	1	5	1	5		3			5	1																							
WRGT IF	1	6	1	6	9	4	7	8	8	1	1	1	1									1	1	1	1	1							2
WCPO C	<<		<<				NR		NR																								
WKRC A	<<		<<			NR	NR	NR																									
WTBS T	<<		<<											1	1							1		1	1								
WXIX IF	<<		<<																														
ESP	<<		<<						NR																								1
NIK	<<		<<			NR		NR	NR																								
TNT	<<		<<			NR	NR	NR																									
USA	<<		<<																														
H/P/T.*	23		23		17	18	14	17	18	12	5	6	6	9	9	10	15	13	18	15	5	9	11	13	13	10	9	4	6	6	7	7	6

7:00A-9:00A

Station	M-RTG	M-SHR	H-RTG	H-SHR	IN-MKT-SHR	NOV'92	JUL'92	MAY'92	FEB'92	P2+	P12-24	P12-34	P18-34	P18-49	P21-49	P25-54	P35+	P35-64	P50+	W18+	W12-24	W18-34	W18-49	W25-49	W25-54	WKG	M18+	M18-34	M18-49	M21-49	M25-49	M25-54	T12-17
WDTN A	10	37	9	33	45	29	33	31	32	4		1	2	3	3	3	6	5	9	6		2	3	4	5	3	3	1	2	2	2	2	1
WHIO C	5	19	5	19	27	22	23	25	23	3	1	1	2	3	2	2	4	3	6	4	1	1	2	3	3	2	2	1	1	1	2	1	1
WKEF N	4	14	3	13	17	8	8	9	7	2	1	1	1	1	1	1	3	2	4	2	1	1	2	2	2	2	2	1	1	1	1	1	1
WKOI I	<<		<<			NR																											
WPTD P	2	7	2	6		4	3		6	1																							
WRGT IF	2	7	2	8	11	5		9	8	1	2	1	1	1	1						1	2	1	1	1	1							2
WCPO C	<<		<<				NR		NR																								
WKRC A	<<		<<			NR	NR	NR																									
WTBS T	<<		1	2										1	1						1		1	1									
WXIX IF	<<		<<																														
ESP	<<		1	2		3			NR																			1	1	1	1	1	
NIK	<<		<<			NR		NR	NR																								
TNT	<<		<<			NR	NR	NR	2																								
USA	<<		<<																														
H/P/T.*	26		27		19	20	18	20	21	14	6	7	7	9	9	10	17	14	22	17	6	9	12	13	13	10	10	5	6	6	6	7	7

9:00A-NOON

Station	M-RTG	M-SHR	H-RTG	H-SHR	IN-MKT-SHR	NOV'92	JUL'92	MAY'92	FEB'92	P2+	P12-24	P12-34	P18-34	P18-49	P21-49	P25-54	P35+	P35-64	P50+	W18+	W12-24	W18-34	W18-49	W25-49	W25-54	WKG	M18+	M18-34	M18-49	M21-49	M25-49	M25-54	T12-17
WDTN A	7	27	7	25	37	27	26	27	27	3	1	2	3	3	3	3	4	4	6	5	2	4	4	4	4	3	2	1	1	2	2	2	1
WHIO C	8	30	8	29	42	28	30	31	30	4	1	2	3	3	3	3	6	4	9	6	2	4	4	4	4	3	3	1	2	2	2	2	1
WKEF N	2	6	2	6	9	3	5	3	3	1	1	1	1	1	1	1	1	1	1	1	1	1	1	1	1	1							

(table continues below the page break)

The basic relationship among the three variables (rating, share, HUT) is easy to understand, but sometimes difficult to remember. Here is a visual aid:

$$\frac{R}{S \qquad H}$$

(Putting the R "on top" is easy to remember because ratings are most important to the station or channel for advertising purposes.) Here's how to calculate: If you want R (ratings), cover the R with your finger. The result is S (share) multiplied times H (HUT). If you want share, cover the S with your finger. The result is R divided by H. Likewise, cover the H to calculate HUT: The result is R divided by S. (The number you get must be adjusted to provide a meaningful answer: If you multiplied, then divide the result by 100; if you divided, multiply the result by 100.) You may not get the exact result shown by Nielsen because the reported figures are rounded.

measure one-minute audiences, but a person or household is counted in a quarter-hour if the television was turned on for a minimum of five minutes during the measurement period.

Although radio and television diaries also measure audience size in fifteen-minute intervals, programmers utilize these data in much larger units—by whole program or daypart. Quarter-hours are the particular concern of those who try to count fickle radio listeners. (Both time units may be too gross for measuring remote control grazers and radio button pushers.)

Cumulative audience measures are appropriate for small audiences that would not show up in rating/share measures. Cume measurements indicate the number of different people tuned in during a fifteen-minute (or longer) time period. Cume figures are always larger than AQH figures.

The basic difference between AQH and cume is that in the average quarter-hour calculation persons can be counted more than once in a total daypart. For instance, a person could tune to a station for five minutes, switch stations or tune out, and then tune back into the original station during a later quarter-hour. This viewer would be counted twice in an AQH calculation, but not in a cume calculation because it counts only the number of different persons listening. Cume is considered to be the reach of a station because it tells you how many different persons were in the audience during a time period or daypart. It also reflects the growth or decay of an audience over time.

Public television and basic cable audiences are often too small for accurate measurement within one quarter-hour, but cumulative ratings over a longer period of time may reflect more substantial audiences. Cumes can also be calculated for a single program over several airings, a common pattern in public television and cable measurements, permitting programmers to estimate the total number of people who watched a program. Commercial broadcasting with its special interest in the number of people watching one commercial spot generally uses AQH ratings.

Reach and Frequency Analysis

Sales people most often use the concepts of *reach* and *frequency*. As we said earlier, **reach** refers to circulation, or the net size of the audience; **frequency** indicates the number of times a person was exposed to a particular advertising message (or program). A high frequency means exposure to a message several times and indicates the "holding power" of a station, network, or program. Programmers usually schedule several interesting programs in succession, trying to create audience flow and achieve a high frequency for advertisers among successive programs appealing to the same viewers.

2.6 NIELSEN LOCAL MARKET REPORT, DAYPART AUDIENCE SECTION

DAYTON, OH

DAYPART SUMMARY

Metro HH R/S	Daypart Time(ETZ) Station	DMA Household R / S / In Mkt	Share Trend Nov92 Jul92 May92 Feb92	Persons (2+ · 12-24 · 12-34 · 18-34 · 18-49 · 21-49 · 25-49 · 25-54 · 35-54 · 35-64 · 50+)	Women (18+ · 12-24 · 18-34 · 18-49 · 25-49 · 25-54 · WKG)	Men (18+ · 12-34 · 18-34 · 18-49 · 21-49)	TNS 12-17 / Child 2-11 · 6-11	Pct Dist (Met · Home DMA · Adj #1 #2 #3)	TV HH Rtgs Adj DMA's (#1 #2 #3)
	4:00P–6:00P								
20 45	WDTN A	18 41 53	34 43 39 39	9 5 6 7 8 8 9 14 12 18 15	8 11 12 12 13 10	7 3 5 5 5 6 4	1 1	71 · 86 12	2
10 22	WHIO C	10 22 28	21 20 19 22	5 3 3 3 4 4 4 8 6 11 7	3 9 4 4 3 3 2	3 3 2 2 2 2	1 1	69 · 92 6 1	2 1
5 12	WKEF N	5 11 15	12 4 6 6	4 7 6 4 3 3 2 1 1 1 3	1	1 4 4 4 2		53 · 68 26 1	1 · 1 1
<<	WKOI I	1	NR				8 10	66 ·	
1 1	WPTD P	1 1						66 · 96 4	
3 6	WRGT IF	3 6 8	7 7 8 8	2 2 2 1 1 1	1 2 2 1 1 1	1 1 1 1 1	3 8 8	51 · 66 33	1
<<	WCPO C	1 1	2 NR NR				2 8 8	51 · 70 24	1
<<	WKRC A	<<	NR NR NR						
<<	WTBS T	1 2	2 2 1	1 1 1	1		1 2 2		
1 1	WXIX IF	<<	2 2 1	1 1	1	1	2 1		
<<	ESP	<<	2 NR				1 1		
1 1	NIK	1 1	NR 2 NR NR		1 1	1	2 3		
<<	TNT	<<	NR NR NR 2						
<<	USA	<<	3 2 2 3				1 1		
44	H/P/T. *	45 35	38 34 36 41	27 23 22 21 21 20 21 30 25 37 32	30 28 26 26 26 22 20	14 15 15 15 16	26 29 31		

Source: Reprinted by permission of Nielsen Media Research.

TELEVISION MARKET REPORTS

Market reports (or "books") are divided into sections to allow programmers, sales people, and advertisers to examine an audience from many perspectives. In television, the major sections are: Daypart Audiences, Time Period Averages, and Program Averages.

Daypart Audience

The Daypart Audience section divides viewing into 29 dayparts, a highly useful format for analyzing a station's overall performance in specific time blocks. For instance, Monday through Friday early fringe (4 P.M. to 6 P.M. EST) provides a quick summary of the ratings and shares for all stations during this daypart. A page from a Nielsen book in 2.6 shows the weekday 4 P.M. to 6 P.M. period in the Dayton market.

Nielsen divides the viewers into 27 demographic (age and sex) classifications for both the DMA and the NSI station totals. For just one station, 580 ratings cells are required to fill out all 20 Nielsen people categories and 29 daypart categories for station totals alone. A single ratings book page contains an immense amount of data.

A look at 2.6 shows that WDTN-TV was the strongest station in the market in the early fringe daypart, with a 18 rating/41 share in the DMA and 20/45 in the Metro. It was very strong with both women 18–49 and men 18–49. No doubt this station's programmer was delighted because these demographics are very easy to sell to advertisers.

Programmers normally compare the current numbers to previous performances. **Tracking** a

daypart shows how the station or program is doing over time. It is also important in selecting syndicated programs (see Chapters 3 and 7). Rarely will program decisions be based on only one book unless the numbers are very low and very credible and no hope for improvement is in sight.

Network Daypart/Time Period Averages

The Network Daypart section provides broad time-segment information for network programming (ABC, CBS, NBC). Arbitron and Nielsen divide data on dayparts and demographic groups for the networks just as they do for stations in each market's report. An example is not included here since the layout of the Network Daypart section is similar to that shown in 2.6. This ratings book section shows how network programming performed on the local station—which on occasion is very different from national averages. The section lets programmers compare the major networks in market-by-market performance.

Television programmers are interested not only in broad dayparts but in quarter-hour or half-hour segments within them. This information, found in the Time Period Averages section of ratings books, is useful in determining a program's strength against the competition for a specific quarter-hour or half-hour. Managers of affiliates look here, for example, to see how their local newscast stacks up against its competitors. It also has an overview of access time and early fringe competition and shows lead-in and lead-out effects. Programmers use these data to analyze performance in time segments. (Sales people use these data to determine spot ratings.)

Averages for the whole week, Monday to Friday, are included in the Time Period Averages section along with most prime-time network programming because it varies from night to night. These figures show performance during a daypart or time period when all days are averaged together, crucial data when a programmer is looking at stripped programming in early fringe and prime-time access.

Program Audience

The last major section of a television ratings book, one television programmers most often use, is the Program Audience section. Rather than lumping a program into a daypart, this section breaks each daypart and program into thirty-minute segments (and some fifteen-minute ones) to isolate individual programs on different days of the sweep weeks. The Program Audience section is considered the "pure programming" section because each program is analyzed individually here. It shows the titles of the shows and any scheduling variations from night to night. This allows programmers to examine ratings for their local news, say, night by night, and to eliminate the odd night when a sporting event, for example, cuts into the news time.

Look at the Program Averages data for Dayton at 7 P.M. in 2.7. The highlighted numbers are the DMA rating/share and Metro rating/share for all weekdays (AV5). Notice that in DMA measurements, WHIO dominates the competition with a 36 share for *Wheel of Fortune*. WDTN and WKEF (affiliated with ABC and NBC, respectively) have a 13 share and an 8 share with *Designing Women* and *Roseanne*. The Fox affiliate WRGT came in third with a 9 share for *Star Trek: The Next Generation*, except in the second week where a Monday pregame show for a local college basketball game only drew a 4 share. This section permits analysis of individual programs without interference from ratings for other programs.

In summary, the sections of a television book provide programmers with at least four different ways to evaluate station performance. Daypart Audience examines broad time periods without regard to specific programs. Time Period Averages provide programming data by quarter-hours and half-hours on a daily basis and are useful in analyzing competitive performance. Finally, Program Averages information isolates the "pure program" data. Each section answers different questions, and television programmers use every section as their questions shift.

2.7 NIELSEN TELEVISION MARKET REPORT, PROGRAM AVERAGES SECTION

DAYTON, OH

WK1 2/04-2/10 WK2 2/11-2/17 WK3 2/18-2/24 WK4 2/25-3/03

METRO HH	STATION DAY PROGRAM	DMA HOUSEHOLD			DMA RATINGS			

(Table of Nielsen DMA Household Ratings and DMA Ratings for Persons, Women, Men, TNS, and Child demographics, with columns for weeks 1–4, multi-week average, HUT, and age/gender breakdowns.)

7:00PM

WDTN	MON	DESIGNING WOMN	
	TUE	DESIGNING WOMN	
	WED	DESIGNING WOMN	
	THU	DESIGNING WOMN	
	FRI	DESIGNING WOMN	
	AV5	DESIGNING WOMN	
	SAT	INSIDE EDITN W	
	SUN	ABC MV SPCL SU	
	SUN	LF GOES ON-ABC	
WHIO	MON	WHEEL-FORTNE	
	TUE	WHEEL-FORTNE	
	WED	WHEEL-FORTNE	
	THU	WHEEL-FORTNE	
	FRI	WHEEL-FORTNE	
	AV5	WHEEL-FORTNE	
	SAT	CASH EXP ANNIV	
	SAT	WHEEL-FORTNE W	
	SUN	60 MINUTES-CBS	
WKEF	MON	ROSEANNE	
	TUE	ROSEANNE	
	WED	ROSEANNE	
	THU	ROSEANNE	
	FRI	ROSEANNE	
	AV5	ROSEANNE	
	SAT	NIGHT COURT	
	SUN	NBC NWS-TERROR	
	SUN	SECRT SRVC-NBC	
WRGT	MON	RALPH UNDRHILL	
	MON	STAR TK-GENRTN	
	TUE	STAR TK-GENRTN	
	WED	BARNEY MILLER	
	WED	STAR TK-GENRTN	
	THU	STAR TK-GENRTN	
	FRI	STAR TK-GENRTN	
	AV5	STAR TK-GENRTN	
	SAT	STAR DS9-AS R	
	SUN	BATMAN-PRM-FOX	
	SUN	FOX NT-MOV SPL	

Source: Reprinted by permission of Nielsen Media Research.

OTHER PROGRAMMING AIDS

Nielsen issues reports on specific demographic groups or types of programs or station market sizes in easy-to-use formats, and stations, reps, and ad agencies rely heavily on them. They also depend on other companies to reanalyze Nielsen's ratings data and to supplement them with other research. Of all these additional services, programmers find analyses of syndicated television programs the most valuable.

Syndicated Program Reports

Affiliates and independents rely on off-network and first-run syndicated programming to fill parts

of their broadcast days. But because syndicated programs are expensive, station decision makers want to know about a program's past performance. Will a program perform well in their market? Will its ratings justify its cost? Reps and program consultants especially want this information because they advise station programmers. Projecting or estimating ratings success for a first-run product is an involved process that finally comes down to an educated guess. The potentials of off-network programs are somewhat easier to evaluate, but even here no hard-and-fast rules exist. Lead-in programs, local competition, and audience fads always influence ratings. *Even the most successful network program may fail in syndication or perform below its network numbers at a given time or in a given market.*

In making decisions about syndicated programs, Nielsen's *Report on Syndicated Programs* is helpful. The major television rep firms also provide similar analyses in less bulky and unwieldy formats. A page from the Nielsen analysis of *Roseanne* is shown in 2.8. At the top right corner of the page, you will find the number of markets telecasting the program, distributor, and other data such as program type and number of episodes available.

The second section provides overall ratings and share data by market rank and by daypart. The number of markets carrying *Roseanne* in early fringe (107 DMA markets) is greater than in prime access, primarily because off-network programs were prohibited from the 7 to 8 P.M. eastern time period until repeal of the Prime Time Access Rule in 1995. For example, in prime access, *Roseanne* had a 7 rating and 14 share in 51 markets, higher than for any other daypart. This section indicates the dayparts and market sizes where the program has played most effectively, quite useful information for programmers. Demographic data by daypart fill out the rest of this section.

The third section of the page shows a market breakout of specific stations carrying the syndicated *Roseanne*. The third market alphabetically is Albany-Schenectady-Troy, which is not a top-50 market where *Roseanne* was forbidden during access time. For example, in that market *Roseanne* ran at 7:30 P.M. on WRGB, a CBS affiliate on

Channel 6, and it had a 9 DMA rating and a 19 DMA (M–F) share. In that market, *Roseanne* got lower ratings than *Jeopardy* (15/30) but higher than *Hard Copy* (8/16) and *Star Trek: The Next Generation* (5/10). However, *Roseanne* wasn't quite as strong as its lead-in, *CBS Evening News*, which had a 10 rating and 21 share. Programmers use this information to purchase or renew the show and to schedule it during a daypart with a lead-in where it will probably be most successful.

This third section also provides data on total persons viewing a program in key demographic groups. In Albany, for example, *Roseanne* was viewed by 27,000 women 18–49 (representing 48 viewers per 100 homes using television). Unlike the *Syndicated Program Analysis* formerly produced by Arbitron, Nielsen's report does not show the demographic breakdown for competing stations. The programmer can, however, turn to the page for *Jeopardy* (not shown here) and see only 25,000 women 18–49 (representing 31 viewers per 100 homes using television). Because *Jeopardy* also has many more women 18+ than *Roseanne*, the programmer can deduce that *Jeopardy* skews toward older women who may not fit the advertisers' target.

Before purchasing a syndicated program, station programmers typically choose markets that are similar to their own in size and regional characteristics and chart the performance of that program to determine its best daypart, its strength and weaknesses against specific competing programs, and its demographic appeal. The *Report on Syndicated Programs* enables programmers to estimate the likely performance of a syndicated program and to schedule it effectively in their lineup. If a program proves unsuitable (demographically or in terms of ratings projections), the analysis is helpful in targeting another program to meet a station's programming needs.

The *Report on Syndicated Programs* is limited to program data about syndicated programs already on the air. Quite often stations must decide whether to purchase a program before it is released in syndication (or even produced). This is particularly the case with **first-run** syndicated programs

2.8 SYNDICATED PROGRAM ANALYSIS (*ROSEANNE*)

ROSEANNE
30 MIN.

REPORT ON SYNDICATED PROGRAMS
NSI AVERAGE WEEK ESTIMATES
JUL 1994

MARKETS REPORTING	165
STATIONS REPORTING	167
TOTAL TV HH'S IN DMA'S	90,099,020
DMA % OF U.S.	96
EPISODES AVAILABLE	122
DIST: VIACOM INTERNATIONAL	
TYPE: SITUATION COMEDY	

SUMMARY BY DAYPARTS

DMA HOUSEHOLD SHARES BY MARKET RANK

DAYPART	1-25 NO.OF DMA'S	1-25 % SHARE	26-50 NO.OF DMA'S	26-50 % SHARE	51-100 NO.OF DMA'S	51-100 % SHARE	101+ NO.OF DMA'S	101+ % SHARE	DAYPART	1-25 NO.OF DMA'S	1-25 % SHARE	26-50 NO.OF DMA'S	26-50 % SHARE	51-100 NO.OF DMA'S	51-100 % SHARE	101+ NO.OF DMA'S	101+ % SHARE
DAYTIME (M-F)†			1	15			1	26	POST PRIME (S-S)	6	11	5	13	6	15	10	18
EARLY FRINGE (M-F)	20	11	22	13	29	13	36	13	WEEKEND DAYTIME(S&S)							3	5
PRIME ACCESS (M-SAT)	3	11	2	11	21	15	25	17	WEEKEND PRE-PRIME(S&S)	5	10	1	10	5	12	6	10
PRIME (S-S)	1	9	3	4	3	6	9	9	AVG. ALL TELECASTS	25	11	25	13	47	13	68	15

TOTAL HOUSEHOLDS AND PERSONS

DAYPART	NO. OF MKT's	NO. OF DMA'S	% U.S. TV	DMA HH AVG. QH RTG	SHR	TOTAL HHLDS (000)	WOMEN 18+ (000)	WOMEN 18+ V/CVH	WOMEN 18-49 (000)	WOMEN 18-49 V/CVH	WOMEN 25-54 (000)	WOMEN 25-54 V/CVH	MEN 18+ (000)	MEN 18+ V/CVH	MEN 18-49 (000)	MEN 18-49 V/CVH	TEENS 12-17 (000)	TEENS 12-17 V/CVH	CHILDREN 2-11 (000)	CHILDREN 2-11 V/CVH
DAYTIME (M-F)†	2	2	1	4	16	45	35	78	25	56	20	45	10	22	6	13	6	14	6	14
EARLY FRINGE (M-F)	107	107	72	6	12	4230	3246	77	2566	61	2067	49	1745	41	1423	34	939	22	1070	25
PRIME ACCESS (M-SAT)	51	51	18	7	14	1264	959	76	737	58	603	48	599	47	454	36	251	20	339	27
PRIME (S-S)	16	16	5	3	6	167	117	70	87	52	76	46	83	50	56	34	30	18	44	26
POST PRIME (S-S)	27	27	21	6	12	1165	931	80	708	61	551	46	551	47	420	36	200	17	106	9
WEEKEND DAYTIME(S&S)	3	3	1	1	5	5	4	84	4	72	2	47	1	21	1	17	2	35	2	39
WEEKEND PRE-PRIME(S&S)	17	17	11	4	11	504	439	87	332	66	270	53	208	41	153	30	103	20	67	13
TOTAL DAY	165	165				5829	4521		3511		2839		2575		2007		1181		1315	
AVG. ALL TELECASTS				6	12	36	28	77	22	61	18	49	16	44	13	35	7	21	8	23

LINE 1 REPORTABLE STATIONS MARKET T.Z. ON AIR / LINE 2 TOTAL DAY STATION CH. NET. DMA SHARE / LINE 3 START NO. OF DAY TIME T/CS. / LINE 4 LEAD-IN-PROGRAM	FOUR WEEK AVERAGE TIME PERIOD AUDIENCES (THIS PROGRAM vs. PRECEDING HALF HOUR) DESIGNATED MARKET AREA — DMA % HH RTG / SHR / PERSONS SHARE % ‡ WOMEN 18+ / 18-49 / 25-54 / MEN 18+ / 18-49 / 25-54 / TNS 12-17 / CHD 2-11	DMA % HH RTG / SHR	PROGRAM AUDIENCE SECTION (SYNDICATED PROGRAM ONLY) STATION TOTALS (000) VS V/100VH / TOTAL HHLD / TOTAL ADULTS / WOMEN 18+ / 18-49 / 25-54 / MEN 18+ / 18-49 / TEENS 12-17 / CHILD 2-11	COMPETING FOUR WEEK AVERAGE TIME PERIOD AUDIENCES CORRESPONDING TIME PERIOD-3 HIGHEST COMPETING STATIONS STATION / PROGRAM	DMA % HH RTG / SHR

Column numbers: 1 2 3 4 5 6 7 8 9 10 11 12 | 13 | 14 15 16 17 18 19 20 21 | 22 23

ABILENE-SWTWATR CE 4
KTXS CH.12 A 12%
M-F 5.00P 20T/C
I DRM-JEANNIE

	1	2	3	4	5	6	7	8	9	10	11	12	13	14	15	16	17	18	19	20	21	STATION/PROGRAM	22	23
M-F 5.00P 20T/C	4	9	9	19	20	8	18	17	13	15	4	9	(000) 5	6	4	3	3	2	2	1	2	KTAB JEOPARDY	13	29
I DRM-JEANNIE	1	4	1	1	1	3	5	5	7	8			V/CVH 110	68	57	59	42	36	19	30		KRBC 9 NWS NEWSBEAT / KDT FULL HOUSE	10 22 / 1 2	
TUE 9.00P 4T/C	4	8	9	16	10	10	17	14	26	8	4	8	(000) 6	11	5	4	4	5	5	2	1	KTAB CBS TUE MOV	15	29
#COACH-ABC	5	11	13	24	18	11	17	15	29	11			V/CVH 162	84	63	54	78	71	31	20		KRBC # DATELINE NBC / KDT REAL-HWY PATRL	10 19 / <<	
MARKET AVG.											4	9	(000) 6 V/CVH 120	7 71	4 58	3 58	3	2 49	1 43	1 21	2 28			

ADA-ARDMORE CE 2
KXII CH.12 C 25%
M-F 6.30P 20T/C
NWS,WEA,SPTS

	1	2	3	4	5	6	7	8	9	10	11	12	13	14	15	16	17	18	19	20	21	STATION/PROGRAM	22	23
M-F 6.30P 20T/C	13	24	25	30	30	25	46	40	51	34	13	24	(000) 14	20	12	8	7	7	6	3	4	KTEN WHEEL-FORTNE	17	32
NWS,WEA,SPTS	22	38	42	30	39	40	39	42	49	20			V/CVH 136	86	55	51	50	40	20	24				

ALBANY-SCH-TROY EA 5
WRGB CH. 6 C 22%
M-F 7.30P 20T/C
CBS EVENNG NWS

	1	2	3	4	5	6	7	8	9	10	11	12	13	14	15	16	17	18	19	20	21	STATION/PROGRAM	22	23
M-F 7.30P 20T/C	9	19	18	24	24	18	22	22	19	22	9	19	(000) 58	75	41	27	27	34	23	5	9	WTEN+ JEOPARDY	15	30
CBS EVENNG NWS	10	21	20	17	19	22	17	21	2	7			V/CVH 130	70	48	47	59	40	9	16		WNYT HARD COPY / WXXA STAR TK-GENRTN	8 16 / 5 10	

ALBUQ-SANTA FE MT 6
KASA CH. 2 IF 10%
M-F 6.00P 20T/C
FULL HOUSE

	1	2	3	4	5	6	7	8	9	10	11	12	13	14	15	16	17	18	19	20	21	STATION/PROGRAM	22	23
M-F 6.00P 20T/C	8	16	15	25	19	13	21	18	43	35	8	16	(000) 45	58	36	31	23	22	19	15	18	KOAT+# ACTN 7 NWS-6	14	26
FULL HOUSE	8	16	14	23	18	10	18	13	53	47			V/CVH 127	79	69	50	48	42	33	39		KRQE+# JEOPARDY / KOB +# NEWS 4 AT 6PM	12 22 / 8 15	
M-F 10.00P 16T/C	3	6	5	8	6	4	6	5	21	11	3	6	(000) 16	20	12	10	8	8	7	7	4	KOAT+# ACTN 7 NWS-10	18	36
VARIOUS	5	9	9	12	9	9	12	11	15	17			V/CVH 124	74	66	50	50	41	47	24		KOB + NEWS 4 / KRQE+ NEWS 13-3	12 24 / 7 13	
MARKET AVG.											6	12	(000) 32 V/CVH 127	41 78	25 68	22 50	16	16 49	14 42	12 36	12 36			

ALEXANDRIA, LA CE 5
KALB CH. 5 N 35%
M-F 3.30P 19T/C
#LEEZA-NBC

	1	2	3	4	5	6	7	8	9	10	11	12	13	14	15	16	17	18	19	20	21	STATION/PROGRAM	22	23
M-F 3.30P 19T/C	8	27	30	30	21	28	29	19	29	15	9	28	(000) 12	12	9	6	4	3	1	2	2	KLFY # MAURY POVICH	3	9
#LEEZA-NBC	9	29	35	30	23	29	25	17	19	7			V/CVH 99	77	49	35	23	12	17	16		KLAX MAURY POVICH / KDW TINYTOONS-FOX	3 8 / <<	

AMARILLO CE 5
KCIT CH.14 IF 9%
M-F 6.00P 19T/C
FULL HOUSE

	1	2	3	4	5	6	7	8	9	10	11	12	13	14	15	16	17	18	19	20	21	STATION/PROGRAM	22	23
M-F 6.00P 19T/C	7	14	11	20	17	12	21	14	41	20	8	14	(000) 13	13	8	7	6	6	5	5	3	KVII+ PRO NWS 6	16	30
FULL HOUSE	7	17	9	19	15	7	12	7	54	51			V/CVH 103	60	52	42	43	38	35	26		KAMR NWS 4 AT SIX / KFDA NEWS CH 10-6	10 19 / 7 14	

ANCHORAGE YU 6
KTBY CH. 4 IF 12%
M-F 6.00P 20T/C
FULL HOUSE

	1	2	3	4	5	6	7	8	9	10	11	12	13	14	15	16	17	18	19	20	21	STATION/PROGRAM	22	23
M-F 6.00P 20T/C	7	15	17	24	18	10	13	11	63	27	7	15	(000) 8.2	8.6	5.9	5.5	4.4	2.7	2.3	2.3	2.7	KTUU # CH 2 NEWSHOUR	17	36
FULL HOUSE	6	15	13	20	15	3	4	4	53	56			V/CVH 104	71	67	54	33	28	28	33		KTVA WHEEL-FORTNE	9	19

(never on a network) and popular off-network programs (often purchased before any station has tried them out). (The subject of purchasing **futures** on programs is covered in Chapters 6 and 7.) In the case of off-network programming, national and local data from the program network performance can be projected to the local market, although many markets differ substantially from the national market. However, purchasing first-run syndicated programs is much riskier because they lack both network and station track records.

Computerized Services

A ratings book represents only a fraction of the data available from Nielsen. The books exclude county of residence, zip code, specific viewing and listening patterns, and each individual diarist's reported age (in ratings books age is only group data such as women 18–34). A diary also tells what the diarist was watching at 5:45 P.M. before he/she began watching the 6:00 P.M. news. Nielsen stores this raw diary information on computer tapes that stations can examine for a substantial fee by means of a computer terminal. Nielsen's systems are called TV Conquest and Megabase. The information on these computer tapes allows programmers to analyze nonstandard dayparts, specific groups of zip codes, nonstandard demographics, county-by-county viewing, and audience flow patterns. In addition, sales staffs use the terminals to compute audience reach and frequency. If a programmer wants more information on selected programs on a market-by-market basis, Nielsen offers its *Cassandra* reports that provide detailed comparisons.

The management of any station, network, or cable service that subscribes to Nielsen (or Arbitron for radio) can personally review viewer or listener diaries. The main reason for inspecting diaries is to search for unexpected entries such as how listeners or viewers recorded the station's or service's name or call letters (or slogan or air personalities). Sometimes diarists name things differently than stations expect them to. A station can remedy incorrect attributions in subsequent ratings periods by submitting a limited number of different

"nicknames" to Arbitron (or by changing a slogan if it is easily confused with a competitor's). Before computerized systems became available, firsthand diary reviews (usually by specialist companies located near the diary warehouses) were standard procedure after each ratings book was published. Computer tape now permits the information to be examined anywhere if the appropriate software is purchased.

Broadcast stations and cable services of all sizes routinely use microcomputers in all their operations, including programming. Television ratings and syndicated program reports are available on disc in several formats. Local station programmers use computer software to schedule shows, print daily, weekly, and annual program logs, and keep track of competitors' program purchases in the same way that reps track purchases for many markets (see Chapter 3).

In addition, some local programmers use microcomputers to keep track of local **program availabilities** (syndicated programs not yet under contract in their markets) and their own station's program inventory, including contract details, plays, and amortization schedule. Television programs are introduced, launched, bought, and withdrawn constantly. Keeping tabs on the daily changes in the program market involves constant record keeping based on information from the trade press and reports from reps and distributors. Only the largest stations and rep programmers have the resources to track this crucial programming information and keep timely records.

RADIO REPORTS

Audiences for the 12,000 radio stations in the United States are more fragmented than broadcast television audiences (although the spread of cable is altering that condition for television). The largest radio markets such as Los Angeles have more than 80 stations, dividing the audience into tiny slivers per station. In general, *radio stations compare their share of the audience and their cumulative*

2.9 ARBITRON RADIO MARKET REPORT, METRO AUDIENCE TRENDS, PERSONS 12+

	MONDAY - SUNDAY		6AM - MID			WEEKEND		6AM - MID		
	Spring 95	Summer 95	Fall 95	Winter 96	Spring 96	Spring 95	Summer 95	Fall 95	Winter 96	Spring 96
WAAA										
SHARE	3.3	3.7	**	3.2	2.6	3.0	3.7	**	2.9	2.1
AQH(00)	168	187	**	163	133	128	163	**	125	96
CUME RTG	10.7	11.6	**	10.8	10.0	5.9	5.9	**	6.2	5.1
WBBB										
SHARE	3.6	3.7	**	3.5	4.4	3.0	3.2	**	3.0	3.4
AQH(00)	183	187	**	179	228	128	143	**	129	150
CUME RTG	11.7	11.1	**	11.6	13.2	5.6	6.4	**	5.8	6.8
+ WCCC										
SHARE	8.0	7.6	**	7.8	9.4	7.5	7.0	**	7.8	9.5
AQH(00)	404	385	**	395	488	324	315	**	331	426
CUME RTG	16.7	14.9	**	15.7	17.1	10.4	9.5	**	10.0	11.1
WDDD										
SHARE	2.5	2.7	**	2.1	2.3	3.2	3.4	**	2.3	2.5
AQH(00)	124	140	**	108	120	136	150	**	97	112
CUME RTG	7.4	8.4	**	6.4	7.1	4.7	5.5	**	4.3	4.7

Metro Audience Trends

Footnote Symbols: ** Station(s) not reported this survey.
+ Station(s) reported with different call letters in prior surveys - see Page 5B.

Source: Arbitron Ratings Co., used with permission.

audience to that of other stations with similar formats in the same market. The most popular stations use shares, and the least popular use cumulative audiences, although formats lending themselves to tuning in and out (such as all-news) use cumulative audience ratings even when they are popular. The top 100 radio markets correspond closely to television DMAs, but because some areas of the United States have radio but no television (largely in the West and South) the total number of radio markets (250+) is larger than the 211 television DMAs.

Ratings books for radio are organized differently from those for television. An Arbitron radio ratings book contains Share Trends, followed by Demographic Breakouts, Daypart Averages, Cume Estimates, Hour-by-Hour Estimates, and a few smaller sections. The age and sex categories used in radio differ from those used for television because radio stations target their programming to more precisely defined demographic groups. Thus, age ranges for radio are smaller than those used in

television, typically just ten years, as in 25–34. Most classification groups end in "4" for radio (24, 34, 44, 54); the groups used for television (18–49, 25–54) are broader, reflecting the more heterogeneous nature of television audiences and thus television advertising sales.

Metro Audience Trends

The Metro Audience Trends section reports a station's Metro shares for five ratings books—the current survey and the previous four surveys—covering a period of about one year. These data show a station's share pattern (its "trend") over time for four separate demographic groups: 12+, 18–34, 25–54, and 35–64. A hypothetical example for the demographic category of Total Persons 12+ is shown in 2.9. A programmer can get a quick overview of all stations' performance in the market from the Metro Audience Trends section.

Consider the Monday to Sunday 6 A.M. to midnight period in 2.9 as an example. It shows that

2.10 ARBITRON RADIO MARKET REPORT, SPECIFIC AUDIENCE,
MONDAY–SUNDAY, 6 AM–MID

	AQH (00)													
	Persons 12+	Men 18+	Men 18-24	Men 25-34	Men 35-44	Men 45-54	Men 55-64	Women 18+	Women 18-24	Women 25-34	Women 35-44	Women 45-54	Women 55-64	Teens 12-17
WAAA														
METRO	174	55	8	15	21	8		112	28	35	30	6	12	7
TSA	186	55	8	15	21	8		124	39	35	31	6	12	7
WBBB														
METRO	322	142	18	68	43		6	177	39	69	41	13	9	3
TSA	370	167	18	78	56	1	6	200	42	87	42	13	9	3
+ **WCCC**														
METRO	636	269	12	23	36	47	59	366	22	19	51	44	88	1
TSA	667	281	12	23	36	53	60	385	22	27	51	46	95	1
WDDD														
METRO	135	55	9	8	18	4	8	69	5	11	19	7	13	11
TSA	135	55	9	8	18	4	8	69	5	11	19	7	13	11
WEEE														
METRO														
TSA														

Specific Audience

Footnote Symbols: * Audience estimates adjusted for actual broadcast schedule.
+ Station(s) reported with different call letters in prior surveys - see Page 5B.

Source: Arbitron Ratings Co., used with permission.

from Spring '95 to Spring '96, WCCC clearly led the market and continued to have climbing shares and cume ratings in the last book. WBBB was the number two station and had an upwardly trending cume. WDDD was at the bottom of the market with flat ratings. WAAA's 12+ share declined from 3.3 to 2.6, but the drop is less than a full ratings point, and the station's cumulative rating remained at 10 percent of the market (near the bottom of the hypothetical market). Up and down data tell a program director that the music probably needs some fine tuning in the Monday to Sunday 6 A.M. to 10 A.M. slot. WAAA's programmer needs to examine additional pages in the book, however, before making any major decision.

Demographic Breakouts

Pages from Arbitron's Specific Audience (2.10) and Listening Locations (2.11) sections illustrate different ways of displaying ratings and share data serving different purposes. Metro and TSA AQH ratings for several ten-year age groups broken out by gender (and Men 18+ and Women 18+), with Persons 12+ and Teens 12–17 listed separately, are presented in 2.10. In 2.11, Metro AQH population estimates are detailed for three different places people hear radio (At Home, In-Car, and Other) for drivetime and three other time periods. These data are reported separately for Persons 12+, Men 18+, and Women 18+ (2.11 shows only Men 18+). These Specific Audience and Listening Locations data help programmers see which dayparts draw which audience subgroups and where listeners most use the station. In combination with other information provided in an Arbitron book, they suggest how different programming (or additional promotion) can improve audience composition (and therefore salability).

Arbitron also reports an hour-by-hour analysis that includes 10 demographic groups by AQH for the Metro area. A programmer can track a station's performance hour-by-hour from 5 A.M. to 1 A.M. to isolate particularly strong or weak hours

2.11 ARBITRON RADIO MARKET REPORT, LISTENING LOCATIONS, MEN 18+

	METRO AQH (00)											
	MONDAY-FRIDAY COMBINED DRIVE			MONDAY-FRIDAY 10AM-3PM			WEEKEND 10AM-7PM			MONDAY-SUNDAY 6AM-MID		
	At Home	In-Car	Other	At Home	In-Car	Other	At Home	In-Car	Other	At Home	In-Car	Other
WAAA	18	26	13	9	27	21	12	8	6	14	18	11
%	31	46	23	16	47	37	46	31	23	33	42	25
WBBB	36	43	57	27	31	92	25	17	18	30	27	43
%	26	32	42	18	21	61	42	28	30	30	27	43
WCCC	129	49	77	122	33	140	118	29	14	114	34	56
%	51	19	30	41	11	48	73	18	9	56	17	27
+ WDDD	29	26	7	19	22	6	22	10	4	24	17	5
%	47	42	11	40	47	13	61	28	11	52	37	11

Footnote Symbols: * Audience estimates adjusted for actual broadcast schedule.
+ Station(s) reported with different call letters in prior surveys - see Page 5B.

Source: Arbitron Ratings Co., used with permission.

during the broadcast day. Other sections of the Arbitron radio book include Exclusive Audience and Cume Duplication, both of which help radio programmers understand how listeners use radio.

Arbitron radio data also come on discs in the IBM-PC format, an option called Arbitrend. Arbitrend reflects only the continuously measured markets and contains only a few demographics. Programmers for music radio stations can also purchase (or write) software to accomplish most of the tedious work involved in developing a station's music playlist. (See Chapter 13 on creating music wheels.) One widely used software program on the market accounts for 50 different characteristics of a song in selecting its position and rotation.

Time-Spent-Listening

Programmers are rarely content with the bare facts reported by Arbitron (or Nielsen in the case of television), so they use all these various ratings to make many different computations. For example, radio programmers generally want to know how long their audience listens to their station, known as **time-spent-listening (TSL).** TSL is computed

by multiplying the number of quarter-hours in a daypart times the rating and dividing by the cumulative audience.

To illustrate, assume we have the Los Angeles Arbitron Radio Market Report and want to compute the 18+ TSL for KABC-AM. We can pull the AQH and cume from the book to produce the TSL. The TSL for adults 18+ for this station, Monday to Sunday, 6 A.M. to midnight, is calculated using the following formula:

$$TSL = \frac{AQH \text{ in Time Period} \times AQH \text{ Audience}}{Cume \text{ Audience}}$$

$$AQH \text{ in Time Period} = 504*$$
$$AQH \text{ Audience} = 872 \ (00)**$$
$$Cume \text{ Audience} = 9{,}875 \ (00)$$

$$TSL = \frac{504 \times 872}{9875} = 39.9$$

*There are 504 quarter-hours from 6 A.M. to Midnight, Mon.–Sun.
**Zeros indicate that these numbers are in thousands, i.e., 87,200.

Therefore, the programmer concludes that the average length of listening to KABC for an adult 18+ is 39.9 quarter-hours during a given week, 6 A.M. to midnight. A high TSL indicates that people (who listen) are listening for long periods of time, not that a lot of listening goes on. TSL refers only to the amount of listening by those who do listen. Television programmers also calculate time-spent-viewing using the same formula.

Turnover

Turnover indexes the rate at which an audience changes, or turns over, during a time period. Turnover is calculated by dividing the cumulative audience by a quarter-hour rating:

$$\text{TURNOVER} = \frac{\text{Cume Households or Persons}}{\text{AQH Households or Persons}}$$

A low turnover rate indicates a loyal audience, and high turnover means a station lacks "holding power." Television stations expect more turnover than radio stations and go after greater reach. Turnover is calculated for public broadcasting and cable as well as for commercial radio and television. Tracking the amount of turnover over time on a graph provides a quick clue to changes in audience listening or viewing patterns for an individual station or service.

CABLE RATINGS

Nielsen reports cable network ratings data separate from broadcast network data for the larger basic and premium cable services (in addition to cumulative totals for all basic and pay networks within the *Pocketpieces* and *NSI Reports*). More than 65 percent of its 5,000 peoplemeter sample are cable subscribers, and Nielsen issues its *Cable National Audience Demographics Report* covering the national audiences for the largest services drawn from peoplemeter data.

In general, the introduction of peoplemeters has benefited cable services far more than most broadcast stations (they also aid some independent stations). Viewers tend to fill in diaries at the week's end, losing track of where VCR recordings came from and forgetting the names of the many (relatively new) cable networks, so the more familiar-sounding networks tend to get undeserved diary entries and consequently high ratings. Peoplemeters, however, record the exact channel viewed, the length of viewing (as do traditional passive meters), and the composition of the audience. Most local markets, however, continue to be measured with diaries or diaries plus passive meters.

On the local market level, individual cable networks are included in Nielsen's *Cable Activity Report* when they achieve a 3 percent share of audience (and pay the cost of data analysis and reporting). Nielsen measures cable service audiences along with broadcast station audiences in the all-market sweeps (using diaries or meters or both). But cable lineups differ from franchise to franchise within one market, and accurate tracking of channel attributions ("I watched Channel 3") has been difficult. For example, the Washington, D.C. area has about 23 cable franchises, which place the dozens of cable networks (and some broadcast TV stations) on widely differing channel numbers.[5] In consequence, ratings for the smaller services have not been stable even within a single market.

To qualify for inclusion in the standard television sweep reports, a cable service must reach 20 percent of net weekly circulation. In other words, 20 percent of the market's television households must view it for at least five minutes during the survey week. In the first year of reporting (1982), only HBO, WTBS-TV (the superstation now called TBS), Showtime, and ESPN qualified. A decade later, however, nearly all of the top 20 largest cable networks qualified in most markets, including A & E, Cinemax, The Discovery Channel, ESPN, The Movie Channel, CNN, USA, The Family Channel, MTV, The Nashville

Network, Lifetime, Nickelodeon, C-SPAN, and TNT. Other cable services such as WGN and WWOR easily qualify in some regions of the country. However, cable networks appearing on only some of a market's systems have more difficulty meeting the minimum viewing level, even when they are regularly watched by the cable subscribers able to receive them.

Premium Services

Pay movie services have special measurement problems. Movies, the largest element in their programming, appear in repeating and rotating patterns to attract large cumulative audiences for each feature. This contrasts with the broadcast television pattern of scheduling a movie or series episode only once in prime time (typically) and seeking the largest possible audience for that one showing.

Indeed, viewers shift the times they watch pay cable so much more than they do broadcast television (by recording movies on home VCRs) that it becomes problematic to use the same measurement criteria. (See Chapters 9 and 11 on program evaluation and audience measurement.) Moreover, the total number of pay households is relatively small for all services except HBO; only about one-third of households take one or more pay services. And the large number of basic and pay-cable television networks split up the ratings much as radio stations do in major markets. Cable programmers use the ratings information available to them to judge individual program popularity and channel popularity, but as yet cable networks win only specific time periods in competition with broadcasters. Frequently, however, the cumulative audiences for all showings of a top-notch movie on HBO equal the size of a television network's audience.

Nielsen publishes a quarterly *Pay Cable Report* and a comprehensive *Video Cassette Recorder Usage Study*, which can help pay cable programmers make sense of reported viewing. The Nielsen Homevideo Index, as contrasted with the Nielsen Station Index, provides many additional specialized reports for cable programmers.

Cable Penetration Measures

Using figures supplied by Nielsen and the industry itself, the industry regularly updates cable statistics, reporting how many households have access to cable at the present time, called **homes passed (HP)**. As of 1995, more than 96 percent of U.S. households were passed by cable wires; that is, people in 96 percent of homes/apartments *could* subscribe to cable if they wanted to. **Cable penetration** is the percentage of television households subscribing to basic cable service (shown as household penetration in 2.12), which was over 65 percent in the mid-1990s. By 2000 about 98 percent of homes will be passed, and cable penetration will be 75 percent or higher. Competition from multichannel providers like direct-to-home satellite, MMDS, and DBS increased substantially in the 1990s, reaching, collectively, about 5 percent of homes.

In 2.12, the number of pay-cable subscribers appears as a percentage of total television households. Another important figure to the industry is *pay as a percentage of basic cable subscribers*, because those are the homes actually able to sign up. For example, 2.12 shows that less than a third of U.S. television households subscribed to pay cable in 1995 but that more than 80 percent of basic cable subscribers took one or more pay channels.

Like radio, cable services are also concerned with audience turnover. In cable, **churn** is the ratio of disconnecting subscribers to newly connecting cable subscribers (the number of **disconnects** divided by the number of **new connects**). The problems associated with a high rate of churn are described in Chapter 9.

Because the audiences for many advertiser-supported networks are too small (at any one time) to show in Nielsen ratings books, many basic cable networks estimate their audiences on the basis of customized research that adjusts the size of the universe of homes to match cable penetration in the markets the cable network already reaches. Direct comparisons of such customized cable ratings to ordinary ratings can lead to confusion because nonsubscribers are not counted.[6] Especially

2.12 1995 CABLE SUMMARY REPORT	
Total Subscribers	62,033,240
Homes Passed	92,524,320
Total Systems	11,351
Household Penetration (universe = 95.3 million)	65.1%
Pay-Cable Households	29.5%
Pay-Cable/Basic	82.8%

Source: Nielsen and National Cable Television Association, May 1995.

for narrowly targeted cable services, advertisers want detailed demographic breakouts, necessitating expensive customized cable research at the local level.

RATINGS LIMITATIONS

Although many broadcast programmers are aware of the limitations of ratings, in practice these limitations are rarely considered. This does not result from ignorance or carelessness so much as from the pressure to do daily business using some yardstick. Programmers, program syndicators, sales staffs, station reps, and advertising agencies all deal with the same numbers. In any one market, all participants—those buying and selling programs, those selling and buying time—refer to the same sets of numbers (Nielsen reports in TV, Arbitron in radio), and they have done so for decades. The "numbers" for any single market usually show a consistent pattern that makes sense in general to those who know local history (such as changes in power, formats, and ownership). Although broadcasters and the ratings companies know that the "numbers" are imperfect, they remain the industry standard. In practice the numbers are perceived as "facts," not estimates.

Occasionally a gross error will require a ratings company to reissue a book, but for the most part small statistical inequities are simply overlooked. To eliminate as much error as possible, the major ratings companies use advisory boards that suggest how to improve the ratings estimates. However, a change in ratings methodology always means additional costs passed on to broadcasters—a fact destined to create a conservative rate of change now that the shift to peoplemeters has been accomplished.

Since the demise of Arbitron as a competitor to Nielsen's television audience measurement, there has been some unrest among television station managers. In 1995 Harry Pappas of Pappas Telecasting formed a coalition of 100 stations, mostly Fox affiliates, to form a new measurement system to compete with Nielsen. Some industry observers believe that the present system is hopelessly flawed and that better data could be collected at less cost. Nielsen, of course, says this isn't so.

The major limitations can be briefly summarized. Readers interested in further information should consult the references listed at the end of this chapter. The following six practical and theoretical problems limit the validity, reliability, significance, and generalizability of ratings data.

1. Sample Size. Although each company attempts to reach a sample that represents the population distribution geographically (by age, by sex, by income, and so on), a shortfall occasionally occurs in a market. Such shortfalls are in fact routine in radio market ratings, and also occur, although less frequently, in television market ratings. In these instances, certain demographic groups have to be weighted to adjust for the lack of people in the sample (such as too few men between 25 and 49).

Weighting by large amounts makes the estimates less reliable. The amount of unreliability is related to the (unknown) differences in responses between those who did respond in the sample and those who did not cooperate or bother to comply with all of the procedures. An expected return rate of 100 diaries from teenagers, for example, with an

actual return rate of 20, should create strong skepticism about how representative the 20 are. The 80 who did not respond would undoubtedly represent this segment of the audience better and more accurately, but because their media usage is not known the ratings services use the 20 responses and compound the error by assigning a weight of 5 to each of the 20 responses (to calculate the number of respondents in this age group as a proportional part of the total sample). While weighting is a scientifically acceptable and perfectly valid procedure, it assumes that those responses being weighted closely represent those responses that are missing (see 2.13 for more on sampling errors). In our hypothetical example, the responses of too few individuals represent too many other people/households.

Sample size is the one limitation that comes to most people's minds when they hear about how ratings are compiled. The typical "person on the street" response is: "How can a few thousand people be used to measure what millions of people watch or listen to?" But they are mistaken; the sample sizes used by the rating companies are not the major problem. **Representativeness** by those selected for the sample is.

2. Lack of Representation. The major ratings companies refuse to sample from group living quarters such as college dormitories, bars, hotels, motels, hospitals, nursing homes, military barracks, and so on. The problem with measuring such viewing is that the number of individuals viewing varies, sometimes greatly, making it nearly impossible to determine how many diaries or peoplemeter buttons need to be provided. They also fail to measure office, workplace, and country club viewing, and watching battery-operated TV sets (over 10 million units in the United States) on beaches and at sporting events. The rating services argue that such viewing accounts for only a small percentage of total national television viewing and is therefore not worth pursuing (that is, not cost-effective for broadcasters to pay to measure). Out-of-home viewing in 1995 represented about 4 percent

more viewing than is reported by peoplemeters. In 1995 Nielsen Media Research estimated that more than 23 million adults watch an average of 5.5 hours of television in out-of-home locations each week. Some of the most common out-of-home locations include work (32 percent), college/second homes (26 percent), hotel/motels (21 percent).

TV programs and some radio formats that appeal to narrow demographic segments go uncounted in calculating the ratings. Estimates for *Late Night With Conan O'Brien*, for example, indicate that as much as one-fifth of the actual audience goes uncounted by Nielsen's ratings due largely to the exclusion of the types of locations where many people watch the program (college dorms, bars). Also, cable services such as ESPN, watched in nearly every bar in the country, suffer from the omission of group audiences. The wide popularity of sports bars in the 1990s (with multiple TV screens) adds substantially to the inaccuracy of samples used to measure sports viewing.

3. Ethnic Representation. Data for ethnic groups are one of the most hotly debated aspects of broadcast audience estimates. Ratings companies have long grappled with the difficulty of getting randomly selected minority households to cooperate with the ratings company by filling out a diary or having a meter installed. Companies have gone to great lengths and expense to provide a more adequate and representative sample of both Hispanics and African Americans.

Critics argue that those minorities who agree to go along with prescribed procedures are much more like white sample participants and are most atypical of the ethnic group they are intended to represent. Thus, a participating black family may not be like the vast majority of black families in a given viewing area. Many minorities remain apathetic to the needs of ratings companies, even though financial incentives are offered. Ethnic populations are undoubtedly undercounted, and those who are counted are often unrepresentative of their ethnic group. Because no standard of "truth" exists by which to compare samples to an entire ethnic group, ratings companies and adver-

tising agencies use the numbers in front of them to make decisions.

4. Cooperation. All ratings companies use accurate and statistically correct sampling procedures: People are selected at random to represent (within a small margin of error) the population from which they were drawn. For representativeness to occur in practice, however, the people originally selected must cooperate when the ratings company invites them. Cooperation was not much of a problem when Nielsen used the older passive television meters, which required little or no action from the participants. But **cooperation rates** for peoplemeters and diaries fall short of 50 percent, and participation differs among key demographic and lifestyle groups. Ratings for children and teens are most problematic. Moreover, long-term cooperation from all viewers may be a problem. Using a diary requires participants' willingness to train themselves to fill it out as they view or listen and to learn how to fill it out correctly. Peoplemeters require pushing buttons every fifteen minutes as on-screen reminders interrupt viewing. They also require assigning spare buttons to casual guests.

When cooperation rates are low, for whatever reason, the participating sample probably differs from those who declined. Those who accept typically demonstrate a highly favorable view of the medium and use it more often than those who refuse to cooperate. Refusals may indicate a lack of interest in the medium or, at the least, too light a use to warrant learning a fairly complicated but infrequently applied process. It is easy to visualize a single person or a young, childless couple who says to the ratings company: "No thanks, I'm (we're) almost never home. I (we) hardly ever watch TV at all." Thus, those who view more or use the medium more are probably overrepresented in the sample, resulting in correspondingly inflated viewing estimates and unrealistic measures of the total television audience's preferences. Of all the limitations on ratings, cooperation remains one of the two most significant and persistent problems. In the mid-1990s, Nielsen claimed to have boosted its cooperation rate to nearly 70 percent by using

"proprietary" methods, meaning that the company will not disclose its new method.

5. Definition of Viewing/Listening. No one seems to be even remotely certain of precisely what it means to "view" television or "listen" to radio. It sounds so simple on the surface, but consider this. For those using peoplemeters to be counted as "viewers," household members must activate the computer with the handheld device only while in the room where the television set is on. At regular intervals, viewers are reminded of the need to "log in" with the meter by pointing their handheld device at the TV set. In all systems, the sole criterion for being a viewer is *being in the room*. Viewers can very easily be reading magazines, talking, thinking, playing a game—in short, paying little or no attention to the picture or sound—but are still counted as viewers. Conversely, a viewer might be in a nearby room doing a menial task and listening intently to a program's sound. This person is normally not counted as a viewer. Being there may or may not constitute "viewing." What the ratings services measure, therefore, are potential viewers with the option of letting television (or radio) occupy their attention. To date, no commercial techniques measure viewing as a function of the attention paid to what is on or to the way that content is used.

Among radio audiences, the parallel problem is no uniform definition (or no definition at all) of what it means to "listen" to radio. When in someone else's car on the way to school or work while this person has the radio on, should the passenger be counted as a "listener" to station WXXX? How about offices where a radio station plays in the background while people work—Are they "listening"? Is the music or information what each person would have chosen had they been able to select the station? Moreover, what does "listening" mean? If a person is paying attention to other things and has the radio on for background noise or a kind of companionship, should that person "count" as a listener?

Both television and radio ratings are plagued by the industry's unwillingness to provide a

standardized, widely agreed upon definition of viewing and listening. So long as the advertising industry remained satisfied with the ratings numbers generated for TV and radio, there was little reason for concern. As Nielsen moved to peoplemeters, however, and as media choices proliferated rapidly through cable and satellite-delivered media services, the reported numbers showed progressive shrinkage. Advertisers began to ask what was "going on," and the broadcast and cable industries began to scramble for explanations. Broadcasting and cable have continued to point the finger of blame toward the ratings services, questioning their methods and the validity of the numbers they report. Lost in all the ongoing measurement arguments is the crux of the problem—No one knows what the ratings services are supposed to be measuring in the first place. This debate has no satisfactory means of resolution until basic definitions are standardized.

6. Station Tampering. A final problem with ratings is that sometimes stations attempt to influence the outcome of the ratings by running contests during the measurement period. Arbitron and Nielsen place warnings on the cover of their rating books advising users of stations' questionable ethics. Of course, there is a grey area: Was the promotional activity (called **hyping** or **hypoing**) really a normal contest or one designed to boost (hypo) the ratings?

Warning labels are not terribly effective when advertising agencies get their numbers from computer tapes or online services, however. There is no "book" on which a warning can appear. The problem of hypoing has grown in recent years, with some local newscasts promoting huge cash giveaways. Many industry experts predict that year-round measurement, abolishing sweeps periods, will eventually solve the hypoing problem.

Peoplemeter Limitations

Not everyone has faith in the reliability of peoplemeters.[7] After thirty years of depending on one ratings system, Nielsen's abrupt change in 1987 from passive meters and diary-based national television ratings to peoplemeters created an uproar. The shift happened all in one year, and many in the industry felt unprepared with so much at stake. One objection to peoplemeters centers on what happens when the handheld devices are not correctly operated. When mistakes are made, as is inevitable, viewing is invalidated and not counted in the ratings. Given the high likelihood that people will have occasional mechanical difficulties and that children and teens will "fool around" with the meter, much legitimate viewing may be lost. Nielsen argues the necessity of omitting figures where the device was misused, claiming that such inclusions would produce unrealistic figures. Nielsen further claims that in a national sample of 5,000 households, occasional omissions have only a negligible impact on ratings.

Another peoplemeter problem occurs with *sample composition*. The issues discussed above concerning who chooses to become part of the sample and who refuses and why are worsened, not resolved, by peoplemeters. Nielsen's own studies show that peoplemeter cooperators differ from noncooperators in that the former are younger, more urban, and have smaller families (they may also differ in other unreported ways). Older people and those living in rural areas are underrepresented in the peoplemeter sample, in part because of many people's reluctance to learn to use "another new technology." However, it is recognized that Nielsen's previous national sample overrepresented older viewers and that post-1987 sample composition more accurately represents the country's overall population.

A third limitation centers on a new form of resistance to allowing Nielsen to install the peoplemeter hardware. Installing the older passive meter involved little or no hassle for participants. Peoplemeters, however, require a substantial amount of wiring and hole drilling. For many people, allowing workers into their homes to do such work is an intolerable intrusion. And, of course, if households allowing the installation do so in part because they are eager to be part of the television sample, they do not represent the overall popula-

2.13 STANDARD ERROR

The concept of **standard error** is not a ratings limitation but rather part of a mathematical model whose use reduces some of the problems associated with rating procedures. In practice, however, very few people using audience ratings ever take standard error into consideration. The "numbers" are seen as factual; sampling errors and other errors or weaknesses in research methodology are not considered in any way.

In essence, using the standard error model compensates for the fact that ratings are produced from a sample of people, not a complete count of an entire population. Whenever researchers project sample findings into the general population from which that sample was drawn, some error necessarily occurs. A standard error figure establishes the range around a given estimate within which the actual number probably falls. The range suggests how high or how low the actual number may be. The formula for standard error is:

$$SE = \sqrt{\frac{p(100 - p)}{n}}$$

where SE = standard error

p = audience estimate expressed as a rating

n = sample size

For example, suppose that a random sample of 1,200 people produces a rating of 20. The standard error associated with this rating is computed as:

$$SE = \sqrt{\frac{20(100 - 20)}{1200}}$$

$$= \sqrt{\frac{20(80)}{1200}}$$

$$= \sqrt{1.33}$$

$$= 1.15$$

A rating of 20 therefore has a standard error of plus or minus 1.15 points—meaning that the actual rating could be anywhere from a low of 18.8 to a high of 21.1.

Another difficulty in calculating error is determining how confident we want to be of the results. It is possible to be very confident (with a 95 percent probability of being right) or somewhat confident (with only a 65 percent probability of being right). Nielsen ratings are generally calculated to the lesser standard. Most social science research uses the higher standard. Nielsen includes standard error formulas in all their rating books for those wishing to calculate error in specific ratings and shares, but of course printing the range for each rating/share would make rating books unusable. Nonetheless, the range is the most accurate version of each rating or share, given its database, which may itself introduce a great deal more error.

tion, probably producing inflated viewing estimates and distortions in program preferences.

A fourth and final limitation occurs because peoplemeters transform generally passive viewers into active viewers. Every time a participant enters the television room or leaves, the handheld device must be activated. Such behavior involves more conscious decisions to view, what to view, and when to stop viewing than does usual television behavior. Research shows that most viewing gets done with little self-awareness on the viewer's part. Now, viewers with peoplemeters must actively record their behavior, and the results are probably atypical viewing. Nielsen maintains that peoplemeter users rapidly become accustomed to them, and "normal" viewing habits soon return, similar to the way viewers become accustomed to using **remote controls** (handheld channel changers).

Problems with sample, hardware, and the unnatural state of "active" viewing necessitated by use of handheld controls have prompted Nielsen to forge ahead with passive peoplemeters. These are electronic devices equipped with infrared sensors that identify people present in the room and record that information along with the tuned program. These new peoplemeters may overcome the "activity" criticism, but testing shows that many people object to the new process, feeling that the camera that recorded their presence in the room spied on them. The other substantial limitations, unfortunately, also remain.

Whether a ratings system uses peoplemeters, infrared sensors recording the presence of viewers in a room, diaries, the old audimeters, or some yet-to-be-developed variation on these methods, ratings remain *estimates* of audience preferences, always subject to a certain undetermined margin of error (this margin may be quite small or very large, but it is unknown with certainty). In the early 1990s, the media industry's temporary solution was to examine more than one set of numbers. Considering numbers from multiple sources and multiple methods is a stopgap while awaiting a more valid measuring system. When all the numbers from different sources agree, confidence in their accuracy rises. When there are variations, programmers and

advertisers are left in the uncomfortable quandary of deciding which numbers to trust, which to use. Some television programs and radio formats will not receive a completely fair rating regardless of which system is used—or even from a combination of measures. Children's and very light adult viewing will probably always remain uncertain.

SUMMARY

Program and audience research splits into qualitative investigations of audience reactions and preferences and quantitative ratings information on audience size, age, and sex. Television, cable, and radio programmers in nearly all markets need a thorough understanding of ratings. The data provided by Nielsen (for television audiences) and Arbitron (for radio audiences) are the "thermometers" for judging the success of programming decisions. The two widely recognized estimates of viewing are ratings and shares, and both figures can be calculated for a whole network, for a particular station, for a whole daypart, for a specific program, for a wide geographic area, for a metropolitan area, for a whole demographic group, for a subset of women or men, and so on. In addition to ratings and shares, the other major measurement tools television programmers use are homes using television (HUTs) and persons using television or radio (PUTs and PURs). Broadcast television programmers use syndicated program reports and other specialized analyses to select and schedule programs. Cable network programmers utilize national cable network ratings and customized research reports, while cable operators focus on measures of penetration and homes passed. Radio programmers often use microcomputer software to help them analyze their demographics and schedule their music. Radio programmers look at computations of average quarter-hour persons (AQH), cumulative audience (cumes), time-spent-listening (TSL), and turnover. Reach and frequency are tools for radio, cable, and public television programming (as well as advertising sales). All rating

or share numbers are only estimates of viewing and listening. They contain significant amounts of error because they are based on samples of the total audience. Unfortunately, for a variety of reasons, ratings data are treated as being more reliable than they actually are, mostly because they "exist" in the form of "hard" numbers that can be manipulated regardless of what the numbers measure. Qualitative research methods interpret ratings information; they tell programmers what ratings information means. Focus groups, microcomputers, and peoplemeters have changed the program decision-making process. New methods of data collection may improve the reliability of ratings, but for now the information on which ratings are based remains problematic.

SOURCES

Anderson, James A., and Meyer, Timothy P. *Mediated Communication: A Social Action Perspective*. Newbury Park, CA: Sage, 1988.

Audience Research Sourcebook. Washington, DC: National Association of Broadcasters, 1991.

Belville, Hugh M., Jr. *Audience Ratings: Radio, Television and Cable*. 2nd ed. Hillsdale, NJ: Lawrence Erlbaum, 1988.

Fletcher, James E. *Music and Program Research*. Washington, DC: National Association of Broadcasters, 1987.

Greenbaum, Thomas L. *The Handbook for Focus Group Research, Rev. Ed.* New York: Lexington Books, 1993.

Hiber, Jhan. *Winning Radio Research: Turning Research into Ratings and Revenues*. Washington, DC: National Association of Broadcasters, 1987.

Klopfenstein, Bruce C. "Audience Measurement in the VCR Environment: An Examination of Ratings Methodology," in *Social and Cultural Aspects of VCR Use*, Julie R. Dubrow, ed. Hillsdale, NJ: Lawrence Erlbaum, 1990.

Larson, Erik. "Watching Americans Watch TV," *Atlantic Monthly* (March 1992): 66–80.

Nielsen Media Research. *Your Guide to Reports & Services: How to Use the Local Market Book and Other Special Reports*. New York: Nielsen Station Index, 1995.

R&R Ratings Report. Los Angeles, CA: Radio & Records, Inc., semiannual special reports.

Webster, James, and Lichty, Lawrence W. *Ratings Analysis: Theory and Practice*. Hillsdale, NJ: Erlbaum, 1991.

Wimmer, Roger D., and Dominick, Joseph R. *Mass Media Research: An Introduction*. 4th ed. Belmont, CA: Wadsworth, 1994.

NOTES

1. The word *ratings* had a clear meaning for much of the history of broadcasting until the recent introduction of content ratings. Content ratings serve as labels to adults who supervise the viewing of children. As the motion picture industry did in the late 1960s, the television industry bowed to government pressure and began putting program content ratings on shows in the late 1990s. This chapter deals with ratings in the traditional sense of audience measurement, not content labeling.

2. For more on this topic, see "Promotion and Marketing Research" by Valerie Crane and Susan Tyler Eastman in *Promotion & Marketing for Broadcasting & Cable*, Susan Tyler Eastman and Robert A. Klein, eds. (Prospect Heights, IL: Waveland, 1991).

3. In 1996 the four largest broadcast television networks announced plans to create a rival service to Nielsen, a new company called Statistical Research Inc. (SRI).

4. The number of households varies annually, and the number of people varies according to census reports. These estimates are from Nielsen Media Research.

5. See Cable Conversion Chart for Washington, D.C. in James G. Webster and Lawrence W. Lichty, *Ratings Analysis: Theory and Practice* (Hillsdale, NJ: Lawrence Erlbaum, 1991), pp.115–116.

6. Ave Butensky, "Monday Memo," *Broadcasting*, 11 January 1993, p. 30.

7. Cook, Barry, "Commercial Television: Dead or Alive? A Status Report on Nielsen's Passive People Meter," *Journal of Advertising Research*, March 1995, pp. RC5–RC10; Baron, Robert, "The Passive People Meter: An Agency Perspective," *Journal of Advertising Research*, March 1995, pp. RC2–RC4; Milavsky, J. Ronald, "How Good Is the A.C. Nielsen People-Meter System? A Review of the Report by the Committee on Nationwide Television Audience Measurement," *Public Opinion Quarterly*, Spring 1992, pp. 102–115.

Chapter 3

Domestic Syndication

John von Soosten

SYNDICATED PROGRAMS

The programs seen on hometown television stations usually get there by one of four routes: *network*, *paid*, *local*, or *syndicated*. The six national television networks, ABC, CBS, Fox, NBC, UPN, and WB, supply **network programs** for which stations receive compensation payments; these programs usually air simultaneously on all affiliates of the network. Stations also receive money from program suppliers to air **paid programs**, often in low-viewership time periods; these shows include paid religion (for example, the *700 Club*), paid political programs, and **infomercials** (such as how to make a fortune in real estate or beauty tips from a celebrity).[1] Stations sometimes create their own **local programs**, such as news, talk shows, or public affairs programs, for which they assume all costs.

This chapter deals with the fourth type of program, **syndicated programs**, which are series, specials, and motion pictures sold to individual stations for exclusive showing for a limited time. A program may be distributed by satellite, especially if the subject matter is timely, or on tape.[2] The local television station licenses a syndicated program from a **syndicator**, a national company that similarly licenses the same program to other stations in other markets (but not others in the same market). The program probably will not air simultaneously in all markets. It probably will not air in all markets, and it probably will not air solely on affiliates of any single network or solely on independent stations. Hence, the program is said to be *syndicated*.

Although some programs may be licensed to national cable networks (which generally precludes sale to local television stations), the term *syndication* applies only to broadcasting. While I focus on broadcast television in this chapter, most of the principles and considerations discussed here apply equally to **cable syndication**. The topic of **radio syndication** is discussed in Chapter 12 and **noncommercial syndication** in Chapter 8.

THE SYNDICATION CHAIN

The syndication chain reaches from the producer through various intermediaries to the station, and it begins with the program itself. Programs for syndication arise in one of three ways:

- If the program was originally created exclusively for syndication and has not previously aired in any other venue, it is said to be **first run**; it is a program that was created for **first-run syndication**. Foreign programs produced for airing in other countries and later placed into domestic U.S. syndication are usually considered first-run because they have not previously been seen in this country. The rare program made for syndication that later gets sold to a cable or broadcast network is called off-syndication.

- Programs that were originally created for one of the broadcast networks that are subsequently sold in syndication are called **off-network** programs. Programs that were created for the national cable networks are also included in the off-network category. (As the number of such programs put into syndication increases, a separate off-cable designation may develop.)

- The third category consists of **feature films**, including **theatricals** (made originally for exhibition in movie theaters) and **made-for-television/made-for-cable** or **movie-of-the-week** (**MOW**) films. MOWs may be off-network/cable or first-run in syndication.

Unlike off-network shows, which are sold for a number of years with a certain number of runs per episode, first-run programs are generally sold in syndication one year at a time with a predetermined number of weeks of original programs and repeat programs. For example, a 52-week deal might include 39 weeks of original programs (195 shows) and 13 weeks of repeats (65 of the original 195 shows). Each year, the contract is renewed (often at a higher price). Fresh episodes are then produced.

3.1 SAMPLES OF SYNDICATED PROGRAM TYPES

Off-Network: *Home Improvement, The Cosby Show, M*A*S*H, Roseanne, Married . . . With Children, I Love Lucy, Cheers, Beverly Hills 90210**

First-Run: *The Oprah Winfrey Show, Ricki Lake, Entertainment Tonight, Star Trek: The Next Generation, Jeopardy, Wheel of Fortune*

Feature Films: Nearly any movie title once it leaves the movie theaters except recent movies still playing on pay-per-view, pay cable, basic cable, or network before they go into syndication

*Note that off-network shows may run simultaneously on the network and in off-network syndication.

These three types of programs are illustrated in 3.1. First-run and off-network programs may also be categorized according to **program type.** Although several systems for classifying programs exist, syndicators and programmers commonly use eight easily recognized categories:

Situation Comedy: Most **sitcoms** are off-network (for example, *Home Improvement, Roseanne, Seinfeld, Cheers*), although some are created for first-run syndication, such as some episodes of *Mama's Family* and all episodes of *Small Wonder*.

Dramas: These may either be off-network (*Matlock*) or first-run (*Star Trek: The Next Generation*) and may include **action-adventure** (*Hunter, Baywatch*) and **dramatic** (*Dr. Quinn Medicine Woman, Beverly Hills 90210*) shows. Although these shows are mostly one hour long, some are half-hours.

Talk: Generally these are first-run one-hour shows. They include *The Oprah Winfrey Show, The Ricki Lake Show*, and others.

Magazine: Most commonly half-hour, first-run programs, these include *Entertainment Tonight,*

Inside Edition, and *Hard Copy*. This category also includes the weekend editions of the same programs: *Entertainment Tonight Weekend*, for example.

Reality: This category is a catchall for first-run half-hours including **reality shows** (*Rescue 911*), **court shows** (*Court TV: Inside America's Courts*), **comedy shows** (stand-up comedy routines), **music shows** (videos, dance music), and **comedy-based shows** (*America's Funniest Home Videos*).

Games: These half-hour first-run shows include "pure" game shows (*Jeopardy, Wheel of Fortune*), celebrity-driven, humor-based shows where the entertainment value is more important than the game itself (*Hollywood Squares*), and "gamedies" such as *Love Connection* and *The Newlywed Game*.

Children's: Designed for viewing by children, these are primarily **animated cartoons**, but they embrace some **live action** programs. Children's shows break out into **first-run animation** (*Teenage Mutant Ninja Turtles, Tiny Toons, Gargoyles*), **off-network animation** (*X-Men, Tazmania*), **live action** (*Mighty Morphin Power Rangers, Romper Room*), and **theatrical cartoons** (*Bugs Bunny, Tom and Jerry*). Although technically not syndicated, the Fox Children's Network shows are generally included in this category because they are treated and scheduled in the same manner as syndicated kids shows.

Weeklies: This category includes virtually all the aforementioned program types, but the shows are first-run and designed for broadcast once or twice a week, generally on Saturdays or Sundays (*Hercules, American Gladiators*, wrestling). After several years of weekly runs, some of these shows may amass enough episodes to be played Monday through Friday (*Star Trek: The Next Generation, Baywatch*).

The syndication chain involves both direct participants—one or more producers and financial backers; a distributor; and the buyer, a broadcast television station, cable network, or foreign network—and indirect participants, who include programmers at the national station representative firms.

The Producer
and Production Company

Many people think of producers as cigar-smoking, fast-talking, jewelry-bedecked guys "taking meetings" by the pool. A few may fit this description, but most would not stand out in a crowd. Actually, the producer is the person who coordinates the diverse elements that constitute a television program. Producers (or executive producers) oversee on-air talent, directors, writers, technical crew, line producers, production managers, production assistants, and researchers. Producers often deal with talent agents, personal managers, union officials, the press, and lawyers. They are answerable for everything: the program concept, program content, the tone or mood of the program, and the overall production. If a program is not delivering satisfactory ratings, its producer is responsible for "fixing" or improving it. The producer is also responsible for delivering the program on time and on or under budget and is directly accountable for contacts with the production company and syndicator that financed the program.

A production company finances and produces television programs, hiring the producer and the staff and possibly proposing program ideas or financing producers who bring in the ideas. Based on a pilot or merely a written presentation, the production company sells programs directly to broadcast or cable networks or, alternatively, strikes a deal with a syndication company to distribute (syndicate) its programs to individual television stations. Sometimes the production company is the syndicator itself and distributes the programs it has created.

The decision to begin production of a new program depends on whether a broadcast or cable network is interested in the idea and advances development funds (see Chapter 4) or whether the program is suitable for domestic and foreign syndication. U.S. cable and sales to foreign television networks are an important **aftermarket** for off-network programs and theatrical movies.[3] However, hour-long dramatic shows have only modest syndication potential even after network airing

(for example, *Melrose Place*) but comedy has always been a gold mine, although most programmers insist that sitcoms must have child appeal to succeed in syndication. *Network carriage is important in giving a program high visibility, but syndication is where the profits lie.*

The Syndicator

Although some syndicators produce programs and others merely handle programs produced by other companies, all syndicators (also called distributors) supply programming to local stations on a market-by-market basis throughout the nation. Unlike ABC, CBS, Fox, NBC, UPN, and WB, syndicators do not have a single "affiliate" in any particular market. (The parent companies of ABC, CBS, Fox, UPN, and WB also operate syndication companies as separate entities.) Instead, syndicators can and often do sell their programming to any and all stations in a market. Depending on the kind of programs offered by the syndicator, certain stations in a market may be more frequent customers than other stations. For example, some affiliates build programming blocks around game shows, others around talk shows. Independent stations are more likely to air movies and children's animated programs. Although the syndicator may have more than one customer in a market, only one station is licensed to carry any particular program at a time. Thus, one station may buy syndicated reruns of *Married . . . with Children* from Columbia Pictures Television, while another station may buy the rights to *Seinfeld,* also from Columbia. And a third station may purchase *Ricki Lake* from Columbia. Each station will have the exclusive right in its local market to all episodes of the series it bought during the term of the license.

The United States has more than 100 domestic syndication companies, and there are scores of others worldwide. Most of the major and medium-sized domestic program syndicators and their hottest properties in the mid-1990s are presented in 3.2. Off-network hits such as *Roseanne* and *Married . . . with Children* average as high as $2 to $3 million an episode in combined syndicated

3.2 PROGRAM SYNDICATORS

Syndicators	Programs
ACI	Movies
Active Entertainment	Children's shows
All American Television	*Baywatch, The Richard Bey Show, Family Feud*
Baruch/BET Entertainment	Movies, specials
Bohbot Entertainment	Children's shows
Buena Vista Television	*Home Improvement, Golden Girls, Blossom, Live with Regis and Kathie Lee, Aladdin, Gargoyles, Darkwing Duck,* movies
Carsey-Werner Distribution	*Grace Under Fire, Roseanne*
Claster Television	*GI Joe, Littlest Pet Shop, Romper Room*
Columbia Tristar Television Distribution	*Seinfeld, Mad About You, The Nanny, Ricki Lake, Tempestt Bledsoe, Married . . . with Children, Designing Women, Barney Miller, Facts of Life, 227, Who's the Boss?,* movies
DLT Entertainment Ltd.	*Benny Hill, Three's Company, Too Close for Comfort*
Fries Distribution Company	Movies, specials
Genesis Entertainment	*Top Cops, Real Stories of the Highway Patrol, Highway to Heaven, Tales from the Crypt*
Group W Productions	*Day and Date, Bob Vila's Home Again*
Hearst Entertainment Distribution	Movies, cartoons
ITC Entertainment Group	*The George Michael Sports Machine, Motorweek, The Saint,* movies, specials
King World Productions	*Wheel of Fortune, Jeopardy, The Oprah Winfrey Show, Inside Edition, American Journal*
Litton Syndications	*On the Road Again, Jack Hanna's Animal Adventures, Working Woman*
MaXaM Entertainment	*The Extremists, The World of Nature,* movies
MCA-TV	*Coach, Amen, Hercules, Charles in Charge, Magnum, P.I., A-Team,* movies
MG/Perin	*The Extraordinary,* specials
MGM Television Distribution	*LAPD, The Outer Limits, In the Heat of the Night,* movies

revenue (for all stations). Of the three dozen or so firms listed in 3.2, seven companies command more than three-quarters of the domestic syndication business: Warner Brothers, King World, Universal, Paramount, Columbia, Twentieth, and Turner.

Syndicators "sell" (license for a fee, hence **license fee**) the telecast rights to a program to the local station for a certain term and for a set number of plays. The syndicator or the producer of the program continues to own the rights to the show. Some syndicators create, produce, and distribute

3.2 CONTINUED

Syndicators	Programs
MTM Television Distribution	*Dr. Quinn Medicine Woman, America's Funniest Home Videos, Newhart, Hill Street Blues, WKRP in Cincinnati*
Muller Media	Movies, specials
Multimedia Entertainment	*Sally Jessy Raphael, Jerry Springer, Rush Limbaugh*
New Line Television	*Court TV: Inside America's Courts, Nancy Drew/Hardy Boys Mysteries,* movies
Orion Television Entertainment	Movies
Paramount Distribution	*Frasier, Cheers, The Cosby Show, Family Ties, Happy Days, Matlock, Hard Copy, Star Trek, Star Trek: The Next Generation, Entertainment Tonight, Maury Povich Show, Montel Williams Show,* movies
The Program Exchange	*Garfield and Friends, Dennis the Menace, Woody Woodpecker*
Rysher Entertainment	*George & Alana, Lonesome Dove, Highlander, California Dreams, Saved by the Bell,* movies
Saban Entertainment	Children's shows, movies
Samuel Goldwyn Television	*Flipper, American Gladiators,* movies
Select Media Communications	Specials, movies, program inserts
Starcom Entertainment	Movies, specials
Syndicom Entertainment Group	*#1 Country, Hot, Hip & Country,* specials
Tribune Entertainment Company	*Geraldo, Charles Perez,* movies
Turner Program Services	*Lauren Hutton, Wonder Years,* movies, cartoons
Twentieth Television	*The Gordon Elliott Show, The Simpsons, Gabrielle Carteris, M*A*S*H, Cops, Doogie Howser M.D.,* movies
Warner Brothers Domestic Television	*Martin, Full House, Step by Step, Fresh Prince, Murphy Brown, Night Court, Growing Pains, ALF, Mama's Family, Carnie, Jenny Jones, Extra the Entertainment Magazine,* movies
Worldvision Enterprises	*Beverly Hills 90210, Barnaby Jones, Little House on the Prairie, Love Boat,* movies

their own programming while others merely distribute (for a commission) programs created and produced by others. Additionally, some syndicators increase their revenues by selling national barter time (advertising spots) within programs. The syndicator licenses ("sells" or leases) the program to a station for a specific term or period of time. During the license term, the syndicator grants the station the *exclusive* right to broadcast the program. At the end of the license term, the broadcast rights revert to the syndicator, who may now license the program all over again to any station in the market.

The syndicator's client is the local television station in the person of the general manager or the program director (also called program manager, director of programming, or other similar titles). The general manager is responsible for the overall station operation, including programming, sales, news, engineering, legal matters, business affairs, promotion, public affairs, traffic, network relations, and labor relations. Because programs are what viewers watch and advertisers buy commercial time in, and because of the considerable cost of purchasing programs, the general manager usually gets involved in most programming decisions. In fact, some important program purchasing or scheduling decisions may bypass the general manager and are made by corporate management or station owners.

The program director is the station executive primarily responsible for developing the program schedule, establishing a relationship and conducting business with the syndicator, managing the station's program inventory, dealing with viewers and community interest groups, and generally implementing and overseeing the station's programming policies. The program director is also responsible for any non-news local programming the station produces, including talk shows, magazines, children's shows, sporting events, and the like. The program director usually works closely with the station's promotion and production departments.

The Rep

The outside party involved in the syndication chain is the **rep programmer**, who works for the national sales representative firm that sells national advertising time for the station. The **rep programmer** acts as an ally for and consultant to the station. Blair, HRP, Katz, MMT, Petry, Seltel, Telerep—these names can be seen in trade publication articles, in advertisements, on research materials, in directories and even on television station letterheads[4]—all these companies (and several smaller companies) are **station representatives**, national sales organizations selling commercial airtime on behalf of local market television stations.

Although the station representative is primarily a sales organization, reps provide additional services to client stations including *marketing support, sales research, promotion advice,* and *programming consultation.* Through these support services, the reps help client stations improve their programming performance in terms of audience delivery, which will in turn lead to increased advertising rates and, presumably, increased profitability for the station and the rep. (However, although revenues may go up, profitability for the station sometimes does not due to increasing programming, operating, and other expenses.) Usually, no additional fee is charged for support services; they are included in the rep's sales commission (see 3.3). The seven major rep firms have programming staffs that work with programmers at client stations to shape and guide the stations' programming schedules. Rep programmers provide ratings information that may support or call into question information syndicators supply, and they advise client stations on the programs that will attract the most viewers in the demographic groups advertisers desire most to reach. At the same time, rep programmers must consider each station's programming philosophy, the mores of the community, and the quality of each program.

One of the rep's most important functions is to regularly disseminate generic national research information and market-specific research to client stations. Most reps maintain close contact with all six networks, enabling them to supply an affiliate with competitive information regarding the other networks. Reps also publish ratings summaries and analyses of new programs, and they provide exhaustive ratings information after each rating sweep period. Because of their national overview of programming and their own experience and that of their colleagues, rep programmers can often look at programming decisions from a perspective not available to a local station's general manager or program director.

3.3 THE NATIONAL SALES REP

Reps sell commercial airtime on local client stations to national spot advertisers. As the advertising agency represents the advertiser in buying commercial time, the station rep represents its client station in selling the time. Local stations of whatever sort sell commercial time to local merchants and other advertisers within the market, and all commercial stations employ a local sales force for this purpose. However, it is not economically feasible for a single station to employ a sales force to sell commercial time to *national* advertisers: There are far too many advertisers and advertising agencies in too many cities to be covered by a station's sales force. That's where the rep comes in. Reps employ sales people in many cities on behalf of the local station to sell to advertisers in those cities. (Several reps have offices in more than 20 cities.) Because reps sell on behalf of many stations, they can maintain sales forces of hundreds of people, selling on behalf of dozens of stations. The largest station representatives have client stations in as many as 200 markets. The rep receives a negotiable commission from its client stations for the commercial time the rep sells. As a rule of thumb, a 10 percent commission rate is the industry norm, but because of the competitive nature of the rep business, such considerations as the overall state of the economy and market size may cause the commission rate to vary widely. Some stations pay only single-digit commission rates to their representative.

PROGRAM ACQUISITION

Syndication is the arena in which most programmers expend much of their energies, and with good reason. *For most stations, the money spent annually to acquire syndicated television shows is their single largest expense.* The station that buys a syndicated program that turns out to be a dud, or the station that overpays for a syndicated show, may be in financial trouble for years to come. And the station that makes several such mistakes (not uncommon) has serious problems.

The rep provides the station management with programming advice supported by research and experience-based opinion. The general manager and the program director get recommendations from their rep on which shows should be acquired, along with a rationale for the acquisition and recommendations on the program's placement in the station's lineup. Although reps spend most of their time dealing with syndicated programming and therefore work closely with syndicators, reps do *not* work for the syndicators. The rep works for the stations; rep firms are paid commissions by client stations based on advertising sales.

Both the station program director and the rep programmer spend many hours meeting with syndicators, listening to sales pitches and watching videocassettes of sales pitches, research information, excerpts of the program, or actual pilots. In the pitch, the syndicator tries to convince the programmer of the program's merits and that the program, if scheduled on the station, will improve the station's ratings. Although the reps do not actually purchase the program, and although the syndicator must still pitch the station programmers directly, a rep's positive recommendation to the station paves the way for the syndicator when he or she contacts the station. Most syndicators maintain close and frequent contact with the station program director and the reps. They inform reps of ratings successes, changes in sales strategy, purchases of the program by leading stations or station groups, and any other information the syndicator feels may win support from the rep. Syndicators often try to enlist the rep's support for a show in a specific time period on a specific station the rep represents. Frequently, syndicators inform reps of programs during their developmental stages, often as trial balloons to gauge the rep's reaction prior to beginning a sales campaign or shooting a pilot of the program.

Syndicator contacts with reps do not replace contact between syndicator and station. Rather,

syndicators take a calculated risk with reps to gain support for a program. If a rep dislikes the show or does not feel it suits a station's needs, the rep's advice to the station can damage the syndicator's efforts.[5] Many stations have refused to buy syndicated shows because their reps did not endorse them.

Scheduling Strategies

When a television station acquires a program from a syndicator, its managers generally have a pretty good idea of how they will use the show. Frequently, they look not only for a program that meets their needs but also for one that fits certain scheduling and business deal criteria. As discussed in Chapter 1, several scheduling strategies are widely accepted. These include:

- **Stripping.** Syndicated series can be scheduled daily or weekly. Generally, 65 episodes (three network seasons) are considered the minimum for stripping, allowing 13 weeks of Monday to Friday stripping in syndication before a station repeats an episode. Between 100 and 150 episodes are considered optimum for stripping, while 200 or more episodes can be a financial and scheduling burden to a station.

- **Audience flow.** As a general strategy, programmers try to schedule successive shows in a sequence that maximizes the number of viewers staying tuned to the station from one program to the next. The shows flow from one to the next, with each building on its predecessor. Theoretically, the audience flows with the show. Additional audience may flow into the program from other stations and from new viewers just turning on their television sets. Thus, audience flow is a combination of (1) *retention* of existing audience, (2) *dial switching* from other stations, and (3) attraction of *new tune-in* viewers.

- **Counterprogramming.** This tactic refers to scheduling programs that are different in type and audience appeal from those carried by the competition at the same time. For example, within one market at 4 p.m. Monday through Friday, affiliate WAAA might schedule a talk show, affiliate WBBB might carry a game show, affiliate WCCC might carry a situation comedy, and independent WDDD might carry children's animation; thus, all stations are counterprogramming each other. In another example, within one market at 10 p.m. EST, while all three affiliates are carrying network entertainment programs, the independent might schedule news, and while the three affiliates carry late evening news at 11 p.m., the independent might counter (go against) with situation comedies.

Deal Points

When the syndicator approaches the station or rep programmer, he or she outlines the terms and conditions of the offering. Most deals include the following deal points or terms:

- **Title.** In the case of programs entering syndication after a network run, the syndication title may be different from the network version. Thus, *Happy Days* became *Happy Days Again* in syndication. Sometimes the title of a first-run program is changed from the time the program is marketed to the time it starts airing, often in an attempt to entice more people to watch the show.

- **A description of the program.** This includes whether it is first-run or off-network, the story line or premise, and other pertinent information.

- **The cast, host, or other participants.** Big-name or emerging talent is often a draw. If additional episodes of a series are planned, notice of long-term contracts with the talent has value.

- **Duration.** The program may be 30-, 60-, or 90-minutes long, or another length entirely.

- **Number of episodes.** This point includes original episodes and repeats. Sometimes a minimum and maximum number of episodes are offered.

- **Number of runs.** The syndicator indicates the maximum number of times the station may air (**run**) each episode.
- **Start and end dates.** Programs are sold for specific lengths of time, such as six months, one year, three-and-one-half years, five years, or seven years. They may be sold months or years in advance of the start date.
- **Commercial format.** Each show is sold with a fixed number of commercial spots. For example, a typical half-hour program might be formatted for (1) *six-and-a-half internal commercial minutes* (in other words, thirteen 30-second units) in two breaks of two minutes each and one break of two-and-a-half minutes within the program plus (2) an *end-break* (external) following the program, typically of 92 seconds.
- **Price.** The cash price may be stated as either a per episode fee (which is one inclusive amount for all runs of a single episode) or as a weekly fee (a fixed amount regardless of the number of times each episode is ultimately shown).
- **Payment method.** Programs are sold for cash, for barter, or for cash-plus-barter.
- **Down payment.** In cash or cash-plus-barter deals, the syndicator might request a down payment (typically 10 to 20 percent) when the contract is signed, which is sometimes several years before the station receives the rights to the show.
- **Payout.** Cash the station still owes to the syndicator (after the downpayment) must be paid when the program begins to air. Typically, the balance is paid in installments over the life of the contract, similar to mortgage or auto loan payments.

A Pitch

Using the hypothetical syndication offering of the equally hypothetical off-network *The Bill Smith Show* as an example, let's look more closely at the syndicator sales pitch to a station.

About 9:30 one morning, the telephone rings in the office of the program director at a medium-sized market independent station on the East Coast. The caller is a Los Angeles-based syndication salesperson (calling at 6:30 A.M. Pacific time from his home) with whom the programmer has developed a professional friendship/relationship. After a minute or so of how's-your-family chatting and two or three minutes of exchanging trade gossip ("Did you hear Jane Green is out as general manager of WBBB? Do you know who's going to replace her?"), the syndicator tells the programmer that he's coming to the market next week and would like a few minutes to tell the program director about his company's latest offering, *The Bill Smith Show*. And how about lunch too? The programmer agrees to see the syndicator the following Tuesday at 11 A.M., followed by lunch.

Tuesday morning arrives, and so does the syndicator, shortly before the appointed 11 A.M. There's amiable conversation about the syndicator's rough flight east, the hot, rainy, humid weather the city has been experiencing for a week, and the good weather the syndicator has left behind in Los Angeles. The salesman asks about the sale of one of his competitors' off-network programs, trying to ferret out competitive information. The program director asks about the status of one of the syndicator's somewhat shaky first-run programs, to which the syndicator replies that the program is stronger than ever but, after a few minutes of verbal fencing, acknowledges it is still not performing up to expectations. Finally, at about 11:10, the pitch begins.

The syndicator removes a glossy, expensively printed, full-color sales brochure from his briefcase. Bill Smith's smiling face and the title of his show are on the cover. The salesman guides the program director through the first few pages, elaborating on the printed descriptions of the show's plot, characters, and leading stars. He makes reference to the show's "outstanding" network history, "the best since *Home Improvement* or *Roseanne*," but he offers no research to support his claims.

(That will come later in the videocassette.) The program director takes the following notes:

TITLE: *Bill Smith Show*

DESCRIPTION: Off-network sitcom about a zany recluse and the lovable neighbors in his apartment building.

CAST: John Jones as the zany but sensitive Bill Smith; Jane Doe as Bill's amorous neighbor Helga; Max Brown as the bumbling building superintendent Sam

DURATION: 30 minutes

The syndication salesman suggests that the program director watch a 15-minute videocassette presentation. As they watch, the programmer sees a succession of hilarious *Bill Smith Show* highlights, followed by clips of several tender, emotional scenes designed to show Bill Smith's acting range. Although *The Bill Smith Show* has been on network television for two years, the producer of the tape is taking no chances that the programmer may not have seen the show. The presentation's producer has also put together many of the show's more memorable or funnier scenes, hoping to create a highly favorable impression of the show.

Now the focus of the tape shifts to the program's network performance. The presentation shows that *The Bill Smith Show* has taken a previously moribund time period on the network and has increased the network's household audience share in the time period by 50 percent over the previous occupant's performance, despite a weak lead-in program and strong competition from the other networks. In fact, in its first season, Bill Smith has single-handedly taken the network from a weak third place to a strong second place. As a result, the network moved *The Bill Smith Show* in its second season to a different night and time, where the results have been similarly impressive. The research focuses on similar gains made by the show in women 18–34, 18–49 and 25–54, children 2–11, and teen demographics. It omits all mention of male viewers over age 17.

In the tape's final minutes, the enthusiastic announcer stresses the usefulness of *The Bill Smith Show* in syndication as a lead-in to an affiliate's early newscast (typically 5 P.M. or 6 P.M.) or an independent station's 6 to 8 P.M. schedule. The tape also compares the show's writing, cast of characters, and network performance to such perceived network and syndication successes as *Roseanne*, *Cosby*, *Married . . . with Children*, *Cheers*, and *Home Improvement*. The tape ends with several additional hilarious scenes and the syndication company's logo.

Now the syndicator hands the programmer a packet containing research studies. Much of the research mirrors the information shown on the videocassette, but it is more detailed. A copy of last week's overnight ratings in the metered markets is included showing *Bill Smith* finished in first place for the fourth week in a row. The programmer and syndicator discuss the research data. The programmer questions the obvious omission of data for the male demographics, which he deduces is one of the show's weaknesses. The syndicator claims that lack of male appeal is not a shortcoming because the time periods in which the program will play in syndication have relatively few male viewers available, and because women and children control the television set anyhow. The programmer continues to question the point, and the syndicator promises to provide additional information to show that males also like the program. And so it goes for about half an hour, with the program director questioning research data and making counterarguments based on his own research. Finally, the program director is satisfied that the syndicator's research is generally accurate—as far as it goes.

Now the discussion turns to the deal itself. In a presentation punctuated by frequent questions and requests for elaboration, the syndicator outlines the rest of the offering. The program director takes notes of the deal points:

PROGRAM TYPE: Off-network situation comedy

EPISODES: Minimum of 96, maximum of 168 if the program runs seven years on network

RUNS: 6

YEARS: 3 to 5 (depending on number of episodes produced)

START DATE: Fall 1999

FORMAT: Cut for 6½ minutes

PAYMENT: Cash

DOWN PAYMENT: 10 percent

PAYOUT: 36 equal monthly installments

ASKING PRICE: $12,500 per episode for the first five network years plus an additional 10 percent per episode beginning with the sixth production season (if the show runs that long on the network)

(In a similar pitch to a rep, the asking price usually is not discussed because the syndicator is pitching the rep on all markets at one time and would prefer to quote the price directly to the customer, the stations.)

Finally, the syndicator has made all his points, and the program director has asked all his questions. It's now time for lunch. (Most syndicator meetings do not involve lunch, but when they do, it's a chance for less formal discussion of the program and other issues.) The programmer and the syndicator walk to a nearby restaurant for lunch. During the meal, the syndicator suggests specific spots in the station's schedule where the show might fit and tries to get a reaction from the program director. The programmer plays it close to the vest.

Eventually the discussion turns to other topics. The programmer and syndicator touch on renewals of one older show. They discuss the syndication company's plans for future first-run shows. At one point, the salesman says he'll be back in town in a few weeks with a new package of 30 movies his company is about to offer. The program director manages to pry out of him three "typical" titles, possibly the three most popular films in the package.

Finally lunch is over. The syndicator goes to his next appointment at another station in town, and the program director returns to the office, possibly for another meeting with another syndicator.

Syndicator/Rep Rules

The relationship between syndicators and reps is generally friendly and mutually dependent. The syndicators need the rep's support in client markets; the reps need to get programming information from the syndicators. Yet the relationship must also be guarded. Because the reps are agents of their client stations, they must maintain their independence from the distributors with an impartiality befitting the trust placed in them by the stations.

Therefore, certain unwritten rules govern the relationship between syndicator and station rep. Reps rarely make blanket program recommendations, and they do not endorse any particular program or syndicator. Although reps often support or oppose a particular genre or programming trend, they are generally quick to point out that not every station in every market necessarily can be included in their assessment. No program will appeal equally in every market, and the stations' competitive needs differ greatly from market to market.

Another unwritten rule is that rep programmers do not supply syndicators with privileged client-rep information. As an extension of the station, the rep programmer does not want to supply information to syndicators that would help the syndicator negotiate against the station. Privileged information includes prices the station would be prepared to pay for programs, prices it already paid for other programs, other programs the station is considering purchasing, its future plans and strategies, contract expiration dates, and any other information that might harm the station's negotiating position.

RATINGS CONSULTATION

Station general managers and program managers talk regularly with their national reps. Rep programmers and station sales management and research directors are also in contact, albeit less frequently (most stations do not even have a research department). The rep programmer occasionally

meets clients, either by visiting the station or when station personnel travel to New York to meet with rep sales management and with advertising agencies. Most general managers/program directors and reps endeavor to meet at the annual conventions of **NATPE** (National Association of Television Program Executives), the **NAB** (National Association of Broadcasters), and at network affiliate meetings.

A good working relationship between station and rep programmer is important. Consultation is not a one-way process; a rep does not presume to be an all-knowing authority dispensing wisdom from a skyscraper in New York. The consultation a rep programmer provides is a give-and-take exchange of ideas. Just as the rep has a national perspective, enabling him or her to draw upon experiences in other markets, the station programmer generally knows his or her market, local viewers' attitudes and lifestyles, and the station's successes and failures over the years better than almost anybody else.

Key Questions

Station management and rep programmers must consider some key questions as they work together:

- How well is the station's current schedule performing?
- Has there been audience growth, slippage, or stagnation since the previous ratings report? Since the same period a year ago? Two years ago?
- What audience demographics are the advertisers and the station and rep's sales departments seeking? Is current programming adequately delivering those demos?
- Are older shows exhibiting signs of age?
- Has the competition made schedule changes that have hurt or helped the client station?
- Does the client own programs that can be used to replace weak programs, or must the client consider purchasing new programs for weak spots?

Generally, a station seeks audience growth over previous ratings books. Of course, for one or two stations to experience audience growth, other stations in the market must lose audience. The rep programmer seeks to help the station stem audience erosion and create growth instead.

Reps also help station programmers analyze the most recent ratings report. Both parties look for trouble spots. If a program has **downtrended** (shown a loss of audience from several previous ratings periods), the programmers may decide to move it to a different, perhaps less competitive, time period. Or they may decide to take the show off the air entirely, replacing it with another program. Sometimes a once-successful but downtrending program can be **rested** or "put on hiatus," perhaps three months minimum to a year maximum, or for a part of the year, such as the summer. When the program returns to the air from hiatus, it often recaptures much of its previous strength and may run successfully for several more years.

The programmers may also note that a certain daypart is in trouble. A wholesale revision of that part of the schedule may be in order. They may need to rethink a station's programming strategy to decide if current programming is still viable or if the station should switch to another genre. For example, if a two-hour off-network action/drama block is not working, should the station switch to sitcoms or talk shows? A change of this magnitude is often quite difficult to accomplish, for the station usually has contractual commitments to run current programming into the future. Also, most viable programs of other genres are probably already running on other stations in the market. It is usually easier to rearrange the order of the existing shows to see if a different sequence will attract a larger audience. It is also easier to replace a single show than an entire schedule block.

While household ratings are an important indicator of a program's relative performance, programmers are primarily concerned with audience demographics. While there are dozens of demographic groupings, the most important demos are women 18 to 34 years old (W18–34), women 18 to 49 (W18–49), women 25 to 54 (W25–54),

men 18 to 34 (M18–34), men 18 to 49 (M18–49), men 25 to 54 (M25–54), teenagers (T12–17), and children (K2–11). Generally, these are the demographic groups most desired by advertisers and therefore the target audiences of most programs. While most programs probably don't appeal equally to all of these groups, programmers try to schedule shows that reach at least several of these demos at times of the day when those people are available to watch television. Even if a program is not number one or two in household rating and share, a strong performance in a salable demographic may make the program acceptable despite the household rating. For example, the program may be number two or three in household rating/ share but may have very strong appeal to young women, making it number one in the market in women 18–34 and women 18–49. These groups are attractive demographics for many advertisers. Thus, the program might be acceptable for the station's needs despite its lower household ratings performance.

In another example, the program might be the number-three rated show in its time period, but may have exhibited significant ratings growth over previous ratings books. Therefore, the programmers may decide to leave the program in place because it is **uptrending** rather than **downtrending**. They may decide instead to change the lead-in show to try to deliver more audience to the target show. They may also decide to promote the show more to build audience.

A key issue in all these decisions is that *programming is usually purchased far in advance of its actual start date*. In the autumn of any year, stations are already planning for the following September, even though the current season has barely begun. Successful first-run shows are often renewed for several years into the future. Off-network programs are frequently sold two or three years before they become available to stations in syndication. Once purchased, the station is committed to paying the agreed-upon license fee to the syndicator regardless of the program's subsequent network or syndication performance. Not uncommonly, a once-

popular network program will fade in popularity in the two or three years between its syndication sale and its premiere in syndication. Although the station may be stuck with a program of lesser value than originally perceived, the syndicator does not waive or offer to drop the license fee. A deal is a deal. Conversely, some network shows increase in popularity as they continue to run, meaning that the station that bought early may pay a smaller license fee than if the program had been purchased a year or two later when its popularity was greater. Reps and their client stations thoroughly research, analyze, and plan acquisitions carefully to purchase wisely.

Research Data

Much station/rep consulting time is spent preparing information, researching program performance, and formulating programming strategy. Ratings information from Nielsen Media Research is the basis for much of this thought. (Until early 1994, similar information was available from The Arbitron Company; Arbitron now only measures radio listenership.) Station, syndicator, and rep programmers and salespeople regularly use Nielsen NSI data published quarterly in VIP ratings books (see below) to make programming decisions, to sell syndicated shows, and to sell advertising time. The syndicators and reps also have available to them additional Nielsen ratings information not generally purchased by stations because of its cost. These reports include:

- **NSI.** The *Nielsen Station Index* is the system used to measure viewership in local designated market areas (DMAs), including local commercial and public broadcast stations, and viewership of some national cable networks, superstations, and spill-in stations from adjacent markets.

- **VIP.** Nielsen's *Viewers in Profile* report is the bible of local television stations, the infamous "book" by which stations (and sometimes careers) live and die. Most commercial TV stations subscribe to this report, for it is the basis

for the advertising rates the stations charge. All advertising agencies, syndication companies, and station reps get this report as well. Using NSI data, the VIP books show viewership over specific four-week periods (the "sweeps") in quarterly reports (November, February, May, July) in 211 markets and in October, January, and March in selected large markets. The information is broken down for dayparts, programs, and individual quarter hours. Ratings and shares are shown for households and key demographic groupings based on age and gender. There is also a section that tabulates viewership as thousands of people rather than as rating or share. The data is shown as a four-week average and is also broken out for the four individual weeks of the ratings period. Both program averages (showing data for only a single program as a single number for the entire length of the show) and time period averages (which may include two or more programs in the same time period during the four weeks and which is broken down by quarter-hour or half-hour) are provided.

- **ROSP.** Nielsen's *Report on Syndicated Programs* provides a complete record of all syndicated programs. The ROSP aids in the selection, evaluation, and comparison of syndicated program performance.

- **NSS Pocketpiece.** Nielsen's *National Syndication Service* weekly report provides national audience estimates for barter programs distributed by subscribing syndicators or occasional networks, including barter specials, syndicated sporting events, and barter movie packages. It is small enough to fit into a man's suit jacket pocket (hence the name) or a woman's purse, making it handy on sales calls.

- **NTI.** *Nielsen Television Index*, based on people-meters, provides daily ratings performance on a national basis for all network programs, including household and demographic audience estimates. The NTI ratings are also available as a weekly pocketpiece.

- **Cassandra.** Nielsen's computerized program analysis system allows comparison of programs (syndicated, network, movie, local news, local sports) by household and demographic ratings/ shares.

- **NAD.** Nielsen's *National Audience Demographics* report provides comprehensive estimates of viewership across a wide range of audience-demographic categories. The *NTI NAD* is published monthly in two volumes and provides national network program viewership information. The *NSS NAD* is a monthly book providing similar data for syndicated programming. *CNAD* is a quarterly report of cable network viewership. Unlike the other NAD reports, CNAD does not provide data on individual programs; it only provides viewing estimates for time periods and dayparts.

- **PTR.** Nielsen's quarterly *Persons Tracking Report* tracks program performance in terms of household audiences and viewers per 1,000 viewing households. The PTR includes "specials."

- **HTR.** Nielsen's quarterly *Household Tracking Report* tracks program performance by individual network within half-hour time periods.

- **NCAR.** Nielsen's quarterly *Cable Activity Report* compares all basic cable, pay cable, and broadcast audience levels.

- **NSI Report on PBS Program Audiences.** Viewership of public television in each of the major ratings sweeps periods (November, February, May, July) is reported as national averages.

- **NHTI.** The *Nielsen Hispanic Television Index Report* evaluates Spanish language television viewing using the same methodology as the company's other national television reports. However, the data are gathered by peoplemeters from a separate sample of randomly selected Hispanic households.

- **Network Programs by DMA.** Nielsen's reports provide audience information by station within each DMA (market) for network programs.

3.4 KATZ'S COMTRAC PAGE FOR *HOME IMPROVEMENT*

HOME IMPROV MF

RANK	MARKET	STATION		DAYS TELECAST	START TIME	Nov 94 LI SH / HH SH	Feb 95 LI SH / HH SH	May 95 LI SH / HH SH	LEAD-IN PROGRAM	HH SH	November 1995 LI HH SH / %CHG D1 W2 M3 RT NV94 RT RT RT	LEAD-OUT PROGRAM	HH SH	HIGHEST COMPETING PROGRAM	Nov 95 LI HH D1 SH SH RT	2nd HIGHEST COMPETING PROGRAM	Nov 95 LI HH D1 SH SH RT
001	NEW YORK	WNYW	5 F	MTWTF.	7:30P	14 13t	10 12t	10 11t	SIMPSONS	12	13 8 0 8 6 7	VARIOUS	15	WPIX FAMILY MATTERS	24 22 14	WABC ABC-WORLD NWS	22 19 11
002	LOS ANGELES	KTTV	11 F	MTWTF.	7:00P	11 13o	13 13o	9 12o	COPS	8	15 9 15 9 6 6	SIMPSONS	18	KABC JEOPARDY	17 20 12	KNBC EXTRA	14 13 8
003	CHICAGO	WFLD	32 F	MTWTF.	6:00P	11 13d	9 12d	9 12d	SIMPSONS	14	20 12 53 12 8 8	SEINFELD	18	WLS WHEEL-FORTNE	24 24 13	WMAQ CHS NWS-6.00	12 11 6
004	PHILADELPHIA	WTXF	29 F	MTWTF.	7:00P	10 13t	8 12t	7 11t	COACH	8	15 9 15 9 7 8	VARIOUS	13	WPVI JEOPARDY	22 24 13	KYW ENT TONIGHT 30	10 15 9
005	SAN FRANCISCO-OAK	KTVU	2 F	MTWTF.	6:00P	9 10d	8 9d	8 8d	BAYWATCH STRIP	10	12 6 20 6 4 4	MARRIED-CHLDRN	11	KGO CH7 NWS AT 6	15 19 9	KRON NWSCNTR 4 AT 6	16 12 6
		KTVU	2 F	MTWTF.	7:00P	8 8a	9 8a	9 7p	MARRIED-CHLDRN	11	14 8 75 8 5 5	SEINFELD	17	KGO JEOPARDY	20 24 13	KRON HARD COPY	11 11 6
006	BOSTON	WFXT	25 F	MTWTF.	7:30P	11 12t	9 11t	9 13t	SIMPSONS	10	13 8 8 8 7 8	VARIOUS	13	WCVB CHRONICLE	22 24 15	WCVB CHRONICLE	14 14 9
007	WASHINGTON, DC	WDCA	20 U	MTWTF.	7:00P	7 7u	6 6u	6 7u	DIFFERENT WRLD	6	10 6 42 6 4 4	HOME IMPR MF B	11	WTTG SIMPSONS	19 19 11	WJLA WHEEL-FORTNE	20 19 11
		WDCA	20 U	MTWTF.	7:30P	7 8u	6 8u	7 8u	HOME IMPROV MF	10	11 7 37 7 5 6	VARIOUS	8	WTTG SEINFELD	19 21 12	WJLA JEOPARDY	19 20 12
008	DALLAS-FT. WORTH	KDAF	33 W	MTWTF.	6:00P	13 12c	11 11c	10 9c	RICKI LAKE	7	14 8 16 8 7 5	SIMPSONS	15	WFAA CH8 NWS AT 600	23 24 14	KXAS TEXAS NWS 5-6	19 17 10
009	DETROIT	WKBD	50 U	MTWTF.	7:00P	17 17o	16 16t	14 14t	ROSEANNE	17	21 13 23 13 11 9	HOME IMPR MF B	18	WDIV WHEEL-FORTNE	25 29 17	WXYZ ABC-WORLD NWS	22 19 11
		WKBD	50 U	MTWTF.	7:30P	17 12g	16 13o	14 13o	HOME IMPROV MF	21	21 13 75 13 11 10	VARIOUS	10	WDIV JEOPARDY	29 27 16	WXYZ ENT TONIGHT 30	19 20 12
010	ATLANTA	WGNX	46 C	MTWTF.	6:00P	9 11d	8 7s	7 7j	ROSEANNE	8	9 5 -19 5 4 4	CBS EVE NWS	7	WSB CH2 ACTNWS 6PM	30 33 19	WAGA EYEWIT NWS 6	14 16 9
011	HOUSTON	KRIV	26 F	MTWTF.	6:30P	14 17t	11 17t	13 17t	SIMPSONS	17	20 12 17 12 8 9	VARIOUS	17	KHOU WHEEL-FORTNE	17 21 13	KTRK EYEWIT NWS 6	20 17 10
012	SEATTLE-TACOMA	KCPQ	13 F	MTWTF.	8:00P	8 12c	7 13c	5 10c	AMW-FINAL-JUST	8	16 9 33 9 8 7	SIMPSONS	9	KOMO WHEEL-FORTNE	20 19 13	KING EVENING	19 14 8
013	CLEVELAND	WUAB	43 U	MTWTF.	7:00P	12 11t	11 12t	10 11t	SIMPSONS	12	16 9 45 9 8 9	ROSEANNE	12	WEWS WHEEL-FORTNE	24 25 14	WKYC HARD COPY	13 16 9
014	MINNEAPOLIS-ST. P	KMSP	9 U	MTWTF.	6:00P	20 13c	22 14o	17 11o	STEP BY STEP	16	20 11 53 11 7 9	HOME IMPR MF B	7	KARE KARE11NWS-6	24 25 14	KARE KARE11NWS-6	18 16 9
		KMSP	9 U	MTWTF.	6:30P	13 11b	14 10t	11 9b	HOME IMPROV MF	19	22 13 100 13 9 8	VARIOUS	12	WCCO+ WHEEL-FORTNE	25 26 15	KARE ENT TONIGHT 30	16 15 9
015	TAMPA-ST. PETERSB	WFTS	28 A	MTWTF.	7:00P	8 9o	7 8u	6 7o	ABC-WORLD NWS	11	13 8 44 8 6 6	VARIOUS	8	WTSP WHEEL-FORTNE	19 21 12	WFLA INSIDE EDITION	21 15 9
016	MIAMI-FT. LAUDER	WDZL	39 W	MTWTF.	6:00P	8 6s	8 6s	7 5o	SIMPSONS	9	8 5 35 5 4 4	SEINFELD	9	WPLG WHEEL-FORTNE	26 25 15	WTVJ HARD COPY	9 11 7
017	PITTSBURGH	WPGH	53 F	MTWTF.	7:00P	12 12t	10 10s	14 12s	SIMPSONS	14	18 11 50 11 11 10	SEINFELD	18	WPXI JEOPARDY	20 26 16	KDKA CBS EVE NWS	24 17 11
018	DENVER	KWGN	2 W	MTWTF.	6:30P	13 14s	12 12s	10 12t	ROSEANNE	12	19 11 35 10 10 8	HOME IMPR MF B	19	KMGH JEOPARDY	14 17 9	KCNC CBS EVE NWS	18 15 8
019	PHOENIX	KNXV	15 A	MTWTF.	3:00P	9 7t	9 7t	9 7t	HOME IMPROV MF	18	20 11 66 11 10 9	VARIOUS		KMGH WHEEL-FORTNE	17 16 9	KDVR+ SEINFELD	12 14 8
		KNXV	15 A	MTWTF.	6:30P	7 13t	7 13t	7 10t	GENRL HOSPITAL	16	12 3 9 3 3 2	COURT TV M-F	7	KTVK OPRAH WINFREY	11 16 8	KPNX GERALDO	9 9 3
		KNXV	15 A	MTWTF.	6:30P	14 12t	12 5w	13 8n	NWS15 AT 6	13	10 6 30 10 6 6	VARIOUS	16	KTVK ENT TONIGHT 30	14 14 8	KPNX EXTRA	16 13 7
020	ST. LOUIS	KDNL	30 A	MTWTF.	7:00P	12 11h	9 8h	8 8h	BLOSSOM		6 10 5 -10 5 4 3	ABC-WORLD NWS	14	KSDK NWS CH5-5P	27 34 17	KMOV CH 4 NWS-5	23 20 10
021	SACRAMENTO-STKTON-	KTXL	40 F	MTWTF.	7:00P	11 13t	10 11t	7 11t	CHEERS	11	19 12 72 12 10 9	SEINFELD	20	KXTV JEOPARDY	19 22 13	KCRA AMW-FINAL-JUST	20 13 8
022	ORLANDO-DAYTONA B	WOFL	35 F	MTWTF.	7:00P	11 14s	10 13s	10 14s	SIMPSONS	12	19 12 35 12 11 12	MARRIED-CHLDRN	14	WCPX JEOPARDY	30 26 17	WESH CURRENT AFFAIR	18 16 10
023	BALTIMORE	WBFF	45 F	MTWTF.	7:00P	12 11t	11 11h	7 11a	MARRIED-CHLDRN	12	12 7 71 7 5 8	SEINFELD	12	WJZ CBS EVE NWS	22 21 12	WMAR WHEEL-FORTNE	16 17 10
024	INDIANAPOLIS	WTTV+	4 U	MTWTF.	6:30P	12 11k	12 11k	10 11k	FRESH PRINCE	10	18 10 63 10 9 7	HOME IMPR MF B	20	WISH CBS EVE NWS	21 18 10	WTHR NBC NITELY NWS	15 14 8
025	PORTLAND, OR	WTTV+	4 U	MTWTF.	7:00P	11 10i	11 10i	11 11	HOME IMPROV MF	18	21 13 110 13 12 9	VARIOUS	16	WISH WHEEL-FORTNE	18 22 13	WRTV INSIDE EDITION	13 12 7
		KPDX	49 F	MTWTF.	7:00P	10 13t	13 16o	9 14o	SIMPSONS	13	16 9 23 9 8 8	REAL-HWY PATRL	11	KATU JEOPARDY	25 23 13	KPTV JEOPARDY	8 11 6
		KPDX	49 F	MTWTF.	7:00P	11 13t	11 15t	9 14t	SIMPSONS	12	13 7 0 7 7 6	REAL-HWY PATRL	10	KATU JEOPARDY	25 23 13	KPTV SEINFELD	8 11 6
026	HARTFORD & NEW HA	WTIC	61 F	MTWTF.	7:00P	10 13s	9 10s	7 8s	COACH	14	14 8 6 8 8 9	VARIOUS	14	WFSB INSIDE EDITION	22 22 13	WVIT AMERCN JOURNAL	17 15 9
027	SAN DIEGO	XETV	6 F	MTWTF.	7:30P	15 8b	15 9b	12 7b	SIMPSONS	13	15 9 87 9 6 7	VARIOUS	16	KGTV JEOPARDY	17 18 11	KGTV AMERCN JOURNAL	17 15 9
028	CHARLOTTE	WCCB	18 F	MTWTF.	7:30P	7 12t	7 12t	5 10t	SIMPSONS	8	14 8 16 8 8 8	HOME IMPR MF B	17	WSOC INSIDE EDITION	26 19 12	WBTV EXTRA	22 17 10
		WCCB	18 F	MTWTF.	7:00P	7 9t	7 8t	7 7s	HOME IMPROV MF	13	17 11 88 11 11 9	SEINFELD	20	WCNC WHEEL-FORTNE	16 18 11	WSOC ENT TONIGHT 30	19 17 11
029	MILWAUKEE	WISN	12 A	MTWTF.	10:30P	26 21g	27 22g	27 22g	CH 12 NWS 10	24	28 13 33 13 10 7	EMPTY NEST	22	WTMJ TONITE SHW-NBC	20 21 10	WITI MASH	15 13 6
030	CINCINNATI	WXIX	19 F	MTWTF.	7:00P	14 12b	13 10b	11 10b	MARRIED-CHLDRN	10	16 8 33 8 6 8	SIMPSONS	13	WCPO WHEEL-FORTNE	23 24 12	WLWT EXTRA	18 14 8
031	KANSAS CITY	KSHB	41 N	MTWTF.	11:30P	9 9b	9 9b	8 7b	TONITE SHW-NBC	9	13 6 25 3 2 1	C O'BRIEN-NBC	7	KMBC WHEEL-FORTNE	25 24 17	KCTV SEINFELD	13 12 4
032	RALEIGH-DURHAM	WLFL	22 F	MTWTF.	7:00P	12 12u	12 11u	10 11t	FRESH PRINCE	9	13 7 8 7 5 5	SEINFELD	11	WTVD JEOPARDY	32 27 15	WRAL INSIDE EDITION	32 22 12
033	NASHVILLE	WZTV	17 F	MTWTF.	6:00P	7 11t	5 8t	4 10t	MARRIED-CHLDRN	8	13 7 6 7 7 6	SEINFELD	13	WSMV SCENE AT 6	27 26 15	WTVF 6PM REPORT	19 21 12
034	COLUMBUS, OH	WTTE	28 F	MTWTF.	7:00P	14 10t	12 13t	10 10t	COACH	13	20 10 100 10 9 9	SEINFELD	14	WLOS WHEEL-FORTNE	25 26 15	WSPA CURRENT AFFAIR	13 13 6
035	GREENVLL-SPART-AS	WHNS	21 F	MTWTF.	7:00P	12 9a	9 11a	9 8a	SIMPSONS	9	13 8 44 8 7 6	SEINFELD	14	WLOS WHEEL-FORTNE	23 26 15	WSPA CBS EVE NWS	20 18 10
		WHNS	21 F	MTWTF.	7:00P	12 12a	9 9a	9 9a	SIMPSONS	9	15 8 66 8 7 9	VARIOUS	9	WLOS WHEEL-FORTNE	23 26 15	WSPA AMERCN JOURNAL	13 14 8
036	BUFFALO	WUTV	29 F	MTWTF.	7:30P	12 12s	10 9s	8 8s	FRESH PRINCE	9	17 9 45 6 6 5	SEINFELD	9	KTVX WHEEL-FORTNE	34 30 17	WIVB AMERCN JOURNAL	13 14 8
037	SALT LAKE CITY	KSTU+	13 F	MTWTF.	7:00P	9 10i	10 11i	8 9i	SIMPSONS	11	19 12 150 12 8 8	SEINFELD	13	WMMT WHEEL-FORTNE	20 30 15	KSL EYWT NWS-6	15 19 9
038	GRAND RAPIDS-KALM	WXMI	17 F	MTWTF.	7:00P	13 10i	11 10i	8 9i	SIMPSONS	11	19 10 90 10 7 8	SEINFELD	13	KMOL JEOPARDY	19 19 12	WOOD EXTRA	18 18 9
039	SAN ANTONIO	KABB	29 F	MTWTF.	6:30P	12 14o	14 14o	14 14o	MARRIED-CHLDRN	13	16 10 14 10 8 9	VARIOUS	16	KMOL JEOPARDY	19 19 12	KENT ENT TONIGHT 30	17 14 9
		KABB	29 F	MTWTF.	10:00P	8 9s	9 10s	6 6s	9 OCLOCK NEWS	9	12 6 10 6 6 6	VARIOUS	12	KMOL MASH	22 25 16	KENS EYSWIT NWS-10	16 23 14
040	NORFOLK-PORTSMTH-	WTKR	3 C	MTWTF.	5:30P	18 18i	12 11i	11 13i	NEWS CH3 3	17	19 9 5 9 5 5	NEWS CH3 6	22	WAVY WAVY10NWS-5.30	20 19 9	WVEC AMERCN JOURNAL	17 18 8
041	NEW ORLEANS	WNOL	38 F	MTWTF.	6:30P	9 11i	8 7i	7 7i	SIMPSONS	8	14 6 43 6 4 4	VARIOUS	12	WWL EYEWIT NWS-10	35 37 22	WDSU ENT TONIGHT 30	16 16 10
		WNOL	38 F	MTWTF.	7:00P	8 8a	8 3a	7 3i	SIMPSONS	6	4 2 100 2 1 2	BAYWATCH STRIP	9	WWL EYEWIT NWS-10	15 19 11	WVUE NEWS 8-10PM	25 22 12
042	MEMPHIS	WLMT+	43 F	MTWTF.	6:00P	5 9s	2 4d	4 7s	COSBY SHOW	6	7 4 -37 4 3 2	VARIOUS	8	WMC WHEEL-FORTNE	32 33 18	WREG ENT TONIGHT 30	16 13 10
043	OKLAHOMA CITY	KOCB	34 U	MTWTF.	7:00P	8 11t	7 9t	7 9t	RICKI LAKE	6	7 4 75 8 8 7	SIMPSONS	9	WKYC NWSCHANNEL 4-6	27 24 13		
044	HARRISBURG-LNCSTR	WPMT	43 F	MTWTF.	7:00P	7 8u	7 7u	6 7u	MASH		14 8 75 8 8 7	SEINFELD	11	WGAL EYEWIT NWS 8	6 21 11	WGAL HARD COPY	22 16 10
045	WEST PALM BEACH-F	WFLX	29 F	MTWTF.	7:00P	10 12b	8 10o	9 11o	SIMPSONS	10	14 8 16 8 9 8	SEINFELD	15	WPTV NBC NITELY NWS	30 27 16	WPEC CBS EVE NWS	22 19 11
046	PROVIDENCE-NEW BE	WNAC	64 F	MTWTF.	7:30P	6 6o	7 7o	7 6o	SIMPSONS	6	7 4 16 4 9 4	VARIOUS	6	WJAR WHEEL-FORTNE	16 21 12	WLNE CURRENT AFFAIR	18 15 9
047	WILKES BARRE-SCRA	WOLF+	38 F	MTWTF.	7:00P	4 4c	5 5c	5 7c	BAYWATCH STRIP	4	10 6 150 6 5 5	SIMPSONS	9	WYOU CURRENT AFFAIR	16 17 10	WBRE NEWS-NBC	12 13 8
048	GREENSBORO-H.POIN	WXLV+	A	MTWTF.	7:00P	0 0	0 0	0 0	ABC-WORLD NWS	7	13 -- 7 7 5	SIMPSONS	9	WFMY WHEEL-FORTNE	33 32 17	WXII NBC NITELY NWS	19 13 7

a. CHEERS	b. COACH	c. COPS	d. COSBY SHOW	e. COSBY SHOW B	f. DIFFERENT WRLD	g. EMPTY NEST	h. FAMILY MATTERS	i. FRESH PRINCE	j. FULL HOUSE
k. GOLDEN GIRLS	l. HARD COPY	m. JEFFERSONS	n. MAGNUM	o. MARRIED-CHLDRN	p. MURPHY BROWN	q. PRICE IS RIGHT	r. RICKI LAKE	s. ROSEANNE	t. SIMPSONS
u. STAR TK-GENRTN	v. TNY TN M-F-FOX	w. WONDER YEARS							

HH = HOUSEHOLDS	D1 = DMA HOMES	W2 = WOMEN 18-49	M3 = MEN 18-49	LI = LEAD-IN	LO = LEAD-OUT	RT = DMA RATINGS	SH = DMA SHARE	%CHG = DMA SHARE

Source: Nielsen data based on Katz analysis. Used by permission of Katz Television Group and Nielsen Media.

- **DMA Test Market Profiles.** These Nielsen reports provide marketing and media information for all markets.

In addition to these reports, which may also be purchased by syndicators, major station groups, and large-market stations, Nielsen can prepare special research reports exclusively for an individual station or tailored for a group of stations such as a rep firm's client list. With the advent of personal computers, the station reps themselves now provide much customized research formerly only available at significant cost from Nielsen. One example of such customized ratings research is the Katz Comtrac system, which has become an industry-standard research tool because it provides easy-to-use comprehensive overviews of station and program performances (see 3.4). The Comtrac reports were originally computed and printed by Nielsen on its mainframe computers; now Katz prepares the reports in-house for its clients on

its own PCs more quickly and at significantly lower cost.

Katz's first page for *Home Improvement* (one of several pages that cover all markets) tracks the show's shares in syndication in a condensed format. It shows which stations in which markets purchased *Home Improvement* and when they scheduled it. Then it lists the shares for the time period performance in the three previous ratings books (November '94, February '95, and May '95 in this example), also telling what kind of lead-in it had and the lead-in's shares. (Since *Home Improvement* was not running yet in syndication in the three previous ratings surveys, the performance of the previous programs in the time period is shown. Had *Home Improvement* been on the air already, its own performance would be given.) Next the Comtrac report shows *Home Improvement*'s current lead-in and shares in each market, and then *Home Improvement*'s own shares and ratings (including some abbreviated demographics) and its lead-out. Finally, the Katz Comtrac page shows *Home Improvement*'s two main competing programs in each market and their audience shares.

Computers for Program Analysis

In recent years syndicators, major-market stations, and rep programming departments have invested heavily in high-end personal computer (PC) systems with large storage capabilities. The PC has given programmers the ability to create sophisticated research tools for programming and useful visuals in the form of pie charts, bar graphs, and line graphs (see 3.5).

Station program directors and reps also use personal computers as information storage/retrieval systems. For example, a PC can list for any given market all programs in syndication, the name of the syndicator, cash or barter terms, number of episodes, runs, years, start date in syndication and, most important, the call letters of the station in the market owning the syndication rights to the

3.5 SNAP

Many syndicators and most reps use the SNAP system, an acronym standing for Syndication/Network Audience Processor, which they license from Broadcast Management Plus, a computer software company. SNAP allows syndicators and reps to rearrange Nielsen data from various ratings periods into easy-to-read summaries. Using SNAP, a syndicator or rep programmer can analyze individual programs, individual markets, multiple market performance of individual programs, time period trends, or program trends. Such elements as program or time period ratings history, lead-ins, lead-outs, competition, and up to 16 demographic groups can be manipulated simultaneously. Losses or gains can be shown as percentage changes. SNAP is more flexible, faster, and more precise than Cassandra. And perhaps most important, the user can set all the parameters. Usually, the information can be retrieved and printed within seconds, although preliminary data gathering and file creation may take several minutes. Nonetheless, retrieving the same amount of data from printed ratings books often takes hours, if not weeks. And some of the more obscure demographics are not printed in ratings books at all.

program, with a blank space indicating that the program is unsold and therefore available.

There are good reasons why syndicators and reps have invested heavily in computers. The complete Nielsen data tapes for all markets in each rating sweep can be loaded into a computer and then transformed into customized research data. Syndicators use this data to sell programs; reps use it to help stations analyze their problem programs. For example, audience flow from one program to the next can be graphically illustrated in audience

3.6 KATZ AUDIENCE FLOWCHART

PROBE PLANNING

AUDIENCE FLOW ANALYSIS

RETENTION

SWITCHING

The left side of the example shows each station's ¼hr. lead-in to its 6 o'clock program as well as the amount of new audience coming into the time period.

Follow the different shadings from the left side of the example over to the right in order to see how much lead-in audience was retained by each station. WAAA held on to 34,000 households from the 50,000 that were viewing the People's Court lead-in. These 34,000 households represent 67% of the People's Court audience or 38% of the total households viewing WAAA's News Center 6.

Follow the individual shadings in each 6-6:15 PM program back to the left side of the example (5:45-6PM) to see where each portion of a program's audience originated. For WAAA's News Center 6, 6,000 Households or 77% of its total audience switched from WBBB's M.A.S.H, 3,000 Households or 4% switched from WCCC's movie and 6,000 or 7% switched from WDDD's Soap.

SHARE OF NEW TUNE-IN

This shading is the amount of households which had not had their sets turned on from 5:45-6PM but are now viewing. The 40,000 new tune-in viewers now watching WAAA's News Center 6 represent 56% of all new households just tuning-in or 44% of the total households now viewing News Center 6.

STA. TOT. - HOUSEHOLDS
JULY -NIELSEN

M-F, 5:45PM - 6:00PM 6:00PM M-F, 6:00PM - 6:15PM

PEOPLE'S COURT

WAAA 50,000

NWS CENTER 6 (RETAINED - 67%; SHAR OF NEW TUNE-I - 56%)
34 8 3 6 40
77% 4% 7% 44%
49,000

MASH

WBBB 54,000

ACTION NWS 6 (RETAINED - 48%; SHAR OF NEW TUNE-I - 25%)
26 6 1 5 18
46% 11% 2% 9% 37%
56,000

MOVIE

WCCC 4,000

NWS 6 (RETAINED - 89%; SHAR OF NEW TUNE-I - 0%)
83%
2,000

SOAP

WDDD 24,000

13 NWS EARLY (RETAINED - 57%; SHAR OF NEW TUNE-I - 18%)
14 3 3 13
35% 7% 8% 8% 34%
38,000

OTHER 14,000

8 1 4

16,000

TUNE OUT

NEW AUDIENCE 71,000

5 2 2
18,000

The audience that had been tuned to WAAA from 5:45-6PM but is no longer viewing that station from 6-6:15PM have either been tuned to another station or turned their sets off. This includes:
— 6,000 Households now viewing WBBB's Action News 6, representing 11% of the total Action News 6 audience.
— 3,000 Households now viewing WCCC's 13 News Early, representing 7% of the total 13 News Early audience.
— 3,000 Households now coming from other station's outside the market.
— 5,000 that have turned their television sets off.

flowcharts. Bar graphs can show, for each station in a market, the amount of audience the target program retained from the lead-in program, the amount of audience tuning into the program from other stations, the new audience turning on their televisions, the amount of audience lost to other stations, and the number of sets turned off from each station in the market (see 3.6).

THE DECISION PROCESS

The syndicator has visited the station and made his or her pitch to either the general manager or the program manager or to both. The rep has consulted with the station, providing research support combined with experience and judgment resulting in a recommendation regarding the program the

syndicator is selling. The station and the rep have analyzed the terms of the deal, and the programmers now must determine how they might utilize the program, if at all.

Each programming decision is different from any other. Each show is different; each deal is different. Markets and competitive situations differ; corporate philosophies and needs not only differ but may also change over time. The personalities and opinions of the syndicator, the station general manager, program director, and rep programmer all enter into the decision. Although innumerable permutations and combinations exist, the basics of the decision-making process involve an assessment of need and an analysis of selection options.

Determining Need

Perhaps the most important part of making any programming decision is establishing whether a program is needed and determining whether the program in question is the best choice to meet that need. Sometimes this task is easy. The need may be quite obvious. For example, a first-run program that many stations carry may fail to attract a large enough national audience and be cancelled by its syndicator. It needs to be replaced on all the stations carrying it. In another example, despite increased promotion and a strong lead-in, a particular program on a given station continues to downtrend in several successive books and from year-ago performance in the time period. It needs to be replaced.

At other times the need may be less obvious. A show may perform reasonably well but show no audience growth and finish second or third in the time period. Should it be replaced? Will a replacement show perform as well, better, or not as well?

When a syndicator is pitching a station, he or she tries to identify or create a need for the station to buy the particular program being offered. Although the syndicator's assessment that an existing program should be replaced may be correct, he or she is looking at it strictly from the perspective of selling a program in the market. The syndicator's

need to sell a particular show may not be the same as the station's degree of need (if any) to replace an existing program.

The station and rep programmers approach the determination of need by first looking at the performance of the existing schedule and identifying trouble spots, including individual programs and entire dayparts. For example, three out of the four programs from 4 to 6 P.M. may be performing quite well, but one may be a weak link and therefore a candidate for replacement. In another situation, the entire 4 to 6 P.M. schedule might be performing poorly and need to be replaced, perhaps including a switch from one program type to another, such as from talk shows to reality and magazine shows.

Selection Options

Once a need to replace a program has been established, a replacement must be selected. Programmers have four basic options at this point. Think baseball, for the alternatives are analogous in both television and baseball:

- **Do nothing at all.** If the station or baseball team is trailing, it's sometimes best to leave the lineup unchanged, hoping for an improved performance or a mistake by the competition. Sometimes there's no alternative, because the bench strength is either depleted or no better than the current players and no stronger players or programs can be substituted.

- **Change the batting (or programming) lineup.** Swap the lead-off hitter with the cleanup batter, or swap a morning program with an afternoon show, or reverse the order of the two access shows. (There are many more examples.)

- **Go to the bench** for a pinch hitter or go to the inventory of programs "on the shelf" (already owned by the station but not currently on the schedule) for a replacement show.

- **Hire a new player** or buy a new show.

Let's look at each area in greater detail.

1. Do nothing. Although a time period may be in trouble, sometimes nothing can be done to improve the situation. The station may not own any suitable replacement shows. Other shows already on the air might be swapped, but the station and rep programmers might feel such a swap would hurt another daypart (perhaps a more important daypart) or that the other program might not be competitive in the target time period. Then, too, potential replacement shows available from syndicators may be perceived as no improvement over existing programming, or they might be too expensive. Often, increasing promotion can help the show "grow." Finally, the programmers may decide to leave the schedule intact as it may take time for viewers to "find" the show and form a viewing habit. The rep may research the performance of the program in other markets to see whether or not the program is exhibiting growth. Sometimes the only choice is to do nothing at all.

2. Swap shows. The second alternative is to change the batting order. Generally, the station and rep programmers look first at the station's entire program schedule to see if the solution might be as simple as swapping time periods for two or more shows already on the air. Often a program originally purchased for one time period can improve an entirely different time period when moved. See 3.7 for an example.

In most cases, syndicators are delighted when a station moves a show from a lower HUT level time period to a time period with higher HUTs. *A higher HUT level means a higher rating, even if share stays the same or drops slightly.* For syndicators selling barter time in a program, higher ratings in individual markets contribute to a higher national rating, which translates into higher rates charged by the syndicator to the barter advertiser.

But for a station, such a move may also mean paying higher license fees to the syndicator. In the case of first-run programs, syndicators often make **tier** or **step deals** with stations. At the time the deal is made, stations and syndicators agree on price levels for different dayparts with higher prices for dayparts with higher HUT/PUT levels, which have more potential viewers available. One

3.7 EXAMPLE OF A SWAP ALTERNATIVE

*T*he Oprah Winfrey Show premiered in syndication in September 1986. It was positioned by its syndicator as a morning program (9–11 A.M.), meaning a reasonably low risk and low purchase price to stations, since morning HUT levels are low. After *Oprah's* dramatic and very strong ratings performance in the November 1986 and February 1987 ratings books, many stations moved the program to the more important and more lucrative early fringe (3–6 P.M.) daypart to improve their afternoon performance. *Oprah* quickly became a dominant early fringe program, vastly improving the time period performance of many stations and increasing audience flow into affiliate early newscasts. In some cases, the program *Oprah* replaced was merely moved to the morning time period previously occupied by *Oprah;* in other situations, stations had to purchase a replacement morning show to fill *Oprah's* vacated time period.

price is agreed upon for morning time periods, a higher price for early fringe, and perhaps a still higher price for access. Four-tier agreements, which may also include late night, are not uncommon. Moving a program from one daypart to another triggers a change in license fee. It is to the station's advantage to negotiate a step deal to avoid a potentially expensive program playing in a low-revenue time period.

Step deals are relatively rare for off-network programming, which generally has a single license fee level priced by the syndicator that is based on the revenue potential of the daypart in which it is presumed the program will play. Thus, when a station buys an off-network sitcom or hour action-adventure show for access or early fringe, the price the station pays remains the same over the life of the contract. If the show is a ratings failure in access or early fringe and must be moved to a less lucrative morning or late-night time period, the

station's financial obligation to the syndicator remains unchanged. Thus, a station can find itself with a very expensive "morning program," a daypart of significantly lower revenue potential than early fringe or access (meaning that the program may cost the station far more than the time period can generate in advertising income).

If the station buys an expensive off-network show that later moves to a time period with lower HUT levels, the station may experience some discomfort in its bottom line (low profitability or a loss), but the consequences are generally not disastrous. However, if the station buys several expensive shows that do not perform and that must be moved to time periods with lower advertising rates, the economic impact can be quite serious. Because of the relatively long license terms of off-network shows (typically three to four years), a station may not recover for years when several such "mistakes" are made.

3. Substitute shows. The third alternative is to go to the bench for a pinch hitter. Programmers have a responsibility to manage existing product and at the same time remain competitive. It's not always necessary to spend more money to buy a new program. Sometimes the station already owns the solution to a problem. A simple swap of programs already on the air may not be the best answer. A station with strong bench strength may have enough programs "in the dugout" to replace a failing show in a competitive manner. Corporate accountants like this sort of solution because it does not add to a station's expenses, and it uses existing product that must be paid for whether or not it airs.

The station and rep programmers look at the strengths and weaknesses of the shows on the shelf, which generally have aired before. They must ask some questions at this point. How well did they work? Have they been rested long enough to return at their previous performance level and, if not, is that reduced level still superior to the current program's performance? Are the shows dated? Will they look "old"? Are the potential replacement shows suitable for the time period?

Are they compatible with the other programs in the daypart? Are they competitive? Are they cost-effective? Do they appeal to the available demographic?

4. Buy new shows. If the first three solutions have been examined and rejected, the programmers at the station and the rep generally consider purchasing a program. Because an added expense is involved whenever a purchase is made, the programmers must determine whether a new program will be superior to an existing show and, if so, will it be strong enough to offset the additional cost?

Although expense is a consideration in any programming decision, programmers and corporate and station management should always keep in mind one very important factor: *They must keep the station competitive.* Remember, their job is to deliver the largest mass audience with the strongest demographics. Although they must always keep an eye on the bottom line and therefore program in a cost-effective manner, a false economy will result from trying to avoid expense if the result would be to lose even more revenue. If ratings decline, eventually revenue will also decline.

Instead, programmers must balance expense against returns, determining the ratings potential and projected revenue in deciding whether a new purchase is practical and, if so, how much the station can afford. The rep's research can help project the future performance of a program, whether it is already on a station's schedule or is to be a future acquisition. Anticipated performance plays a large role in determining the purchase price.

CALCULATING REVENUE POTENTIAL

Based on a program's ratings and the sales department's estimate of **cost per point** (the number of dollars advertising agencies or advertisers are willing to pay for each rating point the station delivers), the programmers can determine the amount of money the station can pay for a show. It works like this. *A rating point equals 1 percent of the televi-*

sion households in a market. If there are 500,000 television households in market A, a rating point represents 5,000 households. A show that receives a 15 rating in market A would deliver 75,000 households (5,000 households per rating point × 15 rating points = 75,000 HH).

Advertising agencies pay a certain amount for each thousand households, called **cost per thousand (CPM)**. Let's say the agency assigns a $5 CPM. A 15 rating in market A would be valued at $375 for a 30-second commercial ($5 CPM multiplied by 5,000 households per rating point divided by 1,000 equals $25/point multiplied by 15 rating equals $375).

Let's say the station is considering a half-hour off-network sitcom cut for six commercial minutes and sold with six available runs over four years. Six commercial minutes in each episode translates to twelve 30-second spots per day. Revenue potential is calculated by multiplying the projected rate per spot at the anticipated rating by the number of commercials to give a gross revenue potential. The gross is now netted down (reduced) to allow for commissions paid by the station to salespeople, reps, and advertising agencies. At a 15 percent commission rate, the station nets 85 percent of the gross. The net is now netted down again to a projected **sellout rate** (the number of spots actually sold over the course of a year is generally less than the number available). Most stations use a conservative 80 percent sellout rate for planning purposes; if they actually sell more than 80 percent of the available time, that's all to the good, and the bottom line. This final revenue figure is called the **net net**. The calculation per episode would look like this:

$ 375	rate per 30-second commercial
× 12	30-second commercials
$4,500	gross per day
× .85	net revenue level (after 15% commission)
$3,825	net per day
× .80	sellout rate
$3,060	net per day

The $3,060 is the daily income the station can expect to generate during the current year for each run of the program.

To compute what the show would generate when it goes on the air, the station and rep sales managers inform programmers of the potential rate for all future years the show will be available. A typical increase in cost per point from year to year might run from as low as 3 percent to as high as 12 percent depending on inflation and local market economy. Using figures supplied by sales, programmers use the formula shown above to project the net net revenue potential of the program over the life of the show. In this calculation, they also revise the rate based on the show's ratings delivery. A program that produces a 15 rating in its first run might be moved by its fifth and sixth runs (as it can be expected to weaken as it is repeated) to a time period with lower HUT levels, such as late night, and may only generate a 5 rating. Therefore, although CPMs are increasing, the lower rating will bring down the spot rate, lowering the revenue potential for the program in that run.

Let's look at a simplified example of the complete calculation. We'll assume the program is available two years from now. There will be 130 episodes, six runs each (780 total runs) over four years. The station plans to trigger the episodes as soon as the contract starts, running five episodes a week for three years, with no hiatus, until all 780 runs are exhausted. Coincidentally, this will take exactly three years (5 days/week multiplied by 52 weeks equals 260 days per year divided into 780 total runs equals 3 years).

The various calculations of the revenue potential for each individual episode are shown in 3.8. The percentage rate increases are estimated by sales. This year and next year are the two years between the time the station buys the show and the time it goes on the air. Years 1, 2, and 3 are the years in which all runs will be taken. The years are not necessarily calendar years; generally they begin in September with the start of the new season or the program's availability date.

Now that we've figured the revenue potential per run of each episode as shown in 3.8, it's easy,

3.8 CALCULATION OF REVENUE PER EPISODE

$5.00	current CPM	*Year 1:* Runs 1 & 2 of each episode in access at 15 rating.
× 1.05	(5% increase estimate)	
$5.25	CPM next year	
× 1.07	(7% increase estimate)	*Year 2:* Runs 3 & 4 of each episode in early fringe at 8 rating.
$5.62	CPM Year 1 of show	
× 1.06	(6% increase estimate)	*Year 3:* Runs 5 & 6 of each episode late night at 5 rating.
$5.96	CPM Year 2 of show	
× 1.08	(8% increase estimate)	
$6.44	CPM Year 3 of show	

YEAR 1		YEAR 2		YEAR 3	
$5.62	CPM	$5.96	CPM	$6.44	CPM
X 5000 / 1000	households	X 5000 / 1000	households	X 5000 / 1000	households
$28.10	cost per point	$29.80	cost per point	$32.20	cost per point
X 15	rating	X 8	rating	X 5	rating
$421.50	rate	$238.40	rate	$161.00	rate
X 12	commercials	X 12	commercials	X 12	commercials
$5,058.00	Gross	$2,860.80	Gross	$1,932.00	Gross
X .85	Net revenue	X .85	Net revenue	X .85	Net revenue
$4,299.30	Net	$2,431.68	Net	$1,642.20	Net
X .80	Sellout	X .80	Sellout	X .80	Sellout
$3,439.44	**Net Net per run**	$1,945.34	**Net Net per run**	$1,313.76	**Net Net per run**

based on projected usage, to compute the total revenue potential for each episode over the life of the contract.

Run 1, Year 1	$3,439.44
Run 2, Year 1	3,439.44
Run 3, Year 2	1,945.34
Run 4, Year 2	1,945.34
Run 5, Year 3	1,313.76
Run 6, Year 3	1,313.76
Total net net revenue per episode	$13,397.08

But we're not quite done. Now, let's figure how much the station can pay per episode. Stations assign percentage ranges in three areas: program purchase cost, operating expense, and profit. Program purchase cost may run as low as 20 to 30 percent of total revenue for an affiliate, which gets most of its programming from the network, to as high as 50 percent for an independent, which must purchase or create all of its programming. Let's use a median figure of 40 percent for our example.

With a total revenue projection of $13,397.08 per episode, the station using a 40 percent program cost figure would estimate the price per episode at

$5,358.83. Because nobody figures so closely (that is, to the exact dollar), a range of $5,000 to $5,500 per episode would be a reasonable working figure. Multiplying these figures by 130 available episodes would establish a total investment of $650,000 to $715,000 for the program. The station would certainly try to negotiate a lower cost for the show but might be willing to go higher, even considerably higher, depending on how badly the station needed the program or if it perceived that the show was important to the station's image (to viewers and advertisers) and to its competitive position.

Unfortunately for the station, syndicators perform the same calculations. They generally quote a purchase price significantly higher than the station wishes to pay. In our example, knowing that the station could expect to make as much as $20,000 in the access time period if all six runs of each episode ran in access, but not knowing that the station might plan to take some runs in early fringe and late night, the syndicator might ask $10,000 to $15,000 per episode. The station might want to pay $3,000 to $4,000 but expect to pay $5,000 to $6,000 per episode and go as high as $7,500 if it really needed the show.

Obviously, the two parties have to reach a middle ground or the show will either be sold to another station in the market or go unsold to any station. And now the fun begins—negotiation.

Negotiation

Syndicators sell most programs to stations through good old-fashioned negotiation. Generally, the syndication company "opens a market" by pitching the program to all stations in the market. The pitch will be the same to every station in the terms and conditions of the deal (episodes, runs, years, availability date, price, barter split, payment terms) but may differ subjectively depending on the stations' perceived needs, strengths, weaknesses, and programming philosophy. The syndicator will try to determine or create a need at each station with the hope that several will make an offer. In this ideal situation, the syndicator will be able to select which station receives the show based on the following considerations:

- Highest purchase price offered (if cash or cash-plus-barter)
- Size of down payment
- Length of payout
- Ability to make payments
- Best time period (particularly important for shows containing barter time)
- Strength of station
- Most compatible adjacent programming

Often the syndicator receives no offers initially but may have one or two stations as possible prospects. Negotiations may continue for weeks or even months, with syndicator and station each making concessions. The station may consider paying a higher price than originally planned or may agree to also purchase another program. The syndicator may lower the asking price or may increase the number of runs and years. The station may raise the down payment, and the syndicator may allow the station to pay out over more time. Negotiation is basic horse trading.

Bidding

Some syndicators of hit off-network programs have sold their programs by confidential bid to the highest bidder in the market rather than through negotiation. In 1986–87, Viacom sold the megahit *The Cosby Show* at megaprices, shattering records in all markets. Shortly thereafter, Columbia Pictures Television sold *Who's the Boss?* at astronomical prices, in some cases eclipsing even *Cosby*'s prices. Both *Cosby* and *Boss* were bid rather than negotiated.[6]

Here is how bids work. The syndicator opens half a dozen or so markets in a week. Each station receives a complete pitch, including research data, terms, and conditions. Financial terms are *omitted* during the pitch. After several days, when all stations have been pitched, the syndicator faxes all stations simultaneously, revealing the syndicator's

lowest acceptable price and certain other financial details. Stations are given a few days, perhaps 72 or 96 hours, to bid on the program. Bids from each station in the same market are due simultaneously so that no station has a time advantage over another. The syndicator analyzes the bid price, the amount of down payment offered, and other financial terms to determine the highest bidder. The highest bidder wins the program, pure and relatively simple.

The rep programmer usually becomes involved in advising client stations during the bidding process. Syndicators notify the reps of the markets coming up for bid, and the reps immediately notify their respective client stations. The reps provide their usual research analyses of the program's performance, coupled with their subjective views of how well the show will play in syndication and in the client's lineup. The reps advise the stations whether or not to bid. The reps frequently project the rating and help clients determine the amount of the bid if a bid is to be made.

Perhaps most important, the reps track **reserve** (asking) **prices** and reported or estimated selling prices in other markets. The rep programmer informs the client of these pricing trends to help the station determine a **bidding price** based on previously paid prices in similar markets. The rep also informs the client of down payment percentages and payout terms in other markets, serving as a guide to successful bidding.

Bidding is a fairly simple, clear-cut procedure for syndicator and station alike. There is no messy, drawn-out negotiation. The syndicator makes only one trip to the market, not repeat visits over many weeks or months. The sale can be accomplished quickly if there is a bidder at an acceptable price. Competition between stations is established, often turning into a frenzied escalation of prices by stations reaching ever deeper into their piggy banks to be sure they acquire the must-have program. And the syndicator generally achieves prices far in excess of the amounts that might be realized through negotiation. *But bidding only works for the must-have shows that are truly megahits.* An atmo-

sphere of anticipation has to preexist, and stations have to have a strong desire to own the program.

Stations generally dislike bidding. It often forces them to pay more than they normally would. In a negotiation, station management usually gets a feel for the degree of competing interest and the syndicator's minimum selling price. In a bidding war, stations get little sense of the competition for the show. A station may be the only bidder, in which case it bids against itself. It may also bid substantially above any other bidder, a waste of money. In this situation, each station works in the dark, which can be unsettling. However, stations realize that if they want to be in the ball game for a bid show, the syndicator not only owns the bat and ball but also makes the rules.

PAYMENT

Payment for programming takes one of three basic forms: *cash, barter,* or *cash-plus-barter.* Payout arrangements vary and are usually negotiated.

Cash and Amortization

Cash license fees are paid as money (rather than in airtime, as with barter). In most cases, cash deals are like house mortgages or auto loans. An initial down payment is generally made at the time the contract is signed, followed by installment payments over a set period of time. The down payment is generally a comparatively small portion of the total contract amount, perhaps 10 or 15 percent. The remaining payments are triggered when the station begins using the program, or at a mutually agreed-upon date, either of which may be a month or two or several years after the contract is signed. If the contract is for a relatively short amount of time or a low purchase price, the payments will be made over a short period of time. A one-year deal may have 12 equal monthly payments, and a six-month deal may be paid in only 2 or 3 installments. However, a five-year contract may be paid out over three years in 36 equal

monthly payments, beginning when the contract is triggered. No payments would be due in years four or five of the contract.

When stations buy programs for cash, whether negotiated or bid, they pay out the cash to the syndicator on an agreed upon schedule, but they allocate the cost of the program against their operating budget via an amortization schedule. **Amortization** is an accounting principle wherein the total cost the program is allocated as an operating budget expense on a regular (monthly) basis over all or a portion of the term of the license. Thus, stations control and apportion operating expenses to maintain a profit margin. Amortization does not affect the syndicator or the amount paid to the syndicator (payout).

Depending on the intended method of airing the program, amortization may be taken at regular weekly or monthly intervals or as the runs are actually used. In the case of programs intended to be played week-in, week-out without hiatus (such as most first-run and some off-network shows), amortization is taken every week or month without exception. This allows a station to predict its ongoing program costs, but it does not allow the station to avoid those costs should it remove the program from its schedule.

Alternatively, for most off-network shows and feature films, the show/movie is expensed (amortized) as runs are taken of the individual episodes or titles. The amount amortized each week/month will vary depending on the number of runs used. If a station must reduce operating expenses, it can do so by **resting** (placing on hiatus) a program or running less expensive movie titles. Conversely, in a period of strong revenues, a station can **play off** (run) more expensive shows or movies. In this manner, a station can control its operating costs to a degree. However, if a station does not play off all the episodes before the end of the contract, it may find itself with unamortized dollars that have to be expensed. Thus, amortization can be a double-edged sword, and the programming executive has to be a bit of an accountant as well as a creative programmer.

Amortization Schedules

Amortization schedules differ from station to station, depending on corporate policy. Some stations use different schedules for different program types or planned usages. The two most widely used amortization schedules are *straight-line* and *declining-value*.

Straight-line amortization places an equal value on each run of each episode. If a program cost a station $10,000 per episode for five runs of each episode, straight-line amortization would be computed by dividing the five runs into the $10,000 cost per episode, yielding an amortized cost per run of $2,000 (20 percent of the purchase price, in this case). If the station had negotiated more runs at the same per episode license fee, the cost per run would decline. For example, had the station purchased eight runs for $10,000, the straight-line amortized cost would be $1,250 per run. The lower amortized cost would reduce the station's operating budget by $750 each time the show is run. On a five-day-a-week strip over 52 weeks (260 runs in a year), the $750-per-run saving would total $195,000, a sizable amount. (You can see why it is important to negotiate well and get as many runs as possible.) The station would still pay the syndicator the full $10,000 per episode, multiplied by the total number of episodes.

With **declining-value amortization**, each run of an episode is assigned a different value on the premise that the value of each episode diminishes each time it airs. Thus, the first run may be expensed at a higher percentage of total cost than is the second run, and the second run may be expensed higher than the third run, and so forth. A typical declining-value amortization schedule for five runs of a program might look like this:

First run	40 percent
Second run	30 percent
Third run	20 percent
Fourth run	10 percent
Fifth run	0 percent

If we compared the same program under straight-line and declining-value amortization systems, operating expenses would be as follows:

	Straight-line	Declining-value
First run	$ 2,000 (20%)	$ 4,000 (40%)
Second run	2,000 (20%)	3,000 (30%)
Third run	2,000 (20%)	2,000 (20%)
Fourth run	2,000 (20%)	1,000 (10%)
Fifth run	2,000 (20%)	0 (0%)
Total	$10,000 per episode	$10,000 per episode

In both schemes, the total amortized amount over the five runs is the full per episode cost of the program. In the straight-line method, the station expenses each run (or "charges" itself) equally, even though the show's performance may decline as more runs are taken of each episode. An advantage of this method is that the initial run or runs are comparatively inexpensive, especially if the show performs well. A disadvantage is that the final run is just as expensive as the first run, even though the show's popularity may have faded and the ratings declined.

Under the declining-value method, the bulk of the amortization is taken on the initial runs, when the ratings would presumably be at their highest. Relatively few dollars would remain to be expensed in the final runs. In this example, 70 percent of the program's cost is taken in the first two runs under the declining-value system, but only 40 percent is taken for the same two runs straight-lined. If the show falls apart in the ratings after two or three runs, the station using the declining-value method has most of its financial obligation behind it, but the station using straight-line amortization has the bulk of the expense still to come. In the example, using declining-value amortizes all the expense of each episode over the first four runs. Because stations sometimes fail to use all the available runs of a program, the fifth run at no charge can be quite helpful to a station. If the run is not taken, there is no charge against the show as there would be in the straight-line system. (Not all declining-value amortization schedules provide

free runs; some companies place some value even on the final run, which serves to reduce the expense on the earlier runs, at least slightly.)

The straight-line system is frequently used to amortize first-run shows that are expensed on a weekly basis and generally run no more than twice per episode. *The declining-value system is often used for off-network programs and feature films* that are generally expensed on a per-run basis and are sold with five to ten runs per episode or film.

Finally, amortization is only an internal allocation of dollars against usage. It does not change the payout of the license fee to the syndicator. The program may be fully run and amortized before payout is completed, or the station may continue taking runs of the show for years after the payout to the syndicator is complete, with the amortization of the episodes allowing the expense against the operating budget to be delayed until the programs are actually run. When all episodes are fully amortized and all payments made to the syndicator, the final dollars expensed in both amortization and payout will be identical.

Barter and Cash-Plus-Barter

The second payment method is **barter**. Barter is a fairly simple payment system. The station agrees to run national commercials sold by the syndicator in return for the right to air the program. No money changes hands. The syndicator makes all of its money from the sale of commercials to national advertisers, and the station gives up some of the commercial time it or its rep would have had to sell.

Cash-plus-barter means exactly what the name suggests. Part of the license fee is paid in cash, albeit a lower cash license fee than if the show were sold for straight cash, and part of the license fee is given by the station to the syndicator as commercial time, which the syndicator sells to national advertisers. A typical cash-plus-barter deal for a half-hour show might be a cash license fee plus one minute of commercial time (1:00 national) for the syndicator, with the station retaining five-and-a-half minutes (5:30 local) for its own sale.

Barter can be both a blessing and a curse. On the plus side, barter can be a way of reducing cash expense at a station. In some cases, especially for untried and unproven first-run shows, stations may be more willing to give up commercial airtime than to spend money. If a syndicator takes three minutes of commercial time within a half-hour show and the station receives three minutes, the syndicator has received 50 percent of the available commercial time, and the station retains 50 percent. As you saw earlier, stations generally figure 30 to 50 percent of their revenue goes to programming expense, so barter may seem expensive. But as stations are rarely 100 percent sold out and may average only an 80 to 90 percent sellout over a year, the barter time the station gives up really represents only 30 to 40 percent of revenue potential.

Because most syndicated programs today contain some barter time, barter can be problematic. Some stations embrace barter so they don't have to spend real money. Others dislike it because commitments to many shows with heavy barter loads means significantly less time for the station to sell, hence less revenue. A typical barter deal could result in as much as half of the commercial inventory not being available to the station to sell. Also, they may not want to give their time to a third party to sell, often at lower rates than the station itself is charging because the syndicator is selling many markets as a package.

Regardless of a station's feelings regarding barter, it has no choice whether to pay cash or give up barter airtime for a show. The syndicator determines the payment terms, not the station. The station's only option is whether or not to run the program. If it doesn't like the terms, it doesn't have to clear the show.

Barter and cash-plus-barter are used primarily for the sale of first-run programs and the first syndication cycle of off-network programs because barter is an effective way for syndicators to maximize revenues to fully cover production and distribution costs. Producing first-run shows is generally expensive, and stations are often unwilling to pay sufficiently high license fees for untried first-run programs. However, the syndicator can generally cover production and distribution costs by bartering a program. By combining cash payment and several barter commercials a day in the first syndication cycle of an off-network program, the syndicator can maximize revenue while allowing the station to spend less actual money than if the program were sold for cash only. Older off-network sitcoms, action hours, and dramas are generally sold for straight cash with no barter because production costs have already been covered and demand for these programs is less.

While clearance in every market in the country is the goal, the syndicator must clear (sell the show to) stations in enough markets to represent at least 70 to 80 percent of all U.S. television households. Based on this minimum figure, the syndicator projects a national rating and, using a national cost per point, determines a rate for each 30-second commercial. The syndicator then attempts to sell all the national time in the show to national advertisers at, or as close as possible to, the determined rate. The syndicator tries to clear the show in the strongest time periods on the strongest stations to achieve the highest rating. The ratings from all markets clearing the show are averaged to produce a national rating that will, it is hoped, equal or exceed the projected rating. If the syndicator can get the 70 to 80 percent national clearance, sell all the spots at or near rate card, and deliver the rating promised to advertisers, the syndicator will make money, and the show will stay on the air. If not, the syndicator will likely lose money, and the show may not be renewed.

Although no standardized ratio of national-to-local commercial time exists, half-hour shows typically range from 2 minutes national/4 minutes local (generally expressed as 2:00N/4:00L) to as much as 3:30N/3:30L. Hour-long shows typically contain from 5:00N/7:00L to as much as 9:00N/5:00L. A one-hour cash-plus-barter program would typically be cut from 2:00N/12:00L to 3:30N/10:30L, plus the cash payment. The amount of national barter time the syndicator can withhold depends on the perceived demand for and strength of the program and the ability of the syndicator's station sales force.[7]

CABLE AND SYNDICATION

Syndication is the distribution of programs through a syndicator (distributor) to many users, typically broadcast stations. This process is analogous to a newspaper features syndicate that distributes national columns ("Ann Landers") or comic strips ("Peanuts") to hundreds of newspapers. Thus, syndication does not include cable networks, and "cable syndication" is a contradiction in terms.

However, broadcast syndicators have found cable networks to be a ready and growing market for programs. Instead of sending a large sales force to call on three to eight stations in each of 211 local markets to sell a program in syndication, that same program could be sold to a national cable network in a single deal, sometimes at prices approaching what might be made in broadcast syndication. And sales staff salaries and travel expenses would be saved.

More recent and vintage off-network programs, not to mention new and continuing first-run programs, are available than can be fit into traditional broadcast station schedules. The huge supply of programs and reduced demand have created a cable aftermarket. Cable networks quickly snapped up hit off-network shows (for example, USA's *Wings* and *Murder, She Wrote*) and vintage programs (Nickelodeon/Nick at Nite's *I Love Lucy*, *Bewitched*, and *The Mary Tyler Moore Show*). Syndicators also find basic cable a competitive marketplace for feature films after their pay-cable and network exposure and before broadcast syndication.

Simultaneously, programs created expressly for cable have found their way into broadcast syndication. Some programs made the transition to broadcast television directly (without being reshot), as in *Brothers*, whereas others were produced anew for syndication (*Double Dare*) or even network airing (Fox's *It's Garry Shandling's Show*).

Inevitably the once-rigid relationships of syndication, broadcast television, and cable will continue to evolve with new and evermore innovative marketing schemes. Just when everybody thinks they understand how the business works, someone invents a better (or at least different) mousetrap.

WHERE IS BROADCAST SYNDICATION GOING?

Broadcast syndication is a rapidly changing business. Headlines in trade publications frequently herald new and innovative syndication deals. Although it is speculative at best to imagine how the industry might look by the next century, several scenarios are plausible.

1. Innovative deal structuring. As the financial stakes get higher and competition becomes more fierce, syndicators and stations alike will become more and more creative in their deal making. Syndicators will make offers more attractive to stations while simultaneously finding new ways to increase revenue to their own bottom line. This may involve barter, payout, additional daily or weekend runs, sharing use with cable, cofinancing with station groups, hiatus periods, and ancillary revenue sources. Deal structure will be limited only by the ingenuity of the participants and will be driven by the need to maximize profits for both syndicators and stations.

2. Cost control. Stations and syndicators are continually striving to manage costs. The days of heady economic growth and comfortable profits of the 1970s and early 1980s seem only a pleasant memory in the 1990s. In the wake of new competition from cable and the softening of the world economy, costs must be controlled. Therefore, whether in deal making, station operation, or expansion of facilities or staffs, broadcasters and syndicators alike share a common goal: the need for efficiency, streamlining, mutually beneficial dealing, and utilizing all assets.

3. Consortiums/coproduction/coventures. All these terms mean much the same thing: Station groups and syndicators are increasingly finding new and exciting ways to work together as partners. Spurred by tough economic times and the

need to control costs, station groups and syndicators can share costs and risks and, perhaps, profits. Station groups will continue to join forces with one another in noncompeting markets to develop and launch first-run programs to meet specific station needs. Increasingly, syndicators will join in these coventures. Because stations will hold an equity position in some shows, these shows will probably gain some extra promotion and perhaps be given a longer time on the air to prove themselves. In other words, coproduced shows will get a good shot at succeeding (*if* the audience likes them!).

4. Cable. Increasingly, programs created for original telecast via one delivery system are finding their way to another: over-the-air to cable and vice versa; network to either broadcast syndication or cable; cable to syndication; cable to foreign; foreign to domestic syndication. These criss-crossing paths already exist, and the separation of network/syndication/cable is now blurring. As cable has grown and solidified its economic base, syndicators have played to that strength. This trend should accelerate. Now cable and broadcast, traditional adversaries, have formed coventures that will benefit both. Just as politics make strange bedfellows, so too do the economic needs of the television industry.

5. Increasing role of reps. Programmers at station representative firms will play an even greater role in the syndication process. As costs escalate and programming decisions become riskier, the rep programmer's expertise becomes more valuable. To control costs, many stations have eliminated the program director position and are using rep programmers instead. This trend is likely to continue.

6. Increasing role of networks. With the demise of the FCC's financial and syndication rules, the networks are starting to get actively involved with the production of syndicated shows. Although it is too soon to tell, many expect the prime access period (7–8 Eastern) to attract more off-network programs now that the Prime Time Access Rule (PTAR) is gone. First-run game shows and magazine formats may have outlived their protected existence in the top 50 markets. Increased competi-

tion for hit off-network programs will affect the price for these shows. Oddly, in 1996 twelve of the Fox-owned stations signed on with Columbia TriStar Television Distribution to create its new game show hour, *The Dating/Newlywed Hour,* based on the hit game shows from the '60s and '70s.

Just as the children and teenagers of the 1950s and 1960s grew up watching *I Love Lucy, The Flintstones,* and *The Brady Bunch,* so too the next generation is finding enduring favorites in *The Cosby Show, Cheers,* and *Married . . . with Children.* Television shows are valuable assets that can enjoy a long economic lifespan. Old favorites in broadcast syndication continue to play and play and play. And the needs of cable have extended the life of many seemingly lesser programs. The Peter Allen song holds especially true for syndication: "Everything old is new again!"

SUMMARY

The key players in the domestic syndication process are the syndicators (distributors) who license syndicated programs to local television stations and cable networks. Station general managers or program directors negotiate with the syndicators in competition with other stations in the same market for the local-market broadcast license to a show. Rep programmers advise client stations on programming decisions. Programmers consider the need of the station for the program, the fit of the program in the station's current or future program schedule, and the competitive picture in the market, including the likely impact if a competing station were to purchase the program. Among other factors, the programmers must consider program type, price per episode, number of episodes, scheduling restrictions (if any), down payment, payout, runs, and start date. Syndicators and programmers alike rely heavily on research data to influence purchase decisions. Personal computers are essential for analyzing Nielsen ratings data. Program

sales may be negotiated or bid, and a program's cost may be amortized using the straight-line or declining-value method. Producers usually make programs because of their enormous revenue potential from domestic and international syndication, and the syndication process involves hundreds of millions of dollars annually across the United States. Broadcasters' and syndicators' need to contain costs had led to trends such as innovative deal structuring, coproducing and coventuring, cable syndicating, and larger roles for rep programmers.

SOURCES

Broadcasting & Cable, weekly.

Brotman, Stuart N. *Broadcasters Can Negotiate Anything*. Washington, DC: National Association of Broadcasters, 1988.

Cablevision, twice-monthly, 1975 to date. Denver, CO: Diversified Publishing Group (Capital Cities/ABC).

Getting What You Bargained For: A Broadcaster's Guide to Contracts & Leases. Washington, DC: National Association of Broadcasters, 1989.

Variety, weekly.

Webster, James G., and Lichty, Lawrence W. *Ratings Analysis: Theory and Practice*. Hillsdale, NJ: Lawrence Erlbaum, 1991.

NOTES

1. When is an infomercial not a television program? Apparently the issue is complicated. In the dispute between Leeza Gibbons and Paramount, it was debated whether her infomercial was a television program, a commercial, or a hybrid. Gibbons contended that her contract with Paramount allowed her to do commercials but not other television programs without the studio's permission. Paramount contended that her infomercial was a program, presented in a talk show format. Regardless of the actual outcome of that case, the status of infomercials is still unclear.

2. Satellites have had an impact on news-gathering practices, making possible a great proliferation of specialized news-agency services. Group W, for example, operates The Newsfeed Network, which delivers current news, sports, and weather material to subscribing stations. Conus Communications, a subsidiary of group-station owner Hubbard Broadcasting Inc. (one AM, one FM, six television), bypasses the large national and international video news agencies by enabling individual station-satellite linkages for news distribution. Thus, Conus helps stations achieve their own unique coverage of distant news and sports events, either as individual contracting stations or as parts of ad hoc groups.

3. A few shows move the other direction. The game show *Remote Control* went from cable to broadcast syndication, the first of a new stream of programs for the syndication market.

4. Cox Broadcasting, which already owns two television station rep firms, TeleRep and Harrington Righter & Parsons, acquired yet a third, MMT Sales, Inc., in 1995. TeleRep has annual billings of about $1 billion. MMT bills around $300 million annually, and HRP is at about the $450 million mark. Also in 1995, the number three rep firm, Petry Television, negotiated to purchase the number four rep firm, Blair Television. Blair bills about $650 million, and Petry approximately $1 billion. These two deals are yet another step in the consolidation of TV rep firms that began in 1992 when Katz started it all by acquiring Seltel. See *Broadcasting & Cable*, 18 September 1995, p. 11.

5. Avoiding an in-person pitch to reps generally has the advantage, in cases where the rep is negative toward the program, of minimizing the strength of the rep's recommendation to stations. Opinions tend to be stronger about shows that have been evaluated firsthand. Reps eventually see pilots or sample tapes of all shows their client stations are interested in, but delay sometimes works to the temporary advantage of the syndicator.

6. In the early 1990s, stations became more cautious about bidding because of competition for off-network shows from cable networks. Mike Freeman, "What Price Comedy?: Tracking Off-Net Trends," *Broadcasting*, 1992 November 16, pp. 30–34.

7. Barter splits may vary widely, even among essentially similar programs. For example, *Geraldo*, *Jerry Springer*, *Oprah*, and *Jenny Jones* are all cash-plus-barter one-hour talk show strips, but the national/local barter splits are quite different, with *Jenny Jones'* syndicator having almost twice as much national time to sell as *Geraldo*'s distribution company: *Geraldo* 2:00N/12:00L; *Jerry Springer* 2:30N/12:00L; *Oprah* 3:00N/11:00L; *Jenny Jones* 3:30N/10:30L.

PART TWO

Broadcast Television Strategies

In the 1950s, broadcast television forced radio out of its leading position; eventually, radio found its more specialized programming niches. Later, cable copied many broadcast television strategies. The television chapters come before cable and radio in this book because broadcast television dominates the audience's and industry's thinking about programming. Because of the huge sums of money involved in television programming decisions, the commercial television networks and major-market stations set the pattern for the rest of the industry.

Part Two consists of five chapters addressing broadcast television programming, each looking at the main components of programming strategy—*evaluation, selection,* and *scheduling*—in a specific milieu. The first two chapters consider network programming, and the last three chapters look at station practices. As the programming strategies of the four full-service commercial broadcast television networks—ABC, CBS, Fox, and NBC—differ more by time of day than they do from network to network, the first two chapters in Part Two subdivide programming by daypart rather than by network. The next two chapters analyze program strategies for network affiliates and independent stations, the latter including Fox, UPN, and WB affiliates. They also discuss the influence of market

size. Markets ranked 1 to 25 by the ratings companies are the large markets, 26 to 100 are the mid-markets, and 101 to 211 are the small markets. The final chapter looks at noncommercial television and the kinds of programming strategies employed by public television programmers.

Chapter 4, the first chapter in Part Two, examines the high-visibility entertainment of **network prime-time programming.** This time period generates most of a network's image in the public eye, and prime-time ratings define a network's commercial value in the minds of advertisers. Chapter 4, therefore, has special importance. The authors cover the theories behind program scheduling and the competitive strategies the four national networks use in pilot selection, program renewal, and cancellation. They look at the distinctive program acquisition and scheduling styles of the networks and the functions of fall premieres and summer schedules. This chapter also contains an analysis of recent trends in program genres, including sitcoms, specials, spinoffs, sports, reality shows, and movies. The authors look carefully at costs for prime-time entertainment programs.

Chapter 5 deals with **nonprime-time programming.** The authors consider program acquisitions and ratings for early morning, daytime, late night,

97

and weekend network programs. They analyze the constraints operating on network news and the major nonprime-time formats of all four broadcast networks—talk shows, soap operas, game shows, children's programming, evening newscasts, and weekend sports and public affairs—describing the importance of time clearances, parity, and targeted program demographics. The authors look at program development and scheduling for each genre and competition among the established networks. Chapter 5 provides an insider's perspective on commercial network television programming for the nonprime-time dayparts.

Chapter 6, one of the station-oriented chapters, deals with **network affiliate programming.** Affiliates have traditionally dominated television in ratings and revenue. Of the nearly 1,600 commercial television stations (1,542 in 1996), the network affiliates typify television in the eyes of the general public. (Fox, UPN, and WB affiliates are considered in the next chapter because Fox supplies largely one daypart, prime-time.) Viewers associate network names more than station call letters with affiliates because the Big Three networks air about 14 hours per day of high-visibility network programming, leaving few hours in which to develop local identities. In Chapter 6, the author introduces the professional programming language station managers and programmers use, writing from the viewpoint of major and mid-sized market affiliates and spelling out the competitive options for the station programmer for each daypart.

Chapter 7 looks at programming strategy primarily from the vantage point of **independent stations** competing head-to-head with network affiliates for audiences and advertising revenue. Chapter 7 shows that once independents became truly competitive in the 1980s the larger stations adopted many of the scheduling strategies and positioning practices of network affiliates, while still filling more nonnetwork time by showing syndicated and

local programs or by affiliating with a shop-at-home or other network. The authors deal with strategies for bargaining for program futures and barter programs and selecting syndicated shows and movies. They analyze local production options and discuss the management troika of programming, sales, and research. The authors also comment specifically on the skills newcomers need to become programmers. The options described in this chapter apply to mid-sized and large-market UHF and VHF independents, including such giants as superstations WGN and WWOR.

Chapter 8 turns to the perspective of the **public television station.** The authors examine the philosophical contradictions inherent in public broadcasting and trace the changes over the decades to the emerging education-oriented philosophy of today. In Chapter 8 the responsibilities of the Public Broadcasting Service and the pressures operating on the network are described. The authors look at the sources PBS can draw on for programs and how the national schedule of satellite-delivered programs is now achieved. They illustrate the ways national commercial ratings are adapted to meet the purposes of public broadcasting. Public television's audience characteristics are discussed in light of its philosophical goals and financial needs, raising controversial issues affecting noncommercial programming and showing how economic pressure is forcing public broadcasting to make use of many commercial strategies. The authors also analyze how public station programmers learn about their audiences and describe the various program resources used by public station programmers. Chapter 8 concludes by returning to the topic of changing perspectives on the future role of public television.

Part Two, then, covers the specifics of broadcast television programming. It focuses on evaluating, selecting, and scheduling programs from the separate perspectives of networks and television stations.

Chapter 4

Prime-Time Network Television Programming

William J. Adams
Susan Tyler Eastman

PRIME-TIME NETWORK AUDIENCES

The economics of the 1990s have led some to believe that broadcast television networks may go the way of big-time radio programming, national general interest magazines, and competing urban newspapers. At the start of the decade, the broadcast networks faced a shaky future. Alvin Toffler succinctly said:

Twenty years ago three television networks, ABC, CBS, and NBC, dominated the American airwaves. They faced no foreign competition at all. Yet today they are shrinking so fast, their very survival is in doubt.[1]

The mid-1990s represented a period of extreme instability within the traditional broadcast network structure. In 1994 RCA introduced the mini-satellite dish. That same year both Paramount and Warner Brothers followed the Fox lead and started their own broadcast networks. Their offerings during that first year were limited to a total of only three nights a week, and they ended the season by canceling all but one (*Star Trek: Voyager*) of their shows. Their entry, however, did signal the next step in competition, with more and more over-the-air networks entering the fight for affiliates, resulting in fewer and fewer truly independent stations. Disney discussed starting its own broadcast network, but then turned around and bought ABC in 1995 for $19 billion. Within a week, CBS had also been sold. Westinghouse paid $5.4 billion for the troubled network. At the same time, the FCC relaxed its station ownership rules to allow any network to buy enough stations to reach one-third of the U.S. public. The FCC then relaxed even that standard to allow the major networks to go as high as 35 percent of the population and issued a special waiver to Rupert Murdoch allowing him to buy stations even though the majority of his Fox network was owned by foreign citizens.

By the 1995–96 season, only two points separated first place NBC from third place CBS in the overall ratings, a statistically small difference. Moreover, some critics even suggested that the

VCR was the real number two network in the United States.[2] If that was not enough, production costs for television skyrocketed. In 1993 *Variety* even stopped listing the fees the networks were paying, although in 1994 *Broadcasting* magazine estimated an average cost of $1.4 million per prime-time hour. Worse yet, affiliates were becoming more and more willing to preempt network programming for local sports and original syndicated series such as *Legendary Journeys of Hercules*, *High Tide*, *Babylon 5*, and *Space Precinct*. But, as can be seen in 4.1, while the rating losses the Big Three networks had been suffering since 1976 continued, the rate of decline had slowed dramatically by 1994. The slide was bottoming out, even in the face of new broadcast network competition.

The buying frenzy following the FCC's relaxation of ownership rules in 1993 caused station prices to skyrocket and resulted in unprecedented instability in affiliations as networks bought new stations or negotiated deals with more powerful ones in markets all across the country. In such an unstable climate, how network programmers reacted and what they decided to offer could be the difference between network failure and survival.[3]

Network television's visibility makes it an inviting target for critics. Its national popularity focuses public attention on its strengths and weaknesses. Of the approximately 21,000 hours the six commercial networks program yearly, about one-fifth is singled out for special critical attention—the nearly 90 hours of prime-time programming each week. That figure, multiplied by 52 weeks, equals about 4,500 hours of prime-time network programs a year provided by ABC, CBS, NBC, Fox, UPN, and WB.

From the 1950s to the present, the main viewing year has periodically contracted until it now consists of about 40 weeks, usually running from late September to the end of May. The remaining 12 weeks (off-season) occur in summer. Audience ratings throughout the day are important to the networks, of course, but ratings in the prime-time hours are absolutely vital. *A failure in prime-time programming may take years to remedy.*

4.1	AVERAGE NETWORK RATING FROM SEPTEMBER TO MAY, 1980 TO 1996					
Year	ABC	CBS	NBC	Fox	WB	UPN
1980–81	18	19	17.2			
1981–82	17.7	18.5	15.2			
1982–83	16.6	17.7	14.5			
1983–84	16.2	16.8	14.5			
1984–85	15	16.5	15.8			
1985–86	14.3	16	17.1			
1986–87	13.6	15.4	17.1			
1987–88	12.7	13.4	15.4			
1988–89	12.6	12.3	15.4			
1989–90	12.9	12.1	14.5			
1990–91	12	11.7	12.5	6.1		
1991–92	12.2	13.8	12.3	8		
1992–93	12.1	12.9	12	8.1		
1993–94	12.1	11.7	10.3	7.1		
1994–95	11.7	10.8	11.5	7.1	1.9	4.1
1995–96	10.5	9.6	11.6	7.3	2.4	3.1

Note: The Fox network started broadcasting before 1990, but for the first few years its ratings were not considered worth publishing by magazines like *Broadcasting & Cable* or newspapers like *Variety*. However, trade reports suggest that its numbers were very close to those achieved by UPN, the Paramount network, during its first year.

The 22 prime-time hours—from 8 P.M. to 11 P.M. (EST) six days each week and from 7 P.M. to 11 P.M. on Sundays—constitute the center ring for all networks, the arena in which their mettle is tested. Fox programs about 14 hours on six nights of the week, competing head-to-head with the older networks. In 1996 UPN and WB each programmed about 6 hours of prime-time on three nights each week. Prime-time programs are the most vulnerable part of the network's schedule because low ratings in these valuable hours lead to devastating losses in advertising revenue. Also in 1996, the networks could charge about $400,000 or more for a 30-second spot in a top-rated series like *Home Improvement*, while a bottom-rated series like the Fox network's *America's Most Wanted* raised only $50,000 per spot.[4] Both *advertisers and networks expect the highest return from prime-time hours.* Indeed, with production costs for an average hour of prime time running around $1.4 million (1995 dollars), anything less would seldom be tolerated.

Ideal Demographics

Some advertisers are interested mainly in tonnage—the sheer, raw size of an audience, as measured by the ratings for a program. This scattershot approach, aiming at all ages and both sexes, best suits advertisers of soaps, foods, over-the-counter drugs, and other general use products. Other advertisers prefer targeting a specific segment of the audience by its **demographics** (age, sex, education, and so on).

Demographic measurements have been part of broadcast ratings since the 1960s, but Paul Klein of NBC, with the support of Mike Dann of CBS, introduced the concept of **ideal demographics,** the theory that all prime-time programming should aim at one young female consumer segment of the audience. This ideal segment, the programmers claimed, both controls most consumer purchasing and succumbs most easily to televised advertising messages.[5] This shift toward a younger, more urban audience deliberately aimed network programming at the major population centers, closer to the coverage area of the network owned-and-operated stations and farther away from the more thinly populated rural markets where the networks had no direct ownership interests.

The network heads of research continue to claim the same group of viewers (the single largest group) as the audience ideal; the group simply ages as the baby-boom generation grows older. By 1996 it consisted of urban women, ages 34 to 44 (all races). Critics, however, argue that there are more people in the other demographic divisions than in the so-called ideal group, so any network or advertising campaign concentrating solely on an ideal demographic could lose more audience than it would attract. Indeed, an excessive emphasis on youthful female viewers may have contributed to the erosion of broadcast network audiences during the 1970s and was producing a severe "gender gap" between male and female viewers by the end of the 1980s. Research also shows that targeting the ideal group led to a decline in program variety and much complaint about the "sameness" of programs on all three networks.[6] Moreover, the Fox network capitalized on this growing dissatisfaction by deliberately targeting younger male demographic segments that the other networks were ignoring. Most cable networks also go after alternate audiences by programming for demographic niches.

An alternative to demographic targeting is **psychographics,** or lifestyle research, which analyzes audiences in terms of their likes/dislikes, political and social attitudes, hobbies, consumption habits, and so on. But gathering psychographic information is extremely expensive.

Moreover, the results are often difficult to interpret and generalize. In the 1980s, marketing firms combined easily gathered demographic information with product purchasing data (from bar code scans) to create distinct lifestyle divisions. The widespread popularity of marketing tools drawing on such marketing data helped force the broadcast networks to switch from the traditional rating methods to peoplemeters in 1987. As explained in Chapter 2, the peoplemeter is designed to keep track of an individual's television viewing (as did the legendary "black box" passive meter patented by Nielsen) while also recording the viewer's demographics, which the black box did not capture. (See 4.2 for more on the peoplemeter.)

Least Objectionable Programming

Unfortunately, aside from their ability to attract viewers, the quality of programs has rarely seriously concerned most advertisers—at least not enough to affect their practices. There are notable exceptions. A select roster of advertisers (Kraft, Hallmark, IBM, and Xerox, for example) has insisted on prestigious programs as vehicles for their advertisements and therefore has tended to sponsor entire programs, rather than merely buy participating spots. In contrast, most advertisers care little about program quality, seeking only vehicles for reaching appropriate markets for their products.

Indeed, some advertising studies have suggested overly strong audience support for a program may actually be undesirable, because excessive program loyalty may interfere with the advertising message. Prime-time network television traditionally strives to provide the largest possible audience (overall or within a demographic group), not necessarily the most satisfied audience. Many programmers believe that prime-time series that generate strong reactions among viewers may in fact split the audience into two groups: those that "love" and those that "hate" a show. A show that generates only moderate liking, but is hated by no one, may get the biggest audiences.

NBC programmer Paul Klein called this idea the theory of **least objectionable programming**

4.2 PEOPLEMETER RESISTANCE

Part of the resistance to the peoplemeters came from greater than anticipated problems with the national peoplemeter service installed by Nielsen in 1987. Almost 40 percent of the people approached to participate in the national sample refused to allow the meter in their homes. While the peoplemeter was designed to overcome major sampling errors in the traditional diary system for recording demographic information, the new methods seem to have introduced as many problems as they solved. For example, the introduction of the meter system on a national level resulted in an across-the-board 2-point drop in prime-time ratings and indicated major shifts in the demographic makeup of the audience. Children and people over 50 almost disappeared, while young men and better educated, upper-middle-class viewers increased. Prime-time soap operas suddenly lost an average of almost 2.5 rating points, while reality-based series, such as *Rescue 911* rose by about 2 points. Even worse, the networks were not all affected evenly. Most cable networks gained in the ratings, while ABC's average rating remained virtually unaffected. CBS dropped almost 3 points, and NBC dropped more than 2 points.[7] It is unlikely that the audience changed so much in just one year. It is more likely that the change in method was the cause of the apparent shift in the audience. These drastic ratings swings led to a great deal of fighting within the industry among advertisers, programmers, and the ratings services, depending on who made and lost money as a result of the changes. This fighting seems destined to result in further changes in the way ratings are gathered during the 1990s.

(LOP). He assumed that viewers of the networks would choose the program that created the least outcry among others in the room, whether anyone actually liked the program or not. LOP has been a major consideration in prime-time programming since the early 1960s and was reaffirmed as late as 1991 by executives from all major networks.[8] The difficulty with the theory today is that it assumes a limited number of program options for viewers.

By 1995 most Americans had six commercial broadcast networks and several independent stations from which to choose. Also, cabled homes had an average of 40 or more channels, with the new RCA mini-dish direct-broadcast-system (DBS) offering more than 100 channels. Fiber optic technologies were expected to offer more than 150 channels of high-definition digital programming by the end of the decade or sooner. Moreover, three-quarters of homes had VCRs, and about 90 percent had remote controls. Under conditions of vastly increased program supply, prime-time programmers face the difficult task of satisfying advertisers' demands for large, well-defined audiences and viewers' demands for programs they really want to see. These conditions have forced the broadcast networks into increased targeting of specific audience segments. The least objectionable program theory became progressively untenable as viewing options increased.

RATINGS

Regardless of whether an advertiser wants sheer tonnage or a specific audience segment, commercial spot costs depend mainly on the absolute ratings (total estimated audience) of the programs in which the commercials occur. A television advertiser, in contrast to an advertiser on a format radio station, must pay for all viewers, whether or not they fall within the desired target audience. Program ratings alone determine the cost of a commercial spot.

However, ratings lack precision. As pointed out in Chapter 2, network ratings *estimate* the number of viewers on the basis of viewing by 5,000 cooperating families representing 95.9 million television households. It is very unlikely that estimates are exactly right. In fact, statisticians sometimes claim

that no substantial difference exists between the fifth-rated and thirtieth-rated shows in prime time; the differences in their ratings could be due to nothing more than inevitable sampling errors. But because advertisers (and ad agencies) have agreed to base the price of a commercial spot on the absolute rating numbers, they ignore their inability to measure small differences. A program with an 18.5 rating will generate millions of dollars more in advertising revenue over the course of a season than a program with an 18 rating, even though the difference between the two is probably statistically meaningless.

The treatment of ratings as absolute numbers by both advertisers and networks has led to fights over unmeasurable fractions of a ratings point and demands for more measurements, produced more often. These demands have led to ratings being reported in a number of different ways. For prime-time programming, the most common of these are the sweeps, overnights, pocketpieces, and MNA reports.

Sweeps and Overnights

Four times each year (November, February, May, and July) a highly controversial rating event occurs—the sweeps. The sweeps use a diary system (and mixed diaries and meters in some markets) to gather ratings, shares, and demographic information for local television stations and for 19 cable networks. The results of sweeps ratings, particularly the November and February periods when audience viewing levels are at their highest, directly affect the rates these cable networks and local stations (including network-affiliated and network owned-and-operated stations) charge for advertising time.

The stations, therefore, demand that the networks display their highest quality merchandise during the sweeps periods to attract the largest possible audiences and maximize ad revenues. The practice of **stunting** (the deliberate shuffling or preempting of the regular schedule for specials, adding celebrity guests and extraordinary hype) makes the four sweeps periods, especially Novem-

ber and February, highly competitive and, at the same time, not always the most valid indicators of a network's or station's real strength.

As described in Chapters 2 and 3, national ratings take several different forms. Aside from the sweeps, the **overnights** (available only in the biggest cities) are the most avidly monitored of ratings data. Overnights, gathered through a set of peoplemeters located in major cities, only take into account ABC, CBS, NBC, and Fox (although overnight information drawn from a national peoplemeter sample is available for purchase for about a dozen major cable networks).

The overnight ratings are used to monitor overall urban audience reaction to such "program doctoring" as changes in casts, character emphasis, and plot line. The overnights also indicate immediately whether a new program has "taken off" and captured a sizable audience in the urban markets. Advertising agencies make predictions about specific shows that become the basis of ratings expectations (and sales rates).

For example, *The Nanny* was predicted to get a share of 14 but actually got a 20, thus making it a hit, even though its ratings were not high compared to many other new series. Continued low ratings in the overnights during the first few weeks of a newly introduced program's run spells cancellation unless the ratings show a hint of growth—or unless the program is expected to have stronger rural appeal. *Matlock* was canceled by NBC but picked up and run successfully by ABC, which argued that it had a strong rural appeal not represented in the city-based overnight ratings.

Sometimes international appeal is a factor in letting a show build an audience. For example, *Lois & Clark* was only a moderate rating success for ABC, losing every week to *Murder, She Wrote*, but it was a huge international success. Thus, *Lois & Clark* stayed on while *Murder, She Wrote* was moved. Such examples demonstrate the inability of programmers to tell to whom a program will actually appeal despite the predictions and expectations of advertisers and the availability of network ratings data. See 4.3 for further discussion of this issue.

4.3 ADVERTISING DECISIONS

In the early days of television, companies owned the programs they placed their advertisements in, but in the late 1950s that changed. Now there is little direct connection between the advertisers and the media. Decisions are usually made by advertising agencies acting for companies. They base their decisions mainly on ratings and demographics. However, about 80 percent of the advertising in prime-time television is actually purchased in late spring and early summer before the season begins. This process is called "upfront buying" and determines the economic condition of the media for the next year. However, as the buying is done in May or June and the shows don't actually run until September or October, there are no real rating, share, or demographic numbers available at the time of purchase. Decisions are made on the basis of what the network is willing to guarantee and what agencies predict a program will do. If the network's guarantees are not met, the network must run makeup advertisements for free until the promised number of rating points is met. If the numbers are better than the guarantee, the advertiser gets a bargain. Therefore, agencies are always looking for shows they feel will do better than the networks think, and the networks are not willing to hold onto any show that is doing worse than their guarantee.

The question is, how good are the predictions? While network guarantees are considered proprietary information and thus seldom released to the public, agency predictions are often released (even though the formulas used to obtain those predictions are closely guarded secrets). The following list shows 20 programs, 10 established and 10 new, for the 1994–95 season. The first number shows what agencies predicted the program would get four months before it actually went on the air, back in May 1994, and the second number shows the actual share of the audience it received.

Established Series	Predicted Share	Actual Share	New Series	Predicted Share	Actual Share
Home Improvement	32	32	E.R.	20	31
Northern Exposure	22	21	Due South	15	19
Beverly Hills, 90210	17	20	Cosby Mysteries	20	18
Fresh Prince of Bel Air	19	17	Touched by an Angel	9	14
Blossom	19	17	McKenna	15	11
Picket Fences	18	20	Chicago Hope	19	17
Diagnosis Murder	17	20	New York Undercover	12	12
Seaquest DSV	14	16	Models, Inc.	14	12
NYPD Blues	25	28	Friends	20	21
Wings	17	21	Dateline NBC (Wed.)	16	15

Pocketpieces and MNA Reports

The ratings report of greatest interest to the creative community is published every other week in a small booklet known as "The Nielsen Pocketpiece." It comes from the 5,000 national people-meter households selected to match census demographic guidelines for the entire country. While this information is only published every other week, these data are available to Nielsen subscribers through a computer data bank on a next-day basis. This data bank provides, upon request, data not only for the four major broadcast networks but also for about a dozen of the major cable networks. Normally, cable ratings appear only in a

4.4 POCKETPIECE PAGE

A-16 *Nielsen* **NATIONAL TV AUDIENCE ESTIMATES** **EVE.SUN. MAR.26, 1995**

TIME	7:00	7:15	7:30	7:45	8:00	8:15	8:30	8:45	9:00	9:15	9:30	9:45	10:00	10:15	10:30	10:45	11:00	11:15
HUT	54.8	57.1	58.7	61.2	62.9	64.1	64.7	65.2	64.0	63.7	62.7	62.1	60.7	59.4	57.9	55.5	48.8	42.5

ABC TV

AMER.FUNNIEST-HOME VIDEOS | AMER.FUNNIEST-HM VIDEOS 2 (R) | ←LOIS & CLARK—THE NEW ADVENTURES OF SUPERMAN→ | ←ABC SUNDAY NIGHT MOVIE—SLEEP, BABY, SLEEP (PAE)→

HHLD AUDIENCE% & (000)	10.5	10,020	12.3	11,730	12.0	11,450			12.0	11,450								
TA%, AVG. AUD. 1/2 HR %	13.3		14.4		16.0	11.3*	12.7*	18.7	11.3*		11.8*	12.3*	12.8*					
SHARE AUDIENCE %	19		21		19	18*	20*	20	18*		19*	20*	23*					
AVG. AUD. BY 1/4 HR %	9.9		11.2		11.9	10.9	11.6	12.5	12.9	11.0	11.6	11.5	12.0	12.3	12.4	12.7	12.9	

CBS TV

←60 MINUTES—(7:06-8:06)(PAE)→ | ←MURDER, SHE WROTE—(8:06-9:06)(R)(PAE)→ | ←CBS SUNDAY MOVIE—THE OTHER WOMAN (9:06-11:06)(PAE)→ | CBS SUNDAY NEWS (11:06-11:21) (PAE)

HHLD AUDIENCE% & (000)	17.7	16,890			14.3	13,640		11.9	11,350							0.7	670	
TA%, AVG. AUD. 1/2 HR %	25.3	16.1*	18.7*	18.7	14.1*	14.3*	19.3	11.3*	11.7*	12.0*	12.2*	0.7						
SHARE AUDIENCE %	30	29*	31*	22	22*	22*	20	18*	19*	20*	21*	2						
AVG. AUD. BY 1/4 HR %	15.5	16.5	18.4	19.0	14.4	13.9	14.0	14.5	11.3	11.3	11.8	11.7	11.8	12.1	12.3	0.7	0.6	

NBC TV

←EARTH 2→ | ←NBC SUNDAY NIGHT MOVIE—BACKDRAFT (R)→

HHLD AUDIENCE% & (000)	6.7	6,390			11.7	11,160			11.9	11,350								
TA%, AVG. AUD. 1/2 HR %	9.7	6.4*	7.1*	25.1	9.8*	11.0*	11.7*	12.7*	12.8*	12.4*								
SHARE AUDIENCE %	12	11*	12*	19	15*	17*	18*	20*	21*	22*								
AVG. AUD. BY 1/4 HR %	6.2	6.6	6.8	7.4	9.4	10.3	11.0	11.0	11.6	11.8	12.6	12.7	12.8	12.7	12.8	12.1		

FOX TV

←ENCOUNTERS—(R)→ | SIMPSONS (R)(PAE) | CRITIC | MARRIED...WITH CHILDREN | TALES-CRYPT PRIME

HHLD AUDIENCE% & (000)	3.4	3.240			8.1	7.730	6.8	6,490	9.5	9,060	6.4	6,110
TA%, AVG. AUD. 1/2 HR %	6.1	3.3*	3.5*	10.2	8.3	11.5	7.5					
SHARE AUDIENCE %	6	6*	6*	13	10	15	10					
AVG. AUD. BY 1/4 HR %	3.2	3.4	3.3	3.7	7.3	8.9	6.9	6.7	9.1	9.8	6.5	6.3

INDEPENDENTS
(INCLUDING SUPERSTATIONS EXCEPT TBS)

	7:00	7:30	8:00	8:30	9:00	9:30	10:00	10:30	11:00
AVERAGE AUDIENCE	6.2	6.7	5.7	5.8	5.4	6.1	10.8 (+F)	8.3 (+F)	6.9 (+F)
SHARE AUDIENCE %	11	11	9	9	9	10	18	15	15

PBS

	7:00	7:30	8:00	8:30	9:00	9:30	10:00	10:30	11:00
AVERAGE AUDIENCE	1.2	1.2	3.0	3.7	4.1	3.9	2.7	1.9	1.7
SHARE AUDIENCE %	2	2	5	6	6	6	5	3	4

CABLE ORIG.
(INCLUDING TBS)

	7:00	7:30	8:00	8:30	9:00	9:30	10:00	10:30	11:00
AVERAGE AUDIENCE	14.7	14.3	14.9	15.2	14.9	14.7	13.4 (+F)	12.7 (+F)	11.0 (+F)
SHARE AUDIENCE %	26	24	23	23	23	24	22	22	24

PAY SERVICES

	7:00	7:30	8:00	8:30	9:00	9:30	10:00	10:30	11:00
AVERAGE AUDIENCE	2.9	2.7	3.3	3.6	4.1	3.6	4.0	3.3	3.1
SHARE AUDIENCE %	5	4	5	6	6	6	7	6	7

U.S. TV Households: 95,400,000 For explanation of symbols, See page B.

Source: Reprinted by permission of Nielsen Media Research.

separate cable report that provides cumulative rather than per episode ratings. These cumulative numbers cannot be compared to the broadcast numbers.

At present, Nielsen is handling almost 1,300 computer requests for these data each month, indicating that this service may eventually replace or diminish the importance of the overnights. These data include ratings/shares and the all-important demographics for both prime time and daytime, plus general information such as average ratings by program type, number of sets in use by days and by dayparts, comparison of television usage between the current season and the one preceding, and other details. Unlike the overnights, the pocketpiece provides estimates for the entire nation. The rating and share information is also widely available each week to the public through such publi-

cations as *Variety* and *Broadcasting* (see 4.4 for a sample pocketpiece page).

Programmers also find Nielsen's Multi-Network Area Report (MNA) very useful. The statistics in the MNA cover the 70 leading population centers in the country—all markets with at least three commercial television stations. The 70 markets represent about two-thirds of total television homes nationally, and MNA measurements are compiled from this two-thirds of the national Nielsen sample. The networks use MNA reports to compare the performance of the major networks without the distortion caused by one- and two-affiliate markets included in the national Nielsen reports. MNA reports include the so-essential demographic breakouts.

Audience Flow

Aside from a program's demographics, the networks look for audience flow from program to program. Does the audience continue to the next program? As explained in Chapters 1 and 3, each network hopes to capture and hold the largest possible adult audience, especially from 8 P.M. until midnight or later. Network strategies are usually directed at achieving **flow-through** from program to program in prime-time series. Networks argue that, on average, 4 out of every 10 points in a lead-in program's ratings will flow through to the succeeding program (that is, much of its audience will continue to watch), although this factor grows weaker as the number of program options increase and as the hour gets later. In fact, studies published in 1995 and 1996 indicated there is much less audience flow than in the past.

Is it any wonder, given demographics, rating/share, and audience flow-through considerations, that the selection of ideas to be developed and entered into program lineups seems as risky as the turn of a roulette wheel? (Roulette, however, would pay off more often!) Recent estimates of the aggregate costs of program development for the three networks in a given year are more than $500 million. This staggering sum does not include the overhead costs of maintaining the de-

partments and individuals who make these decisions. The salaries of top programmers reach the six- to seven-figure level, reflecting the substantial rewards for picking a winning schedule.

The entire process of prime-time programming breaks down into three major phases: *deciding to keep or cancel already scheduled series, developing and choosing new programs* from the ideas proposed for the coming season, and *scheduling the entire group.* To understand program evaluation, selection, and scheduling, the changing concept of a season needs to be spelled out.

NETWORK SEASONS

During the 1950s and 1960s, the season lasted a minimum of 39 weeks each year. By the early 1970s, high per episode costs had cut back the usual number of episodes produced for a series to 32, also dropping the usual length of the season to 32 weeks. But further cost increases combined with a high mortality rate forced an end to that pattern, dropping the length of the season to 30 weeks and decreasing episode orders for renewed series to 26 in the late 1980s, falling to 20 or 22 episodes in the early 1990s. In 1996, however, the networks decided to stretch the season to 40 weeks. The number of episodes did not increase.

The networks now contract for just 6 to 10 episodes of new shows, and contracts say "cancelable any time." To fill out some of the 40 weeks of the regular ratings season, another 10 new episodes may be ordered. As the network license fee gives the right to two showings of each episode for the one payment and the networks need to get their money's worth out of every show, the most popular episodes will be rerun once during the year, often scheduled at the end of the first season in December (no ratings then) or between the February and May sweeps. (Weaker episodes are usually rerun in summer.) Specials, miniseries, and limited-run tryouts fill the remaining weeks of the regular season.

In the late 1980s, the networks began taking popular series off the air for six to eight weeks to try out a new series in prime time. March, April, and sometimes August have become tryout months for **limited series** (generally four to six episodes). This off-and-on method of scheduling allows the networks to test a new program under the best possible conditions without interrupting the May sweeps and while saving reruns for the summer months.

Whether this scheduling method improves a new series' chances for long-term success is debatable. New shows usually get highly inflated ratings while in a popular show's time slot, but these ratings seldom hold up the following year when the new show moves into its permanent slot. In consequence, many limited-run series picked up for a second year are quickly canceled when their ratings fail to live up to expectations. In truth, *the majority of new series are in reality limited run experiments.* By 1995, the majority of new programs tried by ABC, CBS, and NBC ran less than eight weeks. Historically, Fox tended to have new series on for as much as a full season, but by 1995–96, even that network was beginning to copy the pattern of fast cancellation and multiple replacements throughout the year.

During the mid-1990s, the networks introduced a new twist to the scheduling pattern by scheduling top rated or very cheap programs more than once a week. This doubling-up practice had been tried in the late 1960s with programs like *Batman* and *Peyton Place*, but was then dropped. Fox started the movement again with double showings of programs like *Cops*, usually scheduling one episode right after another. The other networks quickly picked up on the idea with double scheduling of programs like *Home Improvement*, *Frasier*, and *Wings* (at least for periods of six or more weeks). In 1994 and 1995, NBC surpassed everyone by scheduling *Dateline NBC* three times a week. As no extra episodes were ordered to fill the extra time, this usually forced a program into reruns sooner, leaving big questions about the effects of doubling-up on ratings and the longevity of the shows involved.

Fall Premieres

Traditionally, the networks premiered their new series during a much-publicized week in late September. However, during the late 1970s, the traditional September **premiere week** slowly spread out. By 1994 "premiere week" actually lasted from late August to November, and series premiered in scattershot fashion, usually throughout September and October (and occasionally as early as August or as late as November). This spreading-out is intended to give viewers maximum opportunity to sample each new network show and to accommodate interruptions caused by baseball playoffs and the World Series.

A large number of new network programs, particularly replacement shows, begin their runs in January or February, thus creating a **second season** on the networks. By late fall the fate of most prime-time programs already on the air is clear. Holiday specials usually preempt those destined for cancellation or restructuring, while more popular series go into reruns and special holiday episodes. By January or February the networks are ready to launch their second season—with almost the same amount of promotion and ballyhoo as are accorded the new season premieres in September.

Many programmers now believe these *second season starts are actually better than the traditional first season rush,* as the audience is at its peak and has more realistic expectations following the fall's original episodes than just after a long summer of reruns. As a result, some of the networks strongest new series are now held for the second season. The initial scheduling of programs such as *Coach, The Simpsons,* and *America's Funniest Home Videos* were examples of the mid-year replacement strategy.[9]

In 1974–75, the number of new entertainment series introduced other than at the start of either season (during September/October or January/February) jumped from three to eight. In 1976 they leaped to 16. The number of such introductions continued to climb until by 1983 they equaled the number of new series offered in September (and showed a third peak in March). See 4.8 later in the chapter to trace this evolution.

Odd-month starts are now almost double the number of new series begun in January/February. As a strategy, this is called the **continuous season** approach. The growth of new summer programming, especially on Fox and CBS, may be the natural extension of this programming theory.[10] However, at present, all this juggling has not improved the networks' **success rate** for new programs.

Summer Schedules

Traditionally, in spite of the sweeps held in May and July, the summer was exempt from the ratings race (although networks often hold new episodes for use in May or plan dramatic, cliff-hanger endings during that month). Summer has been an arena for:

- Reruns (often of weak series episodes)
- Tryouts of questionable new series intended for the next fall
- Leftover pilots
- Episodes of never-scheduled or canceled series

The networks' neglect of the summers made them a gold mine for the pay-movie networks and independent television stations.

In the late 1980s, the networks began using March and April, as well as summer, for testing new program ideas in short runs and airing rejected pilots that did not make the fall schedule. (Previously, these pilots would never have been seen by anyone outside the network programming department.) But by the 1990s, costs for program development were so high networks could no longer absorb the expense of the development stages for new shows that never reached air. Running pilots as made-for-television movies and short-run tests of series helped recoup much of their investment. This practice accelerated in the 1990s, partly to recover development costs, partly to counteract audience losses to independent stations and cable, and partly to satisfy affiliated stations worried about the extreme ratings drop during the July sweeps.

Although there are fewer total viewers in the summer, the size of the overall decline in their collective audience share forced ABC, CBS, and NBC to begin budgeting millions of dollars for new summer programming. ABC started the trend in the summer of 1983, and NBC rapidly followed suit. In the 1990s, CBS's *Walker, Texas Ranger*, for example, began in the months once reserved for summer reruns.

Fox further complicated the summer picture when it discovered the summer was a good time to get people to sample series they did not normally watch. The network was able to build an audience for several of its series with summer starts. To take advantage of the "discovery" potential, Fox began heavily promoting its reruns as a "second chance to see what you had been missing." This strategy was sufficiently successful to force the other three networks to pay more attention to their summer schedules. A network can air several episodes of a proposed new series in the summer and gauge audience reactions over a period of weeks without any risk to regular season ratings. With the advent of **summer schedules** and the promotion of reruns as original programming for people who normally watched the competition, the July ratings book took on more importance as a measure of network and pay-cable pull and as a vehicle for pre-fall testing of programs.

Providing original programming for the summer months became a formidable network strategy in 1991 when NBC held up the introduction of its new series *Sisters* until June, and Fox introduced new episodes of *The Simpsons* and *Beverly Hills, 90210* in July. Third-ranked CBS did the most extensive summer programming: It brought Norman Lear back to weekly television with a limited run series, *Sunday Dinner*, which premiered in June; it scheduled Stephen King's first attempt at weekly television, *Golden Years*, to premiere in July; and aired Rob Reiner's first major weekly series, *Morton & Hayes*, for the end of July to run through August. This marked the peak of the practice of trying new series during the summer. Very low success rates caused the networks to back off from this

approach. However, they have not retreated to using only reruns. Summer continues to be a time for specials, pilots, made-for-TV movies, and a few original series episodes that have been held out from the main season. But the period from September to April still has the largest audiences and therefore warrants the networks' most strenuous programming efforts.

PROGRAM RENEWAL

Evaluation of on-air shows goes on all year. The final decision on whether to return a program to the schedule the following fall is usually made between March and May because the networks showcase their fall lineups at their annual affiliates meetings during those months. However, last-minute changes occur right up to the opening guns in the fall. *The critical times for new programs starting in September are the four or five weeks at the beginning of the fall season (September/October) and the November sweeps.* Typically, programs surviving the waves of cancellation at these times and lasting into January or February are safe until April (when heavy preemptions of soon to be canceled shows occur), although a network might decide, as a result of the February sweeps, not to renew some programs for the next season.

Program Lifespan and License Contracts

In the 1970s the average **lifespan** of a popular prime-time series declined and continued to drop into the 1990's. In the 1950s and 1960s, shows like *The Ed Sullivan Show, Gunsmoke, What's My Line,* and *The Wonderful World of Disney* endured for more than 20 years. These records for longevity will probably never be matched again in prime time. By 1980, a program lifespan of 10 years was regarded as a phenomenon. By 1992, 5 years had become an outstanding run for a successful series.

Several factors account for this shortened lifespan:

- The increased sophistication or, some argue, the shortened attention span of the viewing audience
- The constant media coverage of television shows and stars (as in *Entertainment Tonight*), wearing each episode and series idea out quickly
- The practice of syndicating a series while it continues its network run
- The scarcity of outstanding program forms and fresh, top-rated production and writing talent, which leads to a great deal of copying
- The high cost of renewing writers, directors, and actors after an initial contract expires
- The loss of actors because they become bored or move on to other projects
- A general lack of variety in prime-time programming resulting in a sameness that causes even the best ideas to wear out faster

The shortened lifespan of prime-time series especially reflects the complexity of program license contracts that generally run for five to seven years. When a series first makes it to the air, the network controls the contractual situation and usually requires several concessions from the producer. At this time, the producer has traditionally had to sign over such rights as creative control, spinoff rights, limitations on syndication, and scheduling control. The producer also agrees to a specific licensing fee for the run of the five-year contract, regardless of the program's success (after all, most shows fail). Typically, this licensing fee is substantially less than actual production costs and makes no concession for sharing the profits should the program become a hit.

Producers practice **deficit financing** (paying more to produce a series than the network pays in license fees) because the potential profit from off-network syndication can run into the hundreds of millions of dollars. After the 1971 **prime-time access rule** barred the networks from taking a share of the syndication profits, all three networks demanded that the producers shoulder a larger por-

tion of the production cost. The networks argued that because only the producers get syndication profits they should also accept more of the risk involved in prime-time production. Even the relaxation of the financial interest and syndication section of the rule in 1991 did not alter this network position regarding new series. When a script idea is first proposed, its producer is in no position to argue with this type of network reasoning.

However, at the end of the first contractual period, normally five years, the tables are turned. Now the producer enjoys the advantage. The series has a **track record** and enough episodes in the can for syndicating as a stripped show. In short, since the producers no longer need the network as much as it needs them, producers may demand the return of many of the concessions granted in the original contract. Moreover, a hit series' stars, directors, and other executives now seek much larger salaries and concessions. *Cheers* was a classic example in 1991 when stars and producers demanded the highest per episode license fee ever paid (over $2 million for the half-hour show at a time when the average license fee was around $600,000). Under such renewal conditions, a network can often profit by dropping a popular show with a marked-up price in favor of an untried newcomer, or by replacing a popular star with a newcomer, as was the case with *NYPD Blue* in 1994.

Pivotal Numbers

Of the three phases of planning a fall schedule—evaluation, selection, and scheduling—choosing which programs already on the air will continue and which will be pulled (renewals and cancellations) is perhaps the easiest decision. The decisions are based squarely on the network's profit margin—in essence, subtracting cost per episode from advertising revenue. Normally, revenue is directly related to ratings. Until the 1980s, a weeknight rating below 20 (or an audience share of less than 30) almost always resulted in a program's cancellation on any network. But because of steady network audience erosion, by the early 1990s the target numbers had dropped to a *minimum weekday*

prime-time rating of 12 and a share of 18. These numbers will sink even further as the broadcast networks' share of viewers continues to decline.

Entertainment programs stalling in the bottom third of the Nielsen's are usually canceled as soon as possible, while programs in the top third are usually renewed. The most difficult decisions for network programmers involve programs in the middle third, the borderline cases, or programs that:

- Show signs of fatigue but are still holding their own
- Are only just beginning to slide in the ratings
- Are highly rated but draw the wrong demographics
- Have low ratings but high profit margins (as is often the case with news or people-participation series)
- Produce strong critical approval

Occasionally, the personal preferences of a top network executive, the reaction from critics, letter writing campaigns, or advertiser support may influence a decision, but the prevailing view is that cancellations had far better come too soon and too often than too late.

While audience protests about the cancellation of *Thirtysomething* and *Brisco County Jr.* might be annoying, of far greater concern to network programmers was a new willingness by producers to defy the networks and keep canceled shows in production. Some canceled series were subsequently offered in original syndication (first-run) as direct competition for prime-time network programs. The first rebels surfaced in the early 1970s when Lawrence Welk refused to be canceled and when *The Muppet Show* went into production even after all three major networks had turned the series down. By the 1990s, such series as *Forever Knight* and *Baywatch* were coming back to haunt network executives.

Worse yet, by the 1990s many producers had stopped offering their new ideas to the traditional broadcast networks, choosing instead to offer their

series to cable. The networks might have considered such programs as *Tek War, Exit 57,* and *The Hitchhiker,* but they went straight to cable. Even more top new series went directly to original syndication, leaving all profits and control with the producer. Indeed, by 1995 there was a mild glut in original prime-time shows for local stations, including such series as *Babylon 5, Flipper, The Legendary Journeys of Hercules, Kung Fu, Baywatch, Outer Limits,* and *High Tide.* In some cases, these programs (*The Highlander,* for example) were produced outside the United States to lower production costs. Many also did better in the ratings than network series, further eroding the networks' position, challenging U.S. production houses, and raising serious questions about the networks programming emphases.

Time Slot Ratings

The history of ratings for the time slot a program fills may be the strongest measure of how that program will perform over time. After all, a "history" takes into account such factors as the competition, the leads in and out on all channels, the network's myths and policies, and the public's viewing habits and expectations. The reality is that over half of the series scheduled in new time slots (new or moved shows) do not alter either the ratings or the ranking for their slots. This means that a series placed in a top-rated time slot probably will be a top-rated series, and conversely, a series placed in a weak position will be weak. Another one-third of shows get lower ratings than their time slot averaged in the previous season. This means that when a series does change the historical pattern, the change is usually for the worse. Chances are only about 15 percent that a program will improve the ratings for the time slot it is scheduled to fill.

Low-rated shows are subject to a widely accepted concept called **double jeopardy.** According to this idea, low-rated shows have both low exposure and little chance of getting more exposure. This is because popular programs are both chosen by more people and those viewers are more committed to the shows. Thus, unpopular programs

suffer from increasingly fewer and less committed viewers.[11]

Obviously the best scheduling ploy would be to place every series in an already strong position, an impossibility. The slots open to programmers are usually ones where previous programs failed. In the last 20 or so years, more than half of all new shows have been scheduled in prime-time slots that already ranked in the bottom third of the ratings, and most were also in slots ranked third compared to the competition. Clearly, *the strength of a time slot should be considered when the decision is made to hold or cancel a series.*

However, this has not usually been the case at the networks. A program's rank and absolute rating overrule expectations for a time slot.[12] As a result, a series with an 18 rating would usually be held, while a series with a 10 would be canceled. This was true even if that 18 represented a loss of several points (by comparison to the lead-in program or the previous program in that slot) while the 10 represented a gain. Because there is only a small chance that a series will significantly improve the ratings for a time slot, considering ranking and absolute rating appears to be self-defeating in the long run. As the majority of available slots are going to be weak in any case, wisdom suggests holding onto series that improve the numbers and slowly rebuilding holes in the schedule. Nonetheless, the pattern of the three major networks has been "decide quickly" and "cancel fast."

Program Costs

In addition to ratings, profits left after subtracting licensing costs from advertising revenues influence program cancellations. Two prime-time programs of the same length, on the same network, with identical ratings will, ideally, produce identical amounts of revenue for that network. But if one of them has slightly higher per episode licensing costs (say, $625,000 versus $600,000), over the length of a season that difference may reduce net profit by a half-million dollars. Generally, the number of commercial minutes remain the same for each program, although the networks have begun ex-

perimenting with slipping extra commercials into some series. It is clear that the program with the higher licensing cost will be canceled before the lower cost series.

Production fees (the license fee the networks pay) vary with cost factors such as costumes, special effects, sets, stunt work, whether the show is taped or filmed, the amount of location versus studio shooting, cast size, the producer's and star's reputations, the program's track record, and so on. Since 1971, the networks have concentrated programs into three basic low-cost formats each season, while the more expensive genres, such as science fiction, military, variety shows, and westerns, have almost disappeared. These changes make comparing production fees over the years somewhat problematic.

Originally, the networks concentrated on crime dramas and situation comedies, but as the demand for such programming increased, so did the costs. By the early 1990s, both crime dramas and situation comedies had become enormously expensive. For example, two episodes of *Evening Shade*, a half-hour situation comedy, cost $100,000 more than one hour of *The Flash*, a new science fiction series, and $150,000 more than *The Young Riders*, an established western. A similar increase in costs had occurred for crime dramas. As a result, crime series were gradually replaced by news shows and "real-people" programs, both of which cost about one-third as much as the average program. The networks continue to rely heavily on situation comedies, and sitcoms have an exceptional record in off-network syndication as they tend to attract viewers that advertisers especially want.

Network executives also claim that their confidence in the sitcom is justified because the success rate for such series is higher than average. Some studies contradict this assertion, showing that, despite the best time slots, the success rate (in terms of renewal) for situation comedies is no better than average, and they are no more likely to increase the ratings for their time slots than other program types. The likely explanation is that sitcoms appeal to advertisers, and audiences expect them, thus entrenching them as essential to net-

work programming strategy. In short, programmers tend to believe their own hype. They really believe sitcoms do better than other program types, even in the absence of statistical proof. In any case, by 1995 sitcoms and news/reality programs accounted for more than 60 percent of all prime-time network shows.

The traditional third option, movies, although expensive, fill large amounts of time and are therefore useful for plugging temporary night-long holes in the schedule until more sitcoms and reality-based series can be developed. Movie nights can also be used to test pilots done as **made-for-TV movies,** thus saving on the costs of development. As a result, there are many movie nights, but they come and go very quickly.

News/documentary and reality-based formats are by far the cheapest to produce; most are produced **in-house** and make use of material provided for free by the audience or by the network news divisions when not preparing the nightly newscasts. A news magazine program such as *60 Minutes* or *20/20* can run virtually forever. Reality-based shows, such as *America's Funniest Home Videos*, *Rescue 911*, and *Unsolved Mysteries*, are also very cheap to make and tend to do well in the ratings at least initially. However, reality-based shows usually have only a short network lifespan and no life at all in off-network syndication.

Production fees have increased a great deal from 1970 to 1995 (see 4.5). Advertising rates did not keep up with production cost rises in the late 1980s, and network profits declined drastically, although the networks introduced severe cost-cutting measures, including huge cutbacks in personnel and departmental budgets (see 4.6). Both network news departments and Standards and Practices departments were hit hard by economy measures. All three major networks also began selling off such subsidiary businesses as recording and publishing. CBS introduced the most surprising economic move by adding one or two extra commercial spots to some of its most highly rated programs, in essence letting ratings influence the amount of time devoted to commercials. Many of the networks' financial problems came from

4.5 HOURLY COST FOR NEW PRIME-TIME PROGRAMS

Season	Per Hour Cost
1970–71	$205,523
1971–72	$222,217
1972–73	$227,136
1973–74	$232,829
1974–75	$227,075
1975–76	$253,174
1976–77	$322,674
1977–78	$360,778
1978–79	$443,454
1979–80	$449,663
1980–81	$571,395
1981–82	$594,034
1982–83	$660,063
1983–84	$702,841
1984–85	$757,439
1985–86	$801,628
1986–87	$858,446
1987–88	$866,667
1988–89	$875,000
1989–90	$900,852
1990–91	$979,639
1991–92	$1,005,682
1992–93	$937,386
1993–94	Not available
1994–95	$1,400,000 *
1995–96	Not available

Source: Data taken from estimates provided by *Variety* each September and February. The figures include the Fox network from 1989 on.

*Estimate provided by *Broadcasting & Cable*.

unwise investments during the 1970s and from debt built up during attempted takeovers during the 1980s. As a result, the Big Three networks entered the 1990s in the worst economic condition in their history, causing them to move cautiously. However, the downward trends of the 1980s were only a temporary condition. By the mid-1990s, from a revenue point of view, the broadcast networks were stronger than ever.

NEW PROGRAM SELECTION

Phase two in planning a new fall season—selection and development of new program ideas—poses more difficult problems than ongoing program evaluation. The four networks consider as many as 6,000 new submissions every year. These submissions vary in form from single-page outlines to completed scripts. Decision makers favor ideas resembling previous or presently successful shows. They even quietly agree that almost all so-called original successes are in fact patterned after long-forgotten programs.

Concepts

The four major networks invite submissions from established **independent producers** who enjoy substantial track records, such as Stephen J. Cannell, Steven Bochco, and Witt/Thomas Productions. Studios, independent production companies, and individual writer/producers are sought out if some of their prior output ranks high in the ratings. These companies or individuals must have demonstrated that they have financial stability and the know-how required for dealing with network pressures and red tape. It is a given that long-established organizations have the most successful writers under contract and have the clout to hire exceptional talents, making their submissions more persuasive than those from less experienced sources. One new development in the late 1990s is that big advertisers such as Pepsi and Procter & Gamble are backing development of TV series to gain more control over types of programs offered.

Many program concepts are dismissed out of hand; others are read and reread, only to be shelved temporarily. A few, usually variations on present hits or programs linked to top stars or producers, get a favorable nod with dispatch. Decision makers look for a program with **staying power**— that elusive combination of elements that makes a series continue to fascinate viewers over several years of new episodes using the same basic characters and situations (exemplified by *Murder, She Wrote* and *Home Improvement*).

4.6 ADVERTISING RATES

Advertising rates, the amount paid for a 30-second spot, vary a great deal from one program to the next and from year to year. The traditional rule has been to charge whatever the market will bear. Costs are figured on how much is being paid per rating point. Each point now equals about 959,000 homes. In the late 1980s it appeared that costs had finally gone too high, as large blocks of time went unsold. But, that trend reversed itself in the 1990s. In 1995, in spite of a large increase in the amount advertisers had to pay per rating point, all available time was selling out. The following table shows how the average cost per point has changed since 1972.

Year	Title	Cost Per 30-Second Spot	Cost Per Point
1972	*Bonanza*	$ 26,000	$ 1670 Per Point
1980	*M.A.S.H*	$150,000	$ 5840 Per Point
	Dallas	$145,000	$ 4200 Per Point
1987	*Cosby Show*	$369,000	$13,275 Per Point
	Cheers	$307,000	$11,290 Per Point
1992	*Murphy Brown*	$310,000	$12,255 Per Point
	Roseanne	$290,000	$ 9,390 Per Point
1994	*Seinfeld*	$390,000	$19,310 Per Point
	Home Improvement	$350,000	$17,950 Per Point
1995	*Seinfeld*	$490,000	$24,260 Per Point
	Home Improvement	$475,000	$24,360 Per Point

Sources: *Advertising Age, Broadcasting & Cable,* and *Variety.*

Network programmers often look for ideas that closely resemble current hits. For example, *Roseanne*'s early success spawned a rush to propose stand-up comedians in sitcom roles based on their routines, and the O.J. Simpson trial led to a half dozen attempts at courtroom dramas during the 1995–96 season. Truly original ideas tend to be ignored or given very short runs in weak time slots, and then canceled. The head of programming for CBS pointed to two examples where originality had led to bad cancellation decisions. *The Flash,* a 1990–91 series, would still be running and would be a major international hit if only the network had held onto it; he also suggested that original syndication results proved that the CBS cancellation of *Forever Knight* was a mistake.[13] Few other network executives have been willing to admit any errors.

Of the thousands of submissions that land on the networks' desks, roughly 600 are chosen for

further development at network expense. At this point, the parties sign a **step deal,** contracts providing development funds in stages to the producer, setting a fee schedule for the duration of the contract, and giving the network creative control over the proposed program. The networks also get **first refusal rights,** preventing the producer from taking the idea to anyone else until the network has actually turned down the show. This provision allows a network to hold onto an idea for years. In short, if the network is unwilling to air a program but is also concerned that someone else might, they can permanently shelve the idea. It's a simple matter of never actually turning the idea down. First refusal means that as long as they don't actually say no, the producer can't talk to anyone else about the program.

As a rule, step deals authorize scripts or, in some cases, expanded treatments. The approved concepts often take first form as special programs, made-for-TV movies, test characters in established shows, or miniseries. If a concept was submitted initially in script form, a rewrite may be ordered with specific recommendations for changes in concept, plot, or cast (and even new writers). Until recently, ABC had traditionally supported many more program ideas at this stage than CBS, NBC, or Fox. However, ratings shifts have led CBS and NBC to allot more money to develop new program ideas. Fox has been more daring and more willing to hold onto new programs, but that seems to be changing as they increase the amount of time they fill and move closer to the big three in the ratings.

Most new program ideas are for half-hour comedies or reality-based series. Concepts for one-hour dramas are far fewer. Half-hour sitcoms target the desirable demographic groups of young people and women 18 to 49 and, if successful, usually hit the syndication jackpot. Reality-based series, while rarely successful in syndication, are cheap to produce and fill a great deal of time. Consequently, the networks tend to order, and producers tend to propose, pilots for these types of programs more readily than other types.

Scripts

Before authorizing a pilot, the program executive will first order one or more scripts. In the early days of television, certain program ideas received immediate pilot funding and even guaranteed places on schedules, but such decisions usually depended on the use of a mega-star personality or big-name participation in the production. As of 1995, average expenditures at all three networks ranged from around $40,000 for a half-hour comedy script to $60,000 for a one-hour drama script. Exceptional (read successful) writers demand much higher prices. Before a pilot reaches production, a second or even third script for a proposed series may be called for to test the versatility of the series' idea.

Pilots

A **pilot** is a sample or prototype production of a series under consideration. Pilots afford programmers an opportunity to preview audience reaction to a property. Each of the three biggest networks order between 45 and 50 pilots to fill just over a dozen anticipated gaps in their new season lineup. Of course, new networks like Fox, UPN, and WB need fewer. Once a network decides to film or tape a pilot, it draws up a budget and advances start-up money to the producer. The budget and advance may be regarded as the third major step in the program development process. As of 1995, half-hour pilots cost from $1 million to $3 million, depending on things like sets, costumes, special effects, and so on, with one-hour dramas costing more than twice that amount. Pilot production costs are generally higher than costs for regular season shows, because new sets have to be built, crews assembled, and start-up costs paid.

The very practice of "piloting" creates an artificial situation. More money, more time, and more writing effort go into a pilot than into subsequent episodes of the series. All the people involved do their very best, trying to make the pilot irresistible to network decision makers. The producer often pulls out all the stops and spends more money

than the network agreed to pay, making up the extra expense out of the company's own resources.

Because of its incredible expense and abysmal success rate, the pilot system has been denounced by Fox and many producers. Fox uses five- to ten-minute presentation films in place of full-blown pilots for many shows, but this radical idea has met strong resistance from traditional broadcasters. Nowadays, about 130 pilots are produced annually to fill the three- to five-dozen newly opened slots on the four main networks each year. However, many of these pilots are done as made-for-TV movies, which can be played on regular movie nights and thus recoup the investment even if the series idea is not picked up. Series failing to make the final selection list for the fall season are held in reserve in anticipation of the inevitable cancellations. The networks also "short order" backup series from some of the pilots. They authorize production of four to six episodes and order additional scripts to be ready in case a backup show is successful.

Most contracts require delivery in early spring. When received, pilots are tested on special audiences as described in Chapter 2. Although pilot-testing research is admittedly inconclusive, it exerts considerable influence. The pilots are also repeatedly screened by committees of programming experts. The decision to select a pilot for a series may take into consideration:

- Current viewer preferences as indicated by ratings
- Costs
- Resemblance between the proposed program and concepts that worked well in the past
- Projected series' ability to deliver the targeted demographics for that network and its advertisers
- Types of programs the competing networks air on nights when the new series might be scheduled

Of secondary weight but also relevant to a judgment are:

- The reputation of the producer and writers
- The appeal of the series' performers (the talent)
- The availability of an appropriate time period
- The compatibility of the program with returning shows

These considerations and others are juggled by the chief programmer. ABC's Ted Harbert argues that cost, potential for development over time, and schedule stability should be the major considerations. CBS's Peter Tortorici claims that counter-programming, targeting a younger audience, and balancing programs are the network's concerns. NBC's Lee Currlin counsels that offering something different, attracting attention by stunting, developing audience flow (in terms of aging the audience throughout the night), and having the ability to react quickly to weaknesses in the schedule should be the major considerations when selecting new series. Fox's Sandy Grushow looks for series that can be promoted aggressively, that target underserved demographic divisions in the audience, and that will fit specific nights or time slots (as opposed to fitting with an overall programming strategy).[14] Each network, then, emphasizes different strategies, in part dependent on its network rank at the time and in part dependent on the goals of the chief programmer.

If a pilot passes final muster and gets into the network's prime-time lineup, subsequent episodes will usually cost between $500,000 and $700,000 for half-hour episodes and $1 million to $1.5 million for one-hour episodes. Mega-hits such as *Roseanne* and *Murphy Brown* break all the rules. As 4.7 shows, programming costs vary a great deal because each property differs as to the number and size of cast, sets, and salaries paid. Also, high demand for the product pushes the cost up. Made-for-TV movies cost from $2 million to $4 million, depending on ingredients; miniseries such as *The Stand*, *Scarlett*, and *Woman of Independent Means* cost tens of millions of dollars but, unlike most made-for-TV movies, sometimes provide a potential motion picture for eventual theatrical

4.7 1992–93 LICENSE FEES FOR 14 PROGRAMS

Half-Hours	Cost Per Episode	One-Hours	Cost Per Episode
Cheers (last season)	$2,300,000	*Young Indiana Jones*	$1,000,000
Murphy Brown	$ 610,000	*Murder, She Wrote*	$1,175,000
Roseanne	$ 750,000	*60 Minutes*	$ 600,000
Coach	$ 580,000	*Civil Wars*	$1,200.000
Funniest Videos	$ 425,000	*20/20*	$ 500,000
The Simpsons	$ 615,000	*The Commish*	$ 935,000
Cops	$ 325,000	*Beverly Hills, 90210*	$ 960,000

Source: *Variety*, September 1992.

distribution (especially abroad) or a boxed video set for direct sale to the public.

SCHEDULING STRATEGIES

Ten strategies dominate prime-time scheduling: lead-off, lead-in, hammocking, blocking, tent-poling, bridging, counterprogramming, blunting, stunting, and seamlessness.

1. Lead-off. All schedulers use the strategy of beginning an evening with an especially strong program. Known as the **lead-off,** this first prime-time network show sets the tone for the entire evening. It is believed that this maneuver can win or lose a whole night and thus affect the ratings performance of a full week. Typically the network winning the ratings for the first hour of prime time also wins the entire night.

A strong lead-off is considered so important that the major networks routinely move popular established series into the 8 P.M. (EST) positions on every weeknight. This is done even if it means raiding, and thus weakening, strong nights to get the proven shows for lead-offs. A classic example occurred in 1994 when ABC moved *Coach* from its top-rated position to a Monday night lead-off position.

2. Lead-in. Closely related to the lead-off, the **lead-in** strategy places a strong series before a weaker (or any new) series to give it a jump start. Theoretically, the strong lead-in carries part of its audience over to the next program. A new series following a strong lead-in has a modestly better chance of survival compared to a new series with no lead-in or a weak lead-in.[15] To get a strong lead-in, the networks often shift strong series to new nights or times. No show is safe in any schedule position. *M*A*S*H*, for example, occupied almost a dozen different time slots during its long run.

3. Hammocking. Although scheduling strategies can help bolster weak programs, it is obviously easier to build a strong schedule from a strong foundation than from a weak one. Moving an established series to the next later half-hour and inserting a promising new program in its slot can take advantage of audience flow from the lead-in program to the rescheduled familiar program, automatically providing viewers for the intervening program. This strategy is known as **hammocking** for the new series—a possible audience sag in the middle will be offset by the solid support fore and aft (also called a **sandwich,** with the new show as the filling). NBC, for example, used *Wings* and *Frasier* to create a space (a hammock) for *Friends* in the mid-

1990s, and ABC moved *Full House* from Friday to a Tuesday slot to create a hammock for *Me and the Boys.*

4. Blocking. The networks also use **block programming,** placing a new program within a set of similar dramas or sitcoms filling an entire evening, a venerable and respected practice. The risk with this strategy is that the new comedy may lack the staying power of its "protectors" and damage the program that follows. However, programmers believe that surrounding a newcomer with strong, established programs of the same type ensures the best possible opportunity for it to rate as high as the established hits.

The theory of **blocking** is that an audience tuning in for one situation comedy will stay for a second, a third, and a fourth situation comedy (if of the same general type). The first show in a group usually aims at young viewers or the general family audience. Each ensuing series then targets a slightly older audience, thus taking advantage of the fact that as children go to bed and teenagers go out or do homework, the average age of the audience goes up. Blocking works best during the first two hours of prime time but typically loses effectiveness later in the evening.[16]

Examples of blocking (also called **stacking**) are easy to find in prime-time schedules every year on all three networks. During the 1995–96 season, for instance, CBS formed a sitcom block on Monday nights with *The Nanny*, followed by *Can't Hurry Love*, followed by *Murphy Brown*, followed by *If Not For You*. In the same season, NBC formed a news/reality block on Fridays with *Unsolved Mysteries*, followed by *Dateline NBC*. ABC, in turn, built its own comedy block on Tuesday starting with *Roseanne*, followed by *Hudson Street*, followed by *Home Improvement*, and ending with *Coach*. During the 1970s and 1980s, most of the highest rated nights were built using the stacking strategy, including the most effective grouping of all—*The Cosby Show, Family Ties, Cheers,* and *Night Court* in the mid-1980s on NBC.

5. Tent-poling. Instead of splitting up successful adjacencies to insert an unproven show, in many seasons ABC and NBC turn to **tent-poling,** an alternative to the hammock. Each network focuses on a central, strong show on weak evenings, hoping to use that show to anchor the ones before and after it. This strategy (also called creating a lynch pin) is particularly useful when a network has a shortage of successful programs and consequently cannot employ hammocking. CBS tried this in 1994 with *Murphy Brown*, which was used in the middle of the Monday night schedule with the new *Cybill* and the underperforming *The Nanny* and *Dave's World* as surrounding programs and the new *Chicago Hope* as the follow-up to the block. This strategy is dangerous because it often pulls the central strong show down instead of raising the two ends.

6. Bridging. The bridging strategy is not as common in commercial broadcasting as the others but has been useful to public broadcasting and such cable networks as TBS and HBO. **Bridging** has two aspects: one is the regular use of long-form programs (one and a half hours or more) that start during the access hour and continue into prime time, thus running past the broadcast networks' lead-offs and interrupting their strategy when viewers later switch channels. HBO, for example, often schedules a hit movie starting at 7 or even 7:30 P.M. (EST) to bridge the start of network prime time.

The second aspect of bridging involves starting and ending programs at odd times, thus causing them to run past the starting and stopping points for shows on other networks. This creates a bridge over the competing programs, which keeps viewers from switching to other channels because they have missed the beginnings of the other shows. For example, TBS regularly starts its programs at five minutes after the hour. As a result, TBS viewers are forced either to watch the next TBS show or tune into another program late.

CBS also used the bridging strategy successfully in its Sunday night lineup. The network regularly ran Sunday football games (or other sports) beyond the hour point, thus throwing the rest of the night off by about ten minutes. This meant that

the huge audience that watched *60 Minutes* was stuck with CBS for the rest of the night. The alternatives were to leave a CBS show before it was over or to tune in to the competition late.

7. Counterprogramming. The networks also schedule programs to pull viewers away from their competitors by offering something of completely different appeal than the other shows, a strategy called **counterprogramming.** For many years, for example, CBS successfully countered the strong, action-and-youth-oriented series offered by ABC and NBC on Sunday nights with *Murder, She Wrote*, a series providing continuity for the more sophisticated viewers tuning in to *60 Minutes* while appealing as well to older viewers. Much of NBC's success in the mid-1980s was credited to counterprogramming, with series such as *Highway to Heaven* and *Golden Girls* that targeted underserved segments of the audience at hours when the other two networks were attracting advertisers' most-desired demographics. Perhaps best known of all, ABC has successfully counterprogrammed Monday night for years with its *Monday Night Football*.

8. Blunting. Networks that choose to match the competition by scheduling a show with *identical* appeal are **blunting** the competition. If two networks are already blunting each other, a third network that counterprograms will succeed more often than a network that attempts to "blunt a counter."[17]

In many ways, counterprogramming goes against the ideal demographics concept. Counterprogramming relies on finding a large, ignored group of viewers and scheduling a program for them. Most other strategies are intended to hold viewers who are already watching (flow strategies); counterprogramming interrupts flow to gain different viewers. This characteristic makes counterprogramming an effective scheduling option, especially for the network facing a super-hit program on another network. However, the effectiveness of counterprogramming relates to the number of options available to viewers: the greater the num-

ber of competing shows, the less effective counterprogramming becomes.

9. Stunting. The art of scheduling also includes maneuvers called stunting, a term taken from the defensive plays used in professional football. **Stunting** includes scheduling specials, adding guest stars, having unusual series promotion, shifting a half-hour series to long form, and otherwise altering the regular program schedule at the last minute. Beginning in the late 1970s, the networks adopted the practice of deliberately making last-minute changes in their schedules to catch rival networks off guard. These moves were calculated and planned well ahead of time but kept secret until the last possible moment. These moves are intended to blunt the effects of competitors' programs. Generally these maneuvers are one-time-only, because their high cost cannot be sustained over a long period.

Scheduling hit films, using big-name stars for their publicity value, and altering a series' format for a single evening are common attention-getting stunts. They have high promotional value and can attract much larger than usual audiences. Of course, the following week, the schedule goes back to normal, so these efforts generate sampling but rarely create long-term improvements in series ratings. Creating unusual program **crossovers**—that is, using story lines and characters that involve more than one show—is a related stunt that affects ratings only so long as the crossover continues.

CBS used another form of stunting when it paid more than $4 billion for rights to sporting events (including Major League Baseball) during the early and mid-1990s. This proved to be a financial disaster. While the network expected to lose money most years, they hoped that the rewards from promoting CBS shows during the World Series and championship games would be more than worth the cost. Those hopes proved fruitless, and CBS lost tens of millions. Investing in popular but unprofitable specials to promote other network shows is still a popular form of stunting, however. The Olympics are a perfect

example. In 1995, NBC offered $1.25 billion for the 2000 Summer Games and the 2002 Winter Games. Along with the cash, they promised to run a weekly half-hour program promoting the games for the next ten years.

10. Seamlessness. In the 1990s the networks turned to a new strategy intended to accelerate the flow between programs. First NBC, followed by the other networks, eliminated the breaks between key programs (*Seinfeld* to *Frasier,* for example). Because viewers normally make most use of their remote controls in the two minutes or so that has traditionally occurred between programs, running the end of one program right up against the start of the next avoids the opportunity for remote use. This is called a **seamless transition,** and its goal is to keep viewers watching whatever network they began with.

In another twist, ABC (soon copied by the other networks) instructed producers to cut out all long title and credit sequences and to begin every program with an up-tempo, attention-getting sequence. (Titles may appear later in a program after viewers have, presumably, been hooked.) At the end of programs, all networks have experimented with split screens and squeezed credits to allow some program action (or "bloopers") in part of the screen to hold viewers' attention right into the next program (or very close to it).[18]

Schedule Churn

Stunting during the 1970s resulted in a continual shifting of prime-time schedules. This **scheduling churn** constituted one of the major differences between 1960s and 1970s programming. (Here the term *churn* refers to the continual shifting of programs within the network schedule and should not be confused with subscriber churn as it is used in the cable and pay-television industries.) The 1960s represented a period of extreme stability in television schedules. New series were introduced during late September; second season changes, consisting only of a handful of time shifts and new series, always took place in late December and early January, and virtually no series was canceled

in less than 16 weeks. Preemption of regular series was held to a minimum and concentrated in particular time periods such as Christmas or Easter when the holidays provided a natural reason for specials. The 1960s were also marked by stability within the audience and within the networks' comparative overall rankings. During the entire decade, CBS came in first, NBC second, and ABC third.

During the 1970s, this stability vanished—the combined result of theories discounting the importance of the programming itself, a closer ratings race, pressure from advertisers for "proper" demographics, increased cable penetration, pressure from public interest groups, and declining network audience shares (toward the end of the decade). The number of time shifts—moving series from one slot to another—for example, went from less than half a dozen in 1969–70 to more than 40 by 1981–82. The number of shows canceled in less than five weeks went from 1 in 1969 to a peak of 24 in 1978; early cancellations have held at about 20 per year since then. The number of series frequently preempted (more than one-third of their scheduled times) went from 0 to more than 20. The 1970s also saw the collapse of the seasonal system for introducing time shifts and new programs and the end of ranking stability for the three networks.

The number of series introduced or moved into new time slots during each month from 1971–72 to the 1994–95 seasons is shown in 4.8. The September/January figures represent the traditional first- and second-season starting points. Therefore, series introduced in other months represent changes in the schedule that took place while the season was in progress. The chart shows the schedule churn caused by moving established series into new time slots (program shifting) and the introduction of new programs (replacements, requiring the cancellation of old programs). Included are figures for the first and second seasons only (32 weeks, excluding summers), because they represent the networks' main programming efforts.

As 4.8 shows, the mid-1970s saw a massive increase in schedule churn that has continued into

4.8 PRIME-TIME CHURN: TIME SHIFTS AND NEW PROGRAM INTRODUCTIONS FROM 1971 TO 1995

Season	Sept.	Oct.	Nov.	Dec.	Jan.	Feb.	Mar.	Apr.	Total	Percentage Outside of Sept./Jan.
1971–72	24	—	3	3	14	—	—	—	44	14%
1972–73	19	—	—	3	13	1	—	—	36	11%
1973–74	20	—	1	—	20	2	2	—	45	11%
1974–75	25	2	—	3	13	3	6	1	53	28%
1975–76	29	4	7	6	17	1	4	—	68	32%
1976–77	20	—	15	4	21	6	10	—	76	46%
1977–78	22	7	2	12	13	8	7	12	83	58%
1978–79	25	5	11	1	20	14	19	4	99	55%
1979–80	24	8	2	16	11	2	25	8	96	64%
1980–81	7	4	8	10	13	6	13	8	69	71%
1981–82	6	13	15	4	13	5	18	20	94	80%
1982–83	15	10	2	—	12	10	20	9	78	65%
1983–84	16	5	4	11	17	3	19	5	80	59%
1984–85	21	7	4	10	12	2	14	12	82	62%
1985–86	22	2	5	6	13	5	15	12	80	56%
1986–87	26	2	17	2	11	8	23	8	97	62%
1987–88	30	8	7	15	13	6	17	7	104	58%
1988–89	4	19	8	6	18	7	10	19	92	75%
1989–90	36	4	8	8	13	7	12	21	109	55%
1990–91	32	3	13	5	17	8	17	17	112	56%
1991–92	40	9	11	7	11	8	9	18	113	55%
1992–93	38	3	10	10	12	15	22	17	127	61%
1993–94	29	19	8	6	11	7	5	12	97	59%
1994–95	33	12	7	7	22	6	13	21	121	55%

Source: *Variety* and *TV Guide* listings, prepared by William J. Adams, Kansas State University. The Fox network is included in the figures beginning in 1989. Movies, sports, and specials are not included.

the 1990s. The September 1980 and 1981 figures and the 1988 figures reflect the effects of strikes that delayed the start of those seasons. But for other years, the networks have generally had control over their options and sometimes have purposefully increased their churn.

A program that a network wants to get rid of can be canceled outright or manipulated (time shifted or churned) until its ratings fall. Manipulation sometimes makes good public relations sense when a show is critically successful or widely popular, although not quite popular enough among the desired demographic group (some critics have suggested that this was the problem with *Brooklyn Bridge*). Examination of the results of program churn show that an individual program's ratings

almost always fall when it is moved two out of three weeks (especially when moved in the second season). Studies also show that a new series that has improved upon the time slot it was originally given always fails if it is moved (as was the case with *The Flash*). One hundred percent of programs moved and declining in ratings have been quickly canceled since the 1980s. Other prime candidates for excessive schedule manipulation include those with higher than average production costs but which would cause managerial problems if abruptly canceled (because they are supported by a highly placed executive or advertiser). Many believe that the 1995 shift of *Murder, She Wrote* on CBS from Sunday to Thursday was a clear example of this type of move. Once low ratings or even a downward trend is achieved, network programmers can point to the numbers to justify cancellation (on the few occasions when some justification seems useful).

Cancellations

To attract and hold young viewers in large numbers, the four networks now introduce nearly five dozen new programs to their prime-time schedules each year. Discounting movies and specials, during the 1980s the networks collectively offered an average of 48 new programs, added to the average of 50 established ones returning to the air. Which new entries will beat the odds and survive this critical sweepstakes each year is the key question. Typically, 70 percent overall (75 percent in the 1990s) of new series fall by the wayside. Some are pulled within a few weeks; others may last until early spring if a network believes that too few viewers sampled them in the fall. Some are kept on the schedule only until their replacements are readied (see 4.9).

New programs have a higher cancellation rate than programs overall because the latter includes the few hits that go on from year to year. The long-term average failure rate for all three networks exceeds 68 percent. The network enjoying the highest overall ratings naturally cuts the fewest programs, and conversely, the one with the lowest

average ratings scissors its schedule most drastically. What the network in the middle does varies from year to year. Consider 4.10, listing just the number of new programs canceled after each season had begun.

Promotion's Role

All three networks use **on-air promotion** to introduce new programs. Beginning as early as mid-July and continuing through November (after especially heavy season-opening salvos), networks intensify promotion of their programs and their overall image. In addition, networks use **print promotion**, especially television guides and newspaper listings to catalog offerings for particular evenings. For a long time *TV Guide* magazine was so important to network television that programmers sometimes delayed schedule changes so that the changes could make *TV Guide*'s deadline for affiliate program listings. The promotional value of *TV Guide* is essential both locally and nationally, al-

4.10 NEW PROGRAMS CANCELED (FALL AND SPRING COMBINED)

Number and Percentage of New Shows Canceled*

Season	ABC		CBS		NBC		Fox		Total Number Canceled
1970–71	12	75%	7	78%	7	64%			26
1971–72	8	73%	7	58%	7	47%			22
1972–73	7	58%	4	36%	9	64%			20
1973–74	9	75%	6	60%	12	86%			27
1974–75	11	61%	8	73%	8	50%			27
1975–76	10	50%	9	53%	15	79%			34
1976–77	13	65%	12	71%	12	60%			37
1977–78	11	61%	17	81%	14	70%			42
1978–79	9	60%	14	70%	22	79%			45
1979–80	13	72%	11	58%	14	70%			38
1980–81	6	55%	9	69%	9	50%			24
1981–82	13	72%	8	67%	13	65%			34
1982–83	13	87%	13	81%	8	50%			34
1983–84	11	73%	9	64%	17	85%			37
1984–85	15	94%	8	80%	15	75%			38
1985–86	11	73%	14	82%	11	79%			36
1986–87	12	67%	17	89%	10	59%			39
1987–88	15	71%	13	65%	10	67%			38
1988–89	15	75%	15	83%	10	59%	1	20%	40
1989–90	14	70%	16	80%	16	80%	4	50%	50
1990–91	13	76%	16	76%	14	70%	10	71%	53
1991–92	15	68%	15	79%	11	55%	8	80%	49
1992–93	11	65%	12	67%	9	69%	16	80%	48
1993–94	12	75%	17	68%	11	73%	9	82%	49
1994–95	12	86%	12	80%	10	56%	14	82%	48
Average % Canceled 1970–1984		69%		69%		67%		0%	
Average % Canceled 1984–1995		75%		77%		67%		66%	

*Note: These figures are for new series, including movies, aired between September and May. They show the number of new prime-time programs canceled and the percentage of all new series they represent. The apparent decline in the total since 1979 is misleading because the networks increased March introductions beginning that year; many of these shows, though not canceled during that spring, were gone by November of the following year. Although these programs did not survive for long, they are counted here as survivors from their first season into a second season.

though its format is becoming more unwieldy as the magazine seeks to incorporate more and more program services.

On-air promotional announcements play a pivotal role in the ratings success of a program. Not until a program is safely past the rocks and shoals of its first several airings (or until it becomes clear that nothing can help to get it past these early trials) does promotion let up. On-the-air **promos** plug every program scheduled to appear in a season lineup. Weak or doubtful offerings needing extra stimulus get extra exposure. On-air program promotion continues all year round, with extra efforts devoted to sweeps periods. New slogans and symbols extol the virtues of overall network offerings and accompany all promotional announcements. In recent years it has also become common for the networks to join with major stores, such as K-Mart, to promote the new season.

CHANGING FORMAT EMPHASES

The kinds of **formats** dominating prime time have altered over time. One change is the increased use of *specials*—a term encompassing one-time entertainment programs, major sporting events, docudramas, and documentaries. Other recent changes include increased concentration on sitcoms and reality-based series as well as expansion of prime-time news magazines and greater use of foreign-made television. And to minimize risk, networks rely more and more on book or movie adaptations, spinoffs, and clones of existing series.

Sitcoms and Crime Dramas

Situation comedies and crime dramas have a long history in network television, stretching back to shows like *The Life of Riley* and *Dragnet* in the early 1950s. In the early 1970s, the networks started offering much larger numbers of half-hour comedies and crime shows, and these forms continued to dominate prime-time programming for almost 20 years. From 1971 to 1991 more than

160 crime dramas and more than 375 sitcoms were tried because these two formats were:

- Inexpensive to produce (initially)
- Attracted sizable audiences
- Attracted the ideal demographics

But the cost of sitcoms and crime shows gradually escalated until they cost more than most other formats. As a result, the crime drama began to fade away. Situation comedies, however, remain a dominant feature of prime-time TV. While examples of top-rated shows in both of these types are easy to find, their overall success rate has declined steadily.

Situation comedies fall into two main types: family-based comedies like *The Nanny*, *Roseanne*, and *Home Improvement*, or occupational comedies like *Murphy Brown*, *Coach*, or *Frasier*. Together, these two types account for more than three-quarters of all situation comedies offered over the last 20 years. More unusual sitcom formats, such as *Friends*, *The Simpsons*, or *The Critic*, occasionally turn up, but only in limited numbers and with very few attempts to copy them even when they succeed in the ratings.

Crime dramas slowly changed from private citizen do-gooders like *Magnum P.I.* to gritty police dramas like *NYPD Blue*. The mid-1990s also saw the return of courtroom dramas, often in connection with a police show, as was the case with *Law and Order*.

Specials and Sports

Of the approximately 700 specials each year, more than 500 have been entertainment specials for adults, such as the Garth Brooks specials, or for children, such as the Charlie Brown Christmas specials. About 100 each year are sports specials, including the Super Bowl and World Series games. The remaining 100 divide among dramatic specials and news specials, including interviews such as those by Barbara Walters and occasional documentaries.

Entertainment specials often attract superstars (such as Dustin Hoffman and Katharine Hepburn) whose regular motion picture work or performing schedule (or health) prevents them from participating in series programs. Star-studded specials can invigorate a schedule, encourage major advertiser participation, provide unusual promotion opportunities, and generate high ratings and critical approval.

Because of their popularity, the number of specials steadily increased each season, peaking at the end of the 1970s with the beginning of the economic recession. In the 1980s, specials changed format: Increasingly they became long-form episodes of regularly scheduled series, presented in their usual time slot. For example, the record-breaking final episode of M*A*S*H (amassing an extraordinary 77 share) was an extended episode of the existing series, as was the final episode of *Cheers*. Since the early 1980s, one-fifth of the 500 or so entertainment specials each year have been in fact long-form episodes of regularly scheduled series. Network programmers are awake to the possibility that too many specials differing sharply from the regular programming might interrupt carefully nurtured viewing habits beyond repair—hence, the trend toward long-form episodes of regularly scheduled series. Such shows also have the advantage of being relatively inexpensive to produce.

Nowadays, network prime-time sports consist of ABC's *Monday Night Football* (and lower-rated football and major league baseball games on Fox) and special events such as championships, playoffs, and the Olympics. During the 1950s and 1960s, boxing, roller derby, professional wrestling, football, and basketball filled major chunks of the prime-time schedule, but in the mid-1960s the networks phased out most sports, concluding that costs were too high for their limited appeal in prime time. As a result, sports on CBS and NBC were relegated to the weekends and specials.

Traditionally, ABC was the network that placed great emphasis on sports specials in prime time and was the first to successfully schedule football and baseball games at night. From the mid-1960s through the 1970s, ABC led in sports programming, controlling the television rights to most major sporting events in the United States, and the network is credited with generating the huge popularity of the Super Bowl and Super Sunday by building the entire night around the event and heavily promoting it for weeks in advance.

By the mid-1970s, CBS and NBC were attempting to outbid ABC for the most profitable sporting events. Rivalry for NFL football, college bowls, NBA basketball, and the Olympics resulted in bidding wars that escalated the prices for sports television rights to previously unimagined heights, going over a billion dollars for some long-term contracts. *Monday Night Football*, for example, went from a per game fee of about $700,000 in 1977–78 to about $3 million per game in 1995–96. The cost for special sporting events increased even more dramatically. NBC's $1.25 billion deal for the rights to the 2000 Summer and 2002 Winter Olympics is a case in point.[19] Such price tags cannot be fully recovered from within-program advertising sales, but the prestige and promotional value that attach to airing the Olympics and the benefits to affiliates in local ad sales drive the networks to seek such special events (see Chapter 5 on sports). By the 1990s, the networks were experimenting with sharing costs with pay-per-view services to protect themselves. Such ratings disasters as Ted Turner's Goodwill Games, CBS's baseball deal, and the 1995 baseball all-star game, accompanied by increased competition from cable services for sports rights, has left the broadcast networks nervous about expanding sports coverage in prime time.

Magazines, Docudramas, Documentaries, and Reality Shows

The unexpected ratings success of the **magazine-format** series *60 Minutes* starting in the late 1970s led ABC and NBC to imitate it with such series as *20/20*, *Prime Time Live*, and *48 Hours*. Success also encouraged the development of so-called reality-based programming such as *America's Funniest Videos*, *Unsolved Mysteries*, *America's Most Wanted*,

and *Rescue 911*. While the more recent news/ information magazine series generally win high praise from media critics, few have been ratings successes. But they cost less than half the average for entertainment series, so the networks continue to try new information/public affairs shows, hoping for another *20/20* or *60 Minutes*.[20]

The **docudrama**, a dramatized version of historical fact, began with British imports to PBS such as *The Six Wives of Henry the Eighth*, and became popular in the 1970s. *Washington: Behind Closed Doors* (based on Watergate events), *Missiles of October* (about the Cuban Missile Crisis), and *Roots* (about a black writer's search for his ancestors) are perhaps the best known of the 1970s docudramas. In the 1980s, docudramas included *At Mother's Request* and *Nutcracker: Money, Madness, Murder* (both based on the same famous modern murder case), *Escape from Sobibor* (based on a 1943 Nazi death camp escape), *George Washington*, and *Huey Long*. The 1990s brought *The Kennedys of Massachusetts* and *Girls of the Golden West* (about famous women in the old West), combined with dozens of films taken from the headlines. These docudramas tend to play fast and loose with the facts, leading to some criticism but generally high ratings, especially for stories based on the more sordid or sensational news stories, suggesting that docudramas will remain a popular format with networks and advertisers.

Less noticed by the critics but steadily rising in popularity in the 1970s was the long-form **documentary,** particularly on PBS. While this form has continually increased in popularity, few have been offered by the major broadcast networks. In 1990, the highest rated documentary—*The Civil War*—appeared on PBS rather than on commercial television. The same was true in 1994 when PBS offered its documentary on baseball. Indeed, during the 1980s, PBS pushed ahead with many of the top-rated documentaries while commercial networks tended to do better with celebrity interviews such as the *Barbara Walters Specials*. The success of these programs in prime time exploded the myth that public affairs programs are necessarily ratings losers.

Reality Shows (sometimes called *real people shows*) appeared in early television history in such memorable formats as *Candid Camera* and were revived briefly in the 1980s with *Real People*. The 1990s saw an explosion of such shows, both on the networks and in syndication. However, reality-based series usually generate high initial ratings that fall quickly as the show enters its second or third season. Moreover, this type of programming has no potential for off-network syndication. The boom in the 1990s occurred because reality-based shows, like news magazines, are very cheap to produce and promote, appealing to the networks in tough economic times. The very high ratings for the hit *America's Funniest Home Videos* recaptured network attention in the early 1990s. Programs like *Rescue 911* and *Unsolved Mysteries* became a way to hold down production costs, and as networks were not allowed to participate in off-network syndication until 1995, the lack of longevity of these shows was not a major problem.

Adaptations, Imports, Spinoffs, and Clones

The networks often adapt successful theatrical motion pictures into series formats. Perhaps the foremost example was *M*A*S*H*, derived from a feature picture by 20th Century-Fox. Many **adaptations** use only the feature title on the assumption that it alone will attract audiences. Frequently, the adaptation waters down the original film's story to make it more palatable to television audiences. From feature film hits came series like *Peyton Place*, *Seven Brides for Seven Brothers*, *In the Heat of the Night*, and *Ferris Bueller*. Many other series take the idea of a successful movie but not the title. Examples would be programs like *The Young Riders*, adapted from *Young Guns*, and *Dweebs*, adapted from *Nerds*. Few of these mutations ever enjoyed real success. The 1990s saw an interesting turn in this trend as Hollywood began adapting TV series into movies with films like *The Flintstones* and *The Brady Bunch Movie*.

Several British television imports, however, have been successfully rewritten for American

commercial television. Such adaptations include the hits *All in the Family* and *Three's Company*, two failed 1983 series, *Foot in the Door* and *Amanda's Place*, and the short-lived 1987 fad series, *Max Headroom*. By 1991 CBS joined with Canada's CBC to produce several series to fill the late night schedule and were testing the joint production of original prime-time series. As network economics worsen and the cost of original productions rises, U.S. television began looking more and more to other English speaking countries for programs, particularly where original syndication was concerned. Canada has become a major producer, and series like *High Tide* and *The Legendary Journeys of Hercules* are made in Australia and New Zealand.

Certain supporting characters in a series often become so popular they justify a **spinoff** program—a new series typically using the same actors in the same roles in another setting. This practice makes stars of supporting players who demonstrate a potential to carry their own shows (see 4.11). TvQs, the ratings that measure a performer's likability and recognizability, give programmers clues to the most promising candidates for spinoffs. Strong performers in lesser roles led to such spinoff series as *Maude*, *The Jeffersons*, *Mork & Mindy*, *After MASH*, and *Empty Nest*.

By the end of the 1980s, few spinoffs were getting satisfactory ratings, and as a result their representation in the prime-time schedule had fallen off sharply. However, *Murder, She Wrote* added several special episodes with new characters in 1989 and 1990 in an attempt to find one that would spin off. *Diagnosis Murder* starring Dick Van Dyke was the result. *Frasier* was another spinoff (from *Cheers*) that has proven extremely successful, with 1997 syndication prices projected at $2 million per episode in New York City.

A **clone** is a related idea. It copies an existing program but generally on a competing network (not always, however, as *America's Funniest People* was a clone of *America's Funniest Home Videos*). Whereas a spinoff uses the same characters, a clone uses new characters in a plot and setting that closely resemble aspects of the original program. For example, inspired by CBS's success with

4.11 SPINOFFS

As much as 10 percent of prime-time entertainment in 1979 consisted of spinoffs from situation comedies or adventure/dramas. Because the original writers and directors generally also handle a spinoff series, they can continue their successful teamwork. They bring an experienced production staff from the parent program to support the new series, people familiar with the stars' personalities and the characters they play. Fresh program ideas, however, typically involve new combinations of producers, directors, writers, technical staff, and actors and require lengthy adjustment periods. But the overriding advantage of spinoffs is the ready-made audience they bring from the parent program. Well-known characters such as Shirley and Laverne brought personal followings to their own series from *Happy Days*, just as Lou Grant brought a following from the *Mary Tyler Moore Show* (although from any other perspective his two series had very little in common). A spinoff succeeds best when it begins its run while the parent program is still in the schedule. Delay in getting a spinoff off the ground can ruin its chances for success.

Dallas, ABC cloned *Dynasty*, and when it, too, succeeded (after evolving in its own direction), NBC cloned *The Beringers*, which did not succeed. More recently, the success of *Roseanne* and *Home Improvement* have led to a rash of clones, all starring stand-up comedians in family situations.

MOVIES

Three types of productions regarded as movies fill prime time on the broadcast television networks: (1) **theatrical feature films**, those made originally for release in theaters; (2) **made-for-TV movies**,

similar to feature films but made specifically for network television airing in a two-hour format containing commercial breaks; and (3) **miniseries**, multipart films made especially for broadcast airing in several installments. All three types share these major advantages for the networks:

- They fill large amounts of time with material that usually generates high ratings.

- They make it possible to air topical or controversial material deemed inappropriate for regularly scheduled network series.

- They permit showcasing actors and actresses who would otherwise never be seen on television.

The popularity of superstars such as Tom Cruise, Robert Redford, and Julia Roberts can be tapped by showing their movies. Many other stars, such as Dustin Hoffman, Kirk Douglas, or Katherine Hepburn, who would never agree to star in a TV series, are happy to be showcased in a miniseries or made-for-TV movie.

The three kinds of movies also share one major disadvantage—exceptionally high cost for the networks. Miniseries are typically the most expensive, and theatrical movies the second-most costly. Both are more risky in ratings than made-for-TV movies, but all three remain widely popular because they fill big chunks of time.

Theatrical Movies

The theatrical film or motion picture has been a mainstay of prime-time programming since the mid-1960s, but cutbacks in Hollywood production during the late 1960s and early 1970s caused severe shortages of features. At that time, many critics predicted a phase-out of theatrical films in television prime time. The 1980s, however, saw a revitalization of Hollywood film making. In 1980 only 120 theatrical motion pictures were made, but by 1985 the number had risen to 320, and by 1991 peaked at about 400, reflecting four fundamental changes in the motion picture business—changes in release dates, the addition of sequels,

expanded content targeting, and changes in release cycles. These four changes will be discussed in more detail next.

1. Release dates. Instead of the traditional head-to-head summer/winter release schedule, in the 1980s Hollywood studios began juggling release dates, providing a continuous flow of new films into the market (thereby lessening the effects of strong competition on other movies). For example, *Batman Forever, Judge Dredd, First Knight, Power Rangers, Pocahontas,* and *Species*—all major productions for the summer of 1995—would have been released at the same time in the old days. This method would have caused the inevitable box-office casualties major studios considered part of competition. The new strategy separated their release by a few weeks, allowing each movie to dominate entertainment news during its initial week, a period crucial to theater owners, who demand immediate success (or they pull the film). This strategy also had the unexpected advantage of increasing movie attendance steadily throughout the late 1980s and 1990s.

2. Sequels. During the last decade, Hollywood also began investing heavily in sequels such as *Superman II–IV, Star Trek II–VI, Rocky II–V, Batman II & III,* and so on. Such sequels benefit from built-in audience interest and involvement with the characters as well as from self-perpetuating promotion and reduced production costs. Some films, such as *Back to the Future II* and *BTTF III,* were filmed at the same time for separate, sequential release. The television networks often license sequels for showing during sweeps because they need relatively little promotion compared to made-for-TV movies and miniseries.

3. Expanded content targeting. In spite of endless complaints about the quality of movies today, a comparison of the film subject matter in the 1950s and 1960s with that of the 1980s and 1990s reveals much greater diversity in film topics today. Today's motion picture subjects range from period adventures such as *First Knight* to good old-fashioned romance such as *While You Were Sleeping,* to women's films such as *Forget Paris,* and

children's shows ranging from the politically correct *Free Willy II* to literary-based works such as *Indian in the Cupboard* to a talking pig named *Babe*. Even a few controversial social topics films pop up, such as *Pulp Fiction*. By increasing the diversity in subject matter, Hollywood has learned to thrive on big budget action films such as *Terminator 2, Batman Forever,* and *Waterworld,* melodramas such as *Silence of the Lambs,* sophisticated comedies such as *Hannah and Her Sisters,* romantic fantasies such as *Ghost,* slapstick comedies such as *Naked Gun I and II-1/2,* and even innovative children's features such as *Benji the Hunted.* Instead of narrow targeting to teenage moviegoers, the producers now design some films to appeal to a broad audience base (12 to 44 years). Some producers even began filming two versions of controversial scenes—one for the theater and a second done to meet television standards. These changes have made more feature film output useful to the television networks.

4. Release cycles. Perhaps most important of all to television, theatrical motion picture producers shifted to a new sales structure in the 1980s, allowing them to expand their financial base. During the 1960s, the average theatrical movie had a five-stage sales structure:

1. Release to the theaters.
2. Removal to storage.
3. About two years after the first release, an offer to the broadcast networks.
4. After first run, individual sales to affiliated stations.
5. Sale to independent stations, usually to become part of their permanent libraries.

Considering that seven of ten theatrical movies lose money (at least on paper) at the box office, this traditional sales structure yielded too little profit to justify expanding movie production.

By the 1980s, however, this structure had been transformed (see Chapter 11). Movies continue to be released first to theaters, but when box-office receipts begin to fall off (often in a couple of

weeks), a movie is usually shelved for several months, then **rereleased** for a second theatrical run. About six months after the final theatrical release, movies now appear in the **videocassette** market, first primarily for rental (at a high price), then several months later at a much lower price for sale to collectors (see 4.12). In the meantime, the movie may have appeared on **pay-per-view** television. At about the time videocassette movies go down in price, they are licensed to the **pay-cable networks**. After a pay-cable run, they are offered to the broadcast networks; then, after a couple of years, they become available to **affiliates** and **independent** stations.

Foreign release also expanded in the 1980s, allowing American films to draw in huge sums from foreign markets, often surpassing what they made in the domestic market. Agreements among producers and distributors, primarily with England and Australia, for wider distribution of foreign-made films in the American market also increased movie competition—to the advantage of television programmers.

Motion pictures pose other problems for the broadcast networks. Their popularity on network television is unpredictable. *Star Wars,* for example, got lower ratings than a competing made-for-TV movie. Also, many theatrical films contain violence or sexual content that must be removed before broadcast television airing. Several scenes had to be shortened and lines redubbed before *Risky Business* met network continuity standards for prime-time broadcast, and CBS's attempts to edit *Born on the Fourth of July* actually resulted in a long-term postponement although it had already appeared in the 1990–91 schedule. Editing for television often destroys the flow of a film and may anger viewers. Moreover, the networks now compete with pay cable and with original syndication for the top theatrical films, driving the price for such movies up. Films reaching cable before the networks can show them frequently exhaust mass audience interest, resulting in fewer such films being aired on network television. The theatrical film, even if it became available in unlimited

4.12 SELL-THROUGH VIDEOS

The multipart release pattern currently in use for movies may shift again in the 1990s as advertisers seek to get into the game. The videocassette of the 1986 feature film *Top Gun* contained a built-in Pepsi commercial. This addition permitted an unusually low initial price for the cassette. In spite of the commercial, *Top Gun* enjoyed the largest sale by a cassette up to that time. This success story opened up a new arena for advertisers. Now many major films released on video contain at least one advertisement, and most contain previews of other releases. However, the addition of advertising has not lowered the initial high price for cassettes. Movie distributors soon discovered they could make money from the advertisement and still sell the cassette at a high price.

By the 1990s, the initial cost of a videocassette was not determined by the cost of distribution or copying the film but by the potential for *sell-through*—the number of people who would rather own the tape than rent it. High sell-through candidates such as *Batman Forever* and Disney's *Pocahontas* are usually priced low and released near Christmastime, while less likely candidates for purchase go through the traditional two-stage price release. In contrast, the industry experimented with 1991's top sell-through, *Ghost*, by releasing it at a very high initial price and scheduling a lower priced release for many months down the line; the sell-through potential was so great that the public would still buy the movie even after it had been widely circulated in video rental stores. The success of this strategy may signal an end to initially low sell-through pricing for blockbuster films.

supply, would not be a panacea for the shortage of network programming.

Made-for-TV Movies

Many viewers and critics bewail the disappearance of the dramatic anthology format, sets of single-episode television plays presented in an unconnected series. But in reality, the anthology format went through a style change in the late 1960s and returned as the made-for-TV movie. During the 1955–56 season, the very peak of the anthology era, dramatic anthologies made up about 526 hours of prime time. By 1981–82, made-for-TV films surpassed that total. In 1989–90, a peak year, 624 such movies aired in prime time (not including those made for cable). The best of these movies compare favorably with the best of the dramatic anthologies of the earlier era. For example, *Marty* and *Requiem for a Heavyweight* were classic plays in anthologies, while *A Message from Holly*, *The Silence of Adultery*, and *In a Child's Name* were made-for-TV movies of the same caliber, filling the equivalent role in programming fare.

In the later 1970s, the made-for-TV movie replaced the pilot as the major method for testing out new series ideas. Programs such as *Walker, Texas Ranger* and *Due South* succeeded as television movies before becoming series. Made-for-TV movies as pilots have four distinct advantages:

- They can be profitable.
- They can target a desired demographic group.
- Audiences and affiliates like them.
- They have syndication potential.

Such pilots pay their way whether or not the concept ever becomes a series. Even when such a series later fails, the networks usually have made a healthy profit on the made-for-TV movie's initial run and on the normal advertising revenues from the run of the weekly series. Moreover, the made-for-TV movie has the advantage of being made to

order to fit within a network's existing schedule. It can target a specific audience to maintain a night's flow and avoid the disruptions that theatrical movies often cause.

As a result, the made-for-TV movie pilot has become very popular with networks, affiliates, and, fortuitously, with audiences. The ratings for some of these films equal and even surpass those for feature films shown on television. All of the top ten movies shown on network television during 1994–95, for example, were made-for-TV movies. They also have an aftermarket (revenue streams after network airing): Such movies often command high ratings in syndication and sell well as videocassettes. Many have been sold as theatrical films in foreign markets. This flexibility, their popularity, their precise targeting, and revenue advantages over regular videotape pilots, and the fact that the average made-for-TV movies cost half the license fee of the average Hollywood theatrical movie, have established this format firmly in the economics of network television.

Miniseries

The success of specials and limited series on PBS's *Masterpiece Theater* led the commercial networks into the production of multipart series presented in three to six episodes on successive nights or in successive weeks. Called miniseries, they run for as long as ten or more hours. The best known of recent miniseries include *The Stand, Gettysburg,* and *Scarlett.*

Miniseries typically begin and end on Sunday nights, the night of maximum viewing. Shorter miniseries tend to be scheduled on sequential nights, while longer series, such as *North and South, Books 1 and 2,* stretch over two weeks, skipping the evenings on which the network has its most popular programs. Because of their exceedingly high cost, miniseries are usually only created for sweeps periods.

Both *Roots* (1975) and *The Thorn Birds* (1983) were produced at enormous cost, and both gained unusually large audiences and high revenue. *The Thorn Birds,* for example, averaged a 41 rating and an extraordinary 59 share, making it the second-highest rated miniseries, just behind *Roots* (average 66 share over eight consecutive nights). Aside from winning high ratings and beating the competition, the networks derived considerable prestige and critical acclaim from these programs, which helped to justify the heavy investment. Some miniseries, such as *Rich Man, Poor Man* and *How the West Was Won,* have been turned into regular series, further reducing the financial risk involved.

By the 1980s the costs for **long-form miniseries** (10 hours or more) had skyrocketed to the point that the 30-hour *War and Remembrance* was estimated to cost more than $100 million. At the same time, ratings for such long-form series dropped sharply, losing tens of millions of dollars without bolstering the network's overall ratings position. As a result, in the late 1980s the networks switched from long-form to **short-form miniseries** (4 to 6 hours). Shorter series such as *Tom Clancy's Op Center, Million Dollar Babies,* and *The Burden of Proof* reduced the networks' financial risks and limited the damage that failures could cause to the overall ratings.

However, the success of *Lonesome Dove* single-handedly pulled CBS out of its 1989 rating doldrums, clearly showing that the traditional long form can still be a major factor in network rating strategies. Networks also value the prestige that comes from successful long-form miniseries such as *North & South* and *Love and War,* and when planning the next year's special schedule, some concepts always sound like winners. Consequently, even though the long form may be limited to one or two projects a season, both short-form and long-form miniseries are here to stay because of:

- Blockbuster ratings
- Prestige
- Critical acclaim
- Series potential

By the 1990s the network had also changed the way long-form miniseries were presented. Instead of making one program that ran 10 to 24 hours on successive nights, the networks turned to series that filled as much time but could be separated into several made-for-television movies and shown at the rate of one every one to two months. This strategy worked well with the reintroduction of the old favorites *Perry Mason* and *Columbo* and with the new limited series *Desperado*.

NETWORK DECISION MAKING

Few program decisions precipitate as much controversy as cancellation of programs. Since commercial television is first of all a business, with tens of thousands of stockholders and hundreds of millions of dollars committed for advertising, the networks' overriding aim is to attract the largest possible audience in the ideal demographic range at all times. Networks always aim at the number one position. Traditionally, ratings have been considered the most influential prime-time programming variable, and the networks make many controversial decisions each year based on these numbers. This often results in (1) canceling programs favored by millions of viewers, (2) countering strong shows by scheduling competing strong shows, (3) preempting popular series to insert special programs, and (4) falling back on reruns late in the season when audience levels begin to drop off.

However, the type of program, the ranking compared to the competition, the size of production fees, and the target demographic group may be as important as the ratings in cancellation decisions. New situation comedies and reality-based series are more likely to be held than other kinds of series producing equivalent ratings. Also, series with low production fees are more likely to be held than more expensive programs, and finally, series that appeal to the network's concept of "proper demographics" may be held even when ratings are low.

Programming Styles

The three older networks have exhibited distinctive scheduling "styles" in past decades. For example, ABC tends to keep its schedule intact longer than does either CBS or NBC. It has traditionally used more spinoffs than the other two networks, and it typically aims new shows more directly to the young adult (16 to 34 years) audience, as does Fox. (See 4.13 for an illustration of NBC's style changes.)

CBS usually budgets heavy promotional blitzes to entice viewers into sampling new series and has traditionally pulled more older viewers and more of the rural audience. This continues to be the case into the 1990s. When CBS recognizes program weaknesses, it tends to pull the slow starters off the air, replacing them with specials, as the network undergoes salvage operations. CBS has also developed a reputation for moving strong series around even more than the other two networks. Rescheduling strong new series in new time slots combined with quick cancellations of weak series led to public relations problems for the network in the mid-1980s, eventually forcing reinstatement of the canceled series *Cagney and Lacey*—even resulting in a network apology to fans for the frequent shifts of *Designing Women*.

In addition to exhibiting more patience with **slow-builders** than either CBS or ABC, NBC defied conventional programming wisdom in the 1980s by diversifying into program types that most experts (especially at the advertising agencies) claimed had only a limited appeal at best. For example, *The Cosby Show*'s producer first offered the show to ABC, which rejected it in the belief that modern audiences would not accept traditional values embodied in light family comedies. NBC also took a chance with *Golden Girls*, even though experts said a young audience would reject a program starring older women. Similar moves toward program diversity can be detected in series such as *ALF*, *Miami Vice*, *Amen*, and *L.A. Law*, which helped make NBC the leader in programming innovations in the late 1980s. However, heading

4.13 PATIENCE IS A VIRTUE

In the mid-1970s and early 1980s, NBC had dozens of program failures. Unwilling to extend patience then, it yanked unproductive entries before they could endanger the overall ratings of a night. This strategy seems to have only made the problem worse, and in 1978 and 1979 NBC hit bottom, starting the 1978 season with only 8 established series (compared to 18 for ABC and 15 for CBS). During the year, 4 more of NBC's 8 established series failed, while only 5 of its new series held on.

The network's frantic schedule manipulation may, in fact, have increased rather than decreased NBC's ratings difficulties. Realizing it could no longer afford the luxury of quick cancellations at the first sign of weakness, NBC reversed this strategy in the 1980s, holding onto their almost-successful series. A program such as *Hill Street Blues* illustrated the strategy of leaving a show alone as long as possible to afford the maximum opportunity for audience exposure. It had a disappointing start during the 1980–81 season, but NBC had confidence that ratings would improve as the audience "discovered" the show. That confidence was rewarded in the next broadcast season, when *Hill Street Blues* climbed slowly from an average rating of 13.3 to a respectable 18.4 (and an average share of 31) for 1981–82.

Encouraged by the success of this scheduling strategy, NBC further distanced itself from the other two networks in the mid-1980s by holding onto a high percentage of its low-rated new series, demonstrating a more patient style. As the network entered the 1990s, however, it returned to the traditional practice of demanding fast success, indicating that they had learned very little from history.

into the 1990s its shows are aging, the architect of its successes, Brandon Tartikoff, has departed, and the network seeks anxiously for its next hit.

Fox built its reputation by offering viewers an "alternative" to the Big Three networks while maintaining network quality (big budgets). Fox also went after innovative programs targeting children and young males, notably represented by hit animated shows on Saturday morning and on weekday afternoons, urban comedies such as *Martin*, and youth-oriented shows such as *90210* and *Melrose Place*. Fox also pushed the bounds of accepted taste with *Married . . . with Children*, a family that seems to have all the vices and none of the traditional virtues, and *X-Files*, a story built around the occult, government conspiracy, and horror. Such moves led to critical success in the late 1980s, followed by ratings success in the early 1990s.

Following NBC's and Fox's lead, ABC also attempted its own diversification in the late 1980s and early 1990s, with series such as *Moonlighting*, *Max Headroom*, *Roseanne*, and *Lois & Clark*, capitalizing on an expected "yuppie" bias in the peoplemeter ratings method. This strategy worked well enough to keep ABC the number one network for much of the 1990s. By 1990, even CBS was taking a few chances with shows such as *Northern Exposure* and *Dr. Quinn, Medicine Woman*, but it continued to be more conservative in its offerings than the other three and canceled unusual ideas more quickly.

The move toward program diversity should not be overrated. In most cases, seemingly innovative programs merely vary the established situation comedy and crime drama formats that dominate prime time. None of the networks expect to revive such once-popular formats as variety shows,

science fiction, or costume drama (except in specials). In a 1986 interview on *Entertainment Tonight,* former network programmer Fred Silverman suggested that revivals of such offbeat formats were designed to fail as part of a strategy of offering expensive, unusual series to bring in new viewers; once people grow used to tuning in, however, the network cancels the expensive series, replacing them with cheaper, more conventional series, assuming that many viewers will continue to watch out of habit.[21] This continues to be the rule even in the face of original syndicated success with programs like *Babylon 5, The Legendary Journeys of Hercules, Baywatch,* and *Forever Knight.*

Critics and Censors

Critical approval and the extraordinary promotional opportunity that public acclaim provides also figure in decisions to cancel or hold low-rated new programs. Acclaim usually has some effect only in the absence of other rating successes. The kudos for *Hill Street Blues,* for example, bolstered NBC's image at a time when it was sorely in need of prestige, persuading programmers to stick with the show even in the face of low ratings. However, the fact that Grant Tinker was both head of NBC programming and producer of *Hill Street Blues* may also have been a contributing factor. Even so, under Tinker's direction in 1982–83, slow starters such as *Mama's Family, Cheers,* and *St. Elsewhere,* which might well have been canceled during Fred Silverman's earlier NBC tenure or Brandon Tartikoff's later time, remained in the prime-time schedule. The same connection between critical acclaim and patience even in the face of low ratings can be seen for the low-rated *Party of Five* on Fox. Sometimes the networks decide to go along with the critics, at least until something with better numbers comes along.

Despite such exceptions, the industry depends almost totally on *early ratings* to determine a show's fate, because the major advertising agencies use these figures as the primary basis for buying network time. As of 1995, a single rating point

translated into an estimated 959,000 homes. Over the course of a year, this one point represents more than $70 million in network pretax profits (if the point comes from one of its three broadcast competitors). Small wonder then that ratings rule the networks, public irritation with the process notwithstanding.

The broadcast **Standards and Practices Department**, a behind-the-scenes group, exercises total authority over all network programming. Cynically and often angrily called "censors," the department acts as policeman and judge for all questions concerning acceptability of material for broadcast. It often finds itself walking a thin line between offending viewers or advertisers and destroying imaginative programming that may pull in high ratings. It decides between the imaginative and the objectionable. Members of the department read submitted scripts, attend every rehearsal, filming, or taping, and often preview the final products before they are aired. If, in the department's judgment, a program fails to conform to network standards in matters of language or taste, it can insist on changes. Only an appeal by the chairman or president of the company can overturn its decisions.

Over the years, the department's criteria for acceptability have changed. In the early 1920s one of the hottest issues was whether such a personal and perhaps obscene product as toothpaste should be allowed to advertise over the radio airwaves. By 1983 the hottest question was whether or not NBC's censors would permit a new series, *Bay City Blues,* to air a locker-room scene that included nude men photographed, as the producer put it, "tastefully from the back." By the mid-1980s, child abuse, abortion, and homosexuality were the problematic topics, while the 1990s brought the thorny questions of AIDS, condoms, obscene language, and, as always, how explicitly sex could be shown.

The Standards and Practices Department decides acceptability on a show-by-show basis. While decisions may seem arbitrary, the censors normally follow certain guidelines. For example, a program's perceived audience is an important factor. A show

appealing to children will be regulated much more heavily than one aimed at adults and scheduled later. The program's daypart is also a major consideration. Traditionally, the censors have been much easier on series run during the morning or early afternoon (most notably, the soap operas) than on programs run during prime time. Also, censors tend to be more liberal with specials, miniseries, and made-for-TV movies than with regular weekly series.

During the mid-1980s, broadcast Standards and Practices departments increasingly found themselves fighting organized audience objections to what some perceived as an overly permissive network attitude toward sex. Indeed, content analyses of TV programs showed that the sexual intercourse mentioned on television occurred mostly outside of marriage as a result of one-night stands and that abstinence was depicted as a physical impossibility, a sign of mental illness, or, as shown on one *Beverly Hills 90210* episode, a sign of homosexuality. In 1994–95, *NYPD Blue* broke new ground by showing more nudity than ever before and more graphic sex scenes, resulting in many affiliates refusing to air the series. Feminists, religious fundamentalists, and other groups denounced this portrayal of sex without love or consequences.

At the same time producers, gay groups, and other liberal organizations were demanding even more graphic and controversial portrayals of sex in prime time. Cost cutting measures at the networks were also resulting in fewer "Network Censors" to go around, and producers had learned a new trick to get objectionable scenes into prime-time series: Producers would write "worse" scenes than they hoped to shoot, knowing the censors would object, leaving the producers to "compromise" by submitting the version of the scene that had been planned from the start. Standards and Practices executives often gave in to this ploy. As a result, prime-time television continues to push hard at the evolving bounds of good taste.

The networks now battle advertisers more than the producers or the public over content standards. However, in 1995 a new element was added when government began a move toward requiring the so-called V-chip in television. This would require programmers to rate shows on violence and sex (just as in the movies) and would allow parents to lock out shows with certain rankings. The industry unsuccessfully fought the idea as unnecessary censorship.

Risk and Competition

The three major networks prowl for the breakthrough idea—the program that will be different but not so different as to turn away audiences. *The Cosby Show* was one such show during the 1984–85 season, as was *ALF* in 1986–87. *Married . . . with Children* astonished viewers in 1987, *Roseanne* made a splash in 1988, and *Friends* reintroduced the buddy sitcom in 1995.

In recent years, however, all four networks have had entire seasons without a single new hit. In truth, network programmers can only guess what the next hit will be and why it succeeds. A program failure is easier to analyze. It can result from the wrong time period, the wrong concept, the wrong writing, the wrong casting, poor execution of a good idea, poor execution of a bad idea, overwhelming competition, the wrong night of the week, and a dozen other factors. Conversely, success is very hard to analyze or copy.

Playing it safe with formats known to satisfy audiences is a normal reaction on the part of network executives. Considering the high stakes involved, most program executives naturally resist any program that can be described as a trailblazer until they have nothing to lose. Those programmers who dare to depart from the formulas, however, may occasionally enjoy the fruits of such standout hits as *The Simpsons* or *X-Files*. Indeed, the current rate of program failure suggests that the unusual might be less risky than sticking to copies of old series. But given the rapid turnover in network presidents and vice-presidents of programming during the 1980s, iron nerves are required to allow a really new idea to remain on the schedule long enough to attract a significant following.

SUMMARY

Network prime-time television programming remains a high-risk undertaking. Large amounts of money, prestige, and public interest are at stake. For all of their dollars, their care, their studies, their testing, their research, their meetings, their professionalism, and their strategies, the networks' high hopes for most new programs are repeatedly dashed in a matter of weeks each new season. Cancellation often irritates audiences, but networks point to inadequate ratings (translating into inadequate profits) and swing the ax anyway.

The networks sometimes ensure low ratings for programs by scheduling them against runaway hits or established series or by excessive churn (time shifts). Nine factors affect a proposed program's selection from among the hundreds of concepts, scripts, and pilots. Among them, resemblance to past successes weighs more heavily than originality; costs weigh more heavily than the talent's appeal; competitiveness weighs more heavily than compatibility.

Scheduling strategies such as leading off with a strong program, hammocking, blocking, tentpoling, and stunting are intended to bolster newcomers and create audience flow within a single network's prime-time schedule, whereas the goal of counterprogramming is to interrupt flow to attract the competitors' audiences. However, there is little evidence that such strategies actually make a difference, at least as far as new programs are concerned.

Although annual program introductions shifted from all-in-the-fall to a two-season and then to a continuous-season sequence, program formulas remain much the same from year to year and from network to network. The dramatic anthology was revived as the made-for-TV movie. But the variety that once characterized prime time has disappeared. Three formats—sitcoms, news/reality series, and movies—dominate the schedule.

Network prime-time programming uses conservative strategies because of the enormous risks to individuals and revenues. Continuing audience defections, the breakdown of program scheduling strategies, and mounting program failure rates suggest that viewers are hungry for modest amounts of originality and for scheduling stability. Scheduling practices based largely on mass audience complacency, habitual viewing, or repeating what works for another network may be outmoded in a television environment of VCRs, miniature satellite dishes, and dozens of cable channels. Audience targeting and viewer satisfaction may become the keys to future nationwide broadcasting.

SOURCES

Auletta, Ken. *Three Blind Mice: How the TV Networks Lost Their Way.* New York: Random House, 1991.

Cantor, Muriel G. *The Hollywood TV Producer: His Work and His Audience.* New Brunswick, NJ: Transaction Books, 1988.

Goldenson, Leonard H., with Marvin J. Wolf. *Beating the Odds: The Untold Story Behind the Rise of ABC: The Stars, Struggles, and Egos that Transformed Network Television by the Man Who Made It Happen.* New York: Scribners, 1991.

Montgomery, Kathryn C. *Target: Prime Time. Advocacy Groups and the Struggle over Entertainment Television.* New York: Oxford, 1989.

Paisner, Daniel. *Horizontal Hold: The Making and Breaking of a Network Television Pilot.* New York: Birch Lane Press, 1992.

Shapiro, Mitchell E. *Television Network Prime-Time Programming, 1948–88.* Jefferson, NC: McFarland, 1989.

Tartikoff, Brandon, and Leerhsen, Charles. *The Last Great Ride.* New York: Turtle Bay Books, 1992.

Thompson, Robert J. *Adventures on Prime Time: The Television Programs of Stephen J. Cannell.* Westport, CT: Praeger, 1990.

Tinker, Grant, and Rukeyser, Bud. *Tinker in Television: From General Sarnoff to General Electric.* New York: Simon & Schuster, 1994.

Variety. Weekly trade newspaper of the television and film industry.

NOTES

1. Alvin Toffler, *Power Shift*. (New York: Bantam Books, 1990), p. 5.

2. Max Alexander, "New Study Measures VCR Invasion of Primetime," *Variety*, 15 October 1990, pp. 38–39.

3. Of course, "failure" for a network most likely meant reconstitution as syndicators and producers or sale or merger, not outright bankruptcy or disintegration.

4. Spots in *Seinfeld* went for as much as $1 million for 30 seconds in 1995 because of its appeal to viewers most desired by advertisers.

5. "Programming" by Paul Klein in *Inside the TV Business*, Steven Morgenstern, ed. (New York: Sterling, 1979), pp. 11–36.

6. William J. Adams, "Patterns in Prime-Time Network Television Programs from 1948 to 1986: The Influences of Variety, Churn and Content, with Models for Predicting Nightly Ratings" (Ph.D. dissertation, Indiana University, 1988).

7. William J. Adams, "Changing Rating Patterns for Prime Time Connected to the People Meter," *NAB Report*, Winter 1991, pp. 14–37.

8. "The Fall Guys," *Broadcasting*, 1 April 1991, pp. 35–41; David Kissinger, "Zap-Happy Fellas Widen Ratings Gender Gap," *Variety*, 25 February 1991, pp. 59, 63.

9. Strikes by actors, writers, and technicians have an impact on the length of a season. A delayed fall start, for example, may result in a shorter-than-usual season, at least for one of the networks. See Jeremy Gerald, "A Season the Networks Would Rather Not Repeat," *New York Times*, 16 January 1989, p. 26.

10. The disastrously high level of program failure for all four broadcast networks in fall 1991 led Fox to reject the entire idea of seasons and premiere weeks. The network announced plans to introduce new episodes and new series whenever they were ready, although this may change as Fox becomes more established as a mainstream network.

11. For more information on double jeopardy, see William N. McPhee, *Formal Theories of Mass Behavior* (Glencoe, IL: Free Press, 1963).

12. For example, one study (William J. Adams, "TV Program Scheduling Strategies and Their Relationship to New Program Renewal Rates and Rating Changes," *Journal of Broadcasting & Electronic Media*, Fall 1993, pp. 465–474) showed that half of first-ranked new series got lower ratings than the previous program in the same time slot but were renewed anyway. At the same time, peculiarly, only about 40 percent of third-ranked series that had improved the ratings for their time slots got renewed. In short, the networks seem to hold first-ranked series and dump third-ranked series regardless of their performance. The same study showed that 80 percent of the new series that increased the ratings for their time slot by more than 2.5 points and that were scheduled in a slot already ranked in the top third of the ratings were renewed, while only 59 percent of the series showing the same improvement, but in slots ranked in the bottom third of the ratings, were renewed.

13. Brian Lowry, "Development Execs Do Summer Shuffle," *Variety*, June 20, 1994, pp. 19–20.

14. The big guns of the past had their own views. Fred Silverman, for example, was said to make performer appeal his number one consideration. William Paley traditionally supported updated forms of older ideas. Brandon Tartikoff weighed counterprogramming considerations more heavily.

15. While a strong lead-in improves a new program's chances somewhat, it rarely increases the ability of the series to improve the ratings for its time slot for long. In most cases over the last two decades, the ratings for new series placed after a strong lead-in show are not different from those for new shows having no lead-in or a weak lead-in. The power of the lead-off and lead-in may be more myth than actual in the present television environment: a self-fulfilling prophecy in which programmers expect it to work and therefore see to it that it does.

16. Of the ten programming strategies, blocking is also the only one, based on recent rating studies, that actually increased a new series' chance to significantly improve the ratings for the time slot it was placed in (William J. Adams, "Changing Rating Patterns for Prime Time Connected to the People Meter," *NAB Report*, Winter 1991, pp. 14–37).

17. J. T. Tiedge and K. J. Ksobiech, "Counterprogramming Primetime Network Television," *Journal of Broadcasting & Electronic Media*, 31, 1987, pp. 41–55.

18. Susan Tyler Eastman, Jeffrey Neal-Lunsford, and Karen E. Riggs, "Coping with Grazing: Prime-Time Strategies for Accelerated Program Transitions," *Journal of Broadcasting & Electronic Media*, 39:1, Winter 1995, pp. 92–108.

19. Signing a $1.68 billion deal for Major League Baseball for 1996 through 2000 by Fox, NBC, ESPN, and Liberty Media (owned by TCI) surprised many insiders because baseball appeared to have such a poor reputation with many fans after the players' strike in 1994–95.

20. *Our World* is a case in point. At $450,000 per hour-long episode, the series was well below the average in 1986; it won critical acclaim and made money for the network, even though it was usually last in the ratings. ABC intended to renew it in 1987, only to find its affiliates, who did not share in the network's profit, refusing to clear the time without better ratings. Unable to improve the show's ratings sufficiently, ABC ultimately canceled *Our World*. CBS introduced *48 Hours* in 1988 to showcase anchor Dan Rather and bolster the sagging morale of its news department following massive staff layoffs in 1987. Even though the network continues to offer the series, clearance by its affiliates remains problematic as the ratings stay low. Information formats, however, generate favorable publicity and easy profit for the networks, suggesting that they will remain among new prime-time offerings, even if most are quickly canceled.

21. Fred Silverman, "Discussions of the New Season," interview on *Entertainment Tonight*, 13 September 1986.

Chapter 5

Nonprime-Time Network Television Programming

David Sedman

A GUIDE TO CHAPTER 5

If prime time is the destination for all the exciting, high-budget network programs, you might think the rest of the day must be pretty dull and unimportant. Not true. Afternoon soap operas and late-night comedy are frequently the most provocative and profitable shows on the network. Because these programs are less expensive to produce than their prime-time counterparts, the potential for profit is often greater.

The viewers for shows outside the prime-time daypart are often more fickle and more loyal to their programs. Many football fans plan their whole week around Sunday afternoon professional games. Any programmer who preempts a soap opera for a special program will receive many unpleasant letters and phone calls.

A programmer cannot ignore nonprime-time programs. If nothing else, there are many more hours outside of prime time than inside. The three major networks have separate divisions that schedule nonprime time. Fox is excluded from much of the following discussion because it has much less nonprime-time programming than ABC, CBS, and NBC.

NONPRIME-TIME NETWORK DAYPARTS

Nonprime time describes programming dayparts other than prime time. The broadcast television networks program some or all of the following dayparts (reflected in Eastern/Pacific times):

Weekday Programming

Overnight	2:05 A.M.–6:00 A.M.
Early morning	6:00 A.M.–9:00 A.M.
Daytime	10:00 A.M.–4:00 P.M.
Early fringe	4:00 P.M.–6:00 P.M.
Early evening	6:30 P.M.–7:00 P.M.
Late night	11:35 P.M.–2:05 A.M.

Weekend Programming

Weekend mornings	8:00 A.M.–1:00 P.M.
Weekend afternoons	1:00 P.M.–7:00 P.M.
Weekend late-night	11:00 P.M.–1:00 A.M.

The audience level in nonprime-time dayparts falls considerably below that of prime time. However, all nonprime-time dayparts contribute competitively and economically to the network's performance. There is big money in daytime programming.

Programming executives responsible for nonprime-time dayparts are as dedicated to competing for available viewers as are their prime-time counterparts. In prime-time programming, the "war" is fought night to night and measured in daily ratings gains or losses. Although daily ratings are important to shows in nonprime time, the battle is to get viewers in the habit of watching weekday nonprime-time programs *everyday* from week to week. Of the 15 longest running network series, 14 are nonprime-time series (see 5.1).

In prime time, ratings range from a low of 1.5 to a high of 21.0 between the bottom-rated and top-rated network shows in a given week. This variation translates into vastly differing advertising rates and profit ratios for the network. In nonprime-time programming, a typical range for daytime is from 1.0 to 7.5, quite a different ballgame. The revenues generated are therefore more modest, and programmers use a *low-risk approach* in building their schedules.

A low-risk programming strategy is one in which the programmer concedes that "blockbuster" ratings and the accompanying high advertising rates are virtually impossible to attain. A more conservative approach is taken, which limits production costs and uses tried and true formats. Developing a schedule using a different series each weekday would be a very risky programming venture. Programming is therefore scheduled on a Monday-through-Friday basis (**stripped**). This allows viewers to build ongoing loyalty to a series while lowering the financial risks involved in program developments. To program effectively in nonprime time, the networks must assess the potential audience. Programmers examine HUT levels, clearances, potential advertisers, and likely demographics of audience members.

5.1 LONGEST RUNNING NETWORK SERIES

Nonprime-time series are among the longest running programs in TV history. Only one of the top 15 series, Walt Disney, had its entire run in prime time; all others are nonprime-time series.

Top 15 Longest Running Programs in Network TV History as of 1995–96	Years
1. *Meet the Press*, NBC (premiered 1947)	49
2. *The Guiding Light*, CBS (premiered 1952)	44
3. *The Today Show*, NBC (premiered 1952)	44
4. *Face the Nation*, CBS (premiered 1954)	42
5. *The Tonight Show*, NBC (premiered 1954)	42
6. *As the World Turns*, CBS (premiered 1956)	40
7. *ABC's Wide World of Sports*, ABC (premiered 1961)	35
8. *Search for Tomorrow*, CBS & NBC (1952–87)	35
9. *Walt Disney*, ABC, NBC & CBS (1954–83; 1986–90)	34*
10. *General Hospital*, ABC (premiered 1963)	33
11. *CBS Evening News*, CBS (premiered as 30 min. series,[1] 1963)	33
12. *NBC Nightly News*, NBC (premiered as 30 min. series,[1] 1963)	33*
13. *The Price Is Right*, NBC, ABC & CBS (1956–65,[2] returned 1972)	33
14. *Another World*, NBC (premiered 1964)	32
15. *Days of Our Lives*, NBC (premiered 1965)	31

Notes: *Series title varies; [1]ABC, CBS, and NBC have each had regularly scheduled newscasts prior to the 1950s; [2]*Price Is Right* had a concurrent prime-time run from 1956 to 1964 and two brief runs on prime time in 1986 and 1993.

HUT Levels

Unlike prime time, where HUT levels (households using television) are around 60 percent, HUT levels in nonprime time can be less than 10 percent. Tiny HUT levels limit the potential ratings, which in turn can limit advertising revenue. The programmer must analyze the composition of the viewers who might be watching in the particular daypart when building a schedule of programs.

When fewer people are watching, the opportunity to create a winning franchise for a time period does not suffer. Even small audiences have value to advertisers. In fact, many clients cannot afford to advertise in prime time, so creative programming targeted to the "right" small audience is often very attractive to sponsors. Weekends are a good example. Viewers who tune in on the weekend have a different mindset than do prime-time viewers. They often want more movies or sports than they have time for during prime time. Larger chunks of leisure time can offset the smaller HUT levels: Viewers wind up spending more time watching television, despite their smaller numbers.

Clearances

Nonprime time and prime time also differ in relation to affiliate clearances. When a network makes a program available, an affiliated station has three

options: It can clear the program, it cannot clear it (**preemption**), or it can ask permission to air the program at a later time. When an affiliate agrees to clear a series, it commits itself to carrying the program at the time the network specifies. In some instances, the affiliate decides it will carry the program at a different time. This is referred to as **delayed carriage** and is discouraged by the networks because it hurts the national ratings (especially when major-market stations do it). Excessive acts of delayed carriage are one reason public television's ratings appear so low. Most affiliates clear about 90 percent of their network's total schedule. Prime-time programming is generally cleared by affiliates.

Nonprime-time clearance rates are usually very low in comparison to prime-time rates. In a rather shocking move after nearly 50 years, NBC (which ranked third in daytime programming throughout the 1980s and early 1990s) decided to scale back its daytime schedule from five and a half hours to four hours because of low clearances. When NBC began a daytime talk show in 1994 called *The Other Side*, the show got only a 61 percent clearance rate; almost 40 percent of NBC's affiliates decided to schedule syndicated series instead of *The Other Side*, leading to its weak ratings and eventual replacement in 1995 by a news hour *Real Life*. When CBS premiered the talk show *The Late Late Show* featuring Tom Snyder in mid-season, the "live" clearance rate was 30 percent. In this case, the network's affiliates decided either to preempt or, more commonly, delay the show. Low clearance rates were obviously a major factor in the low ratings these shows received in their premiere seasons.

Besides eroding its size, nonclearance also changes the nature of the national audience for the series. For example, an ABC affiliate that carries *Nightline* following the local newscast provides a stream of viewers who are looking for information. When *Nightline* is delayed to allow the affiliate to carry a sitcom, some of the potential audience goes to bed. The delayed *Nightline* is less likely to attract a large audience when it follows comedy rather than news.

Parity exists when all three networks reach approximately the same number of households in a given daypart. When too many affiliates of one network refuse to clear a particular time period (because a low-rated program is scheduled, for example), that network no longer has any chance of massive improvements in that program's ratings because ratings are a percentage of total U.S. households. And, of course, the network's overall rating is affected, which in turn affects its advertising rates and therefore its profitability.

Advertisers and Demographics

A network determines which segment of the available audience it will target, mindful of its competitors' programming and influenced to some degree by advertiser support for its programming. The network programmer's task is to put together a schedule of programs that will, at the lowest possible cost:

- Attract the most desirable demographic groups
- Maximize audience flow-through
- Build viewer loyalty
- Capture the largest possible audience

One big difference between the major dayparts is that audiences nonprime-time dayparts are more homogenous than prime-time audiences. Typically, three networks schedule the same program type head-to-head, which creates fierce competition (all soaps, all talk, all games, all soft news, and so on). When determining the shows for a particular daypart, the networks give primary consideration to these elements:

- Demographics of available audiences
- Competitive counterprogramming opportunities
- Economic viability

Indirect influences on programming practices also come into play. Daytime programs rely on drug and food companies for advertising revenue.

Hence, programmers are wary of scripts or interview programs that tackle subjects such as tampering with painkillers or rat hairs in cereal. Daytime programming is in much closer touch with its advertising messages than prime time for several reasons: daytime programs contain more commercial minutes per hour; a tradition of sensitivity to advertisers is well established, arising from the early days of sponsor-produced programs; and General Foods and Procter & Gamble dominate the advertising time (and cannot be offended).

EARLY MORNING PROGRAMMING

Early morning programming (6 A.M. to 9 A.M.) has followed a consistent pattern on the broadcast networks for decades. Viewers have come to depend on ABC, NBC, and CBS for news coverage with accompanying weather and assorted features as they start their day.

One of the intricacies of early morning television programming concerns the time zone differences. Prime time in the Eastern time zone is 8 to 11 P.M. and translates to 7 to 10 P.M. in the Central time zone, but because the shows are seldom live, there are few problems. In early morning programming, however, the daypart begins at 6 A.M. in *all* time zones and ends at 9 A.M. in *all* time zones. Hence, morning programs are generally shown live in the Eastern time zone. However, in the Central time zone, programs are tape delayed by one hour or, in rare instances in which the morning show covers live breaking news occurring at 8 A.M. (ET), are seen live for the first hour with the second hour shown on tape. The shows are always tape delayed in the Mountain and Pacific time zones.

Unlike prime time where series may be given a premiere, be moved, and placed on hiatus within the same month, the early morning programming lineup remains fairly consistent. The reward for programmers has been a fairly consistent audience for their long-running series.

Early Newscasts

All three networks provide an early newscast Monday through Friday from 5:30 to 7 A.M. The networks hope to bolster their 7 A.M. programming by getting flow-through from these programs. However, they also realize that many affiliates produce their own morning news shows. Therefore, they try to accommodate affiliates with multiple feeds of these early newscasts and produce the newscasts with flexibility in mind. They all have beginning and end points at the top and bottom of each hour. Hence, an affiliate can "dump out" or join a morning newscast after 30 minutes or 60 minutes.

NBC News at Sunrise and *CBS Morning News* are both designed as half-hour programs. To increase clearance levels, NBC and CBS offer their affiliates the option of carrying either 30 minutes or 60 minutes of the early newscast to mesh with local news schedules. *ABC's World News This Morning* functions in much the same manner. The exception is that ABC's early newscast is divided into six 15-minute segments. All shows provide business news, headlines, weather, and sports, but the pace is slower than in prime time.

Morning Magazine/ Infotainment Shows

Generally, the networks have offered **magazine format** programs between 7 A.M. and 9 A.M. *Today* and *Good Morning America* have been around in their original time period since the 1960s and 1970s. These series provide news headlines, weather forecasts, and interviews ranging from soft entertainment to hard news. They are called magazines because they resemble print publications, containing a series of feature articles, a table of contents at the beginning informing viewers of what will be on that day, and are bound together with a common cover and title.

The magazine structure succeeds during the early morning daypart because viewers are not necessarily sitting in front of their sets for extended periods of time. Rather, they are getting

ready for the day ahead and catching short glimpses of television. The magazine format, with its multiple segments, allows the viewer to watch for short periods of time and see complete items. In addition, the news and weather updates allow viewers to start their days with useful information. The shows are designed with local break points at which an affiliate may air brief local news, weather, or traffic updates.

These magazine programs are a valuable tool for promoting the network's prime-time offerings. When a network has scheduled a prime-time miniseries, the cast and crew of the morning magazine may interview the stars or appear on the set of the miniseries. It is also common practice for prime-time newsmagazine correspondents to make guest appearances on their network's morning shows to promote their prime-time magazine features that night.

NBC News' *Today* show was the highest rated morning news program for 1995 according to Nielsen Research, drawing an average 4.1 million viewing homes each day. ABC News' *Good Morning America* was a close second with 4 million homes. *CBS This Morning* came in third with 2.4 million homes.

Today on NBC

NBC pioneered the magazine format with the 1952 premiere of *Today*. Over the years, viewers have become very attached to the personalities associated with *Today*. Popular *Today* personalities over the years have included Dave Garroway (its original host), John Chancellor, Hugh Downs, Barbara Walters, Tom Brokaw, Jane Pauley, Katie Couric, Willard Scott, and Bryant Gumbel. Although this reads like a long list, most of these hosts stayed many years with the program. Consistency of personalities has the advantage of breeding familiarity and dependability. These are essential ingredients during a daypart in which viewers' behavior is routinized, and this formula made *Today* a solid ratings hit for decades. The *Today* show's ratings dip, which took place in the early

1990s, has been attributed mostly to revolving hosts following the departure of Jane Pauley.

ABC's *Good Morning America*

Prior to 1975, ABC did not offer any network service until 11 A.M. In 1975, it began to compete more vigorously in other dayparts, including prime time, although its small station lineup of **primary affiliates** at the time compared unfavorably with NBC's and CBS's.

Primary affiliates are stations having a regular affiliation contract with one of the major broadcast networks and serving as that network's main outlet for programs. They usually carry most of the network's schedule. In markets with fewer than four commercial television outlets, one station usually becomes a **secondary affiliate** of the unrepresented networks. Stations with two affiliations carry the most popular programs of both networks, although the affiliate will clear much less of the secondary network's schedule. To attract primary affiliates away from competitors, ABC had to compete with a full-network service, including early morning programming.

ABC targeted the *Today* show as its chief competitor when it introduced *AM America*. ABC aimed for a younger early morning audience, particularly women 18–49 who were believed to be less habituated viewers than the over 50 age group. Because the women 18–49 audience is also the group most desired by advertisers, ABC was specifically counterprogramming to this group. By 1980, the retitled *Good Morning America* had moved into first place overall in the ratings. Since then, NBC and ABC have alternated for the top ratings position, and the time period remains competitive.

To some extent, the relative popularity of the leading morning magazine shows is connected to the night-before ratings (*tuning inertia*). If NBC is the number one network, the television set is often switched off at night with the channel position on NBC, and a disproportionate number of viewers turn on their sets and see morning programming from NBC. Similarly, ABC has an advantage when its shows win the ratings the night

before. CBS has never had much success in the morning and probably does not benefit much from tuning inertia. In this case, the viewers' morning habit (NBC versus ABC) usually takes over.

CBS This Morning

CBS has languished in third place in the morning news ratings since the mid-1970s. As the third place network, it has tried over and over to innovate in hopes of escaping its low ratings position. In the mid-1990s, *CBS This Morning* was produced regularly in front of a live audience with the second hour devoted to a single topic or guest. The producers were hoping to achieve a new vitality for the show, much like the enthusiasm generated on the set of such morning talk shows as *Live with Regis and Kathie Lee*. In 1996 CBS completely revamped its morning news show, and the program's future is uncertain.

The ratings competition between the networks for early morning viewers is always intense, but the stakes are even higher during the sweeps ratings periods. To make the shows more attractive, the cast and crew often travel to exotic locations during the ratings period. The cost of remote productions is higher, but they often return higher ratings and create a promotional hook to tempt audiences. During one sweeps period, *CBS This Morning* scheduled an entire week inside the studios of *Late Show with David Letterman* while *Late Show* was in London. This provided cross-promotion between both shows. It also became a test week for *CBS This Morning*'s planned format of including a live studio audience. But once again, CBS lagged behind ABC and NBC in morning ratings.

In addition to their intense competition, the networks now face increasing competition from strong local stations in major markets. Local stations in markets including New York, Miami, Chicago, and Washington are producing their own early morning programs. These magazine format programs have strong local emphases and have garnered strong ratings against network offerings. If network programs are to remain strong

competitors in the major markets, they must adjust to the changing environment. They cannot compete for local appeal, so the morning newsmagazines must continue to send their popular personalities to exotic locales or the sites of national news events.

Children's Programming

Because young children (ages 2–5) comprise a healthy portion of the morning audience, networks and independent stations have attempted to counterprogram TV magazines with children's series. *Captain Kangaroo* was a classic network show designed for preschool children that aired on CBS from 1955 to 1982. The Public Broadcasting Service (PBS), however, provides the most hours of children's programming in the morning, airing such series as *Mr. Rogers' Neighborhood* and *Sesame Street*.

During the 1994–95 season, the Fox Children's Network also began counterprogramming with an hour of shows aimed at the 2–5 age group. *The Fox Clubhouse* was designed to introduce young viewers to subjects such as nature and the environment, socialization, and music and movement. By 1996, Fox was achieving modest ratings.

Children's programming presents a challenge in that it is regulated differently from other programming. Limits are placed upon commercialization within the programs, which, in turn, can limit the revenues brought in by a children's series (see 5.3 for details).

DAYTIME PROGRAMMING

Daytime programming (9 A.M. to 4 P.M.) is one of the most lucrative dayparts for television networks. Its profit margin often challenges that of prime time because its per program costs are substantially less. Producing the average soap opera, game show, or talk show may cost just 5 to 10 percent of a prime-time entertainment counterpart.

While a one-hour drama in prime time usually costs $1 million or more an episode, an hour-long soap opera averages $75,000 to $100,000. Talk shows and game shows can average as little as $15,000 to $50,000 an episode.

In addition to lower programming costs, there are traditionally more commercial availabilities in this daypart. Networks generally schedule about 14 minutes of commercials per hour. Prime time averages about 12 minutes per hour. Despite drawing a much smaller audience than prime-time programs, daytime programming occupies more hours a day than does prime time. It follows, then, that a successful daytime schedule is vital to a financially sound network.

Extraordinary program investments in other dayparts, such as ambitious prime-time miniseries, Olympic coverage, and breaking news coverage, often cost as much or more than the advertising revenue they generate. Daytime programming has traditionally supported these efforts by providing consistently large profits. Until 1996, only ABC, CBS, and NBC provided regular programs Monday through Friday. Fox launched an hour-long daytime TV program late in 1996. Set in a New York apartment, the show featured an ensemble cast, daily celebrity interviews, features, and topical stories.

The three primary genres on network daytime schedules are talk shows, game shows, and **soap operas**. Daytime programmers face enormous competition from cable television, locally produced programming, and syndicated programming. A network talk show might face competition for a similar audience from a dedicated talk show cable network, a locally produced talk show, and a variety of syndicated talk shows an affiliate or a competing station may air. Hence, one reason that soap operas have performed better than any genre in daytime television is because original soap operas are rather rare in local television, syndication, and cable.

Daytime programmers do have some distinct challenges: time zone complexities, the potential for audience erosion, and competition from dedicated cable services and syndication.

Time Zone Complexities

Time zone complexities disrupt daytime schedules. Consider scheduling for a 1 P.M. Eastern time zone soap opera. Its noon start-time in the Central time zone would interfere with the schedules of those affiliates who program a noon newscast. Networks have to schedule multiple feeds of some soap operas to make it easier for their affiliates to schedule them and, therefore, maximize clearances. This explains why *The Young and the Restless* is an afternoon show in the Eastern time zone but a morning show in the Central and Pacific time zones (see 5.2).

Unlike CBS, ABC has yet to offer alternate feeds of its daytime programs to the Central time zone. However, it allows affiliates in the Central time zone that schedule a noon newscast to tape delay *All My Children* (1–2 P.M. ET; noon–1 P.M. CT) by one day and show the soap opera at an earlier time.

Daytime television seems to have the most potential for audience erosion. Compared to the 1950s and '60s, the number of viewers who are at home in the daytime has decreased, particularly because more women work and their children stay at childcare centers rather than at home. The networks had additional worries when younger viewers (ages 18–34 and 18–49) inexplicably fell off further for each of the networks between 1993 and 1995. Cable networks may be responsible for the decline.

CBS won the 1994–95 television year (ending in September) for daytime, averaging 19 percent of the available audience, with ABC and NBC falling behind with 15 percent and 11 percent respectively. CBS's *The Young and the Restless* was the number one rated regularly scheduled daytime program, with NBC's *Days of Our Lives* and CBS's *The Price Is Right* coming in second and third.

Talk Shows

The studio-based talk show is a prime example of low-risk programming. Its minimal start-up and ongoing production costs make it a perfect format

5.2 NETWORK FEED OF DAYTIME PROGRAMMING (CBS)		
	Eastern Time	Central & Pacific Time
The Price Is Right	11:00 A.M.–noon	10:00–11:00 A.M.
LOCAL TIME*	noon–12:30 P.M.	—
The Young and the Restless	12:30–1:30 P.M.	11:00 A.M.–noon
LOCAL TIME	—	noon–12:30 P.M.
The Bold and the Beautiful	1:30–2:00 P.M.	12:30–1:00 P.M.

Note: *Local time is the time that the local affiliate runs local programming, usually news.

for the low-budget realm of daytime television. The talk show has been used to fill hour-long gaps in a network's schedule and has the potential to reach a desirable 25–54 female audience. Further, if a talk show host "connects" with the audience, the series can attract a very loyal audience on a daily basis. With studios and equipment almost always available, talk shows are one of the most easily instituted and adaptable of genres. When a talk show is initially unsuccessful, it often can be reformulated with different personalities. For example, NBC programmed *One on One with John Tesh*, which became *John and Leeza* (pairing Tesh with Leeza Gibbons); when this series ran into difficulties, it then became *Leeza*. With virtually the same production team, the "down" time was low, and the startup costs were kept to a minimum. The ratings, however, stayed about the same.

Controversial topics can work for or against the talk format. Syndicated programs like *Sally Jesse Raphael* and *Jerry Springer* achieved high ratings against daytime network programs in the early 1990s and were partly responsible for NBC's abandonment of the 10 to 11 A.M. Eastern time slot. However, pressure from Congress and advertisers in the mid-1990s brought disfavor to some of the more lurid talk shows in syndication, and network talk shows were tarred by the same brush.

In any event, the most famous talk shows belong to the competition for network audiences during daytime. Shows like *Rosie O'Donnell* and *Geraldo* attract a large following. The networks have not been very successful in creating popular talk shows, partly because of the dominance of other network formats that had been immensely popular in past decades. In the 1980s when *Donahue* and his imitators were getting established, the networks were still enjoying a great deal of success from game shows and soap operas during daytime.

Game Shows

From the 1950s until the 1990s, game shows were a mainstay of network daytime programming and were among the most profitable network programs. Typically, several episodes of a game show are taped in a single day, and these shows use the same sets and props for years. In exchange for on-air announcements, advertisers provide the prizes awarded to contestants. Usually, only the host gets a big salary. In consequence, production costs are minimal.

Networks seldom invest in pilot programs for game shows because they cannot recoup any of their investment by airing them as they sometimes do with prime-time pilots. Game shows are also developed somewhat differently from prime-time programs. Usually, a game show producer presents a concept, and if the network likes the idea, it commissions a run-through. The producer then rehearses the show's actors and participants, and

5.3 NETWORK DAYTIME GAME SHOWS OF THE 1990S

Game shows are rare in contemporary broadcast television. Innovative ideas are even rarer. Here is a look at game shows appearing on the network daytime schedules during the 1990s.

Series Title	Concept	Producer
The Price Is Right (returned 1972, CBS)	Based on NBC version (1956–65)	Mark Goodson
Caesar's Challenge (1993–94, NBC)	New	Cannell Prod.
Classic Concentration (1987–94, NBC)	Based on NBC version (1968–83)	Mark Goodson
Family Feud (1988–92, CBS)	Based on ABC version (1976–85)	Mark Goodson
Wheel of Fortune (1989–90, CBS; 1991, NBC)	Based on NBC version (1975–89)	Merv Griffin
To Tell the Truth (1990–91, NBC)	Based on CBS version (1956–68)	Mark Goodson
The Match Game (1990–91, ABC)	Based on NBC version (1962–69) and CBS version (1973–79)	Mark Goodson
Family Secrets (1993, NBC)	New	Dave Bell
Scrabble (1984–93, NBC)	Based on famous board game	Reg Grundy
Scattergories (1993, NBC)	Based on popular boxed game	Reg Grundy

network executives are invited to see the run-through. At this stage, a network may commission a semipilot, allowing the producer to videotape various versions of the game show with a studio audience and with the addition of appropriate production elements such as music. This is done without going to the expense of an elaborate set.

Development

Some short cuts can occur for a network in game show development. Often, the game show's concept has existed in some other format. Updated versions of *Family Feud* and *Concentration* were examples of game concepts that featured almost identical elements as the original series (see 5.3). Such copy-cat formats simplify a pitch session because the network executives are either already familiar with the concept or can be shown examples of the original series. In some few instances, a network has been given a prototype of the finished product to ease the development process. In these

cases, the producer has assumed the risks of development prior to network exposure. The game show, *Caesar's Challenge* (1993–94, NBC) was produced by Stephen J. Cannell Productions to be a first-run syndicated series. Because too few local stations decided to buy the program, the show was subsequently shopped to NBC, which briefly picked it up. A similar development process occurred for King World's *Monopoly* (a game show based on the famous board game), which became a summer prime-time series on ABC in 1990.

Games began disappearing from the network lineups because of competition from first-run syndicated game shows (including *Jeopardy!* and *Wheel of Fortune*), from cable networks dedicating some or all of their daytime schedules to game shows, and from other syndicated fare. So rare were game shows that CBS's *The Price Is Right* with Bob Barker was the only game show scheduled in nonprime time by any of the broadcast networks as of 1995.

Perhaps the game show format is beginning to show its age. Audiences seem to have grown tired of these squeaky-clean shows, especially when a competing morning talk show is featuring strippers or battling families. Modern viewers are apparently less interested in solving puzzles.

Soap Operas

The most successful daytime programming genre is the soap opera.[1] Successful soap operas build loyal constituencies that last for decades, and viewers can follow a set of characters on a daily basis for years. This sort of loyalty is rare for television programs of the 1990s. To reinforce this habit, predictable scheduling is key to the success of soaps. Interruptions for sports programming or news bulletins can lead to a switchboard full of angry callers. For example, scheduling events for a Summer Olympics has generated complaints (and will again). Even the coverage of the funeral of President Kennedy in 1963 and the moon walk coverage in 1969 upset some loyal soap opera fans.

The soap opera viewer is also among the most active of audience members. Soap fans seek out information from soap telephone services, newspaper columns, and publications such as *Soap Opera Digest*. Viewers often go to great effort to see their favorite soaps, planning daily activities around their soaps and recording them when absence is unavoidable. In network daytime viewing, all ten of the most time-shifted programs are soap operas. A series such as NBC's *Days of Our Lives* is time-shifted more than any of the prime-time series.

One hit soap opera can generate a great deal of revenue for its network. The cost of making a single show is very inexpensive compared to a prime-time program, because the actors are paid less and the production values are lower. CBS's highly rated soap *The Young and the Restless* does better at making a profit and delivering its target audience, women 18–49, than many of the network's prime-time offerings.

Both ABC and CBS have strong daytime line-ups featuring many long-running soap operas

5.4 NETWORK SOAP OPERA RATINGS, JULY 1994

CBS	*The Young and the Restless*	8.8
ABC	*All My Children*	6.9
NBC	*Days of Our Lives*	6.6
ABC	*General Hospital*	5.8
ABC	*One Life to Live*	5.3
CBS	*As the World Turns*	5.3
CBS	*The Bold and the Beautiful*	5.7
CBS	*Guiding Light*	4.9
NBC	*Another World*	3.6
ABC	*Loving*	2.6

(see 5.4). During the daytime hours, audience viewing behavior is highly predictable; typical viewers watch the same programs at the same time each day. Such habituated viewing behavior, coupled with the growing impatience of network programmers with low-rated programs, makes it extremely difficult for new daytime soap operas to succeed. This might explain why no new daytime soap operas were introduced by the broadcast networks between 1990 and 1997.

Development

Establishing a new soap opera demands a long-term commitment. It takes years to achieve audience identification with new characters in their fictional affairs. Development begins with an independent producer providing the network programmer with a basic concept for a new series. If it seems promising, the network will commission a treatment, sometimes called a "bible," analyzing each of the characters and their interrelationships and describing the settings in which the drama will unfold. For a treatment, the writers receive development dollars or seed money. The final step is to commission one or more scripts, advancing more funds to pay writers. The entire development process can take one to two years and an investment of thousands or even millions of dollars. When NBC considered adding a new daytime

soap opera for the 1995–96 television season, the total start-up cost was estimated at $20 million.

Usually, several development projects are abandoned each season; only a few have even made it on the air. Once a network picks up a soap opera, casting begins. Casting the appropriate, charismatic actor for each role is crucial to a soap's success. To this end, CBS, ABC, and NBC maintain their own casting directors to work with producers.

Most network television is videotaped or filmed on the West Coast, where producers contend they can produce programs for less money than in New York. This is due, in part, to the more favorable weather conditions for exterior shooting. Soap operas, however, continue to be taped in New York because much of the shooting is interior and the Broadway theater provides a large pool of actors who are available during daytime shoots. Young actors in the New York area vie for soap roles because a bit part can bring high visibility and a decade of financial security. And soap taping schedules leave plenty of time for stage and screen acting jobs. The international market has become a lucrative secondary outlet for American soaps. Many soaps incorporate plot sequences that take place overseas to appeal to specific foreign markets.

EARLY FRINGE/LATE AFTERNOON PROGRAMMING

The period referred to as early fringe (4 to 6 P.M. ET) is not programmed regularly by ABC, NBC, or CBS. This time slot is handed to the affiliates to program, most often with syndicated talk shows or off-network sitcoms. Occasionally, ABC and CBS offer a children's special.

Local affiliates have to determine what audience to attract in early fringe (see Chapter 6). Some stations target a children's audience, and this has created a market for both network and syndicated afternoon children's programming. Distributors such as Disney and Warner Brothers have created entire blocks of animated series designed for the afternoon. In 1990, the Fox Chil-

dren's Network (FCN) was inaugurated. Its successes have included *Batman: The Animated Series* and the ratings and marketing hit *Mighty Morphin Power Rangers*. While the Disney afternoon animated series might play on any station in a given market, the Fox affiliates have the first right of refusal on the FCN children's lineup. WB followed FCN's success with its own block of network daytime programming debuting in 1995 called Kids Network, and the United Paramount Network (UPN) told affiliates its afternoon lineup would begin in the 1997–98 season.

To stem further Congressional or FCC action, affiliates are anxious to have popular children's programs on their schedules, and they fill later afternoon hours watched primarily by young people. However, these young people tend to be older (age 9–16) rather than young children. As with children's programming in early morning, the afternoon programming falls under the Children's Television Act.

Network children's programming has become a television battleground, not only because of network competitiveness but also because of increased public concern about the quality of programming designed for children. Children are perceived to be more vulnerable to television's impact than adults. Over the years, children's television has repeatedly been the topic of debate in Congress and at the Federal Communications Commission (see 5.5). Much of the controversy in recent years comes not from the amount of children's programming on television but whether the programs are really educational. For example, information about sports in a children's program is hardly "education" in the minds of parents, teachers, and regulators.

Among the more innovative programming efforts are the daytime children's specials. *ABC's Afterschool Special* and *CBS's Schoolbreak Special* are both recurring dramas shown periodically during the year. (NBC also had its own series called *Special Treat* for eight seasons.) These programs focus on such contemporary issues as environmental concerns, AIDS, and drug use. With pressure from parents, Congress, and various interest groups

5.5 CHILDREN'S PROGRAMMING REQUIREMENTS

The FCC has long studied children's television programming. The public, including special interest groups and parents, have stated their concerns about **kidvid.** Three main issues regarding children's television programming are: overcommercialization of children's programming; separation of program content from the commercials; and lack of educational programming options.

- Overcommercialization: In 1990, Congress passed the Children's Television Act, requiring the FCC to impose advertising limits on children's programming of up to 10.5 minutes on weekends and 12 minutes during the week.
- Confusion between program content and commercials: A second limitation on commercialization concerns the content of commercials within a show. The Children's TV Act restricted the use of host-based commercials. A host-based commercial is one that features a character from a particular children's series giving the advertiser's message. A number of commer-

cials featured the Mighty Morphin Power Rangers. Host-based commercials, or those featuring the Power Rangers or products with the Power Rangers, are not to be shown during the airing of *Mighty Morphin Power Rangers* or within 90 seconds before or after the program. If the commercials were to air, then the entire program would be considered a "program length commercial" and, therefore, exceed the maximum advertising time for an hour of children's programming, a clever stratagem to force stations to exhibit some sensitivity to children's vulnerabilities. The prohibition on host-based commercials is aimed at decreasing the confusion a young child likely has in discerning a commercial from the show's content. Even before the Children's Television Act, networks (as well as syndicators and broadcasters) placed interrupters or bumpers to separate the program from the commercials, despite research findings that young children remain confused nevertheless.

- Lack of educational programming: The Children's TV Act also required broadcasters to air educational and informational children's programming. At license renewal time, the FCC is required to consider whether the television station had served the educational and informational needs of children. Broadcasters are now obligated to air programs serving a child's cognitive/intellectual or social/emotional needs. However, the FCC has not specified the number of hours or the actual series that would satisfy the Act.

After the Children's TV Act was in place, the FCC cited statistics showing that educational programming on the networks had actually fallen from 11 hours a week in 1980 to just 5 hours by the early 1990s. The commission was so concerned about the lack of educational programs that it contemplated establishing a quota of a specified amount of educational children's programming that stations would have to air.

concerned with educational children's broadcasts, these specials serve as a public service for TV networks and the affiliates that carry them. Unfortunately, the clearance rate for the specials tends to be rather low, as the series interrupt the daily flow of programming on a given station. These pro-

grams are, therefore, generally scheduled outside of the sweeps ratings periods.

Ironically, by 1996 broadcast network TV viewing by the 2–11 age group was showing one year declines of 17 percent, with teenage viewing down 12 percent. Many observers have begun to wonder

whether youngsters are escaping to cable television or spending more time with their computers.

EARLY EVENING: EVENING NEWS

The evening newscasts are the centerpieces of the ABC, CBS, and NBC television news organizations. These evening newscasts originally provided a service to affiliates, most of which had very limited, if any, news operations. CBS and NBC introduced the nightly newscast to network television in 1948. In the 1950s, network newscasts were generally just 15 minutes in length. Although modest by today's standards, the expenses incurred by a network news operation during those early years were often far more than the income derived from advertising on the newscasts.

Newscasts have been 30 minutes in length since the 1960s. Over the past two decades, networks have repeatedly hinted at their desire to feed an hour-long version of the evening news. Walter Cronkite and other news luminaries have put their prestige to the test in requests for more network newscast time, but affiliated stations have rejected such plans. They can make much more money by scheduling their own program before and after the news. Thus, the nightly network newscast has remained a 30-minute program, despite becoming somewhat anachronistic over the years as lifestyles have changed. People have busier schedules and cannot make themselves available for a specific half-hour every evening for their information. The easy availability of alternate news sources such as CNN and Headline News cable channels has contributed to changes in news viewing patterns. There is no need to wait until 6:30 or 7 P.M. for a network newscast when 24-hour news channels have become so common that NBC, Fox, and CBS announced plans in the mid-1990s to compete with CNN. Moreover, local news programs can compete nowadays with the networks for national and sometimes international stories by producing high quality stories with on-the-spot video via satellite.

Network newscasts are important to network affiliates because the networks can promote the evening's prime-time offerings during commercial breaks. Much like the early morning magazine programs, the newscast also provides benefits to a network's news division by allowing it to promote other news efforts within the newscast. For example, ABC promotes *Nightline* within its nightly newscast, while each of the networks generally incorporate promotion for their own newsmagazines such as CBS's *48 Hours*, NBC's *Dateline*, and ABC's *20/20*.

Network news may not remain a staple of nonprime-time programming if current trends persist, however. In 1996 less than half of the American adult public (only 42 percent) regularly watched network evening TV news broadcasts, down from 60 percent in 1993. Also, network, local, and CNN news audiences slipped the most in under 30-years-of-age viewers, perhaps because networks do not cover issues of interest to younger adults.

Time zone differences present a challenge to both the programming department and the news department. The solution has been a multiple-feed schedule. The first feed of a network newscast is generally 6:30 to 7 P.M. Eastern time. Because some affiliates delay this newscast and the time would be inappropriate for the Mountain and Pacific time zones, a second feed is scheduled for 7 to 7:30 P.M. ET, and a third from 6 to 6:30 P.M. Pacific time. Breaking or updated news stories can be inserted into the later feeds.

With three newscasts competing head to head as well as competition from cable news channels, the news must be made as distinctive as possible. This is one of the key reasons networks create segments within the newscasts. CBS's daily "Eye on America," NBC's "InDepth," ABC's ongoing "American Agenda" and "Your Money, Your Choice" provide hooks for promotional announcements. Viewers may make a link between "Eye on America" and a particular network; the networks hope they might even get into the habit of watching a particular network for a favorite segment.

All elements (news gathering, scheduling, and technology) being about equal from network to

network, one factor that can be manipulated is personalities. Anchors and reporters can be added or dropped in hopes of attaining higher ratings. The most critical factor in news program strategy has become selecting news anchors with charisma and the right "chemistry" in their interactions with other members of the news team and the audience.

NBC *Nightly News* (9.1 rtg)

NBC first offered a regular nightly newscast in 1949, the *Camel News Caravan* with John Cameron Swayze. Swayze was not an experienced journalist and eventually was replaced by Chet Huntley and veteran reporter David Brinkley in 1956. The renamed newscast, *The Huntley-Brinkley Report*, was a ratings hit, becoming the top-rated news program in the late 1950s and for most of the 1960s. When Huntley retired in the 1970s, NBC retitled the show the *NBC Nightly News*. With NBC's news ratings declining in the late 1970s and early 1980s, Tom Brokaw was moved away from *Today* to the *Nightly News* anchor position in 1982.

During the mid-1980s, *NBC Nightly News* expanded its background and analysis of events, cutting some of its hard-news reportage. This strategy worked for a while, and NBC's ratings rose in the late 1980s and early 1990s, although it generally placed third in the time slot. NBC's weakness prompted the network to experiment with its Friday evening format, concentrating the broadcast on a single theme. The newscast provided more analysis, interaction between citizens and experts, and reported the results of weekly news polls in detail. Friday was selected because it is usually a light news day. Although this experiment was not a resounding success, it demonstrates the sort of innovative programming that a network will undertake to increase its audience.

CBS *Evening News* (9.4 rtg)

Walter Cronkite anchored the *CBS Evening News* from 1962 until his retirement in 1981. In times of crisis, more people tuned in to Cronkite than to any other newscaster. During the 1970s, polls repeatedly showed Cronkite as the most trusted source of news. Dan Rather took over the helm of *CBS Evening News* upon Cronkite's retirement. Rather's credentials as a highly experienced journalist would have meant little if his chemistry did not match that of his predecessor's. Even though the ratings of *CBS Evening News* declined after Cronkite's retirement, Rather continued to dominate the evening news ratings until the late 1980s when the reign of ABC's Peter Jennings began. In June 1993, CBS decided to pair Rather with veteran reporter and weekend anchor, Connie Chung. The combination did not work out, and ratings did not improve. Two years later, Chung was demoted from the anchor desk, and the president of CBS News was fired.

ABC's *World News Tonight* (10.5 rtg)

ABC has been airing nightly newscasts since 1953 but for three decades it failed to pose a serious news threat to CBS and NBC. In 1977, in a bold move, ABC surprised the industry by appointing the head of ABC Sports, Roone Arledge, to supervise both its news and sports divisions. Arledge had made ABC the number one network sports organization with his unconventional strategies—introducing offbeat sporting events and building up the dramatic aspects of sports competition. During his tenure as head of news, ABC assembled a stable of highly respected journalists including Peter Jennings, Sam Donaldson, Diane Sawyer, Ted Koppel, and David Brinkley. ABC catapulted into the lead in the evening news ratings. Some observers credit anchorperson Peter Jennings with the success of *World News Tonight*.

ABC's late-night presence with *Nightline* also helped give the network added respect. Spectacular achievements, including the first televised debate between Soviet President Mikhail Gorbachev and Russian President Boris Yeltsin, underscored ABC's news leadership.

LATE-NIGHT PROGRAMMING

The period following the local affiliates' late fringe newscast is the domain of late-night programming (11:35 P.M. to 2:05 A.M.). NBC was the pioneer network in developing new audience viewing trends in this time period. After launching *The Tonight Show* in 1954, NBC won that time period for the next quarter century. It also continued to push the boundaries of late night by adding programs such as *Late Night* and *Later* following *The Tonight Show*.[2]

It is crucial for network programmers interested in late-night success to offer an attractive lineup to affiliates. If the lineup is perceived as "weak," affiliates may preempt or, more likely, delay programming. An affiliate may decide to show an hour of syndicated programming beginning at 11:35 P.M., leaving the network's late-night lineup to begin at 12:35 A.M. or even later. This type of delay is devastating: The later the hour, the more people go to sleep, and thus the HUT levels drop significantly. Such a ratings decrease hampers both the national ratings of that series and the potential advertising revenue to that network.

Nightline

In November 1979, ABC news seized on the American viewing audience's fascination with the Iran hostage crisis and began a late-night newscast to summarize the major events of the day. The show evolved into *Nightline*, an in-depth news program hosted by Ted Koppel. Counterprogramming the network and syndicated talk shows, *Nightline* draws a loyal, upscale audience. The series' ratings tend to rise sharply depending on national crises, wars, and disasters that may erupt on any given day. Although the program is typically a half-hour in length, it sometimes expands for extremely important stories. On those evenings, *Nightline* can obliterate all the competing programs. Events such as the War in the Persian Gulf and the Oklahoma City bombing incident have caused upward spikes in the ratings. When major events are not taking place, *Nightline* has become a solid ratings performer for ABC. The key to its success has been its vigorous campaign to have the show cleared live in most TV markets.

Talk Shows

The genre with the greatest longevity in the late-night time period is the talk show. NBC airs three consecutive talk shows in the late-night period, and CBS airs two talk shows with *Late Show* and *The Late Late Show*. ABC and Fox have tried several times, but ABC has been more successful with movies and action series than with late-night talk shows. Fox had three notable late-night talk show failures prior to shifting gears in 1995. Their talk shows, *The Late Show Starring Joan Rivers* (1986–87), *The Wilton-North Report* (1987–88), and *The Chevy Chase Show* (1993), did not draw significant audiences away from competing talk shows.[3] Hence, in 1996 Fox announced that it would counterprogram against talk shows.

As in prime-time series development (see Chapter 4), pilots are often produced for nighttime talk shows. A variety of elements are tested prior to a talk show's release in an attempt to gauge the show's potential. Commonly examined are the sets, the band, the sidekick, and the pacing of the show, but of course the key is the appeal of the host. When a network signs a major star to a talk show contract, the network may decide to produce "rehearsal" shows instead of a pilot.

The Tonight Show was the first late-night network program. The show has had only four regular hosts: Steve Allen, Jack Paar, Johnny Carson, and Jay Leno. Johnny Carson, the host of *The Tonight Show* from 1963 to 1992, was such a mammoth ratings' success that the network added a one-hour show following *Tonight*, *The Tomorrow Show* with host Tom Snyder, which ran from 1973 to 1982.

After guest hosting frequently for Carson, David Letterman was given his own daytime show on NBC in the 1980s. Because of low clearances and low ratings, his program lasted only four months. However, NBC thought Letterman's

offbeat style might better suit late-night audiences, and it replaced Snyder's program with *Late Night with David Letterman*. Letterman developed a cult following among young viewers, particularly college students, who made up a large portion of the show's audience.

Letterman's show attracted an especially desirable target audience with little fall-off toward the end of the program, and to capitalize on the potential viewership NBC added another half-hour to its late night lineup in 1988. The show, *Later*, was originally hosted by NBC sportscaster Bob Costas. When Carson retired in 1992, NBC had to decide who would replace him. Of its two final candidates, the network chose stand-up comic and frequent guest host Jay Leno over Letterman. Because *Tonight*'s audience aged dramatically toward the end of Carson's reign, Leno retained the opening monologue that Carson had made famous, but changed the show's style, band, and routine to draw a younger audience. Leno's musical guests were selected with careful attention to the younger target audience.

CBS, which was struggling in third place in late night, decided to take a gamble on wooing David Letterman away from NBC. The new *Late Show with David Letterman* gave CBS an instant ratings' success in late night. Following *Late Show*'s success, the network lured Tom Snyder away from his cable talk show on CNBC and gave him his own program, *The Late Late Show*, following Letterman. Prior to acquiring the services of Letterman, CBS had run original dramas in late night to counterprogram against talk shows. From 1986 to 1989 and from 1990 to 1994, a number of different series were scheduled.[4] However, these programs proved too costly (averaging about $850,000 an episode by the 1990s) and CBS signed Letterman.

Late-night shows often travel to remote locations. In one sweeps week, for instance, the New York-based *Late Show* traveled to Los Angeles; ironically, the California-based *Tonight Show* traveled on that same week to New York. The remote locations become promotable events in and of themselves. The competition is fierce. After an initial lead over *The Tonight Show*, Letterman began to trail Leno at the beginning of the 1995–96 season.

The late-night talk show has some of the same benefits of the morning talk show. The talk show can promote network offerings by booking same-network guests. A well-known celebrity appearing in a forthcoming NBC made-for-TV movie can make a timely appearance on the *Tonight Show* and promote the show's exact airdate and airtime. During the 1994 Winter Olympics, CBS's *Late Show* featured nightly reports from the site of the Olympics, for which CBS had the exclusive broadcast rights.

OVERNIGHT PROGRAMMING

The overnight time period (2:05 to 6:00 A.M.) has the lowest viewership of any daypart. But be it second shift workers, nursing mothers, or insomniacs, there is some viewership left in overnight. However, the competition in overnight is not as spirited as in other dayparts. In fact, Alan Wurtzel, ABC's senior vice-president for research said, "The most significant competitor you have is not [the late-night programs]—it's turning off the tube and going to sleep."

Unlike prime time, where HUT levels are around 60 percent, overnight HUT levels are just 10 percent. Given the relatively low number of viewers, the potential ratings for individual overnight programs are also quite low. To complicate matters further, some affiliated stations sign off in the overnight hours, leading to lower clearance rates. Therefore, in the overnight time period, a 1.0 rating is considered very strong.

Given the low ratings and the low HUT levels, you might wonder why a network would bother to schedule any programming overnight. Prime-time spot advertising in 1994–95 averaged around $125,000, making prime time a $4 billion daypart. By contrast, overnight spots sell for $600 to $1,000 each. Even with 16 minutes of commercial time per hour, the entire daypart is only worth $3 to $4 million dollars to each broadcast network. But if the network can keep costs below the

advertising revenue in the daypart and promote forthcoming shows, the effort is worthwhile because the risk is low.

ABC's *World News Now*, NBC's *Nightside*, and CBS's *Up to the Minute* are the traditional overnight news series, although their names have changed over the years. These shows compete against syndicated news programming offered to local stations by CNN, Headline News, and **Conus**. Each network does what it can to keep the costs of production low. *Nightside* recycles features from NBC's newsmagazines, from NBC's *Nightly News*, and from its cable business network CNBC. Though the show occupies a three- or four-hour block, generally only one hour is produced. That hour is then repeated throughout the night. *Up to the Minute* is one of the first network news services to provide video stories "on demand" over the Internet. Computer users can reach the download site on the World Wide Web at *http://uttm.com*.

Limited testing of "value added" programming such as talk shows with product selling and extra runs of programming has been attempted in the overnight daypart. However, news continues to dominate the time period for the networks, vying with cable's movies and rerun entertainment series.

WEEKEND MORNING PROGRAMMING

Weekend morning (8 A.M. to noon) programming schedules used to be fairly predictable. Saturday mornings were filled with wall-to-wall children's programming, and Sunday mornings featured public affairs programs. While Sunday mornings have remained about the same, Saturday mornings have become a challenging daypart for network programmers.

The competition for young audiences is fierce. Beginning in the 1995–96 season, six commercial networks were programming at least a portion of Saturday mornings—ABC, CBS, NBC, Fox, WB, and UPN—with competition from PBS, The Disney Channel, and Nickelodeon. With still further competition from syndicated children's programming, VCRs, and video games, dilution of the audience is a major concern.[5]

The fragmentation of the audience has increased the practice of targeting specific children's audience members. Series are often designed to reach a young children's audience (2–6 or 2–11), a "tweenage" audience (10–14), teenagers, or other demographic groups. The 10–14 target audience is reflected by shows such as Fox's *Batman: The Animated Series* and NBC's *Saved by the Bell*. NBC only offers children's programming in the late morning hours because it provides the two-hour *Today Show* at 7 A.M. Eastern time.

Unfortunately for programmers, children are the most fickle of nonprime-time audience members. Unlike daily shows where a series lasts for decades, children's series ratings rise and fall as fads come and go. Series such as *Smurfs*, *Teenage Mutant Ninja Turtles*, and *Mighty Morphin Power Rangers* captured the attention of a generation of young audience members. However, each program's popularity wanes as its original audience "outgrows" the program. New audiences demand new programs, but the merchandising potential of a hit children's series is enormous, attracting many "wannabe" producers.

Networks with both a weekend and a weekday block of children's programming have a promotional advantage over networks without regularly scheduled daily children's series. Networks such as the WB and Fox are able to cross-promote their weekend and weekday programming. These networks are also able to launch shows once a week on the weekend and, if they prove successful, they can then be stripped five days a week in the afternoon lineup.

As a means of lowering risk, some networks participate in dual offerings of shows that have already been successfully established in daily syndication. The program is shared with the network on Saturday mornings. For example, CBS carried *Teenage Mutant Ninja Turtles* in 1994, a comic book spinoff first appearing on television in syndication. It also carried *Aladdin* and *Little Mermaid*, both of which began as syndicated offerings on

Buena Vista's Disney afternoon lineup, and *Beakman's World*, which began as a cable program and a syndicated series.

To lower costs, networks also have been known to rely heavily on reruns. NBC used repeats of the live action show *Saved by the Bell* long after the series was out of production. Repeats of decades-old Warner Brothers' animated shorts featuring Bugs Bunny, the Road Runner, and Sylvester and Tweety have been recycled on network Saturday morning lineups for years.

Children's Animation and Live Action

The development process for animation is different from that of prime-time programs. Development of an animated children's series begins about 12 months before telecast, with pickups of new series exercised in February or March to allow producers six to seven months to complete an order for a September airing. The first stage is a concept pitched to the network programmers. The next steps are the outline, which describes the characters and the setting, and the art work, which provides the sketches of the characters in several poses and costumes. If a project passes these stages, the next step is to order one or more scripts, which usually go through many drafts before final acceptance.

Pilot programs are rarely commissioned for cartoons because of the long production time and high costs. The production costs for animated programs generally range from $300,000 to $600,000 per half hour. The usual contract for a season of animated programs to be aired weekly specifies production of only 13 episodes. The network generally schedules each episode four times during the first season. The decision to pick up a cartoon series for 13 episodes can entail an investment in excess of $7 million for a relatively small amount of new programming.

The development process for live action is similar to that of animation, but it substitutes a casting tape for the artwork. In hopes of lowering per episode production costs or to target a slightly older target audience, some networks choose live-action programs. These programs can cost as little as $15,000 per half hour, although some cost as much as $500,000.

Magazine/Infotainment Shows

ABC, CBS, and NBC have all opted to program weekend morning magazine/ infotainment programs. (Fox does not yet program Sunday mornings.) ABC airs a Sunday edition of *Good Morning America*, while NBC airs *Today* on both Saturday and Sunday. CBS programs *Sunday Morning*, a 90-minute program reviewing news of the past week and surveying the world of fine art, music, science, and Americana. These weekend shows allow network news divisions to utilize veteran news staff members while also developing and experimenting with new talent on the air.

Only NBC has ventured onto Saturday mornings. The addition of the Fox Children's Network (and later WB and UPN) all but knocked NBC into the basement in what had been a three-network race for children's audiences. NBC decided that it would counterprogram Saturday morning, dropping two hours of animation in favor of *Saturday Today*. (Another half hour of animation on NBC went to the live-action show *NBA's Inside Stuff*.) NBC devoted the remainder of its schedule to live-action shows targeting teenage females.

Sunday Talk Shows

ABC, CBS, and NBC have traditionally aired public affairs interview programs on Sunday mornings. The format usually consists of a panel of journalists interviewing one or more recent newsmakers about current issues and events. These shows have a longevity rare in modern television: NBC's *Meet the Press* began in 1947, and CBS's *Face the Nation* began in 1954. ABC inaugurated its own public affairs show, *Issues and Answers*, in 1960, which was replaced by *This Week with David Brinkley* in 1981. See 5.6 for ratings of these public affairs programs.

5.6 SUNDAY MORNING NETWORK PUBLIC AFFAIRS RATINGS, JULY 1994

Show*	Network	Rating
CBS Sunday Morning	CBS	4.0
This Week with David Brinkley	ABC	3.6
Sunday Today	NBC	3.0
Meet the Press	NBC	3.0
Face the Nation	CBS	2.4
Good Morning America (Sunday)	ABC	1.6

Note: *Start times vary.

These shows do not attract large audiences. However, they remain on the air for a number of key reasons. First, all three of these programs become important news events in and of themselves. Elected officials and reporters appear on them, have a chance to express themselves at length on important issues on them, and watch them avidly. Their words on Sunday morning television often become Sunday night's and Monday morning's news. Second, they attract a desirable upscale audience and, as a result, prestigious advertisers are drawn to the shows.

Despite these attractive attributes, many stations are hesitant to clear these relatively low-rated programs. Affiliates can make more money carrying infomercials or paid religious programming. To provide affiliates with more flexibility, multiple feeds of the programs are scheduled. CBS's *Face the Nation* is fed at 10:30 and 11:30 A.M. Eastern time and 4 P.M. Pacific time. This gives affiliates plenty of scheduling options, although many nonetheless refuse to clear the time.

WEEKEND AFTERNOON PROGRAMMING

Weekend afternoons (1 to 7 P.M.) on the broadcast networks are dominated by live sports programming. The network's sports division is responsible for acquiring the rights to games and events and for producing the telecasts. However, the sports division must work closely with the programming division because of the complexities associated with live sporting events, including overtime pay and weather-related cancellations.

The networks' sports divisions work with the sports leagues to arrange start times to occur when the majority of viewers can watch. Because many sporting events do not attract a "prime-time-sized" audience, they are often scheduled so as not to interfere with prime-time entertainment programs. Football is one of the few events allowed to run over into prime time because it gets huge audiences; golf is not normally allowed to run over because its audiences are small.

In the early days of television, sports were a low-cost programming source that attracted a male audience. The networks continue to value sports because they still attract male viewers as well as female viewers. They enhance the network's image, and they provide opportunities for promoting other programs. However, the competition for rights to sporting events has driven the rights fees for some sporting events to record levels. Sports are no longer a low-cost venture, and low ratings can lead to some serious financial setbacks for a network.

Sports Anthologies

A sports **anthology** program includes a variety of sports such as gymnastics, figure skating, beach volleyball, and offbeat events such as arm wrestling and celebrity competitions. ABC was the first network to capitalize on the sports anthology genre when it introduced *ABC's Wide World of Sports* in 1961. CBS and NBC eventually countered with their own sports anthology series, NBC's *SportsWorld* and CBS's *Sports Show* (originally titled *The CBS Sports Spectacular*). These shows are essentially clones of the pioneering *Wide World of Sports.*

Sports anthology shows usually have regular time slots on weekends. They are typically comprised of sporting events that have been taped and, in some cases, edited. From a scheduling point of view, this makes the anthology more flexible than live sporting events. The anthology can be moved, expanded, or compressed and fit into the lineup around the main events the network has planned to broadcast on a particular day. If the network has a live golf match airing from 3 P.M. to 6 P.M. on a Saturday, the sports anthology can be placed in the 2 P.M. time slot for the Eastern and Central time zones. Since the 2 P.M. feed would air at 11 A.M. in the Pacific time zone, the show would interfere with the morning lineup. Therefore, the taped anthology would be fed following completion of the golf match at 4 P.M. Pacific time, filling in the space before network evening news.

Sports Rights

The networks' sports divisions regularly seek the broadcast rights to major sporting events. The sports rights fees paid by networks to the sports league organizers can range from small amounts for lesser known sports to hundreds of millions for the most popular events. For example, a five-year rights package of major league baseball games went for $1.7 billion in the late-1990s. There are two basic types of broadcast rights: exclusive rights and shared rights.

Exclusive rights allow a single network to broadcast an event or a series of games. CBS purchased the exclusive rights to broadcast the NCAA Division I Men's Basketball Championship through the year 2002 for $1.725 billion. ABC bought the rights to present live coverage of thoroughbred horse racing's Triple Crown events for under $5 million. Both networks promote themselves as the exclusive source of these televised events. (See 5.7 for additional network sports rights deals.) One drawback is that long events provide tricky scheduling problems. The Olympics and sudden-death golf rounds are among the events that force programmers to interrupt regularly scheduled daytime programming.

Nowadays, it is common for a network to arrange **shared rights** with a cable outlet or another broadcast network. Long events are shared because broadcast networks do not want to devote weekday schedules to early rounds of sporting events. Cable networks carry the early rounds of events such as the U.S. Open Tennis Tourney or the Master's Golf tournament, and broadcast networks carry the final rounds on the weekend. Broadcast networks may also incorporate highlights of early rounds in late-night shows. ABC and its co-owned ESPN began using this pattern in the 1980s.

Consider the NBA playoffs. At the beginning of the playoffs, the broadcast networks carry numerous games on weekends. During the week, the games tip-off in prime time. Under the current contract, NBC could have limited rights to carry some of the playoff games in prime time. However, these games would wreak havoc with the prime-time schedule. Therefore, the rights to the playoff games are shared with cable networks TNT and TBS, which carry the weeknight games for the first two rounds of the NBA playoffs. When the games enter their final rounds, tip-off times are moved to later times to accommodate Pacific and Mountain time zone viewers and to attract prime-time viewers in the East and Central time zones.

The Value of Major Sports Contracts

Combining the costs of production and the sports rights fees, sporting events including Wimbledon tennis, pro football, and pro baseball have proven

5.7 SPORTS BROADCAST RIGHTS

Here are some selected sports rights fees paid by networks. These rights do not include the production costs of the events. NCAA basketball is shown here "per year" for easy comparison. All other fees shown are "per package."

Event/Series	Current Contract	Previous Contract
NCAA Men's Basketball Tournament	$216 million, CBS	$143 million, CBS
NHL Hockey	$31 million, Fox	$20 million, ESPN
NFL: NFC games	$395 million, Fox	$290 million, CBS
U.S. Open Golf	$13 million, NBC	$5.5 million, ABC
NBA Basketball	$187.5 million, NBC	$150 million, NBC
Wimbledon Tennis	$27 million, NBC & HBO	$18 million, NBC & HBO
Winter Olympics	$375 million, CBS (1998)	$300 million, CBS (1994)
Major League Baseball	$1.05 billion, Fox & NBC $627 million, ESPN & fX	$300 million, ABC & NBC

to be money losers for the networks. In the early 1990s, CBS paid enormous amounts of money to broadcast baseball, football, college basketball, and the Winter Olympics. Unfortunately for CBS, only the Winter Olympics made money, and losses on sports telecasts drained tens of millions from the network. CBS adopted a more conservative posture on sports following these financial setbacks and did not acquire the rights to professional football or baseball in the mid-1990s, although it made modest bids. The network apparently felt that the financial risks did not offset the potential returns.

However, the loss of a valuable sporting contract can prove detrimental to the entire programming lineup. The many pauses and commercial breaks in sporting events allow promotion of the network's lineup. In addition, some sports franchises become associated with the station on which their games air. The impact of losing a major sports contract was demonstrated when Fox acquired the broadcast rights to the National Football League's (NFL's) national conference games in 1994. CBS's fortunes took a sudden downward turn in the ratings, and its affiliates lost prestige.

During an interview with CNN's Larry King, David Letterman concluded that the loss of the

NFL was a key danger sign that the CBS network was in trouble: "When the NFL football went away, that got my attention because it seemed like the NFL and CBS, you knew that. It was also an excellent promotional vehicle for the rest of the week's lineup. You got four or five hours on Sunday to run promotions for shows for the rest of the week. When that went, that was a loss for us as a promotional opportunity."[6] The year that CBS lost its NFL football contract, it attempted a novel counterprogramming effort. Entitled the *CBS Sunday Afternoon Showcase*, CBS offered a series of movies it hoped would reach a 25–54 female audience. The movies failed to attract a devoted audience following, and CBS later offered the time slot back to its affiliates during football season.

LATE-NIGHT WEEKEND PROGRAMMING

Late-night (11 P.M. to 1 A.M.) weekend programmers generally attempt to reach viewers 18–34 years old. Networks face competition from a variety of sources in the late-night weekend day-

part. First of all, on a given Saturday night many in the desired target audience are not viewing television. Second, cable and syndicated programs attract substantial audiences. As a result, networks have tried a number of unique programs on Friday and Saturday nights to reach this audience, including comedy, news, and music formats.

Sketch Comedy

One of the rare successes in network late-night weekend programming history is NBC's *Saturday Night Live*. Debuting on NBC in 1975, *SNL* was an innovative 90-minute comedy/variety program airing at 11:30 P.M. on Saturdays. Previously, NBC had scheduled reruns of *The Tonight Show* in this time period. On *Saturday Night Live*, a different guest star hosts each week. The roster of former cast members includes Chevy Chase, Jane Curtin, Gilda Radner, Bill Murray, John Belushi, Eddie Murphy, Dana Carvey, and Adam Sandler. However, producing a fresh 90-minute sketch-driven comedy is demanding. Hence, to give cast and writers a rest, NBC has offered some specials and a variety of packaged, thematic best-of-*SNL* shows. During the November, February, and May sweeps ratings periods, however, first-run shows generally air each week.

For the 1995–96 season, Fox countered *SNL* with its own sketch-driven series, *Mad TV*. The network had considered counterprogramming with a soap opera or a reality program, however, it felt that it could draw away some of *SNL*'s viewership by scheduling comedy with a start-time 30 minutes earlier than *SNL*.

Some networks acquire broadcast rights to programs that have aired on other networks or in other countries. These shows are selected because they have already been able to draw a dedicated 18- to 34-year-old audience. They also have the potential to save the network thousands of dollars in production costs. Fox scheduled one hour of Home Box Office's *Tales from the Crypt* on Saturday nights for one season (before moving it to prime time), and CBS aired the Canadian Broad-

casting Company's *The Kids in the Hall* on Friday nights for three seasons.

News Programs

ABC and CBS also offer a late night newscast on Sundays. ABC's is 30 minutes in length and CBS's is 15 minutes. The *CBS Sunday Night News* is the only example of a 15-minute program on network television. The 15-minute format offers flexibility to affiliated stations that have their own 15-minute local newscast on Sundays. By pairing the two newscasts, those stations create a 30-minute block of news. In many markets, the Sunday local newscast extends to 45 minutes by including a lengthy sportscast. Pairing this with the CBS newscast allows a station to fill a one-hour block. Longer blocks of programming are more readily promoted to viewers and sold to advertisers.

Music Programming

A number of music-based shows have been programmed in late-night television. These shows target an audience 18–34 years old. ABC's *In-Concert* aired Friday nights from 1991 to 1995 and featured live performances from such famous musical acts as U2, Vanessa Williams, Pearl Jam, Elton John, James Brown, and Belly. NBC aired a long-running concert program, *The Midnight Special* (1973–81), a music video series, *Friday Night Videos* (1983–92), and a music, comedy, and entertainment news program, *Friday Night* (1995). Because music programming can be targeted to specific late-night viewers, it is likely that networks will continue to develop music programming for weekend late-night.

THE FUTURE OF NONPRIME TIME

Significant viewing shifts in nonprime time seem more difficult to achieve in early morning and daytime programming. Only in rare cases has a network been able to dislodge an established viewing habit. Competition from basic cable services, pay-

cable channels, and videocassette recordings has decreased the number of available viewers during all time periods, making the tasks of network programming even more arduous. Two general themes for the future have emerged.

First, in an age in which many cable networks are 24-hour services, nationally delivered broadcast networks are moving closer to an around-the-clock concept. Fox aggressively expanded its weekend programming in the 1990s. It continues to pursue the concept of providing regular news and public affairs programming in nonprime time. The two most recent broadcast networks, WB and UPN, initially concentrated their programming efforts on prime time. Both have expanded to weekend mornings, and WB began weekday morning programming in 1996 and afternoon programming in 1997. Following the pattern set so successfully by Fox, these new networks are likely to continue to expand their programming efforts in nonprime-time dayparts with the goal of becoming "full service" operations.

Second, the transformation of the Warner Brothers syndicated afternoon of children's programming into a "network-delivered" schedule of programming for the Kids' WB network demonstrates the blurring of the network and syndicated television business. Relaxation of the financial interest and syndication rules (see Chapters 1 and 3) allowed networks to establish themselves as program suppliers to affiliates and nonaffiliates. By 1995–96, NBC owned all of its Saturday morning properties. This allowed the network to sell its series to any station in the United States and overseas. The broadcast networks are increasingly not only programmers but active syndicators both domestically and internationally.

SUMMARY

Nonprime-time dayparts can be more profitable than prime time because program costs are much lower and the time span is longer. Gaining enough affiliate clearances to achieve success is the key

problem for the networks in nonprime-time dayparts. Programmers try to put together schedules that will be watched week after week. The relatively staid programming strategies associated with daily programming have paid off over the past decades. In the short term, newscasts, talk shows, and soap operas will continue to be the predominate nonprime-time genres. However, the changing nature of the syndicated market, the increased competition from cable and emerging networks, and questions about the future of the daytime audience make long-term programming and economic forecasting very difficult.

The importance of sports and late-night programming will also continue to be key to the success of networks' efforts in nonprime time. Fox has already set its sights on those areas in its quest to become a full-fledged network alongside ABC, CBS, and NBC. The most reliable predictor of the overall importance of a particular daypart is access to target audiences, even more so than HUT levels. Advertisers may reach older and female audiences through prime-time shows, but nonprime time is crucial for reaching younger and male audiences. Perhaps this explains why Fox will venture last into morning and afternoon dayparts, except to reach children.

The future of news is a predicament for the networks. Audiences, particularly young audiences, are turning away from information programming in favor of entertainment. Whatever impact the declining news audiences has on the nation's democracy, the lower news shares may eventually bring change to the nonprime-time landscape during the early evening hours, probably in the guise of a more entertaining form of news programming.

SOURCES

Carter, Bill. *Late Shift*. New York: Hyperion, 1994.

"Episode #1456 [Interview with David Letterman]." *Larry King Live*, 9 June 1995, CNN.

Frank, Reuven. *Out of Thin Air: The Brief Wonderful Life of Network News*. New York: Simon & Schuster, 1991.

Gunther, Marc. *The House that Roone Built: The Inside Story of ABC News.* Boston: Little Brown, 1994.

http://www.nbc.com/news/shows/nightlynews

Kessler, Judy. *Inside Today: The Battle for the Morning.* New York: Villard Books, 1992.

Matelski, Marilyn J. *The Soap Opera Evolution: America's Enduring Romance with Daytime Drama.* Jefferson, NC: McFarland, 1988.

Mayer, Martin. *Making News.* Garden City, NY: Doubleday, 1987.

Shapiro, Mitchell E. *Television Network Daytime and Late Night Programming, 1959–1989.* Jefferson, NC: McFarland, 1990.

Shapiro, Mitchell E. *Television Network Weekend Programming, 1959–1990.* Jefferson, NC: McFarland, 1992.

NOTES

1. For more information about soap operas and their audiences, see Carol Traynor Williams, "Soap Opera," *National Forum* 74, Fall 1994, pp. 18–21; Robert C. Allen, ed., *To Be Continued . . . Soap Operas Around the World* (New York: Routledge, 1995); and for a history of the soap opera, Marilyn J. Matelski, *The Soap Opera Evolution: America's Enduring Romance with Daytime Drama* (Jefferson, NC: McFarland, 1988).

2. *Late Night* and *Later* also include the host within their series' titles. For example, *Later with Greg Kinnear* and *Late Night with Conan O'Brien* were the shows'

"official" titles during the time they were hosted by Kinnear and O'Brien.

3. *Arsenio Hall* was a syndicated program that aired successfully for a brief time in the early 1990s on many Fox affiliates.

4. The CBS shows, although expensive to produce, had production budgets slightly less than their prime-time drama counterparts. The first reason for this was that most series were shot in Canada or other countries to avoid the costs associated with U.S. labor unions. The second reason was that these shows were generally co-production deals with other countries. Hence, the shows were cofinanced with another country and broadcast in other countries. In fact, alternate, more steamy versions of the series were generally shot and produced for the European market.

5. The announcement of ABC's Saturday morning schedule for 1996–97 reflected the influence of Walt Disney's merger with the network. Disney planned to produce three of the network's nine Saturday morning shows, representing 90 minutes of ABC's 300 minutes of weekend programming for children. One year before, Disney had no series on the new schedule.

Over at CBS, Dreamworks SKG planned a joint venture on children's TV programming where both companies would share the profits. Dreamworks wanted to become a leading provider of quality children's TV, and CBS needed new children's Saturday morning shows to compete with Fox.

6. "Episode #1456 [Interview with David Letterman]," *Larry King Live*, 9 June 1995, CNN.

Chapter 6

Affiliated Station Programming

Douglas A. Ferguson

WHAT IS AN AFFILIATE?

An **affiliate** (or network affiliate) is a broadcast station that carries the programs scheduled by the network on an exclusive basis in a market. In the past, there were only two kinds of stations: affiliates and independents.[1] Traditionally, affiliated television stations belonged to one of three networks: ABC, CBS, or NBC. These stations comprised the underlying distribution system that served as the foundation of commercial television in the United States. Affiliate and independent station programming is sufficiently different that they will be discussed in separate chapters here. (See Chapter 7 for independent station programming.)

By 1995, Fox had risen to national prominence with its lineup of 180 "independent" stations carrying prime-time programming every night of the week (although this was not enough to satisfy the FCC's arbitrary definition of a network). Even before Fox had acquired NFL football in 1994, it had established a strong presence in children's programming and had won its time period against the Big Three networks with regular shows like *Cops* and *The Simpsons*. Fox affiliates are slowly losing their independent status as Fox becomes more like a full-service network offering a wide array of programming.

In 1995, two new national networks aligned with non-Fox independents (and sometimes with station affiliates from the four older networks). United Paramount Network (UPN) offers three nights of programming, and the Warner Brothers Network (WB) is also dipping its toe into the prime-time schedule. Both hope to follow in the footsteps of Fox, which also started very small.[2]

Affiliates are indispensable to networks, as CBS found out when the Fox network raided its stable of VHF stations in 1994. As Gene Jankowski and David Fuchs note, "the networks have access to virtually every home in the nation provided by affiliates."[3] Broadcast affiliates reach everyone, in contrast to cable and other multichannel providers whose reach is limited to viewers who choose to pay subscription fees. Networks not only use the affiliates to distribute programs but depend on the local environment that affiliates provide via their local news and other local programming.

All of this realignment of networks and stations is very important to the programmer. It is increasingly important for the major studios who believe that a national network is necessary for distributing their products. But how important is the structure of television distribution to the viewers?—not very important.

Programs versus Stations

When most people think about watching broadcast prime-time television, they think about finding a particular program, most frequently from a national broadcast network. The system whereby viewers organize their thoughts and preferences is centered on individual shows. Some of the shows are substitutable: If one show does not please the audience, another program might fill the void instead.

The system of organization for distributing programs, however, is centered on specific channels or stations. In broadcasting, the channel is the electronic assignment for the station and varies from market to market. The station on Channel 9 in Los Angeles is not the same station on Channel 9 in Chicago. The station is the actual point of distribution for programming. A station located in any community broadcasting on Channel 9, for example, is responsible for arranging the programs on its schedule.[4] Of course, the advent of satellite-delivered programs transmitted directly to a home dish antenna (or through a cable system) is slowly changing viewers' channel-specific orientations, but the mass audience still thinks of a program in relation to a particular channel number.

The important thing to remember is that the audience for the program does not care. The show is the important thing. Despite a station's best efforts to make viewers loyal to the station, viewer loyalty is to a particular program or performer. This is evident, for example, when two affiliates swap networks: the audience shifts too. Even so, when affiliates switch channel numbers in a market, many viewers have a difficult time adjusting.

Ask typical viewers about their favorite afternoon show (for example, *Oprah*), and they will likely say that it is an NBC show if the station that carries the program in their city happens to be an NBC affiliate. Viewers are savvy about which shows are local programming but do not always understand that nonlocal shows on an affiliated station are not necessarily network shows, because a show may be syndicated. Nor do they really care if you try to explain. Viewers are not interested in the real source of the programming.

For the programmer, of course, the station is the important thing. If you are the program manager at a station that is affiliated with NBC, for example, you have a totally different level of priorities than if you have a similar job at an independent TV station. Programming a station affiliated with a network is a *smaller task* than doing the same for an independent (or near-independent) station. The NBC network provides many hours of daily programming seen on an NBC-affiliated station: the morning news shows, daytime programs, the prime-time lineup, and late night shows. The programmer at an affiliated station has some responsibility to help the network provide a successful service that will benefit both the affiliate and the network, but the programmer has greater allegiance to the success of the station. Occasionally that means **preempting** the network with station-originated programming. Often the programmer's priority is to serve the local audience (and the local advertisers).

The present system and traditions of scheduling—what shows run when—have grown out of a scarcity of local over-the-air stations. Even today the typical city has only a few TV stations. Before the advent of cable television (where program offerings are often arranged around types of channels), network-affiliated stations traditionally organized their shows by the time of day and the anticipated audience. In almost all cases, the unstated goal was to appeal to as many people as possible because there were so few choices in the days before cable and DBS.

When there was a scarcity of stations, it seemed foolish to choose programs that might be ex-

tremely popular with only a tiny segment of the population. And so affiliated stations, like their networks, reached out to the widest possible audience. But the relative explosion in the number of cable channels in the past 20 years has changed this. It makes perfect sense for a nationally programmed cable channel to do nothing but run cartoons. Such targeted programs make it more difficult for over-the-air stations to compete for a certain category of programs, be it sports or children's programs.

There is an apt analogy in the realm of retailing. Some huge chain stores have become *category killers*. Local hardware stores and regional electronics stores lose out to "superstores." Similarly, cable TV undermines some categories of shows on over-the-air affiliates by offering a single channel dedicated entirely to one category of programming: news on CNN, sports on ESPN, and so on. Affiliated stations are still a product of the way things used to be before the growth of cable TV. Station owners, staff, and even many viewers remember a simpler time when local affiliates were like the family restaurant that offered a little of everything and tried to please everyone. When there are only three restaurants in a town, people take what they can get. When category competition arrives in the guise of cable television or other multichannel providers, some adjustments have to be made.[5]

Localism

The great strength of affiliated stations is that they are *local*. In the early days of television, many locally originated shows existed. But as costs grew, affiliates stopped doing much local production, except for news. Nowadays, an ABC affiliate in one city is not much different from an ABC affiliate in any other city.

Local news is crucial to an over-the-air television station. Affiliated stations started out as the only stations and got into news very early. They learned that the number one news station is almost always the overall number one station in the market. Affiliation with a network is itself a tremendous resource for local news operations

because of cross-promotion opportunities and the availability of national news feeds to fill out the local newscast when there is not enough happening locally on a given day.

Local news is a huge source of revenue (and expense) for local affiliates. So, too, is a successful locally produced talk show or children's show. For short-term growth, it makes more sense to carry the least expensive programming. In the long run, however, stations can lose their unique identity in a sea of choices.

Competition from cable television (offering national channels) has forced affiliates to reexamine their core strength, localism. Affiliated stations are slowly discovering that local shows can create a long-term franchise. The key to success is to broadcast a professional-looking product, because the audience expects every program, irrespective of source, to have the same quality. If the competition provides attractive, high-budget productions, an affiliate is forced to strive for the same level in any local shows it chooses to produce.

Dayparts

In a tradition that dates back to the early days of network radio programming, **dayparts** separate the programs for the convenience of the different types of viewers at different times of the day (for example, morning news shows, daytime programs, the prime-time lineup, late night shows, and others in-between). Programming at the station level is usually done by daypart, and for each daypart, certain assumptions are made about the composition of the audience. Because school-age children are not usually at home between 8 A.M. and 3 P.M., for example, stations rarely use that time period to show children's programs.[6] The job of the affiliated station program manager is to fill in the dayparts that the network does not fill. Each of these dayparts is examined in detail later in this chapter.

Planning Cycle

Stations anticipate their competition and purchase programs years ahead of airing. Such long-range plans depend on a stable marketplace. Regulatory changes sometimes create havoc with the best laid plans. For example, the FCC's repeal of the prime-time access rule (PTAR) in 1995 had the effect of adding more competitors for off-network shows in the top 50 markets. Moreover, some large-market network-affiliated stations invested in expensive multiyear deals for the most successful first-run shows (*Wheel of Fortune, Entertainment Tonight, Jeopardy!*—to name a few) because off-network reruns were assumed to be forbidden by PTAR for years to come. Now these stations may face competitors with more popular shows, making their high-priced investments poor investments. Just like any other business, television is subject to sudden regulatory changes in Washington.

Stations begin thinking about programs early in the year because the tradition, dating back to the networks' simultaneous "premiere weeks" in the 1960s and 1970s, is to launch a new schedule every fall. It makes sense to start indoor television viewing afresh, when the weather for outdoor activities turns cool in much of the nation. In the fall, children go back to school, and families are more likely to stay home in the evenings.

The annual meeting of the National Association of Television Program Executives (NATPE) is usually held in January in a large convention center. Producers, distributors, and other syndicators of televised programming from around the world pitch their shows to local affiliates of broadcast networks (and to anyone else with money, such as independent stations and cable channels). For program salespeople, the big pressure is to sell their shows to stations in the biggest markets (New York, Los Angeles, and Chicago) where the most people are located.

PROGRAMMING STRATEGIES

Affiliated station programmers are somewhat constrained by their network's schedule. For example, weekend sports programs limit the options for

running weekly movies. But sporting events are seasonal, and a station must find programs for those odd times when there is nothing on the network. Ideally, the programs should appeal to the same audience—largely men 18–49—to accommodate the return of sports when the season begins again.

Another aspect of program selection is program type. The major genres—sitcoms, games, talk, dramas, hard news, newsmagazines, sports, movies, and specials—divide into approximately three program lengths. Game shows, sitcoms, and hard news are all generally a half-hour long. Drama and magazine shows are normally an hour long. Movies and specials are usually two hours long, and sports vary widely, especially events that are not rigidly timed, such as baseball.

Movies and other long-form programs, such as specials and miniseries, create the problem of time commitment. Audiences may be reluctant to spend a large chunk of time watching the same program. However, this disadvantage can easily convert to an advantage once the individual audience members have committed themselves to watching. If the movie or special can hook viewers, the station can hold onto them longer than with a half-hour program.

Even so, stations typically prefer half-hour shows because of their flexibility. Of the half-hour shows, sitcoms can be fit into the most time slots. Viewers can "drop in" anytime and usually understand what's going on, and many viewers enjoy watching a familiar episode again and again. Each episode of a sitcom stands alone like some game shows (and like most dramas that do not depend on viewers' knowledge of previous events and characters). Because of cast changes and story lines, however, it is best to play sitcoms in the order in which they were produced.

Dramas are more apt to be serial, and as with movies, require a larger time commitment than a sitcom. Many stations prefer two sitcoms to a one-hour show because there is the potential of adding viewers at the station break. Many successful one-hour programs on the networks are sold only to cable networks, because broadcast stations are reluctant to schedule them in nonprime-time dayparts where flexibility is crucial.

Acquisition Considerations

A programmer must evaluate the audience, the competition, and the advertiser. There are three common situations. The first is when the affiliate is the dominant station in the market. Here, the programmer has the financial resources to acquire the best shows. Viewers already have a history of understanding the current programs. Show contracts vary from one year to five years—whatever the seller demands. Game and talk shows are usually renewable in one- and two-year cycles. Sitcoms and other off-network programs require a longer commitment.

The second situation occurs when the station is the weakest outlet in the market. In this case, programmers can experiment with new ideas without much danger of losing ground. It is a programming truism that being in last place gives a programmer the most freedom to do exciting programming, including locally originated shows. The drawback, of course, is that the financial rewards and employment security are considerably more shaky for a programmer at the last-place affiliate.

The third situation is where the affiliate is neither the best nor the worst in the market. Since most markets have four or more affiliates, most are necessarily in this predicament. If success breeds success, the life of an "also-ran" is often self-perpetuating. The best syndicated shows are locked up by the leading station. As new programs come along, the syndicators often make them available to the leading station first, because ratings of other shows are likely to be stronger on the leading station. Second-place and third-place stations can take heart from the cyclical nature of programming. As the fortunes of the networks experience ebb and flow, so, too, does the luck of affiliates.

Program acquisition is expensive for stations, but group-owned stations have a bargaining advantage because of their sheer size. Large groups can even bypass syndicators. And groups sometimes join with other groups, giving them clout nearly equal to that of a network. For example, five network-affiliated broadcast groups formed Partner Stations Network in 1993 in association with syndicator Twentieth Television to develop programming. Scripps Howard and its affiliated stations formed a similar group. These powerhouses have the resources to hire the best writers, producers, and directors and to hire big-name stars to their productions, putting their shows on the level of network programs. (But remember that most network shows fail; these groups must have the will as well as the resources to dump failures and begin again.)

Shelf Management

Part of the job of programming an affiliated station (or an independent, for that matter) is managing the program materials under contract. It is possible to "own a show" without making payments on it until the first episode runs. This practice, called *triggering* a show, is generally more prevalent at independent stations because they buy more off-network programs, but it can happen at affiliates too. Programmers must be careful about choosing when to trigger a program, because the hefty payments begin at that point.

In the case of first-run game shows and talk shows, the actual programs are recorded off satellite feeds, put on the air, and then erased. Newer off-network shows are sold with national commercials (**barter spots**) embedded in them, necessitating play of the shows in a particular order. Older shows have greater flexibility because these programs are **straight-cash** purchases; episodes can be delayed for a local special, for example, without creating problems.

Occasionally, the programmer is faced with a successful show that has been in the same time slot for a long time. In this case, the station may

consider **resting** the show (see Chapter 3) by scheduling another short-run program to run temporarily, for example, over the summer. Putting a successful syndicated off-network show on **hiatus** prolongs its continued high ratings. Ironically, when networks put a program on hiatus, it usually means that the show is being canceled forever (or long enough to be totally rewritten or recast with new actors).

Another situation involving successful programs is the practice of **double running**. When an off-network program is extremely popular, viewers cannot seem to get enough of it. Stations respond by playing two episodes per day, often before and after prime time. An example of this practice would be the back-to-back or sandwiched *Seinfeld* reruns in some markets. In the case of *Seinfeld*, stations were trying to lighten the cost of each episode by getting double benefit, but the advertisers (whose national commercials were bartered into each episode) were upset that the audience would be diluted by double running.

AFFILIATE-NETWORK RELATIONS

The three traditional commercial broadcast networks (ABC, CBS, and NBC) program approximately 70 percent of their affiliates' schedules, amounting to about 1,144 hours per year.[7] The remainder consists of about 5 percent local programs (news, sports events, and occasional entertainment programs), and 25 percent syndicated first-run shows (*Wheel of Fortune, Oprah Winfrey, Geraldo, A Current Affair, Jeopardy!*) and rerun off-network properties (*Seinfeld, Home Improvement, Cheers, Roseanne, Frasier*). Each program director blends the network, local, and syndicated schedules to fill his or her particular station needs, and with the advent of satellite delivery from independent distributors and group-owned productions, the choices are more plentiful now.

One of the affiliate's foremost obligations is to its network. The network accounts for approximately 3 to 30 percent of total station revenues.

6.1 COMP CUTS AND INCREASES

The networks would be happy to see a different system than compensation. In fact, there was a time in the early 1990s when it looked as if a substitute system would be designed. CBS led the networks toward this goal of cutting comp, although ironically CBS was the network that first dreamed up the idea. The network and financial syndication rules (**fin-syn**) and the prime-time access rule (PTAR) created a regulatory environment in which independent stations, cable networks, and the Fox network were cutting into the profitability of the networks. It seemed that something had to change.

What changed in the mid-1990s, however, was the regulatory situation. The FCC phased out fin-syn and PTAR. Even as it became apparent that the rules would change, the revenue potential for networks heated up; studios like Viacom/Paramount and Time/Warner wanted to acquire or create networks. Every affiliate suddenly became more valuable to the networks, especially because the Fox network had bought several large-market affiliated stations. CBS apparently shot itself in the foot by cutting network comp in the early 1990s; many of its affiliates jumped ship to Fox.

By 1994 the networks, led by ABC, had begun to reverse the trend in comp cutting. Indeed, affiliates had become as powerful as free-agent football stars. The 1993 edition of this textbook had predicted the demise of comp based on then current trends, but by 1995 the networks were enjoying a very high level of clearances because of increased comp payments to their affiliates. I am reluctant to predict a trend today, given the volatility of the network-affiliate relationship over the past ten years.

This figure includes income from **adjacencies** (local spots sold between or within network programs) and **compensation** ("comp") from the network negotiated as an hourly rate. The amount of money derived from the network depends on market size. Large-market stations get more money, but the bigger the market the less comp counts as a proportion of a station's total revenue. The smaller the market, on the other hand, the greater the percentage of station income coming from network compensation. Major-market managers often regard comp as spare change—it provides only 3 percent of revenue in the top ten markets. But comp is vital in markets 110 and smaller and is a reliable source of 10 percent or more of station revenues in markets between 10 and 110. Without network compensation, many very small-market stations would not be profitable to operate. Moreover, comp has intangible value—it has been a key part of the basic network-affiliate deal for many

decades (see 6.1 for more on recent changes in comp practices).

In larger markets, a few independents make even more in gross revenue than the affiliates in the same market. Because their markets have so many millions of people, stations can charge huge amounts for their national and local spots, and independents have more of them to sell. Independents, however, also have higher programming costs, generally leaving the affiliate as the most profitable type of station (in net profit) in any market.

Affiliated stations are *paid by their network to carry the advertising contained in the network's programs* (the reason for network compensation), a system spawned by the radio networks in the 1930s to gain wide exposure across the country for national advertising. Moreover, the networks pay a premium for **VHF stations**.[8] The sole "V" in one Midwestern market gets comp at three times the

rate earned by the city's other two network affiliates, which have **UHF channels**, even though the VHF's audience is no larger.

Regardless of what eventually happens to comp, a network franchise remains a valuable asset for any television station because of the popularity and visibility of network programs, the revenue from compensation and adjacencies (spots next to network shows), and the savings in local program outlay compared with filling an entire broadcast schedule.

Lack of clearances by the affiliate can jeopardize the effectiveness and profitability of network programs (see Chapter 5). If a particular affiliate consistently preempts network programs for its own local shows, the network's Affiliate Relations Department will call the recalcitrant station to determine the problem and coerce that affiliate into the network's preferred clearance pattern. More often than not, compromise is necessary to keep the network-affiliate partnership affable and profitable, and as their financial interests increasingly diverge, compromise could become more and more difficult.

Network Agreement

Television **affiliation agreements** differ for each network but in general contain the following elements:

1. The affiliate has **first call** on all network programs.

2. Acceptance or rejection (**clearance**) of network programming must be made within four weeks of receipt of order, usually three weeks before the show airs. This is to get listings in *TV Guide* and newspaper television supplements, as well as to compile data to justify advertising buys. Presidential press conferences, general news conferences, and news specials require a minimum of 72 hours' clearance. Finally, breaking news stories, such as Senate hearings and fast-breaking domestic or international stories of great import, could require same-day notification and clearance. Controversial episodes of entertainment series or

movies are red-flagged by the network at least five weeks in advance so that the affiliate may screen and decide whether to carry the program. Upon receiving a program rejection, however, the network has the right to offer the rejected program to another television station in the same market.

3. The network's obligation to deliver the programs is subject to the network's ability to make arrangements satisfactory to affiliates for such delivery (via satellite or shipment of videotape).

4. The network agrees to pay the affiliate on the basis of an established affiliated station's network rate. This rate is based on a station's audience position (share of the market), size of the market, and the station's contribution to the total network audience. The contract between network and affiliate is usually renegotiated every two years, but the term can be a year or more longer.

5. Payment for each network commercial program broadcast over the affiliated station during "live time" is based on a percentage table similar to that shown in 6.2. Early evening and prime-time programs are clearly the most profitable to the affiliate because, of course, the networks gain the largest audiences at those times.

6. The network can reduce the affiliated station's network rates if market conditions change (after at least 30 days' notice, in which event the broadcaster can terminate the affiliation agreement within a predetermined time period). The networks retain staffs to reevaluate rates—recommending varied compensation rates in different time slots to get a better clearance pattern from their affiliates.

7. The network agrees to make compensation payments with reasonable promptness within a monthly accounting period.

8. The broadcaster agrees to submit reports related to broadcasting network programs. These are in the form of affidavits.

9. The Federal Communications Commission (FCC) rules originally fixed the term of this agreement to two years, with prescribed periods during the agreement when either party may notify the

6.2 NETWORK COMPENSATION RATES (CBS EXAMPLE)

	Percent of Affiliated Station's Network Rate
Monday–Friday	
7:00 A.M.–11:15 A.M.	7%
11:15 A.M.–5:00 P.M.	12
5:00 P.M.–6:00 P.M.	15
6:00 P.M.–11:00 P.M.	32
Saturday	
8:00 A.M.–9:00 A.M.	7%
9:00 A.M.–2:00 P.M.	12
5:00 P.M.–6:00 P.M.	15
6:00 P.M.–11:00 P.M.	32
Sunday	
4:00 P.M.–5:00 P.M.	12%
5:00 P.M.–6:00 P.M.	15
6:00 P.M.–11:00 P.M.	32
11:00 P.M.–11:30 P.M.	15

other of termination, but network-affiliate agreements no longer have such a restriction. If each party concurs, the agreement is renewed automatically for another multiyear cycle.

10. If a broadcaster wants to transfer its license to another party, the network can examine the new owner before deciding whether to accept the change.

11. The agreement also lists the technical conditions under which the affiliate will carry the network programs (when a broadcast standard signal arrives to ensure picture quality, for example). Clipping (cutting off the beginnings or ends of programs or commercials), reselling (including permitting noncommercial stations to re-air network programs), or altering any of the content of network shows is expressly prohibited.

12. The rights of the broadcaster, derived from the Communications Act of 1934, also are itemized: (a) The broadcaster can refuse or reject any network program that is reasonably unsatisfactory or unsuitable or contrary to the public interest. (b) The broadcaster has the right to substitute programs in lieu of the network's if the substitution is considered in the broadcaster's opinion of greater local or national importance. The network, in turn, has the right to substitute or cancel programs as it feels necessary.

13. The network must tell the broadcaster of any money, service, or consideration it accepted in the preparation of network programs in accordance with Section 317 of the Communications Act of 1934, which requires this disclosure.

14. The network also agrees to indemnify the broadcaster from and against all claims, damages, liabilities, costs, and expenses arising out of broadcasting network programs that result in alleged libel, slander, defamation, invasion of privacy, or violation or infringement of copyright, literary, or dramatic rights involved in programs the network furnished.

This list is a condensed version of a CBS television affiliation agreement, reflecting the basic considerations involved in an affiliate-network partnership. The network connection is primarily a financial agreement. By carrying the network programs, the affiliated station automatically has unsold spot time around and within these network programs (adjacencies). The money received by an affiliate for the sale of these adjacencies is the affiliate's own and is not shared with the network. The more popular the network programs, the more the affiliate can charge for these spots. In addition, an affiliate receives compensation and popular programs and has the bulk of its schedule filled without a cost outlay.

The relationship between an affiliate and its network may sound simple, but an affiliation is like a marriage or a partnership. When affiliates are canceled by their networks, losing the franchise

to a local rival, they are forced into independent station status and struggle, often ineffectively, to maintain a strong position in the marketplace. An affiliation has traditionally been a valuable asset and is cherished and guarded with care—but divorces do happen.

Station Goals

The primary goal of network affiliate programmers is to wrap strong offerings around the national programming, preferably such strong programs that even when the network is not the leader the local station is still number one. Despite the current philosophy of deregulation by government, programmers must be concerned with service to the public and programming for the needs of the station's community. A generous attitude toward local involvement will keep a station's FCC license secure.

The marketplace has become glutted with new television choices. Some of the enemies include:

- Distant signals (WGN, WWOR)
- News and weather services (CNN, Headline, TWC)
- Local religious stations (UHFs) and religious cable networks (VISN, TBN)
- Sports networks (ESPN, SportsChannel America, regional networks)
- Home shopping networks (QVC, HSN)
- Family and health networks (Family Channel, Lifetime)
- Children's and adventure shows (Nickelodeon, Discovery)
- Music channels (MTV, VH1, TNN)
- Pay movie channels (HBO, Showtime, Cinemax)
- Adult entertainment channels (and cassettes)
- Arts channels (A&E, Bravo)
- Local community access channels
- Videocassettes for home rental and sale

Today's programmer faces more predators than at any time in the history of television. None of the aforementioned programming services has enough strength to do major damage by itself, but collectively they add up to shares of 10 to 35 percent in some time slots in the schedule.[9] Markets of various size, listing early fringe ratings and shares for broadcast stations and cable networks (with ratings above 1.0), along with the missing ratings and shares ("Others") accounting for the fractured HUT level are shown in 6.3. In addition to these increased choices, technological changes are bringing digital compression transmission to television—another costly item for stations to consider (see 6.4).

The television spectrum has become a carnival midway with barkers hawking for viewership. The station programmer faces a fractured market; still, an affiliated station will be a dominant factor in the advertising sales of its market if the programmer makes the correct choices.

Weekly Programming Dayparts

Although some affiliates broadcast programming 24 hours per day, the typical local station goes on the air around 6 A.M. and off the air about 2 A.M. (typically later on weekends), which means 20 hours of programming seven days each week (sometimes 24 hours). The broadcast weekday is made up of ten time segments (Eastern/Pacific time), about 30 percent of which must be filled by the local affiliate programmer:

early morning	6:00 A.M. to 9:00 A.M.
morning	9:00 A.M. to 12 noon
afternoon	12 noon to 4:00 P.M.
early fringe (late afternoon)	4:00 P.M. to 6:00 P.M.
early evening	6:00 P.M. to 7:00 P.M.
prime access	7:00 P.M. to 8:00 P.M.
prime time	8:00 P.M. to 11:00 P.M.
late fringe (late evening)	11:00 P.M. to 11:30 P.M.
late night	11:30 P.M. to 2:00 A.M.
overnight	2:00 A.M. to 6:00 A.M.

6.3 COMPETITION OF BROADCASTERS IN FIVE MARKETS, 4 TO 6 P.M.

		Rating	Share
Los Angeles			
KABC	ABC	6	15
KCAL	Independent	2	4
KCBS	CBS	4	9
KCET	PBS	1	2
KCOP	Independent	6	13
KDOC	Independent	1	2
KMEX	Independent	3	7
KNBC	NBC	6	13
KTLA	Independent	3	8
KTTV	Fox	6	14
KVEA	Independent	1	1
AEN	Cable	1	1
CNN	Cable	1	2
ESP	Cable	1	1
HBO	Cable	1	2
MTV	Cable	1	1
NIK	Cable	1	2
TNT	Cable	1	2
Others			1
Boston			
WABU	Independent	1	2
WBZ	NBC	5	14
WCVB	ABC	6	19
WFXT	Fox	4	12
WGBH	PBS	1	1
WHDH	CBS	5	15
WLVI	Independent	1	4
WMUR	ABC	1	3
WSBK	Independent	1	4
WTBS	Turner	1	1
AEN	Cable	1	3
CNN	Cable	1	2
ESP	Cable	1	1
LIF	Cable	1	2
MYV	Cable	1	2
NIK	Cable	1	3
TNT	Cable	1	2
USA	Cable	1	1
Others			9
Detroit			
WDIV	NBC	9	22
WJBK	CBS	6	14

		Rating	Share
WKBD	Fox	4	11
WXON	Independent	3	7
WXYZ	ABC	9	23
WTBS	Turner	1	3
AOC	Cable	1	2
AEN	Cable	1	2
CNN	Cable	1	2
HBO	Cable	1	2
NIK	Cable	1	3
TNT	Cable	1	1
USA	Cable	1	2
VH1	Cable	1	1
Others			5
Portland, Oregon			
KATU	ABC	9	23
KGW	NBC	7	18
KOIN	CBS	8	19
KOPB	PBS	1	1
KPTV	Independent	4	10
KPDX	Fox	3	8
WTBS	Turner	1	3
CNN	Cable	1	3
ESP	Cable	1	2
LIF	Cable	1	1
NIK	Cable	1	2
TNT	Cable	1	1
USA	Cable	1	2
Others		3	7
Columbus, Ohio			
WBNS	CBS	11	35
WCMH	NBC	7	22
WOSU	PBS	1	2
WSYX	ABC	2	7
WTTE	Fox	3	11
WWHO	Independent	1	2
WTBS	Turner	1	2
AOC	Cable	1	2
CNN	Cable	1	2
NIK	Cable	1	2
TNT	Cable	1	2
USA	Cable	1	2
Others		3	9

Source: Nielsen Station Index, July 1994.

6.4 HDTV CONVERSION

Clearer television pictures with the width of movies, called HDTV (high-definition TV) or advanced TV (ACTV), have been made possible by developments in digital compression. As early as 1992, TV sets were being manufactured that allowed viewers to receive both traditional broadcast pictures (called **NTSC**) and newer high-definition/wide screen pictures. Broadcast television stations will be forced, most of them kicking and screaming, away from the technology presently used and into high-definition pictures of one type or another, probably delivering both kinds of signals for several years until most of the 200 million or so television sets in the United States have been replaced. Stations will pay from $5 to $12 million over a period of years for the conversion, with the highest costs to the early innovators. NBC expected to begin sending high-definition digital signals by fall 1997 following FCC testing.

Stations will receive a second channel from the FCC to transmit digital services like HDTV, although in 1995 Fox proposed a flexible arrangement whereby the high-definition picture would only be shown part of the day. The remainder of the day on the second channel could be used to split into five or six different program choices using the old NTSC standard that requires less bandwidth. The big issue is whether such new channels should come to broadcasters for free or should be auctioned off. If stations pay for the channels, they could, of course, use them as they see fit—in the most profitable way.

These dayparts are the standard for Nielsen Media Research in the Eastern and Western time zones, and shift one hour in Central and Mountain time. Ratings researchers use these dayparts to measure audience viewing, and sales departments use them to sell commercial time throughout each day. In a new twist, large-market West Coast stations are shifting to the earlier Central and Mountain time pattern to match local viewing habits; in many households in the West, the TV set goes off at 10 P.M. Ratings analysis becomes increasingly complex as affiliates alter and experiment with time shifts to counterprogram the competition. Programming strategies differ according to the time segment involved.

In four of these dayparts (morning, afternoon, prime time, and late night), the network provides a large portion of the programs. In early morning and early evening, the network contributes part of the programming. Early fringe, access, late fringe, and overnight are wholly local responsibilities. In the remainder of this chapter I will look at the lo-

cal affiliate programmer's options when surrounding or replacing network programming for each of these successive dayparts. The programmer's strategies include targeting, audience flow, lead-in effects, local appeal, and reuse of expensive syndicated programs.

EARLY MORNING
(7 A.M.–9 A.M.) HUT LEVEL* 23%

The strategies for early-early morning (6 to 7 A.M.) and early morning (7 to 9 A.M.) can be very simple for the affiliate program director commanding first or second place: Change nothing—stay with the

*The estimated households using television (HUT) levels throughout this chapter come from Nielsen's July 1994 *DMA Planners Guide*, derived from the July 1994 Nielsen Station Index for the top 100 markets. More variation in HUTs, generally upward, can be expected in the smaller markets depending on the number of competing signals and degree of cable penetration.

network. If an independent is beating the affiliate in this time period, however, surgery may be necessary. Then seven options exist.

1. Children's programming. If the market has enough advertisers who target children, theatrical cartoons and animated half-hours for young children may be the answer. More than likely, however, there is a glut of children's material already on independent stations, which typically specialize in what the station advertising rep's call "kid business."

2. Off-network syndicated sitcoms or one-hour drama/adventure programs. Early morning is a fine place for the sixth and seventh runs of such programming as *Andy Griffith* and *Happy Days* or for burning up the last runs of such properties as *Little House on the Prairie*. Advertiser interest in reruns is more pronounced than for children's shows, and time sales will be evenly distributed throughout the year.

3. Syndicated women-oriented programs. *Sally Jessy Raphael, Live with Regis & Kathie Lee, Geraldo,* and *Donahue* are samples of syndicated shows targeting women. Many of these programs appeal to the stay-at-home women's audience available during these hours.

4. Expandable combinations. A ploy used in several markets has been to invest in a local women-oriented program starting as a one-hour entry and expanding the show to two hours (from 8 to 10 A.M.) when ripe. Such programming is most successful when directed specifically toward the female audience remaining alone after families have left for school and work. The 8 A.M. start is advantageous because it bridges the 9 A.M. slot that syndicated talk shows dominate. A women's show is also highly salable every week in the year. Women's programs also can have frequent community-oriented segments that apply to FCC commitments for public service programming. A good example of this option is WEWS-TV's *Morning Exchange*, 8 to 10 A.M., Monday through Friday. This Cleveland station's program follows the talk/information format but is wholly locally

produced. Another very successful program of this type is *AM Philadelphia* on WPVI-TV.

5. Paid religious programming. Religion will bring in money but dismal ratings, with the demographics in the 50+ age category. Nonetheless, an hour of evangelism can be quite expedient.

6. Syndicated and local news. Some stations have utilized CNN's Headline service interwoven with their own local updates. The structure is most effective in the 6 to 7 A.M. time slot because the early audience is interested in information and turns over frequently. The 8 to 9 A.M. period should have more entertainment value because the majority of heads of households have gone off to work.

7. Infomercials. When an affiliate is really in trouble, it is safest to take the network feed and supplement the surrounding time period with program-length commercials such as *Amazing Discoveries*. The revenue can outweigh the ratings.

MORNING
(9 A.M.–NOON) HUT LEVEL 18%

Syndicated hours and half-hours, sitcoms, network delays, children's programming, talk shows, and local live programs—all have found comfortable positions from mid-morning to noon. The audience during this time consists mainly of preschoolers and homemakers, retirees, and people available at home as a result of an odd-hour work shift. At one time *Donahue* was the "king of the mornings" whatever the competition, but now other talk shows have gained greater popularity. The networks only partly fill the 9 A.M. to noon period (ABC and CBS fill 11 A.M. to noon, and NBC has dropped this time period altogether), so this time period leaves plenty of opportunity for local programmers to exercise one of the following options:

1. Old off-network shows. Write off the station's investment in off-network syndicated properties

(after use elsewhere) by placing them from 9 to 10 A.M. or 10 to 11 A.M., then join the network. Off-network properties such as *Empty Nest, Wonder Years*, and *Mr. Belvedere* will most likely be scheduled here.

2. First-run talk show. Purchase a first-run early morning syndicated talk show. Some programs have been developed precisely for this time slot—*Geraldo, Sally Jessy Raphael*, and *Live with Regis & Kathie Lee.*

3. Local live show. Rating books show many local live programs, such as *AM Pittsburgh, Midmorning, AM Philadelphia*, and *Morning Exchange*. Each of the five ABC O&Os produce a local live program (for example, *The Morning Show, AM Los Angeles*, and *Kelly & Co.*), the structure of which would be worth studying if a programmer is thinking of going in this direction.

4. Movie. Many markets have tried a movie from 9 to 11 A.M. This option has been modestly successful, depending on the competition. It is ideal for an independent station, but a third-ranked affiliate may want to consider it if the station's film library can support it.

5. Game show block. Morning game shows have proved successful as network fare, and two half-hours from 9 to 10 A.M. would make a very good fit for some affiliates.

The 9 A.M. to noon time period is characterized by **passive viewing**, a condition where viewers often leave the room to perform household tasks. A programmer must find shows that do not demand high-intensity viewing for more than one hour at a time. That is why half-hours ideally suit the morning. Many local shows are yet to be born using the minicam, which has the great benefit of going into the community rather than being frozen in a studio on a make-believe set. Major market stations in Boston, Los Angeles, and Cleveland have attempted this kind of morning programming. These shows contain a provincial flavor, making them desirable for the local market but unsuitable for syndication on a national level.

AFTERNOON
(NOON–4 P.M.)* HUT LEVEL 24%

Network soap operas dominate the early afternoon daypart (noon to 3 or 4 P.M.). Affiliates should not consider preempting soap operas, because once the cement of the drama hardens, dedicated viewers are glued—some for as long as 10 or 20 years. Preempting a favorite soap for a sporting event or a news special brings an eruption of ire from addicts. Put the news specials someplace else if not from the network; in a multichannel TV environment, lengthy interruptions of favorite programs make little sense. But several alternative programming possibilities should at least be considered for part of this time period. Most programmers divide the afternoon daypart into two parts: the noon hour and the 1 to 3 or 4 P.M. time period.

Noon news is popular with in-office television viewers and the home-for-lunch and stay-at-home audiences. The noontime pause in at-home and office activities creates an ideal slot for information. Noon coverage of world and local activities is a ritual, as much for stations as for the audience. Stations aspiring to leadership in news coverage cannot omit the noon news. Furthermore, it makes money in spot sales and recycles and updates the top stories from the previous night's 11 P.M. news, which helps spread the high news expenditures.

Although most network affiliates would be committing hara-kiri if they preempted the soaps during this period, a few do manage to get away with substituting either a local or regional talk show or a syndicated property. Generally, they get no better ratings than the poorest soaps.

Lack of clearances for some of the dayparts by many affiliates has resulted in an accommodation by the three television networks. CBS, for example, makes the 12 to 12:30 P.M. time slot available to affiliates for local use. If an affiliate is going to refuse to clear the network, it is wiser to do it before a new series starts; once the public sees the show, cancellation becomes noisy and painful.

*This daypart ends at 3 P.M. in the Central and Mountain time zones.

EARLY FRINGE
(4 P.M.–6 P.M.)* HUT LEVEL 36%

Two major changes occurred during the mid-1980s in the 4 to 6 P.M. time period. First, all three networks relinquished the 4 to 4:30 P.M. time slot because of a consistent lack of affiliate clearances (NBC also ceded 3 to 4 P.M. in the 1990s). Second, many affiliates backed up their local newscasts to 5:30 P.M. and, in some cases, to 5 P.M. In the top five markets, several affiliates even begin their news at 4 P.M. Two stations in Los Angeles (KNBC and KABC) started the news war at 4 P.M., and WLS in Chicago also began its news that early. The advantage is that early local news releases the whole hour of prime access time (7 to 8 P.M. EST) for first-run syndicated programming such as *Wheel of Fortune*, *Jeopardy!*, *A Current Affair*, and the like. Although this strategy leaves the 4 to 6 P.M. time period somewhat fractured, it is still fertile territory for three different strategies: talk shows, first-run magazine programs, and off-network reruns.

1. Talk shows. The granddaddy of all talk shows was *Donahue*, which ended production in 1996 after 27 years. *Donahue* proved a talk show could get big ratings in the morning. Then along came *Oprah Winfrey* in 1986. She proved she not only could win in the morning but dominate in the afternoon. *Oprah* is now called "queen of the afternoons," capturing shares approaching 30 percent in afternoons and reaching nearly 10 million viewers, most of them women (see 6.5). The strongest recent entry has been *The Ricki Lake Show* which targets younger women.

Although talk shows came under fire in 1995 for lurid content, network affiliates continue to enjoy strong ratings with the format. Most (though not all) of the programs have abandoned tawdry topics, and the current success trend is expected to remain. One reason for this is that the

*This time period is 3 to 5 P.M. in the Central and Mountain time zones.

6.5 RANK ORDERING OF EARLY FRINGE TALK SHOWS, 1995		

Rank	Host/Hostess	Rating	Share
1	Oprah Winfrey	8.4	27
2	Montel Williams	5.2	17
3	Jerry Springer	5.0	13
4	Sally Jessy Raphael	4.7	17
5	Maury Povich	4.4	19
6	Ricki Lake	4.3	13
7	Donahue	4.1	12
8	Jenny Jones	4.1	12
9	Geraldo	3.5	11
10	Richard Bey	2.8	5

Source: A. C. Nielsen's Report compiled by Petry Television, May 1995.

shows are topical and fresh, unlike off-network reruns that dominated early fringe for decades.

2. Magazine programs. Another successful format that capitalizes on timely topics and sensationalism is the magazine format. Shows such as *Inside Edition* and *Hard Copy* perform better than many off-network sitcoms, although their success was greatly influenced by the O. J. Simpson trial in 1995. As 6.6 shows, the strongest half-hours can attract nearly as many viewers as second- and third-ranked talk shows. Two characteristics make these shows excellent lead-ins to local newsblocks: their compatibility with other information content (like talk and news) and their convenient 30-minute length. Their chief drawback is that some audiences find them less entertaining than off-network sitcoms.

3. Buying **off-network reruns** is still a viable option for early fringe because it can attract children after school as well as working people as they stagger home in the late afternoon. Between 4 and 6 P.M., affiliates use a strategy called **aging an**

6.6 RANK ORDERING OF EARLY FRINGE MAGAZINE SHOWS, 1995

Rank	Show
1	*Inside Edition* (5.6 rtg./17 sh.)
2	*Hard Copy*
3	*American Journal*
4	*Entertainment Tonight*

Source: A. C. Nielsen's Report compiled by Petry Television, May 1995.

audience. The strategy requires starting with **kiddult** comedies around 4 P.M., phasing into family programs around 4:30 to 5 P.M., and following with adult programs as a lead-in to the 5:30 or 6 P.M. news. Such shows as *Baywatch*, *Cosby*, *Cheers*, *Fresh Prince of Bel-Air*, *Coach*, *Step by Step*, and *Family Matters* now typically appear in early fringe on some affiliates. Four half-hour series are ideal for filling the 4 to 6 P.M. period. If one of the four series is weak, the station can plug in another.

Deals for Stripped Shows

Barter has become a major factor in many off-network and most first-run syndication negotiations (see Chapter 3). For some time now, game shows such as *Wheel of Fortune* and *Jeopardy!* have included one minute of barter in each of their properties. King World's *Oprah* demands two minutes of barter time for the distributor, leaving the station ten minutes to sell (in this 60-minute show). The new "rule" of 60 seconds of barter time for every half-hour applies only to first-run syndicated programs such as *Oprah* at this time; there is no rule for off-network barter deals as yet. However, as stations negotiate for megahits, they increasingly are required to pay cash and give away barter time. The barter consideration seems to be here to stay.

Long-running network series have been scarce in recent years; in consequence, syndicated properties with the 130 episodes ideal to program on a Monday through Friday (stripped) basis are rare. There are actually *260 time slots per year* to fill (52 weeks × 5 days). If the series has 130 episodes, each show can be repeated twice a year with a six-month rest between exposures. This cycle is ideal for a good show. If a syndicated series has fewer than 130 episodes, individual episodes must be re-run more often unless the station regularly schedules sports or election-year programming in that slot. If it has more than 130, fewer reruns are needed, or the cycle can be stretched to cover more weeks. Syndicated series with 160 or more episodes command very high prices in the major markets (see 6.7).

The catch is that back in the 1980s the networks began licensing only 22 or so new episodes of any series each year. (In the 1960s, as many as 39 episodes were produced for a prime-time slot.) A series now has to run for six years to amass 132 episodes, and very few programs have had that kind of longevity. When a show does stay on the network that long, most stations want to buy it, and the distributor jacks up the price to match the demand. Some shows that have hit the golden jackpot in recent years have been *Frasier*, *Seinfeld*, *Home Improvement*, *M*A*S*H*, *Little House on the Prairie*, *All in the Family*, *The Jeffersons*, *Cheers*, *Family Ties*, *Night Court*, *A Different World*, and *Who's the Boss?*

Programmers must beware of hidden futures costs. For example, network cancellation strongly affected the syndicated sale and scheduling of *Webster*. This was an ABC property, placed on Friday nights at 8 P.M. during the 1986–87 season. Paramount, the syndicator, sold futures on 100 episodes of *Webster* to dozens of stations with the understanding that it would deliver a minimum of 100 and a maximum of 150 episodes for stripping on a rerun basis beginning in the fall of 1988. *Webster* was presold to many stations two years before it became eligible to be aired (futures). But in mid-1987 ABC canceled *Webster* on the network (with only 100 episodes produced), and the sta-

6.7 SYNDICATION DEALS

By the early 1990s competition had forced the affiliated stations to vie mightily for high-priced network reruns, driving the prices up still further. Before the demise of the prime-time access rule (PTAR), stations in the top 50 markets could only run off-network syndication during the afternoon. The high costs for off-network programs and the decline of first-run court shows led to an explosion in new first-run talk shows. The success of *Ricki Lake* led to many imitators (and critics) with lurid subject matters and guests who "bare all." If the trend toward controversial-topic talk shows declines, however, it will be because the public tires of them. As it stands, these shows are fairly inexpensive to produce because the guests are willing to appear at little cost to the syndicator of the show.

tions were suddenly faced with a contract clause giving Paramount the right to produce 50 original episodes over the two seasons following network cancellation. This brought to 150 the number of episodes available for syndication but greatly increased the cost of the show to stations. Many programmers did not expect ABC to cancel *Webster* when they signed the contract. Paramount's *Webster* deal was an industry eye-opener.

In addition to barter and futures deals, another method of obtaining strip product is the **front- and backend deal**. This method requires a station to run a property only once a week until enough episodes have accumulated for stripping, usually three to five years. The original syndication contract for *Star Trek: The Next Generation*, for example, required the station to pay so much per episode on the frontend and once again to pay at the backend when the show became available for stripping. The advantage of the deal is that it gives the station control of a once-a-week property that

eventually will accumulate enough episodes to be stripped. If the property falters, the show gets canceled; if it is successful for five to six seasons, the station then has a viable first-run property that it can play any place in the schedule.

Counterprogramming Blocks

Two kinds of shows have characterized the early fringe time period on third- and fourth-ranked affiliates. One strategy is to counterprogram the top-ranked affiliates by blocking several similar shows together, provided they make an effective lead-in to local news. Children's programming and game shows have both been used for this purpose.

1. Children's programming. By the mid-1990s most affiliates had turned away from children's programming in the 4 to 6 P.M. period for two reasons. First, temporary deregulation by the FCC had eliminated its intimidation factor, once forcing stations de facto to air children's programming somewhere in the schedule. Second, the advertising support for this type of programming generally is only available in the third and fourth quarters (back-to-school and Christmas).

Children's fare, after finding a haven on independent stations, will likely return to affiliated stations in the late-1990s because of the FCC's proposal to set quantitative requirements or guidelines on the amount of educational children's TV aired by broadcasters. One plan in 1996 was for the FCC to include a children's TV element as part of broadcast license renewal's public interest provisions. (See *http://www.broadcastingcable.com/wts.html* or *http://www.fcc.gov* for updates on FCC policies.)

Distributors, who have been able to barter children's programs or sell them for cash to independents, will find interested affiliate station buyers. Most stations place these children's programs from 6 to 9 A.M. and from 4 to 6 P.M. Besides being a revenue source, children's programs get kids to turn on the set. Smart programmers start from that point and phase into more adult programming. This practice (aging your demos) characterizes

many affiliates and most major-market independents in early fringe.

2. Game shows. Many affiliates have been successful in developing a game show block. There certainly is an ample supply, although *Wheel of Fortune* and *Jeopardy!* have cornered the market. Game show shares have ranged from 10 to 20 percent and have become an economical form of programming in early fringe (and access) for any size market. Currently, game shows in early fringe are in a lull, like the courtroom dramas that were so popular during the 1980s. Programmers could expect a renewed popularity of game shows, however, if the audience ever tires of talk shows featuring dysfunctional guests. Game shows are inexpensive to produce and can involve the audience because they can play along. At one time, the networks had long-running game shows in prime time. The genre may be asleep right now, but it is far from dead. A clever idea (like reviving *Hollywood Squares* as *Planet Hollywood Squares*) may be all it takes.

EARLY EVENING (6 P.M.–7:30 P.M.)* HUT LEVEL 49%

The 6 to 7:30 P.M. time period is devoted to news on most affiliates. Each network provides 30 minutes of national coverage. Some stations end this time period and begin access at 7 P.M.; others extend news until 7:30 P.M. Three options are commonly evaluated by affiliates when filling this time slot.

1. Half-hour newscast. Affiliates in markets below the top ten adhere to one of two patterns: (a) precede or follow the network news with 30 minutes or one hour of local news, or (b) sandwich the national news between two local news-

casts, a 30-minute one preceding and a 30-minute one following.

2. Local news block. Some stations in the top ten markets have instituted two-hour local news programs that start around 5 P.M. and stretch to 7 P.M., at which time they add the network news, for a total of two and a half hours of news. (In a few cases, this news block starts as early as 4 P.M.) This much news, of course, must utterly dominate the ratings or fall victim to counterprogramming that wins in total audience preference. The total news audience typically skews old, so winning the key 18- to 49-year-old audience is more important for gaining some advertisers, and therefore the all-important revenue, than winning the ratings in the adult 18+ demographic group.

3. Sandwich news. For the average affiliate, 90 minutes of news between 6 and 7:30 P.M. is all its market can handle. The most successful structure has been the **sandwich,** which splits the local news into two sections: The six o'clock unit carries the fast-breaking items, and the seven o'clock segment handles the follow-ups and feature material. Of course, sports and weather can be sprinkled through both portions. Many markets have added a 5:30 P.M. news section featuring hard news headlines and reports from sites in the Designated Market Area. ENG equipment, remote trucks, helicopters, and mobile satellite dishes bring in events from the outlying reaches of a station's coverage (**remotes**), making local people, places, and events more important in the overall news picture.

The affiliate with the strongest news team usually dominates its market. Local evening news is television's front page. Beginning in the 1970s, competition became so fierce that consulting firms such as Frank Magid Associates sprouted everywhere to advise stations on presenters, content, format structure, set design, program pace, and even the clothing to be worn by the on-air personnel. This has resulted in look-alike newscasts across the country featuring Barbie-doll anchors and cloned news stories. An affiliate can avoid this by developing a particular style of presentation and em-

*This time period is 5 to 6:30 P.M. in the Central and Mountain time zones.

ploying on-the-air newscasters and reporters who depend on their journalistic talents more than they depend on their looks.

In the 1990s, affiliate news departments began looking around for ways to stretch the news dollar. In addition to lengthening the hours of evening news and adding newscasts in other dayparts, some stations have opted for **news cooperatives,** coproducing for cable, radio, and even independents in the same market. Simulcasts of local TV newscasts have been cost-efficient for both parties; in one case, an affiliate has begun a radio network that retransmits the evening newscast in expanded form. Rebroadcast synergies enlarge the station's news audience, thereby enabling eventual increases in advertising rates. Original production for independents, cable, or radio has upfront costs but creates more minutes for sale. It may be many years, however, before most of these arrangements bear green fruit carrying dollar signs.

One troubling trend in the mid-1990s is the plummeting of national news shares (see Chapter 5). Although local news has shown only minor declines in viewing, station programmers should study all available data before assuming that the dominance of early evening news will continue. As younger audiences seek out entertainment alternatives on cable networks and independent stations, the overall demand for news may continue to decline somewhat.

PRIME ACCESS
(7 OR 7:30 P.M.–8 P.M.) HUT LEVEL 53%

In the 1970s a time period was set aside so that local affiliates could provide local programming to serve their communities. This was (and still is) called **access time.** The original intent for this time block has been lost for virtually all stations, who mostly fill the time with nationally distributed entertainment programs. The hope that access time would stimulate quality programs has long since faded, and what remains is largely a nightmare of game shows and tabloid journalism.

6.8 TOP TEN PRIME ACCESS SHOWS, 1995		
	Rating	Share
Wheel of Fortune	14.1	30
Jeopardy!	12.7	26
Entertainment Tonight	7.0	13
Hard Copy	6.8	13
Inside Edition	6.6	15
The Simpsons	6.4	10
Current Affair	6.2	13
American Journal	6.1	14
Fresh Prince of Bel-Air	5.9	12
Cops	5.4	11

Source: A. C. Nielsen's Report compiled by Petry Television, May 1995.

The four most common strategies for filling this time period follow.

1. First-run syndicated half-hours. Television logs have become loaded Monday through Friday with such gems as *Wheel of Fortune, Jeopardy!*, and *Inside Edition* (all owned by King World, which also syndicates *The Oprah Winfrey Show*). *Wheel of Fortune* and *Jeopardy!* have dominated access in most of 200 markets for more than a decade. The anemia in first-run programs for access, for stations looking for quality programs, is evident in 6.8, a list of the top ten prime access shows from May 1995 when the O.J. Simpson trial was still draining away audience.

Another syndicated property that has managed to hang on over the years is *Entertainment Tonight.* This is a magazine concept requiring no local station involvement. Slick, polished, and timely, *Entertainment Tonight* combines some of the most successful elements of magazine shows with fan magazine trivia. Other competitors for second and third place include the sensationalist **tabloid program** lineup—the biggest hits being *A Current Affair* and *Inside Edition*, followed by *Hard Copy*.

6.9 THE CLASSIC LOCAL MAGAZINE

In the early 1970s the Group W station in San Francisco, KPIX-TV, applied its budget for prime access to an innovative local magazine show entitled *Evening*. This program reflected San Francisco's lifestyle, its people, its oddities, and its beauty. The show proved such a success that the remaining Group W stations in Pittsburgh, Boston, Philadelphia, and Baltimore adopted the pattern. Eventually, the group-owned stations started to exchange program segments, and it became apparent that other stations might be able to use this material if a show like *Evening* were begun in markets across the country. *Evening* went into syndication as *PM Magazine* in 1978, and it became the backbone of the access time period for nearly 140 stations for several years. However, the ratings for *PM Magazine* waned in the mid-1980s, and finally in 1987 Westinghouse pulled the plug on its syndication. Some stations have made a deal with Group W to continue their season of *PM* in their respective markets with help from Group W O&O stations. The *PM* concept often lacked balance between syndicated material and local stories. If the local material is downplayed, the entire show loses its local flavor and then depends entirely on the universality of the syndicated pieces for its appeal, a risky expectation.

A combination such as *Entertainment Tonight* and *Hard Copy* could cost as much as $5 million a year in a major market back in the early 1990s when the FCC insisted on first-run shows in access. With the demise of PTAR, many first-run shows that place second or third in the ratings will be replaced by off-network sitcoms.

2. Off-network shows. Reruns of the most popular of the recent network successes are typically stripped Monday through Friday (and sometimes Saturday). A program featuring a family will often attract young and old alike. Before the demise of the prime-time access rule (PTAR) in 1995, off-network programs were off-limits for the top 50 markets in this time period. Even so, the strength of smaller affiliates (and the independent stations) is reflected in the rankings in 6.8, where *Fresh Prince of Bel-Air* managed to crack the top ten. In 1995 and 1996, *The Simpsons, Seinfeld,* and *Home Improvement* also invaded the access time period with strong ratings (mostly on independent stations that usually do not influence the top-ten list). Without PTAR the continued success of many first-run tabloid shows is in question. Still, viewers prefer fresh programming. A compelling first-run program, even a popular game show, might attract a larger audience than a rerun.

3. Local access shows. Some stations, unwilling to wait for syndicators to develop a long-lasting new genre to fit the 7 to 8 P.M. time period, are doing it themselves. Borrowing from the Group W *Evening/PM* concept of the 1970s and 1980s (see 6.9), broadcasters are developing formats producible, at least in part, in their own markets rather than continuing to depend on established programs from national syndicators. Some of these efforts have been in conjunction with local cable systems and provide commercial programming both for the broadcaster and the local cable channel.

4. Blocks. The practice of **checkerboarding** (rotating several shows on different weekdays in the same half-hour) in access time is still an unpopular option for most affiliates. Despite a revival in the late 1980s, this strategy of scheduling first-run weekly shows had gone dormant again by 1996. Stations competing against stripped game shows had encouraged syndicators to produce more first-run, once-a-week sitcoms for checkerboarding against a game show block, but the strategy just has not worked very well. Like the once-popular

movie during the afternoon daypart, the weekly syndicated half-hour seems no longer to be welcome during access.

PRIME TIME
(8 P.M.–11 P.M.)* HUT LEVEL 59%

Prime-time is the most highly viewed period of the daily schedule for affiliates. From 8 to 11 P.M., the networks pour on expensive and highly competitive programs, supported by arresting promotional campaigns on the air and in newspaper and magazine ads. Independent stations have been unable to bite into this time period with any consistency, and it remains the payload of the national networks. The networks must get clearances by affiliates for this time if they are to maintain network parity. Any network riddled by a high percentage of nonclearances may damage its position as a leader simply because some of its programming is not being seen by the public. Each nonclearance becomes a zero when the ratings are being tabulated. Even a delayed broadcast of a program would count for something in the tabulation.

Preemption in Prime Time

From time to time, an affiliate may identify a section of the network schedule that needs repair but that the network cannot fix until later in the season. Under these conditions, an affiliate might "pick off" a weak night for a local movie special, a musical-hour special, or a program having some significance to the local community. Networks tolerate these preemptions if they do not happen too often, and the station need only convince its viewers that a preemption is justified. When the public is not convinced, phone calls, letters, and the press scold the affiliate for its defection.

It is best to preempt on different days rather than pick off the same time slot week after week because regular preemptions irritate viewers who are robbed of certain shows. Judgment must be exercised when bumping a new network show that appears to be doomed in the New York or Los Angeles overnight ratings. Many a programmer has been burned by preempting a big-city loser only to find that it became a hit in local markets, and that, with time, it also became a hit in the big city. This situation occurred with *Golden Girls* and *Little House on the Prairie*.

Stations located in university towns with outstanding national football and basketball programs are hotbeds of sports and can often cause a network much consternation. Seventy-five hours or more of network prime-time fare can be refused when regional and local sports bump network shows. When this occurs, the network does not pay its affiliate, and the affiliate must pay for this new programming. If the local team is hot, the ratings can be very high. But a losing season can make the affiliate wish the station had taken the network programming. It is always a risky choice unless the local team is a national contender.

Networks will, under some circumstances, offer an affiliate the chance to place a preempted program in a nonnetwork time slot (**delayed carriage**). The affiliate usually can find a suitable time slot for a preempted program in late night or on weekends. Seldom, if ever, will a network permit a preempted program to cover another network program.

In examining the track record of an affiliate, a network often studies the preemption ratio to determine how "loyal" a station has been over a period of time. The network will use this defection as a wedge, especially if the affiliate wants to increase its hourly compensation rate from the network. A good clearance record is, more often than not, a valued chip to be used in network negotiations. A maverick station not only will be watched carefully but might be subject to compensation cuts if the station does not come into line with other affiliates in total audience delivery. Sweeping cuts in compensation decrease the networks' monetary

*Prime-time extends from 7 to 11 P.M. on Sundays in Eastern/Pacific time, and in Central and Mountain time lasts from 7 to 10 P.M. Monday through Friday and from 6 to 10 P.M. on Sundays.

curb and increase affiliates' disposition to preempt weak network shows. Preemptions allow the local station to charge national spot rates rather than local rates for its prime time, creating a strong incentive to preempt if other program options are available and the penalties are light.

LATE FRINGE, LATE NIGHT, AND OVERNIGHT

Late fringe begins with the half-hour directly following prime time and continues into the late- and late-late-night periods, eventually arriving at morning (6 A.M.) on some stations.

Late Fringe News
(11 P.M.–11:35 P.M.)* HUT Level 47%

Affiliates traditionally reserve late fringe, the 11 to 11:30 P.M. time slot, for late local newscasts. A carry-over from radio, the eleven o'clock news is part of the ingrained tradition of affiliate programming. Only an independent can counterprogram with movies or other programming, and not many have been successful in the 11 P.M. to 1 A.M. zone. The affiliate has the edge, and a habit pattern is very difficult to break.

Independent stations have tried to break the 11 P.M. news hold for years with first-run shows. Only one show—*Mary Hartman, Mary Hartman*—dented the public's late news loyalty. This happened in most markets for only two to three years, then the news regained its losses. In the early 1990s, however, Fox's *The Arsenio Hall Show* temporarily succeeded in challenging affiliate news at 11 P.M.

In some markets, the third-ranked affiliates against two powerhouse local news operations will simply throw in the towel in late fringe and counterprogram the other affiliates. ABC (now NBC)

affiliate WNWO in Toledo, Ohio, has used this strategy since 1990, scheduling syndicated shows like *The Arsenio Hall Show* and *M*A*S*H* at 11 P.M. In 1991 CBS affiliate WKXT-TV in Knoxville, Tennessee, made a similar move, which remains an option for other affiliates.

Late-Night Entertainment
(11:35 P.M.–1 A.M.)* HUT Level 25%

The last weeknight segment some affiliate programmers fill is the 11:35 P.M. to 2:05 A.M. period, **late night**. (Stations began extending their late local newscasts by 5 minutes in the late 1980s.) NBC's *Tonight Show* was untouchable in the ratings for three decades. Jay Leno replaced Carson as the host of *Tonight* in 1992, outdoing even Carson in initial ratings. David Letterman migrated from NBC to CBS in 1993, with initial success after many affiliates began clearing his show live instead of delaying it. In 1995, Leno and Letterman were neck-and-neck in the ratings, although both were occasionally beaten by Ted Koppel's *Nightline* on ABC (in markets where the shows were scheduled head-to-head). ABC is likely to expand its late-night franchise now that NBC and CBS are competing from 11:35 P.M. to 12:35 A.M. See Chapter 5 for a detailed discussion of this time period.

By the mid-1990s, many affiliates were giving live clearances to Leno, Letterman, and Koppel. However, several alternative gambits have modestly successful track records for affiliates at 11:35 P.M. (with some time variations for stations in the Central and Mountain time zones).

1. Carry the network. This option continues to be a sure thing for most affiliates.

2. Sitcoms. Some affiliates place a half-hour off-network sitcom (*Married . . . with Children, Seinfeld, Cheers*) at 11:35 P.M. with a delayed broadcast of the network. Many people who stay up to watch the late news can manage to watch until mid-

*Late Fringe News is from 10 to 10:35 P.M. in the Central and Mountain time zones.

*Late Fringe or Late-Night Entertainment is from 10:35 P.M. to midnight in the Central and Mountain time zones.

night. Stations in the Eastern time zone would prefer to have a syndicated half-hour instead of the network because there are more commercial positions to sell.

3. One hour adventure series. At one time, the hour adventure show had found a home from 11:35 P.M. to 12:35 A.M., but this was when CBS did not have a viable program like *The Late Show with David Letterman*. This is still a viable option in some time zones where viewers are awake for an hour past the end of the network's first late-night program.

4. Movies. Scheduling feature films in late-night time periods (preempting NBC's *Later* or CBS's *Tom Snyder*) became increasingly popular in the 1980s as film syndicators sought to reduce the length of rental agreements. A play or run is one exposure of any part of a program or film on the air, and every airing constitutes a valuable property for both the station and the syndicator. Syndicators want to maximize the number of plays on pay television (see Chapter 11), and short contracts allow a movie to return rapidly to the syndication market for resale. This practice forces an affiliate to use up all the runs the station purchased within a short length of time, as short as three years for many contracts (for three runs). Affiliates and independents (see Chapter 7) traditionally commanded contracts of six or more runs over a period of six years for movie packages but were forced to change their movie scheduling strategies in the mid-1980s. As long as there is a third-place network in late-night, movies will be an option for affiliates into the 1990s and beyond.

Overnight Options
(2:05 A.M.–6 A.M.) HUT Level 7%

For some affiliate programmers, usually in urban markets, one time period remains to be filled, the overnight slot. In some markets, this daypart ends about 4 A.M. or whenever the movie is over. In other markets, stations program all 24 hours, con-

cluding the overnight period at 6 A.M.—just in time for early-early-morning programming. Here are three strategies for filling this time slot.

1. Movies. Most stations program the overnight time period only on Friday and Saturday nights, but a slowly increasing number of affiliates have copied successful independents in their markets and counterprogrammed a second and even third round of movies during the weekday overnight period.

2. More news. CBS affiliates have *Up to the Minute*, ABC affiliates have *World News Now*, and NBC affiliates have *Nightside* (see Chapter 5 for details). Stations can also license Turner's *Headline News* for the full overnight to feed the information-hungry.

3. Experiments. It would be interesting to see some station repeat its 4 to 6 P.M. programming in the 2 to 4 A.M. period. Sitcoms at 11:35 P.M. have proven successful. Why not string a bunch together, even though they are in the seventh and eighth runs, and see what happens? Another experiment would be to take the network's prime time and repeat it from 2 to 5 A.M. Research in the top five markets has indicated that a lot of people are still awake and watching television in this time period—third-shift workers, service workers, and night people pop up in metered markets in surprising numbers. This is another time period badly in need of research, which could result in an untapped revenue source for affiliates. **Residual rights** (royalty payments for reuse of the shows), however, would make rerun programming difficult to arrange.

WEEKEND REALITIES

Saturday and Sunday create a different set of programming problems. Football, basketball, bowling, baseball, tennis, golf, auto racing, horse racing, and boxing all take turns capturing the adult male

viewer. Cartoons draw children, and music sometimes captures female teens.

Saturdays

In 1992, NBC stopped programming its Saturday mornings with cartoons, substituting low-budget news programming. This action benefited Fox's Saturday morning ratings, and opened this time period to syndicated shows on 200+ NBC affiliates (if they chose something other than NBC's Saturday news show). But it is the late morning and afternoons that have the larger audiences that most affiliates want to attract.

On Saturdays, if a station schedules a two-hour movie, perhaps from 10:30 A.M. to 12:30 P.M., family viewing can be encouraged in a time period historically reserved for children. Scheduling a movie also can yield 52-week advertising sales contracts without depending on kid-oriented commercials, which usually are viable only during the third and fourth quarters when advertisers buy time to announce back-to-school and Christmas sales. Careful selection of stars and titles can lure parents into watching the films along with the children. Elvis Presley, Jerry Lewis, John Wayne, Francis the Talking Mule, Ma and Pa Kettle, and science fiction titles are all sure-fire, split-level (kiddult) audience-getters of this type. Unfortunately, in their hunger for programming, the cable networks have successfully captured many movie libraries.

Country-western and Nashville music also can be used for counterprogramming. Saturdays from 2 to 4 P.M. or 4 to 6 P.M. are ideal time blocks for such programming. These shows usually cost little and can be promoted easily if the community likes the music.

The toughest hour on Saturday for the affiliate to fill used to be the 7 to 8 P.M. time slot, but now many affiliates just go with the sixth or seventh rerun of *Wheel* and *Jeopardy!* and the like. Another immensely popular show is the syndicated series *Baywatch.* Its success has spawned many one-hour action series including *Deep Space Nine, Lonesome Dove—The Series, Highlander,* and *American Gladiators.*

Late Saturday night traditionally has been programmed with feature films. NBC's *Saturday Night Live* arrived in the late 1970s, developing a large new audience, the college-age group. Their taste for sophisticated comedy relegated theatrical films to second place in most markets. A programmer must choose contemporary box office hits to stay within competitive reach. If recent movies fail to work, programmers can try lesser-known films of a particular type (Westerns, World War II, horror, or slapstick).

Sundays

The affiliate has very little room to maneuver on most Sundays. The afternoons contain season-to-season sports (network or regional), news from 6 to 7 P.M., and network entertainment from 7 to 11 P.M. The only period left for local development is the morning. This ghetto usually contains network public affairs, religious and cultural programs, infomericials (see 6.10), panel shows, and some kids' shows—all of which spell low ratings and low income.

When scheduling Sundays, the affiliate programmer should consider "service people" who work evenings all week and never have a chance to see prime-time programming on workdays. The night people are out there; they just need something with mass appeal. And how about all those people who go to church early, and all those people who do not go to church?

After paid religion, which brings in the dollars, another option for Sunday mornings is a feature film. Most affiliates, however, are tempted by the information programs from their networks followed by a dose of "Various," meaning infomercials.

Late Sunday night following the 11 P.M. news also remains a difficult time to program—it is the Siberia of the weekly schedule. If the community is large enough, a 60-minute adventure series or a short movie is the best a programmer can do because of the low number of homes watching television. Using HUT levels as a guide always raises the chicken-and-egg question, however. Perhaps HUT levels are down because little worth watching is

6.10 INFOMERCIALS

One continuing development on affiliates is the new respectability of infomercials, half-hour or longer paid commercials that masquerade as programs. Most stations now accept them, even network O&Os in major markets. They are usually buried in low-watched periods on weekday mornings or weekends, filling in dull summer days and late nights between regular shows or Sundays when sporting events have been grabbed by cable. Revenues for half-hours such as $10,000 on weekdays and $40,000 on weekends in major markets tantalize even the most fastidious program director. Traditionally, programmers have argued that occasional paid programming interrupts program flow and weakens a lineup, but grazing with remote controls has pretty much ended stable viewing habits in some time periods, leaving late nights and weekends vulnerable. Thus, the number of infomercials has greatly swelled.

ever scheduled in the late-late time period. Certainly, some independents in major markets draw a salable-sized audience. It might be worth a gamble to try some better quality films and promote them on Sunday nights. In the meantime, most stations solve the Sunday night programming problem by repeating the same infomercials that ran earlier in the day just prior to noon.

THE PROGRAMMING WAR

By studying other markets similar to their own, programmers can learn a great deal from other situations throughout the country. It is not a foolproof system—what works in New York does not necessarily work in Peoria—but if the programmer can align the home market with other similar markets, there is a lot of opportunity.

The affiliate programmer must continue to scan the marketplace to find new forms that might reshape the late afternoon to the station's benefit. Programmers must read the trade magazines religiously and ferret out the unusual and untried, as hit programming sometimes comes from unexpected sources. There is no longer a "little guy" in programming. Many programmers have banded together to form screening committees, which meet before the NATPE annual conference and jointly view first-run pilots, collectively verifying their evaluation of these efforts. This gives the lone affiliate programmer parity with the program teams of group-owned stations. It is most important to be able to screen and negotiate for all properties. To do this a programmer must monitor what's being produced, know which outfit will distribute it, and understand the likely contract terms. The affiliate programmer is no longer bound by the schedule the network sends, although the networks always exact a penalty for disobedience, and the price may be too high for all but the richest or most threatened stations.

Programming is war. The object is to win in all time periods. Winning means high ratings. High ratings bring top dollars from the advertiser, and top dollars let you control the market for another season. If you can do this and still keep a balanced schedule reflecting community needs, cultural roots, and the entertainment demands of your audience, then, indeed, you are a programmer.

SUMMARY

A program schedule must be analyzed hour-by-hour to take into account available options, the competition, and the economic benefits of reusing already-purchased programs. Network affiliates are bound by contract and by financial advantage to their networks. A network affiliation supplies popular programs, adjacencies, and compensation. An affiliate's visibility is generally greater than an independent's (or a public station's), and one of the network affiliates holds top place in nearly every

market in nearly every time period. The strategies that get them there include targeting a major demographic group that is unserved to build a new audience (local women's programs or off-network sitcoms for night workers in mornings) or providing a desirable lead-in to succeeding programs (stripped talk shows or reruns before evening news are an example, cartoons in weekend access are another). Audience flow is the prime consideration in early fringe to attract the right demographics for local news. Throughout the schedule, unused runs of popular syndicated series (off-network reruns) provide the fodder to build strong ratings. Increasingly, however, cable networks are acquiring one-hour programs and movies, leaving the affiliates with sitcoms as well as first-run game or tabloid shows.

SOURCES

Electronic Media. Weekly trade newspaper covering the broadcast industry as well as journalism, cable, and new technological developments. 1982 to date.

http://tvnet.com

Jankowski, Gene F., and Fuchs, David C. *Television Today and Tomorrow.* New York: Oxford University Press, 1995.

NATPE International Newsletter. Monthly trade report of the National Association of Television Program Executives (replaces *NATPE Programmer,* a monthly magazine). 1990 to date.

RTNDA Communicator. Monthly newsletter of the Radio-Television News Directors Association. 1946 to date.

Television Digest. Weekly trade summary of events affecting the television business, published by Warren Publishing, Inc. 1945 to date.

TV Today. Weekly newsletter from the National Association of Broadcasters.

NOTES

1. With the coming of the Fox network in 1987, a new hybrid independent station arose called a "Fox independent." For a time in the late 1980s and early 1990s, it made sense to think of three types of stations: affiliates, Fox independents, and all other independents.

2. Discussions between UPN and WB about a merger in 1995 failed to produce an agreement because they had too many competing affiliates in the top ten markets.

3. Gene F. Jankowski and David C. Fuchs, *Television Today and Tomorrow* (New York: Oxford University Press, 1995), p. 62.

4. To add to this intricacy, cable systems retransmit broadcast channels, sometimes reassigning the channel numbers or blocking out individual shows for legal reasons. UHF stations, whose signals encounter transmission difficulties in proportion to the magnitude of the channel number, are happy to get a lower channel number on the cable selector.

5. Over the years, affiliates have received increased competition from independent stations that benefited from must-carry rules and from the prime-time access rule (PTAR), which was struck down in 1995. A slow strengthening of affiliate ratings is predicted by most observers, although more and more independents are becoming affiliated with new networks like Fox, UPN, and WB.

6. Programming at the national level is different. The Cartoon Channel will operate at 11 A.M. and 3 A.M., largely unconcerned with the available audience, much in the same way a convenience store will remain open at times of the day when most people are asleep.

7. The figure of 65 to 70 percent network programs remained constant for more than three decades, but in the early 1990s, after the FCC ruled that 15 or more hours of prime time constituted a "network," the broadcast networks considered cutting back on the number of hours supplied in low-rated daytime, late-night, and prime-time hours. Indeed, by 1996, NBC had dropped the 10 to 11 A.M. hour, and CBS was considering following suit, while ABC had dropped the late-night hour following *Nightline.* The larger, more powerful affiliates of the third-ranked network usually welcome network reductions because they can fill the time with local news or syndicated shows. Small-market affiliates, however, have less money to spend and oppose any cutbacks. At the same time, all three networks expanded their news programs in the overnight and early-early morning periods in the 1990s.

8. VHF stations are those with channel assignments between 2 and 13, the most desired over-the-air channel positions where most network affiliates appear. These channels have a higher quality over-the-air picture quality than the higher numbered channels, and most viewers check out these lower numbered channels before investigating the upper ones, leading to more

sampling and (probably) higher ratings for VHF signals. Stations assigned to channels from 14 to 69 by the FCC are in the UHF frequencies, and these high frequencies have more technical problems (such as ghosting and interference) in over-the-air reception. Of course, cable distribution of signals evens out any differences in picture quality among channels. In fact, some cable channels encourage their viewers to "check out the good stuff first" on the higher numbered channels.

9. At the end of 1995, one-year declines for the broadcast TV audience continue as more viewers stayed with cable TV and similar competitors. The four broadcast TV networks (NBC, CBS, ABC, and Fox) drew only 66 percent of all prime-time viewers in November 1995, down from 71 percent in November 1994. In 1996 viewing of the Big Four dropped to 65 percent.

Chapter 7

Independent Station Programming

Edward G. Aiken
Robert B. Affe

THE NEW INDEPENDENTS

Independent television rode a wave of prosperity in the 1990s as the American television industry burst outside the constraints imposed by 40 years of dominance by CBS, NBC, and ABC. Leap-frogging technological advancements, combined with the sale of many broadcast properties and their networks as well as the organization of new cable networks, have made the picture for the television business robust and signal further growth for independents.

Most industries settle down as they age—market shares stabilize, prices stagnate, few new companies enter the scene, and business becomes predictable. For example, the largest soft drink distributor in the 1930s, Coca Cola, is the largest today. The number one chocolate company, Hershey's, remains the largest today. Procter & Gamble was the leading personal-care product company when you were born—and it is today. Most industries follow this maturation curve, settling into a medieval-like hierarchy, although all these American companies now operate worldwide. Today is the much same as yesterday; tomorrow will likely be the same as today.

Television is different. The business of television has never been more boisterous. Fueled by 50 years of post-World War II prosperity and a technological/digital revolution, television companies—stations, networks, studios, and advertisers—are jostling to stay ahead of the pack. The struggle to establish and then exploit a distinctiveness from the competition is called **positioning.**

Because of liberation by affluence and technology, the expanding number of independent stations (now up to 600) are able to adapt to the changing world even more rapidly than the 600+ affiliates of full-service networks, who reluctantly realize that they have to give up their monopolistic and increasingly obsolete ways.

From the start of American commercial television in the 1940s, nonaffiliates were the stepchildren of the television station family. In contrast to their big station brethren (affiliates of ABC, CBS, and NBC) who lived on a rich diet of new network programs, large network news divisions, and national advertising and promotional support, independents survived on a thin gruel of syndicated reruns, movies, cartoons, and local team sports. Independents and affiliates lived parallel, but separate, lives. They were in the same business, but hardly competed.

In the 1990s, the nature of networks changed. The Big Three networks increasingly took on the appearance of independents, and independents increasingly acted as affiliates. The new smaller networks—Fox (since 1986), UPN (1995), and WB (1995)—are specialized, offering programs in fewer dayparts than the Big Three, targeted to a specific, younger audience.[1] The three upstarts began their service in prime time, then expanded into children's programming. Fox offered up to five hours daily of network programming as of 1996. In contrast, the Big Three networks offered a program schedule of about 12 hours per day, down from a historic high of 15 to 16 hours. The old networks do not target audiences as precisely as the new networks. *The key distinction between "old" and "new" networks is the number of hours offered to affiliates.* Fox is a hybrid network that behaves both as an "old" network (when it outbids CBS for pro football or big city VHF affiliates) and as a syndicator of programs.

At one time, all independent stations were about equal. By definition, all stations lacking a network affiliation were independent. But the ripening sophistication and financial high stakes atmosphere brought forth a new generation of independent stations, ones which sometimes affiliate with some other network less omnipresent than the Big Three.

Why would a station choose to do that? In the past, a station was either an affiliate (lock, stock, and barrel) or a go-it-alone independent. In today's world of mergers, alliances, partnerships, and special coventures of all kinds, most stations choose to ally with program suppliers. An ABC, CBS, and NBC station is clearly an affiliate, but what of a Fox station? A Fox affiliate has characteristics of both traditional affiliates and independents.

An independent can be defined by what it is not: It is a nonaffiliate according to formal FCC rules. Technically, an affiliate is any station with an agreement to broadcast programs from a source defined by the FCC as providing network programming: "the simultaneous broadcasting of an identical program by two or more [inter]connected stations."[2] The FCC has set a benchmark of carrying 15 hours per week of prime-time programming to qualify as a network affiliate.[3] By that standard, Fox affiliates, with 15 hours per week, fit the definition, but Fox has been granted an exemption as an "emerging network."[4]

In *As You Like It*, Shakespeare wrote, "sweet are the uses of adversity." That quotation best describes the paradoxes in which independent stations operate—and prosper. Independents turn their lack of full schedules of network programming into an advantage by selecting shows for a materially different audience. Indeed, some independents do not affiliate with any of the newer networks.

Disadvantages	Advantages
No network schedule	Flexibility of scheduling
No news leadership	Counterprogramming entertainment programs against news
No local commercials in network programs	Triple the amount of commercial time
No network identity[5]	Can design own exclusive positioning image

As recently as the late 1970s, network affiliates claimed more than 90 percent of the prime-time audience. By 1995, that figure had melted to 55 percent. The networks lost one-third of their audience in one generation. Why?

Starting in the 1970s and 1980s, several cracks appeared in the established order:

1. ABC became the number one network in prime-time, for the first time.

2. The cable industry grew rapidly, giving signal parity to UHF stations, most of which were independents; plus, the development of cable networks and the opportunity of having dozens of channels available instead of the historic three or four.

3. The prosperity of the 1980s and attendant wealth-creation led to new means of corporate financing, and hundreds of new television stations went on the air.

4. The growth of the hybrid Fox Network successfully bridged the gap between affiliates and independents.

5. Fox made a titanic raid of the network affiliation rosters in 1994, particularly wounding CBS. Dozens of stations changed affiliation. The largest group of CBS affiliates, owned by New World, went to Fox.

Independent television stations are tougher to program than traditional network affiliates, because most have no built-in foundation for their schedules in a network feed for most of their dayparts. Although an independent will probably never rank number one in sign-on-to-sign-off ratings against competing network affiliates, it can lead in key dayparts in both households and the most desired demographics.[6] Scheduling strong off-network series during early fringe and prime access, counterprogramming affiliate news, and building a lineup of strong first-run programs and movies in prime time, have dramatically improved the image of the independent station community. A professionally programmed and managed independent with an equally aggressive sales force can attain ratings and economic competitiveness within most markets against ABC, CBS, and NBC affiliates. However, independent programmers must face the unhappy reality of high programming costs while learning to intelligently deploy their main weapon—scheduling flexibility.

It costs more to program an independent than a classic affiliate of ABC, CBS, or NBC. About half an independent's budget goes to programming. Even Fox affiliation does not solve this problem, as Fox fills only about 35 hours weekly (less than half

the program supply of the other networks), leaving as many as 130 hours to program locally.[7] Independent stations now pay nearly as much for an individual program series, such as *Home Improvement* or *Seinfeld,* as they paid for their entire evening schedule just a few years ago. Syndication rights for such network hits as *Frasier* can cost a major-market station upwards of $100,000 per week for a contract lasting as long as six or seven years. Although syndication prices declined somewhat in the late 1980s when the high-water mark was *The Cosby Show,* many stations were still trapped well into the 1990s by the need to pay for previously acquired expensive programs.

The programming environment for commercials on an independent is similar, if not superior to, that of an affiliate scheduling the same advertising spot. Independents generally format their programming to have less **clutter** than their affiliate competitors. Clutter can be defined as all non-programming matter during the interval between the end of one program and the start of another. Count the number of commercial announcements, newsbreaks, station identifications (IDs), network promos, local promos, lottery numbers, whatever—there can be as many as two dozen in an eight-minute period.

In contrast to the cluttered environment of network affiliates, independents (as an unwritten rule) adjust their program formats to eliminate lengthy **endbreaks** (commercial breaks following the closing credits of a program, also known as *terminal breaks*), scattering their advertising throughout each hour and thus creating a less cluttered environment for each ad. This practice moves stations toward **seamless transitions** (or "hot switching") that aids flow-through. As a result of fewer interruptions, many of the breaks within movies, for example, are quite long. In the case of movies, once the viewer is drawn in by the first 15 or 20 uninterrupted minutes, the longer breaks do not usually chase away the audience.

Fox affiliation has been a godsend to most of its affiliates. Fox's prime-time schedule targets teens and young adults 18–34 with off-beat programs that have attracted national press and audience at-

tention. *Melrose Place, Beverly Hills 90210,* and *X-Files* catapulted Fox affiliates into competitive positions within prime time, a time period most independents had once abandoned to the traditional affiliates. Fox affiliation often went to the number two independent in "two-indie" markets because the number one independents, as with many successful businesses, tended to be risk-averse. At the time Fox was proposed in 1986, the largest independents had little to gain, and far more to lose, by allying with an unknown program supplier. Conversely, the number two independent had little or nothing to lose. The advantages of Fox affiliation include:

- **Programming.** Most Fox affiliates have enjoyed unprecedented increases in ratings. Fox affiliates have witnessed a tripling or quadrupling of prime-time ratings since joining the network.

- **Sales.** The combination of high ratings, desirable demographics, and year-to-year ratings increases give credibility to Fox affiliate sales efforts. With selected Fox prime programming successfully battling with the mature networks, the traditional reluctance of national advertisers to buy time on independents has evaporated.

- **Financial.** Fox provides first-run, high production-quality prime-time programming to stations once too financially strapped to be fully competitive in program acquisitions.

- **Positioning.** The brand-name image of a station is elevated by association with the Fox network. As a brash, upstart venture, Fox was an exciting story, generating media and industry attention, often beyond its accomplishments. Even the FCC displays that attention and sympathy, consistently supporting Fox and granting crucial exemptions from regulations that apply to the other networks.

As with any business association, disadvantages accompanied the benefits, among them:

- **Part-time prime programming.** Fox did not fill seven nights of prime time until 1993. Thus, for six years Fox affiliates were "betwixt and

between," part independent and part affiliate, with all the business and image problems of such hybrids.

- **Incomplete nonprime schedule.** Even when Fox's plans for prime time are fulfilled, the network will not supply the complete all-day catalog of other networks. Despite capturing strong VHF affiliates and snaring major sports contracts, Fox still lacked the network franchise properties of daytime, news, and late-night programming as of 1996.

- **Bottom ranking.** Fox is likely to be the fourth ranked network for quite some time, although it has ranked third on rare occasions. The mature network affiliates are still more heavily represented on the VHF band, have stronger local news presence, and have many years' head start as local businesses. Even when Fox attains the same measure of network program development success as CBS, NBC, and ABC, Fox will still be condemned to the same 75 percent failure rate in its annual program lineup, a frighteningly expensive proposition for an underdog.

- **Weaker affiliate lineup.** The imbalance in the network-affiliate relationship is even more glaring at Fox. ABC, CBS, and NBC's strength in a given market is partly due to their VHF affiliates' local success. Thus, their affiliates have more leverage than Fox affiliates when negotiating for network compensation and preemption flexibility. In the mid- to small markets, especially, Fox affiliates are the weakest affiliates in their markets and lack power in bargaining with their network. Most affiliates and networks need each other about equally; Fox affiliates need their network more than their network needs them.

The timetable for introducing new network nights (**roll out**) is spread out over several years. Fox Network developed its prime schedule over six years, and it is described in 7.1.

Ironically, as in the case of Fox, it becomes harder to distinguish small scale from large scale. When Fox becomes a real network (some say it

already has), its affiliates will be unable to call themselves independents. UPN and WB have followed a similar roll out strategy, with at least five years between inception and seven nights per week of prime-time programming. One further sign that independents need a new name came in 1996 when INTV, the organization for independent TV stations, changed its name to ALTV, the Association of Local Television Stations.

Fox had more than 180 primary and secondary affiliated stations as of 1996. The other 450 or so non-Fox independents are of several types:

- 150 stations affiliated with the UPN network
- 95 stations affiliated with the WB network
- 30 affiliated with religious networks, including the 21 contracted with the Trinity Broadcasting Network
- 17 affiliated with the shop-at-home service of Home Shopping Network
- 95 specializing in foreign language programming for a local submarket, most commonly Hispanic

The few others that remain completely unaffiliated totter on the fringes of the commercial television business. There are also nearly 900 **low-power**

television stations (**LPTV**) or "community broad-casters," about half of which are affiliated with national cable/broadcast networks, such as the shopping and religious services above, and about half of which are independent stations, most of which struggle to find programming, advertisers, and audiences.

Some major markets support as many as 6 to 10 full-power independents; mid-sized markets usually have 3 or 4 independents; and the smallest markets might have only one—or none. Religious and shop-at-home independents appear, too, in very small markets; they draw most of their programming and advertising from a specialty network, depending on cable carriage to broaden their reach. Most important, they offer shows not readily available from more traditional program sources.

High cable penetration is crucial to the success of all types of independents. Two of every three American households subscribe to cable, which gives independents signal-quality parity with the traditional affiliates. Most independents are located on the UHF broadcast band, where signals are of weaker propagation and more easily disturbed by atmospheric conditions. Without cable, many viewers wishing to locate a UHF station must resort to affixing a loop antenna to the back of the set, frequently adjusting the loop's position to capture a wavering, sometimes snowy, signal.

The independent's most important programming reality is its greater scheduling flexibility: It is not tied for 12 hours a day to a national program supply. As a result, it can effectively counterprogram the other stations in a market by targeting specific audiences the other services are not reaching, either because their programs are inconveniently scheduled or appeal only to some audiences.

POSITIONING THE INDEPENDENT

Convincing the audience that a station's product is different from its competitors is called **positioning** the station. Every station seeks to project a

unique, attractive image, distinguishing it from the competition and creating in the viewer the desire to tune in. Experience teaches that independents establish their positions by creating "islands of success" using **counterprogramming, audience flow, identity programming,** and **promotion.** To develop counterprogramming, flow, and image strategies, independent programmers must define what audiences the network affiliates or other independents in the market are reaching, what programs are popular, what position is viable for them, and what motivates their viewers.

Counterprogramming

Research continually identifies a substantial portion of the audience that does not watch news. Viewers might not care about current affairs, might want their news from other sources (newspapers, magazine, radio), or just prefer entertainment over news. The independent programmer can counter the early evening newsblock on the network affiliates and establish an island of success of at least an hour's duration. That hour can be extended up to two hours, depending on how long the competition's newsblocks are.

Although counterprogramming the newsblock has proved an enormous boon to independents, many other dayparts present similar opportunity for independent programmers. Countering newscasts and the plethora of weekend sports and public affairs on the networks with comedy/action/adventure programs or movies is also an effective strategy. As independents have been so successful in countering news, some affiliates have cut back on news in favor of entertainment programs (do we label this "*counter*-counterprogramming"?), heating up the competition for viewers.

Countering adult programming with shows that appeal primarily to children in the preschool morning (6 to 9 A.M.) and afterschool afternoon hours (3 to 6 P.M.) also works well, accounting for a significant portion of revenues on independents. The future is uncertain, however. By the 1990s, increased use of child care, the presence of youth-oriented cable networks such as Nickelodeon,

and VCRs in the home had radically reduced the size of the total children's audience available to broadcasters.

Audience Flow

Additionally, the independent programmer must maximize the station's potential for audience flow, just as networks and affiliates (described in preceding chapters) must. Flow can be defined as the sequencing of a program schedule to match the changing complexion of the audience as time passes through the day.

The goals of flow strategy are to maintain current audience while building on it to take advantage of the rising PUT levels (persons using television) of key demographic groups (men and women 18–49 or 25–54, for example). As a programming strategy, this is called **aging an audience.** The following list of programs shows audience flow that builds from one audience to another:

Time/Program	Primary Target Audience
2:30 *Pink Panther*	Preschool children
3:00 *Goof Troop*	Children
3:30 *Bonkers*	Children
4:00 *Aladdin*	Children
4:30 *Gargoyles*	Children
5:00 *Full House*	Children, teens
5:30 *Family Matters*	Children, teens, women 18–49
6:00 *Fresh Prince of Bel-Air*	Women, children, teens
6:30 *Home Improvement*	Women, men 18–49, 25–54
7:00 *Roseanne*	Women, men 18–49, 25–54
7:30 *Seinfeld*	Men, women 18–49, 25–54

In this illustration, the audience is slowly aged by targeting the programs first at children as school ends, adding teens as the afternoon progresses, then women as the afternoon wanes, and later

adding men while retaining the children, teens, and women as long as possible into the evening hours. Unlike ABC, CBS, and NBC affiliates, however, independents do not funnel their afternoon programs toward local evening newscasts; their aging strategy carries right into prime time.

Recall that targeting means selecting programs that have especially strong appeal, as demonstrated by research, for a particular sex or age group. Because they have control of their entire schedule, more precise audience targeting is possible on independents using psychographic program research and other qualitative evaluations of program appeals (see Chapter 2).

Station Identity

With the television business going global and partnerships and mergers abounding, an independent station must be aggressive in establishing an identity for its two constituencies—viewers and advertisers. An independent station has a range of options when creating a *brand-name identity* for itself.

In the 1990s, the most prudent course, paradoxically, is seeking an affiliation with one of the newer networks: Fox, UPN, or WB. This provides the best of both worlds—network quality and independent flexibility. An independent counterprograms as well by developing a program-identified image—such as a "sports station" featuring local, regional, professional or amateur sports or a "movie station" with feature films in every daypart or a "local news station" by scheduling news in nontraditional time periods, concentrating on local events and presenting local angles on national stories. In the San Francisco area, for example, KTVU's *Mornings on Two* regularly beat NBC's *Today*, ABC's *Good Morning America*, and CBS's *This Morning* in 1995. In Phoenix, KTVK's *Good Morning Arizona* was number one from 7 to 9 A.M. only one year after signing on in 1994.

In many competitive markets with no network affiliation of any kind available, a sports image may be the only open avenue, albeit a risky one. Sporting events attract a fickle audience, made up

of a relatively small core of team loyalists sporadically augmented by fair-weather fans who watch when the team is winning but who defect when the home team is losing. Their inconstancy and the probability that superstations and other sports-oriented cable networks have acquired telecasting rights to local team franchises (that used to "belong" to local independents) suggest caution in any shift to a sports image nowadays.

A growing trend is for regional sports networks and local broadcast stations to agree to divide the broadcasts of a team's schedule. In that way some games are preserved for free local TV, and the economies of scale that televised sports necessitates can be achieved by the cable networks. Developing *viewer loyalty* and *habit formation* with more traditional series programming is usually more effective for mid-market independents (and secondary independents in large markets) than developing a narrow station image.

If Fox, UPN, or WB is not an option, another strategy is to affiliate with a religious, foreign language, shop-at-home, or other specialized network. Trinity Broadcasting Network (TBN) supplies programming 24 hours a day and asks local affiliates only to supply short-form program elements (less than 30 minutes long) as evidence of their local program commitment. These filler programs (usually 15 minutes or shorter) consist of local interviews, community information, and brief personality pieces. Shopping services such as Home Shopping Network supply 24 hours a day of retail products available for purchase over the phone. The major Latin networks, Univision and Telemundo, supply 24-hours a day of dramatic serials (called novelas), music, movies, news, and variety programs (see Chapter 10 for more on the Hispanic services). Specialized services help supply independents but go only a short way toward creating a full 24-hour schedule for the general interest station. There is a significant difference between creating a coherent program schedule over a 24-hour period and merely filling up dead air for an entire day.

Positioning an independent is a complex task. One of the television industry's great slogans is:

"People watch programs, not stations," so choice programming at the appropriate times is the most important factor to promote. If promotion is the packaging, the on-air look of the station is the product itself. A station that permits movies to be poorly edited, broadcast on scratched film, or aired from a poorly dubbed master tape denigrates itself. If commercial breaks are too long, too frequent, or poorly constructed, the viewers will hit the remote control.

PROGRAM NEGOTIATING

Buying television programs is one of the few vestiges of pure bargaining left in late 20th-century America. Free market economics and Wild West horse trading still thrive. (See Chapter 3 for a detailed review of the presentation process in syndication sales.) Despite all the sophisticated research available, eventually one person must take primary responsibility for:

- Deciding whether to negotiate for a given product
- Assigning a dollar value to the program
- Closing the deal

In the television station business, program negotiating is the most underrated responsibility. A bad purchase can cripple a station's financial health for years and retard the station's ability to buy product in the future.

On the dollar side, syndication sales is gamesmanship, pure and simple. Locked in the tension and excitement of a negotiation, many programmers forget the first commandment of buying: No product has an inherent fixed price; everything is negotiable. Just because a syndication salesman establishes a price of, say, $1 million for a program, does not mean the program is worth a million— or even half that. *The only true price for a given product is the price that the buyer and seller agree to at the time of contract.* The market, not the seller, dictates price.

However, the law of supply and demand is rigorously enforced. During the Great Sitcom Drought of the mid-1980s, only 20 sitcoms were on the networks' fall 1984 schedules—an average of one sitcom per network per night. Off-network comedies were already in short supply, and those coming to the syndication marketplace—*Cheers, Family Ties, Webster*—sold for record or near-record prices in every market. The network success of *The Cosby Show*, debuting in 1984, persuaded programmers that sitcoms were hot properties again. Thus, in the way the programming market responds to the demand, by the fall of 1995 there were 60 comedies on the network schedule, an increase of 200 percent. Correspondingly, syndication prices for comedies collapsed under the deluge of off-network sitcoms flooding the market.

A final point is that research is a tool, not a crutch. Even though industry marketing and research skills have improved significantly over the years, a point in every negotiation occurs when the intuitive senses, sharpened by experience, must be called into play. If research were perfect, all program buys would be successful, and there would be neither buying mistakes nor regrets. But, research is not perfect, so there will always be a need for programmers.

Program Futures

Futures buying works as follows: The syndicator/seller owns or licenses the right to sell a certain series in syndication; individual stations license the program to air, usually after the fourth network season. (While the program is still on the network, the program may air simultaneously on the network and in syndication.) The syndicator and station/purchaser normally assume that the series will continue on the network for a minimum of five years to generate enough episodes to make the series successful in syndication. An average network season has about 22 episodes. After five years on the network, there are 110 episodes. If the program is stripped in syndication, it will take 22 weeks (110 episodes divided by five times a week)

to cycle through one run of the series. If the network program is on the air 11 years (*Cheers,* for example), there will be upwards of 250 episodes, nearly enough to broadcast every weekday for one year without a repeat.[8] (See what happened with *Webster* in Chapter 6).

Many independent stations bid for an elite program to establish a franchise for themselves in the 7 to 8 p.m. access block. For more than 20 years, from the 1970s to 1996, affiliated stations in the top 50 markets were prevented from playing off-network programs in access because of the prime-time access rule (PTAR). Independent stations loaded up on off-network sitcoms without the financial dilemma of bidding against wealthy affiliates. When PTAR ended in August 1996, large-market affiliates entered the bidding pool for off-network product and prices were driven up in accordance with the iron dictates of the law of supply and demand.

In 1987, *The Cosby Show* entered the syndication marketplace and became the mega-hit show many stations wanted to license (for a fall 1988 starting air date). Viacom, the syndicator, positioned the program not only as a success in its own right but as a key building block for a station in both early fringe and in access. Both independents and affiliates bid record high prices for the program, banking on it to "take" its own time period and also to flow that audience into the following programs. The highest price was paid by WWOR-TV in New York: $350,000 per episode for up to 112 episodes in a three-year contract. Also in 1987, *Who's the Boss?* became a hot property (for a fall 1989 syndication debut), and again stations got caught up in bidding higher and higher prices for the right to *Boss*. Both programs did well in the ratings, but not anywhere near as well as the stations paying mega-prices hoped. Many *Cosby/Boss* stations had to sit out the next round of syndicated programs coming to the market, because they were financially obligated to run their expensive purchases to recoup the enormous cost.

Many stations have gotten badly burned (and still sting) financially from those early high-

cost/low-yield program buying decisions. Stations bidding on *Frasier* and *Friends* in 1996 ran big risks. No single program can "make" a station's program schedule; but a bad deal can "break" a station financially. A strong program can become an island of success; it must, however, be purchased, scheduled, and promoted intelligently to be a worthwhile business decision.

Program Barter

Traditionally, the independent station's alternatives to off-network or locally produced programs were:

- The relatively rare ABC, CBS, or NBC programs it begged, borrowed, or maneuvered from network-affiliated stations when, occasionally, the latter preempted network programs (or, as in the case of *NYPD Blue*, chose not to carry for content reasons)

- Occasional specials and series from ad hoc networks

- Seasonal series from special networks set up for a sporting event

- Programs from the Fox, UPN, and WB networks

The fifth alternative has always been *bartered programs*, which are allegedly "free" but in reality are not. Although no money passes from the station to the program supplier for bartered programs, something of equal and sometimes greater value is given to the program supplier—advertising inventory.

Television stations have two customers—viewers and advertisers. Without the first, it is difficult, if not impossible, to attract the second. Assuming the station attracts a reasonable number of viewers to its programming, it can sell time in or adjacent to its programs to advertisers. Time in this context is **inventory,** a commodity. A television station's advertising inventory (its salable time) acquires an arbitrary dollar value based on the rating each of its programs achieves (or is expected to achieve if it is new programming or in a new time slot). The station's ability to get this dollar value is based on supply and demand for the program itself, the sta-

tion's overall inventory position, and the condition of the market as a whole. If a station pays cash for a program, it can charge advertisers whatever it feels it can get for the inventory within or adjacent to that program, and the station keeps all the revenue those sales efforts generate. But if the station barters for the program, it must give up part of that precious commodity—inventory—to the program supplier.

As explained in Chapter 3, if the station, for example, pays a program supplier $1,000 per telecast for a program having an inventory of twelve 30-second commercial spots, and if the value of each spot (based on ratings and supply and demand) is $500, the total potential return to the station is $6,000 (or a program cost-to-potential-return ratio of 16.6 percent). In the barter case, the program supplier may say to the station, "I'll give you the program for no cash outlay. All I want is 2 minutes for my clients." Those 2 minutes cost the station $2,500 in inventory it cannot sell (or a program cost-to-potential-return ratio of 41.6 percent). Using a nonbarter program allows the station to keep the (potential) $6,000 in revenues. Over a 52-week period, using a barter versus a nonbarter program represents a potential return of $182,000 versus $312,000. This situation compounds when a barter program does not perform in terms of audience delivery. The station is then faced with the dilemma of taking the program off the schedule or moving it to another time period. If it is moved or canceled, the station is still obligated to air the syndicator's commercials in the original time period for the entire length of the contract.

The programmer must answer some rather critical questions concerning barter programming:

- Is the cost-to-return ratio too high?

- Do the program's potential ratings and lead-in value outweigh the cost ratio?

- Is barter the only way to obtain the program?

- How many barter programs can the station afford at any given time?

The networks canceled many long-running programs in the 1970s, series which then became available to independent stations via the barter route. Some of the earliest were *Hee Haw*, *Wild Kingdom*, and later, *Fame*. In the early 1980s, many syndicators began asking for barter time plus cash (**cash-plus-barter**), particularly in the case of expensive, first-run syndication, beginning with *Mike Douglas* and continuing with *Donahue*, *People's Court*, and *Family Feud*. By the mid-1980s, barter fever had spread to programs for major time periods and other program types, such as talk shows (*Oprah*, *Geraldo*, *Live With Regis & Kathie Lee*, and *Sally Jessy Raphael*), game shows (*Wheel of Fortune*, *Jeopardy!*), and infotainment programs (*Entertainment Tonight*, *A Current Affair*, *Inside Edition*, and *Hard Copy*). By 1996, more than 80 percent of weekly first-run programs were bartered, as well as many strippable first-run and even off-network series.

This trend will probably continue for two reasons. First, stations that have purchased substantial amounts of off-network programming must acquire barter programs to operate within their budgets; their cash flow has been restricted by these prior, expensive program purchases. Second, syndicators have found they can make additional money by selling all or part of the advertising themselves within programs stations want, and so the practice is bound to increase among syndicators.

SYNDICATED PROGRAM SERIES

Regardless of the particular strategy for building islands of success, programming requires money. In large markets with strong competition, it means a lot of money. The station has to commit cold, hard cash to build its program schedule to fill an 18- to 24-hour schedule, while promoting and advertising every program itself. Usually, outside of network time, the most important programs are those the independent licenses from syndicators: off-network series, first-run syndication, and movies.

Syndicated programming is the backbone of most independent schedules. It is the best of both worlds: network-level quality at free market prices. Sitcoms, dramas, action/adventure programs—all pour from the network into the syndication market. Such off-network programs appear in every daypart. All off-network syndicated series are bought on a multiple-run basis. As of 1995, an independent typically licensed a network rerun for four years upfront, with syndicator options to extend up to seven years if the program continues on the network. Increasingly, off-network programs are licensed in syndication for shorter times—typically two years—after which there is an exhibition window on a cable network. Movies are a different matter. License terms for films tend to vary in response to demand from nonbroadcast buyers. When basic and pay cable were aggressively buying features at high prices in the late 1980s, studios shortened the license terms to broadcasters to quickly regain the titles for resale to cable networks at heart-stopping prices. With the cable programmers sated from their buying sprees, prices dropped, and studios again relaxed their license terms to the broadcasting community. (See Chapter 6 on series and movie contracts for affiliates, because similar contract restrictions apply. See Chapter 11 on licensing movies for premium services.)

The most cost-efficient series are those that can be stripped (broadcast in the same time period five or seven days a week). The most successful syndicated program on independent stations is the program attracting the most difficult audience to attract. Typically, this group is working adults, especially men. Often, these programs are sitcoms. The second category of station-attractive programs are those that appeal to any underserved audience. For example, affiliates program soap operas and talk shows in the afternoon, leading into their local news. Independents ignore that audience and program for children and young adults with so-called **kiddult** programming.

Deciding which off-network programs will work in any given market is often highly frustrat-

ing for programmers. They must consider the following issues:

- The rating and share of a program while it was on the network—both nationally and in the market in which it will play when purchased
- The time period in which the program will prove itself most cost-efficient
- Whether the program will have staying power as a strip
- Whether the program will do better as a strip or sharing the time period with other programs (checkerboarded)[9]

Many independents do not spend the money to buy the historical data from Nielsen that would document the performance of each program in each market. Syndicators and national sales representatives, however, do buy these data and supply it to client stations. (See Chapter 3 on the roles of syndicators and reps in programming.) Despite the voluminous research materials available, all programmers must rely on their experience to interpret data, because data are contradictory—even for a program as visible as a network hit.[10]

The difference between an astute programmer and a mediocre one is that the latter relies on intuition as a substitute for thought, and the former uses intuition as a tool to pound the unformed mass of raw research into an intelligible decision.

Kid Appeal

A number of programs whose primary appeal is to children (2–11 years) have worked well for independents in both the early morning (6 to 9 A.M.) and early afternoon (3 to 5:30 P.M.) kids' blocks. These programs include the few remaining theatrical cartoons (*Loony Toons, Merrie Melodies, Tom & Jerry*) and cartoon programs produced specifically for television and packaged in syndicated half-hour formats (*Garfield, Flintstones, Animaniacs,* and the rotating quartet of Disney afternoon programs—*Goof Troop, Bonkers, Aladdin, Gargoyles*). The vast majority of children's programs today are marketed by the barter route. Stations pay no cash

in the transaction; instead, the syndicator retains a portion of the commercial inventory (one-third to one-half is the norm) in the program and, in turn, resells the time to national advertisers such as toy manufacturers, cereal makers, and candy confectioners (competing with individual stations' national sales efforts).

Kids usually take control of television sets upon coming home from school. An independent station must entice as many children as possible into watching as early in the afternoon as possible to hold them through the early fringe viewing time.

Kiddult Appeal

Children and young women dominate the audience in the early fringe/newsblock (5 to 7 P.M. or 4 to 6 P.M., depending on the time zone) time period in which potential spot-advertising buyers look not only at household rating points but also at specific demographics, most often women 18–34 or 18–49. The children generate the bulk of household rating points (also known as **tonnage**), while the women are the viewers advertisers seek. Programs such as *Full House, Family Matters, Home Improvement,* and *Fresh Prince of Bel-Air* have strong appeal in early fringe.

Adult Appeal

Many different styles of syndicated programs have been used to attract adult audiences. Game shows ride a cycle of popularity, declining in audience appeal in the 1970s, reviving in the 1980s, and declining again in the 1990s. Action/drama series such as *Magnum, P.I., In the Heat of the Night,* and *Hunter* work well in early afternoon and early fringe (as strips) and on weekends as counterprogramming to network sports. On weekends, such shows attract women, countering the male-oriented sports programming that network affiliates usually offer.

For decades, the talk/variety programs such as *Merv Griffin, Mike Douglas, Dinah Shore,* and *Phil Donahue* were the bread-and-butter series for independents. By the late 1980s, most audience

interest shifted to magazine programs such as *Live with Regis & Kathie Lee*, the reality-based *People's Court*, and soft news feature programs such as *Entertainment Tonight*. The evolution of talk shows in the mid-1990s down the trail of voyeurism and depravity has taken them out of favor for airing on many independents.

MOVIES

Considered the most cost-efficient form of programming available, feature films allow the independent programmer considerable flexibility at relatively modest cost. Dozens of distributors sell movie packages, grouping so-called A, B, and C movies for cash or, increasingly, for barter.

Packages vary in size: a small package is considered to have 6 to 10 titles; a large package, in excess of 25; an average-sized package between 10 and 25 titles. The purpose of packaging is twofold. The seller can unload the less appealing titles only by grouping them with the popular titles in the collection. The buyer benefits because the cost can be averaged down by paying less on a per title basis, by paying less for the C titles than for the A titles that the station really wants. Plus, the dynamics of viewing patterns militate in favor of buying enough cheaper titles to run during low-rated time periods—late night, weekends, daytime, and summer. Despite enormous prices for box office hits (historically as much as $400,000 per title in Los Angeles, although down to less than $1,000 in the smaller markets), independents seek to upgrade their movie libraries and keep their titles fresh.

A movie station's inventory might consist of 1,000 film titles. Movie licensing agreements for cash can average five years, during which time the station may exhibit each title five to seven times. Overexposure of films on pay-per-view, home video, pay cable, and basic cable prior to broadcast licensing remains a key problem; a movie's drawing power cannot be sustained for as many telecasts. Consequently, stations have lowered their purchase prices or have bought fewer telecasts of each title.

Theme Weeks

Movie watchers tend to be women 18–34 or 18–49, especially for familiar titles, superstars, or relationship-oriented plots. One successful movie scheduling strategy is to create theme weeks, heavily promoting a single star, or titles grouped around a related topic (Women in Love, Hunk Week, Lost Innocence). Theme weeks are usually created by **horizontal scheduling** (stripping movies across the week at the same time) or stacking (scheduling similar titles consecutively on the same day). However, stacking has become increasingly less common as a result of independents' affiliations with the Fox, UPN, or WB networks.

Feature films—theatrical, made-for-television, or made-for-cable—are the bulwark of an independent station's schedule for four reasons:

- **Economics.** Dollar for dollar, movies are the most cost-efficient type of program. Because many thousands of titles are available, movie prices are proportionately cheaper on a per hour basis than half-hour or hour series.

- **Variety.** The subject matter of movies varies infinitely; even the fussiest viewer has at least a couple of favorite films. Scheduling a variety of titles encourages occasional viewers to sample the station's other wares by exposing them to on-air promos placed in the movies' commercial breaks.

- **Less risk.** The programmer incurs a steep financial risk each time a program is purchased. It is a winner-take-all, loser-walks proposition. If viewers reject a series, there is little that can be done to resuscitate it. A failing program can be moved to a lower priority time period, but it is then tainted, especially in the eyes of advertisers, and most of the investment in it can be lost. It takes only a few blunders to devastate a station's rating and financial health. In contrast, every movie title has a different potential audience, and titles can be safely remixed in various dayparts throughout the schedule.

- **Reliability.** Off-network programming is a cyclical business. Periodically, sitcoms become

scarce; then, the pendulum swings back to create a surplus. The same holds true for hour-long series. It is difficult to forecast the availability of program series more than two years—at most, three years—in advance. Movies, however, are more versatile and more easily transferred from one medium to another. They are popular in the theaters, successful on cable, and fuel the home video industry. The demand for movies is greater and has a broader base than the demand for series. Thousands of English-speaking titles are released worldwide each year. The supply is larger, more diverse, and more predictable than for television series.

If every movie theater or home video outlet in America suddenly closed tomorrow, there would still be a great demand for movies. For these reasons, it is a good bet that movies will always be a popular form of entertainment and an economic asset for the station.

Stacking

Movies can be vertically stacked (scheduled sequentially on one day). Stacking allows a programmer to air many consecutive hours of similar titles while adjusting the kind of movie to reflect and attract the changing audience composition during the day. For instance, WTOG-TV in Tampa-St. Petersburg airs an eight-hour block of movies on Saturdays with great success by targeting different specific audiences:

- **10 A.M.—Adventure Theater**
 Because affiliates broadcast child-oriented fare from network or syndicated sources, adult men are underserved on weekend mornings and are a viable target audience for the independent. Fitting programming is any movie with action, adventure, or war themes.

- **12 NOON—UPN Movie Trailer**
 The UPN Network offers a young-adult appeal movie from the Paramount movie library. The program is hosted by two youthful habitues of a

recreational vehicle, merrily commenting about the movie.

- **2 P.M.—Hooters Theater**
 Sponsored by a local bar/restaurant with a "beach bar" motif and starring the club's hostesses, movies in this time period combine young adult and teen-oriented comedy, romance, and action with exciting local promotions and events.

- **4 P.M.—The Working Woman's Movie**
 Movies are effective counterprogramming to the spate of network sports. WTOG-TV in Tampa-St. Petersburg offers movies for women who do not have time to themselves to watch television during the week. Women's interest titles predominate—love stories, relationship themes, and women of achievement biographies.

This strategy has enabled WTOG-TV and other independents to be number one in their targeted demographics for years.

Stacking is most successful when used as a thematic showcase. When purchasing movies, programmers can break apart their movie packages and select appropriate titles for specific showcases and further increase the cost-efficiency of the station's movie inventory.

LOCAL PROGRAMS

Even in this era of multiple networks, countless syndication suppliers, and escalating production costs, many independents choose to produce at least some of their own programming. Locally produced programs are an invaluable marketing weapon for any television station. A station-produced program confers many benefits:

- The program is exclusive to the station.
- The production is entirely under the control of the station.
- The budget is set by the station.

- The content can be adapted to suit special advertiser needs.
- Community needs and interests can be explored.

The kinds of self-produced programs are limited only by imagination, but the most popular are:

- News
- Sports
- Public affairs
- Children's
- Talk/magazine
- Charitable fundraiser

Depending on their purpose—profit, community service, FCC mandated—local programs can be budgeted and produced either at network-quality levels or at minimal standards.

News

The technological wave that swept through television newsrooms during the 1980s and 1990s has yet to crest. Portable microwave antenna units, satellite up- and down-links, fiber links, computers, digitized video effects, and equipment miniaturization have resulted in independent news gathering and reporting operations that are professional and competitive. In the past, independent news had to suffer the stereotype of the broadcast equivalent of tabloid newspapers: long on local stories, violence, and fires; short on analysis and production values. Today, microwave and satellite transmissions enable any television station to send and receive live feeds from virtually any place on earth—an astounding leap in bringing space technology into the workplace and a far cry from the days when the news van could not travel any further from the station than it took to hurriedly return to process newsfilm to get on the air by the early newscast. Yesterday's news relied on film or video and was studio-based; today's news is live and on-site-oriented. Altogether, more than 75

independent stations, mostly in the top 50 markets, offer local newscasts. This number is up from 55 in 1990.

One interesting feature of independent news in the 1990s is that many independents, unable to afford a competitive start-up operation, work out an arrangement with a local affiliate whereby the affiliate produces the news for a fee and airs the newscast on the independent (repeat broadcast). In that way, the affiliate wrings more revenue out of its fixed-cost equipment, and the independent has, at minimal cost, an established local newscast at professional standards. Another option is for the affiliate to buy time on the independent and run the affiliate news on the latter. To bolster coverage outside their markets, many independents contract with outside news suppliers such as CNN, CNN Headline, or ITN.

Production values vary from market to market, from basic to elaborate, depending on the strategy of the station. If the rip-and-read approach (announcer rips copy from wire service printer and reads it on air) is used, cost is minimal. A 60-second update every hour or two with a news reader giving details with a video-still backdrop creates few production difficulties. Commercials can be sold at higher rates for news than for regular programming and can often be sold to advertisers who otherwise might not consider advertising on the station.

There is no direct relationship between the amount spent for production and a news program's ratings. Viewers can discern quality but are not entranced by technical razzle-dazzle: They are used to the state-of-the-art production values on the networks, both broadcast and cable. News viewing is a function of habit. Successful stations labor to produce a consistent product with appealing anchors—which is the path to high news ratings.

When the independent decides to take the fully competitive approach, it must hire a full-time staff of a news director, an assignment editor/coordinator, a producer, plus an on-air team of newsanchors, weather, sports, and a team of reporters, photographers, editors, and writers. Staff size will

vary with the market and the amount of news coverage offered by the competitors. Moreover, electronic news gathering equipment (ENG) is no longer an option—it is a requirement. A news operation cannot have credibility unless it has "live" capability via microwave or satellite. In addition, the full panoply of up- and down-link satellite dishes must be obtained. In this age of rapid technological improvement, the financing for this equipment must be as creative as the approach to news presentation.

Although many VHF independents have been relatively successful with news, especially when counterprogrammed against affiliates, few manage to equal the total household rating points of network-affiliated stations. Audience and advertiser perception is that independents cannot or do not offer a competitive news product vis-à-vis the affiliates. That bias persists, although analysis of an independent newscast is likely to reveal no significant difference from a competing network-affiliated newscast in reporting style, content, or overall quality (see 7.2).

This audience myth has proven a stumbling block, as few independents schedule news head-to-head against affiliates. Most independents chart a course of less resistance and broadcast their news an hour earlier than the affiliates (**nontraditional news scheduling**). For example, the superstation WGN-TV in Chicago has broadcast local news for many years with great success. In the early 1980s, *The 9 O'Clock News* averaged a 7 household rating. In the early 1990s, news viewing rose to an 8 rating. Later joined by WFLD's news, the two independents together generated double-digit ratings with their 9 P.M. news in the May 1995 Nielsen measurement.

However seriously the independent chooses to commit itself, news programming carries four major benefits:

- **Programming.** The community is served with important information and original program content.

- **Scheduling.** One common independent practice is to program news in prime time. If the

7.2 COPYING NONTRADITIONAL SCHEDULING

As each rating point multiplies itself into thousands of dollars in revenue over the course of a year, independents foreswore a head-to-head news strategy in favor of the nontraditional time period for news (earlier in the evening than the traditional affiliate time in that market). Earlier newscasts attract viewers who go to sleep earlier, especially commuters and working couples with young children. This strategy has been so successful that a few network affiliates copied it in the early 1990s, moving their late newscasts one hour earlier than their main competitors and threatening the local independent competition. Of course, this necessitates the affiliate advancing the network prime-time schedule, a practice that alters the assumptions about what makes a "network" and makes the traditional networks nervous as network affiliate unity is threatened. However, the withering of traditional network operating practices and time periods does not bode well for independents, because they lose their distinctiveness.

late news airs on the affiliates at 11 P.M. (eastern or Pacific time) or 10 P.M. (central or mountain time), successful independents program their news an hour earlier. This strategy allows viewers to see the news on the independent while the station positions itself in two different time periods: counterprogramming affiliates early with news-against-entertainment, and an hour later with entertainment-against-news.

- **Sales.** Not only is news a public service and a good counterprogramming tactic but news talent helps give the independent a personality to meld with the station's overall imaging efforts. A news program can aid the sales department in attracting advertisers who might initially

hesitate to buy time on an independent and serve as an entree to other dayparts.

- **Financial.** Stations can more carefully control the uncertain costs of programming from outside program vendors by mediating their programming budgets with cost-controllable in-house news production.

The most obvious downside to independent news is that there is no network news division supporting the station with out-of-town bureaus, star anchors, network image, and promotional support. This disadvantage is fading as the networks reassess their financial ability to support worldwide news operations, and doubly fading in the face of independent news sources such as Cable News Network, Conus, the Associated Press, Reuters News Service, and World Television News. These services provide national/international news for packaging with a local newscast. Overall, the amount of locally originated hard and soft news grows steadily on independents. The networks' formerly iron grip on news distribution has been permanently broken by technology.

Sports

As has often been observed, sports and television were made for each other. Each business has made the other wealthy and culturally dominant in 20th-century America. Some of the largest and most successful independent stations in the country have a sports image: WGN in Chicago, WTBS in Atlanta (called "TBS" on cable), and WWOR in New York, to list a few. Independents have the scheduling flexibility to accommodate sporting events during every daypart, and sports events attract a desirable demographic target (men 18–49 and 25–54). Advertisers are willing to pay premium prices to be identified with a televised sport because it is an effective sales tool. This fact makes sports programming a hot strategy for a number of independent stations.

Rights to telecast sporting events are subject to the same exercise of valuation as other programming. When rights fees are overpaid, the results

can be calamitous. CBS and ESPN wildly overpaid for their recent long-term contracts with Major League Baseball (1990–93); but the independent programmer, negotiating prudently for local broadcast rights, can reap sizable tangible and intangible benefits for the station.

There are three cost approaches to sports programming. In the first, a station purchases telecast rights from the team, produces each game (on-air talent, producer/director, production crew, equipment where needed) and delivers the signal back to the station (by microwave, satellite, long lines, fiber, cable, or a combination thereof). Although the upfront costs are steep, this route has the greatest potential for revenue because the station retains all the advertising inventory for sale. This tactic, however, has its risks. Some of the commercial inventory might remain unsold, reducing the potential revenue.

In the second option, the team itself assumes all production and delivery costs, paying the station for the airtime. The team assumes all financial risk and sells the ads, but it will reap most of the potential profits. The station is paid for the airtime (but at a lower price than if it sold the advertising itself) and, in the minds of viewers, gets the credit for bringing them the games.

In the third possibility, an outside producer/syndicator pays the team for the rights to telecast. The producer/syndicator sells part of the available time within the games and barters with the station for the airtime (or purchases it outright). This method is common with college basketball and football.

A local sports franchise can be a valuable asset to a station. It has the following advantages:

- **Hard-to-reach and desirable demographics.** Men are generally light television users, and advertisers have difficulty reaching them at reasonable cost. Many men will watch sports for hours on end (or at least until the beer runs out or the remote control is wrested from their hands). Sports events are ideal vehicles for matching elusive viewers with desirous advertisers. The traditional advertising bias against

independents can be vanquished with sports. As with news, sports programming can be an avenue to direct new viewers to other programs on the schedule through adroit promotion.

- **Nighttime counterprogramming.** Network prime-time programming skews toward women; sports becomes an ideal counterprogramming measure for independents. Most professional games are played at night, making advertising revenue potential for sports higher than for other program types.

- **Image building.** A local sports franchise is an instant image-builder for the station, which can then find innumerable ways of locally marketing and promoting itself in conjunction with the team and its fans.

- **Channel stability.** Cable systems are reluctant to antagonize their subscribers by repositioning a home team sports station to a higher (and thus less desirable) channel.

The downside of local sports programming is that it can be:

- **Risky.** As sports has a narrow programming appeal, a station has little recourse if the team's fortunes fall upon hard times. The station's prospects are in part determined by outside factors: the team's won-lost record, the team's popularity, and the late start times (10:30 P.M. for eastern teams playing in the West) and the early start times—(4:30 P.M. for western teams playing in the East). Lost advertisers are hard to replace.

- **Schedule blocking.** Unlike a weak program that can be moved to a less critical time, the station is at the mercy of the team's performance. Games cannot be rescheduled merely because the team is weak on the field. Sporting events tend to break up audience flow, driving nonsports viewers to another channel. An independent's programming strategy—scheduling consistency—sags if games are telecast sporadically, usually filling no more than two or three slots a week.

Public Affairs

Public affairs programs give independent stations an opportunity to provide a valuable program service at reasonable cost. As someone once said, "Public affairs need not be dull affairs."

Stations historically have been given wide latitude by the FCC in achieving their mandate of operating in the "public interest, convenience, and necessity," a prerequisite for license renewal. In addition to meeting regulatory standards, local programming enables a station to:

- Serve the viewing public with exclusively produced, community-minded programs

- Promote its own on-air talent, enhancing the station-positioning identity it seeks

- Give the sales department an occasional product to sell with strictly local advertising appeal

The **documentary** and **magazine** formats potentially best demonstrate a station's public affairs commitment, but few independents choose this route. Very few UHF independents do more than a bare minimum of public affairs, and much of that during light-viewing hours such as early morning or late-night on weekends. Local weather and other natural phenomena reports offer independent television stations the same opportunity as affiliates and local radio for responding to community events in ways that attract substantial audiences. (See Chapter 14 on news/talk radio for more on local news responsiveness.)

In this era of stretched production budgets, local program production must be more cost-conscious than ever. Creating a program is always an expensive proposition:

- Foremost, the entire affair must be budgeted.

- Studio and production control time must be reserved.

- A production crew with producer and director must be scheduled.

- The equipment itself must be reserved and moved to a studio or location.

- A script must be written, edited, and approved.

- A set must be built in the studio.
- Talent must be engaged.

By way of contrast, securing the broadcast exhibition rights to a syndicated program has few if any costs attached (beyond its license fee). Superstations such as WGN produce excellent public affairs shows, but cost remains a problem. Public affairs programs are notoriously difficult to sell to advertisers, and most stations refuse to invest time, personnel, and money in programs that do not generate a return on investment. Further, many advertisers are reluctant to put their spots in a potentially controversial program, fearing viewer boycotts of their products. It is an exaggerated fear, but it exists in the minds of many advertisers.

Not all news or informational services need be rendered by program-length elements. An independent can serve its community through a series of 10-, 30-, or 60-second **public service announcements (PSAs).** These short spots serve as "bulletin boards," giving notice of community events, activities, public services, legal deadlines, and health/safety advisories. Each station schedules its PSAs differently. The one constant is the fewer the commercials that are on the air, the more PSAs that will run. More PSAs are broadcast in January than in any other month because the fewest commercials run in that month. The Christmas shopping season exhausts consumers, merchants, and the media alike. There is a slump in buyer demand, and a corresponding slump in advertiser interest in buying commercials. Stations staunch the resulting gap with public service announcements. Broadcasting stations no longer are required to commit to a specific number of PSAs in their license renewal applications to the FCC, so the number and types aired vary widely, depending on the station's commitment and commercial inventory position.

Children's Programming

Traditionally, children were among the most loyal viewers of independent stations. Counterprogramming network news programs in the morning and network soap operas and talk shows in the afternoon, independents offered the only suitable programming alternative for children between the hours of 6 to 9 A.M. and 2 to 5 P.M. Augmenting the cartoons was often a program host, who entertained a studio audience, gave away prizes, and maintained a party atmosphere for the children. Bozo the Clown is the archetypical character host.

Because of children's increased worldliness—from watching many hours of PBS and Nickelodeon and from having a standard of affluence unknown to any previous generation of American children—kiddie show hosts hold little appeal anymore. The audience of hosted programs skews very young, in many cases down to the preschool level. School-aged children are just not interested. Consequently, most stations have dropped their locally hosted children's programs. By 1996 studies began to show that children were watching less TV than they previously had. Pre-teenage (ages 2–11) weekly television viewing was down 18 percent, or 5 hours a week, compared to 1984. Yet children still spent more time watching TV than on any other activity, with an average of 21 hours and 38 minutes a week. With more than a third of the TV homes having a personal computer, a growing number of children have begun trading TV time for computer time.

In many cases, stations have dropped their local commitment to children altogether. The issue of how well television is serving children's educational needs has been around as long as television itself. The television industry seeks to serve young viewers through a free market approach, allowing consumers to make their own viewing choices. Professional television activists claim that television should program toward children's educational needs, regardless of whether children watch the program or whether the station makes a profit.

Entering the debate on the side of regulatory intervention, in 1990 Congress passed the Children's Television Act. The bill directed the FCC to enforce the two mandates of the law:

1. **Program content.** Stations were obligated to offer programs that addressed the educational

and informational needs of children ages 16 and younger.

2. Commercial limits. Stations airing children's programming must restrict the amount of commercial advertising in such programs to 12 minutes per hour on weekdays and 10.5 minutes on weekends.[11]

To the consternation of station licensees, the FCC did not define what kinds of programs fit the requirement, nor did it offer guidelines as to what quantity of programs would satisfy the FCC's dictates. As to commercial limitations, the new law merely codified the advertising load customary to the industry.

Advocates of a heavy-handed regulation of television by the FCC rely on the scarcity argument. The scarcity of media outlets, combined with the omnipresence and influence of broadcasting, justify a degree of program content regulation intolerable if ordered in newspapers or other media. Proponents of a free market counter that there is no longer scarcity—cable channels, PBS, and video rentals all offer viewers an outlet for their needs. The battle will go on.

Talk/Magazine

Women make up most of the daytime audience in most markets, and a number of them want more from television than entertainment. They want to be informed, enlightened, and challenged, and a stimulating local live (or taped) program can do all three if properly produced (whether on an affiliate or an independent; see discussion in Chapter 6 on this same topic).

Local talk and magazine programs appealing to women are fairly easy to produce and, with attention to budgeting, not overly costly. Their most important ingredient is the producer/host or hostess, who must be attuned to what is happening in the community that will be of interest to and challenging for area women. The least expensive way of producing such shows is in the **studio** with guests invited from affinity groups. More expensive

is the **remote** (out-of-studio), using ENG equipment to relay live (or for a taped "package") some or all of the material from wherever the activities occur. So far, few independents have seriously tackled local women's programs; but the format has had major success when broadcast on a syndicated basis. The most popular syndicated talk program in the country since 1986 has been *The Oprah Winfrey Show*, which, coincidentally, started out as a local program on WLS-TV in Chicago.

The talk format can accommodate off-length time periods (following full-length movies or live sporting events) and combines community appeal with low cost, all of which should point to its greater use in independents' local production strategy.

Fund-Raiser Appeals

Rare there breathes an independent that has not at one time or another produced a fund-raiser for a local charity, civic organization, or other worthy cause. Affiliates tend to broadcast more fund-raisers than independents. They can offer the nonprofit organization larger production facilities, more on-air personalities, better promotion through a larger news presence, and a wider circulation of audience. Although local telethons are easily lampooned by critics for lack of Hollywood sophistication and occasional lapses into mawkishness, a station often makes a valuable contribution toward its community by donating valuable air time for worthwhile charitable causes.

THE PROGRAMMING TEAM

Programmers cannot operate in a vacuum. Program manager, sales manager, and general manager working in concert can achieve increases in market share in both revenue and ratings. Quite often, owing to their differing responsibilities, the perspective of the program manager is at odds with the sales manager's. In that case, the effective

programmer must communicate to the general manager or the sales manager the rationale for programming decisions. Research, in the form of both raw data and extracted data, becomes the tool for determining whether a program should be procured, what price should be paid, and where the program should be scheduled. Funds must be budgeted for research, program development, and promotion to ensure that the most apposite programming is offered to viewer and advertiser alike.

Programming and Research

If effective communication with program suppliers is the lifeblood for the independent programmer, information gathering, in the form of program research, is the intellect. (Chapters 2 and 3 review the research all stations should consider as they make programming decisions.) In collecting intelligence on a program about to enter the syndication marketplace, independent programmers must review every available scrap of research material—particularly data indicating how, for example, the program in question performed on the network, in the programmer's home market on the local affiliate, in markets similar in viewing behavior, how programs with similar viewer composition performed historically in syndication, and whether competing stations in the market will attempt to purchase it.

Tracking an off-network program in similar markets is essential to learning how that program might perform in a given market. The programmer must check the Nielsen ratings books for the pertinent information on how the program performed in household rating and share. Those demographic categories most requested by advertisers targeted by the sales department are: total adults, adults 18–49; women (18–34, 18–49, and 25–54); total men, men (18–34, 18–49, and 25–54); teens 12–17; kids 2–11, and kids 6–11 through several ratings periods.

Although a program might perform very well on the national level, it will not necessarily have appeal in a specific market—and vice versa. For example, *Murphy Brown* has been a mainstay of CBS's Monday night lineup from 1988 to 1996, but its performance in syndication (since 1992) has been lackluster at best. In contrast, the original off-network *Star Trek* was never a hit on the NBC network but developed a large, faithful audience in syndication, which has lasted more than 20 years and paved the way for spawning successor series: *Star Trek: The Next Generation*, *Star Trek: Deep Space Nine*, and *Star Trek: Voyager*.

The independent programmer must track that kind of information: network track records, syndication dynamics, and local market history. Rep firms will supply ratings information to their clients, and syndicated program ratings are, of course, available through Nielsen as well as from distributors, although the distributor's information should be taken with a spoon of salt (that is, it benefits their sales pitch to embellish a show's strong points and play down its weaknesses). Asking a distributor for ratings research is like asking a barber if you need a haircut. Do not expect objective advice.

Programming and Sales

Programming and sales are inextricably linked. It is imperative for the programmer at an independent station to become familiar with and involved in sales. The programmer must know:

- What budgets spot advertisers have
- What target demographics each advertiser seeks
- What effects local and national economies are likely to have on advertising budgets

Two out of three advertisers and agencies using television spend more than half their advertising budgets on television. Programmers must know which programs appeal to national advertisers and which appeal to local advertisers. (National and local accounts are two entirely different animals.) Ideal programs do both, of course.

The program manager must be an on-call "information booth" for the sales department, not

only answering all questions about programs, scheduling strategies, and future acquisition plans but also able to "sell" an untutored sales force on a program schedule's merits. If the sales department is not convinced of a program's strengths, they in turn will be unable to convince advertisers.

Programmers must attend sales department meetings frequently to understand the singular nature of the sales business and help the salespeople achieve their revenue goals without sacrificing the program department's overall strategy (see 7.3).

From a financial standpoint, programming represents an expense for the station, and sales represents revenue. To turn a profit, revenue must exceed expense. At a typical independent station, *program expenses comprise as much as half of total station expenses.* (Traditional affiliates spend less than a quarter of their revenue on programming, Fox affiliates between a quarter and a half.) Therefore, programmers are responsible for building a coordinated working relationship with sales management and sales objectives. The difficulty lies in reconciling the longer term goals of programming with the necessarily shorter term goals of sales. A programmer's perspective can afford to run on a year-to-year basis—at worst, quarterly (that is, from sweeps period to sweeps period). Sales constantly tracks their performance on a year-to-year, quarter-to-quarter, and month-to-month basis. First thing in the morning, every station looks at its previous day's sales tally.

Consequently, the continuous stream of dialogue between the programmer and the sales manager must cover such subjects as:

- Rating potentials or projections
- Pricing for spots within programs
- Budgets for both national and local advertisers
- Advertiser resistance to certain programs or time periods
- Recommendations on spot versus bartered programs
- Suggestions for methods of selling programs other than the traditional cost-per-thousand, cost-per-point, and cost-per-person.

7.3 UNSALABLE PROGRAMS

Program scheduling must be worked with an eye toward sales. Obvious questions arise when a program cannot be sold by an effective sales team. For example, a program may be scheduled in a time period not meshing with an advertiser's planned marketing campaign. If an advertiser's marketing plan is to break during the middle part of the second quarter of a given year but the television station schedules a program that would be an obvious "buy" for the advertisers in the beginning of the second quarter, that advertiser is automatically eliminated because the marketing campaign does not correspond with the planned airing of the program. Buying or creating a program that demands a premium price from advertisers but appeals to advertisers whose sales plans exclude premium prices creates sales problems as well. Whether a station maximizes its profit potential rests on how well the programmer and sales manager work together. When both constituencies—audience and advertisers—are simultaneously well served, the ideal business environment has been created for the station, even if a given program is not number one rated in its time period. It is not necessary to be number one to win financially. Paradoxically, stations that overpay to secure the rights to a syndicated program often find themselves in a no-win financial position: Even if the program is a ratings hit, they cannot make enough money to cover the expected net revenue for the time period. If the program does not generate ratings, it won't even pay for itself!

Programming's escalating costs make it imperative for programmers to know a program's revenue potential before it is purchased. An open relationship with sales management by a program director who understands sales is essential to station profitability.

SKILLS OF A PROGRAMMER

First, the bad news: There is a chronic oversupply of candidates for entry level jobs. Distracted by the superficial glamour of television, college students often fixate on collateral areas of study (to the detriment of basic undergraduate preparation) in the mistaken belief that a degree in mass communications is a guaranteed and unassailable entree into the profession. Upon attempting to enter the job market, students are shocked to find an overwhelming number of similarly credentialed applicants vying for the same position.

Now, the good news: *The most important skills in this business should and can be learned before you enter it.* (At least there is no catch-22, as in the lament "How can I get skills if I don't have a job, and how can I get a job without those skills?")

Before the Job

The fine mass communications programs offered by many universities are informative, useful, and substantive. They are not, however, a substitute for English and mathematical proficiency.

- **You must be able to use language well.** If you cannot write, speak, and comprehend English masterfully, how can you express yourself and convince others of the merits of your ideas?

- **You must have business math skills.** Fortunately, all the arithmetic a programmer needs is taught by the sixth grade. The trick is in being comfortable enough with numbers to make them your ally, not your tormentor. Once math dexterity becomes second-nature, then rating books, research reports, amortization tables, and budgets will open up their secrets (or at the least not seem as formidable).

For your first job, take any position that opens up. Prospective employers are more concerned with *how employees express and conduct themselves* than with specific job knowledge. Lifetime skills cannot be learned and then discarded. They must be used and sharpened every day. Employers can teach you what you need to know to perform your job, but they cannot teach you to think and solve problems, which are the essence of business life. You might be surprised (but not disappointed!) to learn that television is a fairly simple business once you get the hang of it.

On the Job

Once a tyro programmer reaches competence in general program knowledge, many skills can be honed. Most of these skills are related to verbal and math facilities, and they apply to any local programming position.

- **Syndication community contacts.** Programming is the lifeblood of any television station. To stay competitive, the independent programmer must keep a high level of visibility and credibility among the distribution community, exchanging ideas and information on a steady basis. The more knowledge the programmer has, the better armed he or she will be in planning for and negotiating for product.

- **Finance.** Programmers are responsible for reporting the status of the program department's operations to their station's business manager or corporate office. They must keep aware of the status of the expiration dates of the station's program contracts and understand the methods used by the company to amortize programming (that is, depreciate an intangible asset; see Chapter 3). In addition, program managers must construct, defend, and abide by the departmental budget, not merely for broadcast rights but for all such associated costs of programming as payroll, music license fees, videotape, satellite feeds, editing equipment and supplies, shipping, and payroll. As programming is usually the largest individual line item in any station's budget, it is critical to buy and budget expertly.

- **Contracts.** Gone are the days when program negotiations were diagrammed and sealed on cocktail napkins. Today's purchase prices are staggeringly larger and the contract terms expo-

nentially more complex, requiring a professional means of keeping track of agreements. The programmer must be conversant with the contract law mechanics of *offer, acceptance, amendment, breach, materiality,* and *damages,* as well as with the idiosyncratic versions of contract forms used by the scores of different companies in the distribution community.

- **Computers.** The computer made its way into programming offices in the 1980s and instantly gave programmers the opportunity of accessing information more quickly and accurately than ever. Reports and data formerly compiled tediously by hand over a period of hours or days are now summoned instantly. Programmers need familiarity with the more popular software but must remember that computers and research are only a means to an end, and not the end in themselves.

- **Public relations.** Programmers are influential (if not highly visible) public figures. Local and trade press representatives will telephone seeking information, comments, and background material. Program managers must know both what to say and, equally important, what not to say. The press must be dealt with honestly: refusal to comment is always preferable to dissembling. A program manager must be a one-person public relations firm, intelligence-gathering arm, and public platform for the station's programming policies.

- **Community groups.** Sooner or later, programmers will be invited to speak before community organizations. Sometimes these groups are friendly, in which case the programmer enjoys a pleasant respite from the office routine and can pick up valuable information. Sometimes the meetings are outwardly hostile and threatening, in which case the programmer longingly recalls the alternative career choices too quickly rejected in the past. Audiences can range from a luncheon of receptive business professionals to a politically motivated group lobbying intensely for free air time to proclaim their views. All must be heard. The station is a member of the community, as well as a federal licensee, and it is always smart business to know what is on the minds of others in your market.

Independent programmers must keep up to date on changing program availabilities and strategies if they expect to compete effectively within their markets. Being *aware* of available product is only the first step, however; programmers must aggressively *pursue* and be willing to *take a purchase risk* on programs their judgment concludes will work in their markets. Establishing ongoing, candid relationships with program suppliers and producers is quite important, for those without a pipeline will find themselves out in the cold. Keeping in touch with the business also means reading about trends and tastes and learning what is going on in the production centers of Los Angeles and New York, although what is a hit in those two unique markets only hints at what might work in other markets and may mislead a station in another part of the country. Despite the continuing homogenization of America, personal viewing habits and tastes still vary greatly from one region of the country to another.

PRESSURES AND CHANGES

Most programmers are vividly aware of the constraints various individuals, groups, and circumstances impose. Pressures from community groups both benign and highly politicized represent viewpoints that independent programmers must be willing and able to address in their programming. The injuncture of the Federal Communications Act for stations to operate in the public "interest, convenience, and necessity" does not exclude independent stations. In some respects, independents are even preferred vehicles, because they have scheduling flexibility and can make time available in higher profile time periods than network affiliates.

A programmer cannot always buy and schedule a desired program—the station's budget might not

permit it. The independent's transmitted signal might be an additional impediment to its ratings potential, especially in ruggedly terrained markets. UHF stations have traditionally had more disadvantages than VHF stations in the same market, although cable distribution has leveled the technical characteristics of signals in most larger markets, carrying all channels on a more or less equal basis. Especially when cable systems convert UHF channels to unoccupied VHF channels between 2 and 13 (**repositioning**), independents gain a big boost in the battle to win viewers. The remote control, too, improves UHF viewing levels simply by the fact that there is more channel changing. Tuning all channels in a similar manner (all on consecutive numbers on the same dial or on a keypad) gives underdog independents (and even public stations) more frequent chances for viewer sampling and gives the independent near-parity in cable homes.

The newest problems for independents arise from the promulgation of new **must-carry rules** for cable systems in the 1992 Cable Act.[12] In some cases, cable systems are not required to carry all independent stations in a market. That is a death sentence for a UHF station, an independent, or a new station. Often, the excluded station falls into all three categories. The possibility of institutionalizing **carriage charges** (fees broadcasters pay cable operators for carriage, sometimes known as "retransmission consent") fell flat. After the cable industry announced it was not going to pay broadcasters for carriage, the largest and most powerful broadcasters were able to negotiate only for carriage of their new cable channels (for ABC, ESPN2; for Fox, f/X). The Telecommunications Act of 1996 attempted to resolve the issue, but the Supreme Court later decided the issue of must-carry (presumably on another close vote) after this book went to press.

What does the future hold for independents? There is no consensus. The one constant in the television industry remains the increasing velocity at which changes happen, but three things are arguably clear.

1. Competition for viewers will increase. Cable networks are enacting plans to multiplex (offer multiple program channels simultaneously) their service with staggered schedules or completely different program lineups. Cable's expected expansion to 150 or even 300 or more channels by the late 1990s signals even greater competition for both the general entertainment and specialty independent (see Chapter 10).

Telephone companies are also developing systems to deliver a near-infinite number of channels to households via fiber optic lines. The entertainment portion of these services might mirror the programming offered by broadcasting and cable. The telephone industry has the technological capacity to provide a dazzling array of data services via the phone line, such as banking, shopping, information retrieval, electronic mail, and other unnamed services.

A third competitor might come from the sky. Since 1994, Direct TV and USSB have operated complementary programming services from the first American direct broadcast satellite (DBS). With the capacity to transmit dozens of channels to the continental United States, DBS stands to combine the most desirable elements of cable (expanded channel capacity) with those of the broadcast networks (simultaneous national distribution of signal).

2. Localism will increase in importance. Competing with an abundance of distantly supplied programs from cable, telephone companies, and satellites, independent stations can turn a negative marketing position into a positive. While their behemoth competitors must be all things to all people, the independent has the advantage of concentrating on the local market in programming, sales, and marketing.

Networks are large and cumbersome, like battleships; independents are smaller and nimbler, like corsairs, able to dart in and out of the smoke and fire of marketing opportunities without facing the enemy head-on.

3. A political firestorm will rage over pay media. Whether movies, sports, and specialty pro-

gramming should be offered for pay is not a mere dollars-and-cents decision. This is a larger issue: Can America survive as a free society if most of its mass communication (including television) must be paid for? For better or worse, television is arguably one of the most important 20th-century inventions (others include the automobile, airplane, computer, and antibiotics). Television is the most pervasively influential agent of American life and culture. If the television industry changes to the point where we all must pay to watch news and information as well as entertainment programming (whether online or via Smart TV), America may cleave into two societies: an affluent one that can afford to pay for its information and a poorer "half," unable to pay and sitting, literally, in the dark on matters of great importance to citizenship and self-education. The kind of communications system America has in the year 2000 will tell us a lot about what kind of country we are, how we value our responsibilities to others, and what kind of country we are likely to become.

SUMMARY

There are four facts of life for the independent programmer today:

- **Program sourcing/competition.** John Dunne was right: "No man is an island." Neither can a station survive competitively as a pure independent. Independent stations enjoy the new luxury of choosing among many program suppliers, including the new networks. The cable networks have snapped up both the traditional low-end syndicated programs and the fringe advertising dollars formerly ceded to independents by the affiliates.
- **Fight for distinctiveness.** The lines of demarcation between affiliates and independents are irretrievably blurred. Independents have to learn to act a little like affiliates (many independents have started or expanded their news

coverage), just as affiliates are learning to act like independents. Affiliates are learning to acquire and use more news, local, and syndicated programs in their schedules as networks provide less network programming, especially during daytime.

- **Varying degrees of independence.** Most independents in the top 50 markets are part of large broadcasting companies in which many independent stations are part of the same ownership. Consequently, many programming, promotion, and other operations decisions are made at the group level.
- **Convergence.** There are two converging forces in television. First, station groups need to lock up sources of steady program supply, so they buy (Westinghouse/CBS) or start (United TV/UPN) networks. Conversely, suppliers need guaranteed outlets for their product, so they buy stations or networks (Disney/ABC).

The metabolism of an independent television station is higher than most other media outlets: the independent must purchase, produce, or barter programming to fill 18 to 24 hours every day. Syndicated series, movies, and sports, and the new Fox, UPN, and WB networks make up the bulk of independent programming. Licensing practices for key off-network series now commonly require the purchase of programs two or three years in advance of their availability. Although expensive, off-network series can build the most stable schedule and cultivate loyal audience viewing habits. One of the primary jobs of independent station programmers is tracking the ratings of syndicated series.

Programs come in many categories. Feature films (movies) fill large amounts of time and are more successful when thematically stacked. While sporting events also fill large amounts of time with highly visible programming, their success often depends on circumstances beyond the control of the station, such as on-the-field performance and general fan support of the team. First-run programs are often cheaper to acquire but, lacking previous

exposure on the networks, are harder to persuade viewers to sample without a disproportionate commitment to promotion. Further, first-run programs lack track records on which to base purchasing and scheduling decisions.

Increasingly, off-network reruns and first-run series are being bartered, often to the station's financial disadvantage. Independents typically avoid head-to-head news competition with affiliates and are reasonably successful with nontraditional news scheduling. Counterprogramming, flow control, and promotion are an independent's primary strategies, and scheduling salable programs is an overriding goal.

The continued growth of cable has been a boon to most UHF stations; repositioning on the home receiver allows the independent station to compete based on programming, not signal quality or reception difficulty. The birth of news media technologies will provide competition from all directions. For the future, increased competition will be the problem and increased localism the solution. Programming an independent remains risky and challenging. It is an exciting, fun, and worthwhile career choice.

SOURCES

Bortz, Paul. *Sports on Television: A New Ball Game for Broadcasters.* Washington, DC: National Association of Broadcasters, 1990.

Broadcasting. Washington, DC, weekly, 1931 to date.

Electronic Media. Chicago, weekly.

http://www.foxnetwork.com/

http://www.natpe.org/

http://www.upn.com/

http://www.warnerbros.com/

Nierenberg, Gerald. *The Complete Negotiator.* New York: Berkley Publishing, 1986.

Ogilvy, David. *Ogilvy on Advertising.* New York: Vintage Books, 1985.

Rapp, Stan, and Collins, Tom. *The Great Marketing Turnaround.* Englewood Cliffs, NJ: Prentice Hall, 1990.

Ries, Al, and Trout, Jack. *Bottom-Up Marketing.* New York: McGraw-Hill, 1989.

Ries, Al, and Trout, Jack. *Positioning: The Battle for Your Mind.* New York: McGraw-Hill, 1981.

Television Programming Sourcebooks: Films, Film Packages, and Series. New York: Act III Publishing, annual.

Variety. Weekly trade newspaper of the television and film industry. New York and Hollywood, 1925 to date.

NOTES

1. The Fox Broadcasting Corporation is a division of News Corp., a diversified international media company run by Rupert Murdoch; UPN, the United Paramount Network, is owned by United Television Stations, with Paramount Entertainment (a division of Viacom) holding an option to purchase; WB (sometimes known as "the WB") is controlled by the Warner Bros. studio, a division of Time Warner.

2. Federal Communications Act, Section 3(p).

3. C.F.R. Section 73.662 (f).

4. C.F.R. Section 73.662 (g).

5. Fox, of course, constitutes a network identity. Inevitably, a pseudonetwork like Fox transforms itself into a full-fledged network. Many would argue that Fox independents crossed the line and became network affiliates during the mid-1990s.

6. In what may have been a ratings first for New York, independent WPIX took third place in the November 1995 sweeps, ahead of two major network affiliates, WABC and WNBC. The Tribune-owned station averaged a 4.7 rating/12 share from 7 A.M. to 1 A.M. (sign-on to sign-off).

7. In addition to 15 hours of weekly prime time, Fox supplied 3 hours of children's animation weekdays, 4 hours on weekends, and NFL Football, NHL Hockey, and Major League Baseball as of 1996.

8. A five-day week times 52 weeks equals 260 weekdays. Many popular sitcoms are stripped six days per week.

9. Checkerboarding is a programming concept that works only on a Big Three network. Broadcasting a different program everyday in the same time period is onerous for a local station to promote and requires too much of the viewer who must then remember which program is on which day. Only the networks, with their massive promotion engines, can afford such a strategy.

10. One of the biggest network hits in history was CBS's *The Mary Tyler Moore Show* (1971–77). It was

among the top ten shows throughout its network run. It attracted large purchase prices in the off-network after-market, but it failed miserably in syndication. Ironically, one of syndication's all-time success stories, M*A*S*H, was an indifferent performer on CBS for years. The network shuffled it around in many different time periods, and the first syndication sales prices were unexciting. When M*A*S*H became a syndication hit, its network ratings increased, and the renewal license fees for the second cycle in syndication skyrocketed.

11. Whether Congress rationalized the different amounts of commercial limits for different days of the week by believing that children were more susceptible to commercial messages on weekends than Monday through Friday was left unaddressed.

12. More formally known as The Cable Television Consumer Protection and Competition Act of 1992, P.L. 102–385, 47 U.S.C.A. Sec. 15.1 et seq.

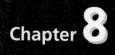

Chapter 8

Public Television Programming

John W. Fuller
Douglas A. Ferguson

A GUIDE TO CHAPTER 8

PROGRAM PHILOSOPHY

Public television, its mission, and its public service objectives occupy a unique position in American broadcasting. Contrary to broadcast development in nearly every other country in the world, public service broadcasting in the United States developed long after the commercial system was in place. This fact has had an immense effect on the general public's attitude toward American public television programming and on public broadcasters' self-definition.

The public debates whether or not public television programs are even necessary and whether they should occupy the time and attention of the nation's communications policymakers in the Congress, the Executive Branch, and the Federal Communications Commission. For example, Newt Gingrich announced in the mid-1990s that as leader of the House of Representatives he intended to zero-out the budget for public television.[1] Federal budget conservatives have always targeted PBS for cuts, but the 1994 elections signaled a fundamental shift in national politics away from federal funding for the arts and humanities. Opponents of public broadcasting argue that the advent of such distribution developments as large-capacity cable systems, direct satellite broadcasting, multipoint distribution systems, videotapes, discs, and so on obviate the need for public television. Proponents counter that the marketplace fails to provide the specialized programming that public television offers and that any belief that emerging technologies will be different from existing media is unfounded. They point to CBS's and RCA's failures when they offered commercial arts and cultural programming on cable and to the very limited success of Bravo and Arts & Entertainment, which supply cultural programming to cable systems. Marketplace critics also state that only public television programming has special audience services for children, the elderly, and ethnic minorities.

The debate over programming content has persisted within the industry since public television began. For stations, the debate centers on the meaning of **noncommercial educational broadcasting,** which is what the Communications Act of 1934 and the Federal Communications Commission call public television's program service. Noncommercial service came into existence in 1952 when educational interests lobbied the FCC into creating a special class of reserved channels within the television allocations exclusively dedicated to "educational television."

One extreme argument defines *educational* in the narrow sense of *instructional*. From that viewpoint, public television (PTV) should teach—direct its programs to school and college classrooms and to out-of-classroom students. The last thing PTV should do is to compete for commercial television's mass audience. At the other extreme are those people who define educational in the broadest possible sense. They want to reach out to viewers of all kinds and generate mass support for the public television service. This group perceives "instructional" television as a duty that sometimes must be performed, but their devotion goes to the wide range of programming the public has come to think of as public television.

The Carnegie Commission on Educational Television introduced the term *public television* in 1967. The commission convinced many in government and broadcasting that the struggling new service had to generate wider support than it had in its fledgling years. One of the impediments to such support, the Commission felt, was the word *educational*, which gave the service an unpopular image. They suggested *public television* as a more neutral term. Thus, a distinction has grown up between **instructional television (ITV)** and **public television (PTV)**—a distinction not altogether desirable or valid.

Lacking a truly national definition for public television's program service, a public television station's programmer must deal with the unresolved, internal questions of what it means to be a noncommercial educational broadcasting service. The PTV programmer must come to grips with a station's particular program philosophy. Philosophies vary widely from one station to the next, but

two common themes persist: being educational and being noncommercial. These terms imply that *public television must directly serve "the people"; it must be educational and different from—if not better than—commercial television.* One of the implications of such a fundamental difference is that public television programming need not pursue the largest possible audience at whatever cost to programming. Public broadcasting has a special mission to serve audiences that would otherwise be neglected because they are too small to interest commercial broadcasting.[2] This difference in outlook has great programming significance. It means that the public station programmer is relieved of one of the most relentless constraints limiting a commercial programmer's freedom of choice.

At the same time, public television cannot cater only to the smallest groups with the most esoteric tastes in the community. Broadcasting is still a mass medium, whether commercial or noncommercial, and can justify occupying a broadcast channel and the considerable expense of broadcast facilities only if it reaches relatively large numbers of people. Public broadcasting achieves this goal cumulatively by reaching many small groups, which add up to a respectably large cumulative total in the course of a week (almost 60 percent of U.S. television households).

THE NETWORK MODEL

Programming the national **Public Broadcasting Service (PBS)** is a little like trying to prepare a universally acclaimed gourmet meal. The trouble is that a committee of 198 plans the menu, and the people who pay the grocery bills want to be sure the meal is served with due regard for their images. Some people coming to the dinner table want the meal to be enjoyable and fun; others want the experience to be uplifting and enlightening; still others insist that the eating be instructive; and the seafood and chicken cooks want to be sure the audience comes away with a better un-

derstanding of the problems of life underwater and in the coop.[3]

The analogies are not farfetched. A board of 35 appointed and elected representatives of its member stations governs the Public Broadcasting Service on three-year terms. The board is expected to serve 198 public television licensees operating 344 public stations all over the country and in such remote areas as Guam, American Samoa, and Bethel, Alaska.

Since PBS produces no programming, it uses a host of program suppliers and tries to promote and schedule their programs effectively.[4] In addition, constituencies ranging from independent producers to minority groups constantly pressure public television to meet their special needs. And, of course, the program funders have their own agendas too.

In *commercial* television, programming and money flow *from* network headquarters *to* affiliates. Production is centrally controlled and distributed on a one-way line to affiliates, who are paid to push the network button and transmit what the network feeds. Most of the economic incentives favor affiliate cooperation with the network, placing tremendous programming power in network hands.

In *public* television, money flows the opposite way. Instead of being paid as loyal affiliates, member stations *pay* PBS, which in turn supplies them with programs sufficient to fill prime time and many daytime hours. Stations pay membership dues to cover PBS's operational budget and, entirely separately, fees to cover part of the program costs. PBS is both a network and a membership organization responsible for developing, maintaining, and promoting a schedule of programs while also providing services to its dues-paying members. A station's remaining broadcast hours are typically filled with leased syndicated fare (movies; off-network reruns; made-for-syndication series, mostly British; and instructional programs for local schools), local productions, and programs supplied by regional public television networks.

Four regional networks also serve the eastern, southern, central, and western sections of the

United States. One, the Eastern Educational Network, formed the Interregional Program Service in 1980 to distribute its programs nationally. It now serves a large group of stations in all regions, functioning as a second major public television distributor.[5] The relationship between the regional networks and PBS is strong: Member stations *pay the regional network*, and it then delivers programs to them. PBS, however, delivers its programs in a *prearranged schedule* whereas the regional networks distribute their programs during off-hours via satellite for local taping and scheduling, more like syndicators. An entire week of daytime PBS programming in 1996 appears in 8.1, covering the hours from 7 A.M. to 11 P.M.

Station Scheduling Autonomy

Much clout rests with the stations. They spend their revenues as they see fit, expecting to be treated fairly and with the deference due any consumer. PBS, as a consequence, has a limited ability to get stations to agree on program scheduling. Citing the principle of "localism" as public television's community service bedrock, station managers display considerable scheduling independence, ostensibly to make room for station-produced or acquired programs thought to meet some local need.

After the nationwide satellite system was phased in (1978) and as low-cost recording equipment became available in the 1970s, stations carried the PBS schedule less and less frequently as originally programmed. Until a networking agreement was worked out with the stations, no two station program schedules were remotely alike. National promotion, publicity, and advertising placement were, if not impossible, extremely difficult to achieve. Nor were corporate **underwriters** pleased at the scheduling irregularity from one market to the next.

The Carriage Agreements

Implementing a networking **"common carriage"** agreement in October 1979 partially ordered this

networking chaos. The nonbinding agreement established a core schedule on Sunday, Monday, Tuesday, and Wednesday nights. During the hours of 8 to 10 P.M. (with time zone delay feeds), PBS fed those programs most likely to attract the largest audiences. In turn, stations committed themselves to airing the PBS core offerings on the night they were fed, in the order fed, and within the prime-time hours of 8 to 11 P.M.

For several years the common carriage arrangement worked well; the typical "core" program received same-night carriage on more than 80 percent of stations. Core slots thus took on a premium quality; underwriters and producers, looking for most favorable treatment for their programs, began to insist they be assigned a time slot within the core period. Maximum carriage was thought to mean maximum audience size. With more core-quality programs on their hands than available hours in the eight-hour core period, PBS programmers were forced in the early 1980s to move some long-standing core programs (for example, *Mystery, Great Performances*) outside the core period to make room for other programs and hope that the stations would still carry them on the feed night.

This move was partially successful; even though same-night carriage for the rescheduled programs fell, it was only to about 55 percent for these noncore programs. But station programmers took these moves by PBS as a sign that core programs could be moved around at will. Station independence began to reassert itself. By the 1985–86 season, same-night carriage of the core itself had slipped to 73 percent. PBS, concerned with complaints from national underwriters that "their" programs were not receiving fair treatment, moved to bolster same-night carriage. In fall 1987, PBS began a new policy of **same-night carriage** by which selected, broad-appeal programs would be designated for carriage the night they were fed. This policy had little effect, however, because PBS did not strictly enforce it.

In 1995 PBS once again attempted to get control of unpredictable station scheduling. Wanting to encourage new corporate underwriting because

8.1 1996 PBS DAYTIME SCHEDULE

	SUNDAY	MONDAY	TUESDAY	WEDNESDAY	THURSDAY	FRIDAY	SATURDAY
7:00		Sesame Street					
8:00	Sesame Street	Barney & Friends					
		The Puzzle Place					
9:00	Mr. Rogers	Sesame Street					
	Barney						
10:00	Magic School Bus	Lamb Chop's Play-Along					
	Wishbone	Reading Rainbow					
11:00	R. Rainbow	Mr. Roger's Neighborhood					
	The Puzzle Place	Shining Time Station					
12:00	Lamb Chop (Tent.)	Lamb Chop's Play-Along					
	Storytime (Tent.)	Barney & Friends					
1:00		Storytime					
		Shining Time Station					
2:00		Barney & Friends					
		The Puzzle Place					
3:00		Mr. Roger's Neighborhood					
		Sesame Street					
4:00							
		Wishbone					
5:00		Where in the World Is Carmen Sandiego?					
		Bill Nye The Science Guy					
6:00	Ghostwriter	The News Hour with Jim Lehrer					
	Ghostwriter						
7:00		The News Hour with Jim Lehrer					
8:00	Nature	Marsalis on Music and Specials	NOVA	Specials	"Explorations"	Wash Week	
						Wall Street	
9:00	Masterpiece Theatre	The American Experience	Frontline	Specials	Mystery!	Specials	
10.00	Specials (Repeat)	Specials	Specials		Specials	Specials	
11:00							

8.2 CORE PROGRAMS IN PRIME TIME, WINTER 1996

Week of: JANUARY 28 – FEBRUARY 3, 1996 PREPARED: 11/15/95

	Sunday 28	Monday 29	Tuesday 30	Wednesday 31	Thursday 1	Friday 2	Saturday 3
8:00 2000	NATURE In the Company of Wolves with Timothy Dalton DVS % NAAT 1101 R +	21ST CENTURY JET: The Building of the 777 "Taking Flight" (4/5) % TCJE 104 +	NOVA B-29 Frozen in Time % NOVA 2303 +	THE METROPOLITAN OPERA PRESENTS Otello *in Italian with English subtitles*	GREAT DRIVES Highway 61 (1/5) % GDRI 101 +	WASHINGTON WEEK IN REVIEW % WWIR 3531 +	PBS DARK
9:00 2100						WALL STREET WEEK % WSWK 2531 +	
9:00 2100	MASTERPIECE THEATRE The Countess Alice	THE AMERICAN EXPERIENCE The Battle Over "Citizen Kane"	FRONTLINE So You Want to Buy a President?		MYSTERY! Inspector Morse IX "The Day of the Devil" (1/2) DVS MYST 1614 +	A. PHILIP RANDOLPH: For Jobs and Freedom	AUSTIN CITY LIMITS B. B. King ((surround sound)) % AUCL 2104
10:00 2200	(1/1) DVS MAST 2213 R +		FRON 1410 +	% LFTM 1903	THE NOBEL LEGACY How Do You Feel, Mr. Jacobs? (1/3) % NOLE 101 R +	DVS APHR 000 +	
	CLUB DATE % CDAT 601 R	DVS % AMEX 807 +	CLUB DATE % CDAT 602 R	ENCORE! % ENRE 201 R		AFRICAN-AMERICAN ARTISTS Affirmation . . . AFTO 000 +	PBS DARK
11:00 2300				CHARLIE ROSE % COSE 6021-6025			
12:00 2400	% STEREO	+ CLOSED CAPTIONS					

Source: PBS Research.

Congress had reduced federal funding, a committee of its board presented the stations with a new common carriage agreement—this time with financial penalties. Some 40 stations refused to sign the agreement until the penalties were removed. The toothless new agreement went into effect in September 1995, "requiring" stations to carry certain programs within prime time on the feed night (see 8.2). The agreement promised that PBS would designate no more than 350 hours per year for common carriage, of which stations could choose up to 50 hours *not* to carry on feed night. Within these limitations, the agreement stated a

goal of 90 percent carriage or better for designated programs. No doubt PBS will be shouting about the same problem in 2005.

While most programs tagged for common carriage were receiving the requested carriage by 90 percent of stations in1996, "untagged" shows continue to receive pre-1979 treatment. Program managers continue to tape-delay programs with limited appeal and air them outside of prime time, using the vacated evening slots for other programming. Carriage on feed night often averages less than 40 percent for untagged programs considered to have narrow audience appeal.

PBS RESPONSIBILITIES

Since its founding, PBS has had two key responsibilities: *to accept or reject programs* and *to schedule those accepted*. The program acceptance/rejection responsibility is grounded in technical and legal standards established by PBS during the 1970s. The technical standards protect stations from Federal Communications Commission violations and maintain high levels of video and audio quality. By their very nature, they can be applied with reasonable consistency. As the steward for underwriting guidelines, PBS maintains stringent rules for on-air crediting of PBS program funders to prevent violations of FCC underwriting regulations and to ensure against public television's appearing "commercial." The legal standards protect stations from libel and rights infringements and alert them to equal time obligations that may result from PBS-distributed programs.

PBS warns stations in advance of programs containing offensive language or sensitive scenes (nudity or violence) and makes an edited version of programs containing extreme material available to stations. In rare cases, controversial programs such as *Tongues Untied* (a documentary on gay black life) have been canceled or postponed, but in general PBS tends toward airing programs as produced.

Day-to-Day Management

An executive vice president heads PBS's National Program Service (NPS). This senior executive sets policy for and oversees the content and array of formats within the program schedule, directing long-range development of major programs. Other managers assist in the day-to-day activities of program development, scheduling management, and acquisition of international programs. Content departments within the NPS concentrate on the development of news and public affairs, children's, cultural, and fund-raising programs. PBS Encore! provides stations with a menu of previously aired PBS programs (reruns) to supplement local sched-

ules. Other departments deliver programs for adult at-home college education, in-school instruction for children, and corporate on-site training programs on a user-pay basis. Interactive and online services, extensions of PBS's programming, were introduced in the mid-1990s—including *Mathline* for students and *PBS Online* on the World Wide Web (*http://www.pbs.org*). Thus, programming for the station broadcasts is only part of PBS activities.

Satellite Distribution

The Broadcast Operations Department manages the daily details of the national schedule much as a traffic department would at a commercial network. All the pieces of the jigsaw puzzle must be plugged into place across an array of satellite schedules, insuring, for example, that (1) the end of a 13-episode series coincides with the start of another ready to occupy its slot; (2) dramas with profanity have an early edited feed available on another transponder; and (3) filler is available when, for example, the Saturday morning schedule of how-to programs runs short in the summer.

PBS owns six transponders on Telstar 401 (four in the Ku-band, two C-band), and with the expanded capacity made possible by digital compression, it will deliver greatly expanded instructional and general audience services in the late 1990s. Experiments with interactive transmissions by VSAT (very small aperture terminals) between classrooms and distant teachers, including digital voice, facsimile, computer data, and scanned photographic images, occurred in the mid-1990s.

Fund-Raising Assistance

The Station Independence Program (SIP), a division in PBS's National Program Service (NPS) is a very successful station service. The SIP schedules and programs three main on-air fund-raising drives a year, called **pledge drives** (a 16-day event annually in March and two 9-day drives in August and December).[6] Stations wishing to avail themselves of the SIP service (and most do) pay PBS additional fees for it. A key SIP function is acquisition,

funding, and commissioning special programs for use during local station pledge drives. Programs with *emotional payoff* tend to generate more and higher pledges, not necessarily those programs with the largest audiences. Self-help programs and inspirational dramas, for example, generally make money for stations, but documentaries on topics such as world economics dó not do well. An exceptional program that effectively combined both emotional tugs and high audience appeal was *Carreras Domingo Pavarotti with Menta: The Three Tenors in Concert* (1994). Both the original and a sequel have performed well in numerous pledge drives.

TYPES OF STATION LICENSEES

One of the difficulties in describing PTV programming strategies is that the stations are so diverse. The 198 **licensees** (as of 1996) operating 344 **stations** represent many management viewpoints. More stations than licensees exist because in 20 states a legislatively created agency for public broadcasting is the licensee for as many as 15 separate stations serving its state. Also, in several communities, one noncommercial educational licensee operates two television channels. In these cases (Boston, Pittsburgh, and Milwaukee, among others), one channel usually offers a relatively broad program service while the second channel is used for more specialized programming, often instructional material.

 Much of their diversity is explained by the varying auspices under which they operate. Licensees fall into four categories: *community, university, public school,* and *state agency,* in the proportions shown in 8.3, and each constrains programming in different ways.

Community Licensees

In larger cities, particularly those with many educational and cultural institutions but without a dominant institution or school system, the usual

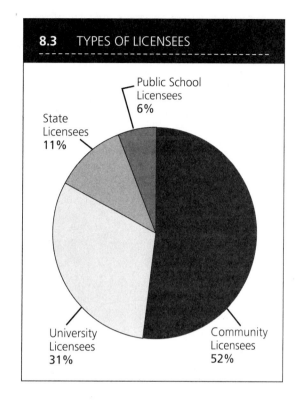

8.3 TYPES OF LICENSEES

Public School Licensees
6%

State Licensees
11%

University Licensees
31%

Community Licensees
52%

licensee is the nonprofit community corporation created for the purpose of constructing and operating a public television station. Because the governing board of such a station exists solely to administer the station (as compared with university trustees who have many other concerns), many feel that community stations are the most responsive type of licensee. As of 1996, 91 such stations operated in the United States.

 Compared with other licensees, community stations derive a higher proportion of their operating support from fund-raising activities (including on-air auctions)—about 26 percent, compared with 21 percent for licensees overall.[7] As a result, much of their programming reflects the urgent need to generate funds from the viewers they serve. Programmers at these stations, therefore, are more likely to be sensitive to a proposed program's general appeal. They will lean toward high quality production values to attract and hold a general audience. These stations cannot grow or improve

8.4 THE ADVERTISING EXPERIMENT

Reductions in federal funding for public television during the Reagan administration's first term forced a greater reliance on public donations. Most stations came to rely more heavily on revenue from nonfederal sources in general and on public donations in particular. Searching for alternative ways to finance public television, Congress authorized a one-year advertising experiment. Ten public television stations, including all types of licensees, were allowed to sell and broadcast advertising from April 1982 through June 1983. Studies showed minimal objection from the public, and some participating stations reported substantial profits (direct cost of sales commissions averaged only 30 percent of gross sales). But advertising revenues are based directly on the size of a station's audience, and because public television ratings are comparatively small, gross sales (and profits) provided stations with only a fraction of their annual budgets. The public television industry could find no cause for enthusiasm in the outcome, and no authorizing legislation resulted. Instead, hoping to stimulate corporate support another way, the FCC loosened their underwriting guidelines to permit, among other things, the display of products and animated corporate logos in program underwriter credits.

The topic of advertising on public television resurfaced in the mid-1990s as new threats by Congress to reduce federal funding appeared as part of the Contract With America agenda. Ervin Duggan, then-president of PBS, predicted such changes would result in a network of new *nonprofit commercial* licensees across the country.

without a rapidly ascending curve of community support. (See 8.4 for an alternative funding idea.)

Within the *community* category, several stations stand somewhat apart because of their metropolitan origins, their large size, and their national impact on the entire noncommercial service as producers of network-distributed programs. These flagship stations of the public broadcasting service are located in New York, Boston, Los Angeles, Washington, Chicago, Baltimore, Seattle, and Pittsburgh. The first four are particularly notable as production centers for the nation, originating such major programs as *The Newshour with Jim Lehrer, Nova*, and *Nature*. Although other public stations and commercial entities often participate in their productions and financing, these large, community-licensed producing stations generate most of the PBS schedule.

Community stations, because of comparatively high levels of community involvement and because of a prevalence of clearly receivable VHF channels, attract larger local audiences than do other types of noncommercial licensees. For example, Nielsen reports that over half of the households in San Francisco, one of the nation's largest media markets, tune weekly to community-operated KQED. With such a high level of viewing, more of its audience sees its fund-raising appeals and contributes money to the station. WNET, New York's largest public television station, is an exception among community stations. It receives a portion of its funding from state government. Despite being widely viewed, WNET was forced to make drastic cuts in its 1991 budget as a result of a "devastating reduction in the allocation for the station in the proposed New York State budget." While the New York station's economic plight was symptomatic of funding ills facing other stations receiving state support, it was not atypical of community stations.

University Stations

In many cases, colleges and universities activated public television stations as a natural outgrowth of their traditional role of providing extension services within their states. As they see it, "the boundaries of the campus are the boundaries of the state,"[8] and both radio and television can do some of the tasks extension agents formerly did in person. Fifty-five licensees make up the *university* group.

Here, too, programmers schedule a fairly broad range of programs, often emphasizing adult continuing education and culture. Some, typically using student staff, produce a nightly local newscast, and many produce a weekly public affairs or cultural program. None, in recent history, has produced a major PBS series for the prime-time core schedule. University licensed stations such as WHA (Madison, Wisconsin) and KUHT (Houston, Texas) contribute occasional specials and single programs to the PBS schedule. WUNC-TV at the University of North Carolina in Chapel Hill produced *The Woodwright Shop* series, and other university licensed stations have supported short-run series aired in the daytime PBS schedule.

As operating costs mount and academic appropriations shrink, some university stations turn to over-the-air fund-raising to supplement their institution's budgets. In doing so, they use tactics similar to those of community stations, including airing programs specially produced for fund-raisers. Expanded fund-raising efforts are generally accompanied by broadening program appeal throughout the station's schedule.

Public School Stations

Local school systems initially became licensees to provide new learning experiences for students in elementary school classrooms. From the outset, some augmented instructional broadcasts with other programming consistent with the school system's view of its educational mission. By the mid 1990s only 10 of these *school licensees* remained. Most of them have organized a broadly based community support group whose activities generate wider interest and voluntary contributions from the community at large. As a result, the average local licensee now draws 14 percent of its income from subscriber contributions. Naturally, programmers at these stations are heavily involved with in-school programming (*instructional television—ITV*), but because they desire community support they are also concerned with programming for children out of school and for adults of all ages. Other than ITV series, most rarely produce original entertainment programs for PBS, and they obtain most of their schedules from national, state, and regional suppliers of instructional programming. Of course, they usually carry such general (non-ITV) PBS educational children's programs as *Sesame Street* too.

State Television Agencies

More than 200 of the nation's public television stations are part of state networks operated by legislatively created public broadcasting agencies. Networks of this type exist in 23 states. Most of them were authorized initially to provide new classroom experiences for the state's schoolchildren. Most have succeeded admirably in this task and have augmented their ITV service with a variety of public affairs and cultural programs furnished to citizens throughout their states.

State networks, such as those in South Carolina, Maryland, Kentucky, Nebraska, and Iowa, are very active in the production and national distribution of programs. Their efforts range from traditional school programs for primary and secondary grades to graduate degree courses offered in regions where colleges and universities are few. These production efforts are the counterpart to the national production centers of the community-based licensees. Although state networks rarely produce prime-time PBS series, they frequently join consortia generating specific programs for series such as *Great Performances*. Others, such as the Maryland Center for Public Broadcasting and the South Carolina ETV Commission, have

produced many long-lived PBS series such as *Wall Street Week*.

Although in recent years these state network stations have gotten more foundation, underwriter, and even viewer support, state legislatures still appropriate more than three-fifths of their budgets. This fact, plus the perception of their "community of service" as an entire state rather than a single city, gives programmers at these stations a different perspective.

Similarities and Differences among Station Licensees

It should be evident from these brief descriptions that each category of public television station poses special problems and special opportunities for programming strategies. Each station type is ruled by a different type of board of directors—community leader boards, university trustees, local school boards, state-appointed central boards. Each board affects program personnel differently:

- Community representatives try to balance local power groups.
- University boards, preoccupied with higher education programs, tend to leave station professionals free to carry out their job within broad guidelines.
- School boards likewise are preoccupied with their major mission and in some cases pay too little attention to their responsibilities as licensees.
- State boards must protect their stations from undue political influences.

All licensees struggle to function with what they regard as inadequate budgets, but there are wide funding discrepancies between the extremes of a large metropolitan community station and a small local public school station. Significantly, all types of stations have broadened their financial bases in recent years to keep up with rising costs and to improve program quality and quantity.

Licensees having the greatest success in securing new funding have, in general, made the strongest impact on national public television programming, partly because the corporations that underwrite programs want to get maximum favorable impact from their investments. In turn, successful public television producer-entrepreneurs are motivated to create attractive new public television programs with broad audience appeal in the hope of securing still more underwriting. Such programs increase viewership and draw more support in the form of memberships and subscriptions. Although this trend has its salutary aspects, it has also diverted noncommercial television from some of its original goals. For example, controversial public affairs programs and those of interest only to specialized smaller audiences—the "meat and potatoes" of public television—do not always receive corporate funding.

PROGRAM SOURCES

Early in its history, PBS developed a characteristic schedule of dramatic miniseries and anthologies, documentaries on science, nature, public affairs, and history topics, concert performances, and a few other types, none of which ABC, CBS, Fox, or NBC offer on a regular basis. PBS's marketplace position has thus historically been that of alternative to the commercial networks. Today, however, several cable networks (including The Discovery Channel, Arts & Entertainment, Bravo, and to a lesser extent, TBS) offer some programs similar to PBS's. From time to time, some members of Congress—important critics because Congress supplies public television with 14 percent of PBS's annual revenue—will argue that PBS has become superfluous because it duplicates programming available on cable. The argument lacks merit because 35 percent of U.S. TV households do not subscribe to cable while 99 percent can receive PBS. Moreover, very few cable subscribers actually watch the cable networks that have PBS-like programs; PBS's ratings are three to four times larger.

Program Financing

How a program gets into the PBS schedule contrasts with the process at PBS's commercial network counterparts. At ABC, CBS, Fox, NBC, and most cable networks, program chiefs order the programs they want, pay for them out of a programming budget, then slot them into the schedule. To minimize ratings failures, the networks first pay for the production of pilot programs each year. Additional episodes are ordered of the most promising, and the series receives a place in the schedule.

At PBS, however, program funding is more complex. A program may have a single financial backer or several. More frequently than not, funding comes from a combination of sources, especially when the project runs into millions of dollars. PBS will, on occasion, fully support a project out of its program assessment funds; but most programs must find their own backing. Producers would, of course, prefer to walk away from PBS with a check for the full amount. Owing to PBS's limited purse, they must usually "shop" a project from one corporate headquarters to the next, perhaps even to foundations and the Corporation for Public Broadcasting. Given the daunting process, producers have been heard to say that they spend more time chasing after dollars than making programs.

Program assessment fees, now levied on PBS member stations, were begun in the early 1990s. It represents public television's response to growing cable-network competition for the limited supply of programs to buy. In 1990, stations voted to streamline the program funding process so that newly offered productions could be snapped up without delays. The first year of program assessment, nearly $80 million was transferred from station hands to PBS's. The chief program executive now handles selected program funding as a centralized responsibility (in contrast to the long-beloved notion that program decision making should be tightly controlled by public television's 198 station program managers). To form this fund, stations are assessed in proportion to their market size. Programs produced either wholly or in part from this fund carry an announcement crediting "viewers like you" because station money is involved, a large part of which comes from viewer contributions.

A program on PBS can have several "fathers," that is, multiple producers. Typically, separate production units shoot film for partners in a coproduction deal, as when PBS joins with the BBC to produce a science or nature program. In such an arrangement, both will have air rights. Sometimes a cable network partners with PBS (although usually only for funding and not actual production). Rather than share a program with a U.S. competitor, public television prefers foreign coproduction over domestic coproduction.

The Major Producers

A very large portion of PBS's schedule comes from series produced by or in conjunction with four major producing stations—WGBH in Boston, WNET in New York, KCET in Los Angeles, and WETA in Washington, D.C. In most years, these producing stations account for well over half of PBS's new shows (see 8.5). Other stations contribute an occasional series or special to the PBS schedule, but most local efforts either focus too narrowly on a topic to be of wide national interest or fall short of national standards for writing, talent, and technical characteristics because they lack sufficient budget. PBS seeks programs equivalent in content and production quality to commercial efforts, and it is especially interested in programs for children.

British programs such as *Masterpiece Theatre* and *Mystery!* have become a staple of American public television because they are high quality programs available at one-tenth the cost of producing comparable fare in the United States. But they, along with other foreign productions, occupy only a fraction of all PBS programs. PBS programming comes from a mix of foreign producers, international coproductions, commercial independent producers, public television stations, and the producing organizations with traditional ties to PBS, such as Children's Television Workshop. Nearly 90 percent are made in the United States (see

8.5 MAJOR PRODUCING CENTERS

Stations	Program Series
WGBH, Boston	*Masterpiece Theatre* *Mystery* *NOVA* *Frontline* *The American Experience* *This Old House* *New Yankee Workshop*
WNET, New York	*Nature* *Great Performances* *Adam Smith's Money World* *Charlie Rose Show* *Metropolitan Opera Presents* *Live From Lincoln Center*
WETA, Washington, D.C.	*Washington Week in Review* *The News Hour with Jim Lehrer* *In Performance at the White House*
KCET, Los Angeles	*The Puzzle Place* *Storytime* *American Playhouse*

8.6 PBS PRODUCTION SOURCES

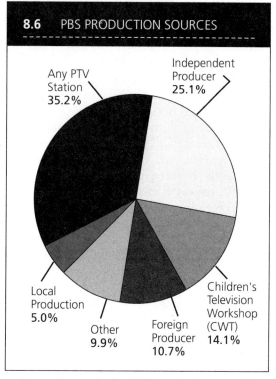

Source: Corporation for Public Broadcasting, *CPB Research Notes,* July 1994.

8.6). This pattern of sources has been consistent over recent years, although increased competition from cable networks for foreign programs has narrowed PBS's options. The greatest change in funding in recent years has been in the distribution of funds by means of program assessment, not in program sources.

Balance in Selection

Responsibility for acquiring programs falls to one of several "content" managers, including the directors of Drama, Performance & Cultural Programs; Children's; News & Public Affairs; and Science &

History.[9] They must view sample tapes (demonstrations) and sift through many hundreds of proposals each year. Based on these written proposals or sample tapes (pilot episodes are very rarely made), the manager decides whether to purchase the program or provide some portion of production funding. In the case of foreign productions, a program can be purchased outright because it is already "in the can" (produced). If the decision on a proposal for a new production is favorable, a small research and development grant is usually the first step, perhaps with a promise of larger amounts to follow. Once production is under way, the content manager will consult with the producer during the production process to guide the outcome toward a satisfactory result. It is important to note that *PBS can order programs to be produced, but it does not itself produce them.*

Through all this, National Program Service executives attempt to maintain balance in the national schedule so that the network doesn't find itself one season with, for example, too many symphony concerts and too few investigative documentaries in the schedule. To better regulate the flow of new productions into the national schedule, PBS established the Public Television Pipeline, a management system for monitoring and coordinating all program development activity from the proposal stage through delivery to PBS. Throughout the year, the Pipeline sends signals to producers about PBS's overall schedule surpluses and shortfalls as well as specific content needs. Proposals are submitted, approval (and perhaps seed money) obtained from PBS, and the final selection process is under way.

Corporate Pressure

Programs occasionally have corporate underwriters who actively participate in program production or acquisition. The executives in charge of underwriting these programs invest not only prodigious sums from corporate treasuries but also personal effort and reputation, and they feel entitled to choice slots in the prime-time schedule. Of course, PBS cannot always fit a program in the time slot the underwriter wants and still maintain a balanced schedule.

Corporate fiscal needs can also affect scheduling. Often, the underwriting corporation requires that a program be played within its fiscal year—irrespective of audience and schedule needs. PBS program executives attempt to accommodate such cases, knowing that if they do not, the corporation in its pique may refuse future requests for support.

The major producing stations also attempt to influence program decisions at PBS on behalf of their program underwriters. For those stations, financial health depends on corporate support, which pays for salaries, equipment loans, and other production expenses. Were just one major underwriter to withdraw support, the financial effect on a producing station could be devastating.

Station Pressure

Other programming pressures occur. Many stations, for example, *refuse* to telecast a program at the time fed because they decide it:

- Does not deserve a prime-time slot
- Contains too much profanity or violence to air in early evening
- Will fail to attract contributors at fund-raising time
- Occupies a slot the station wants for its own programs
- Has little appeal for local viewers

Although each of these reasons has merit at times, the combined effect of hundreds of stations exercising independent judgment has often left the PBS schedule in a shambles and its ratings uninterpretable. PBS program executives assembling a schedule must anticipate these concerns to minimize defections from the live feed.

Program Rights and Delivery

PBS programmers must also wrestle with two problems common to both commercial and noncommercial programming: program rights and late delivery. In public television as in commercial television, standard program air-lease rights are set by contract with the producer, who owns the rights. PBS has traditionally negotiated with producers for as many **plays** as possible so that by airing the same program several times, the typically small (per-airing) PBS audience snowballs. Extra plays also fill out the program schedule.

At the same time, the program syndicator seeks as few airings as possible over the shortest time period to retain maximum control and resale potential for a program. A compromise between various producers and PBS permitting four program plays within three years is now the standard rights agreement in public television.

Late delivery has obvious troublemaking possibilities. One year, so many productions were

behind schedule that the fall schedule premiered without a single new series.[10] As a consequence, in that extraordinary year, the "second season" premieres in January were so choked with overdue new programs that the popular *Mystery!* series had to be popped out and shelved until the following fall!

Tardy arrival also cripples promotion and publicity efforts. The enormous audience and critical acclaim enjoyed by PBS's *The Civil War* in September 1990 owed much to the producer's early completion of the series. That enabled the production of ample promotion and advertising. Perhaps most important, the series was available for screening by an enthusiastic press during the July press tour of the Television Critics Association, which resulted in a gusher of free and favorable publicity.

Noncommercial Syndication

Because of its role in formal education, public television has had to develop its own unique body of syndicated material to meet instructional television needs. A number of centers for program distribution were established to perform the same function as commercial syndication firms, but on a noncommercial, cooperative basis (see 8.7 for more on these centers).

The abundance of ITV materials means that it is no longer necessary to produce instructional programs locally, except where desired subject matter is unique to a community. Local school authorities usually select instructional materials for in-school use, although the public television station's staff often serves as liaison between sources of this material and users. The state may appropriate funds for instructional programs, giving them to public stations within the state, or school districts may contract with a local public station to supply particular ITV programs at certain times. Stations that serve schools usually employ an "instructional television coordinator" or "learning resources coordinator" who:

■ Works full-time with present and potential users

■ Assists teachers in proper use of the materials

8.7 NONCOMMERCIAL SYNDICATORS

The Agency for Instructional Technology (AIT) in Bloomington, Indiana, produces series for primary grades, high school, and post-secondary students. Among the best known are *All About You*, *Mathworks*, *Assignment the World*, and *Up Close* and *Natural*. AIT took the lead in developing innovative classroom programs that operate in conjunction with desktop computers, creating the first interactive lessons on videodiscs.

Great Plains National (GPN) in Lincoln, Nebraska, offers dozens of series for elementary and junior high use along with a great many materials for college and adult learning. Titles in its catalog range from *Reading Rainbow* (for first graders) to *The Power of Algebra*, *Tombs and Talismans*, and *Truly American* (for high schoolers and adults).

Western Instructional Television (WIT) in Los Angeles offers more than 500 series in science, language arts, social studies, English, art, and history. TV Ontario also supplies U.S. schools with dozens of instructions series, especially in science and technology, including *Read All About It*, *The Landscape of Geometry*, and *Magic Library*. Even PBS, through its Elementary/Secondary Service, offers a slate of ITV programs, such as *The Voyage of the Mimi*, *Amigos*, and *Futures with Jaime Escalante*.

■ Identifies classroom needs

■ Selects or develops materials to meet the specific goals of local educators

More than 1,200 hours of the most-often-selected ITV series for kindergarten through 12th grade are made available to subscribers by satellite every day, 33 weeks per year. The National ITV Satellite Service (NISS) is coordinated by the SECA regional network. Over half of all public schools make use of ITV. Subscribers in-

clude public television stations, state departments of education, regional educational media centers, and other authorized educational entities.

Noncommercial Adult Education

Quality programming for adult learners is now available in quantity to public stations. Beginning in the late 1970s, various consortia began to turn out **telecourses** (television courses) for integration into the curricula of postsecondary institutions. These efforts have centered particularly in community colleges, led by Miami-Dade (Florida), Dallas (Texas), Coastline Community College (Huntington Beach, California), and the Southern California Consortium. With budgets ranging from $100,000 to $1 million for a single course, they have proven sufficiently well produced to attract casual viewers as well as enrolled students.

Meanwhile, faculty members at other leading postsecondary institutions began developing curriculum materials to accompany several outstanding public television program series distributed nationally through PBS for general viewing. The first of these was *The Ascent of Man*, with the late Dr. Jacob Bronowski, a renowned scholar as well as a skillful and effective communicator on camera. More than 200 colleges and universities offered college credit for that course. Others quickly followed (*The Adams Chronicles, Cosmos, Life on Earth, The Shakespeare Plays*) as programmers discovered such series furnished the casual viewer with attractive public television entertainment and simultaneously served more serious viewers desiring to register for college course credits.

This experience led many public television programmers to realize that too much had been made of the supposed demarcation between ITV and PTV. Too often during earlier years, many program producers would not even consider producing so-called instructional television. The first Carnegie Commission in 1965 strengthened this presumed gap by not concerning itself with television's educational assistance to schools and colleges and by adopting the term *public television* to mean programming for general viewing.

PBS began its Adult Learning Service (ALS) in the early 1980s, offering over-the-air instruction leading to college credit. As of 1996, more than 96 percent of PBS stations have offered this service, which is utilized by more than 1,800 colleges and universities. Enrollment now exceeds 275,000 annually for the 48 telecourses offered, which cover arts and humanities, business and technology, history, professional development, science and health, and the social sciences.

Shortly after its launch, ALS received a significant boost from Walter Annenberg, owner of *TV Guide*, who established the Annenberg/CPB Project. Through this project, the Annenberg School of Communications gave $15 million to CPB each year for ten years (1983–1993) to fund college level instruction via television and other new technologies. The project resulted in such high-visibility public television series as *The Constitution: That Delicate Balance, French in Action, Planet Earth, The Africans, War and Peace in the Nuclear Age, Art of the Western World, Discovering Psychology*, and *Economics USA*, with subject matter ranging from the humanities to science, mathematics, and business. The net result of Annenberg's entry into this field was not only an increase in the number of adult instructional programs available through ALS, but also, thanks to their above-average budgets, an increase in production values (quality). (*Readers' Digest* has suggested a different kind of project with PBS; see 8.8 for more on this.)

Colleges and universities wanting to offer credit for these telecourses normally arrange for local public television stations to air the series, and all registration, fees, testing, and supplementary materials are handled by the school. Some of the courses use computers, and all are keyed to special texts and study guides. ALS offers programmers one of the most challenging additions to their program schedule. Because such programs require close cooperation with the institutions offering credit, they require a reliable repeat schedule that permits students to make up missed broadcasts.

Experience has demonstrated that ITV and PTV programs can appeal to viewers other than

8.8 FROM *TV GUIDE* TO *READER'S DIGEST*

The Annenberg/CPB Project was a deal that linked PBS's educational programs to donations from *TV Guide* founder Walter Annenberg. *TV Guide* was later purchased, however, by Rupert Murdoch (who also controls the Fox network), ending any further synergies between public television and that magazine.

Another mass-appeal magazine came into the picture. *Reader's Digest* and PBS entered a five-year partnership beginning in 1996 to produce and distribute worldwide new television programs based on *Reader's Digest* stories and materials. *Reader's Digest* planned to invest $75 million in the production of television programs which will be adapted into books, videotapes, audio-books, and CD-ROMs.

those for which they were especially intended. The Annenberg/CPB series is only one example. Another is *Sesame Street*, initially intended for youngsters in disadvantaged households (see Chapter 5). Yet one of the significant occurrences in kindergarten and lower elementary classrooms throughout America has been the in-school use of *Sesame Street*. Ironically, *Sesame Street* may also contribute to the gap in knowledge between advantaged and disadvantaged children because it is widely watched (and learned from) by already advantaged children, perhaps making the disadvantaged more disadvantaged.

Commercial Syndication

More extensively tapped sources, however, are such commercial syndicators as Time-Life, David Susskind's Talent Associates, Wolper Productions, Granada TV in Great Britain, and several major motion picture companies including Universal Pictures. Public television stations sometimes negotiate individually for program packages with such syndicators; at other times they join with public stations through regional associations to make group buys. Commercially syndicated programs obtained in this way by PTV include historical and contemporary documentaries, British-produced drama series, and packages of highly popular or artistic motion pictures originally released to theaters. Such programming, because they were designed for general audiences, are thought to bring new viewers to a public station. Many programmers believe those new viewers can then be persuaded, through promotional announcements, to watch more typical PTV fare.

The proportion of commercially syndicated programming in public television station schedules, nonetheless, averages only slightly more than 4 percent of broadcast hours. The number is small partly because those syndicated programs public stations find appropriate are relatively *expensive*; unless the station secures outside underwriting to cover license fees, it usually cannot afford them. Stations now pay as much as $85,000 for an hour of British television that cost as little as $50,000 a few years ago. Another reason is *philosophical*: Although much commercially syndicated material has strong audience appeal, its educational or cultural value is arguable.

Local Production

The percentage of airtime filled with locally produced programming has gradually decreased over the years as both network and syndicated programming have increased in quantity and quality. Owing mostly to its high cost, the percentage of total on-air hours produced *for local use* by public television stations declined from 16 percent in 1972 to just under 5 percent 20 years later. Moreover, production quality expectations have risen. More time and dollars and better facilities must now be used to produce effective local programs.

Locally produced programs, nonetheless, are far from extinct in public television. A survey of station producers found that among the 79 licensees responding more than 3,000 programs had been produced during the past year. Among them were

weekly and occasionally nightly broadcasts devoted to activities, events, and issues of local interest and significance. Many stations regularly cover their state governments and legislators. Unlike commercial stations, which concentrate on spot news and devote a minute or less to each story, public stations see their role as giving more comprehensive treatment to local matters. But new and public affairs programs were not the only kinds being produced. The survey found stations turning out a spectrum of content: arts and performance, documentaries, history, comedy, science, nature, and even children's programs.

SCHEDULING STRATEGY

Nowadays, PBS programmers want to maximize audiences. Gone are the educational television days when paying attention to audience size was looked upon as "whoring after numbers." The prevailing attitude at PBS recognizes that a program must be *seen* to be of value, and that improper scheduling prevents full realization of a program's potential. Member stations now recognize that bigger audiences also mean a bigger dollar take during on-air pledge drives.

Counterprogramming the Commercial Networks

Competition, of course, is a key consideration. The three ways of responding to it are:

- Offensively, by attempting to overpower the competitor

- Defensively, by counterprogramming for a different segment of the audience than the competitor's program is likely to attract

- Ignoring the competition altogether and hoping for the best

PBS has never been able to go on the offensive; its programs lack the requisite breadth of appeal. Prime-time PBS shows average less than a 3 rating. ABC, CBS, and NBC regularly collect ratings of 10 and higher (although their figures are much smaller than a decade ago, the result of audience defections to the many cable networks now available).[11]

PBS, then, must duck and dodge. By studying national Nielsen data, programmers learn the demographic makeup of competing network program audiences so they can place their own programs more advantageously. For example, a symphony performance that tends to attract well-educated women over 50 (**upscale**) living in metropolitan areas would perform well opposite Fox's *America's Most Wanted*, CBS's *Dave's World*, or NBC's *Unsolved Mysteries*, having **downscale** (lower socioeconomic) audiences. Similarly, in searching for a slot for the investigative documentary series *Frontline*, PBS did not consider for a moment the 8 to 9 P.M. slot on Sundays because football overruns formerly pushed *60 Minutes* into this slot.

PBS tries to avoid placing a valued program against a hit series in the commercial schedules. PBS also has traditionally avoided placing important programs during the three key all-market audience-measurement periods (sweeps) in November, February, and May—times when commercial television throws its blockbusters at the audience. Because the commercial networks have cut back on sweep blockbusters in recent years (especially costume-drama miniseries, which lure away many PBS viewers), PBS has grown more willing to run an important series through a sweep month. This is clearly a calculated risk, a kind of TV "mine field"; a powerful commercial network special could draw off so many viewers from a weekly PBS miniseries that few would return to see its continuation and conclusion.

Further, since public as well as commercial stations are measured during the sweeps, PBS's stations demand a "solid" schedule, with a minimum of "mission programs." This is a mildly pejorative reference to public television's mission to serve all Americans, specifically referring here to narrow-appeal programs of interest only to some very small groups of viewers. Many programs are "good

for the mission" but earn small ratings. Thus, the sweeps now display many of PBS's strongest—not weakest—programs.

Stripping and Stacking Limited Series

A standard among PBS's offerings, the limited series includes both *nonfiction* and *fictional mini-series* (continuing dramas with a fixed number of episodes usually ranging from 3 to 12 or more). Some notable examples of limited series in recent years include *The Civil War, Tales of the City, Baseball,* and *Rock and Roll.* Most limited series appear once a week in prime time, much as weekly series are scheduled on commercial television.

Because short-run series lose viewers across the first few weekly telecasts, however, PBS schedulers have experimented with alternative play patterns in the hope of staunching the dropoff. To borrow jargon from computer technology, they asked whether limited series scheduling could be made more "user friendly." Experiments with the *Holocaust* series and *Shoah* in 1988 showed that limited series having sufficiently engaging material lent themselves to airing on consecutive nights, a practice known in commercial television as **stripping.** This ploy not only attracted at least as many viewers as tuned in to similar programs on a weekly basis but it also encouraged viewers to spend significantly more time watching the series. Moreover, the episode-to-episode ratings dropoff disappeared.

When a limited series has too many episodes for conveniently stripping, PBS bunches episodes together, **stacking** two episodes per evening. *The Civil War,* for example, was scheduled in this pattern, thereby limiting the magnitude of nightly commitment on the part of viewers. PBS's practice is to schedule limited series on a maximum of five consecutive nights (although Ken Burns' *Baseball* required nine evenings).

Which limited series receive special treatment and which must air in the usual once-a-week way hinges on a decision about "sufficiently engaging material." This is in part a function of production budget, advance promotion, stars, subject matter, and less well-recognized variables such as timing, quality, and appeal to the public television audience. Such decisions cannot be supported by audience research alone; the programs must be watched as well. Ultimately, the chief program executive makes the call.

Bridging

Another competitive tactic is **bridging,** illustrated in 8.9. Remote-control "zappers" notwithstanding, most viewers stay with a program from start to finish, thus a lengthy program prevents an audience from switching to the competition's programs at their start. PBS bridges by scheduling mostly one-hour or longer programs during prime time and sometimes breaks its programs at the half hour, thereby crossing over the start time of commercial half-hour situation comedies on the four commercial networks and some cable channels.

Since the commercial networks usually break every night at 9 P.M. (a key *crossover point*), the PBS schedule normally breaks then too, in the hope that some "grazers" might come to public television.[12] Were PBS to schedule a pair of half-hour shows opposite one-hour network programs, the second of PBS's half-hour programs would draw away very little of the locked-in audience tuned to the bridging network shows. When PBS breaks at 9:30, however (as illustrated in 8.9), it has bridged the start of two sitcoms on ABC, two hour shows on NBC and CBS, and the early late news on Fox. Of course, viewers of the second PBS program have to flow out of the lead-in PBS program, come from *Grace Under Fire* (unlikely), or come from homes where the television set had just been turned on.

Audience Flow

Certain PBS series are especially dependent on audience flow from a strong lead-in. New, untried programs especially need scheduling help. The *Ring of Truth,* a six-part series on the scientific method, for example, was not expected to build a

8.9 BRIDGING THE FOUR FULL-TIME COMMERCIAL NETWORKS*

	PBS	ABC	CBS	NBC	Fox
8:00	Live From Lincoln Center	Ellen	Bless This House	Seaquest 2032	Beverly Hills 90210
8:30		Drew Carey	Dave's World		
9:00		Grace Under Fire	Central Park West	Dateline: NBC	Melrose Place
9:30	Songs of the Homeland	Naked Truth			
10:00		Primetime Live	Courthouse	Law & Order	non-network
10:30					

Note: *Wednesday, September 20, 1995

loyal following the way a predictable series such as *The Wall Street Week* has. Thus, it was placed following an established, successful science series, *NOVA*, which regularly draws large audiences (large, that is, for public television) and itself has no need for a powerful lead-in.

Particularly in need of a lead-in boost—on a regular basis—is another PBS staple, the **umbrella series.** These are anthologies of single programs having broadly related content that appear under an all-encompassing title (or umbrella) such as *The American Experience* (history programs) or *Great Performances* (ballet, plays, operas, orchestral music, Broadway shows, and so forth). Because the material offered under the umbrella changes from week to week, the audience never knows what to expect; clearly, the format works *against* habit formation. Thus, it is essential that a strong audience be introduced to each week's episode, if not by costly media advertising (usually out of public television's reach), then by a substantial lead-in.

Some researchers (for example, LeRoy & LeRoy, 1995) believe that public television does not truly flow at all, in the sense of one program leading into another on the same evening. For example, a nature series will attract an audience that appreciates that type of program. Because PBS sometimes schedules a nature program followed by a drama followed by a documentary, the viewers turn over more frequently, which may increase the weekly cumulative audience but sacrifices time spent viewing for each viewer. As a result, say LeRoy and LeRoy, a key ingredient of viewer loyalty (viewing frequency) is lost.

Many viewers accept the flow limitation in order to have an eclectic selection of nontrivial programs. The seemingly different types of programs on PBS share one common attribute—perceived similarity in quality that gives the viewer a feeling that the programming is not a waste of time. Unlike commercial television, loyalty for noncommercial television is to the channel, rather than to

the program. Audience flow is thus more complicated for public television.

National Promotion

Fledgling programs and episodes of an umbrella series need extra help for viewers to discover them. While an effective lead-in program is essential, advertising and promotion can alert other potential viewers to a new program and persuade them to try it. Unfortunately, public television budgets permit little advertising. Only a few underwriters include some promotional allotment in their program budgets.

Still another PBS practice is to carefully schedule on-air promotion announcements for a particular program in time slots where potential viewers of that program (based on demographic profiles) are likely to be found in maximum quantity. Such on-air promotion is crucial as it reaches known viewers of public television. But its effectiveness is somewhat hampered by public television's limited prime-time reach. In one week, a massive on-air campaign promoting one program could hope to reach at best only 20 to 25 percent of all television households.

Considerations at the Station Level

A public television program schedule is a series of compromises meant to serve the total population over time but not the complete needs of the individual viewer. While this is also true of commercial stations, it especially applies to public television schedules. Because they usually are so focused in content, PTV programs tend to be watched by small, often demographically targeted population segments. Seeking the most opportune time slot for reaching those target groups is the program manager's challenge.

No PTV programmer ever builds an entire schedule from scratch (unless the station has just signed on for the first time, of course). Rather, the manager's ongoing responsibility is to maintain a schedule while considering

- **Licensee type,** as each carries its unique program priorities
- **Audience size and demographics**
- **Competition** from commercial stations, other public television signals, and cable networks
- **Daypart targeting,** such as afternoons for children's programs, daytime for instructional services
- **Program availability**
- **Tape-machine capacity**

No single element overrides the others, but each affects the final schedule. Public television programmers seek programs that meet local audience needs and schedule those programs at times most likely to attract the target audience. Since all audience segments cannot be served at once, the mystery and magic of the job is getting the right programs in the right time slots. High ratings are not the primary objective; serving the appropriate audience with a show they will watch that adds to the quality of their life is. A breakdown of PTV program types appears in 8.10.

AUDIENCE RATINGS

Public television must always demonstrate its *utility.* Many contributed to its continuance—Congress, underwriters, viewers. If few watch, why should contributors keep public television alive? Programmers have come to realize that critical praise alone is insufficient; they need tangible evidence that audiences feel the same way. That most convincing evidence comes from acceptable ratings.

Nielsen Data

PBS evaluates the performance of its programs with both national and local viewing data, each having its own particular usefulness in analysis. National audience data are provided by the Nielsen PeopleMeter service (NPM); the Nielsen

8.10 TYPES OF PROGRAMMING BROADCAST BY PUBLIC TELEVISION STATIONS

Type of Program	% of Total Broadcast Hours
Information and skills	28.7
Cultural	17.5
News and public affairs	17.4
General children's	14.6
Instructional	11.6
Sesame Street	11.0
Other	0.6
Total	101.4

Source: Corporation for Public Broadcasting, "Highlights from the Public Television Programming Survey," in *CPB Research Notes, No. 71,* July 1994. Data shown are from 1992 (most recent data). Some overlap in children's programs leads to double-counting.

Station Index (NSI), provides the individual market data (see Chapter 2).

PBS's limited research budget permits the purchase of only one national audience survey week per month.[13] Forty weeks therefore go unmeasured. (The commercial networks, as described in previous chapters, purchase continuous, year-round national data.) However, NSI's ever-expanding Metered Market service (over 33 markets in 1996) provides PBS with a comparatively inexpensive proxy for daily national ratings, because more than half of the country's TV households are within these markets.[14]

A newspaper program listings service, TV Data of Queensbury, New York, provides a critical form of data for PBS. TV Data compiles station-by-station program schedules 52 weeks a year. To ensure accuracy, the company calls all public stations each week to collect last-minute program changes from the previous week. The resulting program carriage data are delivered to PBS on tape, which the network analyzes to understand station usage of PBS programs. The data reveal time zone program shifts as well as delayed carriage patterns. PBS ships computer-tape copies of its carriage data to Nielsen, which marries it with meter viewing data to produce the national PBS ratings.

Public stations use the same Nielsen local **diary** surveys (and the resulting rating books) during the four sweeps as do their commercial counterparts. Nielsen surveys a few large markets in October, January, and March, and public stations in those markets can also purchase these reports.

Commercial network programmers, much to the irritation of advertising agency time-buyers, try to inflate affiliates' ratings by **stunting** with unusually popular specials and miniseries during the sweep weeks (see Chapter 4). These higher ratings provide the local affiliates with an opportunity to raise advertising rates. PBS programmers schedule some new product during sweeps, but lack enough truly top-notch programming to stunt for an entire four-week period. PBS does, however, try to schedule a *representative mix* of PBS offerings during each of the national survey weeks. No more than one opera is permitted, for example, nor are too many esoteric public affairs programs scheduled during that week.

PBS indulges in a kind of stunting during its pledge drives. Just as networks stunt for economic reasons, so too does public television. The difference is structural: Rather than raise revenue by selling advertising time on the basis of ratings, PBS stations raise revenue by direct, on-air solicitation of viewer contributions. Programs specially produced for the drives to reach the viewers' emotions are scheduled alongside regular PBS series. To an extent, larger audiences mean larger contributions, but often a low-rated program finds a small but appreciating audience and proves a lucrative fund-raiser.

Audience Accumulation Strategy

PBS strives for maximum variety in its program schedule to serve as many people as possible at one time or another each week. Unlike commercial network programs, not all public television

programs are expected to have large audiences. Small audiences are acceptable so long as the weekly accumulation of viewers is large, an indication that the "public" is using its public television service. And so, an important element in assessing PBS's programming success is its weekly cumulative audience, or "**cume.**"

As explained in Chapter 2, Nielsen defines a cumulative household audience as the percent of all U.S. TV households (unduplicated) that tuned in for at least six minutes to a specific program or time period.[15] The weekly public television national cumes for prime time (8 to 11 P.M., Mon.–Sun.) averaged 32 percent of U.S. households in 1994–95. Cume ratings for prime-time programs range from under 1 to over 19 percent, the higher figure earned by a yearly *National Geographic Special*. When all times of day are included, the weekly cume rises to nearly 60 percent of the country's households, a respectable figure for the impecunious public network. This statistic, along with **time spent viewing,** constitute the two basic elements of audience data.

Based on prior experience, PBS programmers apply informal guidelines for what rating levels constitute adequate viewing. Nature and science programs typically attract a cumulative audience of 5 to 10 percent of U.S. households, dramas 4 to 5 percent. Concert performances should attract 3 to 4 percent, and public affairs documentaries 2 to 4 percent. Because ratings are not the sole criterion by which PBS program performance is evaluated, however, failure to meet these levels never triggers a cancellation. But repeated failure to earn the minimum expected cumes could eventually result in nonrenewal.

Loyalty Assessment

PBS researchers also study audience loyalty (tenacity) as a way of evaluating a program. Using ratings from the 33 metered markets, which Nielsen provides quarter hour by quarter hour, it is possible to plot an audience's course across a single program or across an entire multiweek series. If the audience tires quickly of a program, the over-

night ratings will slip downward during the telecast (a fate to which lengthy programs are especially susceptible). If the audience weakened in response to the appeal of competing network programs, such as a special starting a half-hour or more later than the PBS show, the overnight ratings suddenly drop at the point where the competing special began. This information tells the programmers (roughly, to be sure) the extent to which the program engaged viewers. Noncompelling programs are vulnerable to competition. Shows failing this test have to be scheduled more carefully when repeated, preferably opposite softer network competition.

The national people meter service, in addition to TV ratings and cumes, provides a different but equally valuable analytical statistic: the number of minutes spent by people (or households) viewing a single program, or even a whole multi-episode series. This time-spent-viewing figure reveals how much of a production was actually watched, in contrast to the **cume,** which simply tells how many watched. As mentioned previously, some miniseries earn higher time-spent-viewing figures when stripped on consecutive nights than when scheduled weekly.

Demographic Composition

Another useful way of evaluating a program is by observing exactly who is watching. If a program is designed for the elderly, did the elderly in fact tune in? When African Americans were the target, did sufficient numbers switch on the program? While households tuning to public television each week are, as a group, not unlike television viewers generally, audiences for individual programs can vary widely in demographic composition. Programs such as *NOVA*, the *Bill Moyers Specials*, and *Masterpiece Theatre* attract older, college-educated, professional/managerial viewers. Because these programs can be intellectually demanding, they tend to attract an upscale (higher education, income, occupation) viewership. Because demanding shows are numerous on PBS, its cumulative prime-time audience composition reflects this ten-

dency. Many programs, though, have broader based followings, among them *Nature* and *This Old House*.

PBS's evening programs have also been found to have an age skew (tendency) favoring adults 35 years of age or older. Few young adults, teenagers, or children watch in prime time. The reason for this skew probably lies in the nature of the schedule, which, despite the occasional light entertainment special, consists largely of nonfiction documentaries. According to CBS's top research executive:

Our analysis shows that over age 35, you get an adult programming taste. Under age 35, you still have a youth orientation. It is only when people reach their mid-30s that their viewing tastes become more like older adults' . . . And their appetite grows for news and information programming.[16]

Still, public television's overall (24-hour a day) cumulative audience demographically mirrors the general population on such characteristics as education, income, occupation, and racial composition, as shown in 8.11. That is partly because it is a large audience, with more than half of all U.S. TV households tuning to public television each week, and about four-fifths tuning in monthly. Another reason for PBS's broad profile is that the overall audience includes the viewers of daytime children's and how-to (hobbies and crafts) programs, many of whom are not frequent users of the prime-time schedule.

Public television representatives frequently are called upon to explain a seeming paradox: How can public television's audience duplicate the demographic makeup of the country when so many of its programs attract the *upscale* viewer? The question is second in importance only to that of how many people are watching; it is often tied to charges of elitism in program acquisition, implying PBS is not serving all the public with "public" television.

PBS replies that it consciously attempts to provide *alternatives* to the commercial network offerings; to do so, the content of most PBS programs

	8.11 U.S. POPULATION AND PTV AUDIENCE COMPOSITION	
	Total U.S. TV Population (percent)	PTV Audience (percent)
Occupation		
Prof/Owner/Mrg	23.8	24.3
Clerical & Sales	15.4	14.8
Skilled & Semi-skilled	30.2	29.3
Not in labor force	30.6	31.7
Income		
$60,000+	20.8	23.1
$40,000-$59,999	19.3	20.6
$20,000-$39,999	28.3	27.7
Less than $20,000	31.6	28.6
Age		
65+	12.5	18.8
50–64	13.8	17.3
35–49	33.7	22.8
18–34	26.0	20.4
12–17	8.6	4.6
2–11	15.5	16.1
Ethnicity		
Non-black	88.7	89.8
Black	11.3	10.2
Hispanic	7.3	6.9

Source: Nielsen Television Index/PBS, Spring 1995.

must make demands of viewers. Demanding programs tend, however, to be less appealing to viewers of lower socioeconomic status (as well as to younger viewers). The result is *underrepresentation* of such viewers in certain audiences. But this underrepresentation is, on balance, only slight and limited largely to prime time, being offset in the week's cumulative audience totals for other programs having broader appeal. Critics often overlook that underrepresentation does not mean no representation. *NOVA*, for example, is watched each week in some one million households headed by a person who never finished high school. Even

operas average nearly 400,000 such downscale households in their audiences.

The kinds of audience statistics just cited serve a unique function: justification of public television. Commercial broadcasters and cable operators justify their existence when they turn a profit for their owners and investors; public broadcasters prove their worth only when survey data indicate the public *valued* (that is, viewed) the service provided.

FUTURE DEVELOPMENTS

Many people in the noncommercial field believe the public television station of today will become the public telecommunications center of tomorrow—a place where telecommunications professionals handle the production, acquisition, reception, duplication, and delivery of all types of noncommercial educational-cultural-informational materials and stand ready to advise and counsel people in the community. In this scenario, existing public television stations will transmit programs of broad interest and value to relatively large audiences scattered throughout their coverage areas; but they will also feed these and other programs to local cable channels and transfer programs of more specialized interest to videocassettes or videodiscs for use in schools, colleges, libraries, hospitals, and industry or for use on home video equipment. Because of its high quality, high-definition television may give public broadcasters the special edge they need—if early adoption proves practical.

The coming years pose special challenges, however, to those who hold public television licenses across the country. To achieve its public service potential and move beyond the limitations posed by broadcast towers into the new video distribution technologies of cable, DBS, home video, and fiber optics, the social value of noncommercial, educational video services must be reaffirmed by American policymakers. Public television cannot make the transition into the new media environment of the 21st century without such affirmation. The public service, and particularly the educa-

tional value of this institution, is founded on the *principle that a certain portion of the public's airwaves should be reserved for noncommercial, educational use*. Public financing was a key element of that founding assumption, and billions of dollars have been invested in making public television available to the entire nation. To continue as the national resource that it has become in broadcasting, public television must extend its mandate to additional video technologies. The educational role of public television is certain to play a key role in achieving that objective.

A renewed focus on its educational mission will guide PBS's program selection and fund-raising efforts in the future. One of its successes, *Shining Time Station*, targets the 3- to 7-year-old audience on weekday and Sunday mornings and attracts as many viewers as the classic *Mr. Rogers' Neighborhood*, about 1.2 million. Another success, *Where in the World Is Carmen Sandiego?* teaches geography to children under 14 with a game show format. On the other side, public television is seeking blockbusters much like commercial television programs that can attract underwriting; one such effort was the timely *Columbus and the Age of Discovery*. These programs may signal directions for the future. By 2005, PBS will still be around, but it may be a smaller force on the national scene because public television faces nearly insurmountable competition for product and funds. On the hopeful side, PBS's average ratings held steady during the first half of the 1990s as the major networks went into viewing decline, and blockbusters such as *Baseball* more than doubled its usual ratings while winning national acclaim. Additional satellite transponders coupled with digital compression and high-definition pictures, combined with exciting program ideas, may revitalize the noncommercial television industry in the late 1990s.

As with all broadcasters, however, PBS is planning for further increases in competition from new, yet to be launched cable networks. In the mid-1990s, nearly 100 hopeful networks were queued, awaiting an expansion of local cable system capacity that would accommodate their carriage. The operative strategy for broadcasters is *alternative*

means of program distribution, including CD-ROM disks and the Internet.

SUMMARY

PBS operates in a more financially straitened environment than the commercial networks. Its member stations pay dues, and PBS serves them with programming. A series of carriage agreements has defined the programs that stations will air as fed and those they feel free to move to accommodate local needs. Corporate underwriters, independent program producers, and member stations exert pressure on PBS in the selection and scheduling processes. Programs come primarily from the major producing stations, foreign producers, and independent producers in the United States. Counterprogramming, stripping, stacking, bridging, and audience flow strategies operate in scheduling the prime-time core schedule. Promotion builds ratings, but funds for it are often lacking. SIP successfully provides stations with special fund-raising programs and assistance.

The disparate philosophies guiding public television programmers have in common the elements of noncommercialism and special audience service. The four types of licensees—community, university, public school, and state agency—follow different mandates in programming to serve their constituencies, although all tend to appeal more and more to the general, entertainment-oriented audience that supports public television with contributions. The public television station programmer draws information from seven sources to evaluate the success of the station's programming strategies, with particular attention paid to the size of the weekly, overall cumulative audience. PBS is the main source of PTV programs; regional and state networks, local production, commercial and noncommercial syndicators, and other sources supply only about 30 percent of station programs. Once sharp distinctions between ITV and PTV are disappearing, especially with regard to adult education programs. Although audience flow,

counterprogramming, and blocking strategies affect program placement on public stations, actual PTV practices differ somewhat from those of commercial television. In selection and scheduling, station programmers must consider license priorities, audience demographics, commercial competition, dayparting, program availability, and equipment capacity. While PBS uses the Nielsen ratings to evaluate its audiences, it focuses on cumulative audiences and measures of loyalty. A long-standing controversy in public broadcasting is whether its programming is elitist; analysis of audience demographics shows that the composite schedule has broad appeal. Although specific programs draw largely upscale viewers, all programs capture some viewers from all demographic groups. PBS plans to refocus on smaller audiences in the future. Public television's educational role remains one of its most distinctive features heading into the 21st century.

SOURCES

Current, weekly Washington newspaper about public broadcasting, 1981 to date.

Facts About PBS. Alexandria, VA: Public Broadcasting Service, July 1995.

Highlights of the Public Television Program Survey Fiscal Year 1992. *CPB Research Notes,* 71 Washington, DC: Corporation for Public Broadcasting, July 1994.

Hoynes, William.*Public Television for Sale: Media, the Market, and the Public Sphere.* Boulder, CO : Westview Press, 1994.

http://www.pbs.org/

LeRoy, David, and LeRoy, Judith. *Public Television: Techniques for Audience Analysis and Program Scheduling.* Washington, DC: Pacific Mountain Network/Corporation for Public Broadcasting, 1995.

Nelson, Anne. "Public Broadcasting: Free at Last?" *Columbia Journalism Review* (November 1995): 16–18.

*A Report to the People: 20 Years of National Commitment to Public Broadcasting, 1967–1987 and 1986 Annual Report.*Washington, DC: Corporation for Public Broadcasting, 1987.

Somerset-Ward, Richard. *Quality Time? The Report of the Twentieth Century Fund Task Force on the Future of*

Public Television. New York: Twentieth Century Fund Press, 1993.

Witherspoon, John, and Kovitz, Roselle. *The History of Public Broadcasting.*Washington, DC: Current, 1987.

Who Funds PTV? A Guide to Public Broadcasting Program Funding for Producers. Washington: DC: Corporation for Public Broadcasting, 1991.

NOTES

1. As this book went to press, public broadcasters and Congress were arguing again. The fight centered around a bill calling for a $1 billion trust fund to be set up for the Corporation for Public Broadcasting (CPB) after the year 2000. PBS argued that $1 billion was not enough to cover the $300 million yearly payout in the late-1990s.

2. In one public presentation, Bruce Christensen, former president of PBS, defined public television's goal as "to provide programming that is largely ignored or is uncommon on commercial TV." He was supported by Michael Checkland, director general of BBC, who said, "Public service to us means serving the whole public, not drawing arbitrary lines between majorities and minorities." *Broadcasting,* 13 May 1991, p. 49.

3. Credit for this analogy and other portions of the chapter goes to S. Anders Yocum, Jr., at that time director of program production for WTTW in Chicago, as published in *Broadcast Programming*, Belmont, CA: Wadsworth, 1980.

4. The rare exception is news programming, coordinated by PBS but actually produced by stations. For example, PBS worked with NBC on nightly coverage of the 1992 Democratic and Republican conventions, but production was handled by WETA-TV in Washington, D.C. as part of the *MacNeil/Lehrer Newshour*. See "NBC to Produce Conventions with PBS," *Broadcasting,* 5 August 1991, pp. 27–28; Bill Carter's "NBC and PBS to Pool '92 Convention Coverage," *New York Times,* 1 August 1991, p. A6.

5. These associations serve not only as forums for discussions of stations' policies and operating practices but also as agents for program production and acquisition. Set up to make group buys of instructional series, the regionals' role has evolved into providing programming for general audiences as well as for ITV use. Distribution is via the public television satellite, traffic over which is managed by PBS.

6. To make things easier, viewers can take a break from the pledge drives and make their donations directly to PBS online at *http://www.pbs.org/store/pledge/*.

7. Corporation for Public Broadcasting, "Average Revenue Profiles for Public Broadcasting Stations, Fiscal Year 1993," in *Research Notes no. 74,* September 1994.

8. This particular expression was coined by President Charles Van Hise of the University of Wisconsin in the early 1900s, but all land-grant colleges espouse similar traditions.

9. PBS actually operates three program services, including the Adult Learning Service and the Elementary/Secondary Service. The largest, however, providing nearly 1,500 hours of original programs each year, is the National Program Service (NPS).

10. This was 1981, the year of the writers' strike.

11. On occasion, PBS will offer a program with mass audience appeal. In 1995, the broadcast of the acclaimed basketball documentary *Hoop Dreams* on a Wednesday night attracted 13 million viewers (approximately 6 percent of the available viewing audience), a substantial increase over typical PBS viewing.

12. TBS stays with its five-minute delay tactic, to defeat the general switching around that normally occurs at 9 P.M.

13. Nielsen measures national audiences 52 weeks a year, but PBS can afford to purchase only 12 weeks annually, one a month. The absence of 40 weeks of data means that PBS often has little information on the performance of many of its most important shows, and it certainly lacks the daily tracking data available to the commercial networks. Overnight ratings for the 33 metered markets, however, fill some of this gap, although extension of these data to all stations becomes "educated guesswork."

14. As of 1995, 33 markets were metered, with more planned. The local Metered Market service employs household meters rather than peoplemeters. Of necessity, then, demographic data on viewers must continue to be collected by the diary method in these markets.

15. Six minutes is a minimum figure, the "ticket" for admission into the cume. Even if the viewer watches for 50 minutes, or leaves and rejoins the audience five or six times during a telecast, that person is still counted only once in the cume, provided the six-minute minimum has been met.

16. Quoted in Bickley Townsend, "Going for the Middle/An Interview with David F. Poltrack," *American Demographics*, March 1990, p. 50.

PART THREE

Cable Programming Strategies

Part Three turns to another aspect of television—program services delivered to homes by cable or other multichannel providers such as DirecTV and wireless cable (MMDS). It also examines the growing influence of *video-on-demand* services. Cable strategies differ from those of broadcasting because cable is a *multichannel technology*; its programmers must consider both broadcast stations and cable-only networks in the same competitive arena. The cable industry has two different types of cable programmers. Programmers for the 12,000 or so cable operators select among the available satellite-delivered networks and over-the-air broadcast stations to assemble dozens of channels on a local cable system or group of co-owned systems. Programmers who work at about 100 cable networks program a single channel (ESPN, Disney, or a local access channel) or a set of co-owned channels (such as three channels of HBO and three channels of Cinemax).

Programming a cable network or a local cable channel superficially resembles programming at a broadcast station. The programmer selects an array of movies and programs to fill a single channel or small group of channels. The programming problems of cable operators, however, differ greatly from those of broadcast station operators. For example, a broadcaster fills one channel all year round, while a cable operator must fill many channels—typically three dozen or so, although the number of cable systems with 100 or more channels continues to grow. A broadcaster purchases and schedules individual programs; cable operators only buy or produce specific programs for local channels. Most cable programming involves obtaining licenses to retransmit whole networks of prearranged and prescheduled satellite programming. A broadcaster with a network affiliation fills up to 70 percent of the station's schedule with one network's programs, and a broadcast station's promotional efforts are generally closely linked to its network's image. But the cable operator is connected with several networks—perhaps 30 or more—while also retransmitting the signals of local and distant over-the-air broadcasters. A cable system's image comes from its total package of channels as well as its local origination programming, public relations, paid local advertising, and on-air promotion. Lastly, broadcast stations receive most of their income from advertising spots sold within programs; cable systems are supported primarily by monthly fees paid by their subscribers, although advertising revenues continue to grow in the larger cities.

Part Three begins with a chapter describing the programming constraints operating on multichannel programmers (the cable system operators) with a focus on local options. The following chapters focus on single-service cable programming, covering basic and premium networks. Each of these chapters follows the structural pattern used previously, examining program *evaluation, selection,* and *scheduling* within a particular programming context.

Chapter 9 analyzes **strategies for cable system programming**. It is difficult to find the boundaries between the "stuff" of this chapter and the topics relevant to the two succeeding chapters. Although this chapter deals with "local" cable matters and the next with "national" cable matters, it is increasingly apparent that local partakes of national, especially in the networking and syndication of some program materials, while national partakes of local, especially in the matter of local advertising inserts. Development of telephone-delivered video and home computer networking further blurs once sharp lines. Nonetheless, this chapter's task is to explain what happens in programming at the local level, surveying cable's problems and the selection, scheduling, and evaluation limits and strategies for cable programmers. The author also explores the various kinds of local programming carried by cable operators and spells out what makes them likely to be successful. The author looks at the ways legal carriage requirements affect system programming at the nearly 12,000 cable systems in the United States. Then, the impact of developments in cable-related technology, the way economic considerations influence program decision making, and the types of marketing strategies utilized by cable system operators are analyzed. All four sets of factors affect cable programming in vastly different ways from their effects on broadcast programming. In this chapter the author shows how turnover and system channel capacity constrain the system programmer (the cable operator), and how principles of marketing affect selection and tiering of national networks.

The chapter deals with local cable programming, including noncommercial access channels, local commercial channels, and ancillary cable services. These three kinds of program content arise from diverse circumstances, but for the most part they share the common feature of originating at the local cable system level as responsibilities of the local cable programmer. The newest development, operator-controlled and advertiser-supported commercial channels on local cable, has become part of the cable operator's emerging strategy for gaining new revenues. The author explains the strategies behind the introduction of local all-news channels and current models for programming them, spelling out the models for success in access programming and distinguishing the major types of public/community, educational, and government access services. The author looks at scheduling strategies and methods of evaluating local cable programs.

Chapter 10 focuses on nonpay or **basic cable network programming**. Like the premium services, basic cable services provide a schedule of programs to "affiliates," the local cable systems, but most are supported by a mix of national advertising revenues and per subscriber fees paid by cable operators. Because of their large number (about 60 national basic networks altogether in 1996) and their diverse programming strategies, in this chapter the author begins with an overview of the appeal of the foundation and niche networks, discusses some implications of the multiplexing process, and describes strategies for financing and producing original cable programs.

After an overview of the three major types of national cable programming services, the author examines the most recent growth phase in national cable as such growth will shape cable programming into the next century. Additionally, the author covers the economics of launching and maintaining a national cable service, the specific programming strategies of cable networks, and the evaluation of cable audiences. Included in the chapter is

an overview of programming on most of the foundation services.

Chapter 11 examines the well-developed **strategies of the premium networks**. For an extra monthly fee or a per program charge, most cable systems deliver to their subscribers one or more of a dozen nationally distributed channels of programming called pay-cable and pay-per-view networks; microwave program distributors (MMDS) also supply many of the same national services using another technology. Video-on-demand may eventually replace schedule-driven programming with menu-driven programming. The revenues, which the premium suppliers and the cable systems share, largely accounted for the resurgence of cable in the 1970s, and premium cable remains central to cable marketing strategy in the 1990s.

The pay services program mostly theatrical movies, so the authors focus on the evaluation, selection, and scheduling of feature films but also look at premium cable's specials and sports. Pay-cable networks and pay-per-view services are described in detail, including number of affiliates, reach, and types of programming. The authors also examine the strategies of international pay television and the role of technology in the growth of pay programming.

Part Three, then, focuses on the special programming circumstances of cable and the unique constraints that operate on different types of cable and other multichannel programmers. This part concludes the discussion on television programming. The final section of this book will examine commercial broadcast radio issues.

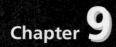

Chapter 9

Local Cable Systems and Programming

Susan Tyler Eastman

Cable programming is caught in the whirlwind created by the electronic information superhighway. The new communications technologies capturing worldwide attention have had far-reaching implications for cable programmers. Rapid transformations in federal regulations and revolutionary developments in the technology of communications have made the decade from 1995 to 2005 a period of fundamental change in the three industries of cable, telephone, and computing. Telephone companies are entering the cable programming field; direct broadcasting from satellites offers an alternative to coaxial cable to every household; broadcasters and newspapers are linking with cable programmers; and the Internet supplies a means of connection to information and entertainment sources that could bypass cable companies. Indeed, communicating via the Web may consume much of the time once devoted to television viewing. As one Bell Atlantic executive put it, "The people who will win this game are the folks who provide depth and breadth in programming and knock-the-socks-off customer service."[1] Although many changes may be invisible to consumers, the underlying technology of cable is altering in ways that will eventually expand national and local television programming options.

The job of cable programmers is to *select, schedule*, and *evaluate* channels of programs from the more than 200 basic and premium satellite services described in Chapters 10 and 11 and to *select* and perhaps *produce* one or more channels of local cable programs. To do these jobs, cable programmers must operate within legal and technical limits while generating revenue for the parent corporation with maximally marketable services. Not surprisingly, the nearly 12,000 cable systems face common problems, operate according to the same principles, and face approximately the same limitations.

THE CABLE SYSTEM ENVIRONMENT

While, on the one hand, communication services are converging into giant multimedia corporations, on the other hand, the various services within indi-

vidual cable systems compete aggressively for viewers and advertisers. The broadcast stations, cable networks, community access channels, local cable news channels, and interactive game and shopping channels are all fighting for the viewer's time and attention—and pocketbook. Many are also competing for the same advertising dollar. If an individual is using cable to shop or make a telephone call, that person is usually not watching a television program at the same time. Indeed, the biggest players are hedging their economic bets by investing in "competing" services, such as direct broadcasting and experimenting with telephone access.[2] For the near future, the audience and advertising pies are not so much getting larger as they are being cut into tinier pieces. Cable operators seek to retain as many of their viewers and advertisers as possible and will expand their systems by adding new programming only if they see an economic payback. Although the theoretical capacity of most systems is extremely high (perhaps 200 to 500 channels), as a practical matter there will be too few channels for all the services that want to get on local systems until several years into the 21st century.

Channel Capacity

One of the cable industry's biggest problems used to be a lack of channel capacity (and that may still be the case in isolated communities and in some countries), but construction of optical fiber systems throughout the United States in the 1990s expanded cable's capacity enormously. In addition, the ability to compress video signals so that several can share a wedge of bandwidth has further increased cable's capacity. However, big portions of that capacity are being used for pay-per-view, and much of the remaining capacity is being reserved for future nontelevision services. Generally speaking, there are about twice as many cable networks vying to get on cable systems as the systems usually carry. Therefore, cable networks, local origination channels, local access channels, and new data and computer services must compete in an aggressive marketplace for carriage.

Audience Churn

Another big problem is audience **churn** or turn-over. Subscribers who disconnect, even if they are replaced, cost the system in hookup time, administrative record changes, equipment loss, and duplicated marketing effort.[3] Cancellation rates of 20 percent or more were common in the 1980s, but cable has become a necessity to viewers in communities with poor over-the-air reception and national churn rates have declined. The **churn rate** for any local system or cable network can be calculated for a year, or any length of time, by dividing the number of disconnections by the number of new connections.

$$\frac{\text{disconnects}}{\text{new connects}} \times 100 = \% \text{ churn}$$

For example, a system with 200 disconnects, which added 300 new subscribers, has a 67 percent churn rate. Usually, annual rates above 30 percent presage financial disaster. Not all cancellations can be prevented, of course, since people move, children grow up and leave home, and local economic recessions cause unemployment and cutbacks on services. College towns normally have lots of cancellations at the end of spring semester and lots of new connections in the fall. But minimizing avoidable audience churn is one of the primary responsibilities a cable system's programming and marketing executives share.

Turnover on premium channels occurs more frequently than with other cable networks. Only instituting charges for disconnecting single channels has defeated the practice of **substitution,** in which subscribers dropped one pay channel to try out another. Operators seek instead to get subscribers to **upgrade,** to add to their total cable package. Nonetheless, several pay channels, such as American Movie Classics and Galavision, have devolved from pay to basic services, and the shaky status of other premium services has motivated mergers, combined marketing efforts by HBO and Showtime—once active competitors—and, finally, will probably result in the disappearance of stand-alone "premium" services. A standardized pay-per-use system for most cable-computer-telephone services will be the eventual outcome of the new digital technologies.

Because marketing and programming are intimately connected in the cable business, mergers and consolidations will increase to thrust well-known brand names into the public eye. It is presumed that consumers will be more likely to try out costly new services if they recognize the brand name. Thus, marketing and programming, through the process called "branding," are intimately connected in the cable business.

Localism

The degree of standardization of channel lineups varies from owner to owner. Some **multiple system operators (MSOs)** favor individualizing their systems to fit local market conditions, while others work toward uniformity in carriage and scheduling. However, most programming decisions are made at the group level by a management team of vice presidents, directors of advertising and marketing, and regional managers for dozens, even hundreds, of cable systems. Local system managers feed their recommendations into the group's decision-making process, although the local voice is often lost amid powerful economic forces at the corporate level. The decision makers must protect the parent corporation's investment in cable networks and new nontelevision services, sometimes at the expense of local subscribers.

SELECTION STRATEGIES

Decisions on how to utilize cable's present and future capacity are subject to several kinds of legal and physical limits. In addition, to be profitable, cable programming must balance licensing and marketing costs with revenue potential. Successful cable programmers juggle all these variables to select the best options for their franchise areas, and the mix of services necessarily varies somewhat from town to town.

Legal Parameters

On the legal side, operators must adhere to federal law, state law, and local franchise agreements. However, federal law shifted several times during the 1980s and 1990s. The Cable Communications Policy Act of 1984 laid out the right of communities to "tax" cable operators for their use of public rights-of-way. In other words, it followed the precedent of charges for use of easements, traditional practice regarding use of someone else's property. It also permitted local communities to require **public**, **educational**, and **government (PEG)** channels and broad types of services but prohibited franchising authorities from specifying which networks (by name) must be carried on a system. The 1984 Cable Act also eliminated local rate regulation.

In the Cable Television Consumer Protection and Competition Act of 1992, Congress did an about-face and directed the Federal Communications Commission (FCC) to tightly regulate the lowest level of cable service (basic service) on the federal level, simultaneously freeing cable operators to gradually raise rates for expanded and premium services. However, the rate calculation procedures (and others) established by the FCC were perceived to be extremely onerous and inhibiting by cable operators and unworkably complex by local franchising authorities. In the meantime, the technology of telecommunications had exploded in all directions, and the so-called Information Superhighway had reached public and Congressional consciousness. In the process of opening up competition among cable and telephone, Congress virtually reversed itself in the Telecommunications Act of 1996. It reinstated rate regulation in the absence of competition (from overbuilds by telephone companies, other cable operators, or MMDS)—but only for the lowest level of service—and allowed for so many rises based on inflation and cost of doing business that rates have crept up. In a 1995 decision, a federal court ruled that cable operators can censor indecent content on leased and access channels, although this decision contravenes decades of rulings upholding

constitutionally free speech and is being challenged by concerned groups.

Another area of federal concern has to do with exclusive rights to show syndicated programs. Federal regulations now enforce the **syndicated exclusivity (syndex)** rule, requiring cable operators to black out syndicated programs on imported signals (distant stations or satellite networks) if a local station possesses exclusive rights to the program. For example, if both WGN, the Chicago superstation, and a local independent carry rerun episodes of *Roseanne*, and the local station has stipulated exclusivity in its contract with the syndicator (usually for a stiff price), the superstation must be blacked out or covered up with another show in the franchise area when *Roseanne* is on. Because most local cable systems lack the insertion equipment to cover up one program with another, the superstations have tried to make themselves "syndex proof" by scheduling only original programming or paying for exclusive national rights to syndicated shows.

Broadcasters and cable operators generally hold opposing views on mandated local station carriage. Broadcasters want all cable systems operating in the same market to carry their stations so they can compete for the largest possible audiences. Without a legal requirement forcing cable systems to carry all local broadcast stations, cable operators can exclude some stations from easy access to cable viewers because the installation of cable connections usually means over-the-air antennas are disconnected. Cable operators can be expected to be desirous of carrying highly watched network affiliates of ABC, CBS, NBC, Fox, UPN, and WB, but less desirous of carrying small-audience religious and shopping affiliates and independents. Shopping channels, for example, may compete for viewers with channels owned by the cable operator or ones with which the operator has a favorable financial arrangement.

In 1992, Congress allowed local television stations to choose between being carried for free by cable systems or negotiating with the systems for some compensation for carrying their signals

(retransmission consent). The rules were considered by the Supreme Court, which did not overturn them, but instead remanded the case to a U.S. district court, which upheld them. However, the dispute returned to the Supreme Court, which is expected to issue a decision in 1997. Thus, federally mandated "must-carry" rules are presently in force, and in addition, local franchise agreements often specify that public access channels and all local broadcast stations reaching the area must be carried. In smaller markets with small capacity systems, carriage for at least one affiliate of each of the major networks (as well as local independent and public stations) is usually what a franchise specifies.

In addition, the policies of the parent corporation may impose restrictions on what a local system can and cannot carry.[4] Some multiple system operators (MSOs), for example, have policies freezing out adult programming; a few have policies favoring access channels. MSOs often sign agreements with program suppliers, the net effect of which is to compel carriage of a particular satellite network on all their systems irrespective of whether it might be the best choice for each market. The cable network naturally wants the largest possible audience and can offer discounts to encourage wide carriage.

On the legal side, then, federal regulations have generally freed cable operators to program as they wish, but local franchise agreements and MSO policies place some limits on what can be scheduled on a channel. Once the cable operator has signed a franchise agreement that specifies particular types of services, the cable programmer must place those services on the system before calculating the amount of channel space (or bandwidth) and locations available for other services.

Technical Parameters

The precise number of channels (or amount of bandwidth) a system can carry is largely a function of its delivery, compression, and filtering technologies as well as its flexibility. Because the newest technologies (750 megahertz and 1 gigahertz) have practically unlimited capacity, cable systems no longer evaluate capacity by maximum bandwidth capability or by the number of 6 MHz analog channels that can be handled (such as 36 or 120 or 500 channels). Instead, the industry views fiber and amplifier technology in terms of platforms or levels of potential capability. A 1 gigahertz platform with appropriate design architecture can be utilized for mixes of analog and digital signals, and the number of functions it performs (and thus services it delivers) can be gradually increased over time. Indeed, the upper levels above 750 MHz are sometimes thought of as "virtual channels," the cable engineering equivalent of "virtual reality." Virtual channels are for streams of digitized information that function as return paths to the cable operator; movement of these digitized streams through a cable (or telephone) system is measured in time and distribution rather than in old-fashioned radio frequencies. The 1 GHz platform is viewed by engineers as practically limitless.

The technical ability to send customized packages of signals to each home with or without certain pay channels or a second **tier** or level (see 9.1) necessitates two-way service or **addressability**. The operator must be able to address (talk to) the set-top box. Without addressability, all channels pass every home, and pay channels must be **scrambled** (electronically jumbled, requiring a descrambler in subscribing homes) or mechanically **trapped** (defeated at the pole or box) to keep them from entering nonsubscribing homes. Traps can only capture about four channels and must be physically installed and removed with every change in service.

With addressability, in theory, headend computers can add or delete services without sending a technician to the customer's home, can direct different sets of channels to individual homes, and can offer pay-per-view movies and events using impulse ordering (rather than prearrangement by telephone or office visits). However, very few cable systems address all subscribers; fewer than half of households have addressable **converters**—the much unloved set-top boxes that convert incom-

9.1 HOW TIERING WORKS

Telecable Corp., a top-25 MSO operating many small systems, charges $11 for a 23-channel basic service and $18 for an expanded 35-channel basic, which includes such popular cable-only networks as ESPN, CNN, and USA Network. In addition, it offers three or four pay services on each of its systems. Of course, individual pay services and the upper tier (in this case called "expanded basic") appear separately on the subscriber's monthly bill, but only if the subscriber agrees to the additional service. Although the subscriber can refuse the expanded basic service, the most popular services are placed there, and many consumers see the mechanism as price gouging. TCI has adopted the strategy of lulling subscribers with initially low prices for expanded basic, as low as $.40 a month, perhaps to get them used to the idea of paying additional fees. Then, year after year, the price for its expanded service rises, far faster than inflation or programming costs.

At the same time, consumers in many cable franchises are frustrated by ill-trained cable system staff (both customer service representatives who answer telephones and repairers who visit homes), badly buried cable lines that surface after frosts and get cut by lawnmowers, and erratic picture and sound quality resulting from inadequate monitoring of signal levels by the cable operator. Higher prices for cable are not often reflected in better cable service.

ing frequencies to a channel a television set can handle. Installing addressable converters has big benefits (and some frustrations) for cable operators because they are outside the FCC's regulations (see 9.2). Operators can charge a monthly rent for the boxes, and they encourage use of unregulated premium services (HBO, Showtime, pay-per-view movies). They are not so advantageous for subscribers, however. Most converters defeat the utility of the television's original remote controls and interact poorly with home video recorders, frustrating subscribers and generating loud complaints. Moreover, subscribers must pay monthly for *each* converter box, raising monthly bills in homes with many television sets (the national average is three and having as many as five or six TV sets is not uncommon).

However, the nation is in a cable transition period, moving from limited addressability toward totally addressable digital systems that will require every home to have converters for every set. The high initial cost of elaborate and sophisticated converter boxes with a million or so circuits is delaying implementation of this portion of the elec-

tronic highway. Present day set-top converters will evolve and mutate, gaining abilities until they reach a full-service (two-way video, voice, data) platform. Once standardization of the technology is achieved—at some fuzzy date in the future—such converters will probably move inside television sets and video recorders, but adoption of such advanced technology will require replacement of all home electronic equipment and thus will be slow in arriving. In the meantime, incorporation of high-definition signals and connections to other digital services must be worked out among industry competitors, further slowing implementation of reconceived services.

One change that is imminent is the loss of the idea of *channels* (see 9.3). **Digitalization** (conversion of all video, audio, and text signals into streams of 1s and 0s) will eventually permit consumers to select the video, audio, and text they want out of the full array available without concern for the source of the programming. The remote control device permits television viewers to watch Program A and Channel 2 at 8 P.M. and then Program B on Channel 22 at 8:30. Within

9.2 CONVERTER PIRACY

For the cable operators, frustrations lie in signal theft and illegally selling set-top converters that descramble premium and pay-per-view channels. One cable company president was quoted as saying that "converters are becoming a cash commodity" and that his company was forced to pay armed guards to protect its warehouses of converter boxes.[5] Pirated converters are often advertised in consumer and electronics magazines for about $350, and the FBI has become involved in seizing illegal converters from independent manufacturers in six states.

Pirated cable signals allegedly cost the industry millions of dollars annually. In addition to grossly illegal practices such as splicing into a neighbor's cable line (thereby degrading the neighbor's picture), some subscribers install fancy electronic chips in their set-top converters, disabling the trapping function to watch unauthorized pay channels. This practice reached such extremes that one cable company "fired an electronic bullet from its headquarters" through all converter boxes in its system that caused illegally installed chips to malfunction. The system urged subscribers with broken converters to bring them in for repair, and then they filed federal suit against several hundred who brought in boxes containing illegal chips.[6]

Whether the next generation of set-top boxes will have sufficient security to defeat piracy is more a question of cost than technology.

the foreseeable future, viewers will use preprogramming from guide listings, previews, and promotional shorts to assemble sequences of segments and whole programs into "their" lineup for an evening or week, beginning and ending at whatever time they like—and, of course, with the option of changing the sequence in progress as mood and interests expand or contract.

Another element in the conversion to digital systems is **fiber optics**. Cable systems and telephone companies began replacing coaxial cable with optical fiber strands in their trunk lines in the early 1990s, and systems are evolving toward "all fiber" communications because of its *much higher capacity* (as much as 1,000 times a comparable thickness of coaxial cable), *better picture quality* (because fewer and different-type amplifiers are required), and *greater reliability* (through redundancy because systems typically use only a portion of capacity and thus have plenty left for backup channels). However, in most systems, fiber installation will end at nodes serving a block or so of homes (*fiber-to-the-node, FTTN*), because installing fiber all the way to individual homes (*fiber-to-the-home,*

FTTH) does not appear cost-effective for the foreseeable future. Most services, including high-speed transmission of on-line services to multimedia computers, pay-per-view (PPV), and personal communications services (PCSs) can be provided with FTTN. PCS refers to low-power, digital pocket-size telephones operated by radio connection to the cable headend or other switching center. PCS is expected to become as common as VCRs and fax in the coming decade because the units can be very small, totally portable, and convenient. They improve on cellular telephones by having nearby pickups requiring far less power in the user's unit and may soon replace much of today's wired and cellular telephone service. PCS is important to the cable industry because its existing copper and fiber optic infrastructures could be the return system from millions of PCS cells.

The very great bandwidth capacity of fiber optics also makes **interactive cable** (two-way television) possible, which may change cable programming to a greater extent than any other technical element. Prior to wide implementation of fiber, nationwide shopping services had to ask prospective

9.3 UNIVERSAL CHANNEL LINEUPS

Even within a single Nielsen DMA, having the most popular advertising-supported services on the same channel numbers on all cable systems makes selling advertising easier. Standardization within a market is called a common channel lineup to distinguish it from the ideal of consistent positions for services from market to market across the country (called a universal channel lineup). Nationwide standardization of channel position would make national on-air promotion more effective. The goal of a uniform channel lineup, even for the dozen most popular services, is a long way from realization. The Los Angeles DMA was the first major market in which several cable operators agreed on a common channel array, and in the late 1980s newly constructed systems (new-builds) in Philadelphia and New York adopted uniform channel configurations. But the pattern adopted in Los Angeles does not match the one adopted in New York. Moreover, technical considerations limit realization of such plans in many markets with long-established systems. If cable becomes a software-driven system, more like the Internet than like present day cable TV, then channel *numbers* will become irrelevant, and it will be standardization among menus and search systems that will be the goal. Uniformity makes sense for viewers, cable networks, and cable systems.

purchasers to *telephone* them to actually make a purchase. Banking and many security services require private, two-way capacity to operate. On the programming side, program guides, home shopping, and games (see 9.4) have been pushing the cable industry toward implementation of true interactivity, but doubts about the public's readiness to foot the big bill have slowed developments. When it arrives, as it will eventually, educational programming may benefit first from the opportunity for the home viewer to communicate directly and instantly with the source of the programs, much as is possible via computers.[7] But it is expected that all kinds of programs—from cooking to situation comedies—may eventually avail themselves of the ability to ask viewers to respond. Interactivity will rapidly revolutionize information gathering about audiences and methods of calculating audience size and will alter content in ways that can only be guessed at presently.

In the mid-1990s, several national cable network programmers announced plans to launch **multiplexed** channels—several entertainment or information channels carried by the same signal, which would be split into separate channels for subscriber viewing. The premium networks were the first to implement the idea, with HBO delivering three channels of programs and Showtime and Cinemax offering two or three. Basic networks followed suit. The Discovery Channel, for example, announced separate adventure, science, and nature channels multiplexed together. Even MTV was considering separate services. But the rapid development of alternate program delivery systems like the Internet have turned network interest away from separate channels and toward interactivity. From the subscriber's perspective, it makes little difference whether hundreds of programs come on different "channels" or from menus under a single brand name.

Still another element that will change how cable and broadcast television operates is **compression**. To compress a signal is to remove redundant information (such as background that does not change for several seconds) and transmit only the changing information. Advanced compression techniques can send between 4 and 12 or more television signals in the 6 MHz bandwidth once required for just one. International telephone and satellite television signals make use

9.4 IS THE SEGA CHANNEL INTERACTIVE?

Video games seem to be inherently interactive, don't they? But the widely popular Sega Channel only gives the illusion of interactivity. When the subscriber chooses a game to play, the computer loads that game from the downstream channel. But all games are being sent past every house every few seconds, just as regular cable networks travel one-way on the wires outside every home all the time. When a game is ordered, the home Sega machine waits until the appropriate data comes down the channel and loads it up. No signal goes back to the cable headend. The player interacts with the television set through the video game terminal, but not through a link to a central location. One journalist once called the Sega Channel "non-interactive interactive television."[8]

of compression. As the technology improves, over-the-air channels will contain many different signals and services, and the user can select whichever one suits his or her needs. Compression holds the promise of greatly reducing limits on capacity in circumstances where optical fiber is not available or appropriate.

What are being constructed nowadays are **broadband** communication systems, not just cable systems. To take advantage of complex information flows and seamlessly mix signals coming from many sources, sophisticated digital switching centers that can transfer among signals from computer data, broadcast television, cable television, telephone, banking signals, shopping credit records, fax, and so on will be essential to realize the dream of the electronic superhighway. However, **interoperability**, the ability for two-way video, voice, and data to operate through the same home equipment, lies some distance in the future. It will require common standards—down to the basics of

jacks and plugs—across the entire communications industry. Widespread adoption of the MPEG II standard (the chip language for digital video compression) is one recent step on the way. But interoperable systems will be largely experimental until the turn of the century, and changeover to fully digital two-way television, plus negotiation and construction of digital switching centers that will permit the home viewer to draw invisibly from multiple sources, may take more than a decade.

As new nontelevision services (banking, shopping, security) become widely available and heavily utilized, it behooves cable operators to offer as many specialized services as possible. Viewers will reach these new services via elaborate menus, preprogrammed selections, and nonlinear voice-activated searching shortcuts. *Ease of use will be critical to viewer acceptance and use.* Having transparent technological processes will be a paramount concern to operators. Because the software and hardware behind such apparent simplicity will be enormously costly and difficult to make work reliably from network to network and service to service, *standardization in all communications technology becomes eventually inevitable.* However, a long period of intense competition amid confusing, incompatible systems will precede **convergence**. As John Malone, CEO of America's largest cable company, Tele-Communications, Inc., has outlined, "the real [challenge] is to figure out what a standard should be . . . to have an open architecture . . . against which everyone can develop standardized applications . . . that are universally accessible—by the TV set in the home with a sophisticated microprocessor [and] the existing generation of PCs."[9]

Economic Advantages and Disadvantages

The most powerful factor affecting carriage of most cable programming is cost to the local system. Operators expend between $3,000 and $6,000 to install a new satellite channel, and marketing it adds another $1 or so cost per subscriber, resulting in a price tag of tens of thousands of dollars in

midsized and large systems. Cost is also directly affected by whether the cable network is advertiser- or subscriber-supported, whether the MSO owns part of the service, and what additional incentives the service offers the operator.

Most advertiser-supported cable networks (usually called *basic networks*) charge local systems a small per subscriber fee to supplement advertising revenue. These fees, ranging from a few cents to a half-dollar per subscriber per month (more for ESPN), become a sizable monthly outlay for a system carrying 50 or more advertiser-supported networks to 10,000 or 20,000 subscribers, as the following equation shows:

$$\$0.10 \times 10,000 \times$$
$$50 \text{ services} = \$50,000 \text{ monthly cost}$$

Network contracts often specify even larger fees if the network is placed on an upper tier, it being assumed that fewer people will subscribe to an upper tier or package of channels. In addition, all cable systems pay **copyright royalty fees** based on a variable fee schedule. These funds are returned, proportionately in theory, to the holders of copyrights, such as the holders of rights for sporting events, music, movies, domestic and foreign television programs, and so on. Moreover, cable systems pay 3.75 percent beyond their base compulsory license fees for each distant broadcast signal they import. This particularly adds costs to the carriage of the superstations: TBS, WGN, WWOR, and others.

On the positive side, programming costs can be offset in the case of the most popular cable networks because the local operator can sell up to 2 minutes of spot time per hour (local **avails**) on each channel for which the operator has insertion equipment. Offering spots for local sale is a major bargaining point for cable networks when renegotiating contracts with local systems. These spots are, for the most part, deducted from program time rather than network advertising time, so they cost the network little. There is, of course, a practical limit to how much a program can be shortened to allow for advertising. Moreover, advertising spots

that cannot be sold (such as spots on unpopular networks or in lightly viewed time periods) offer little advantage to a local system.

When cable programmers are deciding which networks to carry, they also consider how much **promotional support** is provided. On-air promotion as well as print advertising and merchandising are especially valuable for gaining new subscribers, reducing churn, and creating positive images in the minds of current and potential subscribers and advertisers. National networks can supply professional-quality consumer marketing and sales materials, including on-air spots, information kits, direct mailers, bill stuffers, program guides, and other material that the local system lacks the resources to create. In other words, some fees paid to national cable program suppliers are, in effect, returned in the form of advertising avails, co-op advertising funds, or prepaid ads in *TV Guide* and other publications that attract audiences to the local cable system.

Premium cable networks have a different licensing pattern: the local operators get about 50 percent (sometimes only 40 percent) of the fee paid by subscribers. This fee-splitting arrangement explains why cable operators are so anxious for their subscribers to upgrade. Very few cable networks come without charge to cable systems (brand new or highly specialized services), and even fewer actually pay the systems for carriage (mostly shopping and foreign language channels or short-term arrangements by new services). Univision pays cable operators a small amount per Spanish-surname subscriber (rates vary with the quarter of the year), and Trinity Broadcasting Service (a religious channel) pays operators monthly for carriage. Shopping services usually pay local cable operators a small percentage of sales as a carriage incentive and may operate as a **barter** network on an "exchange-for-time" basis, similar to the barter programs discussed in previous chapters. A distributor, such as Home Shopping Network, presells most advertising spots, although a few local avails may be included as an enticement to carry the channel. One method of gaining shelf space is to offer **equity holdings** (partnership) to

cable MSOs. Operators are then motivated to place the service advantageously on the system because they benefit from its success.

Marketing Considerations

After legal requirements, technical limits, and economic benefits and costs have been evaluated, the cable programmer weighs a series of marketing considerations in deciding whether to carry a particular network and how to position and promote it. Cable programmers seek to attract and hold both the local audience and the local advertiser. To achieve this goal, they must maximize new subscriptions and minimize disconnections. The nature of the local audience determines what has particular appeal. National research has established that the cable audience is younger and made up of larger families than the noncable audience, but in particular markets cable subscribers may differ dramatically from national norms. One cable system may have more mid-aged, upscale, urban subscribers with higher than average income, for example, while another may have many more large families of mixed-age members. The upscale might want documentaries and sporting events, while the families might want "G" and "PG" movies and science programs. Program services have to be chosen so that every subscriber has several channels that especially appeal.

Cable networks vary on a continuum between sharply defined **narrowcast** services and those with **broad-based appeal**. A religious network, for example, carries a relatively narrow type of content and appeals to a relatively narrow (defined demographically) audience. In contrast, a superstation such as TBS carries almost as wide a range of programs as a broadcast network and tries to appeal to all ages and all lifestyles with a varied mix of programming. Networks that carry only a single type of program, such as The Food Channel or The Golf Channel, are called **theme networks,** and they embody narrowcasting in its simplest form.

Defining cable program services is usually not simple, however, because two intertwined elements must be separated—the *content* and the *target audience*. Content may be chosen from a restricted genre pool or may represent a range of types and formats; the service may appeal to either the mass audience or a limited subset of viewers. Four possible combinations of program content and audience appeal are shown in 9.5. In one case, MTV combines a restricted range of content (rock-related videos and talk) with a narrowly defined audience (appealing to teens and young adults). In contrast, USA Network's content ranges from soaps to sports to sitcoms to movies and news, and it appeals to the broadest mass audience by dayparting much as broadcast networks do.

In a third conceptual model, Nickelodeon/Nick at Nite programs a broad range of content, including off-network fare, movies, cartoons, and original children's programs, but the service appeals mostly to children and their families. Similarly, Univision carries every kind of program but it appeals primarily to Spanish-speaking households. Lifetime schedules a wide range of health and exercise programs along with movies and series, but

9.5 CONTENT AND AUDIENCE APPEALS

it appeals almost exclusively to women (half the total audience, of course).

In a fourth conceptual model, a narrowly defined type of content may appeal to a wide audience. The Weather Channel carries only weather-related programming, but like CNN and several other narrowcast services, it may be useful to virtually all households for a few minutes weekly. In other words, this theme network has broad demographic appeal. Similarly, ESPN carries only sports-related programs but appeals to at least half the population.

Network concept, then, becomes one more element in the programming mix. As many as two dozen networks are clearly established in the public's mind ("branded"), but the local programming must gamble that new cable networks selected for a system (1) will survive to provide programming for a reasonable length of time, and (2) will project clear and marketable images to subscribers and advertisers. In addition, the array of programming should reflect **channel balance**. There should be something for all members of all types of households, including family programming, arts and culture, documentaries and science, news and sports, old and recent movies, and so on.

Some services of particular appeal are considered to have **lift** in that they will attract subscriptions to higher tiers or premium services. Game channels have this impact for households with children aged 10 to 15 years. However, lift diminishes as systems add more and more services, leading to discounting and bundling of services with high and lesser appeal in upper tier packages. Cultural channels are often marketed more for their balancing effect than for any lift they create, and public affairs channels, classified advertising listings, and community access services are carried because they create a positive image for the cable system. A further strategy, adopted by the entire industry, has been to locate adult programming only on pay tiers, which makes good economic and political sense because so many people are willing to pay extra for adult fare. (See 9.6 for an extreme example.)

SCHEDULING STRATEGIES

Scheduling on cable systems has a special meaning in addition to its usual sense of placing programs in an orderly flow. It also refers to locating whole channels of programs on the lineup or digital displays of home television tuners. The channels have to be placed so they meet federal regulations and limits on the technology while maximizing revenue and marketability.

Cable operators normally follow **channel matching** for the three or four nearest VHF network affiliates; in other words, they place them on the same channels on which they broadcast, although they are not required by federal law to do so (not since 1987). Independent broadcast stations, public stations, and imported distant stations are less fortunate, because their channel numbers may be occupied by a local station or, more likely, by a basic or pay service of more direct value to the cable operator. For example, superstation WGN, licensed as Channel 9 in Chicago, appears all over the lineup on cable systems outside its secondary Chicago coverage area, in part because the number 9 channel may be occupied by other channel 9 broadcasters, in part because programmers locate popular superstations higher in the lineup to encourage sampling of adjacent channels. Local access channels, which are always part of the lowest level of service, can be positioned at virtually any point in the array. And channels in the basic level of service need not be physically adjacent in the frequencies, forcing basic-only subscribers to pass over scrambled and seemingly blank channels to reach all they can view. The **repositioning** of local broadcast stations from the traditional VHF numbers to higher numbers (20s, 40s, and up) threatens station revenues by reducing audience sampling, but it has advantages for cable programmers in that it encourages subscribers to examine the higher channel numbers.

Cable programmers have experimented with **clustering** channels according to their content or appeal. Channels can be grouped according to

9.6 FREE CABLE IN OMAHA: THE ULTIMATE LIFT

In 1995 Cox Communications began offering free basic service in Omaha, Nebraska, where the number three MSO faced direct competition from Baby Bell USWest. Cox created its free LocaLink service by stripping three channels—QVC and superstations TBS and WGN—from an existing 24-channel basic tier that sells for $10.28 a month. The resulting 21-channel tier still had the four national broadcast network affiliates as well as CSPAN, CSPAN 2, The Learning Channel, Mind Extension University, and local sports and entertainment programming. The service captured only 2,500 subscribers, with the overwhelming majority of Cox's 100,000 Omaha subscribers paying either $13.59 for a 31-channel package or $21.56 for a 58-channel package.

Apparently, LocaLink was developed to undercut USWest, which entered the Omaha market with a 12-channel broadcast basic tier costing $5.95. Cox did not plan to offer LocaLink in all of its territories. Cox's plan was announced just a few days before USWest won final federal approval to conduct a one-year video dialtone trial called Tele-Choice aimed at 50,000 Omaha households. The FCC approved a tariff of fees USWest could charge programmers to use the network, with 77 analog channels and up to 800 digital channels.[10]

Such toe-to-toe competition is likely to increase in the future. The main strategy of offering free service to encourage future paid subscriptions, however, could be the ultimate lift for cable operators. There is nothing, of course, to prevent the telephone companies from doing the same.

whether they are all alike in content, such as all news or all sports, or all alike in appeals to a particular target demographic group, such as children who watch channels with reruns and cartoons, or can be grouped so that a tier or cluster (for which a fee is charged) has something for every member of the family. A cluster might consist of a news channel, a sports channel, a music channel, a movie channel, a superstation, and so on. *What defeats effective clustering concepts are short-term marketing needs and lack of channel capacity.*

But as fiber enormously expands capacity and the number of special services and cable networks commonly carried triples and quadruples, operators are expected to go to menu- or topic-driven systems that make channel numbers (and therefore clustering concepts) irrelevant. Just as you get all channels coming through a VCR converted (usually) to Channel 3 on the TV set, so in the future might digital television sets have only a single "channel" and receive all input from a converter box.

EVALUATION STRATEGIES

Evaluation of cable audiences has been a long-time problem. *The overriding difficulty is that cable program audience shares cannot be compared directly with over-the-air audience shares.* As explained in Chapter 2, cable reaches far fewer homes than does broadcast television, and each individual channel attracts only a portion of the people watching cable. Typical cable network ratings range from 1 to 2 percent of households rather than the 10 percent or better that local broadcast affiliates typically attract. During the height of interest in the Oklahoma City bombing or the O. J. Simpson trial, CNN's ratings reached 12s and 14s, but without disasters or extraordinary events, CNN (and other popular cable networks) more usually attract less than 2 percent of viewers—and that means 2 percent of the approximately 650,000 cable homes, not 2 percent of the 950,000 broadcast TV households. And local cable channels attract far fewer viewers at any one time.

Advertisers had little interest in such small numbers of viewers until the cable industry came up with strategies for increasing the number of people reached. Because the geographic areas covered by cable franchises are far smaller than the coverage areas of broadcast stations, the cable industry now links franchises by microwave or cable to create large **interconnects.** Advertising interconnects are arrangements for simultaneously showing commercials on selected channels.[11] Of course, each operator must purchase expensive insertion equipment for each channel that will have local advertising added. (The ads usually cover promotional spots sent by the network, and how many and which ones can be "covered" by local spots is specified in cable network contracts with local cable operators.) Interconnects generally occur in or near large markets, however, leaving thousands of cable systems with unsalable (too small and undefined) audience sizes.

A second strategy is **roadblocking,** scheduling the same ad on all cable channels at the same time so that the advertiser's message blankets the time period. This can be done nationally by buying the same minutes of time on all major cable networks or handled locally in one market by inserting the same ad simultaneously on all channels in an interconnect.

A third strategy has been to develop criteria other than ratings for wooing advertisers. Cable sales executives generally emphasize the demographic (age/sex) and psychographic (lifestyle/income) **homogeneity** of viewers of a particular channel. Viewers of MTV, for example, are alike in age and interests; viewers of Lifetime are mostly women (or doctors on Sundays). A related strategy is **zoning,** which refers to dividing an interconnect into tiny geographic areas to deliver advertising, which permits small local businesses to purchase low-cost ads that reach only their neighborhood. A dry cleaners, for example, hardly wants to pay to reach the other side of town where the competition operates but might find two or three zones on its side of town ideal for reaching potential customers.

On the programming side, program repetition is another strategy used to increase audience size. Sales executives for cable will report how many people saw a program in all its airings, rather than how many saw it on, say, Tuesday night at 9 P.M. The size of the composite or cumulative audience is often more salable than the audience for a single time period.

Beyond programming strategies for dealing with low ratings, some cable operators have begun to collect their own data using set-top converter boxes. In 1994, Garden State Cable TV, a system covering a Philadelphia suburb in the state of New Jersey, began using converter boxes in more than half of its 200,000-subscriber base to collect television ratings data. Older analog set-tops from both General Instruments and Scientific-Atlanta already have some capacity to monitor and take "snapshots" of what channel a TV set is tuned to, a feature typically used in relation to PPV (see Chapter 11).

LOCAL ORIGINATION ON CABLE

At the local level, cable programming means several very different things. On one hand, it refers to the programming activities of the nearly 12,000 operators of cable systems. They may produce channels of information or entertainment supported by advertising. On the other hand, broadcasters also make use of some cable-only channels nowadays, filling them with local programming. But much of this programming did not *originate* for cable; it is broadcast material being retransmitted—creating a second kind of "local cable." Finally, local cable also refers to the programming activities of several thousand not-for-profit *community access groups* over the cable, a third major category of local cable-only programming, and it is the most truly local of all.

Channels provided by cable operators are normally commercial and intended to supplement a system's profits. When they run local channels, cable programmers select, schedule, and market an

appealing array of programs to carry advertising and explore opportunities for additional revenue streams from new commercial services. In dramatic contrast, the public, educational, and government access channels operated by community groups are noncommercial and driven by educational, artistic, and public service goals. They tend to operate on the neighborhood and city level, rarely reaching outside county boundaries.

However, just as is true of communications technology nationwide, the central characteristic of local cable programming is *convergence*. The sharp distinctions between the sources of programs are breaking down. Over-the-air broadcasters are producing for cable; newspapers are producing for cable; cable is sharing with broadcast stations and with newspapers. Even a telephone giant, Ameritech, has moved into cable system ownership to provide video dialtone service. And access services are beginning to join with schools, hospitals, and other community organizations to cablecast wider mixes of programming. What ties these very different services together—and makes them different from the cable networks discussed in the next two chapters—is their predominantly local nature. Wherever their programs come from, their appeal and reach (and means of support) are to the nearby geographic area. But the size of that area is growing to become regional or statewide (and sometimes leapfrogging national distribution to become "local" in other countries). Although Internet connections have created "virtual" communities of widely scattered people with shared interests, the bulk of e-mail, social service communications, and sales messages via computer appear within a small, contiguous geographic area.[12]

Local cable channels consist primarily of (1) entertainment mixed with infomercials and classified advertising channels or (2) news and sports. When produced and controlled by the cable operator, such channels are called **local origination (LO)** channels, although the news channels tend to cover such wide areas that they are referred to as regional cable. Local and regional cable-only channels have the long-term benefit of

differentiating cable from competing direct broadcast services and the short-term benefit of generating advertising revenue. Five opportunities for local origination programming are discussed next.

Entertainment Channels

Around the country, a modest percentage of cable systems operate an entertainment-oriented cable channel for the purpose of selling advertising. Local ads can appear as crawls across the bottom of a screen, which works well with live programming, or spot advertising obtained from local or regional advertisers or through an interconnect. About one-third of local cable channels are operated by religious broadcasters, and they typically mix syndicated programs with local and nationally distributed religious programming, including gospel music, discussions of gospels, sermons, and religiously oriented talk. In addition, a few foreign language cable channels usually have a full spectrum of news, entertainment, and talk in one non-English language.

The remaining local origination channels around the country are mostly either like the news channels described next or are programmed like independent television stations. They can carry nationally syndicated series or movies—very old ones, because they are licensed cheaply as a result of the relatively small cable audiences (compared to broadcast stations). Such programs may be chosen and scheduled locally but, like syndicated programs on broadcast stations, are not very local. Toledo, Ohio, for example, has a popular LO channel called TV5 that is remarkable for its syndicated series and sports. Because Toledo has only five local broadcast stations, TV5 has been able to become the Warner Bros. affiliate for Toledo and to license a great deal of "good" unsold syndication. TV5 carries first-run syndications such as *Hard Copy*, off-network reruns such as *Murphy Brown*, *Top Cops*, and, *Northern Exposure*, older series such as *The World of National Geographic*, and nightly sports (Cincinnati Reds baseball) or movies. Because the local newspaper (*The Toledo*

Blade) owns the local cable company (Buckeye Cablevision) that produces TV5, the channel receives the enormous benefit of a listing at the top of the newspaper's grid, right under the local broadcast channels, instead of burial in the "Ts" as *TV Guide* places it (and similar channels). The combination of national affiliation, having only a few local broadcast stations (only two of which have VHF frequencies), and supportive ownership by the local newspaper places TV5 in the forefront of successful local origination channels that compete directly with broadcast stations.

On other local origination channels, high school and minor league sports are especially effective in attracting audiences of considerable appeal to advertisers. Local talk programs also provide an ideal environment for both local and national **infomercials**. Major national companies, such as Sears, Bell Atlantic, Ford, General Motors, and Procter & Gamble supply the bulk of direct-selling infomercials to cable systems, and these are supplemented by shorter infomercials from local car dealers, restaurants, pharmacies, home builders, and the like. Many of the local infomercials are lengthy commercials, often three minutes or so long, produced by cable system facilities (for a fee).

Classified advertising channels, often produced by local newspapers, are another rapidly growing area for local cable, especially when operated in conjunction with a newspaper. Digital insertion equipment permits quick updating of listings and the use of photographs (and some slow-motion video), making real estate, car, and other classified ads as well as "Yellow Pages" viable as auxiliary revenue streams for cable.

News Inserts

Another approach to cable has been for broadcast stations to negotiate permission to program five-minutes of local news in every half-hour of Headline News. As of 1995, more than 75 television stations had contracts with CNN Headline News to produce such news inserts, and their combined reach was likely to exceed 7 million cable households. Most of the TV stations producing local news inserts retain a portion or all of the commercial inventory within the five-minute newscasts.

Regional News Channels

Modeled on CNN and its repeating counterpart, Headline News, seven cable-only regional news channels have attracted considerable industry attention. Although they required capital investments of many millions of dollars in equipment, crew, reporters, and studios to get going and have high daily operating costs, their revenue potential is usually much greater than for entertainment channels because they attract more regular viewing. What the services share is their recency and their focus on the neighborhood level of service: traffic reports are street by street, weather reports describe in detail what is important in the local areas, and "news" moves down to the level of parades, store openings, and city official activities.

These regional cable-only news services differ from ratings-driven broadcast stations that normally divide their newscasts into half-hour segments, devoting airtime to sensational crimes, fires, and accidents, and including nonlocal stories if they are likely to hold audience interest. That means local events get only a few minutes at most on broadcast stations, and events likely to be of interest to only a few viewers are scrapped. In contrast, hyperlocal cable-only news channels that operate live for several hours daily—increasingly 24 hours as they become established and profitable—can focus on neighborhood events on-the-scene and at length if they might be of interest to a few viewers. Most model themselves on CNN rather than the broadcast network newscasts and carry long, live programming, although New York 1 News is gaining increasing influence with its taped one-hour news wheel. With the luxury of more time to dwell on events, regional networks can spend hours on breaking events and enough time on stories about health, sports, and entertainment events to avoid the taint of sensationalism. An

9.7 REGIONAL CABLE NEWS SERVICES

The first and best-known of the regional all-news ventures on cable was News 12 Long Island. Launched in 1986 by Cablevision, and now partly owned by NBC, News 12 Long Island has a staff of 150 and facilities rivaling those of nearby broadcast stations. News 12 supplies news about the greater Long Island region to residents, beginning each morning with a radio-style mix of news, weather, and hyperlocal traffic reports (live from key points on the Long Island Expressway), then continues at a slower pace throughout the day with reports on local community events, live interviews, local news updates, and reprises of national and international news. Its stories include everything from school parades to unsolved murders to reports on issues like garbage dumping and pollution. Its annual budget is about $10 million, and it attracts enough advertising revenue to make a

profit. Its highest viewing comes in prime time. News 12 Long Island has been so successful that it plans to start comparable channels in Connecticut, New Jersey, Westchester, and Bronx/Brooklyn, where Cablevision has system clusters.

New York 1 News operated on a small scale from 1986 until 1994 but greatly expanded its programming as its reach grew (about 1.5 million in 1996) and competition surfaced from News 12 Long Island. Owned by Time Warner, New York 1 News began with two daily public affairs programs and a nightly sports call-in show and then graduated to 24-hour service. Its use of comprehensive journalists—who report, videotape, and edit their own stories—structured in taped, one-hour programming wheels, has become a global model for inexpensive news coverage. In addition to advertising, it attracts revenue by charging

for consulting about low-budget news for, among others, Telemundo, the Spanish-language broadcast/cable service out of Miami, Florida, a London, England, station called Channel One, and Australian television networks.

In 1990 a local news channel was launched near Los Angeles called Orange County NewsChannel, supported by the Freedom newspaper chain. Using reporters from the *Orange County Register*, it programs news, a daily half-hour sports call-in show, and an hour-long midnight talk show.

In Washington, D.C., there is NewsChannel 8 owned by Allbritton Communications. It has appeared on many of the area's cable systems since 1991, supplying regional editions for Maryland, Virginia, and Washington residents. Although it came for free for the first five years, beginning in 1996 it

intense focus on local interests and, especially in times of stress, carrying lots of ongoing weather and traffic reportage in detail, emphasizing the problems it causes neighborhood residents and businesses, and keeping costs very low are the keys to their success with audiences and owners (see 9.7).

In line with keeping expenses minimal, these regional channels take advantage of the newest roboticized cameras and other automation, which may result in some odd pictures at times but much reduces the technical staff necessary to operate (compared to broadcast newsrooms). The reporters

tend to be young and inexperienced, often interns or working for nonunion salaries, who carry their own handheld Hi-8 cameras with portable video recorders, eliminating still other staff costs. Using portable tripods a reporter can even tape herself (or himself) "on the scene" of events and interviews. As one reporter for New York 1 News put it, "I do a story every day. I dream it up. I set it up. I produce it. I report it, and I even edit it. I get to do everything."[13] The "videojournalist" who functions as correspondent, reporter, camera operator, and producer has become the model for inexpensive news gathering.

9.7 CONTINUED

charged per subscriber fees beginning at 28 cents per month, increasing a few pennies annually until the end of current contracts in 2001. Formerly called All-News Channel, News-Channel 8 carries advertising and gives local operators two minutes per hour to sell. Its staff of 200 provides three local feeds to different segments of the D.C. area, and its highest viewing is in the morning and evenings. Its annual budget approaches $15 million, the highest of any local cable effort to date.

Hearst and Continental Cablevision launched what is now called New England Cable News in 1992. So far, it programs only three hours daily of sports talk, financial issues, and politics. Begun in 1993, Chicagoland Television News carries a heavy dose of Chicago Cubs games and *Chicago Tribune* news coverage. Noted particularly for its heavy local sports coverage, is Vision Cable of Pinellas County, Florida, which does remotes of arena football, high school basketball, pro beach volleyball, and the Special Olympics. In addition, there are a half-dozen regional channels that carry a mix of highly local news, talk, and sports, supplemented by investigative reports, such as Bay TV in the San Francisco area, Pittsburgh Cable News Channel, Cable TV Network of New Jersey, News 12 in Fairfield County, Connecticut, and the Sunshine Network, along with some that specialize in state political and economic news such as The California Channel and the Pennsylvania Cable Network.

Additional regional news channels have been proposed for Florida, Arizona, and the Pacific Northwest. Among these, Florida's scheme is the most elaborate, involving three regional news channels in Miami/ Fort Lauderdale and Orlando, initiated by the Tribune Co., owners of the successful ChigagoLand Television News, and in Sarasota, announced by the local newspaper and cable operator Comcast. In addition, an all-state channel, the Florida News Channel, has been organized by seven NBC affiliates and cable operators. Modeling itself on CNN Headline News, the Florida Channel will program 60 percent local news and 40 percent state news out of Tallahassee using half-hourly news updates and live hourly stories from the newsrooms of various daily Florida newspapers. King Communications has plans for the Arizona News Channel out of Phoenix and the Northwest Cable News Channel out of Seattle. Using local NBC and ABC affiliates, the Northwest channel will broadcast 24-hour regional news from each market.

Although financial support must initially come from a parent corporation with deep pockets and patience, such national advertisers as Coca Cola and Procter & Gamble are getting interested in cable-only news. Moreover, the regional news channels can attract advertising from businesses too small to be able to pay broadcast station rates. Rates on New England Cable News are about $500 for a 30-second spot, compared with $3,000 or so on a Boston network affiliate. Although such networks typically average less than a 1 rating for 24-hours, local disasters drive up ratings dramatically. For example, New York 1 News had ratings of about 6 for its live coverage of the World Trade Center bombing and a winter snowstorm.

The next stage in development of such channels is to add interactivity. Time Warner has experimented in Orlando, Florida, with news-on-demand, which allows viewers to call up a menu of news programs on their television screens using a remote control device. Although Time Warner's experiment utilized national and international stories from *Time* and *Fortune* reporters, the capability of news-on-demand to include highly local events is apparent.

Rebroadcast Channels

Another strategy has been to replay broadcast newscasts on cable channels. Pittsburgh Cable News Channel, for example, began in 1994 as a **retransmission consent** channel. Federal law since 1992 has required local television stations to give permission to cable systems for carriage of their signals and allowed them to negotiate a fee or other compensation from cable operators in exchange for their broadcast signal. Many stations exacted cable channels of their own in lieu of monetary payment. A joint effort of WPXI(TV) and cable operator Tele-Communications, Inc., the Pittsburgh channel launched with only repeats of the broadcast station's newscast as programming but added more original programs of news, special events, and a talk show. The rest of the schedule consists of repeats of WPXI's newscasts. LIN Broadcasting, a group owner, has been successful with local weather channels started by the company's broadcast TV stations that reach over 1 million subscribers.

Such commercial channels are effective promotional tools for both the station and the cable operator and hold the promise of revenue sources. The pricing of ads is comparable to that of local ad inserts on CNN and Headline News, and cable systems carrying the channel receive two minutes of ad time per hour. In the case of the Pittsburgh Cable News Channel, all other advertising revenue is split between WPXI and TCI. In the case of LIN Broadcasting's weather channels, the stations get a percentage of ad revenue plus a license fee for each of the 1 million subscribers. By the turn of the century, most large television stations were expected to have cable channels that they programmed alone or in conjunction with the cable operator.

In addition, cable operators, often in conjunction with local newspapers, are staking out territory in the local and regional news and talk field. Indeed, informal sharing among the major cable-only services has resulted in broader reportage and "virtual interconnects" for selling advertising. It is expected that despite high initial capital costs, regional cable-only channels will prove important in creating distinct images for cable systems (just as local newscasts do for broadcast television stations) and in attracting large amounts of revenue once they become well established. Having hyperlocal services helps systems attract and retain subscribers and keeps them in the good graces of local franchising authorities that grant them their licenses. But in the long term, it is possible that local cable news will expand to most television markets, and local and regional cable-only services may even take over the role that local broadcast stations have traditionally played because cable does not use scarce airwaves.

New Communication Services

Still another strategy for cable companies is to get into new communications services unrelated to television. These range from online computer services to plain-old-telephone (POTS) to personal telephone services (PCS). The ability to pass to all homes digitalized, *two-way* video (called videophone and video dialtone) over the same lines as telephone signals—which looks indistinguishable from the "cable television" subscribers are used to—is the ultimate industry goal. In the near term, the business world's willingness to pay for two-way, full-motion video teleconferencing drives developments in the technology.

However, the first arena for expansion of services for most cable operators will probably be telephony—to compete with local telephone companies for local business and home service and to offer personal communication services to individuals and companies. Although business services have much greater profitability than do residential services, distinguishing between them becomes difficult as work moves into the home, the airplane, and the car. Activities that were once carried out from office buildings, such as word processing, fax, e-mail, and other data communications, can now operate from nearly any location. Cable operators see their broadband capacity as ideal for capturing highly profitable portions of this telephone-related business. As one local manager pointed out, gain-

ing 10 percent of the local telephone company's business represents a lot more money to him than giving up, say, 20 percent of his cable business to a competitor. Subscribers like getting a single bill for both telephone and cable service.

Recent developments in signal monitoring technology that forestall or compensate instantly for power outages seem to be the key to providing reliable telephone service via cable lines. After integrating the technologies, a second integrative stage occurs as marketing functions for cable, wired, and wireless (cellular, PCS) telephony are co-located, probably in shopping malls. One-stop shopping with combined billing are expected to increase revenues for all services. However, telephone has two big differences from cable that slow convergence: (1) telephone delivery areas are far larger than cable franchise areas, necessitating mergers and buyouts until cable operators can reach competitively large geographic areas, and (2) about 80 percent of telephone revenues come from 20 percent of the customers. In telephone, the commercial customers are far more lucrative than the residential customers, whereas in cable the differentiation in rates has been minimal.

Once converged systems are debugged—and Continental Cablevision in Cambridge, Mass., found interconnection of cable and the Internet far more difficult than anticipated—capital costs for providing broadband communications from homes, office buildings, and public places will be high. Each location needs a network interface device to separate and control the television and telephone signals. Although huge initial costs will fall as the technology becomes commonplace, it is important to remember that, in the United States alone, there will be more than a billion locations to be connected.

COMMUNITY ACCESS ON CABLE

Federal law permits local franchising authorities to require cable systems to provide channel space and sometimes financial support for community access services. Although by law these services divide

into three kinds—**public, educational, and government (PEG) channels**—in practice, they usually operate out of Community Access Centers. They are noncommercial and local not just in practice but in active philosophy and provide alternative programming that would never be viable on for-profit stations and that is uncommon on local origination cable channels.

By far the bulk of programming on access channels is wholly local, down to the point that many programs produced by community members are solely of interest to those who appear in them (such as a local church's fair, even a retirement celebration or centennial birthday party). To most access centers, *access* means two things: (1) access to the means of television production through training classes and arrangements for loans of TV cameras and sharing of editing equipment, and (2) access to an audience by cablecasting locally produced programs. The underlying principles guiding the staffs of access centers are the ideas of free speech for everyone, egalitarian use of the media, fostering and sharing artistic expression, the accessibility of all people to affordable education and instruction, and open and participatory government decision making.

In consequence of these commonly accepted principles, local access channels carry all kinds of public meetings, especially those of municipal government and local school districts, but also including environmental protection committees and councils, planning approval commissions, and other ad-hoc meetings on community issues. They also favor arts and educational programming and, increasingly, as channel capacity becomes available, overtly instructional programs and video and performance arts programs gravitate toward full-time access channels separate from those carrying meetings. In addition, local church groups are regular users of public access channels for religious programs, and hospitals and health services are increasingly seeking noncommercial access to cable's audiences.

The once-separate local arts centers and local television centers have come together in many communities to become community media centers

and are evolving into community communications centers. They involve institutional networks, local libraries, health centers, and schools, and connection to each other, community agencies, and the Internet has become central to their future and their survival. It is not the particular technology (television, broadcasting, books, or computers) that ultimately matters but serving the mission in the community—the mission of public access to the means of communication. Three varieties of community access programming are discussed next.

Organizations

Although the more than 4,000 access centers in America come in a bewildering variety of organizational set-ups, many are finding common bonds with farseeing public libraries. As the repositories of printed books and periodicals move into videotape, audio recordings, and computer storage of ideas, their noncommercial, anticensorship, free speech, and open access goals come to resemble those of community access television centers. Many access centers, including one of the oldest in America, Bloomington Community Access Television, have located themselves within a community public library and receive financial support from the city, the county, the library (a taxing authority), and the cable operator. The access center operates two channels as of 1996. Two carry meetings live and taped; one carries arts and community-made programs; another carries local religious programs and a mix of health and education programs. Still another access channel is operated by the local public television station and airs a continuous stream of instructional programs, largely originated by noncommercial syndicators and other public stations.

Nonlocal Programming

Although it was once thought that all access channels would carry locally produced programs, some regional and national sources are now available to supplement what can be locally made. In addition to public broadcasting, noncommercial

services such as SCOLA provide unedited segments of broadcast news from other countries in their original languages. Especially popular in university towns and cities with large foreign-born populations, SCOLA offers news from such varied sources as France, Spain, Mexico, Taiwan, Poland, the United Arab Emirates and Dubai, Germany, Hungary, Italy, Korea, Greece, China, Croatia, Slovenia, Iran, the Ukraine, and the Philippines over the course of a week.

Access TV is, at its best and worst, a forum for community speech and an alternative to commercial television (see 9.8). It is not the same as public broadcasting because the professional licensee makes media *for* the community. Public access inherently means media made *by* community members, not professionals. At the same time, access concepts appear to be leapfrogging nationwide. American distribution has attempted to reach and foster the development of local public access in other countries. However, it is not American access programs that are being dispensed but the ideas and values of community access—free speech, localism, egalitarianism, education for democracy, empowerment, and checks on the commercial marketplace.

In the rapidly changing media environment, three things appear to be central to the long-term success of public access. One of these is reconceiving the mission broadly to include all kinds of communication, from arts to television training to health to education, via all kinds of media—television, radio, computers, newsletters. Another is charging for services such as teacher-training workshops, taping of fairs and festivals and sports, and equipment training. And finally, developing collaborations, partnerships, and affiliations is essential to the survival of public access centers. They must join with city government and community and regional groups, both commercial and noncommercial, to find advocates and constituencies. Despite the fact that religious groups use as much as 4 percent of airtime nationally, they have not generally been advocates for public access. Seeking out constituencies interested in protecting and fostering free speech and the arts and in hav-

9.8 DEEP DISH TV NETWORK

Community access centers can also obtain the Deep Dish TV Network via satellite, a not-for-profit, part-time program distributor supported by donations and grants. Independent and community producers create the highly diverse and largely political documentaries Deep Dish distributes on such topics as housing, the environment, civil liberties, racism, sexism, AIDS, the Middle East, and Central America. Identifying itself as "the first national grassroots satellite network," its promotional materials quote author Studs Terkel:

> The idea of a democracy in this country is based on an informed citizenry, an intelligent citizenry—and you can't be intelligent without being informed. That's what Deep Dish TV is all about.[14]

Deep Dish TV appears unscrambled on commercial satellite transponders, and its programs are carried by 300 or so cable systems and some public television stations. (The name "Deep Dish" refers to parabolic receivers as well as apple and pizza pie!)

ing alternatives to commercial programming and open political and cultural debate is the only direction that will result in adequate financial support over the long haul. In addition, because the federal government is returning many responsibilities to the states, local groups must increasingly seek their financial support at regional and statewide levels. Cable operators have become highly reluctant to pay for access operating expenses, but at the same time cities have great need of franchise fees for other expenses.

Institutional Networks

Public access in the United States is also becoming closely linked to computer services. Not only are communities demanding public (no charge)

access to the Internet for those who cannot afford commercial fees, but they are seeking computer links among community services. Interactive computer channels on which community members request aid and information of local social service agencies, municipal government, and public institutions are becoming increasingly common. The terminals can be located in such convenient places as libraries and malls, and community members can get virtually instantaneous help without cost and without, at least initially, relinquishing privacy. Such services hold the promise for radically altering the delivery methods for social service agencies.

In exchange for franchise renewal and as part of major rebuilds, some cable operators are setting up and maintaining institutional city networks. Jones Intercable, for example, is committed to operating and training community members to use an "I-net" that carries voice, data, and video among municipal buildings, social service agencies, the schools, courts, jails, and libraries for the city of Alexandria, Virginia. It also connects the institutional network to the Internet.

In addition, cities are increasingly working toward a single centralized digital switching center into which feed Ameritech signals, TCI signals, community media signals, computer signals, electronic newspaper signals, and so on, and out of which come a full array of interactive communication media for community residents and businesses. Just as about half or more of telephone calls are geographically local, so will half of Internet communication occur within the local community.

SUMMARY

In sum, television should now be thought of as just one way to produce communication, just as oil paint and carved stone are two of many ways to produce art. The means of distribution of all kinds of signals in the near future will be digital, and mixing sources will become the way of producing,

consuming, and using communication media. Before long, it will be possible to hold a conversation with a friend, primarily in audio as one would on the telephone, but introduce video from a home camera of self or objects and text from paper into the conversation. The impediments to such media mixes are falling rapidly. One widely recognized implication is that "television viewers" and "cable subscribers" and "Interneters" are really "communication users," who will necessarily vary in their need for and sophistication of use of communication media.

It is important to remember that both operator-controlled and community-controlled channels necessarily compete for some of the audience's attention with broadcast stations and national cable networks. Although the total number of people in America rises, it does so very slowly, so the more options viewers have, the fewer that may go to any one programming source. Since advertising revenues are largely based on the size of audiences, having too many competitors cuts the audience pie into slivers too small to measure. Thus, large numbers of channels dilute viewership from the perspective of cable programmers.

SOURCES

Cable Strategies. Monthly trade magazine concentrating on the operations and marketing of local cable services. Denver, CO, 1986 to date.

Cable Television Business (formerly TVC). Biweekly trade magazine covering cable system management. Englewood, CO, 1963 to date.

Cablevision. Monthly cable industry programming magazine; includes monthly status report on cable penetration and subscriptions, schedules for feature films, top MSOs, and top cable systems. Denver, CO, 1975 to date.

Gates, Bill with Nathan Myhrwold and Peter Rinearson. *The Road Ahead.* New York: Viking, 1995.

Heeter, Carrie, and Greenberg, Bradley S. *Cableviewing.* Norwood, NJ: Ablex, 1988.

Multichannel News. Weekly trade newspaper. New York, 1979 to date.

NOTES

1. Kenneth Van Meter, president of Bell Atlantic Video Services' interactive multimedia platform division, speaking before Kagan Services' Interactive Multimedia Forum, 18 August 1994.

2. The telephone companies may eventually rule the multichannel environment. U.S. West Media Group bought Continental Cablevision in 1996 for $10.9 billion in the first major telephone and cable company deal after the Telecommunications Act of 1996 deregulated the industries. This deal made USWest the number one cable operator serving one out of three U.S. cable TV households in 60 of the top 100 cable TV markets. Some observers believe that the eventual outcome of the new regulations will be a "one-wire world" where the telcos dominate the cable operators. Viewers, however, will still think of the multichannel environment as "cable" and will likely continue to view phone service and cable service as distinct services, despite future mergers.

3. The national average for cable penetration was nearly two-thirds of households in 1996, and more than 90 percent of homes were "passed" by cable (meaning they could have cable service as the wires reached their areas).

4. Not all cable systems are privately owned. Some municipalities provide multichannel service, often charging lower fees because existing city workers are used for technical staff.

5. Mark Berniker, quoting Barry Rosenblum, president of Time Warner Cable of New York City. "Cable Thieves Undaunted by New Technology," *Broadcasting & Cable,* 10 July 1995, p. 36.

6. George James, "Cable TV Company Goes After Pirates, on One Zap," *New York Times,* 26 April 1991, p. A1.

7. Bill Gates, head of computer software giant Microsoft, notes that television sets and computers of the future will differ primarily in one aspect, viewing distance. Gates, Bill. *The Road Ahead* (New York: Viking, 1995).

8. Sean Scully. "For Some, Interactive Future Is Now: But Is It Interactive?" *Broadcasting,* 14 June 1993, p. 77.

9. Interview with John Malone in *Cablevision,* 7 June 1993, p. 83.

10. The USWest service contains a broad array of basic and premium networks and a variety of genre-based tiers at relatively low rates. Most are also offered by Cox. But there are some differences, including multi-

plexed movie channels, The Sega Channel, and Digital Music Express on USWest. Cox has its own local sports channel, called O2TV. TeleChoice included four $5.95 tiers called Sports (eight channels), News (11 channels), Family (12 channels), and Variety (12 channels). The designations are loose: "News" includes home shopping and the Prevue Guide. TeleChoice also offered $9.95 multiplexed offerings of three Home Box Office feeds, three Showtime feeds, two Cinemax feeds, or The Movie Channel. Showtime's Flix is sold for $5.95.

11. For example, TCI and Cox signed an agreement in 1995 to swap cable TV systems valued at $600 million. The trend for cable operators to "cluster" systems together not only makes for easier management but encourages interconnects.

12. Internet connections may come through the local cable operator, a nearby university or government agency, or via telephone to a national commercial service provider such as Prodigy or America Online.

13. Jean Seligmann with Jeanne Gordon in Los Angeles, Robin Sparkman in New York, Adam Wolfberg in Washington, Karen Springen in Chicago, and Mary Manz in Boston. "Covering the Neighborhood," *Newsweek,* 13 December 1993, p. 6.

14. From the cover of the 1995 brochure for Deep Dish TV Network in New York.

Chapter 10

Basic Cable Network Programming

Dwight E. Brooks

CABLE PROGRAM SERVICES

Cable is hot, but no one can say where it is going and how fast. Nationally distributed cable services initially proliferated during the 1980s, and then mushroomed in the mid-1990s. In this chapter I examine those cable programming services that are distributed by satellite (or occasionally terrestrial microwave) to cable systems and other multichannel providers around very large geographic regions or simultaneously to the whole country. Traditionally, these services are called **basic cable networks** and include:

- Approximately 150 nationwide basic networks that carry advertising
- A few nationwide networks that do not carry advertising
- About 10 superstations
- About 10 promotional guides channels and interactive services
- A few text-only services
- Some 30 regional services

In addition to these existing services—both established and newly launched young services—about 200 more wannabe networks are poised in the wings. In this chapter I examine the programming practices of the more than 400 cable program services. (See 10.1 for a list of the top 20 cable networks.) I use the terms *network, channel,* and *program service* interchangeably, because many of the companies that provide nationwide programming have adopted these terms in their names and because each of the program services occupies a single channel on cable systems and possesses the primary characteristics of a network: These cable services are (1) centralized and (2) distribute simultaneous programming, advertisements, and adjacencies—if advertiser-supported—to all affiliated cable systems for (3) retransmission to cable subscribers. One week every February, *Broadcasting & Cable* magazine devotes a special issue to cable networks and cable programming,

an excellent source for up-to-date information on cable offerings.

Foundation and Niche Services

National cable networks can be differentiated in terms of how established they are and who they target. **Foundation cable networks**—generally the earliest entries, most firmly established, and most popular—reach about 60 million subscribers (homes) each. The largest (CNN, ESPN, and TBS) reached upwards of 67 million homes in 1996. **Niche networks,** sometimes called **theme networks,** usually have either a single program content type (all comedy, all shopping) or target a defined demographic group (just children, just Spanish-speaking) with a mix of program types. Several niche services can also be considered foundation services, such as MTV (youth audience), Nickelodeon/Nick at Night (kids), and the shopping service QVC. **Microniche services** target a population subgroup (the hearing impaired or foreign language speakers) or provide programming that is a further differentiation of a niche service (women's sports or independent films). Currently, microniche networks include Asian American Satellite TV, Kaleidoscope: America's Disability Channel, The Independent Film Channel, and Z Music (contemporary Christian music).

Finally, and not to be confused with microniche services, are **subniche networks,** where basic and pay services subdivide into even more narrowly targeted channels that are managed and owned by one parent company or network. Most notably, Discovery Communications, which operates The Discovery Channel (foundation) and The Learning Channel, launched several subniche services shown in 10.2. Each of these four new services carries about 25 percent original programming, 50 percent acquired product, and 25 percent that has been run before on either the Discovery or Learning channels. Other examples of subniche services are Black Entertainment Television's BET on Jazz, MTV's MTV Latino, and QVC's Q2.

10.1 TOP 20 CABLE NETWORKS

Rank	Name of Service	Number of Affiliates	Number of Subscribers (in millions)
1	ESPN	26,700	65
2	CNN	11,600	64.7
3	TBS	11,700	64.4
4	TNN	13,650	63.6
5	USA Network	12,500	63
6	Discovery Channel	10,050	63
7	TNT	9,850	63
8	C-SPAN	5,170	61.7
9	Family Channel	10,560	61.4
10	A&E	9,500	60
11	MTV	8,750	59.5
12	Lifetime	5,800	59
13	Nickelodeon/	9,171	59
	Nick at Night	4,390	—
14	Headline News	6,150	56.8
15	Weather Channel	5,550	55.7
16	AMC	NA	54
17	CNBC	4,000	52
18	QVC	5,200	51
19	VH1	5,300	50.2
20	BET	2,625	40.1

Source: NCTA (Paul Kagan Associates), *Cable Television Developments,* Spring 1995, pp. 16–17.

Subniche services are made possible by cheaper satellite time resulting from digital compression. Digital compression encourages a process called **multiplexing,** distributing several different channels simultaneously. In some cases, the "new" services run the same programs scheduled at different times. In other cases, programs are subdivided by target audience, and each channel focuses on one target audience.

Most of the newer and proposed cable services fit into the niche, microniche, and subniche categories. Very few seek broad appeal. According to one cable programmer, these newer services will function like radio station formats, targeting a specific audience segment with demo-specific talent, promotions, and programming.[1]

The Growth Phase

The hype over the promise of the so-called information superhighway and the 500-channel cable universe is one of the factors that has contributed to an explosion of new and proposed cable program services. In the early 1990s, the expectation that federal rules (or the lack thereof) would benefit cable programmers and increasing financial par-

10.2 DISCOVERY'S NICHE/SUBNICHE SERVICES

- The Discovery Channel
- The Learning Channel
- Animal Planet (nature)
- Quark (science)
- Time Traveler (history)
- Living (lifestyle)

ticipation in programming by cable MSOs (equity interest) were additional catalysts in the decisions by many programmers and would-be programmers to develop niche and microniche programming services. Many of these services remain in the planning stages, some are currently operating with limited cable system carriage and limited programming schedules, and several were either scrapped before launch or terminated shortly after launch. The major problem facing these would-be services is distribution: Few cable operators have had channels available to give to new services.

A few services such as ESPN2, fX, Sci-Fi, and The Cartoon Network benefited from the FCC's must-carry/retransmission consent rules. However, for the most part, the 500-channel universe looked less promising in the mid-1990s than it did a few years earlier—at least to the visionaries behind the hundred or so would-be cable networks. Yet despite long odds, most of the aspiring cable networks remained optimistic. New services were announced on a regular basis. Some were stand-alones; others came from established cable players or resulted from partnerships. As they awaited cable carriage, many of these new services sought alternative methods of distributing their programming—in particular, direct broadcast satellites (DBS) and the Internet.

Other factors that have contributed to the surge in cable program services include the expectation of tiering that will accompany expansion of

cable system channel capacity by means of digital compression and fiber technologies. But major barriers stand between these new services and viewers. Despite the expansion of many cable systems' channel capacity in the mid-1990s, most still lack sufficient capacity to add new services. Further, delays in the rollout of digital set-top converters slowed the realization of increased channel capacity (see Chapter 9). Moreover, the FCC's rate rollbacks and "going forward" rules made many cable system operators nervous about their economic health and, thus, cautious of adding new cable services to their channel lineups. In an uncertain regulatory environment, even large MSOs reacted to FCC rulings by limiting their investments in the expensive digital upgrades on which new cable services rely for carriage. Several uncertainties remain regarding the role of the federal government in the regulation or deregulation of cable.

Tiering, grouping basic cable channels in stair steps with increasing monthly charges, has the dual advantage of helping viewers find specific channels (convenience) and providing an additional revenue stream for cable operators (economics). At the same time, tiering poses a threat to the advertising revenues of such broad-appeal (foundation) services as USA Network and TNT while holding out promise of channel space for theme-oriented networks. Successful niche and microniche services that aggressively attract targeted viewers lift the entire group of channels with which they are packaged. However, less-defined channels become vulnerable when tiered as they lose identity unless they have high profile programs. Consequently, tiering has led some cable networks to compete for recent off-network series and led others to increase their efforts in producing or purchasing original programming and undertaking aggressive promotion and marketing. In late 1994, the FCC provided some guidelines related to tiering.

When the FCC ruled that broadcast TV stations could ask for payment from cable operators for retransmitting their signals, major broadcast groups settled for distribution of their new cable

channels rather than cash payment. This gave the few cable networks owned by broadcasters (ABC's ESPN2, Fox's fX, NBC's America's Talking) a head start on the cable gold rush that will come as digitalization and fiber are deployed nationwide.[2] Another consequence was the creation and launch of more cable services that proposed to target even more specific interests.

Challenges and Competition

Outside the cable industry, the proliferation of cable services has been difficult to understand. In the words of former CBS Chair Laurence Tisch, "You can make more money on one hit program than you can on a whole damn cable network." In the view of USA Today columnist Alan Bash: "The world of 500 channels is looking more and more like the world of a few good ideas, imitated several hundred times."[3] While both views are exaggerations, they suggest part of the competitive dilemma that cable programmers face. In short, that dilemma is how to compete and make money in a dynamic and vastly competitive marketplace.

At least 150 services announced launches between 1995 and 1997. Combined, these new and would-be services exist in a crowded, if not hostile competitive environment. Not only do cable program services face continued distribution difficulties (gaining carriage on cable systems) past the turn of the century but they must also create and maintain a brand identity (branding) while winning viewer and advertiser acceptance. In an uncertain regulatory environment and changing economy, cable programmers will confront these and other challenges well into the next decade.

Another obvious and immediate outcome of the proliferation of cable networks is that new cable networks will have to compete not just with other new networks and established services but with other services offered by a common company, as is the case with the several Discovery Networks. In-house development/competition exists between A&E Networks' A&E and the History Channel, at Disney/ABC's ESPN and ESPN2, and at NBC's CNBC and MSNBC.

However, new stand-alone services are more common, such as the American Political Channel, The Auto Channel, the Hobby Craft Network, and the Gospel Network. Most of these services were being born with no space on cable system lineups. (See 10.3 for many of the newest and proposed services as of 1996.) As more cable networks launch, find distribution and, ultimately, acquire broader household penetration, cable program services likely will feast on itself in the same way that it consumed broadcast network share. In the words of Tim Brooks, Senior VP-Director of Research of USA Networks, "cable is cannibalizing on itself."[4]

Despite all the talk of the information superhighway with an infinite number of channels, it will not arrive until well after the year 2000. Significant investments are required in technology, which will take time. New cable networks have important decisions to make about what to do in the interim. As they wait, they have four options: (1) seeking an alternative distribution method such as DBS and the Web, (2) aligning with telephone companies to get early video distribution on their systems, (3) adding an equity partner from among cable's big MSOs, or (4) seeking ancillary revenue streams such as publishing and CD-ROM. Television Food Network has tapped into interactive CD-ROM revenue and struck a deal with a telephone company to offer recipes on demand and other transactional services. As they wait for channel capacity, one successful strategy is to brand their networks with viewers who cannot see them on cable. Cable services are turning to wireless and microwave delivery, C-band transmission, telephone companies, web pages on the Internet, and DBS services such as DirecTv and PrimeStar to get themselves known.

FINANCIAL SUPPORT

Most basic cable networks are advertiser-supported and bundled in tiers by cable systems to subscribers (see Chapter 9). Basic services come either as part of the cable system's standard service (basic),

10.3 CABLE'S NEWEST NATIONAL PROGRAMMING SERVICES

Name	Programming
Action America	Audience participation service with interactive elements
Adultvision	Pay-per-view adult-oriented movies
Air and Space Network	Premium network devoted to aviation and space programming
American Political Channel	Political news, information, and public policy information
America's Health Network	Health information and products
America West Network	Classic western films and TV shows, original programming on the history and myths of the "Old West"
Applause	24-hour general entertainment including six hours of children's programming
Arts & Antiques Network	Magazine-style programming of news and information aimed at the serious antique collector
The Automotive Television Network (ATN)	Automotive news, sports, weather, documentaries, home shopping, and infomercials
The Auto Channel	Live and taped motor sports, automotive related
BBC World Channel	24-hour cable network featuring news reports, magazine shows, documentaries, and informational programming produced by the BBC
The Benefit Network	Ecological and humanitarian programming
BET on Jazz: The Cable Jazz Channel	Jazz, blues, and gospel music
Booknet	News and films based on novels, interviews, profiles of writers, and authors reading their own books
Career and Education Opportunity Network	Career information and opportunities
Catalogue TV	Video catalogue programming service
CelticVision: The Irish Channel	Irish news, sports, movies, and public affairs imported from Ireland-based networks RTE and UTV, and BBC archives
CEO Channel	Newsmagazine format focusing on corporate leaders, their organizations, industries, and organization style
Channel 500	Nonfiction general programming
Children's Cable Network	Children's educational and nonviolent entertainment programs
Chop TV	Magazine-style programming on martial arts
Classic Music Channel	Classical, ballet, opera, jazz, and blues music videos
Classic Sports Network	Classic sports events, television series, documentaries, and specials
CNN Financial News (CNNfn)	24-hour business news
c/net, The Computer Network	Computers, online services, video games, and interactive entertainment
Collectors Channel	Magazine shows, talk shows, live music events, and live interactive auctions

(continued)

10.3 CABLE'S NEWEST NATIONAL PROGRAMMING SERVICES *(continued)*

Conservative Television Network (CTN)	News, information, and entertainment from a conservative perspective
Consumer Resource Network	Infomercial-type programming on consumer products and services
The Ecology Channel	News and issues related to the environment
The Enrichment Channel	Self-help, alternative medicine, spiritual, and enrichment programs
Fashion and Design Television (FAD TV)	Fashion news and videos, home shopping, and a variety of longer programming forms
Fashion and Style Network	Fashion news and information service
The Filipino Channel	Drama, soaps, movies, children's shows aimed at Filipino Americans
Global Village Network	International business and world culture programming
The Health Channel	24-hour channel featuring health, wellness, and medicine programs
Hip-Hop Television	Sitcoms, music videos, arts, and poetry aimed at an 18–34 demographic
The History Channel	Historical documentaries, original and acquired movies, and miniseries
Hobby Craft Network	Hobby and craft demonstrations
Horizons Cable Network	Cultural and intellectual events at universities, museums, libraries, and arts centers
Independent Film Channel	Feature-length premieres, documentaries, shorts, animation, and original productions of independent filmmakers
Intro TV	Channel for showcasing new cable services
Jackpot Channel	Variety/entertainment programs on gaming industry
The Military Channel	Armed forces programming; military documentaries and battle histories, news and information
Nick at Nite's TV Land	A variety of recycled series, including sitcoms, dramas, westerns, and variety shows
Outdoor Life Channel	News and features on fishing, backpacking, hunting, rock climbing, equestrian sports, and skiing
Ovation: The Fine Arts Channel	Arts programming, including music, dance, literature, artist profiles, opera, and museum exhibits
Parent Television	Aimed at parents and parents-to-be; advice and instruction, entertainment, news, discussion, home shopping, and therapy
The Popcorn Channel	Previews of theatrical movies and local information on movie times
Prime Life Network	Entertainment and information service aimed at 50+ audience
Recovery Network/The Wellness Channel	Live documentaries and films associated with addictive disease, chronic illness support, and terminal illness support

10.3 CONTINUED

Romance Classics	Movies, series, and original programming with romantic themes
The Singles Network	Singles-oriented information and entertainment
The Success Channel	Educational and motivational programming; business and personal finance
Sundance Film Channel	Independent films
Total Communication Network	Educational and entertainment programs for the hearing impaired
Trax Television Network	Motor sports/hobby network featuring programs about air, land, and sea recreation vehicles; home shopping
Trio: Family Oriented Channel	Children's programming; live talk shows, teen dramas, documentaries, movies, specials, and miniseries
Wingspan, The Aviation Channel	News, documentaries, and educational programs on air flight and aviation
World African Network	Pay network targeting African Americans; movies, original programs, and films
Zen TV	Religious/spiritual programming

grouped in an expanded basic or new product tier, or are sold separately (a la carte). Even the most widely distributed emerging networks reach only 30 million homes—about half of the national cable universe—but most are happy to reach that many. After calculating actual viewers, most of these newer networks do not attract an audience large enough for buys by most major advertisers, but cable's abundance of narrowly targeted programming appeals to the nation's niche marketers. These smaller specialized advertisers, once restricted to print or an occasional broadcast special, now have the opportunity to reach a broader audience through cable networks. Thus, national cable networks offer advertisers, in the words of one observer, "a rifle shot versus a shotgun blast [of broadcast]."

Besides advertisements, carriage fees are the main support for cable networks. In most arrangements, the cable operator pays a monthly license fee to the program supplier, and these fees normally expand in each contract renegotiation. So

that large systems with more potential viewers pay more than small systems, cable network license fees are usually structured as per subscriber per month charges to the cable operator. The monthly fees range from about 10 cents or less per subscriber for services such as Court TV and The Weather Channel to about 40 cents a subscriber for more popular services such as CNN, ESPN, and TNT.

Despite these two main sources of income, most cable networks encounter economic difficulties from a *lack of programs* and the *credit crunch*. Banks and other financial institutions are loaning less money to the debt-ridden cable industry or charging higher interest for it. Typically, the newer cable services have the lowest **penetration** and are necessarily unprofitable but are in most need of fresh program materials (which creates a need for even more money). It is widely estimated that start-up services have to wait at least seven years before breaking even. A representative of The Talk Channel claimed the network added another

year to its original break-even plan of four years. A spokesperson from the Television Food Network (TVFN) admitted that it would be at least four years before TVFN could reach 25 million homes and break even on its investment of $50 to $70 million.[5] Coventures are one response to the shortages in money and programming.

Joint Ventures

Cable has utilized three types of joint ventures: U.S./international productions between American cable networks and foreign producers, broadcast/cable production efforts (mostly in news), and most significantly, financial cooperation between MSOs and cable program suppliers. Coproduction with international entities generally involves double-shooting (once using an English-language script and once in another language) in foreign locations to keep costs down. Such agreements contain a commitment for prime-time scheduling on the U.S. cable network accompanied by heavy promotion. Thus, U.S./international joint ventures generate programs with assured audiences in at least two countries and have the potential for profits from later syndication.

But international joint ventures contain considerable risk for all parties because some types of programs do not travel well. Programs that depend on verbal exchanges, oral wit or humor, and up-to-date content, such as most sitcoms and talk shows, too often appeal to viewers in the originating country and have little international syndication potential. However, action-adventure programs have worldwide appeal, but initial production budgets are relatively high. One example of a successful international joint production was The Family Channel's *Snowy River: The McGregor Saga*, a weekly action-adventure series about pioneer cattlemen in the mountains of southern Australia (produced by Earl Hammer Jr. of *The Waltons* and *Falcon Crest* and Don Spies). The program's international partners include PRO Films of Australia and Northstar Entertainment Group (Virginia Beach, VA) in association with the Family Chan-

nel and Nine Network Australia. It was distributed by MTM International, and the Family Channel has worldwide distribution rights to the series outside of Australia.

Many programs on The Discovery Channel (TDC) are commissioned or coproduced with international partners. For example, *Beyond 2000*, which TDC originally acquired from Australia, is now coproduced with that country's Beyond International. Arthur C. Clarke's series on TDC is coproduced with England's Yorkshire Television; the issue-oriented *Discovery Journal*, which airs monthly, is produced with England's First Tuesday in conjunction with Yorkshire Television, and *In Care of Nature* is coproduced with France's Marathon Productions. Finally, The Family Channel is producing four motion pictures with Toronto's Atlantis Films, which includes *A Race to Freedom*, which (in an unusual arrangement) premiered as a simulcast on The Family Channel and BET.

By the mid-1990s, network and local broadcasters had finally stopped fighting with the cable industry and begun participating in several broadcast-cable partnerships.[6] Most of the broadcast networks are now involved in cable program services; Disney/Capital Cities' (ABC) has ESPN and ESPN2, NBC has CNBC and MSNBC, and Fox has fX. Even PBS has gotten into the action: A&E and Nickelodeon have formed coproduction partnerships with PBS and have used its production units to make programs. Discovery Communications has proposed to pay PBS as much as 80 percent of the total costs of joint documentary projects as long as they fit the niches of Discovery's proposed services (science, history, nature, exploration, education, and preschool learning). In a rare arrangement, CBS and the pay service Showtime enjoyed strong ratings from a coproduced film *Double Jeopardy* that aired in 1995. In another joint venture, both ABC and Showtime collaborated on an action-adventure movie, *Royce*.

At the local level, there are joint ventures between cable networks and cable systems and local broadcast stations. One of the oldest is CNN Headline News, which adds local news insertions.

A more recent, ambitious venture is NewsTalk Television's "Local NewsTalk." This program offers affiliates two half-hour programming blocks per day (6 P.M. and 12 A.M. ET) for the seamless insertion of locally produced programs that explore the impact and relevance of national and local issues on local communities. Any of five types of local insertions can be used: (1) talk radio station programs, (2) interactive talk (radio or TV) shows, (3) news segments, (4) ethnic public affairs shows, or (5) video "newspaper" shows.[7]

The most common area of joint ventures in cable is between cable networks and MSOs. These joint initiatives often result when a (parent) cable company buys all or part of an existing cable network. For instance, the country's largest MSO, TCI—whose cable systems serve about one in four U.S. cable subscribers—spun off its own programming company, Liberty Media, which in turn, spun off several Prime Sports regional networks under the ownership of Liberty Sports (NewSport Television, Prime Deportiva, Prime Sports Showcase, and Women's Sports Network).[8] In the middle of the 1990s, TCI merged again with Liberty Media and acquired Viacom Cable (adding 1.2 million subscribers to the 13 million it already had) for $2.25 billion.

The Evaluation Problem

The hack press report of one media consultant included the opinion, "I don't think too many networks are executing particularly good programming strategies. They're overspending against a broad cross-section with mediocre programming."[9] However, as the following discussion will reveal, the consultant's views may not be accurate. According to audience ratings data, cable networks are doing a good job of programming—at least better than they have previously done. The evidence indicates that cable networks' increased spending on original programming has begun to provide dividends in viewership and advertising revenues. However, while many cable networks show signs of growth, most basic cable network programming services continue to face severe challenges.

Audience evaluation remains a problem in the cable industry. Inadequate viewing data hampers many national advertiser-supported networks in selling time—especially the newer niche services. Although the total number of a system's subscribers is always known more or less accurately, and the most popular services are rated by A. C. Nielsen, how many subscribers view the less popular nonpay channels cannot now be accurately measured on most systems.

Cable penetration is experiencing some growth in the mid-1990s. Although some observers believed that cable had reached a plateau of about 60 percent of households in America, cable service reached over 65 percent by 1995 and has continued to grow slowly. In addition, cable penetration in foreign countries was bounding ahead. However, individually, audience ratings for most cable networks (excluding the top 10 services) have only occasionally exceeded 1 percent of television households at a time. In fact, the very top services celebrate a 4 rating in prime time (about the same as a 2 among all 96 million television households). TNN's goal was to hit a 1.4 prime-time rating by September 1995.[10] Even extraordinary cable programming, such as ESPN's NFL football and CNN's coverage of the Persian Gulf War and perhaps the O.J. Simpson trial, rarely reach ratings of 10. Within many local markets, the cable-only audience is a very small number of people, but in some mature cable markets, the combined audience for cable-only channels frequently exceeds that of the broadcast channels. Moreover, combined, all of the 100 or so basic and pay-cable networks often capture 30 percent of the national television audience even in prime time. Advertisers traditionally buy one channel at a time, however, so combined ratings are not much comfort to them.

Cable Ratings

As discussed in Chapter 2, ratings for cable networks really represent three audience measurements. One measure is the audience watching a *particular program at a given time*, measured by

AQH ratings and shares as in national broadcast ratings. A second measure is the cumulative audience that watches a *given program in all of its showings,* because some cable services repeat shows. When all viewers of repeat showings of a program (such as a movie) are summed, the audience for that one program may exceed a competing broadcast station's audience. The third and perhaps most important measure to cable networks is the *cumulative audience for a channel.* Although peoplemeters have benefited the established cable networks by increasing their reported share of prime-time viewership, they reveal little about the viewing of less popular advertiser-supported services. Cable networks must conduct or commission their own research to understand viewing by such demographic subgroups as children, teens, and ethnic minorities.

The overriding problem in evaluating cable program audiences is that local audience shares cannot be compared directly with local over-the-air audience shares. As 10.4 shows, cable **franchise areas** differ in size and shape from markets defined according to broadcast station coverage patterns (DMAs). This type of map prevents advertisers from comparing cable's effectiveness with that of broadcasting and other media in one market.

Currently, Nielsen requires a channel to be available in about 3.3 percent of U.S. TV households (about 3.2 million homes) to qualify for its national cable TV ratings report, the Nielsen Cable Activity Report (NCAR). Further, to show up in the report, the channel has to generate at least a 0.1 rating in their coverage area (the number of households a channel is carried in). Despite this evaluation problem, cable program services, at least the established networks, show signs of audience growth.

Collectively, the 31 basic cable networks measured in the NCAR had a 12.1 percent gross rating in 1994, showing some growth over previous measurements. Most of the other 24 rated networks held the same level of viewing. Although total cable originated programming averaged a 14.2 Nielsen prime-time rating in 1994, most viewers apparently watch the established services. Despite gains in basic cable network ratings, it remains to be seen whether they can score consistently good ratings with original programs, especially series. Although TNT's *Good Ole Boys* achieved a 6.3, the top 100 rated cable programs for 1994 were sports, acquired theatrical movies, and off-network series—the fare of the broad-appeal (and largest) cable services. Further growth in the number of channels will make ratings increases difficult. Cable programmers and consultants are divided over how to best increase ratings. Some believe that heavy series production is necessary (USA Network); others argue for original movie production, heavy promotion, and more effective scheduling (TNT).

Niche services face a special challenge. They must create programs that both attract and expand their core audiences. For instance, TNN aims to continue to reach a broader audience yet remain consistent with its country and western theme. In response, the network is developing its own version of A&E's *Biography* and is producing original western movies that star famous country artists. However, programming is not always sufficient. Effective promotion remains crucial to compete with the broadcast networks and their powerful promotional machines. Even services with coverage ranging from 10 million to 20 million subscribers have a difficult time reaching enough viewers to satisfy advertisers, and young services reach fewer than 10 million homes. The tradeoff that some advertisers are willing to make is to sacrifice large numbers for specialized, hard-to-reach consumers.

Cable's Response

Cable has developed criteria other than ratings for selecting and scheduling national and local services and for attracting advertisers. Cable executives generally emphasize the demographic or psychographic **homogeneity** of viewers of a particular service. Viewers of MTV, for example, are alike in age and interests; viewers of Lifetime are mostly women. A second and related strategy is **zoning,** dividing an **interconnect** into tiny geographic

10.4 MAP OF BROADCAST MARKET SHOWING CABLE FRANCHISES

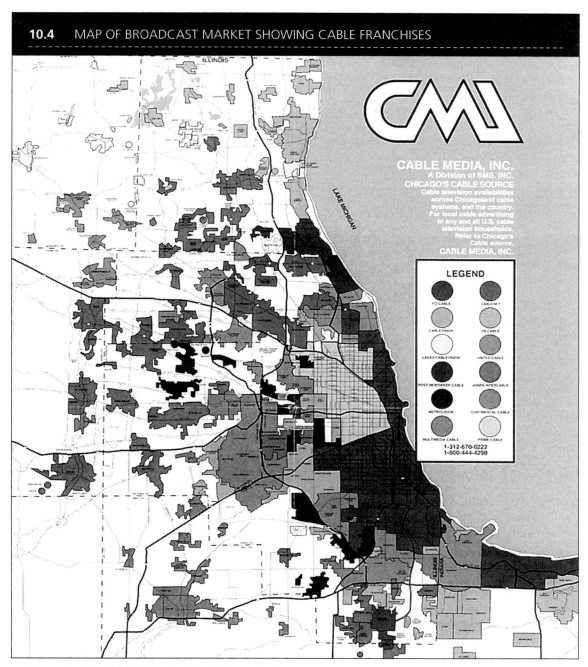

Source: Courtesy Cable Media, Inc. Used with permission.

areas to deliver advertising, which permits local businesses to purchase low-cost ads that reach only their neighborhood. Advertising interconnects are arrangements for the simultaneous showing of commercials on ad-supported services. Although interconnects are cable's primary strategy for increasing the size of salable audiences, they generally occur only in and near large markets, which leaves thousands of cable systems with unsalable (too small and undefined) audience sizes. A third strategy is **roadblocking,** scheduling the same ad on all cable channels at the same time so the advertiser's message blankets the cable interconnect (see Chapter 9). Roadblocking, in theory, keeps grazers from using their remote controls to avoid commercials, although noncommercial channels are available.

Cable networks are analogous to radio stations in a single market: numerous and fragmented. No one can deny their media reach, but few can figure a way for each individual cable service to compete with any of the individual broadcast networks. In some sense, cable programmers must focus their strategies on hard-to-reach audiences, just as radio programmers do.

While no single cable network comes close to delivering the same audience of the lowest-rated broadcast network (in 1996, the WB), collectively all basic cable channels cut into the combined audience share for the major networks. Discounting UPN and WB, the four-way race for broadcast networks (ABC, CBS, NBC, and Fox) accumulated a 65 percent total share of viewers in prime time for February 1996, down from 71 percent a year earlier. Basic cable increased from a 24 percent share to a 29 percent share for the same period.

LAUNCHING A NETWORK

There was a time when launching a new cable network meant selling some advertising time and collecting carriage fees from multiple cable operators (MSOs). However, not only are MSOs less willing

to pay carriage fees but the combined effects of cable rate re-regulation, tiering, limited channel capacity, and increasing competition for advertising has changed the environment in which new services are established. In the words of one consultant, "There's a big difference between a launch date and going on satellite. . . . On the other hand, . . . you can't launch unless you announce you exist."[11] Consequently, as these new services are born, they are forced to find different ways to establish themselves.

One way to facilitate distribution is not to charge cable systems for carriage. International Family Entertainment (The Family Channel) does not charge operators to carry its fitness network, Cable Health Club. To cover its costs, Family sold minority stakes to two strategic partners: sponsor Reebok International and major cable programming company Liberty Media Corporation. But many cable program suppliers claim that they need the revenue stream from cable system operators to help cover the costs of programming licenses. Thus, Arts and Entertainment seeks carriage fees from cable operators for its spinoff network, The History Channel.

While many MSOs claim that they can no longer pay such carriage fees, an A&E executive has argued that most MSOs are willing to pay for high quality programming from reputable program suppliers. However, Time Warner Cable of New York City refused to pay the 25-cent-per-subscriber carriage fee asked by Fox for its fX service; as a result, fX is not seen in Manhattan. In contrast, Television Food Network, which guaranteed 10 years of free carriage to charter cable systems at its debut in 1993, appears on the Time Warner system.

Some cable networks have launched by reversing the traditional model of carriage, paying MSOs to carry them. QVC's sign-off service Q2 offered cable system operators a one-time fee of up to $5 per subscriber to get carriage. Another shopping service, the Black Shopping Network, bought leased time on local cable systems in selected markets, paying each cable system about $250 an hour to air its programming.

Another way to improve distribution of a new cable service is to give MSOs a stake in the network. For instance, Rainbow Programming Holdings, the programming division of Cablevision Systems Corporation, launched The Independent Film Channel in at least 2.5 million homes served by the Cablevision MSO. Similarly, Jones International used its affiliated Jones cable systems to introduce its Jones Computer Network as well as its spinoff Product Information Network. TCI launched its own spinoff services that included a computer-oriented channel—TCI/Microsoft Channel—and tv!, an "incubation" channel that telecasts blocks of programming from a variety of new services. Equity stakes by MSOs helped establish other planned networks such as The Golf Channel, a pay service of Adelphia Communications, Cablevision Industries, Comcast, Continental Cablevision, Newhouse Broadcasting, and Times Mirror. However, for many proposed networks, especially those without the resources of a major programmer or MSO, a viable launch necessitates a costly waiting game.

In the process of waiting for expanded channel capacity, many proposed services remain in a holding pattern, and some never are launched. (See 10.5 for a listing of failed launches.) In the words of one observer:

Many of these can all too appropriately be called "hopefuls"—because hope is all they have. A majority of these wannabes (they can hardly be called players) are facing affiliate hell, without dime one of MSO backing and not a speck of programming to their name. It wouldn't be an exaggeration to say that a substantial part of the action consists of entrepreneurial hallucinations that exist in concept only.[12]

Because of excessive start-up costs, there have always been difficulties launching a new cable network. Start-up costs typically vary from $40 million to over $100 million. It cost Fox $100 million to launch fX with its mix of reruns and original programming. In addition, new networks pay from $100,000 to more than $200,000 monthly to lease satellite transponders—a total of $1 to $2 million

10.5 SOME FAILED LAUNCHES: WOULD-BE SERVICES THAT NEVER MADE IT

- Americana Television Network
- GameNet
- Good Health Channel
- Home Interactive Television
- The Medical Channel
- National Access Television
- National/International Singles TV Network
- OnQ
- S: The Shopping Network
- Sports Recreation Network
- The Therapy Channel

annually. Six million dollars will get a service its own transponder, of course. According to estimates from a Discovery executive, a new network with high quality programming will need an annual revenue of about $200 million to stay afloat—which is what it takes to keep The Learning Channel going. While launch costs are a major hurdle, at least they are definable, unlike the wait for channel capacity.

Outsource Services

Some networks are paying marketers to help them launch. Specifically, to reduce in-house overhead and spend more on programming, many new cable networks leave their business development, marketing, advertising sales, and distribution needs in the hands of outsource firms such as Vision Group Inc. (VGI), Comspan, Team Services, and New Networks Inc. The overriding advice from these firms is that the network should become a multi-revenue stream entity by reducing or eliminating dependency on subscriber fees while generating income off ad sales, home videos, DBS/telco/

10.6 DELAYED LAUNCHES: SERVICES DELAYED AT LEAST ONCE

- The Auto Channel
- BET On Jazz
- Classic Sports Network
- The Gospel Network
- The Lottery Channel
- The Military Channel
- Planet Central Television
- Singlevision
- Talk TV Network
- Women's Sports Network
- World African Network

wireless distribution, home shopping, and online relationships.[13] Several outsource firms encourage their clients to establish an Internet presence before going to cable. A budding programmer's first step can be obtaining a world wide web site for around $30,000. This helps build a brand name among a fairly prosperous demographic group that surfs the net regularly. It also attracts advertisers and can initiate additional revenue opportunities. In one case, the Jackpot Channel established a "Jackpot Zone" Internet space that contained information on gaming destinations, odds, and other relevant statistics, and even computer bulletin boards. However, the first step of most clients of these firms (mostly those without MSO backing) has been to push back their premiere dates (see 10.6).

Sheldon Altfield, a TV show producer and founder of The Silent Network, a service for the deaf and hearing-impaired, is an adviser to would-be cable networks. He conducts seminars around the country on how to start a new cable service and has a book, *How to Start Your Own Cable TV Network*. Among his advice to network entrepreneurs:

- At least five people have the same idea as you. Success depends on execution.
- Start small, a two- or three-hour programming block somewhere. BET started out as a Friday late-night portion of USA.
- Network for financing through sources such as those one meets at Chamber of Commerce functions, or look to overseas investment firms for support.
- Aim for a particular audience, then reach out to community representatives in that group.

Altfield has been surprised by the number of people anxious to start a network. He believes that all the hype over the information superhighway has encouraged people to "do their own thing."[14] Unfortunately, most have no idea how to get started. Altfield's views on the various needs for network survival are listed in 10.7.

Cable networks, mostly those with MSO support, have used various strategies to launch and market themselves. Many unique efforts stand out in the crowded field of hopefuls. For instance, The Game Show Network and fX visited towns and toured malls with various kinds of stunts. BET on Jazz and Ovation cosponsored entertainment festivals and concerts. Home & Garden Television personnel visited flower shows and music festivals.

Incubation strategies have become more traditional (and successful) among new cable networks. Sheltered launches help new networks establish themselves before moving full speed ahead. Americana Television, a 24-hour country lifestyle channel, got its start as a part-time service on Nostalgia Television. Viewers could watch a BET on Jazz program on BET before Jazz Central launched. Turner Classic Movies showed up on TNT, and Cable Health Club was initially part of The Family Channel. To gain sampling, newer networks such as Game Show Network, The Golf Channel, Sci-Fi Channel, Turner Classic Movies, and The Cartoon Network have also turned to DBS for distribution. One final strategy, and a solution to low distribution for new networks, is **piggybacking**

10.7 NETWORK START-UP "SURVIVAL KIT"

Start-up network needs, in order of importance:

- Distribution
- Stable regulatory environment
- Carriage and infrastructure expansion incentives
- Deep pockets
- A la carte distribution
- A well-constructed business model
- Clear niche programming agenda
- Aggressive brand marketing
- Experienced employees

Source: *Cablevision,* 25 July 1994, p. 35.

10.8 TOP 10 NEW SERVICES

1. America's Talking (became MSNBC in 1996)
2. Cartoon Network
3. ESPN 2
4. fX
5. The Golf Channel
6. The History Channel
7. Home and Garden Television
8. Sci-Fi Channel
9. Televison Food Network
10. Turner Movie Classics

Source: *Broadcasting & Cable,* 28 November 1994, p. 10.

or sharing a channel with another service. News-Talk Television launched with 4 million part-time homes as well as 3 million full-time homes.

Until cable system channel capacity expands nationwide, a high mortality will continue among new services. No matter what a network's programming entails, limited distribution into America's cable households will make it difficult to cover operating costs. Thus, three basic ingredients are needed to survive: a good (programming) idea, smart people behind the idea, and money.

In addition, new cable services need to be flexible with tiering, pricing, and packaging. At least two major outcomes will result from this potentially over-crowded cable environment: first, cable operators will remove older foundation services that have become stale in favor of new services; and second, and more common, start-up services will sell out to other (larger) networks. Due to the high cost of maintaining a single network infrastructure in general and of programming in particular, a service that is comarketed with several other networks simultaneously reduces sales, mar-

keting, and engineering/production costs. Further, it helps to be able to lose money through sister companies.

Nevertheless, to compete, a cable network's pricing and program schedule will determine its survival or extinction. If there is a bottom line to the economics of launching and maintaining a cable network, it is the programming. The ten spinoff cable networks most likely to succeed, according to programming executives at seven of the nation's ten largest MSOs, are listed in 10.8.

Aftermarkets

The licensing of many American movies and television programs follows a pattern beginning with the most profitable U.S. markets and ending with international distribution. Basic cable networks bid directly against local broadcast stations for the rights to popular movie packages and off-network television series. Because of the way original contracts for most series are written, cable services pay much lower **residuals** than broadcast stations do. Residuals are payments to the cast and creators

every time the program is shown. Licensing fees for cable networks can be as much as $100,000 per episode, lower than for broadcast stations.

As a result, basic cable television has become a key **aftermarket** in the progression of sales of movies and programs, generating hundreds of millions of dollars in profits for U.S. and foreign program distributors. Since the late 1980s, the largest cable networks have consistently outbid broadcasters for first rerun rights to newly available hour-long adventure and drama series and even some half-hour situation comedies. (As discussed in Chapter 3, in syndication, hour series are less useful to broadcasters, and even some successful action series such as *Magnum P.I.* underperform half-hour sitcoms.) A few theatrical films have gone straight from theaters to basic cable, and many European television series go directly to cable. Basic cable also has become a **foremarket** for some programs that later appeared on U.S. broadcast stations. For example, *Politically Incorrect* migrated from Comedy Central to ABC in 1996.

Traditionally, only a few original cable programs made the jump to syndication. But a growing number of attempts are under way as cable networks pump revenues into original programming. The Family Channel is using its co-owned syndication company, MTM, to distribute its off-cable game show *Trivial Pursuit*. When MTV syndicates its *MTV Video Music Awards* it sometimes receives a higher rating in a replay on New York stations than it does during its original MTV broadcast. HBO's *Tales from the Crypt* has enjoyed some off-cable success on Fox as did *Dream On* and the *Larry Sanders Show*. Cable networks want to own their own programs to benefit from both domestic off-cable syndication and the growing international marketplace.

In another twist, several prime-time series canceled by U.S. broadcast networks became successful on cable when additional episodes were produced; *Molly Dodd* and *Crime Story* are two notable examples. And BET picked up *Out All Night* after it was quickly knocked off NBC. Cable networks can often produce at a lower cost than other sources. Nickelodeon's sitcom *Hi Honey, I'm Home*, aired on both ABC and Nickelodeon and was produced for about the cost of most prime-time situation comedies. (The typical cost for a half-hour show is about $500,000; cable can produce shows from $350,000 to $400,000.)

SIGNATURE PROGRAMMING

Tough competition for viewers drives most cable networks to strive for **signature programs,** unique programs or a pattern of programs that distinguish it from the competition. Signature programs create a well-defined image for the network and breed a set of expectations for both audiences and advertisers. These expectations, whether positive or negative, help viewers select which channels to watch and lead advertisers and their agencies to expect that advertisements on some channels will or won't be effective. A lack of program definition, or absence of signature programs, killed off several early cable services.

Four major types of signature programs appear on cable program services. The first consists of *original movies or series* not shown elsewhere, also called made-for-cable movies and programs. Some original film titles are TNT's *Avenging Angel, The Good Old Boys,* and *Kingfish.* Original series titles include USA Network's *Problem Child* and *Itsy Bitsy Spider* and The Family Channel's *That's My Dog* and *Country Music Spotlight.* Although they are expensive to produce, they are highly promotable and attract new viewers more than repeat programming. A second type of signature programming consists of *narrow theme genres,* such as all live nightclub comedy or all shop-at-home or all instructional programs. BET's *Comicview* is an example of the comedy nightclub genre. A third type consists of programs for a *niche audience,* or viewers with a narrowly defined set of interests or within a targeted demographic group. For example, USA Network's youth-oriented programs include *Street Fighter* and *Highlander: The Animated Series.* The fourth, and least common type of signature pro-

gramming consists of the *cable exclusive*, programs shown once or twice on the broadcast networks but not shown before on cable.

Vignettes

A growing genre in cable are vignettes, or short-form **interstitials**. This type of short-form programming, traditionally a staple of pay services and used between movies that end at odd times, is now finding its way onto basic cable services. Comedy Central spends about three minutes per hour on interstitial programming, including *Topicals*, quick skits on the day's news, and *Pipeline*, clips from stand-up comics. While the primary purpose of vignettes is to promote branding, they also serve as "back-door pilots." Nickelodeon saw interstitials as a way to boost the network's brand name and began putting more money into vignette development, realizing that they are far cheaper to produce than half-hour pilots. Moreover, vignettes can be aired repeatedly to gauge viewer interest. Nickelodeon's *The Adventures of Pete and Pete* series started in short-form, and the network's preschool block used interstitials to test the waters for a new Muppet show.

Many cable networks use interstitials even though the airtime could be sold to advertisers. For example, *Perspectives on Lifetime*, a series of editorials and interviews tied to issues such as breast cancer awareness or events such as Black History Month, contributes to the overall mosaic of the channel. Lifetime has even experimented with live hosting between programs to achieve a seamless look with no commercials on the hour or half-hour, thus keeping viewers away from their remote controls.

For start-up networks, vignettes can help attract channel surfers. For instance, the Sci-Fi channel airs *Faster than Light Newsfeed*, a fictional newscast from the year 2142 that features a holographic anchor. Before NBC converted it into a 24-hour news channel, the America's Talking channel used installments of its original soap opera *Cable Crossings* between shows, providing a be-hind-the-scenes look at a fictional cable network. In the words of one executive, "When you go surfing at the top of the hour, most networks are at the commercial. . . . If you hit on America's Talking, you may find yourself in the middle of a steamy love scene, and you may stop to watch."[15]

Marathons

Marathons, or all-day, all-night continuous program scheduling of the same series, often are used by cable networks to counterprogram major broadcast events like the Super Bowl. Marathons are also scheduled during holidays, protracted bad weather periods, or any time viewers are likely to turn into "couch potatoes." There have been plenty of examples: Leading up to and on Mothers' Day, WTBS gave viewers a *Leave It to Beaver* marathon that included Beaver's mother June Cleaver (Barbara Billingsley) as the host; Nick at Night provided a week-long "Marython"—the return of *The Mary Tyler Moore Show*. During a Super Bowl, The Family Channel ran 14 hours of *Bonanza: The Lost Episodes*, while Nostalgia Television ran 14 hours of *Family*, a 1970s drama, and A&E offered 13 hours of *Masterpiece Theatre's Jewel in the Crown*. Marathons can generate exposure for a newly acquired show as well as remind viewers that a popular show appears on the network.

Because the networks promote marathons heavily, they usually perform well—even better than their average programming. USA's 56-hour *World Premiere* movie marathon on New Year's Day averaged a 2.4 rating with each daypart exceeding its national average. Seven of the 28 movies had ratings of 3.0 and above. Even The Learning Channel's (TLC) eight hours of *Beakman's World* on New Year's Day scored a .6 prime-time rating compared with TLC's prime-time average of .3. TBS ran "8 Great Hours of Andy" on the Sunday before a Super Bowl as its "No football. No problem." event. Trivia **teasers** with bits of information about the *Andy Griffith* show ran throughout the marathon. As a result,

the event surpassed TBS's average fourth quarter rating and household delivery for regular Sunday afternoon programming by 48 percent.

In addition to capturing a larger audience, marathons can cash in on advertising sales. Networks can sell marathons as special programming or as an upgrade to enhance an advertiser's schedule. Most marathons are sold as "TBD" (to-be-determined) specials or move in the **scatter** marketplace (as opposed to **upfront** purchases based on a network's next 12 months of scheduled programming). Planning for marathons rarely takes place far enough in advance to be part of the upfront marketplace. One exception occurs when advertisers purchase big blocks of time. Toy and game manufacturer Hasbro bought 14 hours in a block on *The Great American Toon-In* on the Cartoon Network, and also purchased 700 30-second spots for approximately $1 million in various places on TBS, TNT, and the Cartoon Network. Apparently, both Turner and Hasbro were happy with the deal. Not only is effective promotion a must for successful marathons but, if scheduled too often, they can burn themselves out. The challenge is to make marathons fresh and desirable, with a good dose of fun.

ORIGINAL AND RERUN PROGRAMS

Despite the continued use of off-network programming and, to a lesser extent, vignettes and marathons, the dominant trend for cable networks is toward more commissioned, coproduced or solely produced original programming. The shift began in the early 1990s when the USA Network and Turner Broadcasting's TNT made a commitment to original movies. By 1992, about three-quarters of cable programming overall was original to cable or "first run" of some sort. Most were of the low-budget variety, but in recent years cable networks have increased their budgets for original programming.

One result of the increase in cable's original programming is that conventional distinctions among broadcast network, syndicated, and cable program services have faded. In the words of NATPE president Bruce Johnasen: "With so much uncertainty surrounding the much-promised 500 channel universe of tomorrow, the only thing we know for sure is that programming will be the key to the success of any new delivery system."[16] Cable networks use original programs to distinguish their programming from that of their competitors. The issue of **branding**—defining and reinforcing a network's identity—has become more important as the multichannel universe expands. Not surprisingly, the 20 or so foundation services are leading the charge in original programming, while the newer niche services are a bit more cautious about spending at a rapid rate.

CONTENT AND AUDIENCE APPEALS

It is useful to examine cable programming networks in terms of their content and audience appeal because competition for shelf space on cable systems and advertisers occurs largely among similar services (see 9.5 for graphic display). Some basic services such as the USA Network consist of a broadly appealing mix of program forms similar to those of broadcast television; these are the broad-appeal networks (or full-service) and they include **superstations.** Superstations are typically independent broadcast television distributed by satellite to cable systems across the country or within a given region. As previous discussions have suggested, most cable services—and especially the newer and proposed services—are niche (or theme) and microniche (and multiplexed subniche) services that focus on a particular type of program content or target a specific demographic group.

The top 20 cable networks by number of subscribers and annual revenues as of 1995 are listed in 10.9. These services have subscriber counts of at least 40 million. By the mid-1990s, it was generally believed that *25 million homes* was the minimum reach for a service to project economic stability and attract enough advertising for profit-

10.9 TOP 10 CABLE SERVICES (BY TOTAL ANNUAL REVENUES)

Rank	Network	1994	1993	% change
1	ESPN	$403.4	$342.8	17.7
2	TBS	356.2	298.5	19.3
3	USA	327.2	311.8	4.9
4	MTV	249.8	190.8	30.9
5	TNT	235.0	209.5	12.2
6	Nick	216.0	49.0	45.0
7	CNN	204.3	197.1	3.7
8	Lifetime	189.8	186.9	1.6
9	Discovery	137.2	119.9	14.4
10	A&E	125.0	101.7	22.9

Source: *Advertising Age*, 27 March 1995, p. S-2.

ability. However, as the number of national programming services continues to grow, the minimum reach should drop. For instance, ESPN2's reach of close to 20 million homes (in 1996, after only two years of operation) made it an economically successful network. Like ESPN2, America's Talking (10 million subscribers including MMDS and SMATV) benefited from carriage agreements tied to retransmission consent.

Several national cable services daypart in a manner similar to the broadcast networks by offering a broad program array targeting a mass audience. These broad-appeal services—superstation TBS, Turner Network Television, USA Network, The Family Channel, and WGN (superstation)—are among the most popular of all cable services. Nearly every kind of program seen on a broadcast network has been tried by these full-service cable networks, although not all have proved successful. Despite the shift to more original cable programming, off-network syndicated hours such as *Murder She Wrote, Thirtysomething,* and *Rockford Files* remain very popular with audiences of broad-appeal networks.

Broad-appeal networks generate income for the sale of commercial time because they reach the same mass audience sought by the broadcast networks. Of course, the cable networks reach far fewer viewers, so the price of commercials is less. In some cases, advertisers use the lower rates charged by the cable networks to negotiate for lower rates from the broadcast networks. If the cost-per-thousand (homes reached) is too high for broadcast networks, many advertisers spend less for over-the-air networks and supplement their audience reach by purchasing spots from the cable networks.

BROAD-APPEAL NETWORKS

Throughout the 1980s and 1990s, USA Network was the top-rated basic cable network. The 24-hour broad-based entertainment network airs original series and movies, off-network series, specials, sports, and programming for women, children, teens, and adults. In one of the biggest off-network

program deals, it scored exclusive rights to *Murder She Wrote, Miami Vice,* and *Quantum Leap. Wings* and *Airwolf* have also been successes on USA off-network in prime time. In other dayparts, USA has aired *MacGyver, Knight Rider, Magnum P.I.,* and *Major Dad.* The network also acquired off-network soap operas such as *Search for Tomorrow,* syndicated game shows such as *Tic Tac Dough* and *$100,000 Pyramid,* and the reality-type show *Candid Camera.*

Despite strong off-network shows such as *Murder She Wrote* and *Wings* and successful theatrical releases such as the *Star Wars* trilogy, **USA Network** has increased its original program output. The network also has revamped its movie strategy away from its traditional "women-in-peril" offerings to higher caliber dramatic presentations and literary-type productions. Such original programs make up about half of the network's prime-time schedule, with shows such as William Shatner's *TekWar, Silk Stalkings, Weird Science* and, in the realm of sports, *WWF: Monday Night Raw.* USA also has added original animation for kids to its daytime lineup (as have other networks). The network rebuilt its daytime schedule by repackaging shows with live wrap-around hosts, much like its popular *Up All Night* late-night format. Finally, USA has been one of the largest producers of original movies—as many as 20 to 25 per year (some for its Sci-Fi Network). However, because USA Network's movies have declined in ratings, its plans are to produce fewer titles and increase its promotional efforts. The network has shifted to producing remakes of classic movies from the libraries of parent companies Paramount and MCA/Universal. USA Network spent $175 million on original cable programming in the 1996–97 season, including 176 original episodes of comedy and drama, 20 new prime-time movies, and a miniseries produced by Hallmark.

TBS, second only to USA Network as the country's leading basic cable network, also relies heavily on off-network syndicated programming. In 1995 Ted Turner (then-owner of WTBS) announced the complete conversion of WTBS the superstation to TBS the cable network (using the WTBS broadcast license for local programming for Atlanta). He had been reluctant to make such a move earlier because of uncertainty about the ability to carry baseball games featuring the Atlanta Braves (also owned by Turner). The one-time superstation is trying to broaden its audience to include more shows appealing to younger demographics. Because Time Warner purchased Turner Broadcasting in 1995, some observers believed that the WB network (also seen on superstation WGN) might receive an audience boost because of programming synergies between the two media giants.

TBS has continued with its successful formula of sports, off-network sitcoms, and movies, and series such as *Live from the House of Blues Presented by Pontiac Sunfire* attract younger viewers. Despite occasional original programming such as *The Friendship Games,* TBS has no plans to become a major first-run service. According to president Terry Segal, "Our goal is to find the right mix between popular, enduring programming and first-run product that will help us further carve out our identity."[17] In addition, the network continues to produce high-profile, multipart documentary series such as *Hank Aaron: Chasing the Dream* and *Driving Passion,* a four-hour two-part look at the history of automobiles in the U.S.

TNT offers a showcase of vintage motion pictures, exclusive original films, children's programming, sports, documentaries, and special events. TNT is among the most active producer of made-for-cable movies. Its parent, Turner Entertainment Group, owns both Castle Rock and New Line Cinema. The network is also developing some high-profile specials with ties to its spinoff network, Turner Classic Movies (TCM). Finally, the network's largest single original programming investment continues to be in sports production, including games from the NBA and the NFL and world championship events like the Winter Olympics.

The Family Channel's lineup has included reruns of *The Waltons* and *Bonanza* and other family-oriented programs from the MTM library acquired by Family's parent company, International Family

Entertainment. Although many of the library's shows are tied up in domestic syndication or on Nick at Night, those contracts will eventually expire, making series such as *St. Elsewhere, Hill Street Blues,* and *Lou Grant* available. According to one Family Channel executive, "Network television has produced great family shows over the years and still does. We feel there will always be a certain number of offnet shows on the Family Channel. We can balance our schedule with shows we make that distinctively brand us and ones we buy that reinforce that."[18]

The **Arts and Entertainment Network (A&E)**, formerly a niche service focusing on cultural/performing arts, became a broad-based entertainment network in the mid-1990s. A&E's programming formula consists of biographies, mysteries, documentaries, and specials that range from the performing arts and drama to classic movies and comedy. A&E broadened its formula in the mid-1990s with its first prime-time off-network series, *Law & Order.* The network increased its original programming from about 10 percent in the mid-1980s to about 65 percent by the mid-1990s. Although the network has long-standing ties with the BBC and other international coproduction partners, its U.S.-based productions increase steadily.

Other networks that utilize popular off-network shows are BET, with *Roc* and *What's Happening Now!,* and TNT with *In the Heat of the Night.* Fox's basic cable service, fX, relies on off-network shows such as *Batman* and *Green Hornet.*

NICHE NETWORKS

Comedy Central provides stand-up, sketch, movies, talk shows, improvisation, comedy specials, and classic comedy series. About 40 percent is licensed product, the rest original; these proportions should remain fairly stable because the mix has been successful. Comedy Central carries the off-network sitcom *Soap* and reruns of the comedy classic *Saturday Night Live, It's Garry Shandling's*

Show, and *The Tracey Ullman Show.* Other less notable off-network programs it carries are *The Duck Factory* and *The Famous Teddy Z.* Comedy Central succeeded in popularizing *Mystery Science Theater 3000* and *Politically Incorrect with Bill Maher,* two of its original programs. The network also provides a humorous perspective on current politics and news events sometimes accompanied by commentary, specials, and live coverage.

Lifetime, an entertainment and information service primarily for women, is moving away from its dependence on acquired programming to carrying more original programming. Lifetime airs such off-network shows as *Sisters, Cagney and Lacey, Designing Women, Spencer: For Hire, Unsolved Mysteries, L.A. Law, Midnight Caller,* and *The Commish.* Lifetime avoids the term *reruns,* preferring to promote these programs as "encore performances."

Nickelodeon promotes itself as "the power of 2 networks packed into 1," with Nickelodeon scheduling mostly original programming for children and **Nick at Nite** consisting of older off-network programs, most from the 1960s and 1970s. Nick at Nite bills itself "for the people who grew up with television," and has converted reruns into a genre that it calls "classic TV."[19] Nick at Nite promotes itself to advertisers as a "safe, wholesome environment . . . where adults and kids come together" to watch Emmy Award-winning shows like *Patty Duke, I Love Lucy, The Mary Tyler Moore Show, The Dick Van Dyke Show, Dragnet,* and *Alfred Hitchcock Presents.* The slogan "2 networks packed into 1" has proved an understatement, because starting in 1996 Nick at Nite began a second rerun channel (called TV Land) featuring even more repackaged programs but in a wider variety of genres than Nick carries. The spinoff service also schedules one-hour dramas.

Although talk shows traditionally are not used as reruns, **E! Entertainment Television** runs *Late Night with David Letterman.* With some 35 percent acquired programming, E! is acquiring more original programming to give the network an identity. For example, E!'s highest rated series, *Talk Soup,* a daily roundup of talk shows, has helped attract

attention to the network. E! has 50 in-house producers who develop some 30 new program ideas at any given time, although about one-third of its schedule is reruns.

Most of the cable program services carry a single type of programming or target defined audiences. To build and maintain a unique identity, niche services have increased their development of original programming but schedule a mix of original and off-network programming.

Sports

While several national services provide varying amounts of sports programming on cable, **ESPN** is the undisputed leader. ESPN produces more than 4,500 live or original hours of sports programming per year, including the National Football League, Canadian football, Major League Baseball, college football, NCAA basketball, National Hockey League, auto racing, golf, boxing, tennis, men's and women's bowling, thoroughbred racing, world cup skiing, major league soccer, college baseball, cycling, water sports, track and field, and arena football. Special events include the NFL draft, college bowl games, Baseball Hall of Fame induction ceremonies, World Cup soccer, and the America's Cup. ESPN's high quality presentations of such events have made it one of the most popular basic cable networks.

Labor problems in the major sports leagues and launch of the competing NewSport sports news network have led ESPN to develop new franchises outside major league labor turmoil and to expand its sports news programming. ESPN franchises include the *ESPY* awards ceremony and *The Extreme Games,* a week-long competition that features athletes in such extreme sports as bungee jumping, in-line skating, and mountain biking. Other original series on ESPN are *Baseball Tonight; Up Close,* the daily interview show; *SportsCenter; Outside the Lines; NFL Gameday; NFL Prime Monday; NFL Primetime;* and *College Gameday.* All ESPN programs include cross-promotional ties to **ESPN2**.[20]

Other sports services on cable include The Golf Channel, Prime Network, TNT, TBS, and super-stations WGN, WWOR, and WPIX. Newer and proposed microniche services include Chop TV, Classic Sports Network, NewSport Television, Outdoor Life Channel, Premiere Horse Network, Prime Sports Showcase, TRAX, and two women's sports networks. To gain sufficient revenues to overwhelm this new competition, from 1995 to 1996 ESPN nearly doubled its monthly charge per subscriber to cable operators from 55 to 90 cents. Some of the increased per subscriber cost results from the higher cost of rights fees for major events. As player salaries and rights fees escalate, one wonders if the system will collapse under its own weight. Nevertheless, the late 1990s were the backdrop for many proposed sports channels, including one between Turner Broadcasting System (TBS) and *Sports Illustrated* magazine to create a sports-news network similar to Headline News on Turner's CNN. ESPN responded to new competition with its own channel, ESPNEWS, launched in November 1996.

Music

MTV: Music Television was the first 24-hour music video service and has hung onto its high visibility by being unpredictable, irreverent, and on the cutting-edge spirit of rock 'n' roll, which is the heart of its programming. Besides being first and foremost about music, MTV is also about everything music is about—fashion, style, sports, movies, comedy, and current events. The network targets the young adult viewer and in so doing has often pushed the entertainment envelope and broken the boundaries of television. The network's unique graphic look, its cutting-edge documentaries and public affairs forums, original strip programming, concerts, news and, of course, music videos have made MTV an international name in pop culture. Although MTV has spun off an all-video service called **M2,** the network programs more than a thousand videos a week, along with about 20 hours a week of nonmusic programming. MTV seldom runs videos back-to-back, preferring instead to work its music into half-hour or hour programming series and specials. Some 10 different

music franchises exist, including *Alternative Nation, Headbanger's Ball,* and *Yo! MTV Raps.* The network has also gone into politics with *Choose or Lose,* into TV verite with *The Real World,* and into animation (and controversy) with *Beavis and Butthead* and the Emmy Award-winning *Liquid TV.* MTV not only is in about 60 million U.S. households, but its global affiliates reach 240 million homes worldwide. MTV has developed various international services—MTV Internacional, MTV Japan, MTV Asia, MTV Europe, MTV Latino, and MTV Brasil, and plans include deals that have been struck with South Africa, Doordarshan (India), and Apstar (Asia).

Another MTV Network, **VH1**, targets upscale viewers 25–44, with an emphasis on 25–34. The network overhauled its programming in the mid-1990s, eliminating many of its nonmusic elements and playing down artists that appealed to older viewers such as Billy Joel and Paul Simon while favoring artists Des'ree, Melissa Etheridge, Sting and, of course, Madonna. "Music First" appears in VH1's logo to improve its branding. During the day, VH1 programs 20-minute segments, somewhat like an all-music or all-news radio station. Each segment begins with a music video, follows with a host package (including album reviews and short artist interviews), a new artist music video, and then closes with a classic music video. Music videos featured on the network are about 70 percent current and 30 percent oldies. Long-form music-driven programming runs at night. VH1's signature programs include *VH1 Honors,* a live concert that celebrates top artists and their charitable work, *Fairway to Heaven,* an annual music and sports event that features charity golf, and the *VH1 Fashion Awards,* a live salute to music's impact on fashion (and vice versa).

The Nashville Network (TNN) bills itself as the number one source of country music entertainment, offering original concert specials and series, music videos, entertainment news, interviews, sports, and live variety shows. The 18-hour-a-day service, with such popular programs as *Club Dance* and *The Statler Brothers Show,* has also made some programming changes in the 1990s. While most of the network's programming is original, it has added limited series that provide access to artists who, because of their recording and concert commitments, cannot do 13 or more episodes. For example, *The Legends of Country Music* is a Thursday night concert series that focuses on a single talent for a few weeks at a time. TNN's parent company also owns Country Music Television, a 24-hour music video channel.[21]

Educational/Informational/ Entertainment

One of the most successful cable program services in this category is **The Discovery Channel (TDC)**. TDC provides informative entertainment in the areas of nature and the environment, science technology, world exploration, history, and human adventure. TDC has emerged as one of the premiere basic services on cable. In fact, one sign of its growth was the 1991 acquisition of The Learning Channel, an educational network that serves preschoolers to adults. TDC has moved from a dependence on off-the-shelf shows to original and commissioned programs. As noted earlier, many of TDC's programs were commissioned or coproduced with international or domestic partners. In the science and technology vein, *Invention* comes from Koch Communications, *Movie Magic* is coproduced with GRB Productions of Los Angeles, and *Next Step* is coproduced with KRON-TV, San Francisco. Programming that is not original is usually acquired from overseas and has not previously been seen in the United States. Another strategy used by the network is to update international programs by re-narrating or adding graphics to them. For example, TDC tightened the pacing of *Terra X,* an hour-long German production, cutting it into a half-hour show more suitable for American audiences.

TDC strips its signature category, documentaries, in the 5 to 8 P.M. time period. One of Discovery's most successful shows is Graham Kerr's syndicated cooking show, and the network schedules cooking and how-to shows during daytime dayparts despite competition from newcomers

like the Television Food Network and Home and Garden Television.

With the launch of separate Discovery Channels for Asia and Latin America (in Spanish and Portuguese), an additional criterion for selection of program becomes cross-continent appeal. These channels began with a "best of the best" approach, carrying popular domestic series like *Invention* and *Frontiers of Flight*, which in turn are supported by **interstitial programming** and billboards customized for the particular audience. According to the network's director of international programming, initially Discovery used "what has worked domestically then chisel[ed] away to what works in a particular region. . . . The goal is for Discovery as a whole to create original programming that's able to travel globally and co-productions that can carry over into other regions yet be aware of the sensitivities in various parts of the world."[22]

Virtually all of **The Weather Channel's (TWC)** programming is original. The information service provides current local, regional, national, and international weather information, including customized forecasts for travelers, sports fans, and pilots. TWC also produces features on how certain weather patterns affect people's lives.[23] Most viewers tend to associate TWC's programming with the local weather reports in the form of text (alphanumeric displays) from the National Weather Service. Like most cable networks, The Weather Channel has increased its original series and specials. The network has produced various specials in the *Forecast for Victory Series*, including *D-Day: Forecast for Victory* and *Battle of the Bulge: Forecast for Victory*.

A plethora of new and proposed educational/instructional services exist. Among the existing services are The Weather Channel, The History Channel, SCOLA, Mind Extension University (ME/U): The Education Network, Jones Computer Network, Deep Dish TV, The Idea Channel, and the Consumer Resource Network. Among the many proposed microniche services are the Global Village Network, Booknet, and the Career and Education Opportunity Network.

News and Public Affairs

Besides MTV and ESPN, **Cable News Network (CNN)** may be the most recognizable name in cable programming. Like TBS, TNT, TCM, The Cartoon Network, CNN International, CNN, and its companion service CNN Headline News, are all owned by Turner Broadcasting System, now a division of Time Warner. CNN provides 24 daily hours of in-depth news coverage to U.S. and international cable subscribers, including late-breaking stories, business news, weather, sports, and entertainment stories. Much of CNN's success is rooted in its early application of newsgathering technology, most notably that of communications satellites and "flyaways," portable satellite uplinks such as those that gave the world video and audio during the Persian Gulf War and the abortive coup in the former Soviet Union. However, the network's successes have been copied by broadcast networks, their affiliates and, of course, other cable services, reducing its edge. Specifically, CNN now has competitors in the continuous coverage of national disasters and such events as the O. J. Simpson trial. A persistent ratings slump in the mid-1990s led CNN to shuffle its anchors and introduce more scheduled programs, such as its durable interview show *Larry King Live*.

In the mid-1990s CNN developed two spinoff programs, *Calling All Sports*, a 1 A.M. sports call-in show, and *Talk Back Live*, an afternoon call-in program with a live audience. These two shows joined the ranks of other successful CNN original programs, *Crossfire, Moneyline, Inside Politics*, and *CNN Sports Tonight*. Most of CNN's original prime-time programming is part of the network's newsmagazine series, *CNN Presents*. For example, after CNN's extensive coverage of the O. J. Simpson murder trial, it produced a protracted program that examined the country's legal system. One difficulty is that viewers are likely to tune elsewhere if they tune into CNN to get the latest news and find a talk show. However, CNN's **Headline News** is always there, providing continuously updated half-hour newscasts.

The presence of CNN and its Headline News cohort led to a spurt in cable news services in the late 1990s. NBC, CBS, and Fox attempted to attract viewers to their all-news channels, which benefited from existing newsgathering operations. But first they had to compete for scarce channels on many cable systems. Although movie channels are abundant, most cable operators are reluctant to offer several news channels. NBC had an advantage in that its America's Talking channel (18 million subscribers in 1996) was readily converted to an all-news channel (MSNBC) in cooperation with Microsoft. Fox fought back by offering $11 per subscriber to cable operators who carry its all-news channel (normally, cable operators pay the channel per subscriber). Nevertheless, the original CNN, in normal times and with no real competition, only draws an actual tune-in audience of 400,000 worldwide during peak hours, despite occasional ratings spikes during news crises. One must wonder if there is sufficient demand for three all-news ventures.[24]

Like CNN, the **Cable Satellite Public Affairs Network (C-SPAN)** provided viewers with live coverage from the Persian Gulf and from the Democratic and Republican national conventions. Unlike CNN, C-SPAN provided virtually no commentary during its coverage and no commercials. One of the oldest national cable services, C-SPAN has existed since 1979 as a nonprofit cooperative owned by the cable industry. It provides gavel-to-gavel coverage of the U.S. House of Representatives and supplements this coverage with live and taped events from Washington, D.C. and around the world, viewer call-in programs, National Press Club speeches, Congressional hearings, and other features. Since 1986, C-SPAN II has provided live coverage of the U.S. Senate and other public affairs programming. Congressional employees control the cameras in congressional sessions, much to the dismay of founder and CEO, Brian Lamb. Lamb not only pleads for control of those floor cameras, he also lobbies for coverage of the Supreme Court. Despite the Court's refusal, Lamb has built a successful service with regularly scheduled programs such as *Washington Journal, Road to the White House, America and the Courts,* and *Booknotes,* a one-on-one interview program with an author.

Because C-SPAN/C-SPAN II's live coverage varies with the daily schedules of the houses of Congress, programming has to be continuously revised as events and their lengths demand. In addition to on-screen updates, C-SPAN provides updated schedules via telephone recordings. In spite of its preponderance of "talking heads" and lack of sophisticated visual images (C-SPAN hosts do not announce their own names), C-SPAN apparently attracts a significant, though never counted, audience. The network boasts about the quality of its audience, not its quantity. (See 10.10 for another view on this.) Interestingly, when Lamb offered a commemorative trinket to the first 500 callers on his *Booknotes* programs, the network reportedly was flooded with nearly 10,000 requests.

Neither service carries (spot) advertising, nor are programs interrupted for advertisements. The networks do offer occasional corporate or institutional announcements before and after programs, advocacy messages, and other types of plugs (corporate underwriters are no longer solicited). In terms of carriage, cable systems pay an average of three cents per subscriber for C-SPAN, and C-SPAN II is provided free of charge to systems that take C-SPAN. Cable systems are prohibited from **cherrypicking** one service with parts of the other. C-SPAN's limited funds and technical limitations pose formidable challenges to its plans to expand its foreign coverage. Nevertheless, C-SPAN III launched in 1995, and a fourth and fifth channel were planned for 1997. Congress recognized C-SPAN's value by admitting it to all committee hearings except those dealing with defense secrets.

CNBC provides public affairs information and financial news and reached 56 million homes as of 1996. New competition surfaced in the late 1990s from the CNN financial network (under the name "CNNfn"), which reached 4 million homes in

10.10 C-SPAN MOTIVATES VIEWERS

One indication of what some cable operators and subscribers really think of C-SPAN is the ploy used by one cable operator in New York City to encourage customers to pay their bills that are past due 115 days or more. Rather than block all channels and then deal with service complaints, Time Warner's Paragon Cable merely reprograms all 77 channels to carry the same program: C-SPAN. Once the deadbeat subscribers figure out what's going on, they hurry in to settle their accounts so that they will not have C-SPAN as their only cable option!

1996. Also, Dow-Jones and ITT planned a third financial news network for 1996 or 1997.

Several new and proposed services provide or plan to provide varying degrees of news and public affairs programming. Among the existing services are the All News Channel BBC World Channel, NewsTalk Television, Newsworld International, and The Weather Channel. Proposed services include NET: Political News/Talk Television, The Ecology Channel, and the Global Village Network.

Religion

Religious programming is one of the earliest types of cable programming, and it has undergone a major transformation in recent years. After the scandals involving tele-evangelists Jim and Tammy Bakker, services such as the Christian Broadcasting Network changed their focus—and sometimes their names (CBN became The Family Channel). The five established religious networks are Eternal World Television Network (EWTN), Faith and Values Channel (FVC), The Inspirational Network (TIN), the Trinity Broadcasting Network (TBN), and The Worship Network (TWN).

These networks possess tremendous clout among cable operators for three reasons. Most of these services also have broadcast affiliates that carry their programs, which helps popularize the network to a larger audience reached by cable. They usually pay lucrative carriage fees to cable operators; the most generous, TBN, pays up to $1 per subscriber—although systems have to sign up for a four-year commitment to get that rate. Finally, these networks are very popular among a vocal group of cable subscribers. When a Time Warner system in Milwaukee was considering replacing EWTN with FVC (a cable service created by the merger of the Vision Interfaith Satellite Network and ACTS, the Southern Baptist Convention), it was flooded with more than 600 letters and had a 60 percent increase in telephone calls—virtually all of them expressing opposition to any removal of EWTN. A subsequent poll of cable subscribers resulted in 30,000 responses in support of EWTN. One cable operator claims that he'd carry all the religion channels if he had the capacity.

TIN (formerly Jim Bakker's PTL Network) aims at the very people who have been upset by the way religious programs have disappeared from broadcast stations. Promoting themes such as "traditional family values," TIN has broadened its scope to include spiritually uplifting genres of original music, dramatic, and talk show programs. Meanwhile, FVC is trying to appeal to a more general audience by airing original programming such as a six-part miniseries based on the best-selling book *The Road Less Traveled*, featuring the book's author, as well as a daily series that examines contemporary events from a "values" perspective.

Most religious services are run by nonprofit organizations and face a revenue crunch as advertising dollars splinter in many directions. Religious networks hope that original programming will ease their burden, although that, too, requires money. TBN and EWTN continue to use tele-evangelism to attract viewers and their money, although the time spent on fund-raising has diminished over the years. TIN's primary source of revenue is the sale of airtime to religious program syndicators, who

are allowed a few minutes per hour to plead for funds. In addition, infomercials—mostly for "inspirational" products—take up about a quarter of the schedule. Another potential revenue stream comes from home shopping, which TIN has begun testing. Cable operators want to avoid creating "religious wars" by selecting one or another network for carriage and are letting subscribers choose which network is most appropriate for the community. Besides The Gospel Network, there are few, if any, new overtly religious networks being planned. The handful of existing national services will continue to battle for funds, programming, cable carriage, and viewers.

Home Shopping

Electronic retailing represented a $2.5 billion business by the mid-1990s, and home shopping networks were predicted to generate revenues somewhere between $20 and $100 billion by the year 2000![25] Cable operators have increasingly looked to revenues from transactional services to help pay for the new fiber lines and set-top boxes that must accompany channel expansion. Tempted by the expected channel availability in the late 1990s, new players in home shopping, including major retailers, catalog outfits, communications companies, and other specialty retailers, are setting their sights on this lucrative market.

QVC is the industry leader in retailing, with some 50 million subscribers and net sales of more than $2 billion. Cable operators receive a 5 percent commission from sales. The network offers consumers a wide variety of products (jewelry, apparel, collectibles, cookware, electronics, toys, and home furnishings) and schedules categories of products as "programs" (mostly airing live). QVC CEO Barry Diller is credited with bringing new attention, credibility, acceptance, and polish to both QVC and the home shopping industry in general following his 1992 purchase of the service.

QVC's success led to development of a new service called Q2, which replaced the floundering Fashion Channel. Q2 targets those who watch a

lot of television but have not yet made purchases from TV, offering a mix of unique and known brands in the categories of health and beauty, entertainment, electronics, sports, fitness, and home. Q2 combines regularly scheduled and unscheduled programs seven days a week. Q2 has two programming concepts: Q2 Weekend, targeted to active consumers, and On Q, a weekday feed geared toward younger consumers that features trendier clothing and accessories.

Home Shopping Networks I and II (HSN) are both live video retailing, each reaching between 25 and 30 million homes. The first of the nationwide shopping services, HSN uses celebrity hosts and mixes commission and per subscriber payments to cable operators. A third HSN service, Home Shopping Spree, goes to satellite dish owners and some broadcast stations. HSN has plans for launching a fourth service called TSM: Television Shopping Mall, featuring programs from leading retailers and catalog companies. It hopes to act as a "middleman" by making use of its television expertise while forestalling the entry of still more competitors. Of the more than a dozen home shopping entrants in the 1980s, only two survived into the 1990s, and the high number of failures has tainted the whole business for some years. Finally, HSN has joined forces with a potential competitor, Macy's, to target the upscale market. HSN will provide order-taking and shipping for the Macy's service, TV Macy's.

Valuevision, launched in 1991, is a general shopping service that evolved out of the former Cable Value Network (CVN). Unlike most other shopping services, Valuevision buys time from operators, paying them a flat fee for running the programming. One aspect of its branding strategy is a concept called "video shopping cart," which combines all of the customer's purchases for a 24-hour period into a single shipment with a single shipping and handling charge.

There are several new and proposed home shopping services of the microniche variety. They include Catalog 1, a joint venture between catalog retailer Spiegel and Time Warner; the

Black Shopping Network, for African Americans; Catalogue TV, a video catalog programming service; Cupid Network Television, with adult novelty love and romance products; Merchandise Entertainment Television, a celebrity-driven network; Telecompras Shopping Network and Via TV, two Spanish-language services; and Video Catalog Channel, an art, antique, and collectible service.

Ethnic/Foreign Language

One of the earliest basic cable services, **Black Entertainment Television (BET),** has benefited from corporate partnerships with Time Warner and TCI and from the wiring of America's urban centers to move beyond its roots as a part-time black music video service. Today BET is a 24-hour, full-service network that includes music videos, sports, sitcoms, concerts, specials, talk shows, gospel, and news and information targeted to African Americans. With more than 40 million subscribers (25 percent are white households), BET programming remains skewed toward music videos by black artists. It carries black-oriented music and some sports and public affairs. Its goal is to be the dominant medium for reaching African American consumers.

BET has added to its franchise video programs—*Video Soul, Video Vibrations,* and *Rap City*—to include such original programming as *Bobby Jones Gospel, BET News, Jazz Central, Screen Scene, Teen Summit, Lead Story, Comicview,* and *Out All Night.* BET has become the flagship service of a multimedia conglomerate that includes Action Pay-Per-View, *YSB* (Young Sisters and Brothers), and *Emerge* magazines, BET on Jazz, and a proposed radio network. Based in part on the success of BET; the spending power of black consumers; and the realization that blacks watch more television than whites, several new services have been launched that target African Americans. They include the aforementioned Black Shopping Network; the World African Network, a premium full-service network; and The MBC Movie Network, a pay movie service.

Two services dominate the Spanish-language programming on cable, **Univision** and **Telemundo.** Both services use both cable and television stations to provide movies, novelas (soap operas), talk and entertainment shows, sports, and news to viewers in the United States, Mexico, and Central/South America. Univision, the more successful of the two services, programs 24-hours a day (Telemundo airs 19.5) with an increasing percentage of those programs produced inside the United States. Univision also operates another nationwide service, movie channel Galavision. Univision promotes itself as a family network, programming something for everyone, while Telemundo targets the younger, more assimilated Hispanic. Telemundo reaches nearly as many Hispanic viewers, more than 5 million, but has much lower ratings. Telemundo operates 6 full-power stations and 1 low-power station, and has 20 broadcast affiliates and 250 cable affiliates. In addition to the aforementioned MTV Latino and Telecompras Shopping Network services, several new and proposed services target Latino viewers: NBC's news service, Canal De Noticias; Cine Latino, a premium and pay-per-view service; Gems International Television (for women); La Cadena Deportiva Prime Sports; and Telenoticias, a news service that CBS bought in 1996.

Other foreign language services include the International Channel, a service that provides multiethnic programming in 22 different Asian, European, and Middle Eastern languages; The Filipino Channel; TV Asia; TV5, a French-language service; and ANA Television, a network that provides news, public affairs, educational, and entertainment programming in Arabic and English to Arab Americans. Finally, there is Asian-American Satellite TV, a service providing Chinese-language news, television drama, movies, sports, educational, and entertainment programming via satellite from Asia. Such services should increase as America's ethnic population grows. The Latino population is projected to be the country's largest ethnic (minority) group by the second decade in the 21st century.

Movies and Arts

Several former pay services in this content category have switched to basic. Among the first to switch was **American Movie Classics (AMC),** a vintage Hollywood film service that also expanded its part-time schedule to 24 hours, although AMC repeats its daily cycle of films starting at 9 P.M. The movies are uncut and unedited, and host Bob Dorian provides brief commentaries and biographical material on the films' actors. There are no commercials, although AMC runs old newsreels and promotional material from Hollywood studios. AMC's original series programming includes *Reflections on the Silver Screen with Professor Richard Brown*, *The Movie that Changed My Life*, and *American Movie Classic News*.

Bravo is among the more recent switches to basic. Cable operators have had significant success in marketing the value of this type of change to subscribers. Bravo attracted 2.5 million new subscribers the first six months after moving from premium to expanded basic. Another feature popular with cable operators is that Bravo also provided marketing materials to help with the local transition. Bravo is a 24-hour film and arts network that presents independent and international films, performing arts, profiles, interview programs, musical programs, and programming for young people. The network accepts corporate underwriting. Among its more successful original programs are *Media Television*, *Inside the Actors Studio*, *Opening Shot*, and *ArtsBreak*.

Several cable systems have switched **The Disney Channel (TDC)** from pay to basic. The service promotes itself as having quality programming for the entire family. Besides movies from the Disney studios, TDC produces its own movies (*The Old Curiosity Show*), various "The Making of" specials (*My Fair Lady*, *Aladdin*, and *Pocahontas*), and series (*Mickey Mouse Club*, *Walt Disney World Inside Out*, and *Ocean Girl*). Other new and proposed services in the movie and arts category include Classic Arts Showcase, Ovation, Independent Film Channel, Applause, and the Sundance Film Channel.

As mentioned earlier, Turner's TNT runs many movies, including originals. TNT's spinoff network Turner Classic Movies (TCM) takes full advantage of the vast motion picture library owned by Turner (more than 4,000 titles). For example, Turner paid $1.2 billion for the MGM movie library and another $30 million for 300 classic titles in the Paramount library. Turner also owns the output of RKO Studios (which it subleases to AMC) and has access to the Warner Brothers library through its acquisition by Time Warner. Unlike TNT, TCM is an all-movie channel.

Movies have always been among the most popular of television's programming, but no one can predict how big the viewers' appetite for cable movie channels will be in the future. The advent of video-on-demand and online services suggests that where viewers go for movies is likely to change, eventually, and that fewer services will be needed.

PROGRAM GUIDE SERVICES

To provide the schedules of basic and pay cable channels to viewers, cable systems have three options: (1) provide a printed guide or provide schedule information to a channel listing service; (2) generate an electronic guide; or (3) contract for a video guide channel, called a **barker channel.** Because of the cost, printed guides are more common than electronic guides except in large capacity systems. *TV Guide*, which includes local stations and both broadcast and cable networks, continues to be one of the best-selling sources of program information.

Printed Program Guides

Three types of printed program guides are available: *single-channel guides*, *generic multichannel guides*, and *customized guides*. HBO sells its guide, the most widely circulating single-channel guide, to systems for inclusion in their subscribers' monthly statements. The HBO guide costs the cable system about 5 cents per subscriber.

Discovery and A&E merge their program guides with their magazines and sell them directly to viewers. However, few other basic services develop program guides.

Generic program guides cover several cable networks, usually the most widely distributed premium services and the top 20 basic cable networks. Generic guides carry advertising, and the same guide can be sold to many systems. These guides emphasize prime-time listings and of course omit local cable and broadcast programming. Some guides provide detailed descriptions of program content and include feature articles; others are bare bones. *Cableview* and *Premium Channels*, two of the most widely available generic guides, have about 30 to 60 pages and cost the cable operator between 50 cents and one dollar a copy (plus mailing costs). Two other printed guides are *Cable Connection Magazine* and *Cablewatch;* each costs subscribers about $1.50 a month.

Customized guides can serve as important vehicles for value-added promotions (games and contests) and can be supported largely by advertising. While TVSM's *The Cable Guide* provides only cable program network listings, its *Total TV* provides broadcast as well as cable listings. These guides have more than 100 pages of daily grids, features, and advertisements and cost the cable operator between one and two dollars per subscriber (plus mailing costs). An inherent problem with customized printed program guides is that the greater the number of channels, the more listings: To be complete, all programs on all channels must be listed half hour by half hour (or hour by hour), and guides become difficult to read and awkward to use. Creators of customized guides face a difficult dilemma: Should the broadcast stations that are carried on the system be included? If they are not included, viewers must use *TV Guide* (the grandaddy of customized guides), newspaper supplements, or other program guides. But including over-the-air channels greatly increases the number of listings, making the guides even more unwieldy, and they then duplicate information available elsewhere.

Electronic Guide Channels

Electronic guides tend to be used by subscribers (and to a lesser extent, by cable systems) as supplements rather than stand-alone services. Program information appears in alphanumeric form with some graphic elements. Unfortunately, at the time, video screens display only 20 to 22 lines of copy at one time. The much-anticipated shift to digital television will eliminate this ruinous limitation, so present-day electronic guides can only be considered stop-gaps until the real thing comes. The combination of digitalization and computers (in smart TV sets) will permit both immense complexity and user-friendly simplicity through menus and indexing.

Some services allow cable systems to place the names of important films in a heading on another text channel such as news or weather. Other cable systems dedicate a full channel to alphanumeric listings of program titles that continuously scroll, displaying a full day's programming, half hour by half hour. Because of the immense number of program titles appearing on most systems, listings typically include only the titles of featured films and specials on pay channels and exclude the descriptive material that is so popular with viewers in printed guides.

The most widely distributed barker channels come from Prevue Networks. They include Prevue Channel, a full-service promotion channel with more than 40 million subscribers; Sneak Prevue, a pay-per-view promotion service with 25 million subscribers; Prevue Express and Prevue Gateway, interactive program guides; Movievue, a pay TV/multiplex service; Interactive Program Data, a service for set-top converters; and **EPG,** a program listing service. TV Guide On Screen merged with the Prevue Channel in the late-1990s to form the largest guide channel. Another service, StarNet, is a cross-channel promotional service for both basic and pay programming; StarNet produces The Barker, the first all-digital pay-per-view promotion channel.

AUDIO SERVICES

In addition to video programming and data, cable systems can provide subscribers with audio and radio services. Like video services, cable audio and radio come in both basic and pay forms and are local and nationally distributed. In local cable radio, nearby stations are distributed to cable subscribers, usually free. In national cable audio, basic nonpay services exist; some carry advertising, and some do not. There are also pay services that charge subscribers a monthly fee for a series of specialized music channels, which are collected by the local cable operator and shared between the two entities.

Cable operators are skeptical about the size of cable audio's potential as a revenue stream. The buy rate for all digital audio services is about 15 percent of basic cable television subscribers, and marketing plans generally target the 40 percent of cable subscribers who have compact disc units. On the positive side, consumers have become more sensitive to audio quality since CDs became common and surround sound and other television/audio receiver advances were developed. This new awareness and appreciation of audio should spur the cable audio business.

Basic Audio

Several national services provide audio programming. The AEI Music Network features six satellite-delivered music channels that include classical, country, light rock, light jazz, current hits, and easy listening instrumentals. This is the leading service in foreground music for business. The Cable Radio Network promotes cable programming, provides adult contemporary music, talk, and specialized shows. This service is used as an audio component for character-generated channels, cable FM, and telephone "hold" music. AEI's music is CD quality. C-Span supplies C-SPAN Audio 1 and C-SPAN Audio 2. The former service provides international news and public affairs programming in English from Japan, Canada, China, Germany, and many other nations. The latter service provides live transmission of Great Britain's popular BBC World Service—24 hours of news, music, programs, entertainment, and cultural information. KJAZ Satellite Radio provides mainstream jazz with a strong emphasis on jazz education. The service contains advertising. Moody Broadcasting Network provides religious programming in a variety of formats including music, drama, education, and national call-in programs. SUPERAUDIO Cable Radio Service offers six FM music formats—classical, light rock, new age/jazz, country, classic hits, and soft sounds for background music for text channels. The service also carries three entertainment and information formats, including a reading service for the visually impaired (the In-Touch Network), the Business Radio Network, and Minnesota Public Radio. Yesterday USA is the national radio voice of the National Museum of Communication of Irving, Texas. The service provides old-time radio shows and vintage music free of charge without commercials. Finally, WFMT-FM from Chicago is considered a radio superstation that airs fine arts and arts talk 24-hours a day. The station is sold as a premium service by some systems and allows non-local advertising.

Premium Audio

The two leading premium services are Digital Music Express (DMX) and Music Choice (MC), formerly Digital Cable Radio. DMX provides up to 76 channels of continuous CD quality music for both residential and commercial cable subscribers. MC, like DMX, is a commercial-free service of CD-quality music. MC is offered as both a basic and premium service and features 30 channels of various music genres.

SUMMARY

Despite the overriding problem of distribution (channel capacity), several factors have contributed to a growth phase in the number of new

and proposed cable program services. Cable networks can be divided into categories based on content (programming) and appeals (target audience). Subniche and microniche services will compete for shelf space on cable system lineups as capacity increases. Many of these networks are seeking alternative distribution methods, such as direct broadcast satellite and online services. Most national networks carry national advertising and offer local insertions; many offer equity shares or rebates to cable operators. However, the most important incentive to carriage is exclusive signature programming, most of it original. These national networks will be bundled to viewers on tiers. Some will seek per subscriber fees from cable operators; others will pay cable systems or offer free carriage. About 15 or 20 foundation services command the highest licensing fees. These foundation services are either broad-appeal networks (USA Network, TBS, TNT, The Family Channel) or theme/niche services (MTV, The Nashville Network, Nickelodeon/Nick at Nite). Among the newest and proposed services are an abundance of microniche services that target specialized audiences and program narrowly focused content. Electronic program guides supplying full-motion video will become increasingly interactive as will audio services. Finally, audience evaluation remains a dilemma for most national programming services, although many of the foundation services are showing signs of audience growth as a result of the increase in original programming and promotion.

SOURCES

Broadcasting & Cable. Weekly trade magazine. New York: Cahners Publishing Co.

Cable Television Developments. Published an average of three times per year by the National Cable Television Association's Research and Policy Analysis Department. NCTA: Washington, D.C.

Cablevision. Monthly trade magazine that covers the cable industry. New York: Chilton Publications.

Cablevision's New Network Handbook. New York: Chilton Publications, 1995.

Cablevision's Blue Book. New York: Chilton Publications, 1995.

Electronic Media. Weekly trade publication coverage of electronic media news. Chicago: Crane Communications.

Multichannel News. Weekly trade publication. New York: Chilton Publications.

Picard, Robert G. (Ed.). *The Cable Networks Handbook*. Riverside, CA: Carpelan Publishing Co., 1993.

Whittemore, Hank. *CNN: The Inside Story*. Boston: Little, Brown and Company, 1990.

NOTES

1. Jim Cooper, "Little Big Fights," *Cablevision*, 5 July 1995, p. 10.

2. Under the FCC's going forward rules, cable operators could (1) offer services on an a la carte basis for whatever the market could bear and (2) create "new product tiers" (NPT) that would not be regulated. Further, the rules also permitted operators to duplicate basic (regulated) services on new product tiers, but only if those services remain on regulated tiers. (One exception allows operators to launch new programming on the new regulated tier and then move it to the NPT.) Finally, operators could charge up to $1.50 a month extra if they added as many as six channels to regulated tiers (until 1996). Rates could not be raised more than 20 cents per new channel, with a minimum of 30 cents allocated for licensing fees. In the third year, the cap increased by an additional 20 cents. New cable services with limited distribution and programming planned launches while simultaneously making a case to be added to systems as part of the regulated tiers on basic and expanded basic cable.

3. "They Said It," *Cablevision*, 20 June 1994, p. 9.

4. Joe Mandese, "In New Growth Phase, Cable Feeding on Itself," *Advertising Age*, 27 March 1995, pp. S-1-2, S-10.

5. Jim Cooper, "High Anxiety," *Cablevision*, 25 July 1994, pp. 32–38; Rich Brown, "Distribution Is Cable's Cross to Bear," *Broadcasting & Cable*, 30 January 1995, p. 28.

6. The 1992 Cable Act forced cable systems to negotiate with broadcasters for carriage. Broadcasters had two options. Under what is known as "must carry," local stations could demand that cable systems in their area carry their signal. By invoking "must carry," stations would forfeit their rights to the second option—retrans-

mission consent. Under this provision, stations could demand compensation from cable systems that carried their signals. By invoking this option, stations risk having their signals dropped from the cable system in the event that no agreement was reached. After some initial threats and heated words from both sides, in most cases agreements were reached. As a result of these agreements, some local stations were added and some were dropped from cable system lineups. Also, some cable networks were added and some were moved or dropped from the cable system. Overall, there were minimal drastic changes in most cable system channel lineups.

7. Local television stations and cable systems collaborate most often in the area of news; these efforts usually involve either a repeat showing of a local newscast for placement on a local cable channel or supplementary news footage intended to support a cable-produced newscast. In a few cases, broadcast news personnel appear on or host programs produced by cable systems or by a local origination cable channel. Some broadcasters also supply production facilities for news, sports, or talk programs. These topics were covered in more detail in Chapter 9, as they apply more to local than nationwide cable.

8. TCI has financial interest in some 30 cable services including CNN, TNT, QVC, Court TV, BET, American Movie Classics, The Discovery Channel, and movie channels Starz! and Encore. TCI also owns CableLabs, the cable industry's leading technological center.

9. Michael Wilke, "100 Cabooses, Two or Three Engines," *Advertising Age*, 27 March 1995, p. 28.

10. In September 1994, TNN averaged a 1.1 prime-time rating, up 0.9 from 1992. Rich Brown, "TNN Remake Pays Off with Ratings Boost," *Broadcasting & Cable*, 21 November 1994, p. 32.

11. Sharon Donovan, "Want-To-Be Nets Angle for Openings," *Extra Extra*, 7 May 1995, pp. 1, 8.

12. Jim Cooper, "By Any Means Possible: New Nets Deal," *Cablevision: New Network Handbook*, 1995, p. 10A.

13. Simon Applebaum, "Outsourcers Lend a Hand," *Cablevision: New Network Handbook*, 1995, pp. 24A, 28A, 30A.

14. Simon Applebaum, "Mr. How-To-Launch," *Cablevision*, 9 May 1994, p. 48.

15. Alan Bash, "Vignettes Give Cable Networks Identity," *USA Today*, 14 March 1995, p. D3.

16. Christine Bunish, "Hitters: Top Cable Nets Arm for Battle with Original Programming," *In Motion*, March 1994, p. 23.

17. Rich Brown, "Original Cable Programming: From Series to Movies, Cable Programming Comes of Age," *Broadcast & Cable*, 20 February 1995, p. 38.

18. Christine Bunish, "Hitters: Top Cable Nets Arm for Battle with Original Programming," *In Motion*, March 1994, p. 28.

19. Starting in 1995, Nickelodeon introduced a half-hour program for children at the beginning of prime time, in part to counteract the adult-only programming carried by the major broadcast networks during early prime.

20. In 1995 Fox Broadcasting formed an alliance with cable operator TCI to create a rival to ESPN. Speculation at the time focused on the combined financial resources of Fox, which had acquired NFL football (away from CBS) in 1994 and Major League Baseball (along with NBC) in 1995, and TCI, whose Liberty Media subsidiary controls the programming for more than a dozen regional sports channels through Prime Sports Showcase.

21. Other new and proposed microniche music services include Z Music (contemporary Christian), MuchMusic, The Box, Mor Music, BET on Jazz, Music Video Service, and TMZ/The Music Zone. TCI and German entertainment giant Bertelsmann Music Group have announced plans to launch a music video channel. Perhaps the most ambitious project is the joint venture between music powerhouses EMI Music, Poly Gram, Sony, Ticketmaster, and Time Warner's Warner Music Group. Only a very few of these services will succeed in competing with MTV, VH1, and TNN.

22. Christine Bunish, "Hitters: Top Cable Nets Arm for Battle with Original Programming," *In Motion*, March 1994, pp. 25–26.

23. The Blizzard of '96 brought misery to millions in the East but a blessing to The Weather Channel—its highest ratings ever, achieving a 2.7 rating and outdelivering all television networks except NBC.

24. As this book went to press, CBS was also considering an all-news channel. Some observers believe that an all-news or all-sports channel is an "easy idea" for broadcast networks contemplating a move into cable channels. In 1995 ABC had also planned to launch an all-news channel but canceled the idea in mid-1996.

25. Estimates vary depending on whether online computer services are included and how quickly those are predicted to grow.

Chapter 11

Premium Programming Services

Jeffrey C. Reiss
Jeffrey Bernstein
Douglas A. Ferguson

A GUIDE TO CHAPTER 11

11.1 SATELLITE DELIVERY OF PAY PROGRAM SIGNALS

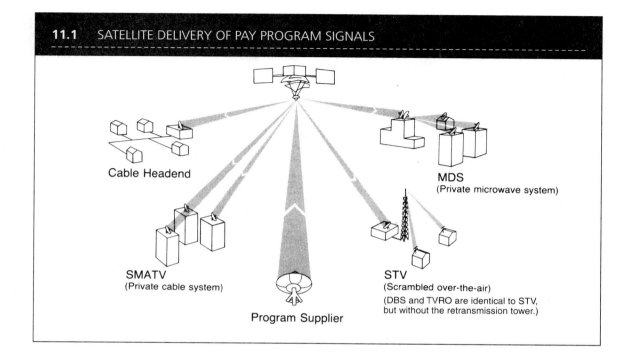

Cable Headend

MDS
(Private microwave system)

SMATV
(Private cable system)

STV
(Scrambled over-the-air)

(DBS and TVRO are identical to STV,
but without the retransmission tower.)

Program Supplier

PREMIUM TELEVISION

Premium television is an umbrella term for a group of specialized entertainment services that, for an optional fee, provide special or "premium" programming to subscribers. These services primarily offer unedited movies and original productions in a commercial-free format. The premium television field divides into two distinct components:

1. pay-cable services, charging viewers a monthly subscription charge, and

2. pay-per-view (PPV) services, charging on a program-by-program basis.

The key difference to consumers is that pay TV means buying a *group of movies* over a month, whereas PPV means purchasing *just one movie*. Premium channels may be distributed several ways to homes, bars, and hotel rooms, including:

- Cable systems
- Beamed directly (DBS) to a home satellite dish (TVRO) or to hotels
- Satellite master-antenna television installations (SMATV)
- Microwave distribution systems (MMDS or "wireless cable")

The illustration in 11.1 shows these transmission methods. **Subscription television (STV)**—over-the-air broadcasting in scrambled form—is limited to low-power television stations in a handful of markets, mostly rural. Future developments in digital compression and transmission of signals may enhance this form of pay-TV distribution. Another possibility is that local stations will use additional channels set aside for HDTV to provide multiple digital channels.

The programming services described in this chapter are most commonly delivered by cable operators to individual homes, although the need

for a cable system has decreased with the advent of **direct-to-home (DTH)** satellite services and telephone-based **video-on-demand (VOD),** which offers multichannel pay-per-view (PPV). The content of a cable system's offering of premium services derives mainly from 6 national pay-TV services and 14 pay-per-view services, each distributing a program schedule to local cable systems by satellite. Each pay-TV service offers several channels.

Another form of monthly pay service is known as **minipay service.** These minipay services usually offer older product and fewer special events than regular monthly pay services, at a much lower monthly fee. The home subscriber pays a basic fee, with additional monthly charges for the regular pay and minipay channels, and per program charges for each pay-per-view (PPV) movie or event.

Direct Broadcast Satellite Systems (DBS)

Through a small (18-inch to 3-foot) dish, subscribers to direct broadcast satellite (DBS) companies such as DirecTV had access to more than 50 channels of PPV in 1995 and were ordering at the rate of 1.5 to 2 movies each month. This compares to regular cable subscribers who, on average, order PPV at about one-tenth that rate. The direct-to-home satellite market threatens to usurp conventional premium channels on cable, at least until channel capacity on both systems reaches parity. DirecTV is partly owned by AT&T.[1] MCI and News Corporation (parent of Fox) invested $1 billion in 1997 and 1998 to create American Sky Broadcasting, boasting 200 (and eventually 400) channels, to compete with DirecTV, which had grown to 2 million subscribers by 1996.

Primestar is cable's answer to DBS. A consortium of cable companies led by TCI operates this service to offer a cable choice to homes outside of cable's reach.[2] Primestar is less sophisticated than DirecTV and its imitators USSB, EchoStar, and AlphaStar. Late in 1995 came the development of Tele-TV, a service owned by a consortium of telephone companies; the system uses land-based

11.2	DBS PROVIDERS BY WEB SITE

DBS Provider	Web Site
Primestar	*http://www-dma-net.digex.net/prime/*
DirecTV	*http://www.directv.com/*
USSB	*http://www.ussbtv.com/*
AlphaStar	*http://www.teecomm.com/alpha.html*
EchoStar	*http://www.echostar.com/*
MCI/News Corp	*http://www.delphi.com/info.htm*

(*terrestrial*) microwave delivery, known as **wireless cable** or **MMDS**. Through 4:1 video compression, it offers 120 channels, a number that should grow as the technology improves. By 1998 the equal partnership between News Corporation and MCI (a major competitor to AT&T) will take advantage of MCI's $682 million bid to license digital DBS service.[3] (See 11.2 for Web sites of DBS providers.)

Video-on-demand (VOD) is a system of pay-per-view movies delivered by telephone companies over digital fiber. Like PPV, the subscriber orders movies from a menu. True video-on-demand systems offer the viewer the option to "pause" the movie, something not widely offered by forerunner services on DBS or cable. Bell Atlantic experimented successfully with VOD and NVOD (near-video-on-demand) in the mid-1990s, but many other regional Bell companies chose to use wireless cable systems in the late 1990s as a stopgap before VOD could be deployed.

The business of providing specialized program channels has become sufficiently competitive that the word *cable* may no longer adequately encompass all the multichannel services. This edition uses the words *cable* and *multichannel* to refer to the same types of programming, especially in light of the increasing popularity of wireless cable systems.

Wireless cable usually refers to terrestrial systems such as MMDS, while DBS refers to direct-to-home satellite services; yet, the two are both "wireless." In the final analysis, however, the subscriber to multichannel services is interested only in the programs, not the technology.

The essential differences between conventional cable television and the more advanced DBS is that the latter boasts more choices, higher quality digital signal (especially desirable for viewers upgrading to large-screen home theater receivers), and the potential to reach any home with an unobstructed view of the southern sky. Cable, whether it is the older coaxial style or the newer fiber optic version, has the advantage of true interactivity or two-way communication. DBS services rely on telephone lines to order programs.

Oddly enough, viewers in areas unreachable by cable sometimes pay a few hundred dollars for the DBS equipment and then announce to their friends that they now have "cable."[4] The word *cable* has come to generically represent all multichannel services.

Shelf Space

One way to understand the multichannel programming business is to consider the wholesaler-retailer analogy: National cable and other multichannel programming services are like coast-to-coast wholesalers in that they sell their product—*programming*—to regional and local outlets, the wired (or wireless) cable system operators. Multichannel providers are like retailers, because they sell their product—*television programming services*—to consumers, home by home and subscriber by subscriber. The wholesaler's four functions are:

- Licensing existing shows or financing original programming created by Hollywood's studios, independent producers, or in conjunction with international joint-venture partners
- Packaging that programming in a form acceptable to consumers (by providing interstitial promotions such as wraparounds, titles, on-air hosts, graphics)

- Delivering that programming (usually by satellite) to cable or other multichannel provider operators
- Supporting their products with national advertising and promotion and by supplying advertising materials and co-op dollars at the local system level

The cable or DBS operator as retailer must decide how best to market the channels of programming within the local system's inventory (as discussed in Chapter 9). Just as a supermarket manager has to allot shelf space to products, deciding to display some more prominently than others, a cable system operator or DBS provider must decide which premium and basic cable services to offer and promote to subscribers. In making these marketing decisions, the local manager considers channel capacity, the demographics of the subscribership, the program distributor's pricing and level of promotional support, and the number of local broadcast stations that are carried. Many programming decisions are made by the MSO for all or most of its systems rather than by local operators.

Shelf space describes the amount of channel capacity each system has to fill, which varies greatly among the more than 11,600 U.S. cable systems. Premium services compete with one another for a share of the shelf space on local cable systems by offering financial incentives as well as promotion and advertising support. (Local systems promote their premium services extensively to increase **lift** and thus revenue from subscriptions.) Premium subscriberships as of 1995 are shown in 11.3. Note that these are *not* **reach** but actual paying subscriber rolls.)

Nearly every cable system in the United States carries at least one premium service, and more than 90 percent carry two or more monthly pay services. Pay-per-view is the most recent addition to the market, with service available nationally only since 1985, and it works primarily on systems with addressable technology (see Chapter 9). In consequence, fewer cable systems offer

11.3 COMPARATIVE PREMIUM SUBSCRIBERS, 1995

Pay-TV	Subscribers (in millions)	PPV	Subscribers (in millions)	
HBO	19.2	Request	30.0	
Cinemax	7.8	Viewer's Choice	30.0	
Disney	12.6	Adam & Eve	3.5	
Showtime	8.1	Cable Video Store	2.8	
The Movie Channel	3.1	Spice	9.0	
Flix	2.1	Spice 2	.5	
Encore 8	6.0	Playboy	9.5	(plus .5 million monthly subscription subs)
Starz	2.0			
		AdultVision	1	(new launch)
		Action	7.1	

Sources: *Pay TV Newsletter, 1996 Broadcasting & Cable Yearbook,* and *Cablevision.*

pay-per-view services. As of 1994, the addressable pay-per-view universe approached 23 million homes, and about half of the 60 million cable subscribers had access to some form of pay-per-view. The newer direct-to-home services like DirecTV are able to offer more PPV channel capacity through the use of digital set-top converter boxes. Cable systems will need to replace their analog boxes with digital boxes (at $250 each) to remain competitive.

If a system has only one pay channel, the odds are very high that it is Home Box Office (HBO), because about 9,300 systems (out of 11,600) carry HBO. HBO achieved its leading position through its early entry into pay TV in 1972 (Showtime began in 1976), early adoption of satellite delivery in 1975 (Showtime moved on the bird in 1978). These early leads were then consolidated through aggressive national marketing campaigns in the 1980s that competitors could not afford with their smaller audience bases. Relatively few systems carry just Showtime, Flix, or one of the other pay services. With HBO in the primary role, the com-

petition among the others focuses on securing shelf space as the second or third (or even fourth) service provider on the local cable system's menu of premium offerings.

HBO's main competition comes from Cinemax, The Disney Channel, Encore, The Movie Channel, Showtime, Flix, and Starz! (a 1994 offspring of Encore). In recent years, several services have shifted from pay to basic, as described in Chapter 10, including American Movie Classics, Bravo, The Nostalgia Channel, GalaVision, and several regional sports services. The Playboy Channel also left subscription pay television—going to pay-per-view and pay-per-night as Playboy at Night, now known as Playboy Television.

The six nationally distributed pay-per-view cable services as of 1995 were Request Television, Viewer's Choice, Cable Video Store, Playboy Television, Action Pay-Per-View, Spice, Adam & Eve (formerly Spice 2), and Adultvision (see 11.3 for comparative subscribership as of 1995). On the direct-to-home satellite front, new distributors include DirecTV and Primestar.

An additional development has been the gradual rollout beginning in late 1994 of The Sega Channel (see 9.4). Subscribers can "download" Sega games to their game equipment for a fee ranging from $11 to $20 per month. Parents can even program the home device to control the amount of time their children spend with the Sega games.

Multipay Environments

The idea of multipay subscriptions—the sale of multiple premium channels to a single cable household—had its most rapid growth in the early 1980s, only to quickly level off in the face of consumer irritation over duplication of film titles and the ready availability of videocassettes. A decade earlier, most cable experts thought subscribers would be willing to pay for one or, at the most, two premium channels. A ceiling effect on total cable bills was assumed. One view was that subscribers would resist paying more for cable than they did for their telephone bills (around $30 per month on average for upper-income families at the time).

However, in the early 1980s **multipay** arrived. When offered a varied selection of pay channels, a large percentage of pay subscribers signed up for two or more services—particularly in newly constructed cable systems (**new-builds**) where enthusiasm for cable was high and promotion strong. In one case, research for Showtime, the second largest pay-cable network, demonstrated that when HBO and Showtime were marketed together in a newly installed system (undergoing first-time sales), 98 percent of basic subscribers took at least one premium service. But the big news for the industry was that 70 percent of that 98 percent took both HBO and Showtime. Thus encouraged, HBO launched Cinemax, a second premium movie channel, developed both as a companion to HBO and as a means of protecting its market share from competitors such as Showtime and its companion channel, The Movie Channel.

Ultimately, while churn accelerated in the mid-1980s, the growth in new multipay subscription sales stalled due to three external factors:

- Home videocassette recorders became cheaper and more plentiful
- Tape rentals mushroomed
- New home construction on a large scale virtually halted, changing what had been a flood of new cable subscribers to a mere trickle

The pay networks originally offered a mix of movie programming with a small amount of sports and entertainment specials having broad appeal to a heterogeneous audience. The prospect of selling an array of pay subscriptions to a single household, however, stimulated creation of even more specialized premium services that targeted their programming to attract narrowly defined (homogeneous) interest groups: for example, Playboy for male adults, The Disney Channel for children, and Bravo for culture buffs. Eventually, most of these specialized services decided they could better reach their target audiences through basic cable or pay-per-view. The Disney Channel is offered on some cable systems as a basic service, because it appeals to both adults and children in families.

Beginning in the late 1980s, cable systems offered pay-per-view services to attract subscribers who had turned to tape rentals for their entertainment. The national pay-per-view services supply the latest movies, special events, and sports programming on an a la carte basis, but without the inconvenience of traveling to and from a videocassette rental store. The average pay-per-view movie in 1995 was about $3.90 versus the 1995 average home video rental of $2.40.

As had occurred with pay services, each of the two leading pay-per-view networks—Request and Viewer's Choice—soon developed *additional* services. And many cable systems were finding that the more PPV channels they had, the higher the **buy rates** (number of purchases of individual events) among subscribers. But by the early 1990s, as basic cable continued to expand its offerings and as basic subscription rates grew, the pay networks were scrambling to keep the gains they had won over the past decade. And a new concept had

entered the scene—multichannel pay-per-view, referring to several multiplexed channels of pay-per-view on a cable system.

Multiplexing (see Chapter 9) heralds further multiplication of pay and pay-per-view channels. Because growth in pay subscriptions nearly stopped in the early 1990s when digital compression technology became available, pay channels became the first services to announce plans for multiplexing two or three channels.[5] Some movie networks adopted the **time shifting** strategy to achieve staggered start times; Disney placed different programs and movies on its second feed. Cable systems that experimented with multiplexing found that the number of subscriptions grew at a rate of 6 to 8 percent with multiplexing as compared to 1 percent without. The networks themselves were split on the benefits of multiplexing. Showtime, for example, saw that most of the growth was toward HBO, the network with more channels. In effect, additional start times for movies on one service makes subscribers wonder why they should pay for a second service—perhaps a signal that mergers might be more profitable than further competition.[6]

Selling subscribers additional premium services has proved an easier task than keeping them. Three patterns in pay **churn** occur. As the initial excitement of signing up for cable services wears off, some subscribers naturally decide to keep only those premium channels they watch and enjoy the most (**downgrade**). Other subscribers, believing that the programming offered by the major movie services is too much alike, cancel those where duplication of movie titles seems the highest or where the perceived value of the entertainment declines. A number of other subscribers migrate from service to service (**spin**). When a new premium service is marketed in a cable system with a long-established lineup of premium services, subscribers tend to cancel one service in favor of a new one (**substitution**). This happened in several communities when the adult-oriented Playboy Channel or, at the other end of the spectrum, the family-oriented Disney Channel were introduced. Many subscribers substituted them for their existing pay services rather than adding them to their current subscriptions.

Pay-cable programmers have adopted strategies focusing on image and programming to combat churn. They try to develop a unique identity or image for a service through advertising and promotion (**differentiation**), and they create unique, original programs and pay high prices to license the **exclusive rights** to movie titles. Those services competing with HBO—particularly Showtime—target their movies to more carefully defined audiences and directly counterprogram HBO's lineup. Differentiating program content through acquisition of exclusive rights to hit movies and developing appealing and promotable original shows has become key to the pay services' competitive strategies.

Revenue Split

Economic considerations come strongly into play when a local system is deciding which premium networks to carry. Cable systems charge their subscribers about $8 to $12 above the basic monthly cable bill to receive a premium channel. The local system operator sets the exact monthly charge, usually within a range negotiated with the program supplier. The revenue for a premium channel is distributed between the *programming service*, which licenses the programming and is responsible for delivering it to the cable system **headend** (its technical distribution facility), and the *cable system operator*, who receives the satellite signal, delivers it by coaxial cable to subscriber homes, and then bills them for the service. Though subject to negotiation, about 50 to 60 percent of the monthly revenue usually goes to the program service, while 40 to 50 percent goes to the cable operator.

Showtime, for example, typically costs subscribers about $10 per month. The operator keeps about $7, and Showtime receives $3. In an HBO deal, the operator more commonly keeps about $6, and HBO gets $4. Disney splits are usually 50/50. To gain carriage and achieve broad local acceptance, the premium programmers also offer cable

operators discounts and financial incentives based on volume and market penetration, further altering this retail-wholesale pricing mechanism. Negotiations for premium services, like all business deals, depend on the size of the market, the number of systems in the final deal, the number of customers, and the number of services in the entire contract.

As a way to further induce pay subscriptions, TCI premiered Encore in 1991 as a new kind of pay service. With lower cost programming in the form of off-network films from the 1960s through 1980s, it sells at wholesale for about $1 a month. Depending on whether it runs in a package with higher priced pay services or on a stand-alone basis, the cost to consumers varies up to $3 a month. Such new multipay channels are inducements for cable systems to reprice and repackage to give pay cable's entire maturing product line a much needed shot in the arm. Yet another new pay service, Starz!, was launched by Encore in 1994 to capitalize on exclusive titles from Universal Studios, New Line, Carolco, Miramax, and Imagine (and even more exclusive titles from 20th Century Fox in 1997).

Showtime also started using pay-per-view impulse technology to sell its monthly pay service in the early 1990s. Basic subscribers who bought, for example, the made-for-cable *Psycho IV* at $1.99 received a free month of Showtime. Or for the price of the regular Showtime monthly rate, subscribers could order a championship fight already running on the service. In reality, of course, they were ordering a month of Showtime at the push of a button.

Pay-per-view services, which sell individual programs, operate somewhat differently from pay services. In general, the distributor and the operator divide sales revenue either 50/50 or 60/40 (in favor either of the pay-per-view packages or the cable operator). However, the **revenue split** often varies from title to title, depending on the *program licensing fee* involved and the *potential audience size*.

In the case of Request Television, the cable operators and the individual studio suppliers negotiate the revenue split directly, sometimes resulting in a more favorable percentage for the system operator. This is possible because Request uses a business model in which the participating studios pay Request a fee for product distribution, eliminating the middle cut in revenues. The other PPV services charge the system operator a monthly per subscriber fee (10 to 15 percent of gross revenues) for handling, scheduling, and distribution.

Because of the favorable revenue splits, pay services have become important components of operators' revenues. In fact, revenues from pay services stimulated the cable industry at various points in its service development.

VIDEO-ON-DEMAND (VOD)

Digital video compression has led to new kinds of television systems that are menu-driven rather than schedule-driven. In Chapter 1, the food analogy was introduced as a way to think about programming. Until recently, the restaurant metaphor for delivery of programming was the cafeteria. The "food" is scheduled by the opinions of the programmers, but there is no menu from which to order. Most of the history of television programming existed in a cafeteria with three large buffet tables managed by ABC, CBS, or NBC. With the coming of cable, there were many more choices, but it was still very much a controlled choice: "Our specials tonight are the following," but there was still no menu.

Video-on-demand (VOD) and near-video-on-demand (NVOD) allow the viewer to create schedules, traditionally one of the functions of programmers. When the video provider supplies an unlimited number of choices, the viewer receives video-on-demand. When the number of options is controlled by the provider ("No substitutions please"), the system becomes *near-video-on-demand*. NVOD is an intermediate step before the technology for "true" VOD finds its way into viewers' homes.

Such a revolutionary change in the way people choose television shows has led some observers to

discredit the notion of menu-driven television. In 1995, Gene Jankowski, former CBS president, predicted that network schedules would not be displaced by the menu concept.[7] Almost certainly, it will take some adjustment for viewers to construct their own programming environment. To the extent that such a concept becomes popular, the definition of the programmer as one who *chooses* and *schedules* will be limited to choice alone. However, viewers' interest in a "brand name" service, such as MTV or PBS, will keep the idea of schedules alive. The determining factor may be the degree to which a program service is focused on a particular style or appeal.

VOD and NVOD are not limited to cable television. Any multichannel provider can offer menu-based services. Indeed, even conventional broadcasting stations can be part of this brave new world through online services and second channels.

Digital signals are well suited to transmission over fiber optic cables, so most of NVOD services in the mid-1990s are played out on conventional cable television services. However, the telephone companies have moved into video transmission, and in the early 1990s GTE provided 28 PPV channels in Cerritos, California. In 1994, Bell Atlantic (part of a Media Company consortium including Nynex and Pacific Telesis) had limited success with its test of Stargazer, a video-on-demand system that featured interactive commercials.[8] As a result of the lukewarm results of Stargazer and the cancellation or postponement of subsequent tests, several telephone companies (except Bell Atlantic) became less interested in wired systems and concentrated their efforts in wireless MMDS systems in the mid- to late-1990s.[9]

But **direct broadcast satellite (DBS)** services actually created the spark toward greatly increased cable channel capacity.[10] Since 1994, Discovery Communications has offered a PPV service called Your Choice that provides NVOD service featuring selected popular TV shows from broadcast and cable networks. The idea is that viewers get a second opportunity to watch a favorite show by ordering it on a pay-per-view basis.

Not everyone is wildly optimistic about widespread video-on-demand in the near future. For one thing, it may not make much sense to invest a lot of money to create complex media options when most viewers are interested in the latest Hollywood releases. Few people go to the video store to rent anything but the most popular movies. The number of options is less important than the ready availability of hot movie titles.

As of this writing, it is not clear what audiences want, even to them, because not all of the options are clear or tested. When sufficient numbers of VOD users subscribe to such services, the cost for each requested program will decline. It is the classic chicken-or-egg situation: Which will come first, the technology at a low price or the programming content?

MOVIES

The staple of both pay cable and pay-per-view remains the Hollywood feature film, aired soon after theatrical release. The rapidity with which a film can be offered to subscribers is central to establishing a premium service's viability and value. Speed is of particular importance to the pay-per-view services, which generally present top movie titles 6 to 9 months after their initial domestic theater distribution—but still usually a few weeks after home video. In contrast, the usual exhibition window for the monthly premium channels is 12 to 15 months after theatrical release, with the broadcast networks following at 18 months to 2 years.[11] Enough money can change the pattern, however, as when CBS premiered ten Universal films prior to pay cable in the 1990–91 season.

None of the national premium services as yet carry commercials. With rare exceptions, films are shown unedited and uninterrupted, including those rated PG-13 and R (containing strong language and behavior normally censored on broadcast television). The PPV services and at least Cinemax on the pay side also run films in the NC-17 category (formerly X-rated).

Rotation Scheduling

Rotation scheduling is a major area of difference between pay-cable and broadcast television. Most pay services offer a range of 20 to 100 movies per month, some first-run and new to the schedule (**premieres**), some repeated from the preceding month (**carryovers**), and some returning from even earlier (**encores**).

In the course of a month, movies are scheduled from three to eight times on different days and at various hours during the daily schedule. Different movie services offer varying numbers of monthly attractions, but all services schedule most of their programs more than once. (Programs containing nudity or profanity, however, rotate only within prime time and late night on most networks.) The viewer, therefore, has several opportunities to watch each film, special, or series episode. These repeat showings *maximize the potential audience for each program*. The programmer's scheduling goal is to find the various complementary time slots delivering the greatest possible audience for each attraction during the course of a month, not necessarily in one showing.

Unlike the monthly pay-cable networks, pay-per-view services rotate *rapidly* through a short list of top-name Hollywood hit films. The same movie may air as few as four or as many as ten times in a day. This occurs because pay-per-view programmers market "convenience viewing." Pay-per-view networks either rotate two to four major movie titles a day, some across multiple channels, or run the same movie continuously all day. As the number of channels available to PPV increases, the trend is to assign one movie per channel, thus emulating the "multiplex" theater environment.

Premium versus Nonpremium

Broadcast television's scheduling practices, organized around the delivery of commercial messages, differ broadly, resulting in the weekly series, the daily soap opera, and the nightly newscast. In most cases, an episode is shown only twice in one year, and the largest possible audience is sought. Some premium networks have adopted the short-length formats of broadcast television, such as 30-minute episodes of *Red Shoe Diaries* on Showtime and *Dream On* on HBO. The shorter length (not to mention the provocative content) helps these first-run shows get sold internationally and later into syndication. Most pay programs, however, run to their natural lengths, ending when and where the material dictates rather than running in fixed segments to accommodate commercials. Even with series programs, frequent repetition and rotation throughout the various dayparts set premium program scheduling apart from broadcast scheduling. Also, broadcasters set their schedules for an entire season—pay and PPV set them a month at a time.

Monthly Audience Appeal

Another major contrast between broadcast television and the premium programming services lies in their revenue-generating strategies. To maximize ad revenues, commercial networks and broadcast stations program to attract the largest possible audiences every minute of the programming day. Premium cable networks, as explained in Chapters 2 and 9, try to attract the largest possible cumulative audiences over the period of a month.

The lifeblood (read *daily operating revenues*) of a pay service is its direct subscriptions. Pay-per-view services must satisfy their customers movie by movie, event by event, or night by night. Pay-television services must satisfy their subscribers month to month, throughout the year, forestalling disconnections. A premium service's success is not determined by the audience ratings of its individual programs but by the general appeal and "satisfaction levels" of its overall schedule. Insofar as quantitative measures such as ratings reflect that appeal (especially for one-shots like boxing matches or a live Madonna concert), they are useful in gauging response. But in cable, where subscribers must be persuaded to pony up month after month, qualitative measures take on greater importance.

Another quantitative measure is subscriber turnover. Since both schedules and subscriber

billings are arranged by the month, viewers tend to evaluate programming in month-long blocks. Subscribers will most likely continue the service for another month:

- If they use their pay service two or three times a week
- If they see benefit in its varied viewing times
- If the service runs commercial-free, uninterrupted program content
- If the service runs unique entertainment programs and theatrical feature films

The pulse of pay-per-view success is measured by the **buy rate**. Careful matching of buy rates and titles offers both the pay-per-view distributor and the system operator a tool for fine-tuning scheduling and promotion plans.

Discontinuing a month-to-month pay service seldom reflects dissatisfaction with one or two individual shows. When viewers disconnect, they feel that the service *as a whole* is lacking. Customers repelled by violence, for example, may disconnect a movie service if a large number of a particular month's films contain a great deal of violence. A family may determine that its desire for wholesome, G-rated fare is not being filled by the programming mix of one particular movie service and so will cancel after a trial month or two.

This process also works in reverse. Favorable word of mouth remains the most potent method of attracting new customers, particularly in nonurban communities. As such, a handful of individual programs each month makes the difference between success or failure when a premium service is new in a community and the local operator lacks a large and stable subscriber base. Having one or two blockbuster films on the order of *Forrest Gump* or *True Lies* undoubtedly attracts new subscribers to a service and holds current subscribers even if their reaction to the balance of that month's schedule is negative. Such blockbusters are also essential in the marketing practice known as "free previews" in which basic cable subscribers receive a premium service free for a couple of days.

Movie Balancing Strategies

Selecting programs that will appeal to different target audiences through the course of a month becomes the challenge for most pay programmers. For example, if a particular month's feature films have strong appeal to teenagers and men 18–49, the obvious choice for an entertainment special is a show that appeals to women.[12] Pay-television programmers break down their audiences according to:

- Urban-rural classifications
- Age groups of 18–24, 25–49, and 50+
- Gender

By scheduling programs each month that will appeal to all these groups, the programmer creates a "balanced" schedule.

Films subdivide into several groups with overlapping appeals. The major audience attractions for that month are the premieres—that is, the films that were recent box-office hits and are being offered for the first time on that premium service. These films may be G-, PG-, or R-rated by the movie industry.

The second group of films placed in the schedule are the major G- and PG-rated films. This establishes a strong pattern of family and children's appeal in the schedule. The third group of films have varied adult audience appeals. Films without notable box office success usually fall into this category. They are repeated slightly less frequently than premieres and G-rated hits.

Other films that were not major theatrical hits may still rate as important acquisitions for pay-television services. Viewers may value seeing a film on television that they might not be willing to pay $3 to $6 to see in a movie theater. Foreign films fall in this group.

Also, if a pay network feels that a particular film has appeal to a segment of its audience, it doesn't matter if it was originally made-for-home video or made-for-broadcast television, films in both categories increasingly show up on pay schedules. Another growth category is film classics.

Title Availability

Balancing the number of major films and lesser known but promotable titles every month, then adding a handful of encore presentations, is one of the key challenges a premium movie programmer faces. A crucial factor in preparing the lineup is title availability. Most films with good track records at the box office are obtained from major film distributors, but an increasing number can be purchased from a wide variety of independent distributors and producers.

Theatrical films distributed by major studios are typically available to PPV services six to nine months after their initial theatrical release, and available to monthly pay services six months after their PPV release. Usually it does not make economic sense for studios to hold a film in theatrical release for more than a year. However, video sales have disrupted this pattern and delayed the availability of some big films. The home video "**sell-through**" is a film priced to be bought rather than rented by consumers. (For rentals, the studios receive revenues only from the initial purchase of each tape by the retailer.) Successful sell-throughs of popular films like *Forrest Gump*, even at much lower wholesale prices, are a distributor's dream—and the studios maximize revenues by delaying pay television release.[13]

Time constraints on the use of films also affect steady product flow, including *how long* and *when* a film is available to pay services. Commercial broadcast television buyers, for example, traditionally had the financial clout to place time limitations on distributors' sales of films to premium services. The broadcasters would seek early telecast of key films to bolster their ratings during Nielsen and Arbitron ratings sweeps, shortening the period of time during which the films were available to premium networks. However, the number of such key films of interest to the broadcast networks has been dropping as their ratings have deteriorated due to home video and pay cable penetration.

Some desirable films are unsuitable for broadcast sale altogether, increasing their pay television staying power. Films like the *Emmanuelle* series, although not recent, crop up again and again because they never enter **broadcast windows**. A film such as *Showgirls* would require such massive editing for broadcast television that it would be destroyed in the process. Therefore, distributors allow premium networks to schedule them as many times as they like for as long as they like.

Occasionally, the major pay movie services disagree about whether or not to schedule a movie *after* it has already had a commercial broadcast network run. But HBO and Showtime have found a pay-cable following for these movies when they are shown unedited and without commercials. Some survey research even demonstrates viewer support for reshowing films that have been badly cut for commercial television presentation or that have exceptionally strong appeal for repeat viewing. Almost all pay services show selected off-network movies, often drawing sizable audiences.

Exhibition Windows

Distributors create a **distribution window** for a film's release when offering it to the premium services. In this arrangement, premium programmers negotiate for a certain number of first-run and second-run plays during a specific time period, generally 12 months. For example, a given film may be made available to a pay-cable service from April to March. It might premiere in April, encore in August, and then play again the following March to complete the run. Programmers must project ahead to see that the scheduled play periods for similar films from different distributors do not expire at exactly the same time. Generally, pay services don't want to waste their scarce resources by running five blockbusters, four westerns, or three Kevin Costner films in the same month. Such clustering can be advantageous, however, when the films can be packaged and promoted as special "festivals."

Film Licenses

Feature films are licensed to pay-television networks in one of two ways: per subscriber or by flat

fee. *Per subscriber* means that the film's producer or distributor negotiates a fee per customer for a specific number of runs within a fixed period, the number varying with the presumed popularity of the film. Such a fee is based on the actual number of subscribers who had access to the film (though not necessarily the number who actually saw it). In a *flat fee* arrangement, the parties negotiate a fixed payment regardless of the number of subscribers who have access to it.

In the 1970s, the per subscriber fees were small compared to theatrical distribution revenues and broadcast license fees, which suited the rapid growth in the premium network subscriber base. The film distributors were satisfied to get a share of every subscriber household receiving the premium network's programming. But once the pay-cable networks grew large enough to pay substantial amounts for the pay-television rights to a movie under that method, they usually abandoned the per subscriber formulas and negotiated flat fee arrangements with the program suppliers. The flat fee method is also used for acquiring original programming. In pay-per-view, however, the cable operator pays a per subscriber fee to either the studio or PPV service provider.

Film Placement

General rules of thumb for film scheduling include beginning weeknight programming at 8 P.M. and starting final showings (of major offerings) as late as 11:30 P.M. to 12:30 A.M. Those networks concentrating on the overnight daypart employ still later final showing schedules. For most of the premium movie services, an evening consists of three to five programs, depending on individual running lengths. Entertaining short subjects, elaborate animated titles, and promotional spots for other attractions fill the time between shows. All-movie networks especially favor movie-oriented shorts, such as interviews with directors or location tours.

The premium services no longer **frontload** their films (that is, schedule most of them at the start of the calendar month). Using 20 or more new films each month (not counting carryovers of the previous month's late premieres) usually means

scheduling *four premieres each week*, gradually integrating first-, second-, third-, and up to sixth-run presentations week by week so the viewer has a constantly changing lineup of material from which to choose—and new movies appear every week.

Counterprogramming broadcast network schedules is another strategic consideration. For example, on Monday nights when *Monday Night Football* is a strong ABC attraction, premium networks tend to schedule films with female appeal. Preceding or following a popular broadcast network show with a program of the same genre on pay cable creates a unified programming block for viewers (requiring channel switching, an easy move in cable homes with remote control keypads). Beginning programs on the hour as often as possible—especially during prime time from 8 to 11 P.M.—makes it convenient for viewers to switch to and from pay cable.

Films and specials containing mature themes are usually scheduled at later hours than G-rated films, even though pay television is not bound by broadcasting's traditions. PG features are offered throughout premium schedules. Monthly program guides have encouraged parents to prescreen all films rated PG, PG-13, or R early in the week to decide which are appropriate for their children to watch on subsequent airdates.

Ironically, all rules with regard to mature themes can vanish during *free preview* promotional periods. Some parents who manually delete unsubscribed pay channels from the electronic tuner on their television sets have discovered that enterprising youngsters learn to key in the channel number to watch R-rated movies during the free showings of premium channels.

ENTERTAINMENT SPECIALS

In addition to theatrical films, several monthly pay-cable services offer original movies, series, and high-gloss entertainment specials created expressly for their subscribers. Other programming formats include original documentaries, magazine series, and blends of entertainment and documentary

styles. A few made-for-cable series employing soap opera or situation comedy formats have been created, and a rare few former broadcast series (off-network) have been licensed to premium networks for new episodes.

Selecting performers to star in original pay-cable specials and choosing properties to adapt to the television medium requires an in-depth examination of subscribers' expectations. Because the major broadcast networks can offer opportunities to see leading entertainers, either on specials or daily talk/variety shows, premium programmers are forced to seek out fresher, more unusual entertainers and material. Among their options are:

- Using performers who are well-known but who appear infrequently on broadcast network television

- Using performers often seen on broadcast television but who rarely headline their own programs

- Developing programs and artists unavailable on broadcast television

Premium programming must also satisfy a difficult to measure price/value relationship in the minds of subscribers. Here, the pay-cable and pay-per-view networks have made a major asset of taping shows on location, offering subscribers a front-row seat at theaters, nightclubs, and arenas around the world. For instance, a Las Vegas nightclub special provides the cable subscriber with the same performance that costs $40 to $60 per couple to see in person. A telecast of a rock concert from New York's Central Park or a country music festival from West Virginia makes the viewer in Columbia, Missouri, or Tempe, Arizona, a part of that one-time event.

Unlike the typical broadcast network special, every effort is made by pay-cable producers to preserve the integrity of a complete performance, without guest stars, dance numbers, and other window dressing used to widen the audience base of most broadcast network variety shows. At their best, these shows are vivid reproductions of live performances. Pay-television's time flexibility also permits nightclub acts and concerts to run their natural lengths, whether 1 hour and 11 minutes or 1 hour and 53 minutes. The private nature of pay-television viewing also allows for telecasting adult-oriented comedy and dramatic material unsuitable for airing on broadcast television.

Not every surefire idea has been successful, however. The much-hyped Woodstock '94 delivered lower than expected buy rates. The concert brought in $10 million, ahead of previous music events but well behind the $16 million grossed by *The Miss Howard Stern New Year's Pageant* in 1994.

Original programming (including made-for-pay movies, series, and specials) makes up as much as 50 percent of some premium networks' monthly schedules, and budgets are rising accordingly. HBO's top original nonmovie programming has included *One Night Stand* concert specials, *The Kids in the Hall*, and *Dennis Miller Live*. Its first series hit, *Dream On*, uses clips from 1950s television series to illustrate sexual fantasies in a situation comedy setting and includes a lot of gratuitous nudity, but it gets cable ratings around 13. *The Larry Sanders Show*, featuring Garry Shandling, is often in the running for Emmy awards.

SPORTS

The third major component in pay programming is sports. HBO and Showtime schedule major, big-ticket, national sporting events in prime time. Sports programming creates a divergence of opinion, however, in the pay-television community, with some programmers arguing that sports blur a movie service's image. In consequence, neither The Movie Channel nor Cinemax carry sports.

Because of the broadcast networks' financial strength and audience reach (and a general consensus that certain events like the Super Bowl should stay on over-the-air television), ABC, Fox, CBS, and NBC still manage to acquire the rights to most major sporting events. Premium networks often have to settle for secondary rights or events of lesser national interest. Nevertheless,

an audience can be found for some sports that broadcast television does not adequately cover, such as middle- and heavyweight boxing, regional college sports, track and field, swimming, diving, soccer, and equestrian competitions. For several years, HBO has aggressively sought and won the rights to a long string of top boxing and tennis events. In 1995, however, the return of Mike Tyson went to HBO arch rival Showtime with a six fight deal. Both Showtime and HBO have developed pay-per-view services that provide the most profitable boxing events to hotels and bars.

Big-ticket boxing and wrestling have been programming staples for pay-per-view packagers for many, many years. In the mid-1980s, the relatively *small number of headline events* and the relatively *small universe of pay-per-view equipped homes* then took PPV out of contention for major events. But the rapid expansion of the number of homes with pay-per-view in the late 1980s, combined with the success of such events as *Wrestlemania* and championship boxing, rekindled cable operator and subscriber interest in pay-per-view sports. In addition, several regional pay-per-view sports channels became successful as PPV technology and marketing improved.

In the mid-1990s, major PPV boxing matches on cable and National Hockey League games on DirecTV not only achieved record buy rates and revenues but helped fuel publicity for PPV itself. The key to success apparently lies in having strong local as well as national marketing efforts.

The most disastrous attempt to sell PPV sports to cable subscribers was in 1992 when NBC offered the Olympics TripleCast—three channels of round-the-clock Olympics coverage from Barcelona on PPV supplementing coverage appearing on NBC. Subscriber fees for converters to descramble this high-price-tag event exceeded $100, with half the revenue going to the cable operator. NBC lost $98.9 million on the experiment. NBC Sports President Dick Ebersol blamed the failure on nonexclusivity of the event and the poor marketing effort.[14]

Basketball has been the newest sports area where pay-per-view revenues have increased.

Local operators in markets with a winning NBA franchise have been able to cash in on their team's success. High consumer demand has led to buy rates in the double digits.

A number of regional pay-television operations have had success with month-to-month sports (see Chapter 10 on cable sports). The premium networks' advantage in sports programming is that they can emphasize sporting contests as entertainment rather than cover events in journalistic fashion. New program formats are emerging that focus on sports personalities and dramatize memorable sports events of the past. Such approaches broaden the appeal of sports, while offering intriguing programming possibilities not characteristic of broadcast television.

PAY NETWORKS

Of the more than a dozen pay services that launched during the 1970s and 1980s, only a few remain, supplemented by one newcomer. However, unusual packaging arrangements melding pay and basic from the point of view of the subscriber are breaking down the distinctions between these channels and the basic cable channels.

The services described next are listed as separate entities, but most are "sister" channels to one another. All are enjoying record increases in subscribers (an average of nearly 10 percent a year in the mid-1990s) after a dry spell in the early 1990s. HBO and Cinemax are at the top of the heap, with 27 million subscribers combined. Showtime, The Movie Channel, and Flix combined account for 13.3 million.

Because cable operators were no longer able to raise prices for basic channels in the mid-1990s, pay channels marketed better and sales grew. Competition from direct-to-home satellite programming was another factor in getting cable systems to work harder at increasing pay-channel subscriptions. DBS companies such as DirecTV gave pay networks a 10 to 15 percent boost in revenues by expanding pay cable's reach.

Cinemax

Time Inc. began Cinemax in 1980 to compete with Viacom's Showtime as a multipay alternative, both to protect HBO's subscriber base and to complement its schedule. Cinemax offers a differentiated selection of feature films geared to a younger audience than HBO's, especially urban professionals under 35 years—the affluent, contemporary crowd. In 1996, Cinemax had 7.8 million subscribers on 5,900 affiliates.

Beginning in 1983, Cinemax modified its programming from its all-movie start, adding entertainment specials and original comedy productions, such as *The Max Headroom Show*, to foster a personality distinct from HBO's. Although one of Cinemax's initial tenets was that it would not duplicate HBO's films within a given month, the smaller service sometimes premieres major movies at the same time as HBO. This permits Cinemax to take advantage of HBO's major promotional campaigns. Cinemax, however, schedules more movies every month than any of its competitors (145 films on average), more than The Movie Channel (125), HBO (75), or Showtime (95). About 10 percent of its schedule is original programming, mostly hip comedy and music.

The Disney Channel

The Disney Channel, launched in 1983 by the Walt Disney Corp., trades on that famous name. While its boosters say that no premium service has been launched with so much product recognition, it is equally true that no service has as much to live up to. The fastest growing pay-cable service in America in the 1980s, The Disney Channel has thrived in good times and bad and was still growing when the other pay services hit the growth wall in later years. In 1996, TDC had 12,630,000 subscribers on 7,000 affiliates.

Anxious to preserve the box-office appeal of its animated classics, The Disney Channel trots out *Pinocchio* and *Sleeping Beauty* only at rare intervals. Instead of its classics, The Disney Channel emphasizes original pay programs appealing to view-

ers of all ages. For children, it has the new *Mickey Mouse Club* and *Kids Inc.* For adults, it acquires such fare as the *Frank Sinatra Television Library* and the 1960s British rock series, *Ready Steady Go*. For the teens, it experimented with a reality series called *Hollywood Lives*, not unlike MTV's *The Real World*. Between movies it uses unique animated and taped interstitial bits (shorts) hosted by Mickey Mouse.

Although The Disney Channel original program content is relatively high, much of the schedule consists of nonclassic Disney library programs such as *The Love Bug* and classic films from other distributors. Older adventure programs are the main fare on its second multiplexed channel, appealing to older children and some adults. In the last couple of years, the network has exclusively premiered such Disney studio hits as *Honey, I Shrunk the Kids* and *The Little Mermaid*. Disney has also been successful in marketing its program guide, The Disney Channel Magazine, to systems and subscribers.

Encore 8

Launched in 1991 by Liberty Media, the programming spinoff company of the mega-MSO Tele-Communications Inc., Encore 8 has an eventual potential audience of at least the 6.5 million subscribers in TCI's owned and operated systems. How many of those basic subscribers will choose to pay between $1 and $5 a month to receive 24 hours of not-quite-recent films should tell a lot about the prospects for pay-cable growth in coming years. Encore 8 had 6 million subscribers on 1,244 affiliates in 1996.

TCI's strategy in launching Encore 8 as a mini-pay premium movie channel is to force the older pay networks to lower their wholesale price to cable operators. Encore 8 also targets an age group bypassed by the other pay services—30-year-olds and over—with 30 titles each month from the 1960s through 1980s. Typical films are *The Way We Were*, *Patton*, and *Dirty Dancing*. Each title runs up to 12 times a month, with no repeats at 9 P.M. and 11 P.M.

Home Box Office (HBO)

As of 1996, HBO had more than 9,300 affiliates (including those owned by its parent Time Warner) and 19.2 million subscribers, making it by far the largest of the pay services (although with only one-third the reach of many basic services). It constantly fine-tunes its programming strategy, but HBO's basic thrust is to license feature films from major studios and independent distributors as soon as possible after their theatrical release, some on exclusive contracts. The service also programs originally produced specials with big-name entertainers (including Madonna, Michael Jackson, and the Comic Relief shows), comedy programs (*The Larry Sanders Show*), children's shows (*Little Lulu*), and big ticket sports (boxing, tennis).

Consistently popular broad-based programming gives HBO nearly 50 percent of the pay market, with a churn rate of only 4 percent. With its sister service, Cinemax, it was the first of the pay-cable networks to scramble its satellite signal and market its service to home dish subscribers. With the enormous financial resources of Time Warner behind it, HBO can finance films during their early production stages in return for exclusive pay-cable exhibition rights (called **prebuying**). It schedules about 75 movies a month, three-quarters of which are unduplicated by the other premium channels, along with several exclusive entertainment specials and regular series. HBO also schedules a number of made-for-pay movies designed to have their first showing on HBO. On still another front, several international coproductions were begun with foreign partners.

HBO, along with CBS and Columbia Pictures, helped create the Hollywood motion picture studio TriStar. Although no longer part of that studio, the deal initially gave HBO exclusive access to still more film titles until Showtime took over. In 1993, Showtime extended exclusive rights to TriStar movies until the end of 1999. HBO will reclaim Tristar in the year 2000. The most recent exclusive deal for HBO has been an agreement reached with DreamWorks, the new Hollywood studio backed by Steven Spielberg, Jeffrey Katzenberg, and David Geffen. DreamWorks will give HBO exclusive rights to upcoming DreamWorks movies through 2006. HBO will show the movies after their theatrical, home video, and PPV windows.

Exclusivity has not necessarily increased subscriber satisfaction with pay services, but it has increased the cost of product to those services and increased the repetition of movies on their schedules. Its effectiveness is still a matter of debate, however. During the 1990s, HBO began adding original series to its lineup, seeking predictable programs that do not depend on megastars or studio whims but that can be promoted as "HBOnlys." HBO's goals are to stabilize the pay market by offering a value-added service; it hopes to invigorate the premium market and reduce disconnect rates, thus spurring operators to add channel capacity and encouraging subscribers to stay with pay cable (rather than substitute pay-per-view).

The Movie Channel

The Movie Channel (TMC), like HBO, Showtime, Cinemax, and Disney, runs feature films as soon as possible after theatrical release. But unlike its competitors, TMC programs virtually no non-movie titles, living up to its movie-only name. And because it airs no specials, it programs a greater number of movies than HBO or Showtime, often drawing on older features to fill the gaps. It shows an average of 125 uncut, first-run motion pictures each month, many of them unavailable on HBO and Cinemax. TMC uses hosts and packages its movies in highly promotable groupings under titles such as *The Breakfast Movie*, *The Laffternoon Movie*, and *TV Dinner Movie*. Its *VCR Overnight* encourages subscribers to tape movies for later viewing. TMC had 3.1 million subscribers on 3,250 affiliates in 1996.

In 1983, TMC's and Showtime's managements were merged, pooling their assets, including transponders, in an attempt to increase their competitive stance relative to HBO. The two pay-cable networks, now wholly owned by Viacom,

share financing, film licensing, production, and distribution. In 1984, they began an exclusive licensing agreement with Paramount Pictures, improving their competitive position but raising their costs, only to lose that pact in 1987 to HBO. Since then, Showtime/TMC has aggressively sought and won exclusive licenses to hit films. While HBO has exclusivity to Paramount films through 1997, Showtime/TMC will reclaim the rights to Paramount movies from 1998 through 2004.

Showtime

Showtime relies on feature films for a major portion of its audience appeal, but it has moved increasingly into dramatic and comedy series programming as well as made-for-cable movies. Showtime has featured a daily *FamilyTime* program block, including such series as *Storybook Classics*, taped musical performances, freewheeling comedy (*Super Dave, Full Frontal Comedy*), and dramatic anthologies (*Nightmare Classics*). Showtime had 8.1 million subscribers in 1996 on 6,000 affiliates, compared to HBO's 19.2 million.

Through series programming, Showtime attempts to create the same kind of program loyalty that the broadcast networks generate with their soaps and prime-time situation comedies. Original and exclusive programming, combined with active marketing, are its primary strategies. It carries *more* original series entertainment than any other pay-cable service. Showtime generally appears as the second or third premium channel on a system, not as the sole pay channel. It participates in the joint production and licensing venture with TMC already described. Operating with TMC, Showtime has moved aggressively into packaging pay channels for home satellite dish subscribers (TVROs) and for hospitals and other group-viewing situations.

In the early 1990s, Showtime's effort in original movies was strengthened greatly when its parent company formed Viacom Pictures Inc. Its higher budget movies, including such titles as *Paris Trout*, are designed to run theatrically in Europe while

premiering on Showtime and TMC in the United States. Showtime multiplexes two channels of movies, using time-shifting by airing both its East and West coast feeds, a strategy requiring no extra transponders. Showtime has taken a proactive stance toward HDTV and has a library of wide-screen movies ready for HDTV transmission as soon as HDTV sets become available in the United States. Showtime hopes to get the jump on HBO by being first with HDTV.

Flix

In 1992, Showtime launched its minipay channel, Flix, competing directly with Encore. Flix targets multipay households by coming free to subscribers with three or more pay channels and charging subscribers (95 cents to $5.95) with two, one, or no other pay channels. Flix offers 60 movies a month (twice as many as Encore), mostly from the 1970s and 1980s. Showtime designed Flix to help reverse the continuing decline of pay subscriptions.

In 1995 Showtime underwent a major shakeup in management. The incoming president of programming announced plans to schedule more original (first-run) movies in a single year than any other network in history.[15] But the late 1990s are expected to be lean years for Showtime as its access to top-flight movies will be limited. Competition from premium channels (like Encore/Starz) with more exclusive product may cause Showtime's number of cable affiliates to decline. Another possibility is that some of the major premium channels will merge.

Starz

Starz (or Starz!) is one of the newer premium channels featuring exclusive theatrical movies. It is an offspring of Encore, created by Tele-Communications, Inc. (TCI). In 1995 it reached fewer than 2 million homes, counting both cable systems and DBS distributors. Through the power of TCI (about the only MSO to carry it), Starz has spent $2 billion on movie deals, or about $1,000 for each of its 1996 homes. These deals include

exclusive output from Universal, New Line, Miramax (*Pulp Fiction*), and Imagine. Starting in 1997, Starz has claim to the Disney movie inventory of Touchstone and Hollywood Pictures.

As a source of exclusive movies, Starz will be a major force, on a par with HBO, by the turn of the century. Its overall success depends on future growth in its so far tiny subscriber base and the continuing importance of Hollywood theatrical movies. The price of Encore's eight channels (Starz is the eighth) was only about $6 in 1996, lower than either HBO or Showtime and their affiliated networks.

PAY-PER-VIEW NETWORKS

The dream of turning the television sets populating America's living rooms and dens into vending machines for the distribution of movies has been kicking around since the 1950s. It moved a giant step toward reality in the early 1980s when several local, stand-alone pay-per-view channels were launched. But it wasn't until the rapid growth of home videocassette recorders threatened cable subscriber rolls and two satellite-delivered PPV movie services became operational—Request Television and Viewer's Choice—that cable operators seriously began to make shelf space for pay-per-view.

Pay-per-view operates as the name implies. Several major PPV service suppliers have tried to move away from the term pay-per-view in their marketing, finding customers confused by it. Request Television, for example, has marketed itself as "The Rent-A-Movie Channel." Subscribers select a program from an a la carte menu and are billed for each individual selection. For the viewer, the selection process may involve a telephone call to the local cable service to arrange for descrambling the signal (or a national 800 number) or may only require punching a code number or a single button on a remote control device (**impulse ordering**). When ordered as VOD, NVOD, or DBS, button punching is all that's needed.

As with other premium services, the primary content is movies, although a large number of sporting events and concerts are offered as well. For viewers, the key advantage to PPV is the early availability of major motion pictures, generally six to nine months after theatrical release and six months ahead of their first pay-cable appearance. The second major advantage is convenience. Movies can already be rented on videocassette (for slightly less and earlier than they first appear on pay-per-view), but the PPV subscriber need not leave home to pick up and return a tape. In addition, there are no "late return" charges, and a movie's availability does not depend on how many copies of top films a store has stocked. (See 11.4 for more on the future of video rentals.) Of course, one advantage of a tape is that it can be stopped when an interruption occurs (phone calls, guest, what have you), whereas a satellite-delivered movie just keeps on playing.

Nevertheless, a survey conducted in 1995 by Chilton Research showed that overall satisfaction with PPV is almost level with home video. The major difference was that only 20 percent of those surveyed had ever used PPV, and all but 20 percent had rented a tape. The top two disappointments with home video were not finding the desired tape and limited selection, while the top two disappoints with PPV were cost and ordering difficulty.[16] (See 11.5 for more on order-taking.)

About 25 to 30 percent addressability appears to be the "critical mass" for launching pay-per-view in most systems, and cable operators occasionally test different systems by offering a national PPV service and a local PPV channel side by side. To be competitive with home videocassette rentals, most pay-per-view movies sell for $3.95 to $4.95 per viewing (with some as low as $2) and are billed monthly along with the subscriber's basic and pay-cable charges. Staying competitive with direct-to-home (DTH) services like DirecTV is a problem because their rate is $2.95 per movie.

Recently the Hollywood studios began to shorten their home video to PPV window. The problem with long windows (60 to 90 days) is that an overabundance of hit movies during the home

11.4 HOME VIDEO RENTAL REBOUND

Conventional wisdom in the early 1990s predicted the decline of video stores upon the arrival of new pay-per-view technologies. Indeed, the annual rental spending per VCR household declined throughout the 1980s. By 1991, the annual spending had bottomed out at $113 per VCR household. Part of the decline resulted from increased numbers of VCR homes at a time when video stores were at a point of saturation. Starting in 1992, however, annual rental spending rebounded to previous levels. By 1996, estimated spending on home video rentals had surpassed the $127 level set in 1986.

As VCR household penetration inches toward a projected 90 percent level by 1999, how long rentals will remain competitive against PPV and video-on-demand is an unknown. Video retailers pay more than $60 per tape on average and make their profits after renting a tape 25 times. Most popular films have high demand for six weeks, so profits are virtually assured for films that reach this level of popularity. Stores get 8 percent of their revenue from fees for late tapes and can sell off surplus copies of used tapes directly to consumers for about $10 apiece.

Will home video rentals survive the high-tech future? No one is sure, but it may be quite a while before videocassettes go the way of the vinyl recording.

video window tends to decrease the buy rate during the PPV window. Even *Jurassic Park* (which grossed $320 million in theaters) missed expected revenues because of overexposure. Studios in 1995 began offering 30-day windows to operators who would guarantee a minimum buy rate, and now 30- to 45-day windows are becoming the standard.

Weekend nights, especially 8 P.M. movie starts, are the most popular with subscribers. About half of PPV subscribers take one event per month, and about a quarter take two events. Only 10 percent or so take four or more events in a month. A recent survey attributed low buy rates to two objections: lack of interest in PPV programs and cost.[17]

From all signals in the mid-1990s, however, PPV finally looks ready to take off, provided that cable (or another multichannel provider) can come up with the channel capacity. Gross PPV revenues grew by about $10 million per year throughout the early 1990s, but rapidly accelerated between 1994 and 1995, with a jump from $413 million to $642 million. Of that $229 million increase, movies accounted for $34 million, but events increased $195 million, largely due to the return of Mike Tyson.[18]

Request Television

Launched in late 1985, with Request 2 added in 1988, Request Television (*http://www.hitsathome.com/request/*) distributes via satellite a menu of four to six major motion pictures each week on each of its five channels. Each month, Request 1 runs 10 to 12 titles and Request 2 carries 15 to 20 titles. Special events such as boxing and wrestling are also offered. Request provides distribution, marketing, and promotional support for its movies, but negotiations for local system carriage of programming occur directly between the cable operator and the movie studios. Founded by Reiss Media Enterprises, Request became a joint venture with Group W Satellite Communications in 1989. Films are delivered 24-hours a day, with staggered start-times on the multiplexed channels.

Request operates differently from other PPV services. It handles movie scheduling and provides the satellite delivery of programming only after negotiations with the studios have been completed by each cable operator. Participating studios include Columbia/TriStar, MGM/Pathe, New Line, Orion, Paramount, 20th Century-Fox, Universal, Disney, and Warner Bros. Operators pay nothing

11.5 ORDER-TAKING FOR PREMIUM MOVIES

Manufacturers are developing more sophisticated *impulse order-taking technologies* to provide the subscriber with easier access to PPV. Order-taking equipment varies from cable system to cable system, depending on how much initial capital investment an operator wishes to make. Some systems use traditional customer service representatives (CSRs) to take individual orders by phone; although subscribers like the human contact, it usually results in telephone gridlock near program time. The cheapest system for pay-per-view is the automatic response unit (ARU), which is located at the local cable system. It can automatically respond to customer requests using preprogrammed, computerized voice response, although the gridlock problem is not solved. Quicker than ARU and cheaper than impulse technologies, automatic number identification (ANI) by the telephone company invites in a third party and also generates some gridlock. AT&T offers cable operators a national 800-number service for PPV ordering. It can handle 35,000 PPV calls in five minutes. These computerized systems respond to customer requests using preprogrammed voice recordings, bypassing customer service representatives and speeding order-taking.

The most sophisticated systems, however, utilize impulse technology. Subscribers can order a pay-per-view program by pushing buttons on a cable converter or keypad. Because telephones are not used (in the more advanced impulse systems), gridlock does not occur. Impulse systems are now replacing ARU and ANI. Although impulse systems involve huge technical and maintenance costs for the cable operator, they generate the most buys and highest subscriber satisfaction. Moreover, impulse technologies become ideal as the industry moves toward video-on-demand.

Systems using these technically sophisticated but consumer-friendly order-entry technologies frequently have higher buy rates, but the rates vary widely, ranging from about 10 percent to over 50 percent, depending on the event, total pay channel offerings, marketing effort, and type of event (live or movie). For movies alone, two other factors affect buy rates: length of home video-to-PPV window and availability of a sell-through videocassette.

The average monthly buy rate for a one-channel system is 10 to 12 percent. This figure increases to 18 percent for an average dual-channel system. By 1995, PPV subscribers had increased to more than 23 million homes (total addressable universe estimated at almost 33 million homes).[19]

for delivery of the encrypted (scrambled) signal; the studios and event promoters (not Request) pay the delivery cost. Revenue from local PPV sales are split between the operator and the supplier (Request). However, cable operators rarely cherrypick the schedule, instead taking the program schedule offered by Request in its entirety. Viewers may either telephone their cable service or push buttons on a keypad to arrange to descramble the PPV movie or event.

Each cable operator chooses the technology and creates the price structure for local viewing, varying them according to local market conditions and the operator's cost for installation and licensing for each movie. By 1996, the five Request services were serving 30 million addressable subscribers. In May 1996, Request and TCI agreed to distribute an additional 30 PPV channels to cable operators.

Viewer's Choice

Viewer's Choice (*http://www.ppv.com/*) includes the following 24-hour services: Continuous Hits One through Four, Hot Choice, and Viewer's Choice. Like Request, Viewer's Choice provides movies from theaters and live events such as wrestling, boxing, and concerts. Also like Request,

Viewer's Choice offers special events such as boxing championships, concerts, and the sports/entertainment Wrestlemania extravaganzas.

Unlike Request, however, Viewer's Choice licenses movie titles from the studio sources, much the way pay-cable networks do, and then sublicenses them to the cable operator. Viewer's Choice sets the wholesale price for each movie, typically $2 to $2.50 for a movie, and remits $1.80 to $2.25 to the film company. Viewer's Choice, the studio or event supplier, and the cable operators split the revenue from subscriber purchases. The breakdown is: studio/event supplier and operator, 40 to 42 percent apiece; Viewer's Choice, 10 to 15 percent. By 1996, Viewer's Choice was delivered to 30 million addressable subscribers nationwide over its six channels.

Cable Video Store

Unlike both Request Television and Viewer's Choice, which concentrate on the latest Hollywood hits, Cable Video Store (CVS) offers a broad menu of 50 to 60 movies a month, only a few of which are new releases (much like a corner video rental store or supermarket booth). This scrambled 24-hour, single-channel service telecasts classic films and older movie hits that may have recently appeared on the monthly pay-cable channels. It charges from 99 cents to $3.99 per movie.

CVS was started in April 1986 by General Instrument's Jerrold Division as a means of pushing its own impulse-ordering technology, requiring a special cable converter in each subscriber's home. Jerrold operated the service until its sale to Graff Pay-Per-View in 1990. As of 1996, CVS served 2.8 million addressable subscribers.

Playboy TV and Spice

After two years of offering Playboy Channel pay-cable programming in some markets on a night-by night or weekend-long basis, called Playboy on Demand, in 1989 Playboy Enterprises Inc. changed the network's name to Playboy at Night and began selling it as a full-fledged PPV service.

While still running as a monthly pay service in some nonaddressable systems, Playboy targets itself to the industry almost exclusively as a PPV option. Unlike the other PPV services, Playboy does not offer subscribers individual programs but rather entire 10-hour nights of programming—all for $3.95 to $4.95 a shot.

The Playboy Channel, evolving out of an early effort called Escapade that was run in conjunction with Rainbow Programming Enterprises, launched as a pay channel in 1982. It then had 800,000 subscribers. By the late 1980s, it had shrunk to only 520,000 subscribers via 600 systems. But by early 1995 Playboy at Night had 9.5 million addressable households as a PPV service, while holding onto about another half million monthly subscribers.

In its PPV format, Playboy promises more than 75 percent original programs, including Playboy's *Hot Rocks* (music videos) and *Tales of Erotica* (anthology). Each week of programming begins on Thursday night, with no duplication for the next seven nights.

Like The Disney Channel, Playboy elicits instant brand recognition from consumers. Most people have a notion of what it is like before they see it. Unlike Disney, however, many large cable MSOs found the controversy associated with carrying Playboy as a pay service not justified by the revenue it generated. At one point in the 1980s, by MSO policy, Playboy as a pay service was locked out of three-quarters of cable homes.

Carrying adult fare on a PPV basis is more apt to pass an MSO's muster. By the mid-1990s, while not shouting the news from the rooftops, some of the larger cable operators were doing quite well not only with Playboy but also with Graff Pay-Per-View's Spice, begun as Rendezvous in 1989 (see 11.6). Unlike Playboy, Spice offers only movies. Spice I and Spice II served 9.5 million addressable subscribers in early 1996. Both Playboy and Spice have so far managed to avoid the sort of problem that doomed The Tuxxedo Network, a victim of satellite banishment after its parent network, Home Dish Network, was indicted on obscenity charges in Alabama for satellite transmission of a more explicit TVRO service. Tuxxedo lasted

11.6 PPV SPINOFFS

The Adam & Eve Channel was originally the second Spice Channel, and it was reaching 3.5 million subscribers by 1995. Playboy also spun off another new service in 1995, AdulTVision, reaching about one million subscribers.

Another PPV genre attracting attention—*action-adventure "B" titles*—is being exploited by Avalon Pictures' Action Pay-Per-View service, begun in September 1990. It picked up 200,000 homes quickly when Graff, following its acquisition of Cable Video Store, dropped its similar Drive-In Cinema service (which reached 1.1 million addressable homes) after less than two years of operation. Action PPV had 7.1 million addressable homes by 1996. The suggested retail price of its movies is $3.99.

Other pay-per-view operations provide full-time service in a single market or group of markets. The Time Warner family is leading the way in this regard. In 1990, the Warner studio started an experimental "Continuous Hits" channel over eight cable systems. It plays one hit movie every two hours for a whole week. Subscribers can elect predictable, fixed times to view, for example, the 2 P.M., 5 P.M., 8 P.M., or 11 P.M. showings, and movies are typically priced at about $4.95 (retail).

barely two years (from December 1987 to the spring of 1990).

In-House PPV Services

Time Warner's own largest cable systems, such as Brooklyn/Queens (BQ) Cable in New York City, took the PPV concept one step further, offering the multichannel, multiplex-type Time Warner Home Theater. BQ Cable also led the conversion to 150-channel capacity in late 1991, offering dozens of PPV choices. A predecessor company, Warner Amex Cable, pioneered development of multi-pay-per-view two-way addressable technology (**Qube**), and Warner has now tested the PPV market longer than any other company (well over a decade in Columbus, Ohio). Warner created the first dedicated PPV channels with a five-minute delay before automatic billing as a method of enticing viewers to check out PPV channels.

In the 1970s, the large number of other channels on Qube systems (100 or more, including all monthly pay services) originally undermined the effectiveness of its pay-per-view marketing because subscribers had so many other unfamiliar viewing options. Over the long haul, however, multiple PPV channels proved to be effective moneymakers for Warner, and the MSO regularly purchases packages of films to schedule on all its systems, which then appear as local exclusives to subscribers.

The potential profitability of pay-per-view has encouraged a few other cable operators to launch their own in-house PPV services. Operators such as BQ Cable in Brooklyn and Queens and other MSOs in large urban cable systems negotiate directly with sporting event packagers and the Hollywood studios for a group of films, eliminating the national satellite distributor. The advantage is that programming is then controlled locally, both in selection and scheduling. The disadvantage is the high cost of building and operating a local videotape facility.

THE GROWTH OF INTERNATIONAL PAY TV

With pay television now a maturing industry in the United States, many U.S. programmers are turning their sights to international markets. This

interest, coupled with the changing political and technological environment in many parts of the globe, has created vast opportunities for growth of international pay television networks, whether they are distributed via cable, over-the-air, wireless cable, or direct-to-home satellite dishes.

Europe

As Europe moved toward a unified common market in the 1990s, television in most European countries gained greater freedom via deregulation and privatization. Pay-TV services were launched in Italy, Spain, Belgium, and Germany, and prospectively in French-Speaking Africa, Eastern Europe, the Netherlands, and Portugal by the mid-1990s. These are signals that the European pay-TV market has emerged in earnest. With a more developed direct-to-home (DTH) base than in the United States, and ambitious cable construction plans in many countries, pay TV promises to be a growth industry in Europe for several years to come.

At the forefront of this expansion is the French channel Canal Plus. The international pay-television scene began in earnest with the arrival of Canal Plus in late 1984. This hugely successful channel distributes its combined sports-and-movie service over-the-air in scrambled form to French subscribers who are equipped with an antenna and descrambler. Canal Plus is able to air movies only one year after their theatrical release and two years before other French TV outlets (compared with a one-year separation between pay-TV and other TV outlets in the United States).

The United Kingdom has also been active in the development of pay TV. (For example, see *http://www.sky.co.uk* for British PPV.) Waiting longer than its French neighbors, the United Kingdom's most serious foray into the pay-television arena was the launch of two direct-to-home services in 1989 and 1990. The bold activities of the two competing networks galvanized attention regarding the potential of the European DTH market and spurred sales of home dishes. The two services eventually merged in late 1990 to

form BSkyB, which has more than 5 million subscribers and made a profit of $400 million in 1996.

Asia

Long characterized by political and moral censorship, the pay-TV market in Asian countries was slow to develop. The 1990 launch of the AsiaSat satellite, however, brought about new interest in satellite-delivered television services. Hutchison Whampoa, a Hong Kong-based conglomerate, took the first steps toward realizing its goal of a pan-Asian service. Eventually incorporating 10 channels (two of which were pay), the STAR TV service spans 40 countries and encompasses nearly 3 billion people. By 1995, media mogul Rupert Murdoch had acquired STAR TV for over $800 million, although censorship problems with countries have created indigestion for his devouring conglomerate, which controls BSkyB.

Japan's first pay TV service, Wowow, was launched in 1991, a joint venture between Reiss Media Enterprises, Inc. and Japan Satellite Broadcasting, Inc. Delivered via high-powered satellite to DTH dishes, Wowow's subscriber growth has been explosive, representing the most successful pay-TV launch in history.

The growth of pay TV in international markets will probably spur the growth of international pay-per-view as well. With modest experiments to date in England, France, Japan, and the Netherlands, pay-per-view has yet to gain a significant foothold in international markets. However, taking advantage of improved technology and experience in the United States, pay-per-view will probably develop more quickly once it is introduced in earnest in international markets. In 1995, a new company called TVN Solomon International was formed to deliver such programs worldwide. Also, in 1995 plans were going forward to bring American- and British-based pay TV to Australia.

Before the end of the decade, every nation in Europe, Asia, and Latin America (where HBO is currently distributed) will probably have some access to pay TV and pay-per-view. It is not unreasonable to assume that the number of global

pay-television households will at least equal, and perhaps exceed, the number of pay-television households in the United States by the year 2000.

Increased growth in international pay TV will continue to contribute to an increase in foreign involvement in American films and foreign and American coproductions. For example, Canal Plus supplies U.S. cable networks with programming through investments in production companies and promises more activity in France and elsewhere in the future. Another example of the trend comes from Wowow, Japan's pay-TV network. It is actively exploring opportunities for prebuying motion picture rights and investing in motion pictures in exchange for Japanese television rights. As global markets continue to offer the promise of growth, foreign coproduction activity will also expand.

Not everything is rosy with regard to selling American programming overseas, however. In 1994, the European Commission tightened TV program quotas and extended them to new services, including pay-per-view and video-on-demand. The tighter quotas had the greatest impact on U.S.-owned satellite spinoff channels in Europe because they rely heavily on American programming.

NEW DIRECTIONS FOR PREMIUM PROGRAMMING

The last 15 years have seen dramatic changes in premium services. While HBO, the leading premium network, continued to dominate the marketplace, the number two service, Showtime, wrestled with strategies to build its market share. HBO turned to national consumer marketing and "triple-plexing" of both HBO and Cinemax, further raising its profile with America's viewing public. Meanwhile, Showtime forged exclusivity of movie product into a primary weapon and further differentiated itself through substantial investment in original programming. Pay-per-view networks entered the picture in the mid-1980s, offering movies and entertainment on an a la carte basis.

The wider availability of top-name movies on pay-per-view and through both sell-through and rental videocassettes reduced the overall attractiveness of theatrically released film titles, pressing the movie-based pay networks into producing even more exclusive and original product. HBO's competitors are likely to pursue stronger creative and financial links, perhaps even partnerships, with program suppliers and cable operators. Carrying advertising is another option for marginal pay services.

Pricing and Tiering

As cable systems continued to expand their program offerings, raising the price of basic service in the process, the pay cable customer's average monthly bill was starting to approach $50 in the mid-1990s. But premium services came under increasing pressure to reduce their retail prices to bring them better in line with customer expectations and spending patterns. A *low-price, high-volume* strategy seems likely to replace the retail pricing strategy that has been endemic to pay-television since its beginning.

As pay-per-view services increase their market penetration, offering the early-release pattern for movies that was once the exclusive province of pay cable, more pay-cable services may evolve into "super basic" channels on many cable systems, functioning to provide lift for a second or higher programming tier. Such has already been the case to a large extent with former pay channels American Movie Classics and Bravo. Disney also appears on expanded basic on some systems. Encore is intended for such a tier, and discounting to operators to gain more subscribers encourages new packaging strategies.

Technology's Importance

As compression allows for greatly increased channel capacity and impulse technology becomes standard for cable converters, a wide range of possibilities opens up for cable operators and programmers alike. Increasing numbers of cable subscribers can now order a pay-per-view movie, concert, or

sporting event in an instant and, increasingly, they will avail themselves of the opportunity. Projections of 20 to 30 million PPV homes in the mid-1990s will entice Hollywood's studios to release movies to pay-per-view services closer to their theatrical release date, truly creating a "home box-office" bonanza for movie makers and event organizers. VCRs and PPV will continue in head-to-head competition through the late-1990s.

SUMMARY

Premium cable networks, for which subscribers pay over and above the cost of basic cable service, primarily provide theatrical feature films, with a significant array of entertainment specials and sporting events. The services divide into six national, pay-per-month pay-television services offering a full menu of programming, and six national pay-per-view services charging per program for a movie, concert, or sporting event. In the multipay environment, HBO is number one, and the rest of the premium services compete with one another for shelf space and for attractive cable channel positions by offering lucrative revenue splits to cable operators. All services suffer from the problems of churn, downgrading, and spin. The major strategies for combating these problems focus on differentiation, exclusivity, and pricing. Pay-movie networks rotate their program schedules to increase their utility to cable consumers, providing a balanced mix of premiere movies, family and children-oriented programs, adult-appeal shows, foreign films, and encores on most services. The pay-per-view services take a more targeted approach, carrying from four to six movies plus special events per week. Premium programmers must consider title availabilities, exhibition windows, and licensing practices in selecting and scheduling theatrical motion pictures. Beyond that, they look for blockbuster events (such as wrestling super-events). The keys to PPV penetration are user-friendly technology, convenient scheduling, and exclusive movies and events. Like pay cable, pay-per-view will operate in a multichannel environ-

ment with addressable homes having several PPV channels. This forces the monthly pay-television services to seek more differentiated images. As channel capacity increases, it will force the PPV services to schedule like multiplex cinemas with one title per channel. For both pay cable and pay-per-view, the major strategies for the 1990s focus on marketing, original product, and balancing the retail price charged for premium services against the rising price of basic cable service. Growth in the international pay and pay-per-view will replace the revenue from lowered retail pricing in the United States.

SOURCES

Cable Television Developments. Washington, DC: National Cable Television Association, annual.

Cablevision. Monthly trade magazine covering the cable industry. Denver, 1975 to date.

Cable World. Weekly trade articles on national cable programming. Denver, 1988 to date.

Multichannel News. Weekly trade articles on national cable programming. New York, 1979 to date.

The Pay TV Newsletter. Weekly trade analyses of the pay and pay-per-view market from Paul Kagan Associates in Carmel, CA. 1983 to date.

The State of DBS: A Guide to the Potential of the Emerging Direct Broadcast Satellite Industry. Carmel, CA: Paul Kagan Associates, 1994.

NOTES

1. In 1996 AT&T Universal cardholders were offered DirecTV charges interest-free for one year. Other AT&T incentives to subscribe to DirecTV included one free pay-for-view movie each week for a year and a free month of premium cable.

2. In Janaury 1996 the Justice Department discouraged Primestar and other cable corporations from venturing further into DBS ownership. The Antitrust Division proposed that if the FCC adopted rules allowing Primestar to obtain high-power DBS channels, Primestar's cable partners should be forced to divest their cable properties so that they serve less than 10 percent of the nation's cable subscribers.

3. DBS is an international force too. News Corp. operates three overseas satellite services: BSkyB in the United Kingdom, Star TV in Asia, and a third service in South America.

4. Idaho is one state where 70 percent of the residents live in small rural communities better reached by DBS or by wireless cable from USWest than by conventional cable companies.

5. By 1996 HBO had expanded its Multichannel HBO from 8 to 12 channels, including a fourth HBO channel and 2 new Cinemax channels.

6. In the early 1990s, pay-TV networks suffered several years of low subscriber revenue, leading some observers to question the viability of several competing services. By 1995, however, the situation had turned around as cable operators devoted more promotional attention to pay. Forecasts made that year put the total revenue mark for pay-TV networks at more than $5 billion.

7. Gene F. Jankowski and David C. Fuchs, *Television Today and Tomorrow* (New York: Oxford University Press, 1995), p. 161.

8. Philip Elmer-Dewitt, "Play . . . Fast forward . . . Rewind . . . Pause," *Time*, 23 May 1994, pp. 44–46; for other information, try *"http://www.cdinet.com/benton/Catalog/Working7/working7.html"* on the World Wide Web.

9. Such distribution systems (sometimes known as MMDS) had not had the channel capacity for advanced video service previous to the advent of digital compression. MMDS services spurred by investments from telcos such as Pacific Telesis, were uniquely positioned to offer digital service from the onset, because their number of analog customers was small.

10. First came the 1990 announcement of SkyCable, later abandoned. As envisioned by Cablevision Systems, NBC, Rupert Murdoch's News America, and Hughes Aircraft, SkyCable was to use a digital compression system to send increased channel choices from satellite to small subscriber dishes. Using 4:1 signal compression, 108 channels would be sent over 27 satellite transponders.

Opponents in the cable industry soon realized that the type of compression needed for SkyCable could work just as well over coaxial or fiber cable, and the cable industry sent its technological wizards into motion. Soon, digital compression was a reality on cable, and SkyCable was dead.

Compression can send three, four, or more video channels over the space formerly used by a single signal. Impressive enough on a conventional system, when applied to a 150-channel fiber system like Time Warner's Brooklyn/Queens system, the programming opportunities seem endless.

11. Sophisticated distributors have been extremely successful with several rounds of alternate theatrical rereleases and pay-television exhibitions. A pay run is a playing period of about 30 days in which an attraction is telecast three to eight times. This pattern applies to premium networks, subscription television, and other pay services.

12. Pay cable typically uses the age categories of 18–24 and 25–49 because these groups best separate people with the most similar entertainment tastes. Broadcasters, in contrast, tend to focus on buying habits. The 18–24 age group watches more films, for example, because the bulk of films are directed toward that age group, in part because their lifestyles permit easy attendance at movie theaters.

13. Disney has been successfully releasing movies to video that it once held for rerelease to theaters, although tape buyers have a limited time opportunity in which to purchase most Disney classics. *Snow White & The Seven Dwarfs* (23 million copies) surpassed *Jurassic Park* (21.5 million copies) for the number one sell-through release of 1994. *The Lion King* sold 30 million copies in 1995 when Disney topped the $2 billion mark for domestic home video sales.

14. Rich Brown, "PPV on the Offensive in New Orleans," *Broadcasting & Cable*, 10 April 1995, p. 48.

15. John Dempsey, "Showtime Takes Original Gamble," *Variety*, 31 July 1995, pp. 21–22.

16. Jim Forkan, "The PPV Satisfaction Survey," *Cablevision*, 21 August 1995, pp. 33–36.

17. "Consumer Poll: Why PPV Buy-Rates Are So Low," *Cablevision*, 5 June 1995, p. 55.

18. By 1996, concerns that PPV boxing would revert to closed-circuit television in arenas had vanished with the continued success of Mike Tyson. His March 1996 bout with Frank Bruno also brought higher than expected buy rates for BSkyB in the United Kingdom's first PPV event.

19. These figures are from *Video Business*, 12 May 1995.

PART FOUR

Commercial Broadcast Radio Strategies

Although radio stations far outnumber television stations (more than 12,000 to under 1,600) the combined revenues of commercial radio stations fall far below those of television stations. For several years, however, radio listening levels have reached three and a half hours per person each day—only an hour short of the average amount of individual television viewing time. Radio is a local medium with lower production costs and correspondingly lower revenues. But the sheer number of stations gives radio programming a major industry role and creates thousands of jobs for programmers. FM has long been the dominant radio medium, getting most of the listening by virtue of its higher quality sound. Most of the 100 FM channels (parcelled into about 5,300 commercial and 1,800 noncommercial stations) are successful in attracting listeners and advertisers or underwriters, but most AM stations have been forced to try new strategies to survive.

By the early 1990s, the Federal Communications Commission had made strides toward reviving AM radio by approving AM stereo, allowing simulcasting of AM and FM, and reducing congestion and interference on the AM dial. Reduced congestion was achieved by increasing the number of AM channels to 117 (540 kHz to 1700 kHz) to allow existing stations to move to uncrowded dial positions and to allow daytimers to expand to 24-hour

service. Altogether, there are just over 4,900 commercial AM stations across the country, although many are unprofitable and still more only marginally successful. To survive, many AM stations have entered local marketing agreements (LMAs) in which two stations share programming, staffing, and commercial time sales functions, much like the joint operating agreements characterizing the newspaper business. In addition, changes to ownership rules in 1996 allowed owners of radio stations to buy out their competition within markets.

Whether AM radio survives until all-channel radios become commonplace and new digital technology replaces current technology is an open question as of the mid-1990s. But FM radio is growing in numbers of stations and appears healthy even in times of general economic recession.

Part Four of this book covers programming strategies from the perspectives of **national radio program suppliers** and **local radio stations.** It emphasizes the local orientation of most radio programming and the changing roles of radio networks and syndicators. The main topic areas are national distribution, music, and information programming, and in each chapter *evaluation, selection,* and *scheduling* of radio programming is analyzed. Although these chapters focus on broadcast audiences, it is important to recognize that more

than 40 percent of radio stations also reach listeners on local cable FM and as background to text-only channels. Listening to these sources is unmeasured and assumed to be insignificant at present, but these options hold potential for growth in the future.

Chapter 12 provides an overview of **radio networks** and **syndicators** and their place in the radio broadcasting industry. Nearly 90 percent of radio stations pull in some programming from satellite transmissions. As the main sources of nonlocal material, networks play a major role as suppliers of information programming to music, news, and talk stations. About 60 percent of commercial stations affiliate with a network to obtain national and international news items, and some networks act as feature resources to stations that otherwise originate most of their own content. Music format syndicators supply geographically scattered, automated-music stations with a complete programming schedule. In Chapter 12 the authors take a national perspective on radio programming, covering the distribution, economics, and content of radio networks and syndicators. Some of the issues raised about national news and talk programs also apply to national television newscasts and public affairs programming; some of the issues raised about national program syndication also apply to cable.

Chapter 13 focuses on **radio music programming.** Music-oriented stations outnumber all other formats combined by a ratio of better than 90 to 1. In Chapter 13 the author concentrates on rock music programming, but its strategies can also be applied to other music formats. To illustrate music radio programming strategies, the author of this chapter creates a hypothetical radio market into which a new station is introduced, step by step. Choosing a commercially viable format for any given market indicates how radio programmers are restricted and the methods they adopt for operating within those constraints. The author reports the process of implementing a new music format, looks at the common types of radio personalities that fit the various dayparts, and explains typical advertising and promotion practices for radio. The author also points out the constraints that the federal government imposes on radio stations.

Chapter 14 examines the locally programmed **information station,** including both *all-news* and *all-talk* variants, as well as **noncommercial public radio.** Although information-oriented stations occur much less frequently than music-oriented stations, they occupy an important media role in times of local emergencies and national history-making events. All-news formats demand a high degree of specialization that can only be supported economically in mid-sized and large markets. News/talk is a freer format, able to shift direction toward entertainment or news as external events require. Most information formats occur on AM stations, while music formats appear on FM because of its technical superiority in sound. However, many of the concerns of the information programmer apply equally to three-minute hourly interruptions inside music formats as well as to more lengthy newscasts. In Chapter 14 the authors also examine the public radio station and its unique programming strategies. Public radio is fighting for its life in the halls of Congress. Political battles are taking their toll on public radio funding. Out of the thousands of radio stations, about one-tenth are noncommercial and one-third of those are public stations—nearly all are FM broadcasters. The authors discuss the six formats that dominate public radio, and show how stations may be affiliated with one or more public networks or remain independent.

Part Four completes this book's overview of programming. Radio programming may not seem complex when compared to broadcast television or cable, but these chapters demonstrate that radio programming strategy is highly developed within music and information formats and that radio networks and syndicators play increasingly important roles in an essentially local medium.

Chapter **12**

Network and Syndicated Radio Programming

Jeffrey S. Wilkinson
Susan Tyler Eastman

A GUIDE TO CHAPTER 12

12.1 SATELLITE RADIO DISTRIBUTION

In one generation the satellite has changed telecommunications forever. There are 180 orbital "slots" for satellites surrounding the earth, and roughly two-thirds of these are already filled. North and South America are served by 43 satellites.

Satellites operate within certain prescribed bandwidths. Civilian communications are served by C-band, C/Ku-band, and Ku-band, but overuse has led to new satellites that use other parts of the radio spectrum band.

The satellite works basically like this: A signal is sent to the satellite by a transmitter on earth (called an uplink). The satellite receives and retransmits the signal through transponders. After receiving the signal, the transponder amplifies it and changes the frequency (to avoid interfering with its own incoming signal). Then the signal is beamed back to earth, where it is picked up by the satellite dish (called a downlink).

The advantages of satellites over earth-based transmissions are that satellites can transmit to an unlimited number of ground stations simultaneously, and their costs do not increase with distance or number of receivers. The area capable of receiving a satellite's transmission is called the satellite's footprint. Because satellites use digitization and compression, a large number of high quality signals may be sent and received at once.

Several policy and practical issues surround satellite technology. Spectrum scarcity and competition for slots are two issues. Also, the limited life expectancy (10 to 15 years) and capacity (number of simultaneous transmissions) are problems that won't soon go away.

Syndicated and network radio programming exerts a huge influence on the U.S. radio industry. Of the 12,000+ stations, virtually all of them use some sort of external (nonlocally produced) feature or program to enhance the station's overall sound in the market. Changes in technology, ownership, and audience needs have altered this landscape forever. In this chapter we will address not only the way things were, but the way they are now, and the way they will probably be in the future.

The traditional differences between networks and syndicators were in the areas of distribution, affiliation (and compensation), and type of programming offered. Networks offered long-form, timely news and sports programming, whereas syndicators tended toward short-form features and undated material. Today there is a vast range of programming material available to radio stations, and a programmer can acquire virtually any show or program for almost any perceived station niche.

There are several dozen radio program suppliers, format providers, and national or regional networks available to local stations. Programmers in the 1990s have maximum flexibility in tailoring their formats to their audiences. To understand where the industry is now, we must look back briefly to see where it has been.

RADIO PROGRAM DISTRIBUTION

The programming roles played by radio networks and syndicators have changed drastically over the past 70 years. In the early days of radio, the networks supplied music and variety programs to affiliates across the country. But when the radio networks lost revenue (and audiences) to television in the 1950s, they cut back to mostly news and sports programs. As a result, radio stations kept a national image that complemented their local identities. Subsequently, radio program syndicators

12.2 TOP RADIO NETWORKS, 1994–95

	April 1994	May 1995
ABC's Prime network	3,600,000	4,000,000
Westwood One Variety	1,970,000	2,170,000
Westwood One CNN+	1,960,000	2,070,000
CBS radio Spectrum network	1,730,000	1,770,000
CBS Radio Network	1,390,000	1,330,000
Westwood One Adult Contemp	1,210,000	1,320,000
ABC's Excel network	1,200,000	964,000
Westwood One Young Adult network	1,040,000	1,170,000
Westwood One Country network	931,000	1,180,000
Westwood One Source network	925,000	872,000
American Urban Radio Networks	824,000	681,000

Note: Listeners are age 12 and older.

Source: Average quarter hour summary figures are RADAR data.

moved in and produced features and short musical programs for the local stations, usually on tape or disc.

It wasn't until the 1980s that national radio networks once again began supplying long-form entertainment programming (half-hour, hour, and longer programs). This coincided with the rise of digital audio technology and satellite transmission (see 12.1). Satellite-transmitted programming and development of the compact disc dramatically changed radio networking and program syndication in the United States.

The method of distribution used to be the greatest difference between networks and syndicators. A commercial network transmitted its programming, either live or prerecorded, simultaneously to all affiliates. Stations either carried the feed immediately or taped it for later broadcast. Conversely, a syndicator distributed programs by tape or disc, and they were aired whenever the station chose.

But this distinction between networks and syndicators has essentially disappeared. Major radio networks such as ABC, CBS, and Westwood distribute some programs via compact disc, while syndicators such as MediaAmerica distribute programming by satellite. Also, dozens of other so-called radio networks have been launched in the past decade or so, and mergers and crossownership have blurred the lines even more. For example, Westwood One owns NBC Radio Network and Mutual and distributes CNN Headline News. ABC Radio remains at the top in number of networks, affiliates, and revenues. CBS continues to be strong, especially its CBS Hispanic Radio Network (the top 11 radio networks are listed in 12.2).

Other major national radio networks that have been around for some years include American Urban Radio Networks, USA Radio Networks, Associated Press Broadcast Services, and United Press International. All these networks distribute programming by satellite.

Now that differences in distribution no longer remain (see 12.3), the main differences between networks and syndicators lie in (1) economics and

12.3 DIGITAL AUDIO

Besides the advent of satellites, invention of the compact disc in the mid-1980s also radically changed the way radio syndicators and networks did business. Traditionally, making analog copies of programs led to less-than-optimal reproductions. This often allowed the networks to enjoy a distinct advantage over syndicators. But digital technology has leveled the playing field. The compact disc (CD), digital audiotape (DAT), and more recently, the digital compact cassette (DCC) allow the smallest syndicator to make high quality copies of programs at affordable prices. This digital process records information in the form of zeros and ones, which is read by a laser, stored, and reproduced in the same pattern. Digital audiotape and more recently the minidisc CD permit exact replicas of programs to be made over and over with no loss in signal quality. This means that even the smallest syndicator can provide radio stations with technically high quality shows. Thus, one of the big differences between networks and syndicators has become program content rather than program quality.

compensation, and (2) program content, specifically, information (news and sports) and entertainment (talk, music features, and music formats).

RADIO PROGRAM ECONOMICS

The economics of radio programming involve the ways programs are purchased and paid for. In addition, network programmers must be concerned about carriage. The key issue here is how many stations actually clear (air) the program and not just the commercials. An understanding of how syndicators sell their shows will lay a foundation for understanding the nature of network affiliation.

Syndication Sales

Radio stations pay for syndicated programming in one of three ways: cash, barter, or both—cash-plus-barter (just as explained for television in Chapter 3).

Cash is the least common method of payment. Cash payments often include the guarantee of market exclusivity—that the buyer will be the only station in a given city to air the show. The price of the program is normally based on the purchasing station's own advertising rates. The higher the rate the station charges its advertisers, the higher the rate it is charged by the program provider (the syndicator).

Barter means that the station can run the program for free, but the syndicator has presold several of the commercial slots within it. These commercials have been sold by the syndicator to national advertisers at radio network rates. The syndicator can charge network rates because having commitments from several stations to run a program has the external appearance of a network to the advertiser. The local station then uses the remaining commercial avails in each program for locally sold advertising.

Cash-plus-barter combines these two methods of payment. The overall dollar amount is less than cash only, because some commercial slots are presold. But because more commercial slots are available than if it were barter only, the station has the potential to make more money from the show. Whether the syndicator sells for cash, barter, or both, the program may be limited in the number of airings, depending on the terms of the contract.

Network Contracts and Compensation

Networks use the system of **affiliation** to generate income. An affiliate signs a contract with a network for exclusive rights to air its programming in a given market. The station agrees to provide airtime to run the network's national commercials and in return gets its choice of the network's programming. ABC, for example, operates in this manner. CNN Radio charges affiliates from $100 to $1,000 per month depending on market size, and Satellite Music Network (owned by ABC) typically charges $1,000 per month, but may agree to half that amount, depending on a station's ability to pay and its standing in the ratings. In addition, an organization like Satellite Music Network may require the station to give them up to six minutes per hour to air presold national advertising.

Network shows are fed with commercials within or adjacent to them. But because many stations do not air all the network programs, they take their quota of network commercials fed in a weekly package and air them throughout the broadcast day. The networks promote their services as "free" to affiliates, but the stations in fact give up hundreds of minutes of airtime each week in exchange for affiliation and program access. For a station unable to sell its total ad inventory locally, the exchange of commercial time for network programming works well.

But in major markets where advertisers are plentiful and local rates are high, affiliates may use few network programs because network affiliation may cost the local station more than it brings in. This has forced the networks to sweeten affiliation deals in many major markets by offering stations **network compensation** (see Chapter 6 on television compensation). In theory, compensation makes up the difference between what a radio affiliate's revenue actually is and what it would be if all network spots had been sold locally, factoring in the value of the network programs. The resulting payments may differ greatly from market to market. Because it may matter for legal purposes, the networks try to keep "comp payments" at realistic and consistent levels. Still, it is not uncommon for important affiliates to be paid more than a million dollars annually for airing several dozen commercials each week, while the stations incur no obligation to air a single second of the network's programs.

The concept of radio affiliation, based on compensation rather than program clearance, pits the networks against the advertising representation companies (ad reps) in the ongoing scramble for advertising money in the national marketplace. The networks reward loyalty (defined as playing the programs as well as the ads) by offering such things as visits by network stars, generous equipment deals, and occasional paid trips to New York for local anchors. Stations that fail to clear the network slots often get budgetary excuses when they want a favor from the network.

Program Clearances and Exclusivity

At one time, network affiliation was important for a station to compete in a local market. The networks provided the image, the authority, and the high quality programming that linked the station so closely with the network. Today, the reasons for network affiliation are different. Only compensation payments, for example, motivate most major-market stations to affiliate.

The networks can no longer require affiliates to clear program offerings as a condition of affiliation. If they tried to, they would lose dozens of major-market affiliates and thus reduce the size of the audience for their programs. Today, the network's only requirement is that the commercials be aired. The network sends the commercials twice. The spots are included in the network programs as they are distributed, and they are also fed all at once in a weekly package to the station. This allows the station to be flexible. Some find it easier to simply air the commercials and none of the shows—including the news.

Another motive for affiliation is to prevent a competing station from airing the network's offerings. An affiliate gains first rights to the program and, if it airs some, can tie up the full network

12.4 SYNDICATED NICHE PROGRAMMING: A CASE STUDY

Lou Adler, president of Eagle Media Productions, Ltd., was an anchor for WCBS in New York City for a number of years and did a daily medical report there. In 1986, Adler used his contacts in the industry to set up syndication of daily 90-second medical reports with stations around the country.

Beginning with 18 stations in 1986, *Medical Journal* reached about 100 radio stations around the country in a decade. In 1990, Adler teamed up with another person and launched *A Matter of Law,* which rapidly zoomed up to about 85 stations. These shows are bartered.

Medical Journal was originally recorded in Adler's home studio and sent out by cassette. At one point it went to satellite but returned to cassette distribution partly because of recurring transmission problems but mostly because only about half the stations wanted it by satellite. The other half reported that they were taking "too much off the bird" and logistically preferred getting it by cassette. Most of the subscribing stations are AM.

package, thus excluding a competitor from affiliation and cherrypicking the programs.

RADIO NEWS PROGRAMMING

News programming has been one of the mainstays of network program offerings and remains one of the primary elements distinguishing networks from syndicators. The familiar "top of the hour" network newscast has helped thousands of local stations maintain a national identity and image. Short features such as ABC Radio's *Paul Harvey News & Comment* help boost a station's reputation and give it a unique identity in that market. Deregulation allowed many stations to cut back news offerings during the 1980s, but there has been a resurgence in the demand for news programming on both AM and FM bands.

National News Networks

Some networks offer affiliates nothing but news and information programming, leaving entertainment programs to syndicators or other network services. Almost all the national news networks have been expanding their services for affiliates.

Since several AM stations have successfully run the audio portion of CNN Headline News as radio programming, the Associated Press now offers its own 24-hour news service, including live reports. To complement the top of the hour newscasts, many networks now offer their own wire service to affiliates.

Specific news needs tend to depend on whether the station is AM or FM. The main areas of interest for most FM stations are music-related entertainment and human interest features. These types of short features work well with a predominantly music format. Meanwhile, AM affiliates generally seek long-form consumer affairs, medical, and financial information—the news that listeners can use. Most stations with news/talk formats can be found on the AM band. (See 12.4 for more on this topic.)

State and Regional News Networks

Local stations are not limited to national radio networks in establishing a news identity. The *1995 Broadcasting & Cable Yearbook* lists almost 100 regional radio networks, varying in size from the Hometown Radio Network with 860 affiliated stations in 17 states to the Pittsburgh Country Network with only three affiliated stations. Stations

can also affiliate at the state or regional level. Many stations have formed and operate cooperatives called state news networks. Member stations both contribute and receive news material from each other, as well as receive hourly newscasts and other features from the news network studios.

Identifying the Right News Network

A programmer or manager must make several decisions regarding network affiliation. Many FM stations with music formats have been successful with *no* news programming. With so many options available today, a general checklist for decision making may go something like this:

1. What demographic does this station wish to serve and with what format?

2. What news and information identity does this station wish to maintain, and what programming will best fit into the format?

3. What is the cost to the station (in terms of method of payment, time, and commercial avails)?

4. How might this affect other stations in the market?

While some research has indicated that news is *not* a tuneout to the audience, it clearly depends on what that news is and who the target audience of the station is. A rock music station aimed at 18- to 34-year-olds might choose ABC's Platinum or ABC Genesis, CBS's Spectrum, or Westwood One's The Source, because these news services use young, hip announcers, fast-paced stories, currently hot topics, and background music (and advertising) designed to fit within rock music stations. Other news services target different groups using easy listening (usually with mature voices) or country music (with appropriately Southern, Texan, or other accents) and advertising messages targeted to the listening audiences. In contrast, American Urban Radio Networks focuses on the news and information needs of urban African Americans, and SIS Notisat Radio Network offers Spanish-language news from the United States, Mexico, and Latin America.

ENTERTAINMENT PROGRAMMING

Stations want high quality programming to set them apart from other stations in their markets. Generally, however, the cost of producing such programs is out of the local station's range. The popularity of **shock jocks** in large metropolitan areas is countered by the expense of lawsuits (see Chapter 14 for a discussion of Howard Stern). Thus, networks and syndicators step in to provide long-form talk programs with nationally known celebrities, as well as coverage of sports contests and hugely popular music events.

Talk Programs

In the 1980s, the established networks returned to long-form entertainment programming—most notably talk shows. ABC's Talkradio, Mutual's *The Larry King Show*, and NBC's TalkNet combined overnight long-form talk and interview programs. Recent years have seen an explosion in popularity for talk shows. While most of the stations programming talk are on the AM band, increasingly FM stations are also experimenting with talk and finding success. Syndicated talk programming has been hot throughout the 1990s. In fact, a syndicated show like EFM's *Rush Limbaugh Show* has meant the difference between profit and loss for many smaller market AM stations.

In 1988 the *Rush Limbaugh Show* debuted on 56 stations in the United States. By 1996, Limbaugh was carried on more than 650 stations, most of them AM. There is evidence that Limbaugh has brought new listeners to the AM band, helping many stations in smaller markets to remain profitable and on the air. Limbaugh positioned himself as the voice of the conservative right and helped to propel talk radio into the center of American politics during the 1990s.

Usually talk stations combine syndicated shows with a network affiliation to provide full-service news and information programming. Many of these stations have demonstrated a long-time commitment to airing information, personality

shows, and sports programs, and have strong issue-oriented images in their communities. With so many stations running network and syndicated programming, it is no wonder that the distinction between networks and syndicators is often blurry.

The number and type of talk radio shows continue to change. Traditional talk has fragmented to include hot talk, advice talk, business, sports, "SuccessRadio," and other niche formats. All variations of talk radio are different in approach, sound, and "attitude." These three factors must be considered by the local station before choosing one over the other.

Sports

Most sports programming still comes from a network. Although a station rarely chooses an affiliation based solely on the sports coverage a network provides, sports affect the amount of affiliation (hours of clearance) and the popularity of the entire service. ABC, CBS, and Westwood radio use many nationally known sportscasters who also cover the same sports for television.

Most network sports programming, however, comes from the various regional networks set up to broadcast events of interest. College games are the most common example, and many colleges and universities direct the negotiations for broadcasting their games within the regions. Big money is involved for the participating schools.

Sports is a good money-maker for both radio networks and stations because it delivers a clearly identifiable audience, largely adult males, 18–49, with strong advertiser appeal. Sports programming is seldom exiled to AM stations, as a number of FM stations have also found that airing games can be profitable. From a national network programmer's perspective, however, there are too few attractive contests. Only games with national appeal are suitable for national distribution, and the cost for the rights to these events keeps climbing. As audiences and advertisers show increasing interest in news and sports programming, this programming will continue to be an area that differentiates network programs from syndicated programs.

MUSIC PROGRAMMING

Thanks to satellite technology, music programming is easily available from either a network or a syndicator. Music programming can be divided into three categories: Short-form, long-form, and continuous music formats. **Short-form** formats include individual programs and series (for example, DIR Broadcasting's 60-minute *King Biscuit Flower Hour*). **Long-form** programming consists of longer running shows such as ABC's *Rick Dees Weekly Top 40*. **Continuous music formats** are just what the name suggests—ongoing 24-hour music selections classified as classic rock, urban gold, hot country, hot AC, and others. The program networks also offer full-service music formats. For example, Westwood One's The Source is a 24-hour music service that includes short feature inserts. In addition to offering hourly two-minute newscasts, The Source schedules short-form features, comedy "drop-ins," and concerts (live and recorded). Also, the news stories are selected to complement the rock and roll music programming and focus on the lifestyles of 18- to 34-year-olds.

Concerts and Specials

The Source, Spectrum, and their rival youth-nets were latecomers to music-oriented programming. Syndicators (such as DIR Broadcasting) and networks (like Westwood One with its many concert series) have long been popular with both stations and advertisers. Concerts command premium prices because they provide exclusive access to top-ranked music in a live setting. Some acts are particularly valuable because they cross over a variety of station formats (for example, from soft rock to country), making it fairly easy for some music shows to air on at least one station in most markets.

On the networks, one-time-only music programs grew from near zero in revenues in 1975 to tens of millions by the mid-1980s. Since the mid-1990s, however, only a few musical megastars have been able to attract national audiences on the

scale necessary to meet network costs and fill high priced advertising time. (Access to these rare concerts and major performers remains beyond the financial reach of most local stations.)

Syndicators capable of recording such shows generally try to sell them to stations at prices from $25 to $50 per hour in small markets to several hundred dollars per hour in large markets. Networks often include these music specials as part of the full-service network programming of news, sports, and music. Networks can also go into the syndication business, offering music specials on a station-by-station basis.

Advertisers will pay a premium rate (above the normal network commercial rate) for music concerts and specials, because the commercials in these shows are fixed, allowing the advertiser to target the commercials to the exact demographics of the affiliates clearing a music special. The advertiser also gets the bonus of being associated with a major musical event.

Access to concerts and specials sometimes becomes a factor in compensation negotiations with affiliates. When a network supplies a program that many affiliates want, the network gains leverage in the annual battles to set compensation rates. Even a slight reduction in compensation payments can balance increased production costs for special programs.

As with any other type of network program, the key to revenue for a music special is the size of its cleared audience. Fitting a particular concert or series of concerts to a demographic category matching a salable number of affiliates is very difficult. Most of these programs target either the youth demographic, aged roughly 18–34 (it may include teens), or the adult demographic, aged 25–54. Each group presents programming problems. In general, a young demographic needs a more careful fit between programs and formats among the affiliates than the adult demographic; young adults are more fickle and are readier to push a button if the sound or voices are too staid, too serious, or otherwise perceived as "not for them." The biggest difficulty for networks, however, lies in matching programs to pure and mixed affiliate formats.

Pure versus Mixed Formats

The old definition for a pure format was "agreement by stations nationwide regarding what artists are included and those that are excluded." As radio enters the 21st century, the pure formats will increasingly be older music (classical, big band, and so forth). This is because popular music and radio have converged to make the notion of a pure format mentally appealing but practically obsolete. For example, album-oriented rock (AOR) was once viewed as a pure format. But AOR has been forced by the audience and the artists to split into classic rock and modern rock formats. Country, urban, and even alternative (college) music have split into two or three somewhat definite variations.

The sheer number and range of crossover artists makes it increasingly difficult for a station to claim its format is pure. Having a pure format works best from a ratings classification standpoint and is useful in promotion and sales to advertisers. But to compete in a market, the programmer focuses on targeting a specific audience (say 18–34 or 25–54, primarily male or primarily female). The goal of the programmer is to best match the overall sound of the music with the overall tastes of the designated target audience. These leads to constant trial of fresh artists.

The live formats will continue to be the cutting edge for programmers because they have the most at stake. Live radio will either win the biggest ratings or lose the most listeners in a given ratings period. The fine-tuning associated with live radio leads to experimenting with new or unknown artists. Sometimes a discovery catches on and attracts listeners; sometimes it doesn't.

Conversely, the role of the network or syndicator is to provide a relatively generic and safe format that will attract enough people to make the station predictably profitable. This means that the network or syndicated programs tend to be the best available version of a pure format for a given audience.

For a network seeking musical concerts and specials, three alternative strategies exist:

1. Produce many shows of varied appeal to capture fragments of the youth or adult audiences.

2. Concentrate on the relatively small number of stars that appeal across the broadest format spectrum.

3. Buy or produce programs that have unique, broad appeals.

The third strategy is the most economically efficient. For example, ABC syndicates *American Country Countdown* with Bob Kingsley and *Rick Dees' Weekly Top 40* on CD. These shows target specific groups who will listen to a wide variety of music over the course of the show. Countdown shows succeed best as regularly scheduled features, and audiences tend to seek them out. These unique music programs tend to clear the broadest range of affiliates, making them potentially the most profitable network programs and competitive with top-rated radio sports.

Music Format Syndicators

Until the late 1970s, stations programmed their own music or purchased long-form all-music programming tapes from syndicators such as TM and Century 21. Satellite delivery brought a new type of syndicated service—the **full-time radio format,** produced live.

The popularity of these services are impossible to ignore. Approximately one-fifth of all operating U.S. radio stations use satellite-delivered network programming as their primary programming source, amounting to nearly 2,500 radio stations. Although not as popular in large markets (New York City has only one full-time satellite station), smaller markets are increasingly turning to these suppliers. The smallest Arbitron-defined radio market, Kenai (Alaska), has seven stations, of which three use full-time automated satellite programming—two others use such services part time.

Modern satellite-delivered networks supply the combined services of a traditional network (news and advertising) and a formatted program service (music and entertainment programs). The result

when purchased is a station that has almost no need for any local programming. ABC Radio's Satellite Music Network (SMN) was the first and is the largest provider of real-time satellite radio in 10 different music formats, including two versions of country, two rock formats, two adult African American targeted formats, two adult contemporary formats, one version of nostalgia, and one version of oldies.

The decision to go with one of these services instead of locally generated and produced programming can reduce operating costs by one-half. Full-time satellite programming eliminates the need for large facilities, large staffs, and large equipment budgets. In smaller markets, going with such a service may allow a reformatted station to break even in less than a year. In addition, there is less competition from other stations. Satellite-delivered formats can provide high quality personalities, music, and news so effectively that some listeners fail to realize the content is not local.

Format syndicators are distinguished from format networks in that the syndicator usually provides only music, which is intended for fully automated stations (see 12.5). Unlike networks, format syndicators commonly do not sell commercial time or produce newscasts. There are approximately 50 major suppliers, and hundreds of regional syndicators market a package or two to a limited number of stations. About half of all commercial stations use syndicated radio programming, from overnight filler to 24-hour "turnkey" operations. Many station programmers prefer locally scheduled music, but nationally programmed song selections are based on professional research the local station cannot afford to conduct. By using syndicated format packages, a small-market station achieves a consistent "big-market" sound with a recognized appeal to audiences and advertisers.

The downside to running full-service satellite-delivered music programming (format network) is the lack of control. Sometimes the network personality talks too much or makes inappropriate comments. One station became upset when the DJ

12.5 MAJOR MUSIC FORMAT SYNDICATORS	
Syndicator	Formats
Broadcast Programming Inc. (BPI)	Country, Adult Contemporary, Christian, CHR, Modern Rock, Gold, Easy Listening, Classical, mixed-formats
Far West Communications, Inc.	True Country, Modern MOR
Jones Satellite Networks	Good Time Oldies, FM lite, US Country, CD Country, Soft Hits, Adult Choice-AC
Premiere Radio Networks	Country, Contemporary Gold, Contemporary Hit Radio, Adult Contemporary
RPM Radio Programming & Management	Solid Gold, Classic Rock, Country, AC, CHR, Christmas
TM Century Inc., Dallas Texas	19 formats varying from Country to Religious

(in Dallas) told Christmas listeners to "avoid the crowds and stay in today," which was then followed by local commercials asking people to do exactly the opposite!

By choosing a format syndicator, a station can exert more control. The price of such control, however, is paying someone to mind the format. For locally controlled stations, this is not a huge concern, and format syndication works well. But for an automated station with a distant owner and a skeleton staff, the format network is a better option.

Feature Syndicators

Syndicated feature programs range from daypart packages such as *Sports Shorts* or Sunday morning religious programs to very brief inserts such as the 90-second *Medical Journal* or interviews with star performers (for example, *Off-the-Record with Mary Turner* from Westwood One). Stations producing their own programming include short features to add spice and variety to a stretch of recorded songs and use the longer programming to fill unsalable time periods. Radio broadcasters also use features to attract a specific target audience, frequently subgroups of the station's overall target demographic group.

Syndicated features are as varied as their producers (see 12.6). Many companies that syndicate long-form format packages also supply short features that fit within their long formats. The short features are also made available to other stations in the same market on a format-exclusive basis. If a feature is format-exclusive, that same short feature can be sold to more than one station in a market if their formats differ, but only one rock or one country or one talk station can license the program. This arrangement assumes nonoverlapping listeners. Drake-Chenault, for example, produces *The Weekly Top 30, The Great American Country Show, The History of Rock and Roll,* and *The Golden Years,* and it produces format packages such as Country, Top 40, MOR, AC, and Soul. Each program normally is sold to only one station in a market.

CRITERIA FOR NATIONAL DISTRIBUTION

The main factor in selecting a program for national distribution is talent availability for writing, performing, and producing the show. In theory at

12.6 FEATURE PROGRAM SYNDICATORS

Syndicator	Sample Features
ABC/SMN	*The Tom Joyner Morning Show, Rick Dees' Weekly Top 40*
EFM Media,	*Rush Limbaugh Show, Dr. Dean Edell*
The Nashville Network Radio (TNNR)	*The Nashville Record Review, The Grand Ole Opry Minute*
Westwood One	*The Casey Kasem Countdown, Last Night on Tonight, Imus in the Morning*

least, talent is scarce, and its cost can be most easily covered by pooling resources. Five interrelated criteria guide network and syndicator choices:

1. A program must first meet the network's or syndicator's standard of professionalism in writing, production, and performance.

2. The program must offer some costly or prestigious element—location, star, budget or, in the case of promotions, some value-added ingredient—that the individual station cannot match.

3. If the first two have been met, the third most important asset is its potential appeal. A program must capture the interest of most people in the desired target group.

4. A fourth criterion is the uniqueness of the concept, style, talent, or presentation. Combining star power with a unique program format can give an edge in the battle for affiliate clearance.

5. Trends or fads become a fifth consideration. Determining what is or will be "hot" requires intimate involvement with and understanding of the medium and its target audience.

Trends in other media can provide clues to likely trends in radio, and widely appealing subjects (celebrities) or forms (all-sports) jump to other media. But the programmer must also be shrewd enough to guess when something popular is losing its appeal. The media have a voracious appetite for programming, and periodic revitalization and replacement are critical for a network or syndicator to remain acceptable to audiences and affiliates (and, therefore, to advertisers).

NEW PROGRAMMING STRATEGIES

Microformat Boundaries

Although the pure format is mostly a concept from the past, the 1990s has ushered in the age of the microformat, where music and information programming is fine-tuned to a specific audience in a specific market. The demand for programmers may actually be increasing, because many stations have complete flexibility on how much or how little they wish to "tweak" the station programming for the listeners.

Actually, they always had the flexibility but few exercised it. When radio was less competitive, programmers could take a cookie-cutter approach to music formats. As more stations entered the local marketplace, however, individual radio programmers learned that they had to work harder and smarter at reaching a particular target group.

Value-Added Promotions

Network and bartered radio programs must also appeal to national and regional advertisers who want large numbers of targeted listeners if they are to pay high rates for national time. To appeal to such advertisers, syndicators have adopted the strategies of packaging several programs reaching across demographic and format lines and making a marketing splash with value-added promotions.

A sales offering can include several different programs (for specific formats), provided each

show targets the same demographic group. Syndicator promotions must be sophisticated, because stations have become more sophisticated in their own promotional efforts. Syndicators have the advantage of occasionally offering extraordinary prizes for games and contests that local stations cannot readily obtain, thus appealing to both advertisers and stations. A trip to New York or to a concert is not enough for listeners today; prizes need to be one-of-a-kind to attract attention. One syndicator, for example, offered Tom Petty's autographed guitar; another prize was a classic Corvette autographed by rock musicians.

TRENDS IN RADIO DISTRIBUTION

Transmission technology changed radio programming by allowing dozens of new entrants into a business once dominated by a handful of companies. Today, producers of even a single show can place it on dozens of stations scattered across the United States, in effect creating their own network, thanks to low-cost time-sharing on satellite transmission channels. Two factors must be considered when deciding how to distribute the program:

- How many stations have contracted to air it
- How time-sensitive it is

If the program is not time-sensitive, recorded formats are still cheaper than satellite distribution. Leasing transponder time on the newest generation of satellites can run $120,000 per month. For occasional users, transponder space costs from $400 to $800 per hour, depending on services, signals, and transmission time.

For various reasons, it may be logistically easier and less expensive to distribute by CD, tape, or cassette. For example, ABC Radio's *Rick Dees Weekly Top 40* is distributed on compact disc.

Another trend that will affect radio programming is duopoly, triopoly, or even quadopoly ownership in a market. With the economies of scale available to group owners when they offer multiple stations in a single market, group owners can use syndicated programming in a two-pronged assault to dominate a market. They can (1) buy out some competitors by purchasing additional stations and programming them as "second-tier" satellite/syndicated formats that have little competition, and they can (2) use multiple-station revenues to go head-to-head with other stations and formats that do compete.

The Telecommunications Act of 1996 brought about a merger mania in the early part of that year. In the first month after the signing of the Act, there were $2 billion in radio station deals. For example, American Radio Systems applied for licenses to own four of the five highest rated stations in Rochester, New York, and own (or control) stations that reach nearly half of the listeners in the Rochester radio market. The competitive implications are fairly clear: Wealthy radio outlets who cannot beat the competing stations will buy them instead.

SUMMARY

Virtually every radio station today uses some form of either network or syndicated programming. Distribution differences between the two has virtually disappeared with the rise of satellites and the compact disc. Differences in the economics remain. Radio stations pay for syndicated programming with some form of cash or barter. Networks still rely on the system of affiliation and network compensation. The networks also still remain the primary provider of news and information programming, but regional networks may be found in any state. Syndicators are the primary providers of talk shows, which are proving to be popular on both AM and FM stations.

Music programming can be divided into short-form, long-form, and continuous music formats.

These formats may be provided by either a network or a syndicator. Special music shows and concerts remain popular, but they must be matched with the appropriate target audience. Radio music formats continue to fragment and grow in number. Network and syndicated music formats will continue to offer stations the closest thing to a pure format. Full-time format suppliers allow stations to turn a profit quickly because of their relatively low cost, but these stations rarely become dominant in their market.

SOURCES

Alexander, S. "Comparing 18–34 and 25+ Targets: Paragon VP Mike Henry Outlines the Musical Similarities & Differences," *Radio and Records* (26 August 1994): 26.

Broadcasting & Cable Yearbook, annual.

Grant, August (Ed.). *Communication Technology Update*. 3rd ed. Belmont, CA: Wadsworth, 1994.

Unmacht, R. (Ed.) *The M Street Radio Directory 1995 Edition*. New York: M Street Corporation, 1994.

Chapter 13

Music Radio Programming

Nick Alexander

MUSIC FORMAT POPULARITY

Although there are many variations, most music radio falls under one of these headings: country, adult contemporary (AC), rock, or black (urban). In the early days of radio when there were fewer stations, it was easy to appeal to a broad-based audience. "Top 40" was the popular music of the day because it appealed to everyone—from kids to adults of all ages. A Top 40 station played a little bit of everything and adjusted the rotation by times of day (**dayparting**) to cater to the available audience. In the midday (considered the "housewife" time) it might have played love songs and beautiful ballads. In the evenings, when teens and young adults were listening, the rotation usually included more up-tempo songs. Over time, as the number of stations and the competition increased, it became impossible to be all things to all people. Stations found it necessary to fine-tune their formats to target a specific audience. Today, each of the major music categories has several subdivisions. For example, country has three subgroups: traditional country, young country, and country gold. Each is aimed at a specific demographic group. Adult contemporary has hot AC, traditional AC, new AC (NAC), and a jazzier version called light jazz or smooth jazz. Black music is subdivided into urban contemporary, urban adult contemporary, urban gold, and rap. Rock formats are divided into contemporary hit radio (CHR, which includes KISS and EDGE formats), churban (a blend of CHR and urban), album-oriented rock (AOR), oldies (which are further divided by decades, '60s, '70s, '80s, and so on) and classic rock. In addition to these formats, big band, alternative, contemporary Christian, classical, progressive, beautiful/easy listening, and variations fill some airwaves.

Format popularity varies by region of the country (see 13.1 and 13.2). For example, the most listened to station in Los Angeles is Spanish, although the format fails to rank in Seattle because of the market's differing ethnic makeup. Nationally, country is the most listened to format, particularly in the South and Midwest. However, it is only the third most popular format in the West, and fifth most popular in the East. As the population has aged and the baby boom generation grown older, the news and talk format has moved into position as the second most popular format nationally, becoming the *most* listened to format in the West and second most popular in the Midwest and East. However, it moves down to the fifth most popular format in the South. Such strong differences mean that a smart program director always tailors a station's programming to the market it serves.

CHOOSING A FORMAT

The first step in analyzing an unfamiliar market is to evaluate its stations and their current programming. This information can then be used to modify or replace existing program formats or to decide which property to buy and what to do with it after purchase. Such an evaluation takes into account: (1) the technical facilities as compared to those of the competition, (2) the character of the local market, (3) the delineation of a target audience, (4) the available budget, and (5) the potential revenue. Once completed, this evaluation will determine which music format is commercially viable and can win in the ratings in a given market.

Comparing Technical Facilities

The best facility has the best chance to succeed. Thus, AM's power and frequency and FM's power and antenna height are crucial considerations. Generally, these elements determine signal quality. A clear, undistorted signal is less tiring to the listener than one that is distorted, faint, or accompanied by natural or artificial interference. All other qualities of similar formats being equal, the station with the best signal will be the listener's choice. Emotional fatigue unconsciously sets in after a period of straining to hear a program with a noisy, uncomfortable signal.

13.1 NATIONAL FORMAT REACH CHART

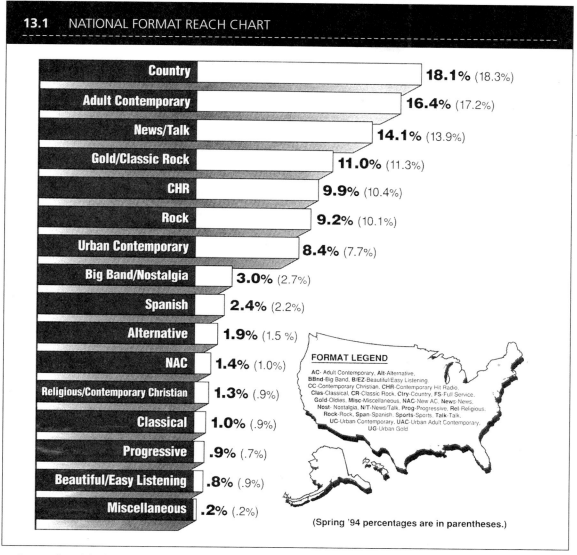

Format	Percentage
Country	**18.1%** (18.3%)
Adult Contemporary	**16.4%** (17.2%)
News/Talk	**14.1%** (13.9%)
Gold/Classic Rock	**11.0%** (11.3%)
CHR	**9.9%** (10.4%)
Rock	**9.2%** (10.1%)
Urban Contemporary	**8.4%** (7.7%)
Big Band/Nostalgia	**3.0%** (2.7%)
Spanish	**2.4%** (2.2%)
Alternative	**1.9%** (1.5 %)
NAC	**1.4%** (1.0%)
Religious/Contemporary Christian	**1.3%** (.9%)
Classical	**1.0%** (.9%)
Progressive	**.9%** (.7%)
Beautiful/Easy Listening	**.8%** (.9%)
Miscellaneous	**.2%** (.2%)

FORMAT LEGEND

AC- Adult Contemporary, Alt-Alternative,
BBnd-Big Band, B/EZ-Beautiful/Easy Listening,
CC-Contemporary Christian, CHR-Contemporary Hit Radio,
Clas-Classical, CR-Classic Rock, Ctry-Country, FS-Full Service,
Gold-Oldies, Misc-Miscellaneous, NAC-New AC, News-News,
Nost- Nostalgia, N/T-News/Talk, Prog-Progressive, Rel-Religious,
Rock-Rock, Span-Spanish, Sports-Sports, Talk-Talk,
UC-Urban Contemporary, UAC-Urban Adult Contemporary,
UG-Urban Gold

(Spring '94 percentages are in parentheses.)

It is likely that **digital audio broadcasting (DAB)** will replace both AM and FM analog broadcasting in the next decade. Proposed standards call for a system that would be compatible with existing AM and FM systems. If approved, broadcasters could add DAB to their existing facil- ities and transmit two signals. As new radio re- ceivers are manufactured with the appropriate chips to decode the DAB signal, stations would gradually replace the obsolete system with DAB.

Veteran radio experts predict that it will be well into the next century before this new radio

13.2 REGIONAL FORMAT REACH RANKINGS

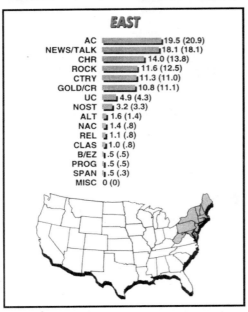

EAST

Format		
AC		19.5 (20.9)
NEWS/TALK		18.1 (18.1)
CHR		14.0 (13.8)
ROCK		11.6 (12.5)
CTRY		11.3 (11.0)
GOLD/CR		10.8 (11.1)
UC		4.9 (4.3)
NOST		3.2 (3.3)
ALT		1.6 (1.4)
NAC		1.4 (.8)
REL		1.1 (.8)
CLAS		1.0 (.8)
B/EZ		.5 (.5)
PROG		.5 (.5)
SPAN		.5 (.3)
MISC		0 (0)

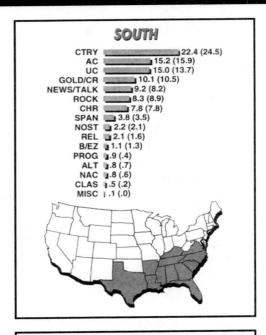

SOUTH

Format		
CTRY		22.4 (24.5)
AC		15.2 (15.9)
UC		15.0 (13.7)
GOLD/CR		10.1 (10.5)
NEWS/TALK		9.2 (8.2)
ROCK		8.3 (8.9)
CHR		7.8 (7.8)
SPAN		3.8 (3.5)
NOST		2.2 (2.1)
REL		2.1 (1.6)
B/EZ		1.1 (1.3)
PROG		.9 (.4)
ALT		.8 (.7)
NAC		.8 (.6)
CLAS		.5 (.2)
MISC		.1 (.0)

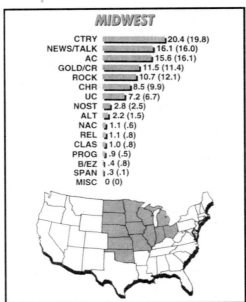

MIDWEST

		
CTRY		20.4 (19.8)
NEWS/TALK		16.1 (16.0)
AC		15.6 (16.1)
GOLD/CR		11.5 (11.4)
ROCK		10.7 (12.1)
CHR		8.5 (9.9)
UC		7.2 (6.7)
NOST		2.8 (2.5)
ALT		2.2 (1.5)
NAC		1.1 (.6)
REL		1.1 (.8)
CLAS		1.0 (.8)
PROG		.9 (.5)
B/EZ		.4 (.8)
SPAN		.3 (.1)
MISC		0 (0)

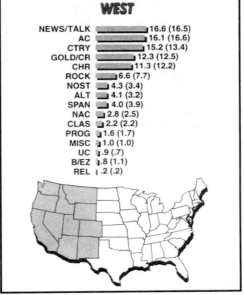

WEST

		
NEWS/TALK		16.6 (16.5)
AC		16.1 (16.6)
CTRY		15.2 (13.4)
GOLD/CR		12.3 (12.5)
CHR		11.3 (12.2)
ROCK		6.6 (7.7)
NOST		4.3 (3.4)
ALT		4.1 (3.2)
SPAN		4.0 (3.9)
NAC		2.8 (2.5)
CLAS		2.2 (2.2)
PROG		1.6 (1.7)
MISC		1.0 (1.0)
UC		.9 (.7)
B/EZ		.8 (1.1)
REL		.2 (.2)

technology replaces AM and FM broadcasting. However, once DAB becomes available, the principle of the better facility dominating the market will hold. Although FM has been the crown jewel of broadcasting, it began to deteriorate as a result of interference when the FCC added more stations, and crowding will eventually force radio into the newest technology, DAB. But for the remainder of the 1990s, the battle goes on between AM and FM and among stations with the same technology.

An FM station with 100,000 watts of **effective radiated power (ERP)** with its antenna assembly mounted on a 1,000-foot tower is a much better facility than a station with the same power but with the antenna mounted on a 500-foot tower. The AM station with a power of 50,000 watts on a clear channel (820 kHz) is a much better technical facility than a station with 5,000 watts of power at 570 kHz. Usually the low-power station is at the mercy of the higher power station. A 5,000-watt facility with a talk or news format may be very vulnerable to a same-format station broadcasting at 10,000 or 50,000 watts.

This rule of thumb does not hold in all cases. For example, a 10,000-watt facility at 1,600 kHz might easily fall victim to a 1,000-watt station at 710 kHz. In AM, both power and dial position are important. The lower the frequency, the greater the range of the AM signal. A 1,000-watt AM station at 710 kHz might easily reach a bigger population than a 10,000-watt station at 1,600 kHz.

In FM, *tower height* and *power* are the principal considerations. A low-power (Class A) FM station with a 1,000-foot antenna might cover more territory than a full-power (Class C) station with its antenna mounted 200 feet above average terrain. Dial position is much less technically important in FM, although the center of the dial gets more sampling. An FM station at the fringe of the band needs an advertising and promotion blitz when altering its format. But always, having the best or one of the best facilities in the market is crucial to beating the competition.

For many years AM was the king of radio. AM stations were tops in ratings, regardless of format.

Beginning in the 1970s, FM began to replace AM as the music format champion. This is because of FM's superior fidelity. Music simply sounded better on FM. Furthermore, FM doesn't fade under bridges or suffer from interference the way AM does. To survive, AM turned toward full-service programming, including elements of news, talk, sports, satellite or syndicated programming, and ethnic (Hispanic or black) and religious (preaching and gospel music) content. The implementation of DAB may level the playing field in the future and allow music formats to return to AM. Digital signals delivered via AM will sound identical to digital signals delivered via FM. DAB is the great equalizer.

The station's technical facility plays an important part in the initial decision to enter music programming competition. It would be aesthetically foolish and economically disastrous to pit, say, a daytime AM against a full-power FM in the contemporary rock field. Conversely, if the leading contemporary music station in a market is AM and the new facility is a high quality FM, the AM station will be extremely vulnerable to a programming assault.

Defining the Competitive Market

In deciding on the potential of various radio formats, a prospective buyer's first step is to review the competition thoroughly. A profile of each station's demographics in a bar graph will show what percentage of each of the six standard demographic groups each station has. The bars in such graphs display the age "leaning" of a station's audiences, suggesting the industry name of **skew graphs.** Arbitron and AccuRatings are the principal sources of these data. The 6 A.M. to Midnight, Monday though Sunday page of a ratings book breaks out the individual demographic groups. However, any audience analysis service providing demographic separation has the necessary information. Skew graphs for two stations in the hypothetical market considered in this chapter are shown in 13.3.

13.3 SKEW GRAPHS FOR HYPOTHETICAL METRO SURVEY

WMMM-AM

Age Group	Size of Group	Percentage of Total Audience
		5 10 15 20 25 30 35 40 45 50
Teens	35,000	
18-24	29,500	
25-34	23,500	
35-44	11,400	
45-54	7,400	
55-64	8,700	
Total	115,900	

WNNN-AM

Age Group	Size of Group	Percentage of Total Audience
		5 10 15 20 25 30 35 40 45 50
Teens	6,000	
18-24	7,000	
25-34	11,900	
35-44	6,300	
45-54	13,600	
55-64	20,000	
Total	64,900	

Source: Arbitron. Used with permission.

With skew graphs of all stations laid out, program strategists can quickly analyze which age groups are best served by which stations and therefore which stations represent major competition. The examples in 13.3 show only age, but a sex breakout would also be useful. For example, an AOR (album-oriented rock) operation might show 30 percent adults 18–34 years, but the males in the audience usually account for 60 to 70 percent of the total.

Identifying Target Audiences

It is not enough to study population graphs and other research data about a market's radio listeners. It is essential to go into the community to find out specifically what people are doing, thinking, and listening to (see 13.4). It is helpful to observe lifestyles by visiting restaurants, shopping centers, gas stations, discotheques, bars, taverns, and other places where people go to have a good time.

Formal research can supplement personal investigation. Most cities have research firms that can be hired to make special studies, and national firms such as The Research Group and Coleman Research specialize in broadcast station research. Other well-known radio consulting firms include Bolton Research and Stratford Research. A study assessing current formats using lengthy, in-depth telephone interviews might get interesting responses: too many commercials, bad commercial production, too much unfamiliar or repetitive music, obnoxious contests, can't win contests, or DJs who talk too much. As you can imagine, a station getting answers like these is ready for a major overhaul.

Many broadcasters employ university instructors and students to do summer studies that can be beneficial. After a programming change, the staff's family and acquaintances provide feedback on how the community is reacting to the station's new programming strategies. Student discos with DJs can provide an additional channel of input.

As an example of the kind of findings that prove useful, a station in Dallas/Ft. Worth identified its typical listener as male, about 30 years old,

13.4 THE LISTENER

The 40-year-old lawyer who dresses in dark suits during the week and has lunch at a stuffy club may be found in the evenings wearing jeans and a T-shirt in a favorite disco. He is hip, married, has two children, and loves to go dancing with his wife. A potential listener to a new rock station? Absolutely! Are there more like him? They number in the thousands in most of the nation's markets.

earning $40,000 to $50,000 a year (in the late 1990s), driving a BMW or other upscale car, drinking imported beer, going out at least twice a week with a date to a good restaurant, and playing tennis. The station sold this audience description to advertisers and to listeners. Promotional material stressed lifestyle to those who listened to this particular station.

Knowing the Available Budget

The usual hit music operation requires six to eight **disc jockeys,** along with a production director and, perhaps, a music director. In a market of 500,000, the program director may earn as much as $50,000 a year. The morning DJ probably gets $50,000 to $80,000, and the afternoon drive DJ may get up to $40,000. The production director's salary is probably between $30,000 and $50,000 per year, and the other five or six jocks fall in the same range. In the top ten markets, stations may have to double or triple these salary figures to get the required talent. Top morning show talent can easily run into six figures, with superstars receiving between $250,000 and $1 million in a major market.

In a medium-sized market (500,000), television and billboard advertising might run $25,000 a month for good exposure. It may cost five times that in a Dallas- or a Chicago-sized market. Not only are unit prices higher in large markets but

more territory must usually be covered. A set of painted billboards reaching the whole population in one market may require 35 billboards, for example, although a similar showing in Dallas would require 125 billboards at an average cost of $2,000 each per month.

Consultants are available to advise on every conceivable aspect of operations. Programming consultants find market voids, spot competitor weaknesses, and frequently even assemble a staff to work up a specific format. A station may employ legal, technical, management, personnel, and sales as well as programming consultants—all of them may be useful at one time or another. Consultation is expensive, however. An engineer may charge $700 a day plus expenses; a programmer may charge $3,000 a month on a three-to-six-month contract. For a complete station overhaul, consultants range from $400 to $1,000 a day. In addition a syndicated satellite program service, depending on market size, could run as high as $10,000 a month. Nevertheless, a neophyte licensee may be literally unable to start up without using one or more consultants. A great deal of highly specialized knowledge and experience must be brought to bear immediately once the Federal Communications Commission has given the licensee authority to start operations.

Estimating Potential Revenue

Television, cable, and newspapers compete with radio for the same advertising dollars. The increasing number of stations, including cable and satellite channels, has fragmented the available audience, making survival more difficult. As market shares shrink, those stations that have high debt service to pay must struggle. During the early to mid-1980s, radio station values skyrocketed following deregulation. Investment money was easy to acquire, and radio stations sold for as high as $82 million (the price, for example, of KVIL, Dallas, in 1987). When investment money disappeared, station sale prices declined. A low rated FM station in Dallas sold for merely $9 million in 1991, whereas the same station might have sold

for $15 to $20 million in the mid-1980s. However, prices escalated again in the mid-1990s following relaxation of ownership rules. Duopoly and local marketing agreements (LMA) now allow an owner or group to own and operate multiple properties in the same market. This has increased the value of stations. That same station that sold for $9 million in 1991 might be worth $20 to $30 million by the late 1990s.[1] All the media compete intensely for local advertising revenues.

In any area, advertisers most desire the 25- to 54-year-old audience (although most stations count all listeners over age 12). In radio, the audience subdivides into 10- to 15-year segments that specific formats target. Following Arbitron's pattern, most radio audience segments end in a 4. If particular advertisers are not seeking all listeners 25–54, then they want a subset of the baby boom generation, now ages 25–54; some seek subgroups of 25–34, 25–49, or 35–54. Selected advertisers may seek the audience aged 55–64. For example, banking and financial institutions and packaged vacations appeal to older people who are generally set in their buying habits; they are regarded as saving money rather than spending it, having bought about everything they are ever going to buy.

But advertisers see the young adult market as having money, responding to advertising, and receptive to buying, even if it means going into debt. Increasingly, stations track the largest population group in the market and adjust their music formats to continue to appeal to this group as it ages. This has resulted in more play of 1960s and 1970s music (oldies or classic rock), capitalizing on the hit songs of the baby boom's teen through twenties years. By the year 2000, however, the baby boomers may be too old to interest most advertisers—unless new products emerge.

STEP-BY-STEP SELECTION PROCESS

Format strategy can be examined by working through a hypothetical market—say, a metropolitan area of 500,000 inhabitants in which 19 sta-

13.5 LIST OF STATIONS, TYPES, FORMATS, FACILITIES

Station	Type	Format	Share	Facility*
WAAA	AM day	Religious	1.0	1 K @ 1500 kHz
WBBB	AM day	Country	4.2	1 K @ 1600 kHz
WCCC	AM day	Talk	3.6	5 K @ 840 kHz
WDDD	AM day	Ethnic	3.8	1 K @ 900 kHz
WEEE	AM day	Local (block prgmng)	0.9	1 K @ 710 kHz
WFFF	FM	Classical	2.1	100,000 @ 700 feet
WGGG	FM	Oldies	5.0	100,000 @ 600 feet
WHHH	AM	Nostalgia / Big Band	4.2	1 KD/.5 KN @ 1480 kHz
WIII	FM	Adult Contemporary	0.8	3000 @ 250 feet
WJJJ	FM	Urban Contemporary	7.5	100,000 @ 540 feet
WKKK	AM	Country	6.7	5 KD/1 KN @ 970 feet
WLLL	FM	Country	9.1	100,000 @ 700 feet
WMMM	FM	Rock	8.5	100,000 @ 600 feet
WNNN	AM	News/Talk	5.7	10K @ 1010 kHz
WOOO	AM	Full Service	8.1	5 KD/5 KN & 1350 kHz
WPPP	FM	AOR / Classic Rock	4.9	100,000 @ 540 feet
WQQQ	FM	Adult Contemporary	3.6	100,000 @ 1000 feet
WRRR	FM	Adult Contemporary	12.1	50,000 @ 750 feet
WSSS	FM	CHR	7.1	50,000 @ 950 feet
Other	(Distant signals)		1.1	

*K = 1000 watts; 5 KD/1 KN means a station transmits 5,000 watts in the daytime, and 1,000 watts at night.

tions are heard, licensed either to the metro area or to its suburbs. Further assume that a small group of radio enthusiasts is about to buy one of these stations and design a program format from scratch. (See 13.5 for a list of the stations in the hypothetical market and their facilities and formats.)

All stations are licensed in the metro area in this example, except for two suburban stations. WEEE, the suburban AM **daytimer,** programs strictly for its local audience. WIII, the low-power suburban FM station, carries a satellite format. But with a technical facility of only 3,000 watts at 250 feet, this station will not be considered. The station about to be sold is WQQQ in the metro competition with a 3.6 audience share of the market—not bad, but well behind the leaders.

In going over the list of 18 stations in the hypothetical market, the planners identify those with which they do not expect to compete seriously. The prospective facility is FM (a decided plus), full power (most desirable), and its antenna is on the highest tower in the market (bingo!). It is otherwise a dog. But the facility is superior to anything in the area.

First, the planners can scratch all AM daytimers as potential competition. (Daytimers like WEEE and the rest are restricted by the FCC from broadcasting after dusk, a key listening period for

most popular music stations.) That narrows the competition from 18 to 13. Next, they can knock out any good classical operations (one in the market, WFFF-FM), as most markets can accommodate only a single classical station. That leaves 12. It would be foolhardy to tackle three country operations: WKKK-FM, WLLL-FM, and WBBB-AM. These three stations lock up 20 percent of the total audience and should be quite sufficient for this market. Scratching these cuts the field to 10. (The AM was already removed from consideration because it is a daytimer.) The FM *suburban* station (WIII-FM) can be eliminated because it will never be in competition with a high-powered *metro* FM; the latter certainly is not interested in duplicating WIII's limited and suburban-oriented format. That leaves 9.

Two ethnic stations (WDDD-AM and WJJJ-FM) have a combined share of 11.3. The market shows a black population of only 30,000, or about 6 percent, and no other substantial ethnic population. It would appear that black-oriented radio is well represented by the two stations, showing a combined audience of almost two times the black population. Scratch one more (the FM ethnic WJJJ as well as WDDD, already counted out as a daytime AM). The field is down to 8, plus the proposed buy.

Of the 8 remaining stations, 3 have very specialized formats:

- A full-time FM oldies format with a 5.0 percent share (WGGG)
- A full-time AM nostalgia/big band format with a 4.2 percent share (WHHH)
- A full-time FM AOR/classic rock format with a 4.9 percent share (WPPP)

Each of the above stations is a one-per-market format. That removes 3 more from consideration and leaves 5.

In the news and information battle we have a 10,000-watt **news/info** AM facility with a 5.7 percent share (WNNN) and a full-time AM **Full Service** with an 8.1 percent share (WOOO). This is a 13.8 market share and more than adequately

represents the audience. Furthermore, news is the most expensive format to program because of the number of employees it takes to run a news operation. Eliminating these 2 stations leaves us with 3.

The rock audience is well represented by two stations: an FM **rocker** with 8.5 percent share (WMMM) and a CHR with a 7.1 share (WSSS). Now we have eliminated all but one station.

The remaining station is an FM adult contemporary (AC) with a 12.1 share. This station would be vulnerable to attack on multiple fronts. First, it is only 50,000 watts. Second, it has the largest audience to steal from. Third, the format is underrepresented in the market. It would also be possible for an adult contemporary station to pick up some additional audience from the oldies station, and the CHR.

Although WQQQ is already adult contemporary, it is poorly run, with virtually no budget for promotion or advertising. Let's take a look at the market demographics to see if there is any hope (see 13.6).

According to census data, the 25–54 age group represents 57.5 percent of the hypothetical market, and adults 55+ make up another 19.2 percent. Altogether, 76.7 percent of this market may be available to tune in WQQQ-FM, leaving a mere 23.3 percent potential for the youth-oriented stations. Advertisers should readily buy time on a new station, which clinches the decision to buy WQQQ and program a mass appeal adult contemporary format.

But radio programmers must stay in close touch with the competition. More than a thousand radio stations change format every year, about one-tenth of all commercial stations.[2]

IMPLEMENTATION

The program director's first step is to get the word out through personal contacts and the trade press that WQQQ is looking for disc jockeys, a production manager, and two or three people to handle the news. The program director will act as tempo-

13.6 POPULATION DEMOGRAPHIC BREAKDOWN (500,000 POPULATION)		
Age	Estimated Population	Estimated % of Total
Male 12–17	25,550	5.11
Male 18–24	33,600	6.72
Male 25–34	56,850	11.37
Male 35–44	51,900	10.38
Male 45–54	35,200	7.04
Male 55–64	21,200	4.24
Male 65+	20,700	4.14
Total	245,000	49.00
Female 12–17	24,500	4.90
Female 18–24	32,750	6.55
Female 25–34	54,800	10.96
Female 35–44	52,400	10.48
Female 45–54	36,400	7.28
Female 55–64	22,550	4.51
Female 65+	31,600	6.32
Total	255,000	51.00

rary music director to structure the music, and later one of the jocks can take over those duties and audience research. The music director works for the program director, doing research and preparing proposed additions and deletions to the **playlist.** The program director usually makes the final decision; the music director does the background work.

Getting CDs is fairly easy in larger markets. The program director makes contacts with friends in the record business (promoters) to get on their call schedules and mailing lists. This ensures that the station will receive all the current material immediately. Belonging to both ASCAP and BMI gives the right to play all the popular music, a necessary expense for virtually all music stations. (Classical stations also need to join SESAC to obtain foreign and other specialized music performance rights.) Small-market stations can improve their record service by reporting their playlist to trade publications who will place them on industry mailing lists. Developing rapport with record company promoters helps also.

Someone will have to dig for the **recurrents** and the **gold**—especially the latter. Because of their age, these records are scarce; distributors are often out of stock, and pressings are no longer being made. It may take months to build the gold library, and these recordings should be kept under lock and key to forestall avid collectors among staff members. Many stations now use "gold services" such as TM Century's Gold Disc™ Library, (a complete oldies library on **compact disc**), or Scott Studio's (a collection of popular oldies on computer hard drive). Country music is also available. The advantage of using a library is the quality and durability of the compact discs. Each disc may have as many as 20 songs on it, recorded in the very highest fidelity. And unlike vinyl discs, compact discs do not scratch or wear out, and they take up much less storage space than records. Furthermore, many companies offer CD juke boxes that contain an entire library kept under lock and key. Only the music director and the program director have access to the discs.

In major markets, most stations now play compact discs on the air, although some still use **carts** (audio cartridges) or even, on special occasions, old-style **vinyl records.**[3] In smaller markets, compact discs are becoming standard as old equipment is replaced, and compact discs will soon eliminate carts and records entirely.

THE MUSIC

No one "right way" to program a radio station exists. Moreover, what works in one format may not work in another. Good research is the sole key to success, and it encompasses all formats. Nonetheless, to show how music is categorized and tracked, in this chapter I will present a model for a *rock*

music system that combines systems used by leading radio stations across the country. This system represents one plan for programming an adult contemporary station designed to achieve maximum attractiveness to the 25–54 demographic target. The system has six major music categories: *power, current, recurrent, power gold, gold,* and *oldies.* Any popular music station can use this formula, whether contemporary hit radio (CHR), adult contemporary (AC), country (C), or black/urban (B/U). It does *not* apply, however, to an oldies format, beautiful music, classical, hispanic, or news/talk.

1. Power. This category contains from 5 to 11 top songs, played at the rate of one to two each hour in adult formats and three to four per hour in CHR formats. Rotation is controlled so that the same song is not played at the same time of day on consecutive days. Rotation time—the time that elapses before the cycle of 11 songs begins again—varies from as little as 1 hour and 45 minutes in a CHR format to as much as 4 hours and 15 minutes in an adult AC format. The exact rotation is decided by the program director. The songs in this category are the *most popular* of the day and receive the most airplay. They are selected weekly based on:

- How they test during **call-out research** with the station's audience
- Their rankings in national trade magazines such as *Billboard, Radio & Records,* and the *Gavin Report*
- Local sales (to a lesser degree)

Area record stores are contacted weekly for this information, which they have begun to record by bar code, providing more accurate reports for radio programmers. Once upon a time, stations also used **telephone requests** as a barometer of song popularity. However, due to the inadequacies of the system and the ability of a few people to make a lot of phone calls for their favorite song (hence, stuffing the ballot box), this method is seldom used anymore. In bigger markets, telephone or auditorium

testing is used instead. A sample audience will hear part of a song and be asked to evaluate it. In smaller markets, rankings of sales and airplay in trade magazines will play the biggest part.

2. Current. This category contains the remaining 15 to 20 currently popular songs. They are played at the rate of two per hour (in an hour with no commercials, three might be played). Some stations subdivide this category by *tempo,* placing slow songs in one group and fast ones in another; other programmers subdivide by *popularity,* grouping those moving up in the charts separately from those that have already peaked and are moving down in the charts. The same research methods used to determine the power songs determine those in the current category. Together, the powers and currents form the station's current playlist of about 30 songs.

3. Recurrent. This category contains songs that are no longer powers or currents but that have been big hits within the last three years. (Some stations will keep songs for up to three years in the recurrent section.) These songs get played at the rate of two to four per hour, depending on commercial load. Some stations limit this category to 30 records played at the rate of once an hour; others may have as many as 100 songs, playing them twice an hour. Songs usually move into this category after being powers or currents, but a few would be dropped from the music list: novelty records that are burned out (see section on research) and records that "stiffed" (failed to become really big hits). These songs can be tested periodically by call-out research.

4. Power gold. This category contains records that were very big hits in the past three to ten years. There may be from 100 to 300 of these classics, and they are played at the rate of two to three per hour, depending on commercial load. The songs are replayed every one-and-a-half to three days and rotated across all dayparts. These are the "never-die" songs that will always be recognized by the target audience and immediately identified by them as *classics.* They greatly enhance the format, because listeners get the impression that the sta-

tion airs a broad range of music. Auditorium research is the best way to test these songs for *desirability, recognizability,* and *burn out.*

5. Gold. The gold category contains the rest of the songs from the past 10 to 15 years that are not in the recurrent or power gold categories. This group of 200 or so titles is played at the rate of one to two an hour, depending on format and commercial load. Songs in this group are carefully researched to make sure they appeal to the station's target demographic group. In an oldies format, these records will be subdivided into **power gold** and **secondary power gold,** essentially splitting the decade in half. This prevents playing two early 1970s songs in a row, or two late 1970s songs in a row.

6. Oldies. This category completes the record library (although CHR stations omit it entirely). Oldies comprise the largest group because it covers the greatest span of time—all the hit songs from the 1950s up to ten years ago. As many as 600 may be in the group, and they are played at the rate of one to three per hour. The commercial load and the number of older listeners the station wants to attract will determine how many oldies get played. Songs in this group had to be hits at the time they were released and must continue in popularity. Programmers for AC and oldie stations subdivide this category by age:

- Mid-1950s to 1964
- 1965 to 1972
- 1973 to 1980
- 1980 to ten years ago

These songs will also be tested by auditorium research for popularity with the specific market. *A song that is a huge hit in one market can be a dismal flop in another.*

Controlling Rotation

Regardless of format, music stations must control **rotation** (the frequency of play of different kinds of songs). Most stations use computers to keep track of what song is played where and what kind of restrictions apply. In smaller markets, however, some stations still use the flip card system. Each song is placed on a 3 × 5 card in a file box, and DJs are instructed to play the next available and appropriate song and place the flip card at the back of the stack.[4] A flip card system, however, leaves the disc jockey rather more discretion than may be desired about what's played and invites the playing of "favorites" (a programmer's nightmare!).

Modern computers can be programmed with a host of restrictions to maintain the exact rotation and balance among songs the music director desires. Computers provide daily or weekly playlists and prevent DJs from cheating. DJs as well as the music and music directors get printed lists of all the songs to be played. (It was easy to skip a 3 × 5 card or cram all the unwanted songs in on the last day of a gold book.) Computers can be programmed to:

- Follow a category rotation
- Avoid scheduling two songs by the same artist closely together
- Balance up-tempo and down-tempo songs
- Prevent adjacent songs of the same type (such as two twangy country songs or two rhythm and blues songs)

Adherence to such restrictions leaves control in the hands of the programmer rather than the on-air personality.

The Music Hot Clock

One of the program director's traditional responsibilities has been to construct **hot clocks.** A hot clock is a design, looking like the face of a clock or a wheel, in which the formula for producing the planned station "sound" is visualized. It divides an hour into portions for music (by category), weather, news, promos, and commercials. Hot clocks tell the DJs where to place the elements that make up the programming for a given hour. The program director devises as many hot clocks

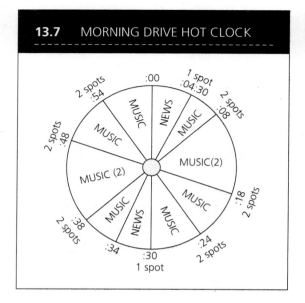

13.7 MORNING DRIVE HOT CLOCK

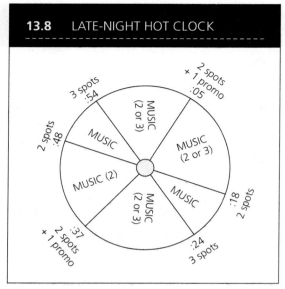

13.8 LATE-NIGHT HOT CLOCK

as are needed: one for an hour with no news, another for an hour with two newscasts, another for an hour with one newscast, another for an hour with 8 commercial minutes (or 10 or 12 or however many the station allows and could sell). Hot clocks are examples of **dayparting**—that is, estimating who is listening and what their activities are and then programming directly to them.

Stations that use computers to program their music embed the hot clocks in the computer software. The computer "knows" that at six minutes after the hour it should play the next power song. Since the computer plans ahead, it will adhere to the usual restrictions, making sure, for example, that another song by the same artist has not played recently.

Typically, morning clocks include news, but 7 P.M. to midnight clocks do not. In all, there may be as many clocks as hours in the day, with a completely different set for weekends.

Besides structuring the news, weather, promos, and commercials, the hot clock also structures the music for a given hour. The music portion of an hour depends on the number of commercials to be

aired. A commercial-free hour, for example, requires many more songs than an hour with 14 or so spots. A morning drive hour designed to handle two newscasts and 14 minutes of commercials appears in 13.7. This leaves room for a maximum of ten songs, depending on how much the DJ talks. The music for this morning hour would consist of two powers, two currents, two recurrents, two power golds, one gold, and one oldie.

The clock in 13.8 is intended for a late-night show that will not have any news. The music selection contains 16 songs, made up of three powers, two currents, four recurrents, three power golds, two golds, and two oldies. This selection fits an adult contemporary format but would differ on a CHR station or an urban or country station. No single set of clock formulas will drive a station to the top in different markets. Recent analyses of Spanish-language radio programming, for example, shows ten different Hispanic formats alive and well in Southwestern markets. The key ingredients in designing a successful format are *careful planning, ongoing local research,* and a *willingness to adapt* to changing audience tastes. Successful music programming is always market-specific.

Music Research

Most music stations employ one or more people to handle **call-out research** and assemble statistics. A rock station's music researcher compiles the list of the local top-selling albums, cassettes, and compact discs based on local record store sales. The researcher also keeps tabs on records the station does not play but that are selling due to airplay on other stations and nightspot exposure. The researcher may be employed full or part time and usually works for the music director.

Trade publications such as *Billboard, Radio & Records,* and the *Gavin Report* (others specialize in a single format) are studied when adding new music to a playlist. Each week the researcher compiles a chart of the top 30 songs from each magazine and averages them to get composite ratings. Analysis of *chart movements* of newer songs and news regarding airplay in other areas are also helpful in choosing the "adds." In markets with a sizable black population, the researcher tracks the black/urban charts as well as pop in *Billboard* and *Radio & Records.* In markets where country wins in the ratings, the country music charts can suggest **crossover songs.** The more objective information the researcher gathers, the easier it is for the programmer to evaluate the record companies' advertising and sales. Record promoters will naturally emphasize their products' victories, neglecting to mention that a record died in Los Angeles or Kansas City. The station must depend on its own research findings to rate a piece of music reliably.

As explained in Chapter 2, call-out research gets reactions directly from radio listeners. Two versions of the technique are used—*active* and *passive*. In active call-out research, the names of active listeners are obtained from contest entrant lists. The passive version selects names at random from the telephone directory. In either case, respondents are asked to listen to *excerpts* (**hooks**) from the songs being researched or to lists of *titles* and to rate them on a scale running from 1 to 7 as follows:

1 = "Never heard of it."

2 = "Dislike it strongly."

3 = "Dislike it moderately."

4 = "Don't care."

5 = "Tired of it."

6 = "Like it."

7 = "My favorite record."

When a sample is completed (50 to 100 calls is typical), the votes for each number on the scale are tabulated. The various totals are then manipulated to obtain interpretations in terms of ratios or percentages (see 13.9).

For example, assume 50 contest winners are called within a week, and 25 records are discussed. Ten listeners say they like song number five, and 14 say it is their favorite record. Twenty-four of 50 rate number five as a 6 or a 7. For the "positive acceptance" measurement, divide 24 by 50; the result indicates 48 percent of the audience want to hear number five played.

Making a Top Hits List

Most adult-oriented stations stopped making the top 30 (or 40) chart years ago. As their audiences grew up, they discovered that most people didn't care whether a song was number 7 or 17. Some CHR stations continue to compile a weekly top 30 list.

To derive their chart, the music director compares the top songs on the current playlist to the rankings in *Radio & Records, Billboard,* and *Gavin.* If a song is number one in *Radio & Records,* it gets 30 points. If it rates number two in *Billboard,* it gets 29 points; a rating number three in *Gavin* gives it 28 points, and so on. After charting each song against the major trade publications, the researcher divides the total by the number of publications to get the average ranking. Local sales figures are tabulated in a similar manner. The figures are combined and averaged to create the station's chart. Trade publication rankings are based on data supplied by hundreds of reporting stations. If the researcher finds from the call-out test that number five is burned out locally but was nevertheless still running in the top three or four nationally, the

13.9 HOW TO CALCULATE VOTES

Total Votes For	Divided by Total of	Equals a Ratio That Measures
6 + 7	sample	Positive acceptance
2 + 3	sample	Negative rejection
5 + 6 + 7	sample	Positive recognition
2 + 3 + 5	sample	Developed dislike
4	sample	Neutral
5	sample	Burnout
6 + 7	2 + 3	Acceptance
6 + 7	2 + 3 + 5	Tolerance
1	sample	Unfamiliarity
2 + 3 + 4 + 5 + 6 + 7	sample	Familiarity

song would be retained but assigned a lower rotation position.

When doing caller research of any kind, it is crucial that the questions be asked in the right manner. Contest entrants, for example, listen to your station and will tend to answer what they think you want to hear (after all, they are pleased with the station at the moment!). It is important to make them understand that they are being asked to shape the station's music selection. During a music interview, contest winners can also be asked to comment on other things they like or dislike about the programming. This requires a sympathetic ear on the part of the researcher.

When calling people randomly selected out of the telephone book, the first step in an interview is to qualify the person—that is, make sure the person is in your target demographic and listens to, or prefers, the kind of music the station plays. The second step is to ask about song preferences.

Another method of radio research (mentioned in Chapter 2) is auditorium testing. Several companies specialize in this kind of audience research. Typically, they bring a test group to a large room and ask them to evaluate music as excerpts are played. As many as 300 songs may be tested, with the audience writing their responses on special forms. The tabulated results will be broken down demographically, usually providing valuable information to programmers on what songs to play in which dayparts.

Additional questions can be asked such as "What station do you listen to most?" "Second most?" "Who has the best news/the best sports/the best personalities?" "What is the most irritating?" and so on.

NEWS

News has always been a problem on rock and roll stations. Adult-oriented stations must provide *information* to their audiences, especially during morning drive. Stations targeting younger listeners, however, usually do not want to carry news, cannot afford it, feel their listeners are bored with it, but think they must provide news to satisfy unwritten FCC requirements. They dutifully promise in their license applications to program a certain percentage of news and are stuck with their commitments.

Do listeners want news on music stations? Studies by consultants have concluded that a large percentage of rock listeners are "turned off" by news. These same listeners also hate commercials, PSAs, and anything else not related to music and fun. However, some studies found that everybody wanted lots of news on their music stations. Organizations such as the Associated Press, which is in the business of selling news services to radio stations, are not likely to publish studies indicating that young listeners do not want to hear news. Consultants, however, are in the business of finding out what is wrong with radio stations and have a vested interest in finding things wrong that can be fixed. At any rate, radio network affiliations continue to rise (see Chapter 12), even though management at many stations claim that news is not relevant to the station's mission.

Listeners expect to hear news on the hour and the half-hour, and the radio networks still schedule news at those times. Knowing this, some programmers schedule news at odd hours (20 minutes after and 20 before the hour, for example), hoping to pick up new listeners when competing stations schedule their news more conventionally on the hour and half-hour.

Some recent thinking on news scheduling hinges on the habits of some listeners and Arbitron's diary method of surveying listeners. The idea is to hold a listener for at least five minutes in any quarter-hour by playing some music (even on a talk/news station) so the station will get credit in a listener diary. On popular music stations, news is therefore buried in the middle of one or two 15-minute periods each hour. This strategy assumes that listeners are turned away by news. Increasingly, stations targeting younger listeners have eliminated newscasts except in morning drivetime.

Journalistic Content

Having decided where to put news, the programmer must then decide how to handle it—whether to go the low road or the high road. On the low road, jocks rip and read news wire copy as it comes out of the machine (for more on this, see Chapter 14). Some low-roaders satisfy the need for local news by simply stealing from the local newspaper or *USA Today* (the news itself cannot be copyrighted, although specific versions of it can be).

Programmers who set higher goals for themselves do well to hire at least two persons to staff the news operation. One staffer does the air work in the morning while the other develops local stories, mostly over the telephone. The two news staffers reverse their roles in the afternoon. The morning person leaves voicers (stories recorded by someone other than the anchor-person) for use during the afternoon and evening newscasts, and the afternoon person leaves them for use early the next morning. This news operation would be relatively luxurious for a music station, however.

The typical full-time news staff in radio stations throughout the country is only one person. Adult-formatted stations, especially those in larger markets, may have a male and a female teamed as reporters and voicers.

Nonentertainment Programming

The deregulation of radio has substantially eased FCC-imposed requirements for nonentertainment programming on radio stations. Minimum amounts of nonentertainment programming for AM and FM stations have been abolished, as have the Commission's formal ascertainment requirements, although a licensee is still required to "informally" ascertain the problems, needs, and interests of the community. On the anniversary date of license renewal, a narrative statement of the problems, needs, and interests of the community and the programming the licensee has broadcast to meet those needs must be placed in the station's public file. However, many older stations, especially those owned by one of the major networks, still abide by the old rules regarding ascertainment, public service announcements, and local public affairs programming.

Section IV of FCC Form 301 requires, for radio stations, only a brief narrative description of the planned programming service, explaining how the projected programming relates to issues of public

concern in the proposed service area. Programming in general, for new applicants and for renewal applicants, has become progressively less and less an area in which the Commission intrudes.

However, programming representations to the Commission, once made, should be kept. A discrepancy between the amount of programming promised and that actually broadcast (a promise versus performance issue) may mean that the Commission denies a renewal application (or at least instigates legal hearings). Moreover, if a *competing application* is filed against the renewal applicant, the licensee has an advantage over the competitor only if the FCC can find a "solid and substantial" service record. This record must include news and information programming, PSAs (public service announcements), and community-oriented programming.

News, public affairs, and "other" nonentertainment programming create a flow or continuity problem for the formula format. The complaint is that "we have to shut down the radio station to air that junk." Junk, of course, is any programming not directly related to the music format. In stations with an information-oriented format featuring network news, local news, talk, and sports, few flow problems exist. Nonentertainment material may be effectively woven into this format. Public service announcements are both nonentertainment and community-oriented programming, and a station can make significant contributions to the community welfare with an aggressive PSA policy.

Radio will probably always be a service medium, and broadcasters will always differ on what constitutes community service. In a competitive major market served by a number of communications media such as newspaper, cable, television, radio, MMDS, ITFS, LPTV, and DBS, the FM radio station that plays wall-to-wall rock music is doubtlessly providing a service, even though it is solely a music service. In information-poor markets, owners may elect to mix talk shows with music, air editorial comments on community affairs and, in general, provide useful information to the community. The services provided should be based on competitive market factors, the owners' and managers' personal choices, and a realistic understanding of the role a radio station can play in some market situations.

AIR PERSONALITIES AND DAYPARTING

In contemporary radio, there are SCREAMERS!!!, trying to wake the very young, and the shock jocks, the adult-male-oriented personalities courting FCC retribution daily. And there are very laid-back jocks who just talk conversationally when they open the microphone switch. Then, there are those "friendly" jocks who fall somewhere in between the screamers and the laid-backs. Once there was also the big-voice-boss who told the listener this was a Big DJ, a know-it-all, but this style faded in the early 1970s.

Dayparting is one of the major strategies of the music station programmer. The programmer's challenge is to make each daypart distinct and appropriate to the audience's characteristic activities and at the same time keep the station's sound consistent. The most important ingredient in making daypart distinctions is the personality of the jock assigned to each time period.

Morning

By and large, modern jocks are friendly, funny, and entertaining. They "relate" to the target audience. Morning jocks, for example, probably will talk more than jocks on other dayparts because their shows are service-oriented. They have lots of time and temperature checks. They may chat with the newscasters before the news, may bring the traffic reporter on and off the air and, in fact, manage the morning team. Listeners preparing for work or school are keen on the time and weather conditions. And *the larger the market, the more important traffic reports become*. Reports of a pile-up on one expressway give listeners a chance to switch their

commuter routes—and the stations a chance to earn a Brownie point.

In many markets, morning jocks are paired in teams of a lead DJ and a sidekick, someone to bounce jokes off, or a co-anchor who can add to the act, commonly a male plus a female. On most stations the morning jock is the only performer permitted to violate format to any appreciable extent (the "morning zoo" approach). Normally, morning drivetime personalities are also the most highly paid. They have a greater responsibility than other jocks because the audience is bigger in the 6 to 10 A.M. period than at any other time of day. As the saying goes, "If you don't make it in the morning drive, you don't make it at all."

Midday

The midday jock is friendly, but the incidental *services* (requiring talk) during this daypart are curtailed in favor of more music. Although there is considerable *out-of-home listening* in the 10 A.M. to 3 P.M. period, Arbitron data show that the majority of listeners are *at home*. Many midday jocks capitalize on the dominantly female audience by being sexy, using **liners** (brief continuity between records) having special appeal to women, and by talking about what the listener might be doing at home. In sum, the midday jock is more laid back than the morning jock and tries especially hard to be warm and friendly.

Afternoon

The afternoon jock (3 P.M. to 7 P.M.) is more up-tempo, as is the music in this period if the station is dayparting. Teens are out of school to listen to the CHR stations, and adults are driving home from work for the AC stations. In small markets, this necessitates a delicate balance between teen-oriented music and music suiting the moods and attitudes of the going-home audience. Again, traffic and weather are important in this period but not as much as in the morning. The afternoon jock alludes frequently to evening activities—about how good it must be to finish work and to

look forward to playing for a few hours, to taking your honey out, to being with your guy tonight, or to doing whatever else people are planning.

Evening

Many contemporary stations program their 7 P.M. to midnight slot much differently from the other dayparts. *Adult listeners decline* (because people watch television or rent videos), creating the opportunity to broaden the programming. Although some stations stick to their formats, others debut new albums or carry a talk show.

More teens than adults are available to listen at night, making this daypart strong for CHR stations. Evening jocks may be screamers with a special appeal to teens. They may talk with teens on the phone and air some of the conversations. They may open the request lines and play specific records for specific people. In major markets, and even in many middle-sized ones, this practice creates problems for the telephone company. In Mobile, Alabama, WKRG-FM asked the phone company to make a record of calls that did not get through to its four request lines. In one week, there were 65,000 such unsuccessful calls. Imagine what the number might be in Los Angeles or New York! In many major markets in the last decade, the telephone company has appealed to station management to stop listener call-ins.

At some top 40 operations, the nighttime slot is regarded as a time for AOR music, but this stratagem has not been notably successful in highly competitive markets—mostly because such a drastic departure from format destroys consistency. A hit station should maintain basically the same sound in the 7 P.M. to midnight slot as it has in the other dayparts.

All-Night

In the all-night period, from midnight to 6 A.M., the jock's attitude is usually one of camaraderie. "We're all up late tonight, aren't we? We have to work nights and sleep days." This jock must commune with the audience: the taxi drivers, revelers,

police officers, all-night restaurant and grocery store workers, insomniacs, parents up giving babies two o'clock feedings, shift workers at factories, bakers, and the many others active between the hours of midnight and 6 A.M. The commercial load is almost nil during this period, so the jock can provide listeners with a lot of uninterrupted music. Many stations use this period to beef up their news or public affairs programming.

Under a strong program director, a kind of "sameness" can develop among all the jocks in a specified format without the drabness or dullness normally associated with sameness. Sameness here means predictability. Listeners tuning in the station at odd hours hear the same "sound" they heard while driving to work in the morning or home in the afternoon (consistency).

ADVERTISING AND PROMOTION

The modern radio station pays almost as much attention to advertising and promotion as to programming. They are essential to keep a station from simply disappearing in the crowd. Nowadays, stations use television, newspapers, billboards, bumper stickers, bus cards, cab tops, and other graphic media. Promotional stunts are the special province of pop radio, involving the cooperation of programming personnel. If our hypothetical station is trying to break into a large market, as much as $2.5 million might be needed the first year for promotion. Many hit music operations, seeking a general (mass) audience with emphasis on the 18- to 49-year-old group, commonly give away as much as $500,000 every year in cash!

Contesting

The traditional promotional stunt is the contest, but the industry favors the word *game*. Many people think they cannot win contests, but they like to play games. For many stations, a contest approach emphasizes a superprize of $25,000 or more. Such amounts can be offered only once or twice a

year (during the Arbitron survey sweeps). And because a station cannot afford to risk losing the big prize on the first day of the game, winning has to be made difficult.

People are more likely to think they can win a small prize than a $25,000 treasure hunt or open a safe containing $50,000. With a superprize, one person is made happy, but thousands are disappointed. Consequently, it is better to break up the $25,000 prize into $25 prizes and scatter them through the year. *Direct mail contesting* is now widely used to increase listening in specific geographic areas.

Currently popular games include birthdays (announce a date on the air, and the first to call with that birthday wins a prize) and **cash call** (make one call-out per hour, and give the jackpot to the person naming its exact amount in the jackpot at the time). Cash call involves a small prize, added to each call until the correct amount is guessed. The DJs ballyhoo the contest before it starts to generate excitement, sometimes for days and days (precontest hype). Then they finally hold the contest.

Jock:	Is this 555-1212?
Listener:	Yes.
Jock:	Well, this is Jocko at station WPPP, and if you can tell me the exact amount in our WPPP jackpot, you'll win!
Listener:	Mmmmmm. Last I heard it was $1,950.
Jock:	Who is this?
Listener:	Mary Jones.
Jock:	That's right! You win! You're right. Mary Jones, you've just won yourself $1,950!!!
Listener:	Oh, wow! I can't believe it.

The more exaggerated the winner's response to his or her victory, the better the programmer likes it. Hyperbole is the element sought. Later the station will air promos in which each winner's response is repeated and repeated (postcontest hype). Jocks should remember to ask questions

such as "What are you going to do with the money? What will your husband/wife say?"

There are three steps to properly promoting a contest: (1) Tell 'em you're gonna do it: "It's coming, your chance to win a zillion dollars!" (2) Do it: "Listen every morning at 7:20 for the song of the day. When you hear it played later in the day, be the first caller at 555–0000 and win the money!" (3) Tell 'em you did it: "KXXX congratulates Mary Smith of your town, winner of a zillion dollars in the KXXX song of the day." It is important to avoid exact addresses on the air. The station might have legal culpability if a robbery or other crime occurs. Also, many DJs do not use last names of callers on the air to discourage possible unpleasantness for their listeners.

Cash call is but one of many games. The people's choice gambit provides a variety of prizes and allows the contestants to identify ahead of time the prizes they want if they win. Studies have determined that cash, cars, and trips are the most desired prizes. Prizes and contest rules should be carefully targeted to appeal to the exact age, sex, and economic groups the station wants to listen.

Exercise caution in recording and airing telephone conversations. Stations have shifted to call-in rather than call-out games because the law requires that the person being called (by the stations) be informed immediately off-air, "This telephone conversation will be broadcast or recorded." Then the dialogue can begin: "I'm Jocko from WPPP." It is a troublesome law that ruins many such calls because, once informed, the listener does not respond spontaneously. Listeners who call in, however, are assumed to be aware that their voice may go out on the air. Management should seek legal counsel on call-out questions and should write specific instructions to programming personnel on how call-out calls are to be handled.

Community involvement projects are as important as contests in programming a successful radio station. The station must be highly visible at local events to gain a strong, positive, local image. The following are community promotions benefiting both the station and the community:

- The station's van (customized to look like a boom box, complete with disc jockey, albums, bumper stickers, and T-shirts) shows up at the entrance to the hall that features a concert that night.

- Two or three jocks take the van and sound equipment to the beach (or any public park) on the Fourth of July to provide music and "freebies" to listeners and friends.

- CHR jocks provide free music for high school and junior high school dances, local fairs, and nonprofit benefits.

Commercial Load

More arguments arise over commercial load than any other aspect of programming a rock format. Before the 1970s, FM stations had few commercials because they had few listeners. Researchers began hearing listeners say, "I like so and so because they don't play commercials" or "because they play so much more music than other stations." Lights flashed and bells rang throughout the industry. Listeners hate commercials! Schulke and Bonneville, two of the early radio programming syndicators, began to employ the strategy of music sweeps and stop sets. A **music sweep** is an uninterrupted period of music; a **stop set** is an interruption of the music to air commercials or other nonmusic material such as news headlines.

Herein lies conflict. Sales personnel must have commercial availabilities (unsold spot time) if the station is to make money. Programmers rightfully argue that if the station is to score big in the numbers, it must limit its commercial load. The answer is compromise. Salespeople agree to raise rates, and programmers agree to provide 9 to 12 commercial minutes per hour instead of the full 18 the sales department wanted. (In 1982, the FCC stopped expecting radio stations to adhere to the now-defunct NAB radio code that specified a maximum of 18 minutes of commercials per hour except during political campaigns and other local, seasonal events when increases were permissible.)

Spot loads vary considerably by format. News and talk operations carry the heaviest spot loads, up to 18 minutes per hour. Popular music stations carry 9 or 10 minutes per hour, with as many as 12 in morning drive, scattered in frequent breaks between songs. Beautiful music stations carry the fewest interruptions, clustering their spots in a few long breaks between long music sweeps.

Not only do many successful rock operations run a reduced commercial load, but they also often program (and promote) commercial-free periods (see 13.10). Further, the *quality* of commercial production is critical. Commercials must complement the format rather than clash with it. A typical commercial for a rock show opens with a piece of the rock group's music, followed by a popular jock touting the show, and ends with more of the group's music. Many rock stations refuse to advertise funeral homes, intimate patent medicines such as hemorrhoidal creams, and other products and services they believe will offend their listeners or not mesh with their format.

One key to understanding radio programming strategy is to compare stations in the *number of commercial spots per break* (**load**) and the *number of interruptions per hour* (**breaks**). Too many spots in a row creates clutter, reduces advertising impact, and encourages listeners to twirl their dials (or push buttons). Conversely, too many interruptions destroy programming flow and encourage listeners to migrate on their dials. Because advertising is necessary, management must establish a policy reflected in music wheels and stick to it.

In the past, stations have kicked off new formats with no commercial load whatever. They typically offer huge prizes to listeners to guess the exact time and date the first commercial will be aired. Another popular audience-holder is the two-, three-, four-, five-in-a-row concept, with the announcer saying, essentially, "We've got five in a row coming up without interruption." The longer the listener stays with the station, the more the station quarter-hour shares are improved. This programming technique is becoming commonplace in music-oriented formats. A tension will

13.10 COMMERCIAL-FREE HOURS

Listeners tune in in droves, at least in major markets, when a new station (or old station with a changed format) announces it will play "commercial-free" for days or even weeks. Stations have been known to zoom to the top of the ratings charts after a month of commercial-free play, and fall into the pits when commercials are introduced. There is a painful irony in stations boosting the fact of no advertising when advertising is what supports the station. Of course, the cost of commercial-free play to a new station is initially low, as few advertisers leap to purchase time on stations without a ratings history. But instituting commercial-free hours for an established station generates an unfortunate tension between the conflicting goals of on-air and sales staffs, and worse, it conveys a naively negative attitude toward advertising messages to listeners, even though it is those messages that keep the station on the air.

continue to exist between the number of commercials and the number of interruptions that can be tolerated.

Call Letters

Gordon McLendon, early innovator of the top 40 format, was one of the first broadcasters to recognize the value of sayable call letters. His first big station was KLIF, Dallas, originally named for Oak Cliff, a western section of the city. The station call was pronounced "Cliff" on the air. Then there is KABL ("Cable") in San Francisco, KOST ("Coast") in Los Angeles, WWSH ("Wish") in Philadelphia, and KEGL ("Eagle Radio") in Fort Worth. These call letters are memorable and distinctive *noms de guerre* and get daily usage. Today, nearly every city has a "Magic," a "Kiss," and a

"Mix." When the Belo Corporation in Dallas developed a new format for WFAA-FM, the historic letters were changed to KZEW, and the station is now known as "the Zoo." (Gagsters used to try to pronounce WFAA, and it came out "woof-uh.")

FM stations often combine their call letters and dial position in on-air promotions—especially if they are rock stations. WKRG-FM in Mobile is G100; the RKO station in New York, WXLO, calls itself 99X. In Indianapolis, an AOR station, WFBQ, calls itself Q95; a Bloomington station calls itself B97. This practice generally involves rounding off a frequency to the nearest whole number (102.7 as 103, or 96.5 to 97). The increase in stereo receivers with digital dial displays, however, has discouraged the use of rounding off. More stations now give their actual dial location on the air.

Jingles and Sweepers

The day of the minute or half-minute singing jingle ID is largely gone. Only adult format stations such as big band still play them. Nowadays, having a chorus of singers praise the station for a minute or half-minute is out of the question. That would take time away from popular music, which people tuned in for in the first place. Most stations keep jingles very short and to the point, and they are available in a wide variety of music types and styles to fit specific formats. Companies like JAM Creative Productions and TM Century (both in Dallas) specialize in radio IDs (identifications, but many use **sweepers** (only a few bars of music under the station's call letters or frequency). Automated stations sometimes effectively use both jingles and sweepers since they lack a live DJ to fill gaps in programming and repeat the station's name.

FCC AND OTHER CONSTRAINTS

Even with radio deregulation, radio broadcasters have to be aware of a myriad of rules, regulations, and guidelines. To keep up with them, radio programmers read trade journals and join the National Association of Broadcasters (NAB). Programmers, too, have to be aware of legal constraints that may limit their ingenuity. Illegal or unethical practices such as fraud, lotteries, plugola, and the like can cost a fine, a job, or even a license.

Contests and Games

The principal point to remember about on-air contests and games is to keep them open and honest, fully disclosing the rules of the game to listeners. Conniving to make a contest run longer or to produce a certain type of winner means trouble. Perry's newsletter, *Broadcasting and the Law,* is useful for flagging potential difficulties.

The perennial problem with many brilliant contest ideas is that they are **lotteries** by the FCC's definition (see 13.11), and advertising lotteries is explicitly prohibited in some states but not in others. If a contest includes "prizes, consideration, and chance," it is a lottery and probably illegal.[5] Consult the station's lawyers or the NAB legal staff if there is the slightest question.

Plugola and Payola

Announcers who "plug" their favorite bar, restaurant, or theater are asking for trouble for themselves and the licensees (**plugola**). Similarly, a jock who accepts a color television set from a record distributor in exchange for air play of a record is guilty of **payola.** But the big payola payoffs usually come in drugs, conveniently salable or consumable so they rarely leave evidence for the law. Nonetheless, such practices eventually surface because talk gets around, leaving the people concerned subject to prosecution. Drugs make station management very nervous; the legal penalties can include loss of the station's license, a $10,000 fine, and jail. Certainly, any tainted jock is likely to be fired instantly. Most responsible licensees require air personnel to sign statements usually once every six months confirming that they have not been engaged in any form of payola or plugola, and some require drug tests for their employees.

13.11 LOTTERIES

Congress changed federal law in 1990 to make state-run or charitable lotteries legal but left each state to determine whether it wanted them legal within the state and would permit them to be advertised. Broadcasting information about a lottery is now permitted under federal law if the lottery is not prohibited by state law and if either (a) the lottery is conducted by a charitable organization (charitable organizations are those that qualify as tax-exempt under Section 501 of the Internal Revenue Code) or (b) the lottery is an occasional promotional activity ancillary to the organization's primary business. Even in the states where advertising lotteries on radio is permitted, many station managers continue to veto most promotional lotteries. Communications lawyers usually advise management to let some other station be the test case.

Sounds that Mislead

Opening commercials with sirens or other attention-getting gimmicks (such as "Bulletin!") unjustifiably cause listeners to believe they are about to receive vital information. Listener attention can be gained in other more responsible ways that do not offend FCC rules or deceive listeners. Monitoring locally produced commercials for misleading production techniques is especially important.

Program Logs

Any announcement associated with a commercial venture should be logged commercial matter (CM), even though the FCC has done away with requirements for program logs per se. Program logs have many practical applications aside from the former legal requirement, including billing for advertising, record-keeping, format maintenance, and format organization. Common sense dictates a continuation of the old method. Advertisers demand proof of performance, and an official station log is the best evidence of whether and when spots were aired. If a station is challenged on the number of PSAs or the nonentertainment programming it has aired, an official station log provides the best evidence of performance.

RADIO'S FUTURE

Music is the main course in radio, although news/talk is gaining, especially in the baby boom generation and older. When it comes to music formats, FM will win over an AM facility whenever a showdown occurs. Spoken-word formats are the rebirth and future of AM radio. A case in point is the sad story of the AM station in Dallas, KLIF, once the unquestioned national leader in top 40 radio. For 20 years KLIF held the number one position in the market and was respected nationally as the station to imitate. Since the mid-1970s, however, Dallas/Ft. Worth has been an FM market. KVIL-FM is the leading AC station and shows no signs of weakening. KLIF no longer places among the top ten stations. It has had to endure two format changes (to country and then to news/talk) and has even changed dial position (from 1190 to 570).

Eight of the top 10 in any market with more than 12 stations will probably be FM. FM has become the home of music radio. What lies ahead for AM radio? Not music, with the possible exception of big band. Most AM stations must program information to older audiences, even though doing so is expensive and complicated. The spoken-word formats, including news, talk, sports, religious, and ethnic, have become viable alternatives for AM radio.

Continued strength in the radio industry nationwide, however, suggests there is room enough for both AM and FM broadcasters. Spot advertising revenues for radio continue to rise, and increasing numbers of new advertisers are learning that radio is an effective medium for them, al-

though cable systems with local origination channels have eaten into radio revenues in some markets (see Chapter 12). The radio programming problem is to locate a sizable audience not being served by a stronger facility in the same market.

For daytimers, religion has become a mainstay, along with limited-audience ethnic formats. However, the difficulties are illustrated by KKDA (Dallas), once a country music station. New owners launched a black-oriented format and quickly gained position in the market. When they then acquired an FM facility and duplicated their format, all of the AM listeners switched over to the FM station. The AM daytimer that once fared well was reduced to an also-ran. Eventually, the programming was refined to target younger audiences on FM and older audiences on AM. Frequently, an FM will show 7 and 8 shares in markets with more than 12 stations, while an AM daytimer plods along with 1s and 2s.

"New wave" was the latest and hottest thing in the music business in the early 1980s. It was a refinement of punk rock, but had more lyrical content and appealed to an audience with downscale demographics. By the mid-1990s, it was being called "alternative" and showing Australian and British influence along with danceable, Americanized lyrics. AOR is now a one-per-market format, but most markets can support two adult stations. The massive return to top 40 occurring under labels such as contemporary hit radio, hot hits, and adult top 40 uses faster rotation times and top-rated songs and incorporates the new music in a flexible, trendy format, influenced by MTV. The most common music formats remain adult contemporary and country, while Hispanic and urban contemporary are growing at fast rates.

Beginning in the late-1980s and on through the 1990s, stations were following the aging baby boom generation by increasing the proportion of oldies in their formats. Classic rock had become the newest fad, and riding this wave, Transtar created "Format 41," targeting adults 33–48, with a median age of 41 (hence the format name). Simultaneously, Z-Rock appeared, a hard rock format targeting the male-dominated 12–24 audience.

But many programmers overreact to fads in music. When disco first appeared, WKTU-FM in New York embraced it and zoomed to first place in one ratings book, then faded. A few years ago, someone conceived of a solid gold format. One station in Detroit tried it, made good gains in the first book, then fell back into obscurity. Another station tried commercial-free radio for three months, soared in the ratings, then fell back into ninth place. There have been All Elvis and All Beatles and All Rap stations. Such formats are like pogs: a craze today, forgotten tomorrow. What works is consistency—in service, in music, in technical quality, in station identity. The fast-buck artist does not stand a chance in the marathon race for big audience and big dollars.

In this chapter I have touched on only the more obvious strategies involved in the fascinating art of programming a modern music station. To the uninitiated, all radio music formats may seem much the same. In actuality, each is replete with subtle and not-so-subtle variations. To program a formula successfully in today's competitive market requires never-ending ingenuity, insight, and professional growth. The name of the game is *change*, but it must be accomplished by consistency in the on-air sound. Radio programming is constantly evolving, and for those who enjoy innovation, it offers a rewarding challenge.

SUMMARY

Five factors determine which music format will win the largest audience market. Of these, the most influential is the quality of the technical facility. FM produces inherently higher quality sound than AM, and that gives it an undisputed advantage in music competition. Among FMs, tower height and power give decided advantages, but among AMs, power and dial position matter. The remaining factors of market, target audience, budget, and potential revenue indicate what programming is most competitive. Once a format has been selected, a staff must be hired and a record

library created. The next big job is to program the music hot clocks for all the major dayparts and weekends. In broadcasting, dayparting means altering the programming at different times of the day to fit the audience's activities. Different styles of disc jockey patter match different dayparts on a popular music station. A rock music rotation system might be composed of power, current, recurrent, power gold, and oldies classifications. How to classify songs and rate them are the functions of the station's music research department and depend heavily on the radio trade press. The role of news and nonentertainment programming on a popular music station remains controversial, but once promises are given to the FCC, adherence must follow. Drug payoffs persist as a payola problem. The amount and kinds of on-air promotion and the number of commercials and breaks in programming also delineate stylistic differences among competing popular music stations.

SOURCES

Beyond the Ratings, monthly newsletter. Laurel, MD: Arbitron Ratings Company, 1977 to date.

Billboard. Weekly trade magazine for the record industry, 1888 to date.

Duncan, James H. (Ed.). *Duncan's Radio Market Guide.* Kalamazoo, MI: Duncan's American Radio, annual with supplements.

The Journal of Radio Studies, Washburn University, 1991 to date.

Keith, Michael C. *Radio Production: Art and Science.* Stoneham, MA: Focal Press, 1990.

Lotteries & Contests: A Broadcaster's Handbook. 3rd ed. Washington, DC: National Association of Broadcasters, 1990.

MacFarland, David T. *Contemporary Radio Programming Strategies.* Hillsdale, NJ: Lawrence Erlbaum, 1990.

Radioutlook II: New Forces Shaping the Industry. Washington, DC: National Association of Broadcasters, 1991.

Radio & Records. Los Angeles: Radio & Records, Inc. Weekly newspaper covering the radio and recording industries.

RadioWeek. Washington, DC: National Association of Broadcasters. Weekly newsletter.

NOTES

1. Radio station prices are based on multiples of cash flow. A low-rated, unprofitable station might sell for 2 to 7 times its cash flow, whereas a top-rated station with large upside potential might sell for as much as 12 times cash flow. Equipment condition, current ratings, market activity, and location of studio and transmitter site also contribute to determination of station value.

2. See *Broadcasting* magazine's annual survey of formats to track changes in format popularity, in particular, "'Baby Boomer Formats' Growth Increasing," *Broadcasting,* 15 April 1991, p. 75.

3. Stations lacking compact disc equipment usually "cart" all music—that is, dub it onto audio cartridges. This enables the station to play its music inventory without damaging the actual discs, whether albums or singles. Carting also produces a control factor. The announcer who wants to play personal favorites will not have the opportunity, if all turntables are removed from the control room, if all music is carted, and if only the carts the program director wants played on the air are allowed in the control room. But carting is costly, time-consuming, and risky, and some programmers believe that dubbing inevitably lowers quality. Digitally recorded compact discs (CDs), using laser-based technology, are improving the quality of aired recordings, and CDs come free to stations just as records did.

4. The *gold book* preceded the flip card system. The programmer listed all songs in a book, numbering the 31 days of the month beneath each song. When a song was played, the DJ marked out the number of the day on which it was played, each DJ using a different color marker for this. Since a new gold book was used every month, at the beginning of the month listeners often heard songs that had recently been played (even the day before).

5. *Consideration* refers to payment of some kind, including both money and extraordinary effort, to be allowed to participate in a contest.

Chapter 14

Information Radio Programming

Jeffrey Neal-Lunsford
Susan Tyler Eastman

A GUIDE TO CHAPTER 14

INFORMATION RADIO FORMATS

In the world of popular culture, television sitcoms of the 1990s based on information radio (*Frasier* and *NewsRadio*, for example) have replaced the comic antics of television-based programs like *Murphy Brown* and *Mary Tyler Moore*, or radio-based shows like *WKRP in Cincinnati*. Information radio, once the weak sibling of music radio, has come into its own in the 1990s. For example, 1,300 out of 10,000 American radio stations have a talk radio format.

Information radio holds a unique position in listeners' media behavior. In cars and offices and stores, nearly everyone turns to radio for the first news of disasters and historic events. Radio has a long tradition of bringing fast-breaking headlines to listeners more quickly than do other media.

Radio audiences, however, have different perceptions of the two radio bands: FM, with its superior frequency response and stereo capability, is the preferred band for music; AM is the band for information, including general and specialized news, talk, sports, farm reports, educational programs, and other information. These listener perceptions were entrenched by the 1980s, forcing most AM station operators to fit themselves to public assumptions by switching to nonmusic formats to survive.

The result of AM's dilemma was the emergence of information radio, which falls into three major categories: all-news, news/talk (see 14.1), and sports/talk (see 14.2). Few stations can be placed entirely within one of these categories; a station that is predominantly all-news may program a few talk shows, particularly on weekends. Similarly, a sports/talk station may also carry such syndicated programming as *The Rush Limbaugh Show* as part of its regular programming.

A recent survey concluded that almost half of all Americans listen to talk radio on a relatively frequent basis. This is borne out by ratings data that show that news and talk stations have taken the lead over other formats in listener shares. Indeed, in the mid-to-late 1990s, talk-based formats became one of the strongest growth areas in radio and helped revitalize the once moribund AM band.

One exception to the FM/AM dichotomy is **public radio.** Although its music and cultural programs go beyond the realm of information radio, the "serious" format of public radio is much closer to the format of many information radio stations than to formats discussed in Chapters 12 and 13. This chapter on information radio concludes with a look at public radio.

Programming Information Radio

Most information radio formats are constructed to showcase different types of content during different dayparts. Talk-oriented stations, for example, schedule a heavy load of news during the **morning drivetime** daypart (from 5 to 9 A.M. or 6 to 10 A.M.) and again during **afternoon drivetime** (from about 4 to 6 P.M. depending on the market). This strategy is aimed at capturing the attention of the large number of listeners driving in their cars either to or from work during these time periods and is often the highest rated daypart of the program day. The rest of the program day is devoted to various kinds of talk programs, often including some type of sports programming. While play-by-play coverage is important to sports/talk stations, talk programs abound in their schedules, along with newscasts, although these are heavily dosed with sports news and game scores. All-news stations air continuous newscasts, usually in 20- or 30-minute segments, for 24 hours each day. An example is WBBM-AM (Chicago), whose slogan is "Give us 20 minutes, and we'll give you the world." Some all-news stations, however, break away from their news cycles to carry live sports, interview programs, or overnight talk programs.

While news and talk stations are often seen as similar because their spoken word formats are so distinct from music stations, they are in fact very different from one another in the way the audience uses them. Thus, they are marketed and sold in very different ways. All-news formats, because they repeat news cycles over and over, tend to at-

14.1 THE BEGINNINGS OF CONTEMPORARY NEWS AND TALK

In the mid-1960s, the foundation for all-news radio was laid by two major broadcasting groups. The first was Group W, the Westinghouse Broadcasting Company, which converted three AM stations—WINS (New York) and KYW (Philadelphia) in 1965, and KFWB (Los Angeles) in 1968—to an all-news format. CBS followed suit with several of its owned-and-operated AM stations, first at WCBS (New York), KCBS (San Francisco), and KNX (Los Angeles), and later at WBBM (Chicago), WEEI (Boston), and finally WCAU (Philadelphia).

By the mid-1990s, hundreds of stations, mostly AM, were identifying themselves as an all-news or news/talk stations, and the format was spreading beyond major cities into smaller markets. While the all-news format is dependent on local programming, network affiliation provides coverage most local stations cannot supply. In addition, a growing number of syndicators are supplying both affiliated and nonaffiliated stations with news services and programs.

The term *talk station* was generally adopted when KABC in Los Angeles and a few other major-market stations discarded their music formats around 1960 and began airing information programming featuring the human voice. KABC started with a key four-hour news and conversation program, *News/Talk*, from 5 to 9 A.M. KGO in San Francisco later adopted the name of that program to describe its overall format. KGO used news blocks in both morning and evening drivetime and conversation programs throughout the balance of the day. KABC focused on live call-in programs, interviews, and feature material combined with informal and formal news coverage. KABC first promoted itself as "The Conversation Station," but news/talk stuck as the generic industry term for stations that program conversation leavened with news during drivetimes.

tract listeners for short periods of time, just long enough to hear one or two of the cycles. Talk-oriented formats develop very loyal listeners who often stay with the station for long periods of time (many hours to all day).

News/talk and sports/talk stations develop a more loyal listenership who often stay with the station for long periods of time. All-sports formats vary between short cycles of sports score updates and long-form game and interview programs.

Because the appetite for news and such surveillance features as traffic and weather reports is greatest in the morning, the audience for news stations often peaks during morning drivetime. Talk stations, however, do a better job of holding listeners through midday and evening hours. Because audiences for news often listen for short periods (except for games), all-news stations must constantly seek a stream of new listeners to replace those who tune out. Thus, all-news is a cume for-

mat: It depends on high cume ratings to counteract low average-quarter-hour shares. Because of this, the locally produced all-news format is usually limited to larger markets, those with enough overall radio listenership to generate the needed constant audience flow to the station.

The all-news programmer oversees the equivalent of a single program airing 24 hours a day, whereas news/talk and sports/talk programmers deal with diverse blocks of programming lasting from one to four hours. Thus, a talk radio program director is much like a television programmer: Both must consider how one program leads into the next, strategically plotting **audience flow** while attempting to attract and maintain an audience with demographics that will appeal to advertisers (see 14.3). The talk programmer must also consider that listeners have different reasons for tuning into their station. Some are attracted by the personality of the hosts, such as Howard Stern

14.2 THE GROWTH OF SPORTS/TALK

Sports/talk radio is described as a "rising star" in information radio. Just a few years ago, only a handful of stations dedicated their formats to sports programming. Now, more than 100 commercial sports/talk stations are on the air, with some major markets supporting two sports/talk stations. The vast majority of these stations are AM, but a few FM sports/talk stations exist as well. Some of the leading stations in this genre include WFAN-AM, New York, WMVP-AM, Chicago, and WIP-AM, Philadelphia.

The growth of sports/talk has been fueled not only by the overall success of information formats but by the format's success in drawing men in the 25–54 or 18–34 age groups, a demographic much sought after by advertisers. Another factor in sports/talk's success is its use of a growing number of ex-athletes as hosts, including such former stars as Pete Rose and Tom Seaver.

Stations programming a sports/talk format feature a variety of programs. Of course, play-by-play coverage of games is an important element, but other popular sports/talk staples include scoreboard shows, interview shows, and talk programs with a sports slant. As one sports programmer put it, a successful sports/talk station is more than just the games: "It's not necessarily the sports, it's the talk that goes along with it. Just like the fun of sports is not just in going to the game but in the tailgate parties and Buffalo wings. It's the lifestyle of the sports fans on the air that really makes this format work."

While most sports/talk stations create some of their own programming, there is a growing number of syndicated programs to help them fill the broadcast day. This is particularly important to smaller market stations, which do not have the resources to produce a great deal of original programming or hire high-profile hosts. Currently, syndicated programming is available from such sources as the ESPN Radio Network, Sports Byline USA, the SportsFan Radio Network, NBA Radio, and ABC Radio Networks.

or Rush Limbaugh. Others use talk radio primarily as a way to gather information. Still others listen to hear viewpoints that differ from their own.

The talk format is both fluid and stable, whether focused on local events, social problems, world issues, or sports. Talk frameworks are usually fixed but flexible enough to respond to issues on a day-to-day basis and quickly reflect changing community moods. Good air personalities can sense audience moods and respond accordingly. Talk hosts, unhampered by music rotation lists and the like, can alter the tone of on-air talk more rapidly than can announcers working in other formats.

When an issue or news event is significant enough to color the outlook of an entire community or even the entire nation—a war, a weather disaster, or a major win or loss by the home team—the sound of the talk station will reflect the mood of the audience. Covering significant events preempts the regular schedule and previously booked guests. Like most broadcasters, a talk station responds to major news events on the air, but talk and all-news stations respond to events even more rapidly with on-hand personnel and equipment and, when appropriate, devote all the station's airtime to the event, which gives them an advantage over their competitors who rely on music programming.

Because the news/talk and sports/talk formats present "verbal information," the audience readily accepts a news break. The interruption may be a network bulletin or a casual sounding "visit" from a member of the station news staff who joins the talk host in the studio to break a story fresh from a

14.3 THE PROGRAM DIRECTOR

At talk stations, a special kind of partnership, involving a great deal of mutual trust, grows up between air personalities and their program directors. Program directors establish station policies that ensure not only journalistic standards but also account for the bounds of good taste, Federal Communication rules, libel laws, and industry practices. Having established and communicated such policies, an individual program director must recognize that day-to-day errors and the occasional controversy will occur. The air personality has to make instant decisions and respond immediately. A conversation host interacts with phone callers for two to four hours a day. Callers can be assertive, aggressive, and belligerent. And no format is easier to second guess. Program directors should therefore avoid impulsively calling air personalities to task; in almost every case, the personality is the first to know when something has gone wrong.

In fact, talk radio is often radio waiting for something to go wrong. When things do go astray, the program director's first approach should leave an opening for the air personality to say, "I know it was bad. The reason was . . ." Although program directors are responsible for determining that the on-air talent understands what happened, they must then act as intermediaries and arbitrators between management and on-air personnel.

wire service or a local reporter. The newsperson's presence in the studio on such occasions provides the opportunity for questions and answers or conversation between the host and the newsperson. Assuring the audience that the station's news staff will follow the story and keep listeners informed as it develops will keep them tuned in.

Operating Costs

News breaks; it doesn't wait. If management cannot afford a story because complex costs surround its on-air repetition, the story gets short shrift, if any attention at all.

Information formats are considered to be more expensive to operate than music stations. All-news is the most expensive of all radio formats because it requires many reporters, anchors, writers, editors, and other staff. Talk-oriented stations are also more expensive than their music counterparts because they too require a commitment to newsgathering. And talk shows require producers, telephone screeners, and other behind-the-scenes staff members.

A key factor in operating costs is the presence of unionized employees. In most major markets, union rules govern production personnel—a constraint for management. Most unionized radio stations have contracts with the American Federation of Television and Radio Artists (AFTRA), although many stations also have Newspaper Guild writers in-house. Union contracts set work rules, pay provisions, and exclusivity that affect the nature of news programming. Contracts exist in which repeating a story in later shifts of dayparts carries a residual payment to the original reporter, writer, or anchor. Sometimes this kind of provision is designated a "within-shift" rule, allowing the story's use within the individual's scheduled shift but adding a fee when used outside the particular shift. Added to that may be special tape **reuse fees** or added costs if another station in the network or group uses the material. When reporters cannot edit tape, write their own **extraneous wraps,** or do simple editing because of contract constraints, the subsequent delay becomes a handicap. And handicaps can lead to dissention and threaten cost control.

In addition to personnel costs, programming expenses must be accounted for. In recent years networks and program syndicators have begun delivering programming that makes it possible for stations in both formats to operate at reduced costs (see Chapter 12). CNN, for example, delivers an audio version of its Headline News cable television service, making it possible to operate an all-news station with no newsgathering personnel on the local station staff. Audiences like the familiarity of CNN audio in their cars because it sounds like the popular cable network. Some smaller stations depend entirely on CNN, and many larger ones mix it into their overnight schedule. Similarly, talk stations now have access to a number of sources that deliver enough network programming to fill an entire broadcast day.

INDEPENDENT AND NETWORK COMPETITION

A competitive pattern has emerged in the short history of news and talk radio stations: A well-operated information station in a major market can count on a 5 to 10 percent audience share. If two information stations operate in the same market, they divide the audience share (given relatively equal effort and appeal). The news and talk formats are not normally subject to radical ratings swings, except during world crises, perhaps because their audiences are quite loyal. In general, ratings for both types of information stations climb during periods of intense world news interest.[1]

Information competition usually occurs between a network outlet and an independent station (see 14.4 for more on news competition). The network-affiliated programmer has the advantage of network resources but must air obligatory network news or talk shows at key times. Thus, if the breaking story is local, the affiliate may be running behind the story, being forced to air the network feed that ignores a big local event. Added to that is the gnawing feeling among the news staff that they are second-class citizens because the network

voice automatically preempts their voices. The other side of the coin is that local stations must scramble to equal the network staff's professionalism to create a consistent sound. The independent station does not have this problem, but it does face the burden of producing more of its own news and talk programming, requiring more staff, or buying programming from syndicators. Either way, the independent often must allocate more of its budget to programming expenses than does the network affiliate.

Aside from head-to-head combat, information stations face a subtler form of competition arising from the *drivetime news block confrontation*—usually instigated by a well-established music station in the market with a fairly strong news department. To cope with the all-news station's intrusion into its market, a music station will often expand its news programming, particularly in morning drivetime. Since the music station can afford to compress its news staff effort into a two- or three-hour period, the facade of an important news effort can be erected. This tactic, coupled with a well-regarded local disc jockey, can be formidable indeed. Pulling away from such a station over a stretch of time is not too difficult, however, because sustained, tight utilization of news team strength will tell. Heavy use of well-researched and well-programmed news series made up of short vertical or horizontal documentaries in morning drivetime is one of the most effective countermeasures. (**Vertical documentaries** are stories aired in brief segments throughout one day; **horizontal documentaries** occur in segments over several days, perhaps weeks.)

PROGRAMMING STRUCTURE

The programming of a station carrying an information format is not happenstance but the result of a carefully designed programming strategy that takes into account both the programming of the station and the programming of competing stations, as well as other competing media, such as television and newspapers. At one time, programming deci-

14.4 PROGRAMMING THE COVERAGE AREA

Difference in signal strength among stations is often mentioned as a key advantage or disadvantage. For news stations, too strong a signal may lead to spreading its resources too thinly. For network-owned or affiliated news stations, this is not a hazard because the network base is broadly appealing without the constant need for as much local backup as the independent programmer has to muster. Concentrating on the smaller metro-area audience can be more rewarding for the independent station in terms of audience loyalty than trying to be too many things to too many people at once. Such a situation exists in the Los Angeles area. There, listeners can tune (within the L.A. primary-coverage zone) to a 5,000-watt independent, while a 50,000-watt network

outlet serves a much greater audience area. Power limitation, translated to audience limitation, is an obvious programming constraint. The programmer must be aware that many in the metro audience relate to outlying population groups and want to know, to some degree, what is going on "out there." Still, the metro-limited station cannot afford to cover the fringe audience too generously. Adding a metro-assignment reporter to the staff of the metro-only station tends to pay bigger dividends than making a spread gesture by setting up a suburban bureau in an area with few listeners. Suburban bureaus are for stations with wide-area signal coverage and adequate support budgets.

Setting up suburban bureaus, however, manned by outside reporters, ensures regional cover-

age. This strategy has its limitations—high cost in areas of necessary concentration—but it works to great station advantage. When economic factors dictate, **stringers** (freelance reporters paid per story) can often cover an entire geographic area for the station, an especially useful approach for small- and medium-sized stations. The prime advantage of full-time reporters is their visible and audible station presence in the outlying areas. Serving the major-market bedroom communities nets the station their involvement and empathy. If, however, population is sparse or mainly rural, stringers are the cheaper alternative. A well-managed pool of stringers can add informed reporting of local issues without requiring local bureaus.

sions were initiated with the construction of a **wheel,** a clock face or pie chart that displayed the station's programming blocks (see Chapter 13). Nowadays, the programming wheel has been replaced by computer software that performs the same functions but in a more flexible and efficient manner. The use of computer software allows a station's programming and traffic departments to carefully plan the timing of each segment of programming as well as scheduling such elements as commercials, public service announcements, and promos.

The programming infrastructure created on the computer forms the skeleton on which hang the sections of hard news, features, talk programs,

game coverage, sports commentaries, editorials, and so on. At all-news stations, newscasts are repeated in 20-, 30-, 45-, or 60-minute sequences, although most stations prefer the shorter 20-minute cycles. Cycle length affects spot and headline placement, time, traffic, weather, and sports scheduling, major news story development, and feature scheduling. Advantages and disadvantages accrue to all lengths; which cycle a programmer chooses depends on local market conditioning to the format, staff capability, editorial supervision, and program content.

The programmer connected with a group or chain of stations will probably have major cross-feeds from sister stations and possibly a

Washington or New York bureau on which to draw. A bureau provides stories, analyses of national political and economic news, and coverage of special events such as press conferences, U.N. developments, and personality interviews. Added to these highly professional programming sources is the freedom to develop local staff and resources. Degree of station independence varies considerably among group-owned stations, but scheduling is normally left to the local manager.

Typically, each hour on an information station contains 12 to 18 minutes of spot announcements spaced out in 8 to 18 interruptions. Information formats will accept a larger commercial load than music stations because the spots are less intrusive in speech-oriented formats. Formatting a talk station's drivetime news blocks is very similar to that of an all-news station. Hard news, features, sports commentaries, editorials, commercials, and so on must also be displayed on the station's computer-generated log.

Headlines

Headlines are an important element in attracting listeners to a news segment. Normally programmed at the top of the hour and at the half hour, headline presentation style and substance must be determined carefully. If headlines tease or bear only a slight relation to the stories that follow, credibility suffers. For example, a tease headline might be written, "The Senate passed a bill today that will put a dent in your wallet." This tabloid approach is damaging. The ethical headline runs more like, "The Senate voted today to eliminate government control of cable television rates, which will likely result in higher cable costs for consumers."

Time and Traffic

Once the spots and headlines are set, personal service elements such as time, traffic, weather, and sports can be keyed in. Time and traffic announcements gain in importance during certain dayparts, especially morning drivetime. Determining length

is a pivotal decision, as is frequency. And when time lags occur between on-site observation and actual broadcast, inaccurate traffic information seriously undermines the credibility of an information station.

Arrangement of personal service components should be extremely flexible within the program schedule. At times, of course, weather and sports become major hard news stories in and of themselves, such as during a big blizzard or when a local team wins a championship or fires its coach.

Weather and Sports

Accurate weather information is an invaluable asset to any information station, particularly in prime programming periods. If a professional meteorology service is used, the station gains credibility. Even in-house use of National Weather Service wires, area airport reports, local weather radar, Coast Guard data, or standard wire service reports can be mixed to fit local audience needs. It is desirable, however, for the announcer to supplement wire reports by looking out the window.

Drivetime weather reports are usually short, covering only immediate-area conditions. An occasional forecast can be added to tell commuters what to expect going home and for the night to come. When a significant number of boaters, private pilots, or farmers are part of the audience, special weather reports are useful at intervals. And the long distance business commuter should get at least a spot check two or three times a day on weather in major cities the local airport serves. Special weather reports can run from 30 seconds to 2 minutes and can be tied to a hard news story if conditions warrant. In general, weather is increasingly important as it becomes extreme (affecting commuting), during holidays (affecting travel), and as the weekend nears (affecting leisure plans).

Sports is generally granted the quarter- and three-quarter-hour time slots on all-news stations, with local interest, volume, time of day, and pressure from other news features determining its

length. Sports reporting is anchored to scores and area team activities, but sportscasts are normally expanded on weekends to cover many more games or contests at distant points—after all, in the farthest reaches of Maine and California, Notre Dame alumni associations persist. Although weekday sports segments are usually held to about 2 minutes at the quarter- and three-quarter-hour marks, weekend sportscasts are easily expanded to 10 or 12 minutes. The situation is obviously quite different at sports/talk stations, where sports programming of various types runs throughout the day.

In both weather and sports reporting, accuracy and timing are critical. A careful study of the market for various kinds of weather and sports information will dictate if segments should expand or contract. As in all other news areas, being right is more important than being first. The programmer who neglects a sizable special interest group will find the competition filling the gap.

Editorials and Features

Many all-news and news/talk stations air **editorials,** using an editorial director as writer, and the general manager often reads the material on the air. For editorial content, most stations stick to local issues, avoiding national controversies and apparently unresolvable social problems. Widely reported local problems on which closure will occur in coming months are especially suitable. They fit easily into the brief format used for most editorials, and listeners already know a great deal about the subjects. Issues that will be resolved by coming elections or events of moderate interest are also usually safe for editorial comment. Those problems about which all listeners agree (public safety, drunk driving, utility rate hikes, the dearth of children's television, violence in the streets) provide easy editorial programming.

Many editorial subjects raise fairness issues, and despite the demise of the FCC's **fairness doctrine,** station owners usually have policies granting airtime for expression of positions opposed to editorial comments. At their best, some editorials have

stimulated legislative action and public awareness because of their hard-hitting content.

Editorials are best scheduled away from the top stories, assuming news items are mainly local and editorials deal with local issues. Such scheduling means that editorials appear toward the end of a 60-minute cycle. Local editorials and syndicated or network commentaries can be easily confused in some listeners' minds because they come from "strange" voices and are both persuasive statements, seeking to alter the listener's point of view. Separating editorials and commentary by at least 15 to 20 minutes is best, but one of each can fit into a 60-minute cycle. In any case, features, including editorials, should never be clustered, causing the listener to lose identification with the station as a hard news voice.

Features are another important element of an information format for both news and talk stations. In most cases, the reports or miniprograms are between 90 seconds and 2 minutes long. Independent stations either hire commentators and feature editors or purchase syndicated material from production houses or network sources without market presence. Group stations usually do both; network affiliates, of course, share in the popularity of established news personalities. Public affairs programming, 7 to 8 percent of the program mix, usually includes such content as science and medicine, business and finance, reviews of local theater, and educational features.

NEWS SCHEDULING CONSIDERATIONS

Because the programming of all-news stations is usually based on repeating cycles, scheduling considerations tend to be tighter than for talk stations. On the average, news occupies about 75 percent of airtime on an all-news station. The basic elements at an all-news station include:

- **Hard news** copy
- Recapitulations of major stories (**recaps**)

- Question-and-answer material from outside reporters via mobile radio
- Telephone (**actualities**)

These elements form the bulk of radio newscasts. To them, stations add in-studio interviews, news conferences, roundtable discussions, and special remotes to balance coverage and add local flavor and variety.

In a full-hour cycle after playing commercial clusters, headlines, and basic format elements (time, traffic, weather, sports, and so on), eight fairly stable sections for news are left. The first and fifth sections contain the hard news, as shown in 14.5. The second and sixth segments normally deal with news stories of less immediate importance. The remaining sections incorporate some soft news and a mix of carefully selected features and news of local value. The fourth or eighth sections often include a station editorial—meticulously identified as management opinion. This pattern gives the listener headlines, hard news, more news, soft news, and features in a repeating hourly cycle, although the sources and specific content always vary.

Priorities

Earthshaking news developments on a global or national scale are not necessarily uppermost in the audience's notion of what is news. During morning drivetime, weather and traffic reports should be emphasized as they will determine how listeners start their day. Schedule in this way: Time announcements at least every 2 minutes; weather information (of the moment and forecast) no more than 10 minutes apart; traffic information every 10 minutes; plus, interspersed, allied information such as school closings, major area sports events, and so on. In other words, the top priority in any all-news format is local, personal service programming. Item repetition slows during the midday and is stepped up during evening drivetime (4 to 7 P.M.). Predictability is important in news programming, because the audience will get used to coming to the station at specific times for program elements

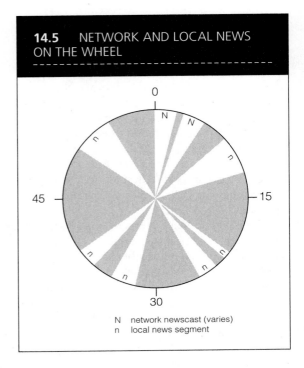

14.5 NETWORK AND LOCAL NEWS ON THE WHEEL

N network newscast (varies)
n local news segment

such as time, weather, and sports. Effective news management means carefully watched story placement, creative rewriting of leads, and precisely calculated lifespan for individual stories.

Repetition

Next to credibility, predictability demands primary consideration in news format construction. The programmer may wrestle a long time with this issue, because program elements such as time, weather, and sports are usually fixed within the cycle for audience access. But too many predictable items reinforce the canard that all-news is little more than endless repetition.

Programmers must remember that they and their staffs are handling, not manufacturing, the product. The placement and rotation of its basic elements become important, in a sense, inversely to momentum. In time periods in which local, national, or world news creates a **critical information pile,** the cycle almost moves itself. During world

14.6 COST AND QUALITY

In a 24-hour period the average news operation takes in about 400,000 words from all sources, including teletype; telephone; line-feeds from network, group, or contract services; stringers; and its own beat reporters. Of these data, less than half will be aired. Control of product vis-à-vis control of cost requires a finely honed strategy. Cost control cuts in many directions, but it counts most when the opportunity arises to "own a story." A lack of budget reserve at those crucial moments leaves a manager unable to capitalize on strength and gives the competition an audience edge hard to overcome.

The shrewd news programmer will be keenly aware of news themes that are being "ridden" in the market—a tendency among radio reporters and editors to follow on a story a local newspaper or television station generated, such as series on child abuse or auto repair swindles. If a radio news reporter picks up such a theme and converts it to a series of reports, it is not only duplicative (even when new material is exposed) but also drains budget. Rather, the prudent programmer hoards a portion of the operational budget for other opportunities—a local disaster, major storm, or an original investiga-

tive project by the station staff—and then goes all out to swamp the story from every possible angle, thus "owning" it compared to the competition. One dividend of this maneuver is that such coverage is very likely to be an award winner in one of the several national or regional competitions wire services, universities, and professional associations sponsor. The station not only owned the story but picked up some prestige along the way. Corporate management likes to see awards on the wall as visible proof of station status and enterprise.

crises, such as the Persian Gulf War or the collapse of communism in the Soviet Union, listeners become transfixed by the unfolding events each day, altering the usual story selection and scheduling strategies of news and talk stations. When such events dominate news sources, the editor has many opportunities to choose among wire services, external story angles, and a variety of reaction sources. In effect, the story runs itself. In the slow news spaces, product management becomes crucial. The news programmer then controls the story, planning a measured release of information on the air, affecting the news event's very real impact on the audience (see 14.6).

Scheduling features is the fine art of format structuring. Beware of three pitfalls:

- Scheduling repeats too frequently

- Scheduling material requiring more retention than listeners find convenient

- Including irrelevant nonlocal material

For example, if a feature segment is aired on a Wednesday at 10:40 A.M., then aired on Thursday and Friday at the same time or within an hour either way, chances are that the audience will be largely the same. Scheduling the repeat of a morning drive feature in evening drivetime merely causes resentment in many drivers that catch both broadcasts.

The important question is how much soft (as opposed to hard, fast-breaking news) material is available? When? How often? What kind? Most soft material based on an audience's natural interest in medical and health information, the entertainment industry, or leisure time material, finds a catholic reception. Local audiences vary, of course, in what they need and will accept. The lesson from the consumer reporter fad of the 1970s was

that when a special feature blurs into the normal flow of news, the program manager should take a hard look at its value as a separate program item.

Internal Problems Programmers Must Solve

All-news radio presents an almost Kiplingesque "if" situation: If the general manager is interested mainly in short-term corporate tactics; if the sales manager musters a sales force that sells only numbers rather than the news product; if the promotion manager has no appropriate promotional strategy; if the chief engineer sees fit not to apply maximum special support requirements; if, in other words, management regards the format as an ideological loss leader and insists on "yo-yo" format deviations to compete in the ratings scramble, then the all-news programmer is in deep trouble. All-news demands complete support from all parts of the organization. Here are a few internal problem areas with which programmers must be prepared to deal.

1. The incompatible commercial. Many advertisers think it is just the thing to submit copy that sounds like a fake news bulletin (that contains verbiage that seems interwoven with hard news copy) or that requires an anchorperson to do ethnic dialects. Erosion of credibility is obvious.

2. The jingle jokers. Many in promotion and, sadly, even in programming feel that the all-news format is inherently dull and repetitious and, therefore, needs hyping. They frequently insert jingles unrelated to the basic format sound package. They recommend promos that tease, non-news-related contesting, and sensational headlines. They become especially frantic with promotional distractions during periods in which ratings firms are known to be gathering their listening data.

3. The tech wreckers. The demands of processing a heavy daily load of tape material, extra production requirements, and sudden, awkward remote broadcast assignments have forced more than one technician to retreat to the sanctity of the trans-

mitter. The chief engineer then announces sharp increases in "obligatory" meter readings and adjustments. Engineers will make themselves inaccessible if they feel they are being asked to do more than they think fair.

4. The dull danger. As TV blurs the line between news and promotional entertainment, news radio tends to program in small bites for short attention spans. Too many stories in too short a time serve no interests well.

5. The bottom line is all there is. "You've blown the budget on the snowstorm, and we'll have to cover the capital hearings off the wire." Programmers often hear such talk from general managers. Programmers have to challenge poor-mouthing, perhaps their most dangerous confrontation with management. Many have fought with too little, for too much, at the wrong time, and over the wrong issues. The successful programmer finds out where the land mines have been placed before rushing into the fray.

NATIONAL AND LOCAL TALK PROGRAMS

Until the late 1980s it was generally held that a talk station must be locally programmed throughout the daylight hours to be successful, and most networks and syndicators limited their offerings to the evening and overnight hours. That premise was shattered by the phenomenal success of *The Rush Limbaugh Show* in 1988, syndicated by EFM Media (see 14.7). The program, usually fed via satellite at noon EST, was an instant success and by 1991 had been acquired by nearly 500 stations. "Rush Rooms" sprang up in restaurants across the nation as diners listened to the program over lunch. Limbaugh mixes humor and production elements with a conservative view of the day's political issues, and his show quickly became the highest-rated in midday on most stations that carried it.

The success of *The Rush Limbaugh Show* had a dramatic effect on the economics of talk radio pro-

14.7 THE RISE OF RUSH

After a relatively nondescript career including various jobs as a radio personality and a stint in the advertising office of the Kansas City Royals' baseball team, Rush Limbaugh found his voice as the host of his own syndicated program. Beginning in 1988, and buoyed by Limbaugh's considerable skills in promotion, *The Rush Limbaugh Show,* with its decidedly conservative political stance, quickly found an audience at stations across America. Limbaugh's devoted listeners call themselves "dittoheads," ditto being short-

hand for the praise that initially began each caller's remarks.

Limbaugh's radio success has spread to other media. By the mid-1990s, the radio host was the author of two best-selling books and the host of a syndicated television program. He also produces a newsletter and occasionally pops up on such television programs as ABC's *Nightline* and NBC's *Meet the Press.* While Limbaugh often takes a provocative view of the issues of the day—as with his notable quote, "The most beautiful thing about a tree is what

you do with it when you chop it down"—he is firmly entrenched in American popular culture and widely imitated.

gramming. Other network daytime programming became available, which permitted local stations to reduce their costs significantly. In radio, as Chapter 12 explains, network talk programs are provided to stations on a **barter** or **cash-plus barter** basis. Many programs are structured to provide breaks for 14 to 18 commercials per hour, and the network retains three or four spots for its own commercials. The balance is available for local sale by the affiliated station. Thus, the local station gets quality network programming to attract a large audience without a significant cash outlay.

On nonsports talk stations, to complement nationally distributed talk programs, programmers schedule local talk programming that provides an opportunity for local listeners to call in. Nowadays, trendy local shows target specific demographic groups with participation formats focusing on *services,* not *issues.* Radio flea markets and swap shops in which callers describe on the air something they have for sale have broad audience appeal. By capitalizing on fads and hobbies, in some

markets these specialized programs have succeeded in attracting new listeners to talk radio. The key element is that the listener contributes to the program within a highly controlled structure: "Tell the audience what you have for sale, what's special about it, what your price is, and how they can get in touch with you."

HOSTS, AUDIENCES, AND GUESTS

Conversation program hosts are often generalists, as are most broadcast journalists. They have developed the ability to grasp a subject's essence. The host of a general interest talk program will discuss world and local affairs, politics, medicine, economics, science, history, literature, music, art, sports, and entertainment trivia—often on a single program. It thus becomes a vital part of the host's daily preparation to keep abreast of current events and to have at least some familiarity with a wide range of topics.

14.8 THE KING OF ALL MEDIA

In a career that in some respects closely parallels that of Rush Limbaugh, shock jock Howard Stern has become a powerful voice in information radio. Beginning with a morning drivetime program in New York, *The Howard Stern Show* found success in major markets across the country. Like Limbaugh, Stern's radio success led to two best-selling books and a television program (on the E! Entertainment cable network). Stern has also hosted successful pay-per-view cable specials and appeared in a film based on his first book, *Private Parts*.

The road to success has not always been smooth for the self-proclaimed "King of All Media." In 1995, Stern's employer, Infinity Broadcasting, agreed to pay the FCC fines totaling nearly $1.7 million for alleged violations of the Commission's indecency standards. Despite this controversial action by the FCC, Stern's popularity continues unabated—his program wins the crucial morning drivetime slot in most markets in which he is heard, while advertisers pay top dollar to be heard during the program. Although the subject matter of Stern's program may

be of questionable taste, he is an undisputed money-maker for the stations on which he appears.

The best of talk radio is either broadcast journalism or closely akin to it. Much of it, however, stresses entertainment over information and opinions over facts. Professional newspeople filter out their own biases as they write and prepare stories. In live conversational radio, the on-air person will generally be encouraged to express personal points of view. Many talk hosts do not see themselves as journalists but as entertainers. This has resulted in charges that many talk hosts are guilty of spreading "disinformation" or "misinformation." The problem grew to the point where the chairman of the FCC felt obliged to lecture the industry on its responsibility to provide the public with accurate information.

When a station adopts a live talk format, management has to admit that the on-the-air team has individual biases and must be allowed to express viewpoints on issues discussed. Management can, however, expect program hosts to treat guests and callers with respect when they represent opposing

sides of issues. This philosophy is based on the experience of finding it fruitless to ask on-air personalities to be unbiased. Program hosts are often investigators, sometimes advocates, and biases are doubtless part of their stock in trade. Some talk hosts represent the listeners' own opinions or cases of "the man you love to hate." Others, popularly called **shock jocks,** advocate radical positions to capture audience attention. Howard Stern has parlayed his seamy radio show into pay-per-view cable television specials and best-selling books, but his antics cost his employer, Infinity Broadcasting, $1.7 million in fines to the FCC over broadcast indecency in 1995 alone (see 14.8).

Callers and Listeners

The talk format appeals to an older audience than most music formats attract. The most frequent talk target is the 25–54 group. Even when directed at this demographic group, the format will usually at-

tract a substantial proportion of those 55 and over. During the 1960s and 1970s, these demographics were a disadvantage: Most advertisers were trying to reach the large segment of the population that fell in the 18–34 category. During those years, programmers tried to lower the average age of their audiences with youthful program hosts, but with little success. Moreover, not only did the attempts fail in drawing young listeners, they also alienated the older, hard core listenership.

By the 1990s, that inordinately large population segment that once fell into the younger demographic groups had moved into the 35-years-and-over bracket that talk radio effectively reaches. The format thus became more attractive to advertisers (who in turn had raised their demographic target and begun cultivating the older audience). Even so, programmers should keep the audience from skewing toward the top age demographics.

The typical caller does not represent the typical listener to talk radio except that both tend to be older. Some studies show that callers fall in lower income groups and are lonelier than radio listeners in general; some even form an unnatural bond with the station and a personality. However, callers represent only a small fraction of the audience, and they differ from one another depending on the nature of the program. Most important, they are inherently different from listeners to the same programs. According to a survey by the Times Mirror Center for the People and the Press, only 11 percent of Americans say they have attempted to call a talk radio program; of these, only 6 percent report that they made it on the air.

Talk listeners, unlike callers, have higher than average spendable income and savings account balances; they take more than the average number of trips by air, buy more luxury cars, and so on. Callers do not reveal an accurate profile of listeners, but station personnel frequently become so focused on calls that they forget about the audience—which should be their prime concern. Switching the emphasis to the listening audience usually makes ratings go up.

Structuring Issue Debates

Discussion of controversial issues is a central part of talk programming. In structuring programs on controversial subjects, a key question arises: Is it wiser to invite representatives of each point of view to a single program and structure a debate or to invite individuals to express their points of view separately on consecutive hours of a single program or on successive programs?

Answers differ by station, but the common denominator is how to maintain control. Program producers cannot manipulate what individuals will say, but they can design program segments so that listeners perceive that the content is "under control." At a minimum, two persons participate in a telephone talk program: the host and the caller. A program guest adds a third presence. If two guests appear on the program, there are now four voices. Because it is radio, listeners have no visual reference and can easily lose track of who is speaking when there are more than three voices. If a debate gets out of control, listeners hear a cacophony of voices, one speaking over the other. As a rule of thumb, have few voices on a single show and keep them easily identifiable. The host can do the latter by referring to guests by name when prefacing their statements or asking them questions. Three guests are plenty for most debates, and too many for most call-in programs.

Targeting the Content

Programmers can manipulate a demographically top heavy talk audience downward by rigidly controlling subject matter. The program manager and the on-air staff must construct each programming hour to appeal to the target demographic group. Free-form (sometimes called open-line) programs in which callers set the agenda must be severely limited or entirely prohibited.

KTRH (Houston), for example, aired a significant amount of free-form programming when it began its talk format and found that it reached a predominantly older audience. Moreover, the older listeners added to the problem because they

dominated the call-in airtime. They felt free to dial the station at any time and discuss issues that were of interest to them but not to younger listeners. When the station imposed controls on the on-air subject matter, the station markedly reduced the average age of its audience.

One strategy for forcing down the median age of an audience is to program a sports conversation show. Aired in late afternoon or evening, such a program will attract a significant audience younger than the normal 25+ target group without relinquishing males 25–49 who are the backbone of the station's potential evening drive audience.

Interviews

Effective guests for talk radio come from all walks of life. They range from established actors and politicians to unknowns on the air for the first time. A good guest must have something to communicate that interests the audience—odd information, offbeat experiences, unusual opinions, or a unique mode of self-expression—and that usually generates argument. The most popular shows investigate issues and explore the facts, using guests who can supply a strong informational component. As competition builds between talk stations, the content of some programs has begun to push the envelope of appropriate content, at least in the eyes of the FCC (see 14.9).

If a talk station is sufficiently involved in its community, it attracts influential civic and business leaders, political figures, and intellectual leaders from all walks of life. It is not unusual, even in a radio market the size of Los Angeles, for public figures to call an ongoing program in response to the mention of their names on the air.

Too often stations and hosts pursue well-known names as guests—people who will bring "star value" to their programs. But the best guest might be a local person whose name is unknown to the listeners, provided he or she can talk on a topic of current local interest. Although distant from the "talk show circuit," the small-town station can program relevant topics without looking beyond

14.9 LOVE ON THE AIRWAVES

In the 1970s a new and very popular programming fad called "topless radio" swept radio stations across the country. Radio stations that aired topless radio programs invited women to call up and talk on the air, usually live, about their sex lives. Some of the conversations got somewhat earthy, and the FCC, which had come under pressure from Congress and citizens' groups to do something, fined an FM station $2,000 for obscenity violations, which helped put a damper on the topless programs. In the 1990s, however, with the rise of talk radio, such programs may be back as a staple of late night programming. WKXW-AM (Trenton, New Jersey) airs a program called *Passion Phones,* described by its host as "voyeurism at its finest." KROQ-FM in Los Angeles airs a similar program, *Loveline,* and in New York, *Love Phones* became the second-highest rated program with listeners 12 and over, despite the fact that it airs between 10 P.M. and midnight. While such programs got their start in major markets, some stations are syndicating the shows to medium-sized markets, where they are finding ratings success.

its own coverage area for guests. An hour spent with a movie star might better be spent with a feisty mayor, a money-hungry school superintendent, a worried game warden, a thoughtful newspaper publisher, an opinionated football coach, or a knowledgeable auto mechanic. Actors often have plenty of eye appeal (and instant promotion value) but are of little interest as voices. Good radio conversation requires controversial ideas and opinions, not good looks. Public relations firms representing nationally known figures deluge major-market stations with offers for celebrity appearances. Those responsible for scheduling talk guests

should consider a potential contribution to programming, not merely the promotional value of the guest's name. A mix of "big names" and "big opinions" usually attracts audiences.

Stations can interview guests by telephone that otherwise would never be available, and a conference call permits local callers to participate in the conversation. However, programmers still prefer to have guests in the studio when possible. Face-to-face conversation has an interactive dynamic quality that is often missing telephone conversations.

Commercial Interests

Of all radio formats, the talk format is the most vulnerable to unscheduled commercial matter. **Payola** and **plugola** have been associated with the music industry, but the talk format offers the greatest opportunities for such abuses. An hour of friendly conversation presents endless opportunities for the on-air host to mention a favorite resort or restaurant or to comment on a newly acquired automobile. Moreover, the program host is often in the position of booking favored business acquaintances as guests. The on-air personality therefore receives many offers, ranging from free dinners to discounts on major purchases. Policies aimed at preventing violations must emphasize that management will severely penalize violators. Most stations require their on-air talent and producers to sign affidavits showing that they understand the law on these points, and some stations hire independent agencies to monitor programs for abuses. More than one station has reinforced this message by billing on-air performers for time if their casual conversations become commercials.[2]

However, guests representing commercial enterprises may certainly appear on the station. It is appropriate, for instance, for a local travel agent to discuss travel in mainland China or for the proprietor of a health food store to present opinions on nutrition. And, obviously, many personalities on the talk show circuit have something to sell—a book, a movie, a sporting event, a philosophy, and so on. Some mention of the individual's reason for

appearing is appropriate because it establishes the guest's credentials. An apt reference might be, "Our subject today is solar energy, and our guest is Colin Wadgren, author of a new book entitled *The Many Uses of the Sun*."

As a rule of thumb in the booking of all guests, make sure that they contribute to building or maintaining audience. Equally as important, ensure that neither the station nor any individual in the station's employ may benefit from the appearance of the guest unless the remuneration is properly accounted for and commercial references are logged and announced.

ON-AIR TALK TECHNIQUES

Call-in programs are the backbone of talk radio. They can also be complicated to produce, especially if a program has a dozen phone lines to deal with. To help the on-air personality run a smooth show, the call screener (or producer) has become a vital part of the talk radio staff. As described by one talk host, the screener is a "warm-up artist" for the host, building up the caller's enthusiasm and excitement so that it comes through in the caller's interaction with the host.

Telephone Screeners

Screeners add substantially to station budgets, but a station can control its programming only through careful screening. Airing "cold" or unscreened calls is comparable to a disc jockey reaching blindly into the music library and airing the first record that comes to hand. Some talk hosts, such as Jim Bohannon of the Mutual Broadcasting System, prefer the spontaneity of unscreened calls; Bohannon asks his screener to indicate only from where the call originates.

The screener for a talk program functions as a gatekeeper, exercising significant control over the information that reaches the air. Screeners constantly manipulate the lineup of incoming calls, giving priority to more appropriate callers and

delaying or eliminating callers of presumably lesser interest. The screener asks each caller a series of questions to determine whether the call will be used: "What topic do you want to talk about? How do you feel about it? Why do you want to speak on the air?" At the same time, the screener determines if the caller is articulate, if their comments are likely to promote the flow of the program, and if they possess some unique quality that the host and audience will find appealing.

Philosophies on exactly what constitutes the ideal caller vary from market to market. According to a talk radio programmer in Los Angeles, for example, calls that are in vehement, rational (or sometimes even irrational) disagreement with the program host are to be expedited and cherished. This executive feels that the conflict such calls produce can serve as a shot of adrenaline to the program, increasing listener interest.

The screener filters out the "regulars" that call the station too frequently, as well as inebriates, people with thick accents, and others unable to make a coherent contribution. Callers thus dismissed and those asked to hold for long periods often complain of unfair treatment, but the screener must prevail, insisting on the right to structure the best possible conversational sequence. Effective screeners perform their jobs with tact and graciousness.

When screeners must dump a caller, they say something like "Thank you for calling, but I don't think we'll be able to get you on the air today." Most stations prohibit the use of the caller's full name to forestall imposters, callers identifying themselves as prominent people in a community and then airing false statements to embarrass the individuals they claim to be.

When a program depends on callers, what happens in those nightmare moments when there are none? For just this emergency, most talk show hosts maintain a **clipping file** containing newspaper and magazine articles saved from their general reading to provide a background for monologues when no calls come in. Another strategy is the **expert phone list,** a list of 10 or 20 professionals with expertise in subjects of broad appeal. Resorting to the list should yield at least one or two able to speak by phone when the host needs to fill time to sustain a program.

Screening Systems and Delays

Various systems are used for the screener to signal to the on-air host which incoming call has been screened and is to be aired next. Most talk stations now utilize computer software they have developed themselves or a commercial product. Using computers places greater program control in the hands of the on-air host. The computer display indicates the nature of the calls prepared for airing; the host can then alter the complexion of the program by orchestrating call order. The information displayed for the host usually includes the first name, approximate age and sex of the caller, and may specify the point the caller wishes to discuss. The display frequently includes material of practical conversational value, such as the current weather forecast. Hosts often use a timer to monitor call length. Many hosts cut a caller off, as politely as possible, after 90 seconds to 2 minutes to keep the pace of the program moving. Occasionally, a guest will get more airtime if he or she is particularly stimulating or is a celebrity or well-known authority on a topic.

All talk stations use a device, usually an electronic **digital delay unit,** that delays the programming about seven seconds to allow the host or audio board operator to censor profanity, personal attacks, and other unairable matter. The on-air host generally controls a "cut button" that diverts offensive program material, although the engineer should have a backup switch.

Because the program is delayed, the screener instructs all callers to turn off their radios before talking on the air. Failing this, callers hear their voices coming back at them on a delayed basis and cannot carry on a conversation, causing the host to exclaim, "Turn your radio down!" Listening only on the telephone, callers hear the real-time program material and can talk normally with the host.

CONTROVERSY, BALANCE, AND PRESSURE

Although talk radio programmers get many opportunities for creative expression, they also must devote considerable time to administration. Because the station deals almost constantly with public affairs issues, its programmers spot-monitor the station's programs for compliance with FCC rules such as equal time for political candidates and to avoid legal pitfalls such as libel. A programmer, however, having many other duties as well, rarely knows as much about the minute-by-minute program as heavy listeners do. Therefore, backup systems must be established.

Until 1987, when it was repealed, the Fairness Doctrine required stations to identify issues of public controversy and allow opposing sides on the issue to express themselves. Now it is up to individual stations to present issues fairly. Talk stations deal with controversial issues every broadcast day, so it is important that talk programmers take steps to ensure that the station's overall programming reflects a fair presentation of controversial issues. Most do so because overall balance is part of talk radio's tradition and audience expectations, and because management will want to point to a history of overall fairness at license renewal time and whenever there is public outcry.

Talk stations frequently find themselves the targets of pressure groups, activist organizations, and political parties trying to gain free access to the station's airtime. Although most partisans deserve some airtime (in the interest of fairness and balance) management must turn away those seeking inordinate amounts of airtime.

Political parties are well aware of the impact of talk stations and have been known to organize volunteers to monitor programs and flood incoming phone lines with a single point of view. Politicians seeking airtime have sometimes misused the idea of fairness, confusing it with the equal-opportunity provision for political candidates—sometimes through ignorance, at other times to confuse the program executive.

Because an effective talk station frequently deals with controversial issues, management can expect threats of all kinds from irate audience members. A provoked listener will demand anything from a retraction to equal time and, on occasion, someone will threaten legal action. Potential lawsuits usually vanish, however, when management explains the relevant broadcast law to the complainant. When the station is even slightly in the wrong, it is usually quick to provide rebuttal time for an overlooked point of view.

Often, the issue that draws the audience's wrath is not a serious, controversial subject but a frivolous one. One such that drew many shots of righteous indignation was a Los Angeles sportscaster's opinion that Notre Dame's basketball team was superior to UCLA's. That remark drew phone calls and letters demanding the statement be retracted and the sportscaster discharged. Such small tempests, while not serious, make demands on the time of talk programmers.

THE COST AND THE REWARD

Listeners will tune out a poor phone call on a talk station just as they would a weak record on a music station. Therefore, station programmers must control the on-air subject matter and the flow of program material rather than letting callers dictate the programming. Nationwide, the talk stations with the highest ratings have adopted the strategy of focusing on the needs of the listeners, not the wants of the callers. The talk host who in the past had generated telephone calls because of an argumentative personality or an "over-the-back-fence" nature was replaced or redirected toward informational or entertaining radio programming. A primary ingredient in the recipe for success in any talk format is commitment at the top—at the station management level. A timely and innovative music format can catapult a station from obscurity to the number one ranking during a single rating period. Talk stations and all-news stations, however, generally take years to reach their potential.

But once success is achieved, the talk station enjoys a listener loyalty that endures long after the more fickle music audience shifts from station to station in search of the hits. *High figures for time-spent-listening and long-term stability in cumulative ratings demonstrate audience loyalty.*

The talk station producing a significant amount of local programming generally is more costly to operate than a music operation. Good talk personalities are often higher paid than disc jockeys, and they must be supported by producers, call screeners and, frequently, extra administrative personnel. Salaries of talk hosts vary a great deal, of course, from city to city. Some, in smaller markets, earn $20,000 to $30,000, but major-market personalities are paid as much as $600,000. Screener and producer positions are often entry-level jobs paying the minimum wage or just above, but they offer an opportunity to enter the industry and acquire experience.

The news/talk radio station of the 1990s combines news and conversation formats in a blend of programming characterized by live interviews, telephone actualities, and on-air audience feedback. It has great journalistic flexibility and local responsiveness but will continue to be known best for its colorful host personalities.

PUBLIC RADIO PHILOSOPHY AND FORMAT

Of the four types of noncommercial radio stations—*public, religious, college,* and *community*—433 highly visible stations receive funding (Community Service Grants and National Program Production and Acquisition Grants) from the Corporation for Public Broadcasting (CPB), making them public broadcasters. Qualifying for CPB grants necessitates:

- A large budget (over $195,000 annually of non-federal revenue)
- At least five full-time, paid staff members

- A powerful transmitter
- Complete production facilities (a studio and control room)
- An 18-hour daily program schedule
- A commitment to public service

Public stations are explicitly committed to serving as an *alternative* to commercial broadcasting, providing programs for specialized, small audience needs.[3] The remaining 1,000 or so noncommercial stations operate on smaller budgets and with smaller facilities and staffs than **CPB-qualified stations.** Most low-power radio stations are either religious broadcasters serving a sectarian group or college/university stations reaching a tiny geographic area such as a college campus, even a dormitory. The fourth group, free-form community stations pioneered by Lorenzo Milam, emphasize public access. Only about 70 or so community stations remain active over-the-air broadcasters today, although some counterparts survive on cable FM (see Chapter 10).

Programming strategies for public radio must consider the relationship between a station's philosophy to its audience and its fund-raising capability, its degree of localism, and its integrity. As in public television, the nature of the licensee determines many of the goals of the station. About 60 percent of public radio stations have colleges and universities as their licensees, while about one-third are licensed to independent community organizations, 6 percent to local school districts or local governments, and 4 percent to state governments.

Audiences and Fund-Raising

The purpose of noncommercial, educational (public) broadcast licenses is intentionally different from the purpose of commercial broadcast licenses, but both licensees are challenged to use their channel assignments in the most productive manner to reach the largest possible audience given their program services. Even though a public broadcast station may serve a disparate audience

with highly specialized programs, *its overall objective is to reach as many listeners as possible.*[4] Commercial broadcasters want to attract large audiences to generate operating revenue and profits for their stockholders. Public broadcasters have the same objective but reinvest their profits (nonprofit revenue) in the program service.

One ongoing, even acrimonious, controversy within public radio concerns target audiences. This has two aspects. First of all, more than 80 percent of Americans do not listen to public radio. Those that do tend to be professional or managerial, hold college degrees, earn more than $30,000 per household, value information very highly, and are socially conscious individuals.[5] Second, most public stations today target adults, not children.

A recent widespread practice, copied from commercial broadcasting, of creating smooth, seamless formats appealing to a targeted demographic group killed off several award-winning series for children and minorities, among them *Kids America* from WNYC in New York. Only 26 out of more than 300 broadcasters could fit a children's show within their schedules because so many now try to increase time-spent-listening (see Chapter 2) rather than total cumulative audience as public television does. The reality is that narrow programming for a targeted adult group generally does better in attracting listener support than more varied public radio programming.

The challenge to the public radio programmer, then, is to design an alternative program service that differs significantly from program formats other commercial and noncommercial stations in the market offer. Nowadays, public radio programs usually target one of three main groups: the core listener, the fringe listener, or the light fringe listener. The selected format must attract sufficiently large upscale audiences to generate direct listener support of the station and encourage philanthropists, government agencies, foundations, business, industry, and corporations to invest. Motivating support for a public radio station requires evidence that substantial numbers of people in a community use, want, and need the program service.

Localism and Integrity

A unique sound captures the imagination of the potential listening audience. Programming elevates a public station into a position competitive with other radio services. It is not enough to say, "We are public, therefore we are better," or to rely on the lack of commercial announcements to build an audience. **Localism** is a key factor in developing radio formats. Radio is a flexible medium using lightweight equipment that enables it to respond quickly to spontaneous events. The more live local events and happenings included in a broadcast schedule, the higher the probability for success.

The fast-growing development of alternative audio delivery systems, such as digital cable radio and direct broadcast satellite, pose a new challenge to local radio. The basic program materials of national and international news, classical music, and jazz are increasingly available to local radio listeners from a variety of nationally and internationally distributed radio stations and program services. By the end of this decade, radio listeners worldwide will have access to hundreds of radio services from cities and countries around the world. **Digital audio broadcasting (DAB)** holds the potential for greatly improving the technical quality of radio sound, but many public broadcasters lack the funds for early equipment conversion. Public radio stations will be required to provide highly individualized and distinctive programming to survive in this tougher new competitive climate.

Public broadcasting's most valuable assets are the *integrity* and *quality* of its programs. Whatever format is selected, success is predicated on delivery of a program service that will inform, entertain, and enhance the life of each listener and improve the quality of life in the community. Those goals are idealistic, but they create the margin of difference that will attract listeners to public broadcasting regardless of the station format. Commercial broadcasters are less able to pursue such lofty ideals. They must turn a profit, so even their most deliberate attempts to achieve excellence are often compromised.

PUBLIC RADIO FORMAT OPTIONS

Public radio uses six basic formats: *classical music and fine arts, jazz, news and public affairs, community service and public access, eclectic,* and *instructional.* Another option mixes two in a dual format. Americans are accustomed to selecting radio stations according to format. Nothing annoys radio listeners more than tuning to a news station for news only to hear classical music. Educating the public to accept more than one sound from radio is a slow process. Most public as well as commercial broadcasters therefore deliver the expected format. In the 1980s, however, some evidence had emerged that radio audiences were beginning to listen to radio for individual programs and that public radio stations were challenging the rigid rule that people listen to radio stations, not programs.

The extraordinary success of such programs as *Morning Edition, All Things Considered, Marketplace, The Car Show, A Prairie Home Companion,* as well as radio adaptations of *Star Wars* and *The Empire Strikes Back,* inserted in any of the basic formats, suggests a change in the audience's expectation of uniformity in radio programming. These programs have enabled public radio stations to distinguish themselves clearly from commercial radio and are leading the trend away from tightly formatted radio program services.

Classical Music and Fine Arts

All-music formats depend on prerecorded music for the majority of their broadcast schedules. Public radio stations choosing the classical music and fine arts format have a competitive edge over their commercial counterparts because they can broadcast long, uninterrupted performances of classical works. They can surround these performances with informational modules to enhance the audience's listening experience but avoid the abrasive intrusion of advertisements. Public radio stations' ability to put aside time restraints contributes substantially to the quality of presentation of classical music.

The classical music format has become a staple in public broadcasting. Because it is considered a safe format, many social activists criticize managers who select it. Their criticism is usually a result of misplaced values. The priority for arts and music in our society is low. Music and arts are tolerated, but most people have a limited understanding of their value in stimulating many higher aspirations. A format that feeds those aspirations is as important as any service public radio provides. The size of audiences and the financial support for the classical music and fine arts format are sufficient evidence of the need for them.

The classical music and fine arts format can take several forms. WNED-FM (Buffalo, New York) broadcasts all classical music with only the briefest interruptions for information about the performers.[6] KUSC-FM (Los Angeles), licensed to the University of Southern California, schedules 85 percent classical music. The other 15 percent includes news, fine arts modules on subjects other than music, and programs about classical music. In the late 1980s, WFMT-FM in Chicago began syndicating the Beethoven Satellite Network, and Minnesota Public Radio offered an overnight classical music service for noncommercial and commercial stations. Public broadcasters from Minnesota to Florida pick them up, because they allow stations to expand to 24-hour service at low cost while retaining high quality. The success of these syndicated classical music services underscores the fact that such programs can originate from anywhere and serve "local" audiences.

Live classical music concerts have also returned to radio. Unlike the stereotypical classical music jukebox using scholarly announcers to introduce one record after another, public radio now produces major programs featuring live concert music from concert halls throughout the world. KUSC, for example, records more than 90 live concerts each year, including the seasons of the Los Angeles Philharmonic and other major orchestras and chamber ensembles in southern California. Minnesota Public Radio, WGBH in Boston, KQED in San Francisco, and WNYC in New York also record many live concert events and major Ameri-

can music festivals. Moreover, live broadcasts from Bayreuth, Salzburg, and other European cities now arrive via satellite for listeners throughout the United States. Public radio is leading the way in abandoning traditional styles of presenting live concert music and developing new personality-based formats for the aural exhibition of orchestral music.

Jazz

Jazz is even less commercially successful than classical music. Full-time jazz radio is nearly extinct. Public radio began featuring jazz music programming in the late 1970s. Like the classical station, the few jazz stations combine recordings with live events. Although they often record concerts in clubs and from concert stages, they also produce jazz events themselves—which are then recorded or transmitted live to local and national audiences.

KLON-FM, Long Beach, California, WUNC in Chapel Hill, KVNO in Omaha, and WBGO in New Jersey are the four public radio stations currently producing the largest number of jazz concert events. The Long Beach Blues Festival, featuring some of the nation's best-known blues performers, has become a national event as a result of KLON's efforts to record and promote the annual day-long concert. By 1990, KLON was the sole supplier of jazz radio in the Los Angeles radio market. The last remaining commercial jazz station contributed its library, its well-established program hosts, and its affiliation with the national satellite jazz network to the public station. KLON has now begun international distribution of its jazz program service to the Netherlands.

National Public Radio was a pioneer in regenerating interest in live radio broadcasts of jazz performances. *Jazz Alive* presented jazz concerts from all over the United States. The program was canceled during NPR's financial crisis in 1982, but producing stations such as KLON and WBGO continue to make original jazz programming available to other public radio stations.

Public stations selecting the jazz format have a particular problem they must address: They usually do not find much audience support for this program service. The audience for jazz music tends to be less affluent than other public radio audiences. As a result, many public stations, such as WUNC, emphasize jazz programming but include other program elements to attract financial support. The *all-jazz* format also persists on some university-licensed public radio stations, for example, WRTI-FM at Temple University in Philadelphia, which do not seek financial support from their audiences.

News and Public Affairs

The all-news and public affairs format, although seemingly a natural for public radio, has been less used than might be expected. The apparently endless appetite of radio listeners for news now supplies public radio with a new opportunity for success. In the early days of public radio, it was nearly impossible to raise money for news programming, but it has now become easier to generate revenue for news than for classical music and arts programs.

National Public Radio (NPR) is the leading supplier of public radio news. *Morning Edition* and *All Things Considered* are the best known and most used news programs in public radio. At least one station in every public radio market carries both programs. Recently, however, **Public Radio International (PRI)** began distributing competing national and international news programs from diverse production sources. *Marketplace*, the first daily half-hour news program to originate from the West Coast, is a highly successful business news program produced by KUSC. PRI also distributed the BBC World Service, CBS's *As It Happens*, *The World,* and two daily news programs produced by the Christian Science Monitor, *Monitoradio* (evenings) and *Early Edition* (mornings). NPR has concentrated on the development of major national news programs, while PRI focuses on developing major international news programs. The increased quality and diversity of news programs for public radio is providing stations and listeners with more outstanding choices for news.

Only two public radio stations, however, use an *all-news* format. WEBR-AM in Buffalo, New York,

was the first to do so, but it fills out its broadcast day with jazz. Minnesota Public Radio also has one all-news station, KNOW-FM. WEBR-AM and KNOW-FM follow the traditional, commercial, all news format, using cycles of national and local headlines, local news coverage, commentary, public policy discussions, business news coverage, agriculture, sports, weather, and so on. The major difference between noncommercial and commercial all-news stations is that public stations have no commercial restraints. Thus, topics local advertisers might consider touchy are not given "kid glove" treatment, and individual item length can be as long as necessary to adequately cover the topic.

Some statewide news programs for public radio emerged in the 1980s. KLON in Long Beach produced *CALNET*, a daily statewide news program for California. KNOW-FM in Saint Paul, Minnesota, is the anchor station for the owned-and-operated stations of Minnesota Public Radio, which has developed a statewide *hourly* news service for *commercial* stations. This business venture is an imaginative way for a public radio organization to use its resources to earn revenue through a commercial business whose profits then subsidize its noncommercial programming.

The Pacifica stations—WBAI-FM (New York), WEFW-FM (Washington, D.C.), KPFT-FM (Houston, Texas), KPFA-FM (Berkeley, California), and KPFK-FM (Los Angeles)—pioneered the news and public affairs format for noncommercial public radio.[7] The Pacifica Foundation, licensee of the stations in this group, has a specific social and political purpose that influences its approach to news and public affairs (see 14.10). The listener has little difficulty recognizing the bias, and Pacifica is open about its philosophy. These stations were especially successful during the late 1960s and early 1970s when the nation was highly politicized over Vietnam and Watergate. They demonstrated the vital role of broadcasting that is free from commercial restraints in their reporting of that war and the surrounding issues. They played a similar role for the brief time of the Persian Gulf War.

14.10 NEWS PERSPECTIVES

WEBR and the Pacifica stations differ in both format and point of view. WEBR concentrates on hard news reporting and investigation, similar to all-news commercial stations. They use their noncommercial status to provide more complete news coverage than is possible in commercial all-news operations.

The Pacifica stations present a variety of news and public affairs programs in a somewhat eclectic format. The listener may hear an in-depth news report on Third World nations, followed by a program on automobile maintenance with a consumer emphasis, followed by a dialogue on Marxism, followed by a gay symphony concert, followed by a lecture on socialism. Listeners cannot predict what they will hear but can usually expect the ideas expressed and programs broadcast to reflect a nonestablishment, nontraditional point of view, whether the content is hard news reporting, commentary, news analysis, documentaries, or public affairs programs. Although the majority of program ideas are oriented to the political left, the managers of the Pacifica stations recognize their responsibility to present unrepresented right-oriented political philosophies. They tend to leave the broad middle, the traditional point of view, to other noncommercial and commercial broadcasters.

News and public affairs programming has become increasingly viable in public radio because an information society demands high quality news programs. The extraordinary popularity of the nationally distributed news programs, NPR's *All Things Considered, Morning Edition,* and *Weekend Edition,* along with the BBC's *The World, Marketplace, Monitoradio,* and *Early Edition* (distributed by PRI), has bolstered audiences for news programs on public radio. These programs have won many awards for broadcast journalism, and they provide a prestigious base for local station news-

casts and supply sufficient national and international coverage to support expanded news programming in all public radio formats.

These news programs now attract large amounts of private and corporate financial support. News programming was uniformly difficult to underwrite locally or nationally until NPR pioneered a fund-raising strategy—the News & Public Information Fund—that enabled corporations, foundations, and individuals to invest jointly. This fund in turn supports individual news programs.

Community Service and Public Access

Often considered the only legitimate format for public radio, community service and public access programming is essentially directed at the specific needs of unserved or underserved minorities. The programs provide information needed for social and economic survival and the opportunity for the public to use radio to vent emotions or solicit political support. KBBF-FM (Santa Rosa, California) is one of the few minority-owned public radio stations in America.[8] Its programming is directed at Spanish-speaking and bilingual audiences in the Santa Rosa Valley, and it has become a major production center for the network of radio stations serving the Spanish-speaking farm workers in California and other special interest constituencies within the Latino community.

KYUK-FM (Bethel, Alaska), licensed as a community station to Bethel Broadcasting Co., serves its community with programs that include the broadcast of personal messages to individuals isolated by weather and geography. Moving from ice to deserts, KEDB-FM (Ramah, New Mexico) is licensed to the Ramah Navaho School Board and provides instructional services and specific education in the culture and history of the Navaho Indians.

The community service and public access format is highly individualized. As such, it is often so specialized that it fails to serve the community's broader needs. It frequently becomes the instrument of a vocal minority and fails to reach the

people who need it. When people scream at people about a need that the people who are being screamed at already know exists, it accomplishes little beyond catharsis for the speaker. Those who could actually do something about the need being expressed listen to a different radio format, and those in need are likely to be so bored by discussion of issues they are already familiar with that they also listen to something else.

Eclectic

The most common public radio format is the **eclectic** format, which operates on the premise that public radio should have a little something for everyone. Although eclectic stations will occasionally emphasize one theme, listeners expect anything from a symphony concert to a school board meeting, to jazz, to cooking lessons, to folk music, to news, to soul music, to lectures on almost any topic. Increasingly, public radio stations are turning to narrower formats (or a two-part format), finding eclectic hard to program and weaker at generating listener support than more narrowly focused formats. Many listeners, however, enjoy turning on a radio station knowing it might broadcast a concert, a lecture by Herbert Marcuse, a community forum, or a discussion of motorcycle riding. Essential requirements for this format are good quality and a logical program sequence. Listeners will depend on a program service that delivers a variety of programs as long as they can reconcile its scheduling logic and theirs.

The key to an eclectic format is achieving *continuity*—making the diverse parts a whole. The eclectic is the most difficult to design of all radio formats because it requires a logical program sequence that enables the listener to follow from one program to another with a sense of appropriateness. This logic comes from carefully planned program blocks that lead from one set of ideas or listening experiences to another. Listeners must be able to anticipate what they will hear when tuning to the station. The program manager must satisfy that expectation by programming so that listeners

identify that station whenever they tune that frequency on the dial.

The critical difference between a successful eclectic format and an unsuccessful one is whether the listener gets a meaningful sequence of diverse programs or a program hodgepodge broadcast at the whim of a programmer attempting to keep the listener off balance. In communities where the commercial stations rely primarily on popular or beautiful music, the eclectic public radio service provides an interesting option for listeners who will be attracted by the station's diversity.

KCRW-FM (Santa Monica, California) is one of the best examples of an eclectic station.[9] It programs jazz, classical music, folk music, esoterica, coverage of local school board and city council meetings, Santa Monica College sports, political opinion, arts, news, and music/talk mixes, such as its *Morning Becomes Eclectic* and *Evening Becomes Eclectic*. Although this format may seem to be the hodgepodge for which public broadcasting is notorious, people who listen regularly to KCRW know what to expect when they tune to the station.

Instructional

The instructional format was at one time the dominant format for noncommercial educational licensees. Some public radio stations licensed to school boards still broadcast classroom instruction, but in-school programming has generally moved to public television to gain the visual element. KBPS-AM in Portland is the prime example of the radio instructional format. It broadcasts other public radio program material but designates a part of its broadcast day for instructional broadcasts.

The Dual Format

Dual format stations appeared in public radio in the 1970s and became increasingly common in the 1980s. This format is similar to the eclectic but concentrates on two specific program forms—such as news and jazz or classical and news. The dual format station focuses on building two distinct but comparable audiences for the station. WEBR-AM,

Buffalo, for example, is all-news during the day and jazz at night; no attempt is made to mix the two formats. WUWM-FM in Milwaukee is also news and jazz. During the early morning and late afternoon drivetimes, WUWM broadcasts news; late morning, afternoons, and evenings are for jazz. But WUWM's manager includes one or two jazz recordings in the news wheel to provide continuity and tries to maintain similar announcing styles for news and jazz. Continuity of style and an occasional reminder of both formats during the news and music segments provide the essential glue for both versions of the dual program format. In 1991, Minnesota Public Radio purchased a commercial FM channel for its classical music service, KSJN (99.5), and abandoned its AM news channel, also moving its news service, KNOW (91.1), to the FM band.

NATIONAL PUBLIC RADIO NETWORKS

About 40 percent of public radio airtime consists of network or syndicated programs, mostly national and world news and radio drama.[10] Although one network, National Public Radio (NPR), has had long visibility as the national noncommercial service, other radio networks emerged in the 1980s to compete for public radio affiliates, the most successful of which was Public Radio International (PRI). These newer networks have been aided by the switch to satellite distribution, which has increased program availability (see 14.11).

National Public Radio

Nearly one-third of noncommercial radio stations are members of National Public Radio (NPR). This system of about 433 nonprofit radio stations broadcasts to communities in 48 states, Puerto Rico, and the District of Columbia. Each station, itself a production center, contributes programming to the entire system. Each station mixes lo-

14.11 THE PUBLIC RADIO SATELLITE SYSTEM

In the 1970s public radio switched from land-line interconnection to satellite interconnection. The Corporation for Public Broadcasting, NPR, and public stations created a system of earth satellite stations (PRSS) that freed public radio from dependence on low quality, monaural telephone lines. Public radio leased 24 channels of full fidelity stereo transmission on Westar I to transmit and receive radio programs and data information. Sixteen uplinks and 280 downlinks were built.

The main originating terminal was constructed in Washington, D.C., and NPR was to manage the new distribution system. The system's primary purpose is to provide high quality NPR programming to public radio stations, but the system is interactive, permitting origination of whole or partial elements of programs from all 16 uplinks. Through the Extended Program Service (EPS), producing stations and independent producers can distribute their programs by satellite to interested stations. As of 1991, PRSS was sending out 8 to 12 programs simultaneously, and the system is available to any public radio station for a low fee. Interconnection with European and Canadian satellite systems also enables U.S. public radio to use live programs originating outside the country.

Introduction of the satellite distribution system greatly increased the number of high quality programs available to individual public radio stations. It also provides public radio with its best opportunity for generating commercial revenue to support NPR. By selling unused satellite time (excess capacity) to commercial users, public radio generates badly needed revenue without decreasing program availability.

cally produced programs with those transmitted from the national production center.

NPR, a private nonprofit corporation, distributes informational and cultural programming by satellite to member stations daily. Funds for the operation of National Public Radio and for the production, acquisition, and distribution of radio programs come from corporate underwriting, private foundations, government agencies, and member stations.

From 1970 to 1987, CPB contributed directly to NPR's budget, supplying funds for operation and production. Following a 1987 reorganization of public radio, CPB paid all programming funds directly to CPB-qualified stations (NPPAG grants). In response, NPR **unbundled** its programming in 1988. Instead of each member station paying for the entire schedule, irrespective of need, stations now choose to purchase one (or all) of three NPR chunks: the morning news service, the afternoon news service, or the performance programming.

Partial users pay only for the programming unit desired, but at much higher than previous rates. As recently as 1984, most public radio stations paid almost nothing for NPR programs, but by the late 1980s costs ran from $25,000 to more than $300,000, depending on the amount of federal financial support and amount of programming used. Rates increased for two reasons: Two-dozen large public stations dropped NPR programming in the late 1980s/early 1990s, leaving fewer stations to pick up programming costs, and CPB ended direct financing of NPR programs, meaning that stations now pay full production and transmission costs (plus a portion of the network's overhead).

Stations contribute about 70 percent of NPR's operating revenue, and about 30 percent comes from underwriting and foundation contributions. Almost no money comes from the federal government, with the exception of an occasional NEA grant (see 14.12). According to NPR president Douglas Bennett, the network's radio audience is

14.12 NPR'S FINANCIAL CRISIS

In the early 1980s, the Reagan administration advocated a phaseout of federal funding for public broadcasting. In response, NPR began a campaign to end its reliance on federal dollars. One part of that effort was creation of NPR Ventures in 1983, a company joining commercial partners in new business activities to develop profits to replace federal dollars. Because the new ventures business is highly risky, many of NPR's first ventures failed to materialize.

A naive optimism on the part of NPR management was the major cause of a serious financial crisis in 1983. The attempt to realize huge profits from venture activities distracted NPR's officers from the daily operation and administration of the company, allowing a major failure of the budget control and financial accounting system to nearly destroy NPR.

Nonprofit organizations traditionally downplay the importance of financial accountability, moving revenue from budget category to budget category without careful controls on dollar flow. NPR's imaginative attempts to stretch income to serve too many budget purposes created a revenue shortfall that resulted in an insurmountable deficit. Another related characteristic of nonprofit companies affecting NPR's deficit was overly optimistic income projections. That NPR had no plan to reduce operational costs in the event of a financial crisis was also typical of nonprofit company problems.

NPR was saved from bankruptcy by a $9 million loan from the Corporation for Public Broadcasting. NPR member stations agreed to pay $1.6 million annually for three years (1984–86) to NPR to assist in repaying the loan. Some member stations also agreed to forego their entire annual Community Service Grant to collateralize the loan. The Corporation for Public Broadcasting forced NPR to sell its satellite equipment to a special public trust to secure the future of the public radio interconnection system in the event of a loan default or other financial crisis.

NPR's president and several NPR officers were forced to resign as a result of the financial crisis, and more than 140 NPR employees lost their jobs. *All Things Considered* and *Morning Edition* were given top budgetary priority, but most of NPR's cultural and arts programs were lost. Recovery in the mid- and late-1980s allowed NPR to expand back to 24 hours of classical music, seven days a week, add a daily ten-hour jazz service, reinstate its news and public affairs, and add news performance programs. But by the late 1980s, two dozen large stations had stopped carrying any NPR programs.

The picture is even less rosy in the 1990s. In 1995 the House of Representatives voted to cut NPR's budget by 15 percent in 1996, and by 30 percent in 1997. The organization manages to survive, however, and its program schedule is published at *http://www.npr.org* on the World Wide Web.

younger than its overall audience, and NPR is striving to become more "multicultural, innovative, and diverse" to retain that younger audience for more of its programming.[11]

NPR programs news, public affairs, art, music, and drama to fit into whatever formats member stations choose. The news and information programs already discussed—*Morning Edition*, *All Things Considered*, and *Weekend Edition*—are NPR's most distinguished trademark and the core of its program service. It also has provided leadership in music and arts programming for the public radio system, such as *Performance Today*, *The World of F. Scott Fitzgerald*, *Jazz Alive*, *NPR Playhouse* (featuring new radio dramas), and live broadcasts of musical events from Europe and from around the United States. NPR has also provided stations

with in-depth reporting on education, bilingual Spanish news features, and live coverage of Senate and House committee hearings. Satellite distribution of the NPR program service has meant better quality transmission of existing programs and distribution of up to a dozen stereo programs simultaneously. The high quality of national programs frequently entices stations to use NPR programs.

During the Persian Gulf War, NPR provided extensive, round-the-clock coverage of events, but such an unusual effort proved costly for NPR. As a consequence, member dues increased again in 1991. Meanwhile, state support dropped in many areas. Gulf Crisis coverage cost NPR about $300,000 more than its monthly $1.2 million budget, and although the war ended quickly, it was followed by rising costs for coverage of the Soviet coup. During such news crises, NPR usually goes from 18- to 24-hours a day and adds an extra, 5 A.M. feed of *Morning Edition* and a late-night feed of *All Things Considered*.

In addition to Programming, two other NPR divisions, Representation and Distribution, also provide valuable services to member stations. The Representation Division, like a trade organization, represents NPR and public radio before the FCC, the Corporation for Public Broadcasting, Congress, and any government agency involved with matters of importance to public radio. Member stations pay dues to support the Representation Division. Because it acts as an advocate for member stations in disputes with NPR, it must be funded separately. The Distribution Division operates and maintains the satellite relay system. It also works with some autonomy within NPR because it has broad responsibility for the overall management of the information system. Stations also pay separately for program distribution (transmission). NPR also conducts a joint Public Radio Conference with PRI annually in the late spring.

Public Radio International

In 1982 a group of five stations formed a second national radio network called American Public Radio (APR), later renamed Public Radio Interna-

tional (PRI). Minnesota Public Radio, KUSC-FM in Los Angeles, KQED-FM in San Francisco, WNYC AM/FM in New York, and WGUC in Cincinnati initially joined together to market and distribute programs they produced and to acquire other programming to distribute to affiliates. The name was changed in 1994 to help end the commonplace public confusion between APR and NPR and also to underline the network's interest in building imports and exports of radio programming in the international marketplace.

PRI differs from NPR in three ways. First, PRI is not a membership organization but a network of affiliated stations paying fees to become the primary or secondary outlet for PRI programs in their community. Second, unlike NPR (but like commercial networks), PRI offers its programs to only one station in each market (exclusivity), and fees are based on market size. However, when a primary affiliate refuses a program, it is offered to the secondary affiliate, much in the way small-market affiliations operate in commercial television. Third, PRI's charter does not permit it to become a national production center. Like PBS, all its programs are acquired from stations or other sources. A program fund, supported by major foundations and corporations and administered by the PRI board of directors, provides revenue for producers with ideas that fit the PRI program schedule.

The most successful program PRI distributed in its first year (1982) was *A Prairie Home Companion*, produced by Minnesota Public Radio. When host Garrison Keillor left *Prairie Home* in 1987, Minnesota Public Radio created replacement programs before the eventual return of Keillor and his show in the 1990s. The majority of PRI's schedule consists of original performances by orchestras, soloists, and ensembles, and it programs a daily concert series. PRI also offers the BBC's World News Service, *The World*, *Monitoradio*, *Marketplace*, and *As It Happens*, but its programming emphasizes classical music.

Like commercial network affiliates, PRI affiliates select programs individually for use in their schedules from more than 300 hours of weekly

programming. Although programming 24-hours a day, PRI does not supply a continuous long-form music schedule. It does supply an overnight classical music concern service in conjunction with Chicago-based WFMT, as well as news, public affairs programs, and other programs daily. More than 530 public radio stations affiliate with PRI, most also continuing their membership in NPR. About two-thirds of PRI's operating budget comes from station fees for programs, the balance from underwriting, grants, and foreign syndication, with no direct governmental funding. (See *http://www.pri.org* for more information.)

Other Distribution Organizations

WFMT's Beethoven Satellite Network, U.S. Audio (formed by Eastern Public Radio), Audio Independents, and the Longhorn Network, began in the 1980s. Like PRI, these networks and syndicators market and distribute programs nationally. A variety of station programming consortia also emerged in public radio, paralleling those in public television, commercial broadcasting, and cable. The Public Radio Cooperative, a joint venture of individual public radio stations largely in the northeastern United States, supplies programs to stations that pay a broadcast fee. Member stations produce many of the programs; the rest come from commercial syndicators. The appetite for more programming than NPR can supply is strong.

Public radio also supports several regional groups that distribute programs and consults on station operation. These include Southern Educational Communications Association, Eastern Public Radio, Public Radio in Mid-America, West Coast Public Radio, and Rocky Mountain Public Radio.

TRENDS IN PUBLIC RADIO

Public radio grew considerably in the 1970s and 1980s and will expand further in the future. Both public and commercial radio audiences will con-

tinue to grow as long as radio provides local, personal, informational, educational, and entertaining services. Public radio audiences, especially, will increase as public stations mature and become more professional.

The introduction of the Public Radio Satellite System opened up opportunities for independent producers, production companies, syndicators, and public radio centers. This inexpensive distribution system created competing networks of program suppliers, increased the program market, and diversified program offerings. The emergence of Public Radio International and the fall of National Public Radio from dominant supplier of public radio programs mean more variety within public radio. Although NPR will continue as a major programming producer, new networks supply alternative programming, thus increasing the competition for funds from listeners and corporations for program support. The new competition has three positive side effects:

1. More and diversified programs are available to local communities through their public radio stations.

2. Increased competition stimulates donor interest in public radio.

3. Public radio no longer relies on a single programming source, minimizing the effects of any future network financial problems.

The chief threats to public radio continue to be *lack of funding* and the *government bureaucracies* that manage the system. Public radio is relatively inexpensive. Because it costs less, it is often difficult to convince the persons and agencies that finance public broadcasting to allocate sufficient funds to accomplish the quality of service listeners demand. Bureaucrats also tend to consider radio and television as one—lumping them together as "the media"—ignoring their subtle but substantial differences. This view is as disastrous as expecting a basketball team to use a football because both basketball and football are sports that use a ball. If public radio is left with its existing structure intact, it has a great future.

SUMMARY

Information formats comprising mostly news and talk dominate AM radio programming. The all-news format is costly and demanding, but, if given time to build an audience, it can command a highly loyal audience—although the demographics skew toward older listeners, and it is most successful in major markets. In addition to commercial spots, seven content elements make up the fundamental structure of the news wheel: headlines, time, traffic, weather, sports, editorials, and features. In scheduling, the highest priority goes to those items (whether hard or soft news) providing local personal service, especially during morning and afternoon drivetime. Talk radio varies from station to station in the proportion of live call-in programs, on-air interviews, network or syndicated advice shows, feature material, and news. One key to effective live talk programming is the on-air personality; he or she may introduce journalistic bias into programs but stimulates loyal listening. Most talk radio targets an audience of prime interest to advertisers, although the station must rigidly control content to avoid attracting too large a proportion of older listeners. In-person and telephone guests and callers supply the content for talk radio, and the screener plays a pivotal role in structuring the flow of call-in programs. Talk radio has become listener- rather than caller-oriented, striving for a broad appeal through general informational programming, but any controversial coverage will generate public and private pressures on the station. In such cases, detailed, written station policies and electronic logs provide the best offense and defense for the talk programmer. To remain competitive, an information station requires a high budget and a high level of commitment from management.

Public radio seeks to combine localism and programming integrity to attract big cumulative audiences that will actively support its fund-raising activities. Public radio stations use six formats to meet this challenge. The classical format shows how a clear set of objectives, a high quality staff, and ongoing evaluation help a public station meet its commercial competition in the ratings. Although only a few public stations use the all-news format, news itself is playing a greater role in all public radio, partly due to the strong news base NPR provides. Jazz listeners are not usually financial donors. Community service and public access programming typify public radio in many people's minds, and the format generally serves minority audiences with informational rather than entertainment programming. Eclectic programming is the most common and most difficult format to succeed with. The instructional format was once the easiest, usually having a built-in market, but radio now plays a diminished role in schools—television has preempted its function. The dual format combines programming for two separate audiences by shifting from a daytime format to a nighttime format.

Promotion, development, fund-raising, and strict accountability are the major tools that assist the public radio broadcaster to high levels of achievement in programming. NPR's high quality news and arts programming occupied center stage in public radio programming for a decade, but partly as a result of NPR's financial crisis and partly as a result of cheap satellite distribution technology, joint ventures, consortia, and new networks such as PRI, its role has changed. Because CPB now funds public radio program production and acquisition directly (NPPAG grants) and NPR unbundled its programs, programmers today can choose only the programs that best suit their needs, creating more diversity and differentiation, as well as more competition, in public radio.

SOURCES

Brewer, Annie M., and Brewer, Donald E. *Talk Shows and Hosts on Radio: A Directory Including Show Titles and Formats, Biographical Information on Hosts, and Topic Subject Index.* 3rd ed. Dearborn, MI: Whitefoord Press, 1995.

Duncan, James H., Jr. *Duncan's Radio Market Guide.* Kalamazoo, MI: Duncan's American Radio, Inc., annual.

Giovannoni, David. "Radio Intelligence: The Economics of Programming," a multipart series on programming in *Current*, 1987 and 1988.

The Journal of Radio Studies, 1992 to date. Kansas: Washburn University.

Laufer, Peter. *Inside Talk Radio: America's Voice or Just Hot Air?* Secaucus, NJ: Carol Publishing Group, 1995.

Lewis, Peter M., and Booth, Jerry. *The Invisible Medium: Public, Commercial, and Community Radio.* Washington, DC: Harvard University Press, 1991.

Looker, Tom. *The Sound and the Story: NPR and the Art of Radio.* Boston: Houghton Mifflin, 1995.

Milam, Lorenzo. *The Radio Papers: From KRAB to KCHU.* San Diego: Mho & Mho Works, 1986.

Station Policy and Procedures: A Guide for Radio. 2nd ed. Washington, DC: National Association of Broadcasters, 1991.

Wertheimer, Linda. *Listening to America: Twenty-five Years in the Life of a Nation, as Heard on National Public Radio.* Boston, MA: Houghton Mifflin, 1995.

NOTES

1. "News-Information Wins Big in Winter Book," *Broadcasting*, 22 April 1991, p. 44.

2. Station policies differ on the degree to which hosts can be involved in commercials. Many individuals fear losing their journalistic credibility, and personalities known for their balance want to avoid a persuasive role. Ironically, it is the outspoken advocate host who often makes the most appealing salesperson.

3. These commitments were spelled out in the Public Broadcasting Act of 1967 and resemble those for public television.

4. One in five U.S. households does not receive a public radio signal.

5. "Public Radio's Dilemma: What to Do about the 80% Who Ignore It Now," *Broadcasting*, 30 May 1988, p. 45.

6. WNED-FM is one of three stations licensed to Western New York Educational Foundation. WNED-FM and WEBR-AM were commercial stations the foundation purchased to operate as noncommercial broadcast stations. The price of approximately $1.8 million is believed to be one of the highest outright purchase prices ever paid for a noncommercial station.

7. The Pacifica stations were founded in 1949 in Berkeley, California. All of the stations qualify for financial support from the Corporation for Public Broadcasting, but only one—KPFT-FM in Houston—is a member of the national public radio system. Primary support for Pacifica stations comes from listener donations, and the stations generally refuse support from business and industry.

8. KBBF-FM is licensed to the Bilingual Broadcasting Foundation. The station was established by funding from the National Campaign for Decency of the Roman Catholic Church and was set free to develop its own support in the community. While the station struggles to survive, it has become a major training center for Spanish-speaking personnel for local public radio stations and National Public Radio.

9. KCRW-FM is licensed to Santa Monica Community College. The majority of the staff are professionals or community volunteers; however, some students work at the station for college credits.

10. *Public Broadcasting Statistics In Brief*, Corporation for Public Broadcasting, Spring 1989, p.11.

11. "Public Radio Gears Up for Recession," *Broadcasting*, 19 November 1990, p. 36.

Abbreviations and Acronyms

Boldface terms are explained further in the Glossary. See the Index for text page references.

AAA	Association of Advertising Agencies
AC	adult contemporary
ACE	awards for excellence in cable programming
ACT	Action for Children's Television
ADI	**area of dominant influence**
AFTRA	American Federation of Television and Radio Artists
AGB	marketing company collecting people-meter ratings
AID	Arbitron Information on Demand
AIT	Agency for Instructional Technology
AOR	album-oriented rock
AP	Associated Press
AQH	average quarter hour
ARB	Arbitron Research Bureau
ASI	market research company
ASCAP	**American Society of Composers, Authors, and Publishers**
ATC	American Television & Communications Corp.
BEA	Broadcast Education Association
BM	**beautiful music**
BMI	**Broadcast Music, Inc.**
CAB	Cable-Television Advertising Bureau
CATI	computer-assisted telephone interviewing
CATV	community antenna television
C-BAND	low-power communications satellites
CBC	Canadian Broadcasting Company
CBN	Christian Broadcasting Network
CD	**compact disc**
CEN	Central Educational Network
CHN	Cable Health Network (now Lifetime)
CHR	contemporary hit radio
CM	commercial matter
CNN	Cable News Network
CP	construction permit
CPB	**Corporation for Public Broadcasting**
CPM	cost per thousand (used in advertising)
CRT	Copyright Royalty Tribunal
C-SPAN	Cable-Satellite Public Affairs Network
CSRs	customer service representatives
CTAM	Cable Television Administration and Marketing Society
DAB	digital audio broadcasting
DBS	**direct broadcast satellite** (also direct satellite services)
DJ	**disc jockey**

DMA	**designated market area**
DSS	Direct Satellite System (RCA trademark for DBS)
DTH	direct-to-home
EEN	Eastern Educational Television Network
EEO	**equal employment opportunity**
ENG	electronic newsgathering
ERP	**effective radiated power**
ESF	**expanded sample frame**
ESPN	Entertainment and Sports Programming Network
FBC	Fox Broadcasting Company
FCC	Federal Communications Commission
FNN	Financial News Network
FTC	Federal Trade Commission
FTTC	fiber to the curb
G	movie code: general audiences
GPN	Great Plains National Instructional Television Library
HBO	Home Box Office
HDTV	**high-definition television**
HTR	Household Tracking Report (Nielsen report)
HHs	**households having sets**
HP	**homes passed**
HUTs	**households using television**
ID	station identification
INN	Independent Network News (now USA Today)
INTV	Independent Television Station Association
IRTS	International Radio Television Society
ITFS	**Instructional Television Fixed Service**
ITNA	Independent Television News Association
ITV	**instructional television**
Ku-Band	high-power communications satellite frequency
LIFO	last in, first out
LO	**local origination**
LOP	**least objectionable program**

LPTV	**low-power television**
LULAC	League of United Latin American Citizens
MBS	Mutual Broadcasting System
MDS	multipoint distribution service
MFTV	**made-for-TV**
MMDS	multichannel multipoint distribution service
MNA	Multi-Network Area Report
MOR	middle-of-the-road
MOW	movie of the week
MSO	multiple system operator
MTV	Music Television
NAACP	National Association for the Advancement of Colored People
NAB	National Association of Broadcasters
NAD	National Audience Demographics (Nielsen report)
NAEB	National Association of Educational Broadcasters (now BEA)
NARB	National Association of Radio Broadcasters
NATPE	National Association of Television Program Executives
NCAR	Nielsen's Cable Activity Report
NCTA	National Cable Television Association
NET	National Educational Television
NFLCP	National Federation of Local Cable Programmers
NHTI	Nielsen Hispanic Television Index
NOW	National Organization of Women
NPPAG	National Program Production and Acquisition Grants
NPR	**National Public Radio**
NPS	National Program Service
NSI	Nielsen Station Index
NSS	National Syndication Service (Nielsen report)
NTI	Nielsen Television Index
NTSC	National Television Systems Committee
NVOD	near video-on-demand

O&O	**owned-and-operated**	SIP	Station Independence Program (fund-raising service of PBS)
OPT	Operation Prime Time	**SMATV**	satellite master antenna television
PAF	Program Assessment Fund	SMPTE	Society of Motion Picture and Television Engineers
PBS	**Public Broadcasting Service**		
PDG	Program Development Group	SNAP	Syndication/Network Audience Processor (computer software)
PEG	**public, educational, and government**		
PG	movie code: parental guidance suggested	SRA	Station Representatives Association
PMN	Pacific Mountain Network	SSS	Southern Satellite Systems
PPV	**pay-per-view**	STV	**subscription television**
PRI	**Public Radio International**	TBN	Trinity Broadcasting Network
PRSS	Public Radio Satellite System	TCI	Tele-Communications, Inc.
PSA	public service announcement	TNN	The Nashville Network
PTAR	**prime-time access rule**	**TSL**	time-spent-listening
PTR	Persons Tracking Report (Nielsen report)	TvB	Television Bureau of Advertising
PTV	**public television**	TVHH	television households
PUR	persons using radio	TVPC	Television Programmers' Conference
PUT	persons using television	**TvQ**	television quotient
R	movie code: restricted	**TVRO**	TV receive only
RAB	Radio Advertising Bureau	**UHF**	ultra high frequency
RBDS	Radio Broadcast Data Systems	UPI	United Press International
RCD	**remote control device**	USA	USA Network
ROSP	Report of Syndicated Programs	VBI	vertical blanking interval
RPC	Radio Programming Conference	**VCR**	videocassette recorder
RTNDA	Radio Television News Directors Association	**VHF**	very high frequency
		VHS	video home system
SCA	Subsidiary Communications Authorization	VIP	Viewers in Profile (Nielsen report)
		VJ	**video jockey**
SECA	Southern Educational Communication Association	VOD	**video-on-demand**
		VSAT	very small aperture terminal
SESAC	Society of European Songwriters, Artists, and Composers	WCA	Wireless Cable Association (MMDS operators)
SIN	Spanish International Network		

Glossary

This list includes **boldfaced terms** in the text and other vocabulary but excludes phrases boldfaced in text for emphasis only. *Italicized words* in the definitions indicate other glossary entries. See the Index for text page references.

AC Adult contemporary, a soft rock music format targeting the 25–54 age category.

access Public availability of broadcast time. In cable, one or more channels reserved for noncommercial use by the community, educators, or local government, possibly requiring fees to cover facility costs. See also *prime-time access rule*, *access time*, and *community access channels*.

access time The hour preceding *prime time*, usually between 7 and 8 P.M. (EST), during which the broadcast network affiliates cannot air off-network programs. See also *prime-time access rule*.

ACE Awards sponsored by the National Cable Television Association for local and national original cable programs.

actuality An on-the-spot news report or voice of a news maker (frequently taped over the telephone) used to create a sense of reality or to enliven news stories.

adaptation A film or video treatment of a novel, short story, or play.

addressability Remote equipment that permits the cable operator to activate, disconnect, or unscramble signals to each household from the cable *headend*.

This technology provides maximum security and is usually associated with *pay-per-view* channels.

ad hoc networks Temporary national or regional hookups among radio or television stations for the purpose of program distribution; this is especially common in radio sports.

ADI See *Area of Dominant Influence*.

adjacencies A commercial spot next to a program that can be sold locally, especially spots for station sale appearing within (or next to) network prime-time programs.

affiliate A commercial radio or television station receiving more than 10 hours per week of network programming, but not owned by the network. This also applies to cable system operators contracting with *pay* or *basic cable* networks, or occasionally to public stations airing noncommercial programming from the *Public Broadcasting Service*, *National Public Radio*, or *American Public Radio*.

affiliation agreements Contracts between a network and its individual affiliates specifying the rights and responsibilities of both parties.

aftermarket Syndicated sales of programs to a different industry than the one for which they were originally produced, as in sales of broadcast programs to cable and original cable programs to U.S. or foreign broadcasters.

aging an audience A strategy for targeting slightly older viewers in the early-fringe daypart, starting with children in the afterschool time period and

moving toward adult, male viewers for the early evening newscast. Colloquially called "aging your demos."

AID Arbitron Information on Demand, a computerized service that identifies the best times for airing station promotional spots after factoring in program sequence, network promo content, target audience, and so on.

aided recall In survey research, supplying respondents with a list of items to stimulate their memory.

air-lease rights Permission to broadcast a program.

a la carte Programs chosen separately by viewers, as items on a menu. See *video-on-demand.*

American Society of Composers, Authors, and Publishers (ASCAP) An organization licensing musical performance rights. See also *Broadcast Music, Inc.*

amplifier Electronic device that boosts the strength of a signal along cable wires between telephone poles.

amortization The allocation of syndicated program series costs over the period of use to spread out total tax or inventory and to determine how much each program costs the purchaser per airing; a station may use straight-line or declining value methods.

ancillary markets Secondary sales targets for a program that has completed its first run on its initial delivery medium. Also called "backend" or *aftermarkets.*

ancillary services Revenue-production services other than the main broadcast or cable programming.

anthology A weekly series consisting of descrete, unrelated programs under an *umbrella* title; these may be a playhouse series consisting of dramas by different authors or a sports program consisting of varied sporting events (often in short segments) and related sports talk. This technique is used by over-the-air networks for packaging unused program *pilots.*

AOR Album-oriented rock, a rock music format appealing to a strongly male audience, aged 18–34, consisting of less well-known songs by avant garde rock artists and groups as well as their most popular works.

appeals Elements in program content that attract audiences, such as conflict, comedy, nostalgia, and so on.

Area of Dominant Influence (ADI) One of over 200 geographical market designations defining each

radio market exclusive of all others. It indicates the area in which a single station can effectively deliver an advertiser's message to the majority of homes. ADI is Arbitron's term; Nielsen's comparable term is *Designated Market Area.*

ascertainment Determining a community's needs, interests, and problems to file a report with the FCC showing how a station responded to these with programming. The method of collecting information is determined by the station.

architecture In communications, the design of a channel.

ASI Market Research Los Angeles company specializing in program and commercial testing using invited theater audiences.

audience flow The movement of audiences from one program or time period to another, either on the same station or from one station to another; this includes turning sets on and off. Applied to positive flow encouraged by similarity between contiguous programs.

audimeter Nielsen's in-home television rating meter, used until 1987. See also *peoplemeter.*

audition tape A demonstration of an anchor, host, disk jockey, or other personality's on-air abilities and appearance or sound; in radio, this may include short clips of interviewing or song announcing. Also called a *demo tape.*

auditorium research In radio, mass testing of song hooks to measure their popularity.

automation Use of equipment, usually computerized, that reproduces material in a predesignated sequence, including both music and commercials. This produces a log of airings acceptable to advertising agencies. Also used for traffic and billing and in some television production processes.

avail Short for a sales *availability.*

availability Commercial spot advertising position (*avail*) offered for sale by a station or a network; also, syndicated television show or movie ready for station licensing. See also *inventory* and *program availabilities.*

average quarter hour (AQH) Rating showing the average percentage of an audience that tuned in a radio or television station.

backfeed line A line from the production site or studios to the cable *headend* for the purpose of delivering programs.

barker channel A cable television channel devoted to program listings; this may include video as well as text listings.

barter Licensing syndicated programs in exchange for commercial time (*inventory*) to eliminate the exchange of cash.

barter spot Time in a syndicated program sold by the distributor.

barter syndication The method of program distribution in which the *syndicator* retains and sells a portion of a syndicated program's advertising time. In *cash-plus-barter* deals, the *syndicator* also receives fees from the station licensing the program.

basic cable Those cable program channels supplied for the minimum subscriber rate, including most local broadcast stations, some noncommercial channels, and assorted advertiser-supported cable networks. See also *basic cable networks*.

basic cable households The number or percentage of total television homes subscribing to cable service.

basic cable networks Those cable services for which subscribers do not pay extra on their monthly bills (although the cable system may pay to carry them); they are usually supported by advertising and small per subscriber fees paid by the cable operator. Contrast with *pay-cable networks*.

beautiful music (BM) A radio format emphasizing low-key, mellow, popular music, generally with extensive orchestration and many classic popular songs (not rock or jazz).

Big Seven The major Hollywood studios: Columbia-TriStar, Walt Disney Studios, MGM-UA, Paramount, 20th Century-Fox, Universal, and Warner Brothers.

billboard In radio promotion, either an outdoor sign or an on-air list of advertisers; in television promotion, either an outdoor sign or an on-screen list of upcoming programs in text-only form.

bird A satellite.

blackout A ban on airing an event, program, or station's signal; this is often used for football games that have not sold out all stadium seats. Also FCC rules for blocking imported signals on cable that duplicate local stations' programs for which *syndicated exclusivity* has been purchased.

blanket licenses Unlimited rights to plays of all music in a company's catalog by contracts; this applies especially to music used by radio and television stations.

block booking Licensing several programs or movies as a package deal.

blockbusters Special programs or big-name films that attract a lot of attention and interrupt normal scheduling; these programs are used especially during *sweeps* weeks to draw unusually large audiences. They normally exceed 60 minutes in length.

blocking Placing several similar programs together to create a unit with audience flow.

block programming Several hours of similar programming placed together in the same daypart to create audience flow. See also *stacking*.

branding Marketing a program channel as a targeted product separate from the changing shows carried.

break averages Ratings for the breaks between programs, usually calculated by averaging the ratings for the programs before and after the break.

breaks Brief half-hourly interruptions of programming to permit station identification and other messages.

bridging Beginning a program a half hour earlier than competing programs to draw off their potential audiences and hold them past the start time of competing programs.

broadband Having a wide bandwidth capable of carrying several simultaneous television signals; used for coaxial cable and optical fiber delivery.

broadcasting Fundamentally, spreading a modulated electromagnetic signal over a large area by means of a transmitting antenna; more precisely, the industry consisting of unlicensed networks and licensed radio and television stations regulated by the Federal Communications Commission. These are *over-the-air* stations and networks, which distinguishes them from wired, *cable-only* networks; they may eventually include *direct-to-home* satellite transmissions.

Broadcast Music, Inc. (BMI) A music-licensing organization created by the broadcast music industry to collect and pay fees for musical performance rights; it competes with the *American Society of Composers, Authors, and Publishers*.

broadcast window The length of time in which a program, generally a feature film that was *made-for-pay* cable, is made available to broadcast stations in syndication. See also *pay window* and *window*.

broken network series Canceled network series revived for *syndication*, mixing *off-network* and *first-run* episodes of the series; usually a *situation comedy*.

bumping Canceling a showing.

bundling Grouping several cable services on a pay *tier* for a single lump monthly fee; also, grouping radio programs on a network for a single fee. See *unbundling*.

buying Renting programs from *syndicators*. See also *license fee* and *prebuying*.

buy rate Sales per show, or the rate at which subscribers purchase *pay-per-view* programs, calculated by dividing the total number of available PPV homes by purchases. For example, if 50 of 100 PPV households ordered one movie, the buy rate would be 50 percent; if 50 of 100 PPV households ordered two movies, the buy rate would be 100 percent.

cable audio FM radio signals delivered to homes along with cable television, usually for a separate monthly fee; same as *cable radio* or *cable FM*.

cablecasting Distributing programming by coaxial cable as opposed to broadcast or microwave distribution; also, all programming a cable system delivers, including local cable, *access*, and *cable networks*, except *over-the-air* signals.

cable FM FM radio signals delivered to cable subscribers, usually for a small installation or monthly fee; same as *cable audio* or *cable radio*.

cable franchises Agreements between local *franchising authorities* (city or county government) and cable operators to install cable wires and supply programs to a specific geographic area; usually involves payment of a franchise fee to the local government.

cable network National service distributing a channel of programming to cable systems.

cable-only Programming or services available only to cable subscribers; also, *basic cable* and *pay cable networks* that supply programming to cable systems but not to noncable households.

cable penetration The percentage of households subscribing to *basic cable* service.

cable radio Radio signals converted to FM and delivered to homes along with cable television, usually for a separate monthly fee; same as *cable audio* or *cable FM*.

cable service Same as *cable network* or *cable system* or both; also including local offerings such as an *access* or *local origination* channel and alarm or security signals.

cable subscriber A household hooked up to a cable system and paying the monthly fee for *basic cable* service.

cable system One of about 11,600 franchised, non-broadcast distributors of both broadcast and cablecast programming to groups of 50 or more subscribers not living in dwellings under common ownership. See contrasting *SMATV*.

cable system operator The person or company managing and owning cable facilities under a franchise. See MSO.

call-ins People telephoning the station.

call letters FCC-assigned three or four letters beginning with W or K, uniquely identifying all U.S. broadcast stations. (Stations in other countries are assigned calls beginning with a different letter, such as X for Mexico and C for Canada.)

call-out research Telephone surveying of audiences initiated by a station or research consultant; this is used extensively in radio research, especially to determine song preferences in rock music. Contrast with call-in research referring to questioning listeners who telephone the station.

call screener Person *screening* incoming calls on telephone call-in shows and performing other minor production functions as assistant to a program host.

camcorder A portable video camera and videotape recorder in one unit.

captive audience Television programming for viewers who have few options other than viewing, such as standing in supermarket checkout lines, waiting in airports, or viewing in classrooms as part of school lessons.

carriage charges Fees paid to a cable network or, hypothetically, to a television station for the right to carry specific programming.

cart machine Automated radio station equipment that plays cartridges of music, commercials, *promos*, jingles, and *sweepers*.

cash call Radio giveaways requiring listeners merely to answer the phone or call in.

cash flow Operating revenues minus expenses and taxes, or cash in minus cash out.

cash-plus-barter A syndication deal in which the station pays the distributor a fee for program rights and gives the *syndicator* one or two minutes per half hour for national advertising sale; the station retains the remaining advertising time.

casting tape A videotape showing prospective actors in various roles; used especially for proposed *soap operas* and live-action children's programs.

CATV The original name for the cable industry, standing for "community antenna television" and referring to retransmission of broadcast television signals to homes without adequate quantity or quality of reception.

C-band The frequencies used by some communications satellites, specifically from 4 to 6 gigaHertz (billions of cycles per second). See also *Ku-band*.

channel balance Carrying several cable services having varied appeals.

channel capacity The maximum number of channels a cable system can deliver.

channel matching Locating *over-the-air* stations on the same cable channel number as their broadcast channel.

channel piggybacking Two cable networks time-sharing a single channel. See also *piggybacking*.

channel repertoire The array of television channels a viewer usually watches, on average 8 to10.

charts Music rankings as listed in trade publications.

checkerboarding Scheduling five daily programs alternately, one each day in the same time period; that is, rotating two, three, or five different shows five days of the week in the same time period. This is a prime-time access strategy on some affiliates.

cherrypicking In cable, selecting individual programs from several cable networks to assemble into a single channel (as opposed to carrying a full schedule from one cable network).

CHR Contemporary hit radio, a format that plays the top songs but uses a larger *playlist* than the top 40.

churn Turnover; in cable, the addition and subtraction of subscribers or the substitution of one pay-cable service for another. In broadcast network television, shifting of the prime-time schedule. In public broadcasting, changes in membership.

churn rate A cable industry formula that accounts for subscriber connects, *disconnects*, *upgrades*, and *downgrades*.

classic rock Radio music format consisting of older (1950s, 1960s, 1970s, even 1980s) songs.

clearance Acceptance of a network program by affiliates for airing; the total number of clearances governs a network program's potential audience size.

clear channel An AM radio station the FCC allows to dominate its frequency with up to 50 kw of power; usually protected for up to 750 miles at night.

clipping Illegally cutting off the beginning or end of programs or commercials, often for the purpose of substituting additional commercials.

clipping file A collection of newspaper and magazine articles saved for some purpose, such as background and fill-in material for talk show hosts.

clocks Hourly program schedules, visually realized as parts of a circular clock. See also *wheel*.

clone A close copy of a prime-time show, usually on another network. Compare with *spinoff*.

closed captioning Textual information for the hearing impaired—transmitted in the vertical blanking interval—that appears superimposed over television pictures; requires special decoders for reception.

clustering Grouping channels on a cable system for marketing and pricing purposes.

clutter Excessive amounts of nonprogram material during commercial breaks; includes credits, IDs, *promos*, audio tags, and commercial spots.

coding In radio, classifying songs by type or age of music and play frequency.

commentary Background and event interpretation by a radio or television on-air analyst.

commercial load The number of commercial minutes aired per hour.

common carriage Simultaneously airing prime-time PBS programs.

common carriers Organizations that lease transmission facilities to all applicants; in cable, firms that provide superstation signal distribution by microwave and satellite. They are federally regulated.

common channel lineup Identical service arrays on cable channel dials/tuners/converters on most cable systems within a market.

community access channels Local cable television channels programmed by community members, required by some franchise agreements.

community service grants Financial grants from the *Corporation for Public Broadcasting* to public television and radio stations for operating costs and the purchase of programs.

compact disc (CD) A small digital recording read optically by a laser; it may be used for computer data, visuals, or sound.

compensation A broadcast network payment to an affiliate for carrying network commercials, usually within programs (but sometimes radio affiliates carry only the commercials embedded in a local program).

compensation incentive Usually a cash payment by a network or syndicator to encourage program clearance.

composite week An arbitrarily designated seven days of program logs from different weeks, reviewed by the FCC in checking on licensee program performance versus promise (until 1982 for radio).

compression Technical process for reducing the necessary bandwidth of a television signal so that 2, 4, or more signals can fit in the same width of frequencies. Used on satellites and cable.

compulsory licensing Federal requirement that cable operators pay mandatory fees for the right to retransmit copyrighted material (such as broadcast station and superstation signals); the amounts are set by government rather than through private negotiations. See also *copyright*.

concept testing Research practices asking audiences whether they like the ideas for a proposed program.

consideration Payment of some kind (usually money or extraordinary effort) to be allowed to participate in a contest. The combination of consideration, chance, and prize is considered to be a *lottery* by the Federal Communications Commission.

contemporary FCC radio format term covering popular music, generally referring to rock and broken out into the subcategories of adult contemporary (*AC*), contemporary hit radio (*CHR*), and urban contemporary (*UC*).

continuity acceptance Station, network, or system policies regarding the technical quality and content claims in broadcast advertising messages.

continuous season Network television scheduling pattern spreading new program starts across the September to May year rather than concentrating them in September/October and January/February. In other words, having program starts scattered from September to April, and perhaps even year-round.

Conus A nationwide news service for licensing television stations using satellite delivery of timely news stories from all over the country.

convergence Technological melding of seperate communication devices (TVs, computers, telephones) into one system.

converter An electronic device that shifts channels transmitted by a cable system to other channels on a subscriber's television set.

co-op Shared costs for advertising.

cooperation rate In ratings, the percentage of contacted individuals or households agreeing to participate in program or station/network audience evaluation, such as by filling out a diary or agreeing to have an electronic peoplemeter installed in the home and attached to TV sets.

coproduction An agreement to produce a program in which costs are shared between two or more companies (studios), stations, or networks.

copyright Registration of television or radio programs or movies (or other media) with the federal Copyright Office, restricting permission for use.

copyright fee In general, a fee paid for permission to use or reproduce copyrighted material; in cable, a mandatory fee paid by cable operators for reuse of broadcast programs.

copyright royalty fee Money paid for permission to use copyrighted material.

core schedule In the early 1980s, two hours of programs fed to PBS member stations for simultaneous airing four nights a week; this began in 1979 and ended in 1986. The term now loosely refers to primetime programs tagged for same-night showing on public television stations. See *same-night carriage*.

corporate underwriters National or local companies that pay all or part of the cost of producing, purchasing, or distributing a noncommercial television or radio program; they may fund programs on PBS, NPR, or local public broadcast stations. See also *underwriter*.

Corporation for Public Broadcasting (CPB) A government-funded financial and administrative unit of national public broadcasting since 1968.

cost per episode The price of licensing each individual program in a syndicated series.

cost per point The amount an advertising agency will pay for each ratings point.

cost per thousand (CPM) How much it costs an advertiser to reach a thousand viewers, listeners, or subscribers.

counterprogramming Scheduling programs with contrasting appeal to target unserved or underserved demographic groups.

coventure Shared program financing and production among two or more stations, networks, cable systems, or other programming entities.

CPB-qualified stations Public radio stations receiving *community service grants* from the *Corporation for Public Broadcasting*. The prerequisites for qualification include a large budget, paid staff, strong signal, and so on.

crime dramas Hour-long television series with main characters who are detectives, police, district attorneys, lawyers, and so on; these series are usually aired first in *prime time*.

critical information pile A quantity of important news breaking simultaneously that causes massive alterations in planned news coverage.

crossmedia ownership Owning two or more broadcast stations, cable systems, newspapers, or other media in the same market. This was prohibited by the FCC unless an exception was granted (temporary or grandfathered) until ownership rules loosened somewhat in 1992 and again in 1996.

crossover Temporarily using characters from one program series in episodes of another series. Compare with *spinoff* and *clone*.

crossover points Times when one network's programs end and another's begin, usually on the hour and half-hour, permitting viewers to change channels easily (although a long program such as a movie may bridge some hour and half-hour points).

crossover songs Music (or performers) that fit within two or more radio formats (for example, songs played by country and AC disc jockeys).

crossownership rules FCC rules prohibiting control of broadcast, newspaper, or cable interests in the same market.

cume A cumulative rating; the total number of different households that tune to a station at different times, generally over a one-week period. This is used especially in commercial and public radio, public television, and commercial sales.

cybercasting Using the Internet and other online services to transmit live audio and video.

cycle Span of news flow between repeat points in all-news radio.

DAB *digital audio broadcasting*, the next generation of radio technology that is incompatible with present-day analog broadcasting equipment.

daypart A period of two or more hours, considered to be a strategic unit in program schedules (for example, morning *drivetime* in radio, 6 to 10 A.M., and *prime time* in television, 8 to 11 P.M.).

dayparting Altering programming to fit with the audience's changing activities during different times of the day (such as shifting from music to news during *drivetime*).

daytimer An AM radio station licensed to broadcast only from dawn to dusk.

DBS Programming from *direct broadcast satellites* going from satellite to home receiving dishes, bypassing a ground-based distributor such as a broadcast station or cable system. See also *TVRO, DTH, VSAT*.

deficit financing Licensing television programs to the broadcast networks at an initial loss, counting on later profits from syndication rights to cover production costs. This is practiced by the major Hollywood studios.

delayed carriage Airing a network program later on tape.

demographics Descriptive information on an audience, usually the vital statistics of age and sex, possibly including education and income.

demo tape Demonstration tape of a program, used for preview without the expense of producing a *pilot*.

designated market area (DMA) Nielsen's term for a local viewing area. See also Arbitron's *Area of Dominant Influence* (ADI).

diary An instrument for recording hours of listening or viewing of a station or cable service. Used by

Arbitron, Nielsen, and other research firms, it is filled out by audience members.

differentiation The perceived separation between networks, stations, or services by the audience and advertisers, generally based on programming differences and promotional images.

digital Technology that utilizes the binary code (on/off) of computers as opposed to continuous signals (analog).

digital audio broadcasting (DAB) A proposed system for *over-the-air* broadcasting utilizing *digital* encoding and decoding that will be incompatible with present broadcasting equipment.

digital compression A technology that eliminates redundant information in a television picture or radio sound to reduce the bandwidth needed for transmission; missing information is recreated at the receiving end.

digital delay unit An electronic device to delay programs for a few seconds between studio and transmitter to permit dumping of profanity, personal attacks, and other unairable material. This is commonly used on *call-in* programs.

direct broadcast satellites (DBS) Special satellites intended for redistribution of high powered television signals to individual subscribers' receiving dishes, requiring only small home or office receiving dishes; recently called *direct-to-home* transmission. See *DBS, DTH, TVRO,* and *VSAT.*

direct-to-home (DTH) Television signals distributed by satellite to receivers on individual homes and office buildings, bypassing *over-the-air* stations and cable systems. See also *DBS, DTH, TVRO,* and *VSAT.*

disc jockey (DJ) A radio announcer who introduces records.

disconnects Cable subscribers who have canceled their service.

dish Receiving or sending antenna with a bowl shape, intended for transmitting satellite signals; also called *earth station.*

distant independent An independent station signal imported from another market, especially a superstation.

distant signals Broadcast station signals imported from another market and retransmitted to cabled homes; usually independents. See also *superstations.*

distribution window A period of time in which a movie or television program is available to another medium. See also *window, pay window,* and *broadcast window.*

docudrama A fictionalized drama of real events and people.

documentary A program that records actual events and real people.

double jeopardy When shows with low appeal attract smaller audiences, which in turn lowers the ratings.

double running The practice of showing additional episodes of a successful show on the same day.

downgrading Reducing the number or value of pay services by a subscriber (reverse of *upgrading*).

downlink Satellite-to-ground transmission path, the reverse of *uplink*; refers also to the receiving antenna (*dish*).

download Transmission and decoding signals at the receiving end; used for satellite program (and computer) signals.

downscale Audience or subscribers with lower than average socioeconomic demographics, especially low income. See also *upscale.*

downtrending A pattern of declining ratings/shares over time (reverse of *uptrending*).

drama A prime-time series program format, usually one hour long, contrasting with *situation comedy.* It includes action-adventure, crime, doctor, adult soap, and other dramatic forms.

drivetime In radio, 6 to 10 A.M. (morning drive) and 4 to 7 P.M. (afternoon drive).

drops Individual household hookups to cable wires, running from the street to the house or apartment.

DTH *Direct-to-home* satellite signals, bypassing *over-the-air* stations and cable systems. See also *DBS.*

dual format A public radio format consisting of two unrelated formats, usually news and jazz or news and classical, attracting different audiences.

duopoly rule An obsolete FCC rule that limited ownership of stations with overlapping coverage areas.

duplicator dilemma The problem of having the same NPR programs on more than one public station in a market because affiliations and program rights are not exclusive.

early fringe In television, the locally programmed period preceding the early news, usually 4 to 6 P.M. See *fringe*.

earth station Ground receiver/transmitter of satellite signals; when transmitting it's called an *uplink*; when receiving, it is used to receive signals from a satellite. In television or radio, its purpose is to redirect satellite signals to a broadcast station or to cable *headend* equipment. It is also used to receive signals directly at homes or offices without a broadcast or cable intermediary; see *TVRO, DTH, VSAT*. Most are receive-only stations, also called antennas or *dishes*.

eclectic A mixed radio format applied to varied programming in radio incorporating several types of programs; a recognized format in public radio.

editorials In broadcasting, statements of management's point of view on issues.

educational programs Television programs for schools or adult at-home viewers that have instructional value. See also *telecourses*.

effective radiated power (ERP) Watts of power measured at receiving antennas on average; it is used to measure the strength of antennas.

electronic program guide On-screen program listings to promote more viewing and aid subscribers in choosing programs.

electronic text Alphanumeric video representations of words and sometimes diagrams, excluding moving video images. It includes teletext, videotex, and cabletext news services such as those supplied by the Associated Press and United Press International wire services.

encore In *pay-cable*, repeat scheduling of a movie or special in a month subsequent to the month of its first cable network appearance.

endbreaks Commercial breaks following a program's closing credits.

ENG Electronic newsgathering. This refers to portable television equipment used to shoot and tape news stories on location.

episode One show out of a series.

episode testing Studies of audience reactions to plot changes, characters, settings, and so on while the show is in production.

equal employment opportunity (EEO) Federal law prohibiting discrimination in employment on the basis of age, race, or sex.

equal time An FCC rule incorporated in the Communications Act of 1934 requiring equivalent airtime for candidates for public office.

equity holdings A financial interest from part ownership of a business; it is the same as "equity interest" or *equity shares*.

equity shares Ownership shares offered as compensation or incentive to cable operators for making *shelf space* for a cable network, especially newly introduced networks such as shopping services.

ethnic Programming by or for minority groups (for example, Spanish-speaking, Native Americans, or African Americans).

exclusive rights The sole contractual right to exhibit a program within a given period of time in a given market. See also *syndicated exclusivity rule*.

expanded basic tier A level of cable service beyond the most basic *tier*, offered for an additional charge and comprising a package (or *bundle*) of several cable networks—usually advertiser-supported services.

expanded sample frame (ESF) The base unit for a sampling technique that includes new and unlisted telephone numbers.

extraneous wraps Reusable closings for radio news, prerecorded by an announcer or reporter for later on-air use; often used around wire service stories.

Fairness Doctrine A former FCC policy requiring that *stations* provide airtime for opposing views on controversial issues of public importance. This requirement ended in 1987.

feature Radio program material other than hard news, sports, weather, stock market reports, or music; also called *short-form* programs. In television and cable, this is generally short for theatrical feature films.

feature film A theatrical motion picture, usually made for theater distribution, followed by *home video* sales, *pay-per-view*, and *pay-cable* play; some are aired by the *over-the-air* networks. Feature films occupy about one-fifth of the total syndication market.

feature syndicator Distributor of short, stand-alone programs or series, as contrasted with *long-form* (continuous) programming; used mostly in radio, less in television and cable.

fiber optics Very thin and pliable glass cylinders capable of carrying wide bands of frequencies. See also *optical fiber*.

Financial Interest and Network Syndication Rules FCC regulations prohibiting broadcast networks from owning an interest in the domestic syndication rights of most television and radio programs they carry; modified to increase the number of hours a network can produce for its own schedule in 1991; eliminated in 1995.

Fin-Syn Industry shorthand for *Financial Interest and Network Syndication Rules*.

first refusal rights The legal right to consider a program proposal until deciding whether to produce it or not; this can stymie a program idea for years.

first-run The first airing of a television program (not counting the theatrical exhibit of feature films).

first-run syndication Distribution of programs produced for initial release on stations, as opposed to the broadcast networks. Compare with *off-network syndication*.

flat fee A method of payment involving a fixed lump price; contrasts with a sliding scale (usually based on number of viewers).

flip card A filing system for record rotation at radio stations.

flipping Changing channels frequently during programs. See *grazing*.

focus group A research method in which people participate in a joint interview on a predetermined topic.

foremarket The migration of a cable-originated program to a broadcast network. See *aftermarket*.

format The overall programming design of a station, cable service, or specific program, especially used for radio and cable program packages.

formula The elements that define a format.

foundation cable networks In cable, the earliest established and most widely carried *cable networks*, those most cable operators think it essential to carry if they have the capacity.

franchise area A license granted by local government to provide cable service, based on the local government's right to regulate public rights of way (cable requires installing wires in a community or portion of a community). The franchise agreement delineates a geographic area to be wired.

franchising authority The local governmental body awarding a franchise to build and operate a cable system involving wires that cross city streets and rights of way. A fee is charged to cable operators, based on the principle that the public should be reimbursed for use of its property in a commercial business.

free-form A talk radio *format* in which callers' interests set the program's agenda; also called "open-line" talk.

free-form community stations A public access radio format, begun in the 1960s most notably by Lorenzo Milam.

frequency In advertising, the number of times the audience was exposed to a message. Also, the portions of the electromagnetic spectrum used for AM, FM, and television broadcasting, cable distribution, and satellite *uplinks* and *downlinks*; a channel number is shorthand for an assigned frequency. See *C-band* and *Ku-band*.

fringe The television time periods adjacent to *prime time*—from 4 to 7 P.M. and 11 P.M. to midnight or later (EST). *Early fringe* means the time preceding the early local newscast; late fringe starts after the end of late local news, usually at 11:30 P.M.

front- and backend deal A program licensing agreement in which the *station* pays a portion of the fees at the time of the contract and the remainder when the program becomes available; see *futures*.

frontload In pay television, to schedule all main attractions at the beginning of the month.

futures Projected episodes in a series that have not yet been produced; typically, network series programming intended for syndication that may be purchased while the series is still on the network for a negotiated price that accounts for the purchaser's risk.

gold A hit song or record generally with lasting appeal; in sales, a song selling a million copies, an album selling 500,000 copies.

Gold Book A list of *gold* (classic) records for use in radio programming.

grandfathering Exempting situations already in effect at the time a new law is passed.

graphics Titles and other artwork used in programs, newscasts, *promos*, or commercial spots.

grazing Checking out many television channels using a remote control.

gross rating points In advertising and promotion, a system for calculating the size of the delivered or anticipated audience by summing the rating points for all airings of a spot.

group The parent corporation, owners of several broadcast stations or cable systems.

group-owned station A radio or television station licensed to a corporation owning two or more stations; a cable system owned in common with many other cable systems. See also *MSO*.

group owner An individual or company having the license for more than two broadcast facilities. Compare with *MSO*.

guides Program listings, presented in printed or electronic form.

hammocking Positioning a weak program between two successful programs; they support a new or less successful program by lending their audience to it.

hard news Daily factual reporting of national, international, or local events, especially focused on fast-breaking events. Compare with *soft news*.

headend Technical headquarters for receiving and transmitting equipment for a cable system where signals are placed on outgoing channels.

heterogeneity Audiences consisting of demographically or psychographically mixed viewers or listeners. Compare with *homogeneity*.

hiatus A period of weeks or months in which a program is pulled off the air, usually for revamping to improve its ratings when it returns to the air, although many series never return.

high-definition television (HDTV) Various technical systems for distributing video with higher quality and a wider aspect ratio than standard television broadcasting, generally using a greater *bandwidth* in the spectrum and more scanning lines. See also *aspect ratio*.

home video The movie and television program sales and rental business.

homes passed (HP) The total number of buildings cable wires pass, irrespective of whether the occupants are or are not cable subscribers.

homogeneity Audiences composed of demographically or psychographically similar viewers or listeners.

hook A plot or character element at the start of a program that grabs audience attention; also, in radio research, a brief song segment characterizing a whole song.

horizontal documentaries A multipart treatment of a news subject spread over several successive days or weeks. Compare with *vertical documentaries*.

horizontal scheduling *Stripping* programs or episodes across the week. Compare with *vertical stacking*.

host A personality who moderates a program or conducts interviews on radio, television, or cable.

hot clock See *wheel* or *clocks*.

households having sets (HHs) A ratings industry term for the total number of homes with receiving sets (AM or FM radio, UHF or VHF television, or cable hookups); that is, the total potential audience.

households using television (HUTs) A ratings industry term for the total number of sets turned on during an *average quarter hour*; that is, the actual viewing audience to be divided among all stations and cable services in a market.

hyping or hypoing Extended promotion of a program or airing special programs to increase audience size during a *ratings period*.

ideal demographics The theory that a particular age and sex group should be the target of prime-time network television programs.

impulse ordering Technology that permits a cable viewer to punch up and purchase a *pay-per-view* program or merchandise using a hand-held *remote control*.

incentive An enticement to make a deal or sign a contract. Examples include additional local *avails* offered to *stations* or cable systems by a *syndicator* or *network* or payments for clearing a program; also, discounts and prizes offered to lure potential cable subscribers.

incubation strategy Launching a new network by sheltering the new service under an existing network (aka, sheltered launch).

indecency A subcategory of the legal definition of obscenity, enforced by the FCC. Generally it refers to prohibited sexual and excretory language and depictions of such behavior.

independent A commercial television broadcast station not affiliated with one of the national networks

(by one FCC definition, carries fewer than 15 hours of network programming per week).

independent producers Makers of television series, movies, or specials who are legally separate entities from the Hollywood movie studios.

infomercial A long sales pitch disguised as a program, called a "program-length commercial," usually lasting from 15 to 30 minutes or more and presented on cable television or independent television stations in less popular time periods.

infotainment A mix of news and entertainment.

inheritance effect A research term for an audience carried over into a subsequent program's audience. See *lead-in*.

in-house Programs produced in the station's own facilities as opposed to network or syndicated shows; also shows such as *soap operas*, newscasts, and public affairs that the broadcast networks produce themselves. Also called *house shows*.

insertion news In local cable, short commercial newscasts provided by broadcasters for inclusion on local cable channels.

instructional television (ITV) Programs transmitted to schools for classroom use by public television or radio stations.

instructional television fixed service (ITFS) A television distribution system delivering programs by line-of-sight microwave to specific noncommercial and commercial users within a fixed geographic area; the usual means for delivering instructional programming to schools by public television stations.

in-tab Diaries actually returned to the ratings service in usable form and counted in the sample.

interactive cable Two-way cable that permits each household to receive one stream of programming and also to communicate with the cable *headend* computer.

interconnection grants Funds from the *Corporation for Public Broadcasting* for public television stations to cover satellite transmission costs.

interconnects Transmission links among nearby cable systems permitting shared sales and carriage of advertising spots.

interdiction In cable, a recently developed technology for interrupting unwanted (not paid for) television signals outside the household, such as on a pole or the side of a building.

interoperability The ability for two-way video, voice, and data to operate through the same home equipment.

interstitial programming Short programs intended to fill the time after an odd-length program is completed. Also called *shorts*.

inventory The amount of time a station has for sale (or the commercials, records, or programs that fill that time).

Iris Awards for outstanding local programming given by NATPE.

jock See *disc jockey* and *video jockey*.

joint venture A cooperative effort to produce, distribute, or market programs.

kiddult Television programs appealing to both children and adults.

kidvid Television programs for children.

Ku-band Frequencies used for transmitting some high powered satellite signals, the band between 11 and 14 gigaHertz (billions of cycles per second), which require smaller receiving *dishes* than *C-band*. Compare with *C-band*.

large-market stations Broadcast stations in markets 1 to 25, as defined by the ratings companies. Compare with *mid-market stations*, *small-market stations*, and *major market*.

late night Television daypart from 11:30 P.M. to 1 A.M.

lead-in A program preceding others, usually intended to increase *audience flow* to the later programs. Called *lead-off* at the start of *prime time*.

lead-off See *lead-in*.

leased access Channels available for commercial lease, occasionally required by a cable franchise agreement, sometimes voluntarily offered by large-capacity cable systems.

least objectionable program (LOP) A theory holding that viewers select not the most appealing program among those available at one time but the one that offends fewest viewers watching together; it presumes that channel switching requires an active effort occurring only when the channel currently being viewed presents something new and objectionable.

legs Trade slang meaning a program will provide dependably high ratings, as with *blockbuster* off-network television series.

licensees Entities legally holding broadcast licenses.

license fee The charge for the use of a syndicated program, feature film, or network service.

lifespan In television, the number of years a series stays on network television.

lift Added audience gained by combining popular and less popular cable services in marketing.

limited series A television series having only a few episodes for airing.

liners Brief ad lib comments by *disc jockeys* between records on music radio.

live Not prerecorded, or in the record industry, recorded as performed, not edited.

live assist Programming combining *disc jockey* chatter and automated music programming on tape.

live feed A program or insert coming from a network or other interconnected source without prerecording and aired simultaneously.

localism An FCC policy encouraging local ownership of broadcasting and community-oriented programming.

local marketing agreements (LMAs) Contracts for sharing the functions of programming, staffing, and commercial time sales largely entered into by economically weak AM stations, much like newspaper joint operating agreements within a market.

local origination (LO) Cable programs the cable system produces or licenses from syndicators to show locally, including access programs, as contrasted with *basic cable* networks or *pay-cable* networks.

log The official record of a broadcast day, kept by hand or automatic means such as tape, which notes opening and closing times of all programs, commercials, and other nonprogram material and facts. Once mandated by the FCC, it is now used as proof of commercial performance.

long-form Longer than the usual length of 30 minutes for most television series and 60 minutes for *dramas* or *specials* (for example, a 90-minute fall season introduction to a new prime-time *series*) or playing the entire two or three hours of a *feature* film in one evening. It also refers to a *miniseries* of 10 hours or more. In radio, it is nationally distributed programming using a single musical *format*, as in automated beautiful music or rock, as opposed to syndicated feature programming or *short-form* news.

long-form nights Evenings on which a two-hour movie or *special* is scheduled by a network.

loss leader A program (or *format*) broadcast because management thinks it is ethically, promotionally, culturally, or aesthetically worthwhile rather than directly rewarding financially; in cable, carrying cultural channels used as image builders.

lotteries Contests involving the three elements of prize, *consideration*, and chance. Prohibited by the FCC for broadcast stations except as an occasional contest or game and prohibited on broadcasting by law in some states.

low-power television (LPTV) A class of broadcast television stations with limited transmitter strength (usually covering less than 10 miles), generally assigned in areas where a full-power signal would interfere with another station using the same channel.

made-for-cable Movies produced specifically for cable airing, many are financed by the *premium networks*. Also called *made-for-pay*.

made-for-pay Programs, usually feature films, produced for *pay-cable* distribution; they may later be syndicated to broadcast stations.

made-for-TV (MFTV) A movie feature produced especially for the broadcast television networks, usually fitting a 90-minute or two-hour format with breaks for commercials.

magazine format A television or radio program composed of varied segments within a common framework, structurally resembling a printed magazine.

major market One of the 100 largest metropolitan areas in number of television households. See also *large-market stations*.

mandatory licensing A nonvoluntary arrangement requiring cable operators to pay fees for the right to reuse copyrighted broadcast programming; the fees are returned by CRT to rights holders, also called *compulsory licensing*. See also *copyright*.

market report An Arbitron or Nielsen ratings book for a single market.

matching In cable, assigning the same cable channel number as a station's *over-the-air* channel number. See also *repositioning*.

MDS Multipoint distribution service; a system of distribution of pay television using microwave to

rooftop antennas. It generally distributes *pay-cable* networks (without using cables outside buildings). See also *MMDS* and *wireless cable*.

metered cities The largest markets in which the stations pay Nielsen to provide overnight ratings from metered households.

Metro Area The most densely populated center of a metropolitan area, defined by Arbitron and Nielsen for rating a geographic subset of a market.

microniche services *Theme networks* targeting a population subgroup such as the hearing impaired or foreign language speakers. This is not to be confused with multiplexed *subniche networks*.

midband Channels on a coaxial cable falling between broadcast channels 6 and 7, requiring a converter, cable-ready TV set, or VCR to tune.

mid-market stations Broadcast stations in markets 26 to 100, as determined by the ratings companies. See also *large-market stations* and *small-market stations*.

minicam A small, portable television camera. See also *ENG* and *camcorder*.

minidoc A short news documentary.

mininetworks Regional, special purpose, or part-time networks formed to carry a limited program schedule, such as news reports, a holiday *special*, or sporting events. See also *ad hoc networks*.

minipay service A basic cable network that charges cable systems a small amount per subscriber per month for its programming.

miniseries Prime-time network television *series* shorter than the traditional 11 episodes.

mixed format Radio formats that use a common name but differ from station to station in the song-lists they play (AC, soft rock). Compare to *pure format*.

MMDS Multichannel multipoint distribution service, a form of pay television also called *wireless cable* that distributes up to 33 channels (and more with compression) in a market. See also *MDS*.

movie libraries Those *feature films* under contract to a *station* with *plays* still available.

movie licenses Contracts for the right to play a movie a fixed number of times; currently, contract lengths average five years.

movie repetition Repeating movies on a cable network.

movie rotation Scheduling movies at different times of the day and days of the week on a cable network.

MSO Multiple system operator; owner of more than one cable system. See also *group owner*.

multichannel multipoint distribution service See *MMDS*.

multimedia Programs, presentations, or facilities combining computerized video, audio, and data; used especially in educational and business training applications.

multipay A cable environment with many competing premium services; also, cable subscribers taking more than one pay channel.

multiple franchising Licensing more than one cable company to wire the same geographic area and compete for subscribers; this occurs very infrequently. See *overbuild*.

multiple networks In radio, several co-owned services such as ABC's six radio networks or Westwood's five networks.

multiplexing Simultaneously transmitting (via subcarriers) one or more television (or radio) signals in addition to the main channel; utilizes *digital compression* to fit a 6 mHz *NTSC* signal into a narrower band; in radio, carries *RBDS* signals.

music sweep An uninterrupted period of music on music radio.

must-carry rule An FCC requirement that cable systems had to carry certain qualified local broadcast television stations, ruled unconstitutional in 1987.

narrowcasting Targeting programming, usually of a restricted type, to a nonmass audience, usually a defined demographic or ethnic group. This is used when either the programming or the audience is of a narrow type.

National Public Radio (NPR) The noncommercial radio network service financed primarily by the *Corporation for Public Broadcasting* (CPB); serves affiliated *public radio* stations.

national representative See *station rep*(resentative).

net net The final revenue figure for a syndicated (or local) program after all program costs, commissions, and unsold time estimates are subtracted.

network An interconnected chain of broadcast stations or cable systems that receive programming simultaneously. This also refers to the administrative

and technical unit that distributes (and may originate) preplanned schedules of programs (for example, ABC, CBS, NBC, Mutual, PBS, NPR, HBO, ESPN, Showtime).

network compensation Payments by broadcast networks to affiliated stations for airing network programs and commercials.

network one stop Marketing service controlled by TCI that supplies a package of 16 satellite-delivered networks for backyard *dishes* (*TVROs*).

network parity Equality in network audience sizes, usually calculated by comparing the number of affiliated stations in large, middle, and small markets. See also *parity*.

new-build A recently constructed residential area in which cable wires pass all houses.

news block Extended news programming. In radio, the time immediately before and after the hour when stations program news; in television, the period between 5:30 and 7:30 P.M. (varies with market).

new connects Newly built homes with cable hookups.

news cooperatives Joint arrangements between radio and television stations and cable systems for co-producing news.

niche networks Cable networks carrying a single type of programming, usually targeting a defined audience; also called a *theme network*.

nonclearance Written refusal to carry a particular network program by an *affiliate*.

noncommercial educational broadcasting The system of not-for-profit television and radio stations, and the networks that serve them, that operate under educational licenses. These include public broadcasting, public access stations, and many religious and state- or city-operated stations.

nonduplication An FCC policy that prohibits airing the same program material on two co-owned radio stations (such as an AM and FM) in the same market (exceptions are granted in some very small markets or *grandfathered* cases and in cases of financial need).

nonentertainment programming News and service information such as weather and traffic reports.

nonprime-time In network television, the hours outside of *prime time*, especially morning, day, and late night; nonprime-time programming sometimes

excludes news and sports because they are handled by separate network departments and may schedule programs within *prime time*.

nontraditional scheduling Putting news or other programs in time blocks other than the ones normally used by network-affiliated stations.

novelas Spanish-language serials resembling *soap operas* but concluding in 6 months or 1 to 2 years. They generally have specific educational goals but are presented in the guise of entertainment.

NTSC National Television Systems Committee, the system of television (named after the group that developed the standard) prevalent in the Western Hemisphere until the introduction of *high-definition television*.

NVOD Near video-on-demand, meaning that the viewer gets almost any program requested from a video library but is limited to the most-requested titles. See *video-on-demand*.

off line Use of program elements as they are fed from a network or other source.

off-network series Former broadcast television network show now syndicated.

off-network syndication Selling programming (usually *series*) that has appeared at least once on the national networks directly to stations or cable services.

off-premises equipment In cable, traps and converters installed on telephone poles or the sides of buildings outside the subscriber's home.

off-season For the broadcast networks, the 12 weeks of summer (the season went to 40 weeks in 1996).

operating income A company's profits before taxes and interest payments are deducted.

optical fiber Very thin strands of glass capable of carrying hundreds of video signals and thousands of audio or data signals; used in cable television to replace coaxial cable trunk and feeder lines, and in telephone to replace telephone trunk wires.

overbuild A second cable system built where another firm already has one. See also *multiple franchising*.

overmarketing Persuading people to subscribe to more cable services than they can readily afford.

overnight Radio airtime from 1 to 4 A.M.; television programming from 1 or 2 A.M. to 4 or 6 A.M.

overnights National television *ratings* from metered homes in major cities available the following day to network programmers.

over-the-air Broadcast, as opposed to delivered by a wired service such as cable television.

owned-and-operated (O&O) station Broadcasting station owned and operated by one of the major broadcast networks.

parity Audience equivalence; in network television, having equal numbers of *affiliates* with equal *reach* so that each network has a fair chance to compete for *ratings/shares* based on programming popularity. Also applied in comparing VHF and UHF stations and broadcast stations with and without cable carriage. See also *network parity*.

passive meter An electronic meter recording viewing (or listening) and channel tuning that requires no action by viewers, such as pushing buttons. Compare to *peoplemeter* and *passive peoplemeter*.

passive peoplemeter A new generation of passive television meters incorporating an automatic camera with a computer recognition system (which matches viewer silhouettes with stored demographic information) to record viewer demographics. See also *passive meter*.

passive viewing Watching television without actively consulting all the competing program options.

pay cable Cable television programming services for which the subscriber pays an optional extra fee over and above the normal monthly cable fee. See also *pay television*, *premium networks*, and *pay-per-view*.

pay-cable households Number or percentage of total television households subscribing to a *premium* cable service.

pay-cable networks National satellite-distributed cable programming for which subscribers pay an extra monthly fee over and above the monthly fee for *basic cable* service. See also *premium networks*.

pay channel *Pay-cable* and *pay-per-view* channels supplying mostly movies, sports, and specials to cable subscribers for an optional extra monthly or per program fee.

payola Illegal payment for promoting a recording or song on the air.

pay-per-view (PPV) Cable or subscription television programming that subscribers pay individually for, purchased per program viewed rather than monthly.

pay radio Premium *cable FM*, cable networks available to subscribers for a monthly fee.

pay run Length of a movie's license (*rights*) on a cable network.

pay television An umbrella term for any programming for which viewers pay a fee; includes *pay cable*, *subscription television*, *pay-per-view*, *MMDS*, *DBS/DTH*, and *TVRO* packages.

pay window A period of time in which a program, usually a *feature film*, is made available to *pay cable*, generally from 6 to 12 months. See also *broadcast window* and *window*.

PCN Personal Communication Network, a system of very small, portable telephones connected by radio signals to cable wires within a building, and from there connected by cable to the public telephone network.

penetration *Reach*; in a given population, the percentage of households using a product or receiving a service.

peoplemeter An electronic meter attached to TV sets measuring both tuning and audience demographics; it requires viewers to push buttons to identify themselves. Variants are used by Nielsen and AGB. See also *passive peoplemeter*.

pilot A sample first program of a proposed television *series*. Often longer than regular episodes, it introduces characters, set, situations, and program style and is generally accompanied by heavy promotion before it is aired.

pilot testing Comparing audience reactions to new television program under controlled conditions prior to the program's appearance in a *network* schedule.

play A showing or *run* of a program. Also, one to two showings of each episode of a program until all rights are exhausted as specified in a licensing agreement.

playlist Strategically planned list of records to be played on music radio.

plugola Inclusion of material in a program for the purpose of covertly promoting or advertising a product without disclosing that payment of kind was made; penalties for violating *payola* or plugola regulations may be up to a $10,000 fine and a year in prison for each offense.

pocketpiece An abbreviated version of weekly national ratings, available to network executives, covering prime-time broadcast and larger cable network programs.

population All homes with television sets or radios; cable population is all the homes with cable service. See also *universe*.

positioning Making the audience believe one *station* or cable service is really different from its competitors; especially important for *premium channels*, *independent* television stations, rock music radio stations, and cable shopping services.

prebuying Financing a movie or television series before production starts to obtain exclusive future telecast rights.

preemption Cancellation of a program by an *affiliate* after agreement to carry the program, or cancellation of an episode by a *network* to air a news or entertainment *special*. This is also applied to cancellation of a commercial sold at a special preemptible price to accommodate another commercial sold at full rate.

premiere week Start of the new fall prime-time season.

premium networks In television and radio, pay services costing subscribers an extra monthly fee over and above *basic cable*; in cable, called *pay cable* and *pay-per-view*. It also includes *STV*, *SMATV*, *MMDS*, and *DBS/DTH* services. In radio, called *pay radio* or premium *cable FM*.

prerun Showing before network television air date (usually on pay television).

presold Series episodes or film idea sold before being produced (generally related to the high reputation of the producer). See also *buying* and *prebuying*.

primary affiliate A station that carries more than 50 percent of a network's schedule. See also *multi-affiliates*.

prime time Television *daypart*; in practice, 8 to 11 P.M. (EST) six days a week and 7 to 11 P.M. Sundays. Technically, any three consecutive hours between 7 P.M. and midnight.

Prime-Time Access Rule (PTAR) FCC rule forbidding network *affiliates* from carrying more than three hours of network programs and *off-network* reruns (with some exceptions) in the four hours starting at 7 P.M. EST. The rule was eliminated in 1995.

production fee License fee the broadcast networks pay for new programs.

program availabilities Syndicated programs not yet under contract in a market, therefore available to stations for license.

program log A station's record of all programs, commercials, *public service announcements*, and *nonentertainment programs* aired.

Program Practices Department Network department that clears all programs, *promos*, and commercials before airing and is responsible for administration of network guidelines on such subjects as nudity, sex, race, profanity, and appropriateness for children. Also called "standards and practices" or "continuity acceptance department."

promo A broadcast advertising spot announcing a new program or episode or encouraging viewing of a *station's* or *network's* entire schedule.

promotion Informational advertising of programs, *stations*, or *networks*.

promotional support *Network* or *syndicator* assistance with promotion in the local market, consisting of *co-op* funds, *ad slicks*, or other aids to increase viewing of a specific program.

protection In radio, a form of *exclusivity* in which the *network* supplies a program to only one *station* in a market, even if the *network* has *affiliates* whose signals overlap.

psychographics Descriptive information of the lifestyles of audience members, which includes attitudes on religion, family, social issues, interests, hobbies, and political opinions.

Public Broadcasting Service (PBS) The noncommercial, federally supported interconnection service that distributes programming nationally to member *public television* stations. It also serves as a representative of the public television industry.

Public, educational, and government (PEG) *Access channels* on cable television.

public radio The noncommercial radio stations in the United States qualifying for grants from the *Corporation for Public Broadcasting*, mostly FM licensees.

Public Radio International (PRI) A not-for-profit radio network serving public radio stations.

public station Television or radio station receiving a grant from the *Corporation for Public Broadcasting*;

prior to 1967 they were called educational stations. They are licensed by the FCC as noncommercial educational broadcast stations.

Public service announcement (PSA) Noncommercial spot advocating a community event, not-for-profit activity, charity, or public service.

public television (PTV) Overall term replacing "educational television" to describe federally funded noncommercial television.

pure format A radio format appealing to an easily definable demographic group who like the same music and announcing style (AOR, country). Compare with *mixed format*.

PUTS/PURS Persons using television/persons using radio, measurements utilizing individual audience members viewing and listening habits instead of household data; especially important to radio and sports programs where much listening and viewing takes place away from homes.

qualitative research Systematically gathered information on broadcast and cable audiences and program viewing other than *ratings* collected by the industry; also used in sociological research to contrast with other quantitative research methods.

Qube Warner Communications' interactive cable system installed in Columbus, Ohio, Pittsburgh, and other cities. It was once considered to be an innovative two-way system but is now utilized primarily as an addressable system for *pay-per-view*.

rankings In radio, lists of songs and albums by popularity, commonly published in trade magazines. In television, share rankings are lists of television shows with highest to lowest percentages of homes watching (out of homes using television).

rate structure Arrangements for revenue paybacks or licensing rights between cable operators and cable program suppliers.

rating An audience measurement unit representing the percentage of the potential total audience tuned to a specific program or station for a program or time period.

ratings period Usually four sequential weeks during which local television station *ratings* are collected, reported week by week, and averaged for the four weeks, called a *sweep*. Four *sweeps* are conducted annually—in November, February, May, and July. In radio, this may refer to as many as 48 continuous weeks for larger markets, fewer weeks for smaller markets. In network television, it may refer to only one week in a *pocketpiece*.

RBDS Radio Broadcast Data Systems, a recently developed radio technology using FM subcarriers to *multiplex* a visual display (such as an automatic station ID) and limit electronic scanning of stations to those with a prespecified *format*.

reach Cumulative audience or total circulation of a station or service.

reality shows Low-budget television *series* using edited tapes of real people at their jobs (supplemented by on-camera interviews and reenactments), especially police, and fire crews, and emergency workers.

rebroadcasts Newscasts or programs repeated, commonly used for broadcast station newscasts repeated on local cable channels.

rebuilding Redesigning and reconstructing a local cable system.

recaps Recapitulation of news events or news stories.

recurrents Songs that have been number one on *playlists* in the recent past; this is used in scheduling songs on popular music stations.

relay communications satellite A satellite that retransmits cable, telephone, and other signals to *earth stations* (for example, the Galaxy and Satcom cable satellites).

remote Live production from locations other than a studio (such as football games and live news events).

remote control device (RCD) A handheld, infrared-operated device for tuning television channels, turning set on and off, muting sound, controlling VCR operations, and other functions.

repackaging Unearthing old television shows to run as a tribute to a performer or a network.

repositioning Moving *stations* and *networks* to different positions on a cable channel array; this generally refers to moving broadcast stations away from channel numbers corresponding to their *over-the-air* channel numbers. Compare with *matching*.

rerelease Second round of theater showings of a recently made movie.

rerun Repeat showing of a program first aired earlier in the season or in some previous season. Commonly applied to *series* episodes.

resale rights Permission from wholesaler to offer copyrighted material for retail sale (republication or retelecasting).

reselling Offering a program to the public for purchase as in the videocassette rental and sales business. See also *resale rights*.

reserve price The minimum acceptable bid for a syndicated television program.

residual rights Royalty payments for reuse of shows or, in the case of radio, voiced announcements, news features, and other content.

rest The length of time a *feature film* or other program is withheld from cable or broadcast syndication (or local station airing) to avoid overexposure.

resting Shelving a movie or *series* for a period of time to make it seem fresh when revived.

retransmission consent Control by originating station of the right to retransmit that station's signals for use by cable systems. Also, a proposal to require agreement from copyright holders (probably for a fee) before programs can be picked up by resale carriers (*cable systems, common carriers*). This issue particularly affects *superstations*, cable operators, satellite carriers, and writers/producers. It cannot be implemented without giving up *mandatory licensing*.

reuse fees Royalties for replay of recorded material.

revenue split Division of pay revenues from subscribers between cable operator and cable network (usually 60/40 or 50/50).

rights Legal authority or permission to do something, especially with copyrighted material.

rip-and-read The simplest form of newscasting; the announcer rips copy from the wire service and reads it on the air.

roadblocking Simultaneously airing a program or commercial on all three networks to gain maximum exposure for the content (for example, presidential addresses, political campaign spots, and commercial spots).

rocker Colloquial term for a radio station with a rock music *format*.

roll out The period for developing, producing, and scheduling new programs. Also applied to the Fox Network's multistage plans for filling *prime time*.

rotation In radio, the frequency with which different types of songs are played.

rotation scheduling In television, repeating programs (usually movies) four to six times during a month on different days and often in different *dayparts* to encourage viewing, creating a cumulatively large audience. This technique is used by *pay-cable* and *public television* services. In radio, the pattern of song play.

royalty Compensation paid to copyright holder for the right to use copyrighted material. See also *copyright* and *compulsory licensing*.

run The play of all episodes of a *series* one time or play of a movie.

run-through Staging a proposed show for preview by program executives; this often replaces a script for game shows.

safe harbor Late-night time period in which children are not likely to form a large part of the viewing audience.

same night carriage An agreement between PBS and *public television* stations to air tagged programs on the day and time they are delivered by PBS.

sample size The number of people surveyed (in radio or television, asked to fill out a diary or have a meter installed). See *in-tab*.

sampling frame The population from which a ratings sample is drawn.

sandwich For affiliate news, splitting the local news into two sections placed before and after the network newscast. In promotion, standardized opening and closing segments of a *promo*. See also *Long Sandwich*.

scatter Advertising time purchased on an as-needed basis.

schedule The arrangement of programs in a sequence.

scramble Altering a television transmission so that a proper picture requires a special decoder; the purpose is to prevent unauthorized reception.

screener An assistant who preinterviews incoming callers or guests on participatory programs; also called *call screener*.

screening In research, locating individuals fitting specific age or gender criteria.

seamless transition An *audience flow* scheduling strategy that cuts all interrupting elements at the

break between two programs to move viewers smoothly from one program into the next. This is difficult to achieve because most contracts with producers require playing closing and opening credits, and the advertising time at breaks between programs is especially valuable.

second season Traditionally the 11 to 13 weeks of episodes (of new or continuing programs) beginning in January.

sellout rate The percentage of advertising inventory sold.

sell-through The potential of a movie on videocassette to attract purchase rather than solely rental in video stores.

semipilot A sample videotape version of a proposed game show with audience and production devices (such as music) but no finished set.

series A program that has multiple *episodes* sharing a common cast, plot line, and situation.

service information Hourly reports (in some *dayparts*) on weather, traffic, school closings, sports scores, and other matters of practical value to local listeners.

share A measurement unit for comparing audiences; it represents the percentage of total listening or viewing audience (with sets on) tuned to a given station. The total shares in a designated area in a given time period equal 100 percent.

shelf space Vacancies on the channel array of a cable system.

shock jocks Talk-show *hosts* and *disc jockeys* who attract attention with controversial material; this is generally targeted to adult males with off-color patter and jokes, usually in major markets.

shopping services Cable networks supplying merchandise for purchase as *long-form* programming.

short-form Program material in less than 30-minute lengths on television; typically one to five minutes long for radio. This also refers to *miniseries* that are four to six hours long. Compare with *long-form*.

shorts Very brief programs, usually five minutes or less in length. See also *interstitial programming*.

signal-to-noise ratio The relationship between the amount of transmission noise in a signal and the intended sounds or data.

signature programs Key programs that give identity to a *network* or *station*.

sitcom See *situation comedy.*

situation comedy A program (usually a half hour in length) in which characters react to new plots or altered situations.

skew graphs Bar graphs showing the percentage of each of six demographic groups a station reaches; they are used to compare all stations in a market.

slow-builders Programs acquiring a loyal audience only after many months on the air.

small-market stations Broadcast stations in markets 101 to 212, as defined by the ratings companies. See also *large-market stations, mid-market stations,* and *major market.*

small sweeps July *ratings* period. See *sweeps.*

SMATV Satellite master antenna television, also called master antenna television (MATV); this is satellite-fed television serving multiunit dwellings through a single satellite *earth station*. The service is distributed within a restricted geographic (private property) area not requiring a *franchise* to cross city streets or public rights-of-way. Otherwise similar to cable service, they charge a monthly fee and usually deliver a mix of satellite-distributed pay and basic networks.

soap opera A serial drama generally scheduled on broadcast networks during weekday afternoons. Advertisers (such as laundry detergent manufacturers) targeting homemakers dominate advertising time.

soft news Opposite of *hard*, fast-breaking news; consists of features and reports that do not depend on timely airing (for example, medical reports, entertainment industry stories, leisure, health, and hobby material).

soft rock A radio music *format* consisting of current hits but without heavy metal and other hard rock songs.

special One-time entertainment or news program with special interest; usually applied to *network* programs that interrupt regular schedules.

spin In *pay cable*, the migration of subscribers from one pay service to another; also called *substitution*. See also *spin research*.

spinoff A *series* using a secondary character from another series as the lead in a new prime-time series, usually on the same network. Compare with *clone*.

spin research SRI's method of testing what station time periods work well for a particular show.

spot A commercial advertisement usually of 15 or 30 seconds in length, or a period of time in which an advertisement, a *promo*, or a public service announcement can be scheduled.

stacking Sequential airing of several hours of the same kind of programs; similar to *block programming*.

standard error A statistical term accounting for unavoidable measurement differences between any sample and the population from which it was drawn.

Standards and Practices Department See *Program Practices Department*.

station A facility operated by licensee to broadcast radio or television signals on an assigned frequency; it may be affiliated by contract with a *network* (for example, ABC, NPR) or *independent* (unaffiliated), commercial or noncommercial.

station rep(resentative) Firm acting as the sales agent for client station's advertising time in the national market.

staying power A *series* idea's ability to remain popular year after year.

step deal An agreement to supply funds to develop a program idea in stages from expanded concept statement to scripts to *pilot* to four or more *episodes*.

stockpiling Preemptive buying of syndicated programs for future use that also keeps them off the market and unavailable to competitors. See also *warehousing*.

stop set Interruption of music on radio to air commercials or other nonmusic material.

stringer A freelance reporter paid per story rather than by the hour or the month.

stripping Across-the-board scheduling; putting successive episodes of a program into the same time period every day, five days per week (for example, placing *Star Trek* every evening at 7 P.M.).

strip run/strip slot See *stripping*.

stunting Frequently adding *specials* and shifting programs in the schedule; also using *long-form* for a program's introduction or character *crossovers*. The goal is to attract audience attention and consequent viewership. This technique is frequently used in the week preceding the kickoff of a new fall season combined with heavy *promotion*; also used in *sweeps*.

STV See *subscription television*.

subniche networks Second and third television program services (*networks*) *multiplexed* with the established signal to capture more of the viewing audience. Not to be confused with *microniche networks*, although they may both target small audience groups. Alternatively, subniche networks may reschedule the established network's movies or programs (*time shifting*) to gain large cumulative audiences for the same programming.

subscription television (STV) *Over-the-air* pay television (scrambled).

substitution Cable subscribers replacing one cable pay service with another. See *spin*.

success rate The percentage or number of programs renewed for a second year.

summer schedules A recently introduced *network* practice of scheduling original *series* in the summer. Compare with *second season* and *continuous season*.

superband Channels on a coaxial cable between the broadcast frequencies of channels 13 and 14 (above VHF and below UHF); they require a converter or VCR tuner.

superstation An *independent* television *station* that has its signal retransmitted by satellite to distant cable companies for redistribution to subscribers (for example, WGN-TV from Chicago).

sweepers Bars of music or sound effects accompanying the voicing of a radio station's *call letters* or other identifier on audiotape for play as a recurring station identification.

sweeps The periods each year when Arbitron and Nielsen gather audience data for the entire country; the ratings base from a sweep determines the *network* and *station rates* for advertising time until the next sweep. For television, the four times are November (fall season ratings are most important because they become the ratings base for the rest of the year); February (rates fall season again plus replacements); May (end-of-year ratings); and July, when a small sweep takes place (summer replacements). Radio sweeps occur at different times and vary from 48 weeks to two to six occasions annually depending on market size.

switched video A digital process permitting consumers to select from libraries of program or movie titles for instantaneous viewing, rather like dialing a

telephone number switches the caller to another telephone. See also *video-on-demand*.

switch-in Adding a new cable service to an established lineup (usually involves canceling one existing service).

switch-out Dropping one cable service from an established lineup, generally to replace it with another service.

syndex *Syndicated Exclusivity* rule governing syndication of television programs.

Syndicated Exclusivity Rule Called *syndex*, an FCC rule (reinstated in 1989) requiring cable systems bringing in *distant signals* to block out syndicated programming (usually on *superstations*) for which a local broadcaster owns *exclusive rights*.

syndication Marketing programs on a station-by-station basis (rather than through a *network*) to *affiliates*, *independents*, or *cable systems* for a specified number of *plays*; *syndicators* are companies that hold the rights to distribute programs nationally or internationally. See also *off-network syndication*.

syndication barter The practice in which the advertiser rather than the *station* buys the rights to a *syndicated* program and barters the remaining spots to stations in exchange for airing its own spots free in the program. Same as *barter syndication*.

syndication window The length of time a program, usually a *feature film*, is made available to broadcast stations, generally ranging from three to six years, but it may be as short as two months for pay television. See also *pay window*.

syndicator A company marketing television or radio programs to *stations* and *cable systems* within the United States and in other countries.

tabloid program Sensationalistic news or entertainment shows resembling supermarket tabloid newspapers (for example, *Hard Copy*, *Inside Edition*, *A Current Affair*).

talk A radio *format* characterized by conversation between program *hosts* and callers, interviews, and monologues by personalities.

targeting Aiming programs (generally by selecting appropriate appeals) at a demographically or psychographically defined audience.

teaser A very brief news item or program spot intended to lure a potential audience into watching or listening to the succeeding program or news story; referred to as the "teaser" when used as a program introduction.

telecourses Instructional courses viewed on *public television* or a *cable network*, offered for credit in conjunction with local colleges and universities.

tent-poling Placing a highly rated program between two *series* with lower ratings (often new programs); it is intended to prop up the ratings of the preceding and following programs.

theatricals Movies made especially for showing in motion picture theaters (as opposed to *made-for-TV* or *made-for-cable*).

theme networks Cable networks programming a single type of content such as all-weather, all-news, or all-sports. Also called *niche networks*.

theme weeks Daily movies grouped by genre or star on *independent* television stations.

tier In cable, having multiple levels of cable service, each including some channels and excluding others, offered for a single package price. In syndication, having different price levels for different *dayparts*, pricing going up when *stations* place a syndicated program in a small-audience time period.

tiering Combining cable channels to sell at a package price; this may be only basic services or a combination of pay and basic networks.

time-buyers Advertising agency executives who purchase station time on behalf of client advertisers.

time shifting Scheduling programs or movies at alternate hours for the convenience of viewers (as on *multiplexed* channels); also, playing back a home recording of a broadcast or cable network program for viewing at a time other than when it was originally scheduled.

titles Text portion of a program with the name of the program or stars or credits or source.

tonnage Raw audience size (as opposed to demographic subgroups); used in advertising.

top 40 Radio music *format* consisting of continuous replay of the 40 highest rated popular songs; generally superseded by *CHR* and *AC* except in the largest markets.

tracking Monitoring a syndicated or local program's *ratings* over time, often in several different markets if syndicated.

track record Performance history, as in how a program rated in previous *plays* on other *stations*; also, how a writer/producer worked out on past productions. Network track records are important for predicting how a show will perform in *syndication*.

transponder One of several units on a communications satellite that both receives *uplinked* signals and retransmits them as *downlinked* signals (amplified on another frequency). Some users lease the right from satellite operators to use the entire transponder (40 MHz *bandwidth*); others lease only a part of a transponder's capacity. Currently, most satellites have 24 transponders, and *digital compression* of video signals will greatly increase transponder capacity.

traps Mechanical or electronic devices on telephone poles or ground-level pedestals for diverting premium services away from nonsubscribing households.

treatment Outline of a new program (applied especially to *soap operas*); describes characters and setting of program (before a script is prepared).

trending Graphing *ratings/shares* over a period of time or on a series of stations to anticipate future *ratings/shares*, especially of syndicated *series*; same as *tracking*.

TSL Time-spent-listening, a measurement of continuous tuning to one radio station.

tuning inertia A theory that viewers tend to view the next program on a channel without switching until moved by unacceptable programs to actively switch.

turnkey system An arrangement for turning over a responsibility to a second party. In *pay-per-view* cable, ordering and billing may be handled by a special company or the telephone company. Also, arrangements whereby local and regional cable advertising is sold and inserted within programs by a specialized advertising company rather than by the cable operator. In radio, arrangements whereby an automated radio station is programmed by satellite by another entity.

turnover Changes in the number of subscribers, listeners, or viewers; in cable, the ratio of disconnecting to newly connecting subscribers. See also *churn*.

TvQs Program and personality popularity ratings, typically measuring familiarity and liking, characterized by viewer surveys asking respondents to tell if a program or a personality is "one of their favorites."

TVRO Television receive-only, referring to owners of backyard satellite *dishes* and the home satellite market. See also *DBS*, *downlink*, and *network one stop*.

UHF channels Ultra high frequency television signals having less advantageous positions on the broadcast band than *VHF*, requiring separate receiving antennas in the home. Most public and many commercial *independent* television stations are UHF.

umbrella series An *anthology* television (or radio) program of only broadly related content under an all-encompassing title (for example, *Great Performances*).

unbundling Breaking apart previously grouped programs, services, or channels for separate licensing or member purchase; used in cable and public radio.

underwriter Foundation or private corporation giving grant money to cover the costs of producing or airing a program or *series* on *public television* or radio.

unduplicated Said of programming that is not available on any other local or imported station signal in a market.

uniform channel lineups In cable, having the largest *cable networks* on the same channel numbers on most cable systems nationwide. Compare with *common channel lineup*.

universal lifeline service A minimal cable service for a low monthly fee available to all subscribers. Also called "economy basic" and other names.

universe In cable, the total population of cable subscribers within all franchises.

upfront Advertising time sold in advance of the new program season.

upgrading Adding pay channels at the request of cable subscribers (reverse of *downgrading*).

uplink Ground-to-satellite path; also the sending antenna itself (reverse of *downlink*).

upscale Audiences or subscribers with higher than average socioeconomic demographics, especially income. Compare with *downscale*.

uptrending A pattern of increasing *ratings/shares* over time (reverse of *downtrending*).

value-added promotion Contests, games, and other promotions offering more publicity than just spot advertising on radio, television, or cable to the advertiser.

V-chip An electrnic system requiring the broadcast networks to add a code to each television show that

indicates the amount of violence, sex, strong language, or mature situations in each individual show. Using TV equipped with the V-chip, parents would be able to program the television set to show only those programs deemed appropriate for the family.

VCR Videocassette recorder; used for playback and recording television programs.

vertical documentaries In-depth factual treatment of a subject in many segments broadcast on the same day. See also *horizontal documentaries.*

vertical integration An industry in which the owners of the means of production also own the means of distribution; in cable, a concentration of companies owning both *cable networks* (producers) and *cable systems* (distributors).

vertical ownership Owning both the program supply and the means of distribution; in cable, owning a cable program network as well as cable systems.

vertical scheduling Placing program segments sequentially on one day; also called *vertical stacking.* Used by *independent* stations and *cable networks* in scheduling movies of one type; also used in radio to scatter portions of a taped interview or minidoc throughout the day. Compare to *theme weeks.*

vertical stacking See *vertical scheduling.*

VHF stations Very high frequency; the segment of the electromagnetic spectrum in which television channels 2 to 13 fall, the most desirable broadcast television stations.

videocassette Packaged videotape unit for recording or playback.

videodisc Prerecorded video information on disc for playback only; usually read by laser.

video jockeys (VJs) The announcer/*host* on rock music programs, corresponding to a radio *disc jockey.*

video-on-demand (VOD) Proposed systems for instantaneously delivering to the home only those programs a consumer wants to see.

videos Taped musical performance *shorts* used for promotion and programming (on MTV and others).

videotex Two-way interactive electronic signals requiring telephone line or cable to connect a central computer with the home user's computer screen.

VOD See *video-on-demand.*

voicers Stories prerecorded by someone other than the announcer or *disc jockey.*

warehousing Purchasing and storing *series* and movies primarily to keep them from competitors. See also *stockpiling.*

weighting Statistically matching a sample to the population by increasing the numerical weight given to responses from one or more subgroups.

wheel Visualization of the contents of an hour as a pie divided into wedges representing different content elements; used in radio to visualize a program *format,* showing designated sequences and lengths of all program elements such as musical numbers, news, sports, weather, *features, promos,* PSAs, commercials, IDs, and time checks. See also *hot clock.*

window The period of time within which a network or distributor has the *rights* to show a *feature film* or other program (generally after the first theatrical distribution if the program was not *made-for-pay*); windows vary from a few months to many years. See also *pay window, syndication window,* and *broadcast window.*

wireless cable See *MMDS.*

zapping Erasing commercials on home-taped *videocassettes.* Sometimes used synonymously with *flipping*—changing channels by *remote control* to avoid commercials.

zipping Fast-forwarding through commercials on home-taped *videocassettes.*

zoning Dividing a cable advertising *interconnect* into tiny geographic areas to allow small businesses to purchase ads reaching only specific areas.

Annotated Bibliography

This is a selective, annotated listing of books, articles, guides, reports, and trade magazines on broadcast and cable programs and programming published since 1992 along with some seminal works. An item is included if it contributes unique or otherwise useful insights into the factors affecting television, radio, or cable programming strategy. The bibliography lists major trade publications, books published, and scholarly research articles in journals about programming theory and practice. Additional citations appear at each chapter's end under "Sources" and "Notes." For publications prior to 1992, consult the bibliography and chapter sources to the fourth and previous editions of this book.

Adams, Michael H. *Introduction to Radio: Production and Programming.* Madison, WI: Brown & Benchmark, 1995. A guide to radio programming from a production point of view.

Adams, William J. "TV Program Scheduling Strategies and Their Relationship to New Program Renewal Rates and Rating Changes," *Journal of Broadcasting & Electronic Media 37* (Fall 1993):465–474. A scholarly article on factors affecting program scheduling.

Albarran, Alan B., and Umphrey, Don. "An Examination of Television Motivations and Program Preferences by Hispanics, Blacks, and Whites," *Journal of Broadcasting & Electronic Media 37* (Winter 1993): 95–103. Scholarly article on TV motivations and viewing preferences of 1,241 adults representing three ethnic groups—whites, blacks, and Hispanics.

Anderson, James A., and Meyer, Timothy P. *Mediated Communication: A Social Action Perspective.* Newbury Park, CA: Sage, 1988. Scholarly exposition of accommodation theory explaining media behavior as constructed performance rather than a series of one-way effects.

Assael,. Henry. "Can Demographic Profiles of Heavy Users Serve as a Surrogate for Purchase Behavior in Selecting TV Programs?" *Journal of Advertising Research 34* (January 1994): 11–17. Scholarly article comparing three TV program selection methods to examine consumer purchasing behavior.

Audience Research Sourcebook. Washington, DC: National Association of Broadcasters, 1991. Beginning handbook on radio and television station research for station executives.

Aufderheide, Patricia. "Why Kids Hate Educational TV," *Media Studies Journal 8* (Fall 1994): 21–32. Scholarly article on the lack of educational and informational programming for children on commercial TV.

Auletta, Ken. *Three Blind Mice: How the Networks Lost Their Way.* New York: Random House, 1991. Detailed chronicle of the broadcast television networks during the 1980s, emphasizing changes in ownership and economics.

Baldwin, Thomas F., and McVoy, D. Stevens. *Cable Communications.* Second edition. Englewood Cliffs,

NJ: Prentice-Hall, 1988. Definitive text on the technology, regulation, and operations of cable systems and cable program suppliers, including the Cable Act of 1984; detailed, readable, and scholarly.

Barnes, Beth E., and Thomson, Lynne M. "Power to the People (Meter): Audience Measurement Technology and Media Specialization." In *Audience-making: How the Media Create the Audience*, James S. Ettema and D. Charles Whitney, editors. Thousand Oaks, CA: Sage, 1994. Scholarly report on ratings technology.

Barnouw, Erik. *Tube of Plenty: The Evolution of American Television*. Third edition. New York: Oxford University Press, 1990. Condensed version of his monumental, three-volume *History of Broadcasting in the United States*, this one-volume, authoritative, and readable history of television in the 20th century explores the influences on it.

Beyond the Ratings. Laurel, MD: Arbitron Ratings Company, 1977 to date. Monthly trade newsletter on developments in and applications of Arbitron local radio ratings for broadcasters.

BIB Television Programming Sourcebooks. Philadelphia, PA: North American Publishing, 1996–97 edition. An expensive, annual four-volume listing of theatrical and made-for-TV movies, TV series, specials, and miniseries, including information on distributor, running time, cast and plot, ratings/share, and other information, intended for television station and cable programmers.

Billboard: The International Newsweekly of Music and Home Entertainment. New York, 1888 to date. Weekly trade magazine of the record industry.

Brabec, Jeffrey, and Brabec, Todd. *Music, Money, and Success: The Insider's Guide to the Music Industry*. New York: Maxwell Macmillan International, 1994. Economic aspects of the music industry: Chapter 4 focuses on television, but there is little radio information anywhere in the book.

Brinkley, David. *David Brinkley: 11 Presidents, 4 Wars, 22 Political Conventions, 1 Moon Landing, 3 Assassinations, 2000 Weeks of News and Other Stuff On Television and 18 Years of Growing Up in North Carolina*. New York: Alfred A. Knopf, 1995. An insider's view of television news programming.

Broadcaster: The Magazine for Communicators. 1942 to date. Canadian trade magazine on the radio, television, and cable industries, with especial emphasis on news.

Broadcasting. 1931 to date; cable added in 1972; radio and Washington politics dropped in 1992. Major weekly trade magazine of the broadcasting industry; see "Special Reports" on cable, children's television, independents, journalism, media corporations, radio, reps, satellites, sports, syndication, and television programming listed in this bibliography.

Broadcasting and the Law. Knoxville, TN: Perry Publications, 1972 to date. Twice-monthly newsletter and supplements explaining findings of the Federal Communications Commission, courts, and Congress affecting broadcast operations.

Broadcasting & Cable Market Place (replaced *Broadcasting Yearbook* in 1992). Washington, DC: Broadcasting Publications, 1935 to date, annual. Basic trade directory of radio and television stations and support industries; added cable in 1980.

Brooks, Tim, and Marsh, Earle. *The Complete Directory to Prime Time Network and Cable TV Shows: 1946–Present*. Sixth edition. New York: Ballantine, 1995. Annotated directory of most network television programs with details on casts and content for each show.

Brosius, Hans-Bernd. "The Loyalty of Television Viewing: How Consistent Is TV Viewing Behavior?" *Journal of Broadcasting & Electronic Media* 36 (Summer 1992):321–335. Scholarly article on different conceptualizations of TV loyalty over time with regard to selected channels, preferred program types, and preferred programs within program types.

Cable Marketing. New York: Communications Technology Publications Group, 1981 to 1990. Former monthly trade magazine focusing on management, technology, marketing, and promotion of cable services. In late 1990, the magazine's name was changed to *MSO's Cable Marketing* and its size reduced.

Cable Services Directory. Washington, DC: National Cable Television Association. 1978 to date, annual (title varies). Annual directory of information on individual cable systems including amounts and types of local origination.

Cable Strategies: The Operations and Marketing Journal of the Cable Television Industry. Englewood, CO: Communications Technology Publications Corp.,

1986 to date. Monthly trade magazine featuring brief articles on hot aspects of cable television audience ratings and marketing.

Cable Television Business (formerly, *TVC*). Colorado, 1963 to date. Semimonthly cable industry trade magazine published by Cardiff Publishing Company, focusing on issues and events affecting cable system managers.

Cable Television Developments. Washington, DC: National Cable Television Association, annual. Yearly trade summary of changes in the cable industry with tables and charts.

Cablevision. Denver, CO: Diversified Publishing Group (Capital Cities/ABC, Inc.), 1975 to date. Biweekly cable industry trade magazine devoted to programming, economics, and marketing of cable and related new technologies; in-depth articles and monthly series and cable industry statistics.

Cable World. Denver, CO: Cable World Associates, 1988 to date. Weekly trade articles on national cable programming and other topics from a managerial perspective.

Carroll, Raymond L., and Davis, Donald M. *Electronic Media Programming: Strategies and Decision Making*. New York: McGraw-Hill, 1993. Another perspective on the material in this textbook.

Clifford, Brian R., Gunter, Barrie, and McAleer, Jill. *Television and Children: Program Evaluation, Comprehension, and Impact*. Hillsdale, NJ: Erlbaum, 1995. Report of scholarly research on the effects of programming on children.

Comm/Ent: A Journal of Communications and Entertainment Law. San Francisco: Hastings College of the Law, 1978 to date. Law journal, published quarterly, containing articles summarizing the law on specific issues including broadcasting and new technologies.

Community Television Review. Washington, DC: National Federation of Local Cable Programmers, 1979 to date. Bimonthly newsletter of the NFLCP for local cable programmers, covering public, educational, and government access television on cable and local cable origination.

Cooper, Roger. "An Expanded, Integrated Model for Determining Audience Exposure to Television," *Journal of Broadcasting & Electronic Media* 37 (Fall 1993): 401–418. A scholarly article on predicting the choice of syndicated program based on audience flow.

Cooper, Roger. "The Status and Future of Audience Duplication Research: An Assessment of Ratings-Based Theories of Audience Behavior," *Journal of Broadcasting & Electronic Media* 40 (Winter 1996): 96–111. A scholarly article on audience behavior.

Current. Washington, DC: Public Broadcasting Service, 1981 to date. Weekly Washington newspaper focusing on public broadcasting.

C-SPAN Update. Washington, DC: C-SPAN Network. 1982 to date. Weekly newspaper of program content and issues affecting the broadcasting of public affairs on radio and television.

Daily Variety. Hollywood/New York: Variety, 1905 to date. Trade newspaper of the film and television industries. Daily version of *Variety* magazine oriented toward film and television production and programming.

Danaher, Peter J. "What Happens to Television Ratings During Commercial Breaks?" *Journal of Advertising Research* 35 (January 1995): 37–47. Scholarly article on television audience levels during commercial breaks using second-by-second people-meter data.

Dates, Jannette L., and Barlow, William. *Split Image: African Americans in the Mass Media*. Second edition. Washington, DC: Howard University Press, 1993. A compilation of essays surveying the treatment of black Americans in the media from the 18th century to the present.

David, Nina. *TV Season*. Phoenix, AZ: Oryx, 1976 to date, annual. Annotated guide to the previous season's commercial and public network and major syndicated television programs.

DBS News. Washington, DC: Phillips Publishing, 1983 to date, monthly. Newsletter covering international regulatory, technical, and programming developments in direct broadcasting.

Duncan, James H., Jr., editor. *American Radio*. Kalamazoo, MI: Duncan's American Radio, Inc., quarterly plus supplements. Industry sourcebook for radio ratings and programming information for all markets with extensive tables and charts.

Duncan, James H., Jr., editor. *Duncan's Radio Market Guide*. Kalamazoo, MI: Duncan's American Radio,

Inc., annual. Companion reference volume on the revenue ratings histories and projections for 170 markets, including market descriptions and many charts and tables.

Eastman, Susan Tyler, and Klein, Robert A. *Promotion & Marketing for Broadcasting and Cable*. Second edition. Chicago, IL: Waveland, 1991. Text on strategic planning for marketing networks, stations, and cable systems to audiences and advertisers, with a chapter on promotion and marketing research methods.

Eastman, Susan Tyler, Neal-Lunsford, Jeffrey, and Riggs, Karen E. "Coping with Grazing: Prime-Time Strategies for Accelerated Program Transitions," *Journal of Broadcasting & Electronic Media* 39 (Winter 1995): 92–108. Scholarly article on the types and lengths of transitions between prime-time programs for the four broadcast networks in two seasons.

Eastman, Susan Tyler, and Newton, Gregory. "Delineating Grazing: Observations of Remote Control Use," *Journal of Communication* 45 (Winter 1995): 77–95. Scholarly article on the very limited use of remote control devices.

Eastman, Susan Tyler, and Otteson, Julie Lynn. "Promotion Increases Ratings, Doesn't It? The Impact of Program Promotion in the 1992 Olympics," *Journal of Broadcasting & Electronic Media* 38 (Summer 1994): 307–322. Scholarly article on network spending to promote winter and summer Olympic games.

Electronic Media. Chicago, 1982 to date. Weekly trade periodical published by Crain Communications covering topical news in broadcasting, cable, and new media technologies.

Erickson, Hal. *Television Cartoon Shows: An Illustrated Encyclopedia, 1949 Through 1993*. Jefferson City, NC: McFarland, 1995. Reference material on children's programming.

Evans, Craig Robert. *Marketing Channels: Infomercials, and the Future of Televised Marketing*. Englewood Cliffs, NJ: Prentice Hall, 1994. A handbook on paid program-length commercials.

Facts About PBS. Alexandria, VA: Public Broadcasting Service, July 1991. Annual overview of the activities and audiences of public television and public radio.

Ferguson, Douglas A. "Channel Repertoire in the Presence of Remote Control Devices, VCRs and Cable Television," *Journal of Broadcasting & Electronic Media* 36 (Winter 1992): 83–91. Scholarly report of the number of channels commonly viewed by cable subscribers, VCR users, and remote control users.

Ferguson, Douglas A. "Measurement of Mundane TV Behaviors: Remote Control Device Flipping Frequency," *Journal of Broadcasting & Electronic Media* 38 (Winter 1994): 35–47. Scholarly article on the difficulty of using self-reported audience data to measure remote control activity.

Ferguson, Douglas A., and Perse, Elizabeth M. "Media and Audience Influences on Channel Repertoire," *Journal of Broadcasting & Electronic Media* 37 (Winter 1993): 31–47. Scholarly article describing the relationships among mindful channel repertoire and several media and audience factors.

Fletcher, James E. "The Syndication Marketplace." In *Media Economics: Theory and Practice* (pp. 283–308), Alison Alexander, James Owers, and Rod Carveth, editors. Hillsdale, NJ: Erlbaum, 1993. Economic analysis of syndicated programming.

Friedland, Lewis A. "Public Television as Public Sphere: The Case of the Wisconsin Collaborative Project," *Journal of Broadcasting & Electronic Media* 39 (Spring 1995): 147–176. Scholarly examination of public TV as a public sphere institution through the case of a programming cooperative contributing to the national PBS schedule.

Fuller, Linda K. *Community Television in the United States: A Sourcebook on Public, Educational, and Governmental Access*. Westport, CT: Greenwood Press, 1994. A guide to cable television's PEG channels.

Gitlin, Todd. *Inside Prime Time*. Revised edition. London: Routledge, 1994. Seminal criticism of commercial television.

Greenberg, Bradley S., and Gantz, Walter. *Desert Storm and the Mass Media*. Cresskill, NJ: Hampton Press, 1993. Edited volume of scholarly research on the impact of televised news programming on public opinion.

Gunther, Marc. *The House That Roone Built: The Inside Story of ABC News*. Boston: Little, Brown, 1994. An insider's view of television news programming.

Hayes, Diane Aden. "The Children's Hour Revisited: The Children's Television Act of 1990," *Federal Communications Law Journal 46* (March 1994): 293–328. Scholarly article on the failure of vague federal programming standards.

Head, Sydney W., Sterling, Christopher H., and Schofield, Lemuel B. *Broadcasting in America: A Survey of Electronic Media.* Seventh edition. Boston: Houghton Mifflin, 1994. Basic reference text on American broadcasting, covering technology, economics, regulation, history, social effects, and programming; newest edition contains three chapters on program strategies, network and non-network programs.

Heeter, Carrie, and Greenberg, Bradley S. *Cableviewing.* Norwood, NJ: Ablex, 1988. Unusual examination of the process of choosing channels to view in cable television homes; introduces concepts of viewing style and reports results of several scholarly studies of cable viewers.

Howard, Herbert H. *Ownership Trends in Cable Television.* Washington, DC: National Association of Broadcasters, annually since 1987. Continuing comparative series on the 50 largest cable multiple-system-operations; tables and charts.

INTV Journal: The Magazine of Independent Television. New York: View Communications, 1985 to date. Bimonthly (seven times a year) trade magazine for members of the Association of Independent Television Stations and others interested in the non-network television business.

Jankowski, Gene F. *Television Today and Tomorrow: It Won't Be What You Think.* New York: Oxford University Press, 1995. A view of the future of networks and affiliates, one that predicts a large dose of the past.

Jones, Glenn R. *Jones Cable Television and Information Infrastructure Dictionary.* Fourth edition. Englewood, CO: Jones Interactive, 1994.

Journal of Broadcasting & Electronic Media. Washington, DC: Broadcast Education Association, 1955 to date. Scholarly journal covering research in all aspects of television and radio broadcasting, especially emphasizing those topics with industry impact.

Journal of Radio Studies. Topeka, KS: Washburn University, 1991 to date. Scholarly articles on historical and contemporary radio, including programming.

Kamil, Bobbi L. *Delivering the Future: Cable and Education Partnerships for the Information Age.* Alexandria, VA: Cable in the Classroom, 1994. A reference guide to cable television in education in the United States.

Kassaye, W. Wossen. "TV Stations' Use of Barter to Finance Programs and Advertisements," *Journal of Advertising Research 33* (May 1993): 40–42. Scholarly report on TV station managers' use of barter to deal with the risk of program acquisition.

Keith, Michael C., and Krause, Joseph M. *The Radio Station.* Third edition. Stoneham, MA: Focal Press, 1993. Multiple-authored text on the business of running a radio station.

Klopfenstein, Bruce C. "From Gadget to Necessity: The Diffusion of Remote Control Technology." In *The Remote Control in the New Age of Television,* James R. Walker and Robert V. Bellamy, Jr., editors. Westport, CT: Praeger, 1993. Scholarly study of the development of remote control devices.

Krugman, Dean M. "Visual Attention to Programming and Commercials: The Use of In-Home Observations," *Journal of Advertising 24* (Spring 1995): 1–12. Scholarly examination of eyes-on-screen times for both program and commercial viewing.

Kunkel, Dale. "Children's Television Advertising in the Multichannel Environment," *Journal of Communication 42* (Summer 1992): 134–152. Scholarly report on the nature and amount of advertising during children's programs on broadcast networks, independent stations, and cable networks.

Lee, Teresa A. *Legal Research Guide to Television Broadcasting and Program Syndication.* Buffalo, NY: W.S. Hein, 1995. Information on the laws regarding programming.

Limburg, Val E. *Electronic Media Ethics.* Boston: Focal Press, 1994. Moral and ethical aspects of programming.

Lin, Carolyn A. "Network Prime-Time Programming Strategies in the 1980s," *Journal of Broadcasting & Electronic Media 39* (Fall 1995): 482–495. A scholarly article on prime-time television schedules.

Lloyd, Frank W. *Cable Television Law 1995: Coping with Competition and Regulation.* New York: Practis-

ing Law Institute, 1995. An annual guide to cable regulation.

The LPTV Report. Butler, WI: Kompas/Biel & Associates, monthly since 1985. Trade magazine that is the official information channel of the Community Broadcasters Association, an organization of low-power television broadcasters.

MacDonald, J. Fred. *One Nation Under Television*. Chicago: Nelson-Hall, 1994. An historical analysis of the growth and decline of ABC, CBS, and NBC, focusing on programming trends, updated and enlarged.

MacFarland, David T. *Contemporary Radio Programming Strategies*. Hillsdale, NJ: Lawrence Erlbaum, 1990. Text on the role of radio in society, format structure, personalities, and production procedures.

Miller, Phil. *Media Law for Producers*. Second edition. White Plains, NY: Knowledge Industry Publications, 1993. A handbook for producers covering such topics as litigation and arbitration, contracts, copyright, releases, privacy, licensing music, royalties, and union employees.

Minow, Newton N., and LaMay, Craig L. *Abandoned in the Wasteland: Children, Television, and the First Amendment*. New York: Hill and Wang, 1995. A critical look at children's television programming.

MSO: The Magazine of Cable System Operations. Denver, CO: Communications Technology Publications, Corp., 1989 to date. Trade magazine targeting cable operators, including technology, programming, and marketing for cable systems.

Multichannel News: The Newspaper for the New Electronic Media. New York, 1979 to date. Weekly trade newspaper of regulatory, programming, financial, and technical events affecting electronic media.

NAB Legal Guide to FCC Broadcast Law & Regulation. Washington, DC: National Association of Broadcasting. Regularly updated. Loose-leaf one-volume compilation of selected FCC broadcasting regulations (many on programming) with analysis and commentary designed for station managers.

NAB News. Washington, DC: National Association of Broadcasters, 1989 to date. Monthly reports on during 1989–90 on developments in federal regulation, ratings research, and other matters affecting broadcasters, later becoming a report on the NAB convention.

National Federation of Local Cable Programmers. *Cable Programming Resource Directory 1987*. Washington, DC: Broadcasting Publications, 1987. A guide to local cable program centers and organizations supplying full-length noncommercial programs and public service announcements.

NATOA News. 1980 to date. Bimonthly newsletter of the National Association of Telecommunications Officers and Advisors and the National League of Cities. Short reports on current events affecting local cable franchise regulation and technology, including legislative updates.

NATPE International Newsletter (formerly *NATPE Programmer*). Washington, DC: National Association of Television Program Executives, 1990 to date. Monthly trade newsletter of the national programmers' association.

New York Times. 1850 to date. Daily and Sunday national newspaper covering business and entertainment aspects of broadcasting and cable television.

Nielsen Media Research. *What TV Ratings Really Mean: How They Are Obtained, Why They Are Needed*. New York: Nielsen Media Research, 1993. A guide to ratings information from Nielsen.

1990 Cable and Station Coverage Atlas. Washington, DC: Warren Publishing, 1989 to date. Annual reference source for broadcasters and cable operators showing locations of all cable systems, contour maps, and listings of all stations and cable systems by market, county, and state.

Noam, Eli M., and Millonzi, Joel C., editors. *The International Market in Film and Television Programs*. Norwood, NJ: Ablex, 1993. Scholarly report on developments in international program syndication and national restrictions.

Norberg, Eric G. *Radio Programming: Tactics and Strategy*. Newton, MA: Focal Press, 1996. This textbook presents another perspective on radio programming strategy.

The Pay TV Newsletter. Carmel, CA: Paul Kagan Associates, 1983 to date. Weekly trade summaries of analyses and events affecting premium cable television.

Perse, Elizabeth M., and Ferguson, Douglas A. "The Impact of the Newer Television Technologies on Television Satisfaction," *Journalism Quarterly 70* (Winter 1993): 843–853. Scholarly study focused on the gratifications of remote control devices and cable TV.

Picard, Robert G. *The Cable Networks Handbook.* Riverside, CA: Carpelan, 1993. A reference guide to the cable network channels.

Pringle, Peter K., Starr, Michael F., and McCavitt, William. *Electronic Media Management.* Third edition. Boston: Focal Press, 1995. Text covering managerial issues and functions, including programming, at broadcast stations and for cable systems.

Producers Quarterly. Port Washington, NY: Producers Quarterly Publications, 1991 to date. Trade magazine for executives in the movie and television production business, covering developments in production technology and animation, production problems and success stories, and interviews with producers.

Radio & Records: The Industry's Newspaper. Los Angeles, weekly, 1974 to date. Trade magazine of the record industry ranking songs and albums.

Radio Only: The Monthly Management Tool. Cherry Hill, NJ. 1981 to date. Monthly trade magazine covering issues of concern to radio station managers and programmers.

RadioWeek. Washington, DC: National Association of Broadcasters, 1960 to date. Weekly newsletter on matters affecting radio broadcasters, including proposed changes in federal regulations and standards.

R&R Ratings Report. Los Angeles: Radio & Records, Inc. Semiannual special reports on the state of radio programming.

Rather, Dan. *The Camera Never Blinks Twice: The Further Adventures of a Television Journalist.* New York: W. Morrow, 1994. An insider's view of television news programming.

Religious Broadcasting. 1968 to date. Monthly magazine emphasizing evangelical broadcasting on radio and television with informal style.

RTNDA Communicator. 1946 to date. Monthly newsletter of the Radio-Television News Directors Association.

Rust, Roland T. "Viewer Preference Segmentation and Viewing Choice Models for Network Television," *Journal of Advertising 21* (March 1992): 1–18. Scholarly attempt to construct a program model to explain the relationship between programs and viewer decisions.

Sackett, Susan. *Prime-Time Hits: Television's Most Popular Network Programs, 1950 to the Present.* New York: Billboard Books, 1993. A compilation of successful prime-time series.

Satellite Times: The News Source for the Home TVRO and Cable Industries. Shelby, NC: Triple D Publishing, 1986 to date. Biweekly trade periodical concentrating on home satellite and cable-only industries.

Schlegel, Julia W. "The Television Violence Act of 1990: A New Program for Government Censorship?" *Federal Communications Law Journal 46* (December 1993): 187–217. Scholarly criticism of the effectiveness of federal rules to limit violent program content.

Shapiro, Mitchell E. *Television Network Prime-Time Programming, 1948–1988.* Jefferson, NC: McFarland, 1989. A useful reference book exhaustively listing all television network programs, divided by night of the week and month.

Shapiro, Mitchell E. *Television Network Daytime and Late-Night Programming, 1959–1989.* Jefferson, NC: McFarland, 1990. A companion reference book giving an exhaustive month-by-month listing of daytime and late-night network TV programs for ABC, CBS, NBC, and Fox, including charts, series premieres, cancellations, and programming moves.

Shapiro, Mitchell E. *Television Network Weekend Programming, 1959–1990.* Jefferson, NC: McFarland, 1992. The third in a series, this volume is on weekend network programs, listing all network television shows aired on Saturdays and Sundays, with reference charts and tables.

Sherman, Steve M. "Determinants of Repeat Viewing to Prime-Time Public Television Programming," *Journal of Broadcasting & Electronic Media 39* (Fall 1995): 472–481. A scholarly article on PTV viewing.

Smith, Anthony, editor. *Television: An International History.* New York: Oxford University Press, 1995. A history of international television programs.

Somerset-Ward, Richard. *Quality Time? The Report of the Twentieth Century Fund Task Force on Public Television.* New York: Twentieth Century Fund Press, 1993.

Special Reports—Cable. "Telephony to Star at NCTA," *Broadcasting & Cable* (April 24, 1995): 44–45; "Cable's New Competition: Cities," *Broadcasting & Cable* (October 2, 1995): 42–43. Series of articles on cable's role in multichannel programming.

Special Reports—Independents. "Independents Emphasize Creative Approach," *Broadcasting & Cable* (January 23, 1995): 86–88. Special article on independent television stations in the late 1990s and beyond.

Special Reports—Radio. "Syndication Brings Big Names to Smaller Markets," *Broadcasting & Cable* (June 13, 1994): 34–35; "Network Radio Ratings Dip," *Broadcasting & Cable* (September 18, 1995): 37–38; "Syndicated Shows Rise as Satellite Costs Fall," *Broadcasting & Cable* (May 17, 1993): 38.

Special Reports—Sports. "Baseball's New TV Rights Contract," *Broadcasting & Cable* (November 13, 1995): 16; "Fox NFC Telecasts Score a Touchdown," *Advertising Age* (January 23, 1995): 8; "Satellite Sports: Stealthy Sidebar?" *Variety* (January 16, 1995): 33, 36; "NBA: Ball-to-Ball Coverage," *Broadcasting & Cable* (May 2, 1994): 20–22. Analyses of professional and college sports on television from a broadcasting industry perspective.

Spragens, William C. *Electronic Magazines: Soft News Programs on Network Television.* Westport, CT: Praeger, 1995. A guide to reality programming on prime-time television.

Station Policy and Procedures: A Guide for Radio. Second edition. Washington, DC: National Association of Broadcasters, 1991. Practical handbook for station executives covering legal considerations and promotional strategies.

Sterling, Christopher H., and Kittross, John M. *Stay Tuned: A Concise History of American Broadcasting.* Second edition. Belmont, CA: Wadsworth Publishing Company, 1990. Exhaustive scholarly text on the history of the electronic media, packed with tables and charts.

The Television Audience. Northbrook, IL: A.C. Nielsen Company, 1959 to date, annual. Trends in television programming and audience viewing patterns.

Television Digest. Washington, DC: Warren Publishing, Inc., 1945 to date. Weekly trade summary of events affecting the television business.

Terrace, Vincent. *Television Character and Story Facts: Over 110,000 Details from 1,008 Shows, 1945–1992.* Jefferson, NC: McFarland & Co., 1993. Reference material on prime-time programming.

TV Today. Washington, DC: National Association of Broadcasters, 1970 to date. Weekly newsletter addressing matters of interest to broadcast station members, including developments in technology, regulation, and member services.

Vane, Edwin T., and Gross, Lynne S. *Programming for TV, Radio, and Cable.* Boston: Focal Press, 1994. Another perspective on the material in this textbook.

Variety. New York and Hollywood, 1925 to date. Weekly trade newspaper covering the stage and the film, television, and recording industries.

Walker, James R. "Catchy, Yes, But Does It Work?: The Impact of Broadcast Network Promotion Frequency and Type on Program Success," *Journal of Broadcasting & Electronic Media* 37 (Spring 1993): 197–207. Scholarly article on the effectiveness of promotions in stimulating interest in new and returning network programming.

Walker, James R., and Bellamy, Robert V., Jr. *The Remote Control in the New Age of Television.* Westport, CT: Praeger, 1993. An edited volume of scholarly studies that examine remote control use.

Waterman, David. "'Narrowcasting' and 'Broadcasting' on Nonbroadcast Media: A Program Choice Model," *Communication Research* 19 (February 1992): 3–28. Scholarly article on economic models of program choice.

Waterman, David. "The Economics of Television Program Production and Trade in Far East Asia," *Journal of Communication* 44 (Summer 1994): 89–111. Scholarly article examining programming on 34 broadcast TV networks in 9 Far East Asian countries.

Waterman, David. "Vertical Integration and Program Access in the Cable Television Industry," *Federal Communications Law Journal* 47 (April 1995): 511–534. Scholarly article on how the FCC prohibits

vertically integrated cable programmers from any price discrimination.

Webster, James G. "Structural Determinants of Exposure to Television: The Case of Repeat Viewing," *Journal of Broadcasting & Electronic Media 36* (Spring 1992): 125–136. Scholarly article on how the audience for one program watches subsequent episodes.

Webster, James G., and Lichty, Lawrence W. *Ratings Analysis: Theory and Practice*. Hillsdale, NJ: Lawrence Erlbaum Associates, 1991. Text describing and analyzing audience ratings data for industry and scholarly ratings users, covering applications, collection methods, and models for data analysis.

Wicks, Jan LeBlanc. "Does Infomercial Clearance Vary by Managerial, Organizational, and Market Factors?" *Journal of Broadcasting & Electronic Media 38* (Spring 1994): 229–239. Scholarly article on how stations decide to clear television infomercials.

Wimmer, Roger D., and Dominick, Joseph R. *Mass Media Research: An Introduction*. Fourth edition. Belmont, CA: Wadsworth, 1994. Revised text on applied research methods in mass media emphasizing broadcasting; includes survey methods and peoplemeter ratings.

Wyche, Mark C., Trautman, James M., and Bortz, Paul I. *Sports on Television: A New Ball Game for Broadcasters*. Washington, DC: National Association of Broadcasters, March 1990. Report on the trends in sports carriage and associated economic and public policy issues, prepared by Bortz & Company, Inc.

Youn, Sug-Min. "Program Type Preference and Program Choice in a Multichannel Situation," *Journal of Broadcasting & Electronic Media 38* (Fall 1994): 465–475. Scholarly study of viewers' program choices in a multichannel situation compared to a broadcast-channel-only situation.

About the Contributing Authors

William J. Adams, associate professor at Kansas State University in the Department of Radio-Television since 1986, completed his Ph.D. at Indiana University in 1988. He holds an M.A. from Ball State University in journalism and a B.A. from Brigham Young University. He has published extensively as a journalist and scholar, especially focusing on network prime-time programming. His articles have appeared in the *Journal of Communication*, the *Journal of Broadcasting & Electronic Media*, and the *Journal of Media Economics.* He has also been published in such periodicals as *NAB Magazine* and *Feedback.* His research on network programming trends was supported by grants from the National Association of Broadcasters, and he has won awards from the Broadcast Education Association.

Robert B. Affe is a broadcasting executive, attorney, and teacher. He is program manager at WTOG-TV, Tampa-St. Petersburg, Florida, one of the most venerable independent television stations in America. As a communications attorney in Washington, D.C. during the early 1980s, he represented station clients before the FCC and worked with international broadcasters. He helped found WTXX-TV, Hartford-New Haven, in 1982, the first independent in the state of Connecticut, becoming the station's program director in 1983. In 1985 he moved to Cleveland as program manager for the construction and sign-on of WOIO-TV. Two years later Mr. Affe joined Hubbard Broadcasting's WTOG-TV. A graduate of George-

town University (A.B.) and the New York University School of Law (J.D.), he has been admitted to practice before the New York State Supreme Court and the District of Columbia Court of Appeals. He contributes to industry trade periodicals, is active in the National Association of Television Program Executives, serves as a program and operations consultant to independent stations, and is adjunct professor of Mass Communications at the University of South Florida, in Tampa, where he designed and teaches two courses: Broadcast Management and Communications Law.

Edward G. Aiken is president and general manager of WTOG-TV, Tampa-St. Petersburg, Florida. He gained experience as producer/director and promotion manager at WBAY-TV in Green Bay, Wisconsin, before going to WNEM-TV in Saginaw, Michigan, as program director in 1970. He joined KPHO-TV in Phoenix, Arizona, in the same capacity in 1973. In the 1970s KPHO became a leading independent television station, winning against affiliate competition in several time periods and creating a programming model for other independents. In 1980 Mr. Aiken became vice-president/director of programming for Petry Television, Inc., one of the largest station representative firms in New York. He specialized in syndicated television programming, especially movies, for independent client stations, advising stations on syndicated purchases and scheduling, and representing the rep point of view as an industry spokesperson. In

445

1984 he became vice-president and general manager of Pappas Telecasting's KMPH-TV in Fresno, California. The following year, he was named senior vice-president of Pappas Telecasting as well as vice-president and general manager of a second station, WHNS-TV in Asheville, North Carolina. In 1986 Mr. Aiken joined Hubbard Broadcasting's WTOG-TV. He has had wide experience with television station strategies.

Nick Alexander, vice-president and general manager of Loomis Productions, began his professional radio career at KAND in Corsicana, Texas, becoming program director before moving to larger markets. He served variously as disc jockey and music director in stations in Tyler, Texas, Ft. Worth, Texas, and Fresno, California, eventually becoming operations manager of KYNO-FM for the Drake-Chenault organization. In 1976, he moved back to KLIF in Dallas working for Edd Routt as a disc jockey, music director, and assistant program director, later joining him as programmer for WKRG-FM in Mobile, Alabama. In 1979 Alexander became production director of WFAA Newstalk 57 and KZEW in Dallas. In 1984, he shifted to KVIL as operations manager. In 1988 he moved out on his own as a freelance voice talent and advertising agency executive.

Jeffrey Bernstein, vice-president of programming and marketing for Request Television, the multichannel PPV subsidiary of Reiss Media Enterprises, Inc., heads up all studio relations and programming efforts for the network's five PPV channels and is in charge of marketing and public relations. He came to Request Television after ten years at Warner Brothers Pay-TV, Cable & Network Features, where he was vice-president, marketing and responsible for all PPV licensing and marketing. Mr. Bernstein is also the founder of Cable Positive, the cable industry's AIDS Action Organization. He is a native of Gladwyne, Pennsylvania, and received his B.A. in Economics from Columbia University.

Dwight E. Brooks, assistant professor in the Department of Telecommunications at Indiana University, Bloomington, teaches and does research in broadcast and cable programming. Brooks also teaches and publishes in cultural studies, with particular emphasis on advertising and consumer culture. He also writes on African Americans and mass media. Before joining

the faculty at Indiana University in 1992, he taught at Illinois State University. Brooks has a B.A. from East Stroudsburg University, an M.A. from the Ohio State University, and a Ph.D. from the University of Iowa. He has received a Faculty Development Grant from the National Association of Television Program Executives. He serves on the Bloomington Telecommunications Council (which monitors the local cable franchise) and is a regular participant at the national shows of the National Cable Television Association. Brooks also has extensive experience in professional radio and produced *Landscapes in Color* for WFIU-FM, Bloomington, Indiana.

Susan Tyler Eastman, associate professor of telecommunications at Indiana University, teaches, publishes, and consults in cable programming. She has published journal articles on research methods as well as many books on programming and related topics. She is co-author of "Promotion and Market Research" in Susan Tyler Eastman and Robert A. Klein's *Promotion & Marketing for Broadcasting & Cable* (Waveland, 1991) and author of "Community Service Promotion" in McKinsey and Company's *Radio in Search of Excellence: Lesson from America's Best-Run Radio Stations* (National Association of Broadcasters, 1985). She co-authored and edited *Promotion & Marketing for Broadcasting & Cable* (Wadsworth, 1982; Waveland 1991) and all five editions of this book—*Broadcast/Cable Programming: Strategies and Practices* (Wadsworth, 1981, 1985, 1989, 1992, 1997). Both books received Broadcast Preceptor Awards from San Francisco State University for their contributions to knowledge about the industry. Eastman also contributed the programming chapters in S. Head and C. Sterling's classic *Broadcasting in America*, 5th and 6th editions (Houghton Mifflin, 1987, 1990) and its brief edition (1991), authored chapters on cable programming for French- and Spanish-language publications, and contributed chapters on programming to books on sports (1989) and the influence of the remote control device (1992). In addition, she researches and writes about the role of computers in teaching writing skills. Before joining the faculty at Indiana University in 1981, she taught at Temple University in Philadelphia. She has a B.A. from the University of California at Berkeley, an M.A. from San Francisco State University, and a Ph.D. from Bowling Green State University. In 1980 she was awarded a charter faculty

internship by the National Association of Television Program Executives at WCAU-TV in Philadelphia. She served as chair of the Bloomington Telecommunications Council, which monitors the local cable franchise and consults on cable television. She also has producing and directing credits and regularly conducts seminars and workshops about programming.

Douglas A. Ferguson, associate professor of telecommunications at Bowling Green State University, was program director of NBC-affiliated WLIO(TV) in Lima, Ohio, from 1976 to 1987. During that period WLIO regularly achieved 70 percent shares in its local news programming and featured the most popular syndicated programs. Before returning to graduate school, he was a member of NATPE (National Association of Television Program Executives). His doctoral dissertation explored the relationship between lead-in/lead-out program shares and markets with varying penetration of VCRs and cable television. Since 1990 he has taught media management and television programming strategies. His research on remote control devices appears in various research journals. He also serves as assistant dean for resources and planning in the College of Arts and Sciences at BGSU.

John W. Fuller, director of research at PBS, came to the national public network in 1980 as head of the research department in Alexandria. He started in television as studio director of WJKS-TV in 1966 in Jacksonville, Florida, moving to promotion manager in 1968. He then became research director for WTLV-TV in Jacksonville, and soon served as program manager as well at the same station from 1972 to 1976. From there he went to Arbitron as research project manager in Laurel, Maryland, moving to the Public Broadcasting Service four years later. He holds a B.A. in radio-television from Florida State University and an M.A. from the University of Florida in communications research. As research director for PBS, he oversees a seven-person department responsible for program performance analyses, daily tracking of prime-time program audiences, management of market research projects, collection of national carriage data, and research consultation and support for PBS and public television station staff.

Timothy P. Meyer, professor of communication on the faculty of Information and Computing Sciences at the University of Wisconsin-Green Bay, holds the Ben J. and Joyce Rosenberg professorial chair. He actively consults in marketing and advertising research and works in organizational and management communication. He is co-author of *Advertising Research Methods* (Prentice-Hall, 1992), *Mediated Communication: A Social Action Perspective* (Sage, 1988), and "Sports Programming: Economics and Scheduling," in *Media, Sport & Society*, Lawrence Wenner, editor (Sage, 1990). In addition, Dr. Meyer has published numerous chapters and papers on programming and marketing in scholarly journals and edited books. He received his B.A. from the University of Wisconsin and his M.A. and Ph.D. from Ohio University. Before joining the University of Wisconsin, he taught at the University of Texas at Austin and the University of Massachusetts, Amherst.

Jeffrey Neal-Lunsford, assistant professor at Central Missouri State University, has industry experience in radio on-air and television production. After getting his Ph.D. from Indiana University–Bloomington in 1993, he taught at Kansas State University. His B.A. and M.A. are from Drake University. His dissertation proposed and tested a model for analyzing the aesthetics of animated films. He has published an article on early televised sports in *The History of Sport Journal*, coauthored a chapter on the remote's impact on programming in Walker and Bellamy's *The Remote Control in the New Age of Television* (1993) with Susan Tyler Eastman, and coauthored two research studies on programming structures (one funded by an NAB grant) published in the *Journal of Broadcasting & Electronic Media*. He has taught courses in television and radio production, programming, promotion, media history and policy, and media aesthetics.

Jeffrey C. Reiss, chairman, president, and chief executive officer of Reiss Media Enterprises, Inc., founded Request Television and its five PPV national services, now co-owned by Tele-Communications, Inc. and Twentieth Century Fox. Reiss Media Enterprises is a leader in the distribution and licensing of pay-per-view programming domestically and a pioneer internationally. Before forming his own company in 1984, Mr. Reiss was instrumental in founding Showtime and later the Cable Health Network, which subsequently merged with Daytime to form the basic cable network now known as Lifetime. Mr. Reiss served as president and chief executive

officer of both networks. Mr. Reiss is credited with developing the concept of multipay marketing while with Showtime and was responsible for several original pay-cable productions, including the first made-for-pay series, *What's Up America*. Before joining Viacom, Mr. Reiss was director of feature films for ABC Entertainment (1973–1976), where he helped pioneer the two-hour made-for-TV movie. He joined ABC from Cartridge Television, Inc., the manufacturer of the first home videocassette recorder, where he directed program acquisitions and development. As a partner in Kleiman-Reiss Productions, he presented several theatrical productions. Earlier in his career, he worked as a story editor for Norman Lear's Tandem Productions and in the literary department of General Artists Corporation. Mr. Reiss has taught at Brooklyn College and New York University.

David Sedman, assistant professor in the Center for Communication Arts at Southern Methodist University since 1994, teaches broadcast-oriented courses. Before moving to SMU, he was an assistant professor at the University of Arkansas-Little Rock. He holds a Ph.D. from Bowling Green State University in 1990 and a B.A. and M.A. from Southern Illinois University-Carbondale. He has published as a television critic in newspapers and presented papers devoted to programming trends at conferences. In 1990, he was awarded a fellowship from the National Association of Television Program Executives (and is a current member of NATPE's College Television Society).

Mitchell E. Shapiro, assistant dean and professor in the School of Communication at the University of Miami, Florida, has been program director for the school's broadcasting and broadcast journalism programs since 1982. Before moving to Miami, he was an assistant professor at Illinois State University. He earned a B.A. at the University of Miami and an M.S. and Ph.D. at Florida State University. He authored *Television Network Prime-Time Programming, 1948–1988* (MacFarland, 1989), *Television Network Daytime and Late-Night Programming, 1959–1989* (MacFarland, 1990), and *Television Network Weekend Programming, 1959–1990* (MacFarland, 1992). He regularly consults for television stations and teaches courses in programming and audience measurement and analysis. In addition, he has published scholarly articles and presented papers at professional association meetings on programming history, theory, and strategy.

John von Soosten is former senior vice-president and director of programming for Katz National Television, part of Katz Media Group, the largest television representative firm, with more than 350 client stations. The Katz Programming Department provides clients with programming research and advises stations on programming decisions. Before joining Katz in 1984, Mr. von Soosten was vice-president and program manager for five years at Metromedia's WNEW-TV (now WNYW-TV) in New York. Prior to that, he was production manager at WNEW-TV for eight years. Earlier in his career, Mr. von Soosten taught television production at the college level and was a production technician at WOR-TV (now WWOR-TV) in New York. Mr. von Soosten holds a B.S. degree from Ithaca College and an M.S. from Brooklyn College. He has been president of the National Association of Television Program Executives (NATPE), vice-president of the International Radio Television Foundation (IRTF), and secretary of the NATPE Educational Foundation.

Jeffrey S. Wilkinson, assistant professor of broadcasting, received a B.S. in broadcasting from the University of Florida, his M.A. in journalism, and a Ph.D. in mass communication from the University of Georgia. Dr. Wilkinson held several positions in radio and television from 1979 to 1985 in Florida and Georgia including news director, talk show host, anchor, reporter, production director, and announcer. In November, 1983, he received an AP radio news award for his eyewitness account of an execution; in 1984 he was commended by the Alachua County sheriff's department for assisting in the capture of a murder suspect. He has been involved with research on advertising copytesting and cable franchise price configurations. Dr. Wilkinson has presented papers at various conferences and co-authored research appearing in *Journalism Quarterly* and *Journal of Mass Media Ethics*. His research interests include commercial and college radio management and programming, broadcast news processes and effects, ethics, and new technologies.

Bookmarks for the World Wide Web

Please note:

- This list was current for August 1996. It is continually updated on the homepage for this textbook at *http://www.wadsworth.com*
- If you encounter difficulties with any of the addresses, try entering the minimal URL address by deleting any material after the ".com"
- You may also link to a list of bookmarks from the homepage for one of the authors: *http://www.bgsu.edu/~dfergus*

General Interest Sites

http://tvnet.com
http://www.broadcastingcable.com/glos.htm
http://www.fcc.gov
http://www.nab.org
http://www.natpe.org

Updates and News Summaries

http://www.broadcastingcable.com
http://www.multichannel.com
http://web.bu.edu/COM/html/comnews.html
http://www.mediacentral.com
http://www.tvspy.com

Schedules

http://www.iguide.com/tv/tvguide/ez/
http://www.clickTV.com

Ratings Research

http://www.nielsen.com/home/media/med-res.htm
http://www.arbitron.com
http://www.playlist.com/accu.html
http://www.katz-media.com/index.html

Broadcast Networks

http://www.abc.com
http://www.cbs.com
http://www.nbc.com
http://www.foxnetwork.com
http://www.warnerbros.com
http://www.upn.com
http://www.pbs.org

Cable Networks

http://www.paytv.com
http://www.usa-network.com
http://www.cnn.com
http://www.hbo.com
http://comcentral.com
http://www.betnetworks.com
For others, see *http://tvnet.com/tv/us/cable.html*

DBS

http://www-dma-net.digex.net/prime/
http://www.directv.com
http://www.ussbtv.com
http://www.teecomm.com/alpha.html
http://www.echostar.com
http://www.delphi.com/info.htm

Radio

http://www.rronline.com
http://abcradio.ccabc.com
http://www.npr.org
http://www.allaccess.com

Media Organizations and Associations

See the list in 1.9 on page 22 of this textbook.

Index to Program Titles

This is a guide to specific television, radio, and cable **programs** and **movies** mentioned in the text. (Television, radio, and cable **networks** appear in the General Index.)

General Index

Definitions and major text references appear in **boldface**.

DATE DUE

NO 07 00			
NO27 00			
DEC 18 00			